Sun Symbolism
and Cosmology
in Michelangelo's
"Last Judgment"

Habent sua fata libelli

Sixteenth Century Essays & Studies Series

General Editor
Raymond A. Mentzer
Montana State University–Bozeman

Editorial Board of Sixteenth Century Essays & Studies

Elaine Beilin
Framingham State College

Miriam Usher Chrisman
University of Massachusetts—Amherst

Barbara B. Diefendorf
Boston University

Paula Findlen
Stanford University

Scott H. Hendrix
Princeton Theological Seminary

Jane Campbell Hutchison
University of Wisconsin—Madison

Christiane Joost-Gaugier
University of New Mexico

Robert M. Kingdon
University of Wisconsin, Emeritus

Roger Manning
Cleveland State University

Mary B. McKinley
University of Virginia

Helen Nader
University of Arizona

Charles G. Nauert
University of Missiouri, Colmubia

Theodore K. Rabb
Princeton University

Max Reinhart
University of Georgia

John D. Roth
Goshen College

Robert V. Schnucker
Truman State University, emeritus

Nicholas Terpstra
University of Toronto

Merry Wiesner-Hanks
University of Wisconsin–Milwaukee

Valerie Shrimplin

Sun Symbolism and Cosmology in Michelangelo's "Last Judgment"

Sixteenth Century Essays & Studies 46

Truman State University Press
Kirksville, Missouri

ND
623
.B9
A69
2000

Copyright © 2000
Truman State University Press, Kirksville, MO 63501
www2.truman.edu/tsup
All rights reserved
Printed in the United States of America

Library of Congress Cataloging-in-Publication Data

Shrimplin, Valerie
 Sun-symbolism and cosmology in Michelangelo's Last Judgment / by Valerie
Shrimplin.
 p. cm. — (Sixteenth century essays & studies ; v. 46)
 Based on the author's thesis (doctoral—University of the Witwatersrand,
Johannesburg, 1991).
 Includes bibliographical references and index.
 ISBN 0-943549-65-5 (Alk. paper)
 1. Michelangelo Buonarroti, 1475–1564. Last Judgment. 2. Michelangelo
Buonarroti, 1475–1564 Themes, motives. 3. Cosmology in art. 4. Symbolism
in art. 5. Judgment Day in art. I. Title. II. Series.
 ND623.B9 A69 2000
 759.5—dc 21 98-006646
 CIP

Cover: Teresa Wheeler, Truman State University designer
Composition: BookComp, Inc.
Printing: Sheridan Books
Body text: Berkeley Display type: Morticia

No part of this work may be reproduced or transmitted in any format by any means,
electronic or mechanical, including photocopying and recording or by an information
storage or retrieval system, without permission in writing from the publisher.

♾ The paper in this publication meets or exceeds the minimum requirements of the
American National Standard—Permanence of Paper for Printed Library Materials, ANSI
Z39.48 (1984).

LONGWOOD COLLEGE LIBRARY
FARMVILLE, VIRGINIA 23901

Photo Credits

Figs. 1, 51, 52, 53, 54, 55, 56, 57, 58, 59, 60, 61, 62, 63, 112, 113, 114, 124. Monumenti e Gallerie Pontificie, Città del Vaticano.

Fig. 2, Houghton Library, Harvard University.

Figs. 5, 8, 9, 10, 11, 12, 18, 19, 20, 29, 30, 31, 33, 34, 35, 36, 37, 38, 39, 40, 43, 44, 46, 47, 48, 63, 66, 70, 72, 73, 75, 81, 83, 87, 107, 112, 117, 118. Alinari/Art Resource, New York.

Fig. 6, Bayerisches National Museum.

Fig. 7, Prado, Madrid.

Figs. 14, 15, Biblioteca Apostolica Vaticana.

Figs. 16, 65, 78, 95, Biblioteque Nationale de France.

Fig. 17, Herzong Library, Wolfenbuttel.

Figs. 22, 23, 24, 26, 28, 68, Giraudon, Paris.

Fig. 25, Katy Shrimplin.

Figs. 27, 81, Metropolitan Museum of Art.

Fig. 41, Pinacoteca, Bologna.

Figs, 42, 69, 84, 118, Bayer, Staatgemaldesammelugen, Munich.

Fig. 46, Chapin Library, Williams College, Mass.

Fig. 50, Doucet, S.P.A.D.E.M.

Figs. 51, 52, 126, 127, Valerie Shrimplin.

Fig. 70, RIBA.

Fig. 82, Staatliche Graphische Sammlung, Munich.

Figs. 87, 89, British Museum.

Fig. 89, Royal Library, Windsor Castle, reproduced by permission of Her Majesty the Queen.

Fig. 91, Barry Moser/University of California Press.

Fig. 97, Biblioteca Trivulziana/Foto Saporetti Milan.

Figs. 98, 103, 104, 105, 107, Bildarchiv Preussischer Kulturbesitz Berlin.

Fig. 99, Biblioteca nationale Florence/Donato Pineider, Florence.

Figs. 101, 102, 106, 108, British Library.

Fig. 117, Kunshistorisches Museum, Vienna.

Fig. 116, Courtesy of Museum of the Jagiellonian University, Kracow. Photo by Janusz Kozina, 1992.

Figs. 119, 120, Bayerische Staatsbibliothek, Munich.

Fig. 125, Huntington Library, San Marino, California.

Contents

Illustrations

Preface

Michelangelo has imitated those great philosophers
who hid the greatest mysteries of human and divine
philosophy under a veil of poetry that they might not
be understood by the vulgar.
 Pietro Aretino on Michelangelo's Last Judgment

Contemporary comment by Pietro Aretino on Michelangelo's fresco of the *Last Judgment* in the Sistine Chapel indicates an awareness of hidden symbolic meaning in the fresco soon after its completion and unveiling in 1541. Explanation of the "most profound allegorical meanings, understood by few" and the identification and importance of biblical and literary sources which Michelangelo might have used for the *Last Judgment* continue to provoke discussion as further attention is focused on the fresco since its cleaning and restoration in the early 1990s. The question remains as to whether the hidden symbolism of the fresco and the meaning of its thematic deviations from the norms of *Last Judgment* iconography might ever be fathomed by anyone except the artist—and especially at a distance of more than four hundred fifty years.

Problems of art historical interpretation are concerned with the innate meaning of a work in the context of its time and place of creation. Difficulties arise as the attempt is made to determine the intention of the artist and the possible underlying meaning in the work by an elaborate reconstruction of the sources and influences which had contemporary significance and which might have contributed to the formation of his thinking. No single source of religious, philosophical, or cultural influence may be argued for Michelangelo's Sistine *Last Judgment*, but the attempt can be made to consider the broad spectrum of the complex prevailing theories and ideas of his age which contributed to the multilayered intention of the fresco's final program.

An interdisciplinary approach to the art historical problem of Michelangelo's *Last Judgment* can shed new light on the work in question and increase our understanding of the artist himself. Meaning derives from the historical or intellectual context from which a work emanates. However, as Erwin Panofsky, Ernst H. Gombrich, and others have pointed out, it is important to remain wary of reading too much into a work or of forcing it into a predetermined scheme. The writer should always consider the extent to which the interpretation is in keeping with the known personality and tendencies of the master, and also remain aware of the difference between what may be regarded as hypothesis and what may be regarded as truth. On the other hand, is unwise to accept unquestioningly traditional interpretations of famous works and simply reiterate the usual platitudes.

After examining the background to *Last Judgment* iconography in general and the existing interpretations of Michelangelo's fresco in particular, consideration is given to the sources—religious, literary, and philosophical, for instance—which likely contributed to the final program of the work. A major problem with this approach (which is broadly concerned with the history of ideas as much as the history of art itself) is that each section or chapter of this book easily could be developed into a separate volume. As the discussion ventures into other disciplines, the attempt is made to be as thorough as possible within the constraints of a single work in order to demonstrate the ubiquity of the concepts and motifs being examined. The main viewpoint remains that of an art historian rather than theologian, historian, philosopher, or still less a scientist; but an interdisciplinary, sixteenth-century outlook has been assumed as far as this is possible.

This work is based on my doctoral thesis (University of the Witwatersrand, Johannesburg, 1991) which was supervised by Professor Elizabeth Rankin, whose helpful criticism and suggestions are gratefully acknowledged. I am also particularly indebted to a number of anonymous readers and referees who provided valuable comment and suggestions as the work progressed, and to those who helped see the work through to publication, particularly Professor Charles G. Nauert and Professor Robert V. Schnucker. Assistance received from libraries, museums, and art galleries in Rome, Florence, London, Cambridge, Munich, and Bayonne as well as in Pretoria and Johannesburg is also acknowledged. I am particularly grateful to the Vatican authorities for cooperation in providing illustrations for the work and for enabling me to visit the Sistine Chapel and view the restorations from the scaffolding in March 1989 (before the submission of my thesis) and again in July 1993, when the *Last Judgment* was undergoing cleaning and restoration. I should also like to acknowledge discussion of my ideas held with the late Dr. Fabrizio Mancinelli as the fresco underwent

the cleaning and restoration process. Financial assistance in the form of research grants from the University of the Witwatersrand, the South African Human Sciences Research Council, the University of Luton, and the Dr. M. Aylwin Cotton Foundation all helped to make this work possible. Special thanks are due to Dr. E. A. Evangelidis and to my children, Anna and Aleko.

Chapter 1

Introduction

In the midst of all assuredly dwells the Sun. For in this most beautiful temple who would place this luminary in any other or better position from which he can illuminate the whole at once? Indeed, some rightly call Him the Light of the World, others, the Mind or the Ruler of the Universe: Hermes Trismegistus names him the visible God, Sophocles' Electra calls him the all-seeing. So indeed the Sun remains, as if in his kingly dominion, governing the family of Heavenly bodies which circles around him.

—*Nicholas Copernicus*
De Revolutionibus Orbium Coelestium[1]

L ines that seem to be descriptive of Michelangelo's *Last Judgment* (fig. 1)[2] were in fact written by Nicholas Copernicus in his revolutionary heliocentric cosmology, published in 1543 (see diagram, fig. 2). The idea that Michelangelo's equally revolutionary design for the traditional scheme of the *Last Judgment* in the Sistine Chapel (fig. 3) was an expression of the Copernican theory of the sun-centered universe was first considered by Charles de Tolnay as early as 1940.[3] Commenting on the fresco's remarkable deviation from the usual *Last Judgment* iconography and composition,[4] Tolnay's interpretation here concentrated upon his argument that Christ is unusually depicted in Michelangelo's fresco in the form of the pagan sun god Apollo, in the center of a circular composition. He is situated as if "in the center of a solar system . . . in the unlimited space of the universe."[5]

In the final paragraph of his paper, Tolnay suggests that the cosmic scheme seems to form an analogy with Copernicus' theory of heliocentricity in which the sun, rather than the earth, was situated in the center of the universe. It seemed to Tolnay that Michelangelo, in placing Christ in

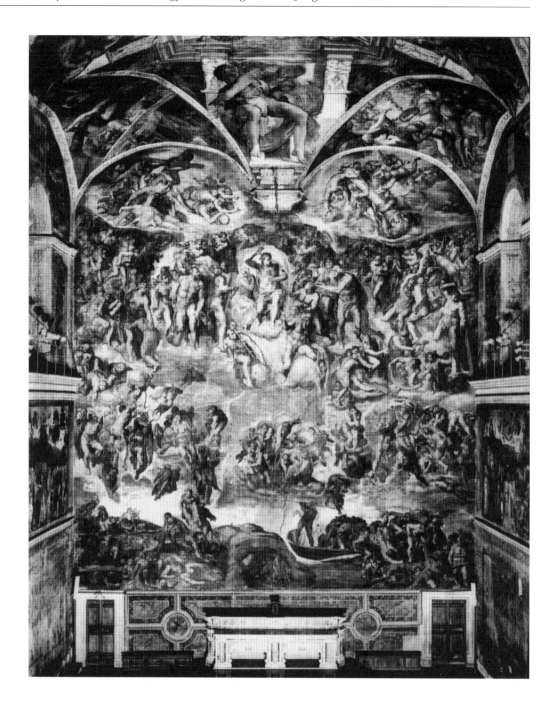

1 Michelangelo, *Last Judgment* (1536–41). Fresco (13.7 x 12.2 m), Sistine Chapel, Vatican City Rome. This and all other details of Michelangelo's *Last Judgment* (figs. 51–63, 112–13, and 124) have been reproduced from photographic material supplied by Monumenti e Gallerie Pontificie, Città del Vaticano.

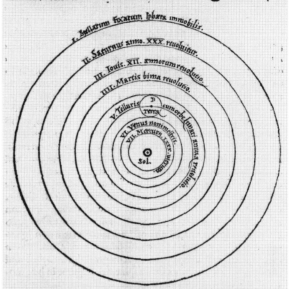

2 Copernicus, *De Revolutionibus Orbium Coelestium,* book 1, chapter 10, in its printed form. Houghton Library, Harvard University

the form of a Sun-Apollo in the center of a "macrocosmic" view of the universe, had arrived in his own way at a vision of the universe which "curiously corresponded" to that of Copernicus. According to Tolnay, both Michelangelo and Copernicus had taken up the heliocentric hypothesis formulated in antiquity. Tolnay wrote that Michelangelo, by his representation of unlimited space in the fresco, was anticipating the concept of the infinite universe as formulated later in the sixteenth century by men like Giordano Bruno.[6]

Subsequently, in 1960[7] Tolnay developed the theme he had raised in this early paper. He again drew attention to his concept of the depiction of Christ in the form of a sun symbol and commented further on what he had

3 Sistine Chapel, interior, looking towards the altar. Vatican, Rome.

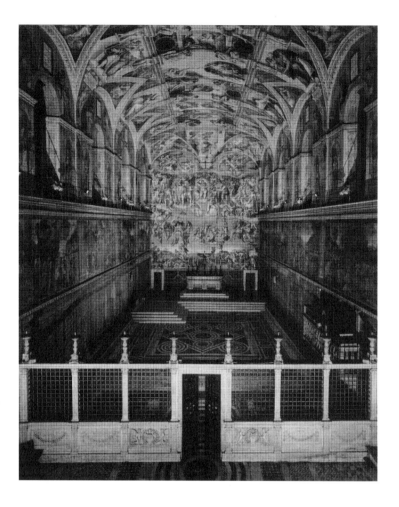

viewed as a curious correspondence between Michelangelo's vision and that of Copernicus. Tolnay expanded his hypothesis of the cosmological depiction of Christ as a sun symbol, but he now explicitly dismissed the possibility of any direct Copernican influence on Michelangelo on the grounds that the date of publication of Copernicus' theory postdated the creation and completion of Michelangelo's *Last Judgment*. In volume 5 of his definitive work on Michelangelo he wrote:

> By means of the central place which Michelangelo reserved in his composition for the Sun (Christ-Apollo) whose magic power determines the unity and the movement of his macrocosmos, the artist came of himself to a vision of the universe which, surprisingly, corresponds to that of his contemporary Copernicus. Yet he could not have known Copernicus' book which was published in 1543—at least seven years after Michelangelo conceived his fresco.[8]

In the accompanying notes, he added his conclusion that "Michelangelo's *Last Judgment* is a heliocentric image of the macrocosmos *anticipating*

the Copernican universe" [italics added].[9] He also commented that heliocentrism was "rejected by the official theology of the sixteenth and seventeenth centuries."[10]

Because of the apparent discrepancy Tolnay found between the dating of Copernicus' book and Michelangelo's fresco, he felt forced to dismiss the idea of direct Copernican influence on Michelangelo and implied only that Michelangelo "of himself" came to the same conclusions as Copernicus and independently devised the heliocentric astronomical theory. Tolnay therefore pursued the specifically Copernican and heliocentric argument no further, but, unwilling to abandon his cosmological view of the "Sun-Christ," he looked elsewhere for explanations and sources and proceeded to develop an alternative, complex argument for this symbolic depiction of Christ. Considering the fresco in terms of a cosmological vision, his perception of the overall composition based on circles and circular movement around a central Sun-Christ was finally related to ancient astral myths and legends derived from pagan sources but also linked to certain medieval concepts.[11]

Although Tolnay's study of Michelangelo's *Last Judgment* embraced many other aspects of the work,[12] his interpretation of the fresco as a cosmic view of the Sun-Christ remained his predominant theme. In his later (1975) summary publication of this extensive five-volume work,[13] the major stress in the interpretation of the *Last Judgment* is still placed on the circularity of the composition and its cosmological overtones. Describing the work as "the grandiose vision of a heliocentric universe,"[14] he still appeared unwilling to dismiss the heliocentric idea as a force in the composition of the fresco; but, because of the discrepancy in dating with Copernicus' publication, he again reverted to the astral myths of antiquity to support his cosmological interpretation.[15] He gave little detailed explanation or further references for these ideas, but they are emphasized and proposed as source material for Michelangelo's fresco in the absence, in Tolnay's opinion, of the possibility of a more direct contemporary cosmological basis for the work.

Charles de Tolnay has been recognized as "the great scholar whose work is the foundation of all modern Michelangelo scholarship,"[16] and his interpretation of the *Last Judgment* has played a major part in the Michelangelo literature. His discussion of Michelangelo's *Last Judgment*, from 1940 through to 1975, remained fundamentally cosmological, even though the possibility of any direct and concrete influence of contemporary sixteenth-century cosmology was discounted. His perception of the fresco as a cosmic drama and his assessment of the Apollonian Sun-Christ have continued to receive a great deal of attention and have exerted enormous influence on subsequent interpretations of Michelangelo's *Last Judgment*. The cosmological interpretation of the fresco is extremely important since it appears to have affected the majority of art historians since the

1940s. References to "the cosmic design," "the circularity and circular motion," and "the Apollo Sun-Christ" are legion.[17] Tolnay's ideas soon permeated the Michelangelo literature of the 1940s and 50s;[18] in the 1960s similar interpretations and descriptions of the Sun-Christ and the "cosmic" qualities of the fresco are common, also pervading the increasing amount of more popular works on Michelangelo.[19] More recent and detailed Michelangelo scholarship in the 1970s, 80s, and even 90s also continues to show an appreciation and consideration of Tolnay's approach in discussion of the underlying significance of the *Last Judgment*.[20]

So many important modern authors have alluded to the cosmic overtones of Michelangelo's great fresco and for the most part the idea seems to have been generally assimilated. Yet few if any, however, have pursued this significant concept in any depth. Among the more well known, Redig de Campos gave Tolnay's theory some serious consideration[21] and Steinberg in 1975 alluded to the Copernican theme, describing Christ as "Sun-like, Copernican" in the course of his argument that the *Last Judgment* is actually heretical.[22] Only Salvini, it seems, has attempted to examine Tolnay's theory critically.[23] Although he too referred to the fresco as "cosmic,"[24] Salvini also dismissed the possibility of any direct Copernican influence on Michelangelo's *Last Judgment*, as well as Tolnay's theory of sun symbolism in general, on the grounds that the sources argued by Tolnay in ancient astral myths were too complex and too contrived and thus totally out of character with the artist whose schemes, says Salvini, tended rather toward themes of "a simple magnificence."[25] "It is difficult," he says, "to interpret the dark, desperate atmosphere of the *Last Judgment* in terms of any solar myth."[26] In other words, Tolnay's cosmological interpretation of the Sun-Christ is rejected *because the sources seem contrived.*

Although Michelangelo's *Last Judgment* has frequently been described as "cosmic" in the broadest terms in art historical interpretation, little account has thus been taken of contemporary cosmological theory as it existed in the mid-sixteenth century. Cosmology is currently defined as "The science or theory of the universe as an ordered whole and of the general laws which govern it. An account or system of the universe and its laws, a branch of metaphysics dealing with the world as a totality in space and time,"[27] and in our own times, its major usage is in the scientific context, where cosmology and astronomy are studied as distinct disciplines based on separate but related areas of physics and applied mathematics.[28] Cosmology, as an account of the physical universe, now represents the combination of observational astronomy and theoretical physics, but this was manifestly not the case in the mid-sixteenth century. The modern definition of "cosmology" as the study of the ordered universe has highly specialized scientific and mathematical overtones but in Michelangelo's time, as will be demonstrated, cosmology was regarded as inextricably linked with the disciplines of theology and philosophy rather than as an

independent scientific study.[29] The separation of the various disciplines of cosmology, physics, mathematics, astronomy, religion, and philosophy is a post-seventeenth-century phenomenon.[30]

It is the contention of the present hypothesis that cosmology, in the broad, sixteenth-century meaning of that term, provides a basis for an understanding of Michelangelo's *Last Judgment*. To reassess properly, therefore, the nature of the sources and influences that might have contributed to Michelangelo's final program of the fresco, and to reexamine the theory of a cosmological basis for its composition and iconography, it is essential to adopt a somewhat broader approach to the problem than that currently existing in the literature and to view it from an interdisciplinary standpoint. The apparent portrayal of Christ in the form of a sun symbol should be examined in depth in relation both to its classical and Christian meaning. The loosely cosmological approach to the fresco, emphasized by Tolnay and followed for the most part by subsequent writers, requires accurate and specific examination within this interdisciplinary sixteenth-century context. It is important to look at the work of art in the context of its time and place of creation and as a reflection of the ideas of the age as well as of the artist's own vision.

In order to assess the relevance of both traditional and "new" ideas that were important to Michelangelo and his contemporaries, it will be necessary to reconstruct as much as to discover and to pursue many facets of Michelangelo's *Last Judgment* fresco, examining the sort of sources to which Michelangelo might have had access.[31] Firstly, as the fresco is situated on the altar wall in the most significant chapel in Christendom, it seems appropriate to begin with an examination of the relevant theological concepts, embracing, of course, the relationship between cosmology and theology. The theological view of the universe, its creation and disposition may be considered in general terms; but special emphasis should be laid on the importance of the contemporary view within the context of the religious turmoil of the sixteenth century. As the theological importance of sun symbolism and cosmology is considered, the iconographical tradition of the *Last Judgment* scene and the possibility of its basis in cosmology requires discussion. Previous examples of the subject will be examined, in a comparative way, with special reference to Italian versions of the two centuries prior to Michelangelo.

In addition to theology, contemporary philosophy should also be considered since its effect upon cosmology and worldview was highly significant; the links here between the two major themes of cosmology in the overall format and of sun symbolism in the figure of Christ are particularly noticeable. The doctrine of Neoplatonism played a major role in the contemporary view of the universe in Renaissance Italy and also held particular interest for Michelangelo himself. Other sources for the Italian Renaissance view of the universe will include literary sources of

a type likely to have influenced the artist. Among these, the influence of Dante's writings on Michelangelo's works, which has already received some attention, should be further examined, as well as contemporary poetry, including works by Vittoria Colonna and Michelangelo himself.

Last, but perhaps most important of all, it is necessary to consider the contemporary view of the cosmos from a scientific point of view. Here, the forerunners of Copernicus in the examination of the heliocentric theory should be considered, as well as Copernicus' own hypothesis and the precise chronology of his discoveries. Because of the theological significance of Michelangelo's *Last Judgment* in the Sistine Chapel, the attitude of the Church and the papal patrons of the fresco to these philosophical and scientific concepts is relevant, especially concerning the heliocentric theory of Copernicus and the notion of it as heretical.

In this way, an elaborate reconstruction of ideas that were important and relevant to Michelangelo and his contemporaries may be built up. For the sake of convenience and clarity, these various aspects of the sixteenth-century total worldview will be examined separately in the following chapters, but their interconnectedness will be at once apparent. Arguing from the basis thus formulated and reconsidering the fresco in its now cleaned and restored state as the point of departure, it should be possible to deduce anew the underlying meaning and significance of Michelangelo's fresco.[32]

The identification and relative importance of the various biblical, literary, and philosophical sources that Michelangelo may have used for the *Last Judgment* continues to be a matter of major controversy. Alternative sources will be proposed in the pages that follow, in the light of newfound evidence, to support the argument that a cosmological interpretation of the fresco is a valid one and that sun symbolism and Copernican heliocentricity could be regarded as a major, overriding theme in the fresco. The sources to be proposed here are basically fourfold, but at the same time very much interlinked. They derive from the Catholic revival at midcentury of early Christian concepts that analogized Christ with the sun; Neoplatonic sun symbolism in the tradition of Ficino; the Italian literary tradition, especially Dante; and, lastly, the actual scientific theory of the heliocentric universe proposed by Copernicus who was, in turn, also strongly influenced by the first two themes.

While Tolnay's cosmological interpretation of Christ as a sun symbol in the fresco does appear to have had some measure of validity, his argument was weakened by his references to the impossibility of Michelangelo's having known of heliocentric cosmology; hence the idea was never fully or seriously explored. This is now proven to be incorrect, for Michelangelo, nurtured on Neoplatonism and involved at the time of the *Last Judgment* commission in the Catholic revival of Early Christian themes, was also quite definitely in a position to have known of Copernicus' theory.

Notes

1. Nicholas Copernicus, *De Revolutionibus Orbium Coelestium* (Nuremberg, 1543), 1:10 (my translation). See facsimile edition, ed. Jerzy Dobrzycki (London: Macmillan, 1978), 1:10 and 2:22 (this ed. referred to henceforth as Copernicus, *De Revolutionibus*). Translation also available in Thomas S. Kuhn, *The Copernican Revolution* (Cambridge: Harvard University Press, 1957), 131; Alexandre Koyré, *From the Closed World to the Infinite Universe* (London: Oxford University Press, 1957), 33; Joseph Louis Emil Dreyer, *A History of Astronomy from Thales to Kepler* (New York: Dover, 1953), 328. The Latin text reads, "In medio vero omnium residet Sol. Quis enim in hoc pulcherimo templo lampadem hanc in alio vel meliori loco poneret, quam unde totum simul posit illuminare. Siquidem non inepte quidam lucernam mundi, alii mentem, alii rectorem vocant. Trimegistus visibilem Deum, Sophoclis Electra intuente omnia. Ita profecto tanquam in solio regali Sol residens circum agentum gubernat Astrorum familiam." See also fig. 2.

2. Michelangelo Buonarroti, *The Last Judgment*, fresco, Sistine Chapel, Vatican, Rome. 13.7 x 12.2 m, 1533–41.

3. Charles de Tolnay, "Le *Jugement Dernier* de Michel Ange: Essai d'Interpretation," *Art Quarterly* 3 (1940): 125–46.

4. Tolnay, "Le *Jugement Dernier* de Michel Ange," 125 and 141.

5. Tolnay, "Le *Jugement Dernier* de Michel Ange," 142.

6. Tolnay, "Le *Jugement Dernier* de Michel Ange," 144. The French text reads, "Par le rôle primordial qu'il réserve au soleil dont le pouvoir magique commande l'unité du macrocosme, Michel Ange arrive, par ses voies propres, à une vision de l'univers qui correspond curieusement à celle de son contemporain Copernic. Tous deux, d'ailleurs, reprennent l'hypothèse heliocentrique formulée déjà dans l'Antiquité (Aristarque de Samos). Enfin, par sa conception de l'espace illimité, Michel Ange anticipe sur 'l'univers infini' de Giordano Bruno."

7. Charles de Tolnay, *Michelangelo*, 5 vols. (Princeton: Princeton University Press, 1943–60). Also Charles de Tolnay, "Michelangelo Buonarroti," in *Enciclopedia universale dell'arte*, 10 (Rome: 1962).

8. Tolnay, *Michelangelo*, 5:49.

9. Tolnay, *Michelangelo*, 5:120.

10. Tolnay, *Michelangelo*, 5:122.

11. Tolnay, *Michelangelo*, 5:47–49. These sources are discussed more fully in chap. 4, sec. 4.

12. Tolnay, *Michelangelo*, 5:33–35. Tolnay examines in detail the various proposed biblical and literary sources of the fresco's iconography.

13. Charles de Tolnay, *Michelangelo: Sculptor, Painter, Architect* (Princeton: Princeton University Press, 1981; 1st ed. 1975).

14. Tolnay, *Sculptor, Painter, Architect*, 59.

15. Tolnay, *Sculptor, Painter, Architect*, 60; cf. Tolnay, "Le *Jugement Dernier* de Michel Ange," 143; and Tolnay, *Michelangelo*, 5:48.

16. John W. Dixon, "The Christology of Michelangelo: The Sistine Chapel," *Journal of the American Academy of Religion* 55 (fall 1987): 502–33, esp. 506.

17. Previous interpretations of Michelangelo's *Last Judgment* (both academic and more popular), with special reference to these themes, are fully examined in chap. 4, secs. 3–5.

18. For example, Deoclecio Redig de Campos (1944), Herbert Von Einem (1959), and Johannes Wilde (1950s lectures, published 1960).

19. These include authors like Rudolf Schott (1963), Frederick Hartt (1965), Mario Salmi (1965), Robert Coughlan (1966), and Ettore Camesasca (1969).

20. Important scholarship concerning Michelangelo's *Last Judgment* includes the work of Howard Hibbard (1975), Leo Steinberg (1975 and 1980), Marcia Hall (1976), Romeo de Maio (1978), Roberto Salvini (1978), Robert S. Liebert (1983), Linda Murray (1984), Pierluigi de Vecchi in André Chastel et al. (1986), Bernard Lamarche-Vadel (1986), and Jack Greenstein (1989).

21. Deoclecio Redig De Campos, *Michelangelo: The Last Judgment* (New York: Doubleday, 1978), incorporating material from Deoclecio Redig de Campos and Biagio Biagetti, *Il Giudizio Universale di Michelangelo* (Milan: 1944), 89.

22. Leo Steinberg, "Michelangelo's *Last Judgment* as Merciful Heresy," *Art in America* 63 (1975): 49–63.

23. Roberto Salvini, chapter on "Painting" in Mario Salmi, ed., *The Complete Works of Michelangelo* (New York: Reynal, 1965) esp. 223; and Roberto Salvini, *The Hidden Michelangelo* (London: Phaidon, 1978), 124–39.

24. Salvini, *Hidden Michelangelo,* 123.

25. Salvini, *Hidden Michelangelo,* 131.

26. Salvini, *Hidden Michelangelo,* 132. This was written about the fresco in its uncleaned state.

27. *Oxford English Dictionary.*

28. See, for example, the summary of developments in cosmology in Charles W. Misner, Kip S. Thorne, and John A. Wheeler, *Gravitation* (San Francisco: Freeman, 1973), 752–62; and authors like James Jeans, *The Mysterious Universe* (Cambridge: Cambridge University Press, 1947); Hermann Bondi, *Cosmology* (Cambridge: Cambridge University Press, 1960); and, more recently, Fred Hoyle, *Astronomy and Cosmology* (San Francisco: Freeman, 1975), esp. sec. 6; and Paul Davies, *God and the New Physics* (London: Dent, 1983).

29. Differences among the earlier meaning and modern scientific concepts and usage are discussed in Peter T. Landsberg and David A. Evans, *Mathematical Cosmology: An Introduction* (Oxford: Clarendon, 1977), esp. 25–26; and Fred Hoyle, "The Relation of Cosmology to Other Subjects," in *From Stonehenge to Modern Cosmology* (San Francisco: Freeman, 1972).

30. In Renaissance times, the idea of separating worldview, theology, philosophy, science, and even art was inconceivable. See Agnes Heller, *Renaissance Man* (London: Routledge and Kegan Paul, 1978), esp. chaps. 12 and 13; Phillip Lee Ralph, *The Renaissance in Perspective* (London: Bell, 1974). For the Enlightenment, see Ernst Cassirer, *The Philosophy of the Enlightenment* (Princeton: Princeton University Press, 1951).

31. The writings of Michelangelo's contemporary biographers, Condivi and Vasari, may form a starting point for this. Ascanio Condivi, *Life of Michelangelo*, (1553), ed. Helmut Wohl (Oxford: Phaidon, 1976), is regarded as having been virtually "dictated" by Michelangelo. The second edition of Vasari's *Lives* was revised according to Michelangelo's influence. See Thomas S. R. Boase, *Vasari: The Man and the Book* (Princeton: Princeton University Press, 1978). More easily accessible than the classic Italian version by Gaetano Milanesi is the recent edition of the translation by Gaston de Vere, *Giorgio Vasari, Lives of the Most Eminent Painters, Sculptors and Architects,* 1568, trans. Gaston du C. de Vere, 3 vols. (New York: Abrams, 1979). References will also be given to the Penguin abridged version, which may conveniently be used: *Vasari, Lives of the Artists*, trans. and ed. George Bull (Harmondsworth: Penguin, 1971).

32. Art historical method that concerns the possibility of discovering the artist's intention by means of deductive processes in relation to history, philosophy, and literature, which was established by Warburg, Panofsky, and Gombrich, has recently been reconsidered by (among others) Michael Baxandall, *Patterns of Intention* (London: Yale University Press, 1985), and Mark Roskill, *What is Art History?* (London: Thames and Hudson, 1982).

Chapter 2

Theology, Cosmology, and Christian Iconography

In the beginning God created the heaven and the earth. And the earth was without form and void: and darkness was upon the face of the waters.

—Gen. 1:1–2[1]

Cosmology and Religion

Before looking closely at a cosmological interpretation of Michelangelo's *Last Judgment*, it is necessary to assess the role cosmology has played in the traditional iconography of this subject. This is dependent in turn upon the ancient relationship between cosmology and religion.

Humanity's changing view of the universe traditionally has been connected with spiritual and religious consciousness. From earliest times, the realms of theology and cosmology were regarded as contiguous as humanity attempted to explain the universe and its own existence in spiritual and philosophical terms. This principle also applied, of course, to religions outside the Judeo-Christian influence, as many other systems of belief, primitive or otherwise, also discuss or explain the existence of humanity and the universe in spiritual terms. Creation myths of other religions, for example, also confirm the wide basis of the links between cosmology and theology, but these are not directly relevant here.[2]

The separation of cosmology as an independent scientific discipline is a relatively recent development, as humanity has attempted to render explanations based on systematic knowledge of the laws of physics and mathematics rather than on metaphysical speculation. Within the Christian religion, however, worldview, cosmology, philosophy, and science were inextricably combined. Such concepts were of ancient biblical origin and traditionally linked with each other throughout the

early Christian, medieval, and Renaissance periods. Until the beginning of the Enlightenment in the seventeenth century, there was little distinction between biblical cosmology and any kind of scientific interpretation of the universe, for they were both dependent upon and derived from biblical sources.[3] The importance of cosmology in the scriptural context is at once apparent for the origin and creation of the universe itself; the idea of its being the handiwork of God is given pride of place in the very first chapter of the Bible, Genesis 1. Cosmological concepts are also expressed in the all-important Nicene Creed of the Christian Church.[4] The theme of God as Creator or Builder of the universe is reinforced throughout the Bible, both symbolically and literally; references to "the Lord that made Heaven and Earth" are very common.[5] Besides the theological interpretation of the creation of the universe, the Christian vision of the actual physical disposition of the universe was also derived from the biblical evidence. Thus what is usually termed the "flat-earth" view of the universe was dependent upon scriptural source material. The view of the stationary, flat earth, enclosed and surmounted by the canopy of Heaven, is based on such sources as Isa. 40:22, which refers to the Lord who "stretcheth out the heavens as a curtain, and spreadeth them out as a tent to dwell in."[6] Jerusalem was regarded as the center of the flat-earth system, according to Ezek. 5:5, and the stability of the earth was given theological and symbolic significance in the same way that the movement of the sun in its orbit around the earth also received scriptural support.[7]

The view of the Christian universe with the earth situated in a central position, with Heaven above it in the skies and Hell beneath the earth's surface, is very much reinforced throughout the Old and New Testaments. References to the idea of ascent into Heaven and, conversely, descent into Hell are far too numerous to list.[8] This physical description of the universe is easily perceived as very closely related to theological and philosophical ideas such as the ascent of the Christian by degrees toward God. Such concepts serve to demonstrate the very close relationship and interaction between the cosmological view of the universe and religious dogma. Christian cosmology was inextricably linked with theological meaning.

The parallels between the fixed ascending/descending arrangement of the universe and humanity's earthly existence assumed major importance in the early Church. Hierarchical schemes of Being, which were derived from the arrangement of the cosmos, were also based on the notion of ascent by degrees to God in Heaven, together with the opposing notion of descent into Hell. Such schemes were gradually codified and laid down by the early Church Fathers, passing into the official dogma of the early church. Writers from Augustine to Aquinas, too numerous to discuss in full here, have commented on the implications of cosmology and the scriptural evidence for God's creation and ordering of the universe. In an examination of the relevance of the direct links between scriptural

cosmology and Christian iconography, perhaps the most influential writings on the hierarchical levels of existence in the real and celestial worlds were those drawn up by the writer known as Pseudo-Dionysius the Areopagite.[9] Although purporting to be the work of Dionysius, companion to Saint Paul in the first century, these writings have been dated to the early sixth century.[10]

In two important treatises, *On the Celestial Hierarchy* and *On the Ecclesiastical Hierarchy*,[11] Pseudo-Dionysius related the Christian cosmological worldview to the ordering of the Church and humanity on earth. These writings were influenced by the early Neoplatonic system of mystical theology concerning the scheme of Being in the universe. Pseudo-Dionysius' works demonstrated the relationship between the Christian doctrine of hierarchies and the cosmological hierarchies in the real world and achieved great authority in medieval Christendom. The universe was shown as proceeding from God as a hierarchy ranging through several ranks of angels to humanity and thence to the realm of organic creatures to, finally, the inorganic matter of the world. God is perceived as the source of the world, the Creator, and Supreme Good from which all else issues forth.[12] Corresponding with the celestial hierarchy was the ecclesiastical hierarchy of God's church on earth. This consisted of the Sacraments, those who administered them (namely, the members of the church disposed according to rank), and lastly the laity and penitents. The concept of hierarchy or ascent and descent by careful gradation, as demonstrated in the works of Pseudo-Dionysius, was the essence of the so-called cosmological Chain of Being and became standardized in both Eastern and Western Churches in the Middle Ages. The same concept, in turn, also closely underpinned Christian church iconography.[13]

Cosmology and Christian Iconography

The standard types of Christian hierarchical schemes, as expressed in the writings of Pseudo-Dionysius, were, in turn, traditionally reflected and carried over into church architecture and decoration. Christian art and architecture were in this way very much linked to the official view of the universe and used doctrinally to reinforce the Christian hierarchical and cosmological precepts. This practice was common from the earliest Christian times and was related, again, to the biblical examples. An important cosmological concept, for example, was the idea that the Holy Tabernacle, built by Moses and described in Exodus chaps. 25–27, corresponded to the same shape as the cosmos. The Tabernacle was rectangular and twice as long as it was wide: the earth was held to be of the same shape, placed lengthwise in the universe.[14] Similarly, the architectural design and proportions of King Solomon's Temple detailed in

the Bible were founded on the same concept and related to the structural foundation of the universe.[15] It is significant that the dimensions of the Sistine Chapel (40.93 m long x 13.41m wide) relate to those given by the Bible for Solomon's Temple, and its original ceiling decoration was the traditional one of the blue firmament covered with stars as the vault of heaven (fig. 4).[16]

In addition to the cosmological foundation of ecclesiastical architecture as evinced by the building of Solomon's Temple, the concept of God's stretching out the Heavens as a canopy over the universe (emphasized in Isa. 40:22, 42:5, 44:24, and 51:13) also became directly transferred to church architecture. This may be seen especially in the preference for domed architecture, which was prevalent in the early Eastern Christian church. The use of the dome is basically imitative of natural-eye observation of the flat earth covered by the "dome of Heaven" and it is thus evidently of distinct cosmological origin, as at the Mausoleum of Galla Placidia, Ravenna, where it is also decorated with stars (fig. 5). Similarly, the use of barrel vaults over longitudinal churches also related to perceptions of the structure of the universe.[17]

The concept of a relationship between the view of the universe and church architecture was carried over into schemes of Christian Church decoration in which mosaics or frescoes were commonly arranged in layers or zones, relating both to the architectural structures and to the hierarchical schemes of the cosmos as outlined above.[18] Different areas of architectural surface were arranged and decorated with subject matter suitable to their positioning and in accordance with the evaluation of the

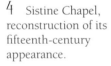

4 Sistine Chapel, reconstruction of its fifteenth-century appearance.

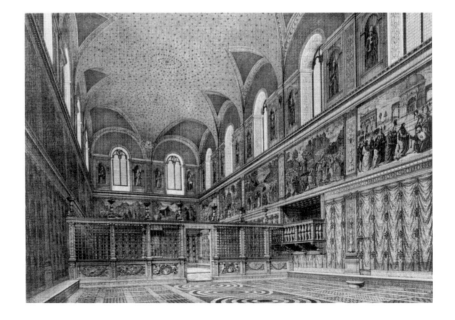

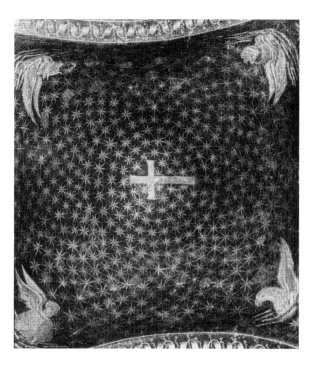

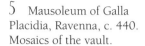

5 Mausoleum of Galla
Placidia, Ravenna, c. 440.
Mosaics of the vault.

hierarchies in the universe.[19] Byzantine and medieval schemes of fresco
and mosaic decoration were thus arranged as a symbolic reflection of the
divine order of the universe. The church itself was the "microcosmos of
the macrocosmos."[20]

It is significant that there was a revival of interest in these concepts,
particularly related to domed architecture, during the Renaissance period.
Evidence suggests that the cosmic significance of church architecture
was understood by architects like Brunelleschi (1377–1446), Alberti
(1404–1472), and later Bramante (1444–1514) and Antonio Sangallo
(1483–1546). The importance of the revival of the circular plan during the
Renaissance has been examined by Wittkower, who comments extensively
on its usage as having cosmic overtones as the image of God's universe.[21]
Hautecoeur also discusses the revival of circular and domed architecture in
Renaissance Italy. He draws attention, for example, to the Old Sacristy at the
Medici Church of San Lorenzo where the dome is covered with astrological
symbols, and he also cites various designs for domed ecclesiastical
architecture by Leonardo da Vinci, Bramante, Raphael, and Michelangelo
himself—especially in relation to the designs for Saint Peter's.[22]

The relationship between the Christian image of the cosmos and
church architecture and decorative schemes was a principle also broadly
applied to individual iconographical schemes—a tradition that will prove
relevant in the consideration of Michelangelo's *Last Judgment*. A number

of subjects in Christian iconography were commonly based on the underlying Christian hierarchical view of the universe. The idea of the flat earth surmounted by Heaven above (with Hell beneath the earth's surface) is implicit in the standard iconography of scenes such as the *Resurrection, Ascension,* and *Anastasis of Christ* (for example, fig. 6).[23] It is especially common in scenes of the *Annunciation* and *Baptism,* where the heavenly presence of God the Father is signified by a hand emerging from the clouds at the top of the format, and examples show that this tradition continued into the Quattrocento (see figs. 7, 8).[24]

The cosmological significance of biblical events has also frequently been indicated in the depiction of God as creator (fig. 9) or ruler of the world (fig. 10);[25] likewise, the theophany, or depiction of God in majesty, frequently has zodiacal or astronomical overtones (fig. 11).[26] In a more incidental sense, the inclusion of astronomical symbols, such as the sun and moon in the *Crucifixion*[27] or stars in the *Nativity,*[28] demonstrate the continuing interest and importance of this theme. Specific astronomical events, such as Joshua's commanding the sun to stand still, have also been depicted, as at Sta. Maria Maggiore, Rome (fig. 12).[29] By far the most

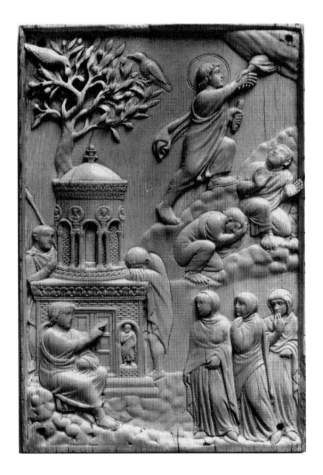

6 *Resurrection of Christ,* fifth century. Ivory panel. Bavarian National Museum, Munich.

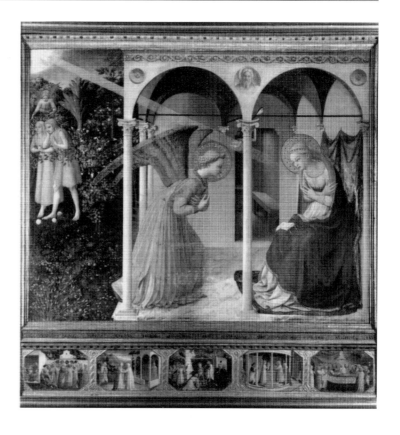

7 Zanobbi Strozzi (or Fra Angelico), *Annunciation*, 1430–45. Panel from S. Domenico, Fiesole, 192 x 192 cm, Prado, Madrid.

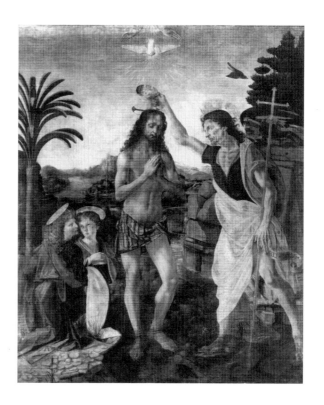

8 Andrea Verrochio, *Baptism of Christ*, c. 1470–73. Panel, 177 x 151 cm. Uffizi, Florence.

significant role played by cosmology, however, appears to be asserted in the various traditional depictions of the *Last Judgment.* Here the subject appears to be particularly closely related to the Christian hierarchical view of the universe.

Cosmology and the *Last Judgment*

The Last Judgment is especially suited to a cosmological interpretation since it is the major scene in Christian iconography where the parts of the universe, Heaven, Earth, and Hell, would naturally be depicted together at the same time. When portrayed in art, even more than when discussed metaphysically, the scene was also intended to reflect the actual relative physical positions of these three major zones in the real world. This realization might suggest a new direction to follow in the interpretation of Michelangelo's *Last Judgment.*

The theological concept of the Last Judgment, that at the end of time Christ will return to earth in glory, preside over the resurrection of the dead, pass judgment on all, and then assign to each their eternal destiny in Heaven or Hell, is central to Christian doctrine and inextricably linked with the Christian view of the universe. The Last Judgment represents the ultimate triumph of Christ and His final victory over death and Satan. It has immense importance, both as Christian dogma and as an actual

9 Unknown Sicilian-Byzantine artist, *God Creating the Universe,* c. 1175. Mosaic, Cathedral of Monreale, Sicily.

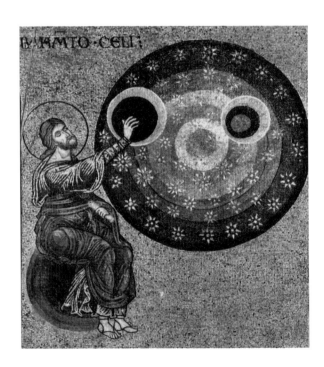

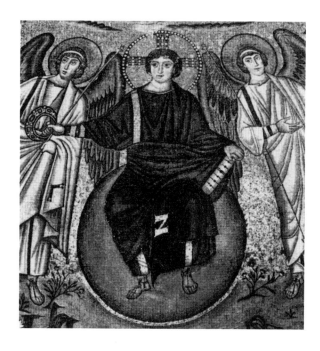

10 *Christ Enthroned on the Sphere of the Universe,* first quarter sixth century. Apse mosaic, S. Vitale, Ravenna.

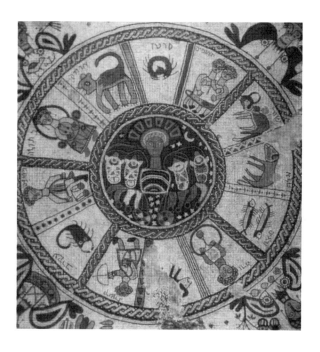

11 Theophany, c. 520. Floor mosaic, Beth Alpha.

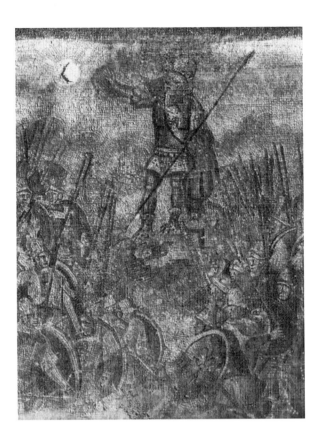

12 *Joshua Stopping the Sun,* c. 432–430. Mosaic, S. Maria Maggiore, Rome.

event taking place in time and space. The significance and meaning of the *Last Judgment* scene in Christian iconography, its usual biblical sources, its separate specific iconographical components, and its apparent use as disciplinary propaganda for the laity, have been debated extensively and discussed in the literature.[30] Commentary on the concept generally focuses on certain major themes: the change in emphasis between the Old Testament idea of divine retribution in the punishment of the damned and the New Testament concept of love and universal salvation through Christ; the theme of the Last Judgment as representing justice and the law; the nature of the resurrection and the contrast between the idea of full bodily resurrection and the ancient idea of the immortality of the soul; the timing of the event and the "location" of Heaven and Hell (which both have particular cosmological implications); millenarian concepts of Christ's Kingdom on earth; and (concerning the period in question) the Reformation debate about all these concerns. When depicted in art, therefore, the *Last Judgment* scene may be viewed as a prime example of the depiction of very complex dogma in a single image.

The belief in life after death is the cardinal point of the Christian religion, and the idea of bodily resurrection and eternal life, offered almost

uniquely by Christianity, was inextricably linked with the concept of the God of love of the New Testament. The fact that Christ was resurrected after death was regarded as proof of the Incarnation of the Godhead and hence also as proof that humanity, too, would be resurrected on the Last Day.[31] Alongside the New Testament attitude to the basic Christian doctrine of universal salvation, however, the eschatological approach of the Old Testament also retained a central place in dogma. The importance attached to the four last things—death, judgment, Heaven, and Hell—gave some the impression of a religion of fear as much as a religion of love and hope, and a great deal of discussion has taken place around the apparent dichotomy between the concept of judgment and condemnation and that of universal salvation. The hypothesis that humanity was to be rewarded or punished according to virtue or sin led to a firm belief in the Last Judgment among the masses of the Christian peoples during the early Christian, Byzantine, and medieval periods up to and including the Renaissance. Based on scriptural, patristic, and conciliar authority, it was argued that salvation is dependent not simply on God's love, but on the fitness of the individual. In other words, while the deserving were to be saved, those who had not lived well (that is, according to God's law) are to be subjected to eternal damnation. The threat of the Last Judgment had value as a deterrent, but after the judgment itself and the cessation of time, no further merit or demerit would be possible.[32] In turn, the question of humanity's resurrection and judgment after earthly death, at the time of the Second Coming of Christ, consequently became a key subject for depiction in Christian iconography. Actual iconic images of Jesus in Glory, calling all before him and consigning the blessed to heaven and the damned to hell, haunted and possessed Christians, especially during the medieval period when, as we shall see, graphic depictions of the Last Day were everywhere to be seen in churches across Europe.[33] The *Last Judgment* was the fundamental image used for visual representation of the concepts of good and evil, and hence law and justice, crime and punishment. Even during the sixteenth-century religious upheavals, the Reformation churches retained the concept as a central doctrine. They simply placed a new interpretation on the precise nature of the Last Judgment and reassessed the specific criteria by which souls might be judged (condemned or saved).[34] The idea of the Last Judgment in itself was scarcely called into doubt.

A major concern about the Last Judgment, from the earliest times, was that so little explicit information was provided by Scripture about the events to take place. As Cardinal Newman pointed out :

> Considering the long interval which separates Christ's first and second coming, the millions of faithful souls who are waiting it out, and the intimate concern which every Christian has in the determining of

its character, it might have been expected that Scripture would have
spoken explicitly concerning it, whereas in fact its notices are brief
and obscure.[35]

Newman concludes that the "silence" of Scripture appears intentional,
with a view to discouraging too much speculation, but the sources that do
exist are in the main to be found directly in the Bible.

References to the Last Judgment ("the Day of Judgment," "the Day
of Wrath," or "the Day of the Lord") permeate Scripture in various forms.
They are common in the Old Testament, for example, Ezek. 37:1–9, Dan.
7:13–24, 12:1–3; Ps. 9:7, and Job 19:25. Isa. 13:6–9 paints a particularly
dramatic picture, beginning, "the day of the Lord cometh, cruel both with
wrath and fierce anger, to lay the land desolate: and he shall destroy the
sinners thereof out of it. . . ." Such Old Testament references, derived
from ancient Hebrew apocalyptic visions, consist mainly of eschatological
visions of the fate of humanity at the end of the world, and they are filled
with the drama and horror of the penalties of the damned. Such scenes
were vividly represented in Christian art.[36]

The idea of a loving God does occur in the Old Testament, for
example in Psalm 103, which speaks more optimistically of the Lord's
mercy and forgiveness toward the oppressed and sinners, for he is "slow
to anger and plenteous in mercy . . . he will not always chide, neither will
he keep his anger for ever" (v.8–9, also Ps. 77:7–9). But this approach to
resurrection and life after death is far more common in the New Testament.
The idea of a loving God and universal salvation becomes clearer here,
because of acceptance of the Messiah. A key reference is at the raising of
Lazarus, where Jesus, coming to Lazarus' tomb "in a cave," states: "I am the
resurrection, and the life: he that believeth in me, though he were dead,
yet shall he live: and whosoever liveth and believeth in me shall never
die" (John 11:25–26). At the Crucifixion, the penitent thief is immediately
saved simply by pure faith in Christ, outweighing the consequence of his
former actions (Luke 23:40–43).

At many points in the New Testament, particularly in the writings
of the Evangelists, comment on the afterlife refers more specifically to the
event of the Last Judgment and the role played by Christ as Judge. It is faith
in the Messiah who had suffered and died that is the means of salvation and
the way to escape eternal condemnation; and while Christ's first coming
was for salvation, the second is to be for the purpose of judgment. The
Day of Judgment is vividly described in the Gospel of Matthew with the
appearance of the Son of God in Heaven and the summoning of the elect
and damned, separated on God's right and left hand respectively, to be
accorded everlasting punishment or life eternal, according to merit (Matt.
24:30–36 and 25:31–46). The sheep would be separated from the goats
(v. 32–34). Citations at Mark 12:25, Luke 14:14 and 17:22 appear mainly

concerned with the doctrine of the resurrection of the dead, while John 3:17–19 and 5:28–29 are more optimistic with emphasis laid on Christ's role as savior (3:17) and the idea of judgment in relation to merit (5:29), so that the just will have nothing to fear. The idea of peace, rest, and harmony at death after the struggle of life is also particularly expressed in John's gospel (14:27; 20:19, 26).

Following the Gospels, the Pauline writings (such as 1 Corinthians 15 and 1 Thess. 4:16–17) are also important sources that again appear to lay more emphasis on the saving of the just than on the condemnation of the damned. One of the most powerful statements of salvation through Christ occurs in the key chapter of 1 Corinthians 15. The victory over death is achieved through Jesus the savior: "O death where is thy sting, O grave where is thy victory," (1 Cor. 15:55) and this has been claimed as a key source for Michelangelo's own fresco of the Last Judgment.[37] In the book of 1 Corinthians, it is never lost sight of that those who reject Christ will remain under God's wrath (1 Corinthians 18, compare Rom. 1:18, 2:1–3) but the attributes of Christ at the Second Coming—omniscience, power, righteousness, holiness, love, his anger and mercy—are all represented at the same time. Christ acts as judge but also as mediator, a combination that embraces both the pessimistic and optimistic aspects of the event.

Finally, the major New Testament source for the Last Judgment event is the book of Revelation itself (especially chaps. 1, 8, and 20), where the apocalyptic vision marks a return to a more powerful type of eschatology and bears close resemblance in many ways to Old Testament sources.[38] Various ancient Jewish apocalypses existed, but without being regarded as authoritative; the book of Revelation survived because it was believed to have been written by the beloved disciple, John.[39]

The idea of prolonged pain (or even just the threat of it) leading to receptivity and suggestibility, where conversion is easily achieved, has been exploited by numerous régimes, up to and including the present age of the twentieth century (when the dying process often appears to be more feared than the actual state of death itself). In the book of Revelation are to be found the most graphic descriptions of a very powerful eschatological vision (20:1–3 and 7–10). Hell is the bottomless fiery pit, and torments await sinners day and night for eternity in the lake of fire and brimstone (v. 10). All would be judged and "whosoever was not found written in the book of life was cast into the lake of fire" (v. 15). Although such terrors might have been more familiar to those accustomed to war, plague, famine, and torture in the Middle Ages, it was clear that Hell must be, by its very nature, even worse than anything that had ever been experienced in the real world, the embodiment of evil. Everyone was to be judged by their actions (1 Cor. 3:13, Rev. 20:12) and the issue of judgment was sealed at death, according to actions performed "in the body" (1 Cor. 5:10). While the book of Revelation describes the thousand years of the

millennium when believers would live and reign with Christ, the rest of the dead would not live again until the thousand years were ended (Rev. 20:4–5). The judgment was fixed at death and would not alter between death and the Day of the Last Judgment. This would be a day of wrath for the unbelievers (Rom. 2:5 and 2 Thess. 1:9), but the same time would herald redemption for believers, when they would inherit the kingdom (Matt. 25:34) and enjoy the true bliss of heaven.[40]

The interpretation and depiction of the scene of the Last Judgment in art is founded on the key biblical texts mentioned above but, in addition to the Scriptures, other literary and theological sources are argued to have been influential in the interpretation and iconography of the depiction of the Last Judgment, including the writings of Saint Augustine, Saint Ephraim the Syrian, the *Golden Legend* of Jacobus de Voragine, the *Dies Irae* of Thomas of Celano, and, in Renaissance Italy, the *Divina Commedia* (*Inferno*) of Dante Alighieri.[41]

The Meaning of the Last Judgment

The present study is primarily concerned with the cosmological aspects of the iconography of the Last Judgment, but these key scriptural sources for the subject raise questions of perennial concern in the surrounding theological debate. Such issues cannot be resolved here, but many of them have cosmological implications and were also certainly very much under scrutiny during the Reformation and at the time Michelangelo was painting his fresco. Sixteenth-century religious debate, matters of reform, and the conflict between the Roman Catholics and Protestants reflect a particular concern with the key questions surrounding the Second Coming and the subject of the Last Judgment.

This late Renaissance debate is effectively summarized by Walker, who concentrates especially on what the reformers perceived as "weaknesses" in the doctrine of Hell.[42] Although there was strong scriptural authority for the doctrine of the condemnation of sinners, the New Testament theme of Christ as the savior of all is specifically stressed in several places (1 Tim. 2:4, Rom. 11:32, 1 Cor. 15:22, 28). Christ's readiness to wait, "not willing that any should perish, but that all should come to repentance" is also an important theme (2 Pet. 3:9). Universal salvation and the resurrection of humanity by the merciful God was also preached by Saint Augustine, whose ideas were revived during the course of sixteenth-century Reformation debate,[43] but the Roman Catholic concept of free will and insistence that humankind was responsible for its actions remained at odds with Protestant ideas on predestination. It was difficult to accept scriptural references to eternal punishment as well as the doctrine of the salvation of all humanity, and the Protestant reformers maintained that certain persons

were preordained to be saved. As with the ancient Hebrew concept of the Chosen People, each group tended to consider themselves "chosen."

Another major doctrinal problem associated with the Last Judgment consists of its role in the notion of crime and punishment. In the absence of effective judicial systems, the threat of the Last Judgment appears to have contributed to the general maintenance of law and order.[44] In most systems and at most times, punishment normally plays one of several roles: curative, deterrent, or punitive (retributive). The idea of punishment being curative would not apply to the Last Judgment, since the event signifies the end of time. Similarly, the notion of punishment as a final deterrent cannot apply at the end of time after which all actions cease (although the idea of the Last Judgment as a sincere warning against the possible effects of sin, founded in a genuine aim to help and save, also existed). The remedial aspects of punishment were also partly embraced within the Roman Catholic idea of an "interim" Purgatory and the expiation of sin before movement Heavenward. This was related to the selling of indulgences, a popular topic at the beginning of the sixteenth century. The practice was particularly objected to by the Protestants, who rejected the idea of Purgatory.[45]

In addition, the idea of Hell as remedial or as a deterrent is problematic, since it cannot act as deterrent to nonbelievers and atheists. In the case of disbelief, then, there would naturally be no fear of Hell, and no fear of death for the wicked if there were no concept of an afterlife.[46] Only Christians would believe in the Christian Hell, and those expecting the punishment of nonbelievers would tend to exclude themselves. The main function of the Last Judgment would seem, therefore, to be punitive, and since God controls all action, so, it has been argued, would there appear to be a strong emphasis on the vindictive aspect of God's justice (which does not relate well to the doctrine of love and universal salvation). The doctrine of free will suggests that humanity is able to choose but that God will punish those who make the wrong choice. If crime is the result of free choice, then punishment must be deserved. Laying aside the concept of original sin, sinners are thus considered not only wicked but also responsible for their wickedness, and free will would seem to justify the doctrine of Hell, unless God is simply vengeful. The Protestant doctrine of predestination or justification by faith alone, on the other hand, seems to deny this freedom of choice, and thus remove the responsibility. The idea of possible universal salvation, *sola fides*, formed a marked contrast to the Roman Catholic idea of the efficacy of good works.

The idea of ascribing retribution or vindictiveness to satisfy God's anger is ascribing very human instincts and emotions to God. The idea is further complicated if predestination is accepted, because it suggests that God capriciously made the wrongdoers act thus, having decided to exclude them.[47] Predestination seems to imply vindictive judgment by the

omnipotent deity, but the small number of Calvin's elect in Geneva clearly counted themselves among the saved, as "true believers." The elect are to be saved to demonstrate mercy and the wicked damned as examples of justice, but the condemnation of the majority, when a few would suffice for the purpose of deterrence, appears unnecessary. Mercy would be more amply demonstrated by the saving of sinners, not the virtuous, especially since virtue would be no virtue if it were only pursued for fear of Hell. As Walker puts it, in the end Satan's kingdom of Hell is not only permitted by God but is an essential part of the plan to demonstrate the system of justice to be manifest for all eternity.[48]

Related to the notion of judgment of the resurrected is the theology of the actual nature of the resurrection itself, namely the debate concerning the concept of full bodily resurrection versus the ancient (classical) concept of the immortality of the soul. This was a major topic of discussion, particularly at the time when Michelangelo was working on the *Last Judgment* fresco. As already mentioned, 1 Corinthians 15 is a key source for the full bodily resurrection of all believers (in an ideal form, with infirmities restored).[49] Yet the spiritual aspect of the resurrection is also emphasized here: "It is sown in a natural body; it is raised in a spiritual body. There is a natural body, and there is a spiritual body" (v. 44).[50] During the Renaissance period, the Christian belief in the bodily resurrection of the flesh came increasingly under discussion in relation to the parallel but contrasting idea of the immortality of the human soul. The traditional belief in the resurrection of the flesh had been a major point of conciliar discussion, is highlighted in the Nicene Creed, and was considered in the Reformation debate.[51] The whole Church was founded on the significance of Jesus' resurrection and the belief that just as Christ rose (in the flesh) from the dead, so indeed would each person, on the Last Day,[52] yet attempts were made in the late Renaissance to bring about reconciliation between the biblical notion of bodily resurrection and the ancient Greek concept of the immortality of the soul. This was particularly emphasized by the followers of Renaissance Neoplatonism although it has been argued that, by the 1530s, it was once more agreed that the orthodox Catholic view must be founded on actual bodily (rather than spiritual) resurrection.[53]

Apart from the nature of resurrection and judgment, the timing and the location of the Last Judgment were also perennial themes for debate, which came under discussion in the sixteenth century. In early Christian times, when the Church was in a relatively weak position, the Coming was regarded as imminent. Early Christians, in the same way as the oppressed races of the Old Testament, had looked to the Second Coming as very close at hand—as a time when their enemies and oppressors would be punished and they would inherit the kingdom. Alongside the remedial/punitive nature of Christ's Judgment of the Second Coming, the

vision of universal salvation and well-being therefore existed in the form of a vision of a new paradise on earth: an ideal world, free from suffering and sin, which would finally be enjoyed by the deserving poor, who had been deprived of comfort in their material existence. As time passed, however, the distance of this appeared to recede, as the event seemed to be put further into the future, up to the late medieval period. Throughout the Middle Ages, when the Catholic Church was in a very powerful situation and far from oppressed itself (with an acknowledged prime position in all areas of life, government, and state), there appeared little need to preach the imminence of the Second Coming, but rather a wish to maintain the status quo that was being enjoyed (in contrast to the situation in the first centuries following Christ's death). By the time of the Renaissance and the Reformation, however, the Second Coming was again regarded as imminent, if not already taking place.[54] While the event itself was to occur "In a moment, in the twinkling of an eye, at the last trump" (1 Cor. 15: 52), the precise date at which it would happen remained unspecified and a matter for debate.[55]

Whether the Second Coming was regarded as imminent or as deferred to some future date, then, the question remained about those Christians who had already died, whether they were already judged at their own death, or whether they were merely "sleeping" or "waiting" while their reward or punishment was postponed to the Last Day, when time would cease and no further action could take place. If each individual is to be judged at the time of his or her death, then the Last Judgment would appear to apply only to those alive at the time of the Last Judgment, but, according to dogma, the full story of individual biography would finally end after the resurrection on the Last Day, not at earthly death. The actual expression "Last Judgment" (or "Giudizio Universale" in Italian) implies that earlier judgments have taken place, the first judgment having been caused by Adam as the result of the Fall in the Garden of Eden and resulting in the misery and death of all (Gen. 2:17 and 3:14–19).[56] The book of Revelation suggests resurrection for the just at the beginning of the millennium when the blessed will "reign with Christ for a thousand years" after which the remainder of the dead would be raised (20:2–5). This raises the question of the number and proportion of the damned. The concept of the elect suggests a minority (since "many are called but few are chosen," Matt. 7:14, 20:16, 22:14, and Luke 13:24) and implies a cosmic struggle between the forces and balance of good and evil in the universe. The good must surely exceed the damned in order to comply with the New Testament vision, and there would be little reason to resurrect evil simply in order to punish it. Such a process, if all are resurrected for judgment, would lead to an enormous majority of the damned, and a preponderance of evil in the universe, for all eternity—in contrast with a small minority of saints and blessed.[57] In the light of the doctrine of eternal salvation, and

to avoid the primacy of evil after judgment, it ought rather to follow that the damned must eventually be forgiven, or that punishment should be remedial.[58]

In Michelangelo's fresco, unlike some earlier versions, a far greater proportion of the fresco surface is devoted to the saved, who are resurrected in perfect bodily form. Even though Michelangelo did not choose to depict the pleasures of a Renaissance paradise, a greater area is allocated to the resurrected, the saints, and the saved than to the damned, who are being driven out of view and presumably out of the universe, suggesting (by weight of numbers alone) a more optimistic view than expressed in many sources cited in the Bible. There is little in Michelangelo's *Last Judgment* to suggest that severe pain should lead to reform and forgiveness, or that Hell is perceived here as remedial, but there is certainly less emphasis in the fresco on the vengeful physical punishment described in the Old Testament sources and depicted with relish in medieval versions of the *Last Judgment*. Perhaps because of changes in attitude to other people's suffering by the time of the Renaissance, this aspect of Hell gradually became obsolete, and the notion of pity became evident. The damned seem more tormented psychologically than physically, as the eternal torment of remorse and despair comes from within.[59] Although it is universally regarded as unjust if the wicked are to escape, the idea of suffering and punishment as the natural and the inevitable result of sin appears more in tune with modern thinking than endless physical punishment imposed externally by a vengeful, punishing God. Michelangelo's *Last Judgment* could therefore be understood as marking the beginning of a more modern (post-Renaissance) approach, compared with earlier medieval and Renaissance examples of the subject. Aiming to depict Hell as a state of mind as much as a physical place, Michelangelo has expressed the conscience-stricken guilt of the sinners whose penalty is to be deprived of God. Their fate is the direct result of sin, rather than simply punitive action by God, suggesting that humanity remains master of its fate, according to the doctrine of free will. In spite of free will and humanity's responsibility for actions, the power of God is not questioned, nor is Christ's ability to act as savior for all. Thus the dual nature of God's love and anger, of the vengeful Lord and the Johannine God of love, is evident in Michelangelo's interpretation.

Discussion of the timing of the Last Judgment leads on to consideration of the nature and location of Heaven and Hell, which similarly has cosmological implications. It was often supposed that Hell should possess an actual physical location in relation to the earth and to the universe in general, and attempts were sometimes made to suggest locations for Hell in the real world. The common idea of Hell's location as subterranean was derived from scriptural sources indicating a clearly

downward movement (such as Isa. 15:15, Ezek. 31:16 and Amos 9:2), and Hell is specifically described as a subterranean "bottomless pit" in the book of Revelation (20:1, 3). This presented few problems in the traditional flat-earth system of the universe, but the notion of Hell as bottomless was to become problematic, if not untenable, following the acceptance in contemporary cosmology of the spherical earth. Similarly, attempts were often made to establish the physical location of heaven. The spiritual idea of the afterlife as a metaphysical state with saints, angels, apostles, and saved in eternal ecstatic contemplation of God was often replaced in the popular imagination with more material visions of a distinct place with a geographical location, complete with gardens, rivers, perfumes, and other forms of earthly delight, where all defects would be restored and an eternity of bliss would await the blessed, just as an eternity of misery awaited the sinners.[60]

Hope for a physical heaven to be realized on earth led, at different times, to upsurges in millenary feeling (inspired by Rev. 20:4–5). In the Middle Ages (as demonstrated in early medieval versions of the *Last Judgment*), the idea of a saintly population existing in a glorious afterlife received less emphasis than the condemnation of wickedness and evil, on which a far greater stress was laid. The apocalyptic visions of the twelfth century (such as Beaulieu and Conques) gradually gave way to an emphasis on actual judgment and the fate of the saved and damned in the later medieval period (such as at Notre Dame). The psychological refusal to link the end of physical existence with the end of being and to insist on continued bodily existence after death was linked to the basic concept that the deserving should be rescued, while the wicked condemned. This was extended in the view of the millenarians to the idea of the victory of the poor and oppressed over their oppressors/tyrants, and assumed important social and political dimensions. The concept that those who suffer in life would be rewarded while their exploiters were punished found scriptural authority in the account of the beggar Lazarus, who was rewarded in Heaven, while Dives, the rich man, was condemned to Hell (Luke 16:19–31). Like the episode of the penitent thief, it is implied that the post mortem judgment is immediate.

The theme of counteracting the discrepancies wrought by real life when the righteous are downtrodden whilst the unrighteous prosper also has a vengeful aspect, much emphasized in the course of millenary fervor at various stages. All will be resolved at the Last Judgment in a sudden miraculous event when good will triumph and the worshippers of the Lord shall "look upon the carcases of the men that have transgressed . . . for their worm shall not die neither shall their fire be quenched" (Isa. 66:24). The world would be utterly transformed, because there would be "a new heaven and a new earth when the former things would pass away" (Rev. 21:1) with "no more death, neither sorrow, nor crying, neither shall

there be any more pain: for the former things are passed away" (v. 4). But this overwhelming message of consolation to the oppressed, the idea of the millennium and of the formation of God's kingdom on earth, came to be related either to a very ethereal spirituality or, in other cases, to very earthbound materialism.[61] The promise of a bodily afterlife was a major tenet of Christianity and possibly one of the main reasons for its early and sustained popularity. Whether among the Early Christians, martyred by the Roman state, or the oppressed classes of the Middle Ages, many Christians (whether orthodox Catholics or part of schismatic sects) consoled and fortified themselves in the face of oppression with a millenary fervor, based on the conviction that they were chosen to be saved. The impression that Christ's return to earth was imminent suggested an urgent need to address the nature of Judgment, both as a doctrine and as a historical event.

Many of the sixteenth-century religious reformers indicated a wish to return to the spiritual ideas of the Early Church, and the millennium again came to be regarded as imminent and spiritual. As mentioned, millenary fervor increased around the year 1500, and from this time, with the religious upheavals of the sixteenth century, many reformers alleged that contemporary problems of the Roman Church as an indication that the expected age seemed to have arrived.[62] Perennial interest in death and the afterlife (or some form of postdeath existence) became linked with social and political unrest in many areas, in a time of immense change and upheaval. Luther in particular saw the Catholic Church as collapsing and the Reformation as heralding the end, although this was not an opinion shared by the Catholic authorities. Radical millenarians, such as the Anabaptists in the Low Countries, set up millenary kingdoms, awaiting Christ's coming, physically and literally, on earth. Fantasies abounded about the vision of a paradise on earth, a world free from sin and suffering, and this was often fused with the desire of the poor and oppressed to improve their condition, in a sort of "paradise regained" based on social aspirations as much as apocalyptic tradition.[63] Doctrines ranged from the very spiritual to the materialistic and even the violent and aggressive, and groups of the needy and oppressed across Europe (who had survived all sorts of troubles, war, plagues, and famine) were often convinced by some millennial prophet to look forward to a world that would be inhabited only by what was good and perfect, when their enemies would be cast down and "the New Jerusalem" rebuilt, as they were reunited with lost loved ones.[64] Revolutionary eschatology, the promise of future compensation for present affliction and the reassurance that all would finally be well after the overthrow of a world dominated by evil tyranny persisted in popular religion and appealed especially to the lower strata of society. The establishment of a perfect earthly kingdom or paradise for a thousand years seemed preferable to waiting until the end of time for an otherworldly one. The idea that the just should "live and reign" with Christ a thousand

years (Rev. 20:4) prior to the resurrection of the dead was taken literally and expected with great excitement at various stages from the first to the sixteenth century, not regarded as remote and indefinite. There was a constant expectation, with people on the watch for signs like evil rulers, war, drought, famine, plague, and comets, of which there was clearly never any shortage. The propaganda of better times to come was utilized to compensate the oppressed at the same time that the threat of punishment was used to keep the masses in order. The Counter-Reformation was to present the Second Coming in terms of terror, but the reformers, both Catholic and Protestant, placed more emphasis on the saving and future comfort of the faithful, among whom, of course, they all naturally counted themselves.[65]

Problems facing theologians in the sixteenth century and the identification of issues dividing Roman Catholics and Protestants are far more complex than space allows here. The literature on the history of dogma and problems of doctrinal development is immense.[66] In the above discussion of some major aspects of the lengthy debate concerning the doctrine of the Last Judgment and the nature, timing, and location of the event itself, it is clear that cosmological concepts play an important role. It also becomes clear that the use of symbolism is immensely important, both in the metaphysical discussion of the subject as well as in its literal physical depiction in art. The varying range of symbolism used in medieval and Renaissance depictions of the Last Judgment appears to relate partly to the changing attitudes toward eschatology over the centuries, such as whether the emphasis should be laid on the punishment of the wicked, the state of the blessed, or the concept of universal salvation through Christ. In light of this debate, and in spite of the comments related by Vasari on the artist's independence, it does seem that it would have been unlikely for Michelangelo to have worked on the theme of the Last Judgment totally without theological advisers, or without reference to the demands and approval of his papal patrons, in determining the content and design.[67] However, whatever advice Michelangelo may have received, the final translation of the theological concept into the artwork must belong to the artist.

The potential sources for the fresco still suggest certain overriding themes concerning the ultimate role of Christ as Lord, Judge, and Savior of the universe, and indicate the importance of a cosmological interpretation of the subject. As we shall see, from the time of the medieval acceptance of the spherical earth, the timing and location of the Last Judgment event became increasingly questioned as traditional concepts were rendered somewhat untenable in physical terms. Deriving perhaps from an emphasis on universal salvation as opposed to the punishment of the damned, the idea of Heaven and Hell as psychological states rather than physical

places seems to have been examined by Michelangelo in an interpretation reflecting Renaissance spirituality rather than medieval threat. Issues concerning the nature of judgment and salvation, its timing and location, all have immense cosmological implications, especially when the three areas of Heaven, Earth, and Hell were required to be depicted together simultaneously in art. The scriptural flat-earth view of the universe became superseded by the system of medieval cosmology, inherited from Aristotle and Ptolemy and based on the conception of the universe as a series of concentric nested spheres, culminating in the ninth sphere of the primum mobile, beyond which lay the empyrean—eternal, infinite, without location, unmeasurable, and tranquil. Further speculation during the Renaissance, and then the Enlightenment, was to lead to further questioning, finally resulting in symbolic reading of scriptural accounts of cosmological events like the Creation and the Last Judgment.

The relative importance of the various sources for *Last Judgment* iconography may be more precisely assessed by an examination of versions prior to Michelangelo, and a consideration of previous renderings of the *Last Judgment* is a necessary prerequisite to a detailed assessment of the iconography of the version of the *Last Judgment* by Michelangelo himself. By analysis and comparison, it should be possible to discover whether a traditional formula was established by the sixteenth century and whether such a basic formula was related in its overall disposition to a view that reflected biblical and/or contemporary cosmology and symbolism. Leading on from this, the extent to which Michelangelo's version complied with or deviated from that norm may then be considered, with a view to examining the possible relationship between any change or variation in the scene's iconography and any change or variation in worldview and cosmology during the sixteenth century.

Notes

1. Biblical quotations are all taken from the Authorized version of the Bible, unless otherwise stated. Where detail is required for verses proposed as specific source material for Michelangelo, comparison will be made with the Latin Vulgate version.

2. The close connection between theology and cosmology is made clear at once from the Bible in Genesis 1. For theological and historical discussion of the association, see, for example, Arthur O. Lovejoy, *The Great Chain of Being* (Cambridge: Harvard University Press, 1936); John Louis Emil Dreyer, *A History of Astronomy from Thales to Kepler* (New York: Dover, 1953), esp. 1–9, "The Earliest Cosmological Ideas." More recently, Wolfgang Yourgrau and Allen D. Breck, *Cosmology, History and Theology* (New York: Plenum, 1977); N. Max Wildiers, *The Theologian and His Universe: Theology and Cosmology from the Middle Ages to the Present* (New York: Seabury, 1982); Colin A. Russell, *Cross-currents: Interactions between Science and Faith* (Leicester: Intervarsity Press, 1985). Arthur Koestler, *The Sleepwalkers: A History of Man's Changing Vision of the Universe* (Harmondsworth: Penguin, 1984), pts. 1 and 2; and Gordon Strachan, *Christ and the Cosmos* (Dunbar: Labarum, 1985), have

discussed the way in which humanity has attempted to explain the creation and the order of the universe in spiritual terms.

3. Works dealing with the separation and consequent conflict between religion and science after the seventeenth century include John William Draper, *Religion and Science* (London: King, 1875); Andrew Dickson White, *A History of the Warfare of Science with Theology in Christendom* (New York: Dover, 1960; 1st ed. 1896); and Bertrand Russell, *Religion and Science* (Oxford: Oxford University Press, 1960; 1st ed. 1935).

4. God is referred to as "Maker of Heaven and Earth"; note also the references to Christ's descent into Hell and ascent into Heaven, *Book of Common Prayer* (London: Eyre and Spottiswode, n.d.), 50.

5. For example, Pss. 104, 115:15, 124:8, 134:3, 146:6; Isa. 37:16; Jer. 10:12, 32:17; and in the New Testament Acts 4:24, 14:15; Heb. 3:4; Rev. 14:7.

6. See also Isa. 45:12, 51:13, 55:9; and Ps. 104:2.

7. Pss. 104:5, 19, 22, and 119:90, mainly concerned with the concept of the immobility of the earth; see Josh. 1:12; Ps. 19:4–5; and Eccles. 1:5 for the movement of the sun.

8. For example, Gen. 28:12; Deut. 4:39; 2 Kings 2:1; Pss. 14:2, 80:14, 103:11, 139:8; Isa. 14:12, 13; Dan. 4:13; Luke 24:51; John 1:32; Acts 1:11; 1 Thess. 4:16; 1 Pet. 1:12; and Rev. 8:10, 10:1, 11:12.

9. Probably a Syrian monk (flourished c. 500), who is known only by his pseudonym. He wrote a series of Greek treatises and letters for the purpose of uniting Neoplatonic philosophy with Christian theology and mystical experience. His writings became of decisive importance for the theology and spirituality of both Eastern Orthodoxy and Western Catholicism. See Emile Mâle, *The Gothic Image* (London: Collins, 1961; 1st ed. 1913), introduction, passim; and J. Parker, ed., *The Works of Dionysius the Areopagite* (New York: Richwood, 1976). The continued importance of Pseudo-Dionysius into the Renaissance period, together with the idea of a correspondence between earthly and heavenly hierarchies, has been demonstrated in a book on sermons given in the Sistine Chapel and St. Peter's basilica, 1450–1521 by John W. O'Malley, *Praise and Blame in Renaissance Rome* (Durham: Duke University Press, 1979), 10–11, 107, 159, 161.

10. Since they reveal the strong influence of the philosopher Proclus (d. 485) and the first reference to them dates from 532, they are almost certainly the work of a late-fifth/early-sixth-century monk, not the companion of St. Paul; René Huyghe, ed., *Larousse Encyclopaedia of Byzantine and Medieval Art,* (London: Hamlyn 1981), 18. Parker is in the minority for proposing otherwise; Parker, *Works of Dionysius the Areopagite*, 2:5–20.

11. Reprinted in Parker, *Works of Dionysius the Areopagite*, 2:1–66 and 67–162. See Koestler, *Sleepwalkers*, 98–99, for the "immense influence" of these writings.

12. Pseudo-Dionysius, *On the Celestial Hierarchy*, caput 1, secs. 1 and 2.

13. See Mâle, *Gothic Image*, 8–9, and Lovejoy, *Chain of Being,* for the widespread nature of this notion. The entry "Cosmology and Cartography" in *Encyclopedia of World Art,* 3:836–64, contains useful discussion of "Cosmological Ideas and Allusive and Symbolic Images of the World."

14. Discussed by Koestler, *Sleepwalkers*, 92–93.

15. See 1 Kings 6, where the precise dimensions of Solomon's temple are given.

16. See André Chastel et al., *The Sistine Chapel: Michelangelo Rediscovered* (London: Muller, Blond, and White, 1986), 12, 40; and Lutz Heusinger and Fabrizio Mancinelli, *The Sistine Chapel* (London: Constable, 1973), 3. The currency of the concept of a parallel between the universe and the Temple in the Renaissance is demonstrated by O'Malley, *Praise and Blame*, 132–33; and Peter Burke, *Culture and Society in Renaissance Italy, 1420–1540* (London: Batsford, 1972), 156–57.

17. See Karl Lehmann, "The Dome of Heaven" in W. Eugene Kleinbauer, *Modern*

Perspectives in Western Art History (New York: Holt, Rinehart, and Winston, 1971), 227–70. Lehmann discusses the concept of the ceiling or dome as sky, drawing a link with the architectural structure and various cosmic symbols. See also Otto Demus, *Byzantine Mosaic Decoration* (London: Routledge and Kegan Paul, 1948), esp. 14ff.; John Beckwith, *Early Christian and Byzantine Art* (Harmondsworth: Penguin, 1970), 28–29, "The Church Building as the Cosmos,"; and Louis Hautecoeur, *Mystique et Architecture: Symbolisme du Cercle et de la Coupole* (Paris: Picard, 1954). Also Koestler, *Sleepwalkers*, 91–92.

18. See Demus, *Byzantine Mosaic Decoration*, 15–29. Although written some time ago, this still remains one of the best explanations of Byzantine schemes of decoration.

19. For example, the Virgin was normally portrayed in the conch of the apse as the "bridge" between the Heavenly and earthly zones. Important Byzantine schemes demonstrating these hierarchical systems are to be found at Hosios Loukas and Daphni, for which see David Talbot Rice, *Byzantine Art* (Harmondsworth: Penguin, 1968), chap. 5.

20. Demus, *Byzantine Mosaic Decoration,* 3. Similar principles applied in the West, in painted barrel vaults of which few survive, in the curved areas of Romanesque tympana, corresponding to the "Dome of Heaven" seen in cross-section, and also in the vertical emphasis of Gothic structures, aspiring heavenwards. Otto von Simson, *The Gothic Cathedrals: Origins of Gothic Architecture and the Medieval Concept of Order* (Princeton: Princeton University Press, 1956), 35–36, discusses the Western type of cathedral as a model of the cosmos and an imitation of God's created universe. The inclusion of the signs of the zodiac and the labors of the months in the programs of the great cathedrals confirm the way in which medieval decorative schemes incorporated the total worldview.

21. Rudolf Wittkower, *Architectural Principles in the Age of Humanism* (London: Tiranti, 1967), esp. 27–33, "The Religious Symbolism of Centrally Planned Churches." Burke, *Culture and Society*, 157, also comments on the significance of the circular plan in the Renaissance.

22. Hautecoeur, *Mystique et Architecture*, esp. 274–80; see also "Cosmology and Cartography," in *Encyclopedia of World Art,* for comment on the reemergence of the ancient cosmological symbolism of art and architecture during the Renaissance (esp. 841–44).

23. This may readily be seen in numerous Byzantine, medieval, and Renaissance examples. See Gertrud Schiller, *Iconography of Christian Art*, trans. Janet Seligman, 2 vols. (London: Lund Humphries, 1971).

24. For examples of this practice in the early Renaissance, see the Master of the St. Francis cycle at Assisi, *St. Francis Renouncing His Earthly Possessions*, 1290s; Giotto, *Joachim's Sacrifice*, Arena Chapel, Padua, c. 1305.

25. Important creation cycles occur at Monreale, Palermo, the Florence Baptistery, and St. Mark's, Venice. Christ is shown seated on the sphere of the universe at St. Vitale, Ravenna. For details of these and other examples see J. Zalten, *Creatio Mundi* (Stuttgart: Klett-Cotta, 1979).

26. As for example in the synagogue at Beth Alpha, at Bawit, and in the Dalmatic of Charlemagne, for which see, respectively, Michael E. Stone, "Judaism at the Time of Christ," *Scientific American* 228 (January 1973): 80–87; André Grabar, *Christian Iconography: A Study of Its Origins* (London: Routledge and Kegan Paul, 1969), fig. 118; and Tolnay, *Michelangelo*, vol. 5, fig. 272. The concept of the integration of cosmic and Christian symbolism is also particularly discussed by Louis Bréhier, *L'Art Chrétien* (Paris: Renouard, 1928); Lehmann, "Dome of Heaven"; and Ernst Kitzinger, "World Map and Fortune's Wheel: A Medieval Mosaic Floor in Turin," in *The Art of Byzantium and the Medieval West* (Bloomington: Indiana University Press, 1976), 327–56.

27. For example, at Hosios Loukas. See Schiller, *Iconography of Christian Art*, vol. 2., figs. 342–43, for this and other examples.

28. Giotto's *Nativity* in the Arena Chapel, Padua, c. 1305, is significant for its apparent

inclusion of the star of Bethlehem in the guise of Halley's comet, which appeared in 1301; J. E. Bortle, "A Halley Chronicle," *Astronomy* 13 (October 1985): 98–110, esp. 103.

29. See Josh. 10:12. The example in Sta Maria Maggiore is discussed by Grabar, *Christian Iconography*, 49.

30. Discussion and debate about humanity's fate after death and the concept of an apocalyptic Last Judgment predates the Christian religion. Comprehensive discussion of the historical and religious debate on the issue that has taken place during the two thousand years since the time of Christ lies outside the scope of the present iconological discussion but some key themes will be highlighted, which are clearly of particular importance for the fresco of Michelangelo. For some further discussion of the key issues, see Ray Sherman Anderson, *Theology, Death and Dying* (Oxford: Basil Blackwell, 1986); Philippe Ariès, *Western Attitudes toward Death from the Middle Ages to the Present,* trans. Patricia M. Ranum (Baltimore: Johns Hopkins University Press, 1974); Daniel Pickering Walker, *The Decline of Hell: Seventeenth-Century Discussions of Eternal Torment* (London: Routledge and Kegan Paul, 1964), esp. pt. 1; Paul Badham, *Christian Beliefs About Life after Death* (London: MacMillan, 1976); Colleen McDannell and Bernhard Lang, *Heaven: A History* (New Haven: Yale University Press, 1988); Norman Cohn, *The Pursuit of the Millennium* (Fair Lawn, N.J.: Essential Books, 1957). For discussion on the history of dogma and doctrinal development, see Jaroslav J. Pelikan, *Development of Christian Doctrine: Some Historical Prolegomena* (New Haven: Yale University Press, 1969), and for the situation in Renaissance Rome, see O'Malley, *Praise and Blame.* For the Last Judgment and its depiction in art, see especially Louis Réau, *Iconographie de l'Art Chrétien* (Paris: Presses Universitaires de France, 1957), 727–57; Mâle, *Gothic Image*, 355–89; Robert Hughes, *Heaven and Hell in Western Art* (London: Weidenfeld and Nicolson, 1968); and Redig de Campos, *Michelangelo, Last Judgment*, 59–68.

31. This concept was emphasized by the Fathers of the Church, for example, St. John of Damascus, *De Fide Orthodoxa,* trans. F. H. Chase (Washington: Catholic University Press of America, 1970), 401–402, and St. Augustine, *City of God,* trans. Henry Bettenson, (Harmondsworth: Penguin, 1984), 1,027–28.

32. See Walker, *Decline of Hell,* esp. 17–27.

33. See, for example, Hughes, *Heaven and Hell;* and in the following chapter of this book.

34. Geoffrey R. Elton, *Reformation Europe* (London: Collins, 1971), 274–75; James P. Martin, *The Last Judgment* (Grand Rapids: Eerdmans, 1963).

35. John Henry, Cardinal Newman, *An Essay on the Development of Christian Doctrine* (New York: Doubleday, 1960; 1st ed. 1845), 83.

36. Numerous Byzantine, Romanesque, Gothic, and Renaissance examples remain.

37. Marcia B. Hall, "Michelangelo's *Last Judgment*: Resurrection of the Body and Predestination," *Art Bulletin* 58 (March 1976): 85–92.

38. Revelation 20 closely parallels the predictions of the prophet Daniel; see Dan. 12:1–4 and compare to Rev. 20:11–15.

39. Cohn, *Pursuit of the Millennium*, chap. 1, pp. 1–13.

40. It may be noted that descriptions of Hell are almost always more explicit than those of Paradise, where discussion centers more on methods of getting there than on its precise nature.

41. For general comment on these sources, see Redig de Campos, *Michelangelo, Last Judgment,* 63–67; Mâle, *Gothic Image*, 365–66. For the material proposed, see St. Augustine, *City of God,* esp. 20:895–963; Ephrem le Syrien, *Textes Arméniens relatifs S Ephrem,* trans B. Outtier (Louvain: Corpus Scriptorum Christianorum, 1985), vol. 16; Jacobus de Voragine, *Legenda Aurea* (New York: Arno, 1969). For the *Dies Irae*, see Ariès, *Western Attitudes towards Death,* 29–39, esp. 32, where he describes the thirteenth-century Franciscan work

as "a cosmic book, the formidable census of the universe." Discussion of such sources for Michelangelo's *Last Judgment* is included by Tolnay, *Michelangelo*, 5:34, 109–11.

42. Walker, *Decline of Hell*, pt. 1, esp. 33–34.

43. Augustine, *City of God*, bk. 21, chaps. 17–18 (ed. cit. 995–98).

44. Samuel Y. Edgerton, *Pictures and Punishment* (Ithaca: Cornell University Press, 1984), 22ff.

45. See Geoffrey R. Elton, *Reformation Europe* (London: Collins, 1971), 18–20. The concept of the soul flying into Heaven as the coin drops in the box was anathema to the reformers. There are implications here for Michelangelo since some of the funds thus raised were used for the Sistine.

46. Among the ancients, Plato commented that afterlife in Hell should be eternal for the very wicked, "For if death were an escape from everything, it would be a boon to the wicked, for when they die they would be freed from the body and from their wickedness together with their souls. . . ." Plato, *Phaedo*, 106C—115A, esp. 107D; see also idem, *Republic* 10, 614A—621D for discussion on judgment and the way "the righteous journey to the right and upwards through the heaven . . . and the unjust take the road to the left and downward" (614D).

47. Walker, *Decline of Hell,* 48.

48. Walker, *Decline of Hell,* 58–59.

49. The concept of the full restoration of the body upon resurrection was the source for witticism on the part of Michelangelo. As Vasari relates, on being shown a painting where an artist had copied extensively from other works, Michelangelo was prompted to comment: "at the day of Judgment when every body takes back its own members, I don't know what that picture will do, because it will have nothing left" (Vasari, *Lives*, ed. Bull, 427–28).

50. Compare John 3:6, "That which is born of the flesh is flesh; and that which is born of the Spirit is spirit."

51. Space does not allow full consideration here of the attitude of the reformers, particularly Luther and Calvin, toward the doctrine of full bodily resurrection, but the following may be consulted for the basic historical background: Geoffrey R. Elton, ed., *New Cambridge Modern History*, vol. 2. *The Reformation 1520–1559* (Cambridge: Cambridge University Press, 1958).

52. Badham, *Christian Beliefs About Life after Death*, chap. 2, pp. 18–19, 47–64; Anderson, *Theology Death and Dying,* 57–58. The concept of spiritual immortality had been reinforced by St. Augustine (*City of God*, bk. 22, chap. 20), although he considered that belief in the immortality of the soul was not enough (*City of God,* bk. 14, chap. 5). The most powerful argument was Jesus risen in the flesh.

53. Hall has argued for an emphasis on bodily resurrection in Michelangelo's fresco; Hall, "Resurrection of the Body," esp. 88.

54. Evidence for this may be found in the prophecies and visions of Savonarola in late-fifteenth-century Florence, claimed as an influence upon the inscription added by Botticelli to his *Mystic Nativity*, in the National Gallery, London: "This picture I, Alessandro, painted at the end of the year 1500, in the troubles of Italy . . . during the fulfilment of the eleventh of John, in the second woe of the Apocalypse . . . ," for which see Ronald Lightbown, *Sandro Botticelli: Life and Work*, vol. 1 (London: Elek, 1978), 30, 134–38.

55. A "cosmic pause" is described at one particular stage of the process, after the opening of the seventh seal: "And when he had opened the seventh seal, there was silence in heaven about the space of half an hour," Rev. 8:1.

56. Faith in Christ is the only means of escape from the death wrought on humankind by Adam; 1 Cor. 15:21–24.

57. Walker, *Decline of Hell*, 35–36.

58. This has been argued with respect to Michelangelo's *Last Judgment,* by Steinberg, who has assessed "remedial" themes in the fresco; Steinberg, "Merciful Heresy".

59. Certainly, in Michelangelo's own poetry, such feelings of psychological torment and of his own unworthiness are expressed. For discussion of this theme, see Tolnay, *Michelangelo: Sculptor, Painter, Architect*, esp. 106–107.

60. Cohn, *Pursuit of the Millennium,* 21–32.

61. Cohn, *Pursuit of the Millennium,* chap. 1.

62. Millenarian feeling is also be identified in the present age, at the end of the twentieth and beginning of the twenty-first century.

63. Cohn, *Pursuit of the Millennium,* esp. 13–32. Movements in Belgium, northern France, and Germany were linked with severe revolutionary chiliasm and related to political upheaval in areas of rapid social change. In spite of the expansion of trade, industry, and population and the change from the agricultural basis of society, life continued to be a ceaseless, losing struggle for the masses, characterized by poverty and hardship. Improvements did take place toward the end of the Middle Ages, but the unstable situation contributed to the feeling that the Messiah would save his chosen people, who would eventually enjoy riches, security, and power for all eternity.

64. Cohn, *Pursuit of the Millennium,* esp. chap. 1. The Old Testament idea of the chosen people was transferred from Jew to Christian and thence to both Catholics and Protestants.

65. The contrasting approaches by Catholic and Protestant reformers to the doctrine of the Last Judgment and the related concepts of Heaven and Hell is examined in McDannell and Lang, *Heaven: A History*, esp. chap. 6, "God at the Centre: Protestant and Catholic Reformers," 145–80.

66. See, for example, Jaroslav J. Pelikan, *The Development of Christian Doctrine: Some Historical Prolegomena* (New Haven: Yale University Press, 1969).

67. Vasari, *Lives* (ed. de Vere, 1882–83; ed. Bull, 378–79).

Chapter 3

Iconography of the Last Judgment

And then shall appear the sign of the Son of man in heaven . . . and they shall see the Son of man coming in the clouds of heaven with power and great glory.

—Matt. 24:30

Origins and Early Examples

The consideration of depictions of the Last Judgment[1] prior to the version by Michelangelo demonstrates a relationship between the iconographic scene, based on the notion of ascent to Heaven and descent to Hell, and the prevailing worldview of the universe according to which Heaven was situated above and Hell beneath the earth's surface. A comparative study of more than one hundred examples of the Last Judgment scene reveals several major themes that may be traced in these works. Certain features are shared by Italian and non-Italian examples, both of which have been discussed in order to establish the broad spectrum of the scene's iconography, its traditional format and component parts, and above all, its relationship with worldview and astronomy and cosmology in general.

The majority of representations of the Last Judgment, from the earliest surviving examples in the sixth century until the time of Michelangelo, share certain common ideas and features that are derived from the scriptural sources. Apart from the question of the general overall disposition or arrangement of the scene, different specific themes seem to be common to all major examples. The iconography is complex, since events taking place sequentially in verbal descriptions are shown as taking place at the same time and in the same place in visual depictions. For example, as outlined by Mâle[2] and Réau,[3] the scene generally comprises the following features: forewarning signs of the impending event, the appearance of the

Judge (showing His wounds and the instruments of the Passion), angels with the symbols of the Passion, the Virgin and Saint John as intercessors, the Resurrection of the Dead (as skeletons, clothed or shrouded figures, or in some combination of these), the act of Judgment itself with Christ and the Apostles and Archangels as assessors (as in the weighing of souls), the consequent separation of saved and damned, and finally, the bliss of the rewarded and the punishment and despair of the damned. This chronology of scenes is most often simultaneously depicted and, in the examples examined, many or all of these features are found to be included.

Very early examples of the *Last Judgment* scene are rare. In the seventh century, the Venerable Bede mentioned a *Last Judgment* of earlier date that had existed in the Basilica of Saint Peter's in Rome[4] but no visual record of this seems to have survived. Thus the earliest known surviving pictorial version of the subject is that of Cosmas Indicopleustes in his *Christian Topography*.[5] Cosmas Indicopleustes was an Alexandrian monk and traveler, active in the mid-sixth century. His *Christian Topography* is important for the way in which it summarizes Early Christian and Byzantine cosmology, based primarily on the Bible but also strongly influenced by the writings of the early Church Fathers.[6] Cosmas consolidated the cosmological theory of the earth that had already been started by men like Clement of Alexandria and Lactantius, basing his arguments on the biblical foundations derived from the accounts of the creation in Genesis, Isaiah, and the Psalms.[7] The universe, according to Cosmas, is the same shape as Moses' Tabernacle or the Temple of Solomon with flat base, perpendicular sides, and a semicylindrical roof. The earth itself is a flat plane resting on the base. Cosmas' manuscript concerning Christian cosmology is especially significant art historically since, unlike the writings of Pseudo-Dionysius, it is illustrated with diagrams as an integral part of the text. The diagram of the universe (fig. 13) is conceived as a finite figure with four vertical walls placed at right angles to each other and covered with a semicircular barrel vault that represents the celestial zone or Heaven. This is a slight variation on the "dome" principle but the underlying notion is the same. Cosmas' drawing of the walled-in universe relates very closely both to his own view of the universe and to the type of church architecture prevalent at the time of his writing in the sixth century, namely the early basilican church form.[8]

Thomas Kuhn points out that although the cosmologies of men like Cosmas (and Lactantius) were never specifically adopted as official church doctrine, they were, nevertheless, typical and representative.[9] Summarizing an already established tradition, both Cosmas and Lactantius dismissed ancient pagan theories of the sphericity of the earth as ludicrous[10] and combined geography, astronomy, and theology to explain the very basic concept of the organization of the universe with an "up for Heaven" and "down for Hell" approach. What is especially significant here is that

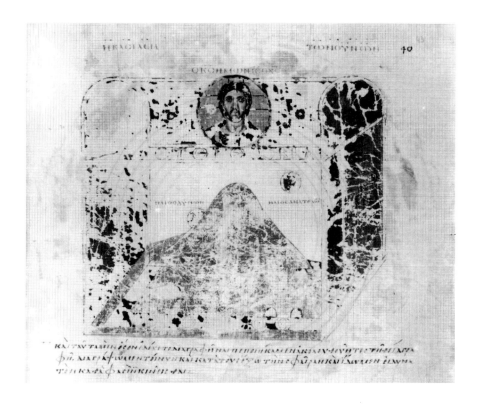

13 Cosmas Indicopleustes, *Christian Topography* (Vat.
Gr. 699), diagram of the Universe, sixth century. Vatican
Library, Rome.

Cosmas' symbolism was also extended to individual iconographic subjects
as well as church design in general, and the scene of the *Last Judgment*
is given particular emphasis. He depicts the diagram of the universe in
elevation (fig. 14), with inscriptions indicating the different levels in the
universe ("the waters above the firmament, the firmament called by God
'Heavens,' connected to the first heavens; the earth connected to the first
heavens along its width"),[11] before going on to discuss the iconography of
the Last Judgment, the scene in which Heaven, Earth, and Hell would be
depicted together. Cosmas' design for the *Last Judgment* (fig. 15) shows an
immediate and obvious correspondence with his diagram of the universe
(fig. 14). The scheme is compartmentalized, with no unifying background
or landscape, and there seems little doubt that here a direct relationship
was conceived between the celestial arrangement of the hierarchical
scheme of superimposed layers, mounted by the vault of Heaven as if seen
in cross-section, and the physical, topographical view of the universe.
Cosmas' version of the *Last Judgment* scene is quite distinctly related to
his own cross-sectional diagram of the universe, and corresponds exactly

14 Cosmas Indicopleustes, *Christian Topography* (Vat. Gr. 699), cross-sectional diagram of the universe, sixth century. Vatican Library, Rome.

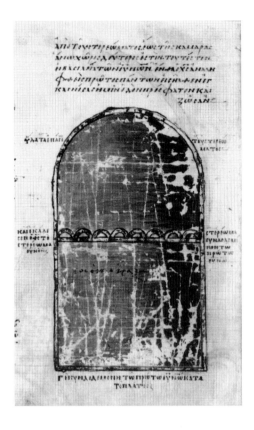

15 Cosmas Indicopleustes, *Last Judgment* (Vat. Gr. 699), sixth century. Vatican Library, Rome.

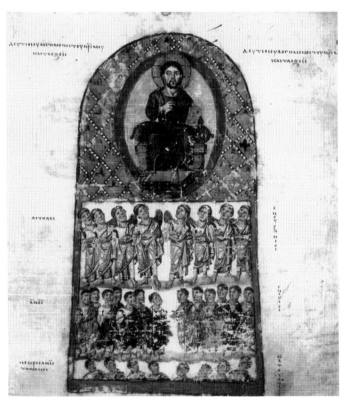

with his concept of the walled-in flat earth with Heaven above and Hell beneath the earth's surface. The different levels in Cosmas' *Last Judgment* are similarly labelled, "the blessed," "the angels, —the first Heavens," "the saints—the empyrean," and "the dead—those under the earth," corresponding to the hierarchical pattern of the universe where each is disposed according to rank.[12]

Cosmas' *Last Judgment* is of prime importance in a discussion of the iconography of the subject, since it is on such a historical, composite approach to the subject that the traditional depiction of the scene was founded.[13] In its general features, this early depiction of the *Last Judgment*, dependent as it is upon the prevailing view of the universe, is typical of later Byzantine representations of the scene, and is being basic to representations in the medieval west. As far as Michelangelo's possible knowledge of the origins of such schemes is concerned, it is significant to point out that of a total of three surviving manuscripts of Cosmas' *Christian Topography*, one is in the Laurentian Library in Florence and one in the Vatican Library at Rome, and they were already there by the time Michelangelo was working on the *Last Judgment* fresco.[14]

The cosmological basis of the *Last Judgment* as typified by Cosmas' manuscript was generally adhered to throughout later Byzantine versions as the tradition gradually extended westward. In manuscripts, frescoes, and mosaics, Christ is shown in majesty in the topmost zone, frequently enthroned or within an aureole or mandorla. Saints, angels, and the blessed are arranged in rows beneath Christ, according to a strict hierarchy and usually diminishing in size. Beneath this, those living and those being resurrected or judged stand within the zone representing earth. Farther below are the dead and damned, arising and looking hopefully upward or situated permanently in the underground abode of the dead.[15] This scheme thus possessed symbolic meaning and the figures are disposed according to a specific cosmological ordering that eliminates any possibility of a purely pictorial solution to the treatment of the composition as a whole.

The history of the representation of the Last Judgment reveals that this system, with its zonal implications, was closely adhered to for many centuries. For example, in the ninth-century manuscript of the Sacra Parallela (fig. 16), where a miniature depicting the Last Judgment appears in the margin, Christ is depicted seated at the top in a semicircular structure that echoes the heavenly vault of Cosmas' diagram. Groups of angels, saved and damned souls are arranged in tiers below. While not identical, this early version of the *Last Judgment* is disposed, overall, according to Cosmas' general scheme. Medieval manuscript versions show a similar hierarchical organization (fig. 17), and it was especially by means of such portable manuscript versions that the standard iconographical format was to spread widely in the west of Europe as well as in the east. The school of Reichenau in Germany, active in the eleventh and twelfth

16 *Sacra Parallela* (fol. 68v, MS gr. 923) ninth century. Bibliothèque Nationale, Paris.

17 *Last Judgment*, Wolfenbutteler Evangeliar, 1194.

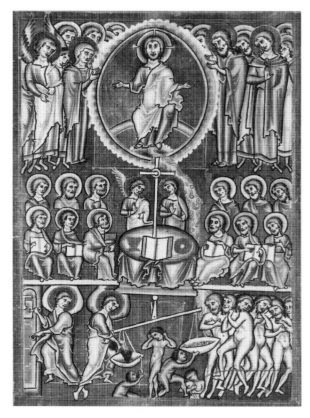

centuries and centered around the church of Saint George Oberzell, was a major center for the production of manuscripts in the form of Psalters or Apocalypses, and from the Reichenau-Bamberg area many were dispersed throughout western Europe. Manuscript versions of the *Last Judgment* issuing from this major center were largely based on the fresco of the subject in the church of Saint George Oberzell itself, which was arranged on separate levels with clear division into horizontal compartments (fig. 18). Other early western versions also tend to follow this similar, now standardized, pattern. The fresco at Sant'Angelo in Formis, 1072–87 (fig. 19), which might perhaps have been known to Michelangelo,[16] follows the same arrangement, as do other eleventh-century examples in northern Europe at Saint Jouin de Marne and Saint Michael Burgfelden, c. 1075–1100. These clearly adhere to the same arrangement as Cosmas' original manuscript tradition in the depiction of Christ in Judgment at the top and different, compartmentalized layers or zones arranged in separate levels of descending tiers down to hellfire below. A single composition was divided horizontally into bands in superimposed sections to accommodate the different events of the Last Day simultaneously. In accordance with the idea of expressing a complex dogma in a single hieratic image, there was rarely any attempt to depict the sequence of events of judgment in a narrative or chronological fashion. The ordering of the complex scene was achieved by relating it to the ordering of God's universe.

Within the overall format of the scene, the most important themes included in representations of the Last Judgment were the Christ of the Second Coming in Judgment positioned at the top, the separation of the righteous from the wicked, the resurrection of the dead below, and the punishment of the damned. Eastern Byzantine examples also continued along these lines but often included the *Hetoimasia* (Throne prepared for the Second Coming), the *Resurrection of Christ,* or the *Anastasis* (or *Christ's*

18 *Last Judgment,* 1110. Fresco, Saint George, Oberzell (monastery of Reichenau).

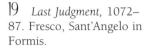

19 *Last Judgment,* 1072–
87. Fresco, Sant'Angelo in
Formis.

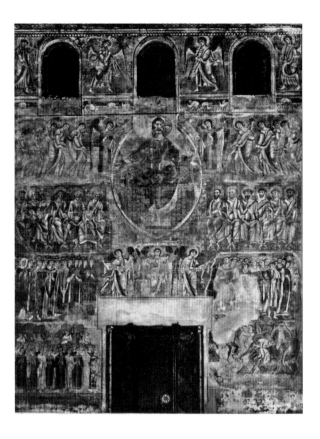

descent into limbo).[17] These additional scenes are also depicted in works
by Byzantine artists on Italian soil, which, again, may have been known
to Michelangelo. For example, in the *Last Judgment* on the interior of the
west wall at Torcello near Venice, dating from the twelfth century (fig. 20),
there are no less then five main horizontal bands that may be compared
with a similar, but not identical, arrangement at Sant'Angelo in Formis,
mentioned above (fig. 19). The independent horizontal compartments
are surmounted on the wall at Torcello by a large *Anastasis,* which is,
properly speaking, related to rather than part of the *Last Judgment* scene.
This section is probably of slightly different dating.[18] It is also interesting
that a left/right distinction in the arrangement of the lower levels of the
blessed and the damned with respect to Christ is becoming increasingly
emphasized, as also indicated at Sant'Angelo. This is evidently based on
the biblical text of Matt. 25:33–34: "And he shall set the sheep on his
right hand, but the goats on the left," and refers in turn to the common
concept of the right hand as a privileged position, as Christ was generally
placed on God's right hand (as in the Nicene Creed). The ascending and
descending notion, related to cosmological precepts, is combined with the
scripturally based left/right divisions.

20 *Last Judgment,* twelfth century. Mosaic, Sta Maria Assunta, Torcello.

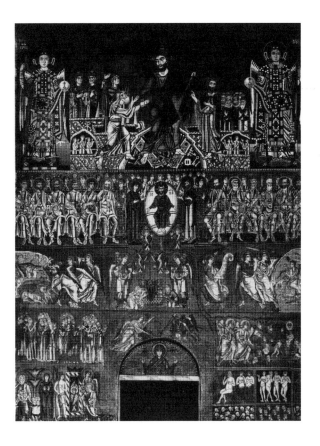

Other examples of the *Last Judgment* scene in Italy in the region influenced by Byzantine style and iconography include the Palatine Chapel at Palermo, 1129–43, and Monreale, 1174–82. These latter works, while probably no more familiar to Michelangelo than examples in the Byzantine east, do serve to demonstrate the prevalence of the standard type of the *Last Judgment* scene, based on hierarchical banding, which is found in many such examples and which also extends to later works like the Benedictine altarpiece, now in the Vatican Gallery, usually dated to the twelfth century (fig. 21). The format here is circular, suggestive of the sphere of the universe, but the division of the scene into ascending levels with Christ at the top is quite clear.[19]

The *Last Judgment* in Northern Europe

In medieval Europe, depictions of the *Last Judgment* were especially popular in the sculptural programs of the great French cathedrals of the twelfth and thirteenth centuries. Although Michelangelo did not travel

21 *Last Judgment,* twelfth century. Altarpiece, Vatican Gallery, Rome.

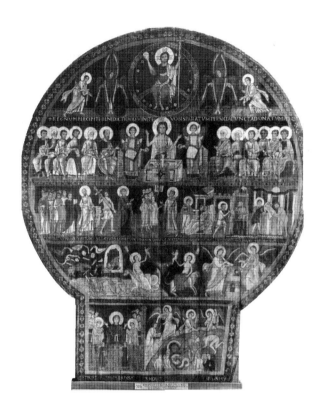

outside Italy, a brief consideration of this group is important for the confirmation it gives to the very widespread nature of the cosmological basis for Last Judgment iconography. In French portal sculpture, the *Last Judgment* scene was usually placed in the tympanum of the west portal and, as Mâle points out,[20] was featured on almost all major French cathedrals of the thirteenth century, although this sculptural type was rare in Italy. This important positioning of the subject over the main portal signifies its doctrinal importance, for in such a prominent position the impression on the laity would be very great. It evidently served as a strong reminder that Judgment was an imminent occurrence for which preparation should be made. There are also cosmological or astronomical associations since the west portal was positioned to face and be lit by the setting sun at the end of the day. When painted or frescoed in the interior of a church, the scene also generally had a western emphasis (by being placed normally on the interior of the west wall), thus being viewed by the congregation as a reminder on exit, and again associated with the end of the day or the setting of the sun. This association assumes significance where Michelangelo's *Last Judgment* is concerned, and the fresco's problematic positioning on the altar wall of the Sistine Chapel, which has an unusual western orientation, will be discussed in a subsequent section.

In versions of the *Last Judgment* in French cathedral sculpture, the shape of the tympanum itself, where the scene was usually depicted, relates directly to the contemporary worldview in terms of the "dome of Heaven" since it seems to correspond to the cross-section of this.[21] In the early twelfth century at Autun (fig. 22), the large-scale figure of Christ traverses and dominates the scene and figures are adapted and distorted to fit into the appropriate place in the format. Being semicircular, the tympanum does not lend itself to a vertical emphasis and the left/right distinction is emphasized at the same time as the top-to-bottom layering. At Autun, Hell is actually in the lower right of the tympanum proper. The development of the scene in French portal sculpture may be traced through other such early examples as Sainte Foy de Conques, 1115–25 (fig. 23), Beaulieu, 1135, and Carennac, c. 1130–50. While the separated saved and damned are sometimes depicted at either end of the lowest level in these examples (unlike the earlier arrangement of Hell alone as the bottom layer), Christ is still clearly in the most prominent position at the top. At St. Denis, 1135–44 (restored by Viollet le Duc in the nineteenth century), the huge Christ dominates in a cruciform position (fig. 24), while at St. Trôphime at Arles, 1150, the composition is carefully ordered in separate hierarchical layers. In comparison, at Laon, 1160–1225, the scene of the resurrecting dead on the lowest level seems somewhat cramped and overcrowded. Slight variations lead, as Mâle points out, to the "final formulation" in Notre Dame at Paris, 1163–1250 (fig. 25).[22] This established formula is largely pursued in the great thirteenth-century developments, where even more tiers are shown, as at Chartres, 1200–60, Bourges, 1210–75, Rheims, 1211–90, and Amiens, 1220–88 (as exemplified by fig. 26). The different components are carefully disposed in the curve of the tympana

22 *Last Judgment*, 1130–40. Tympanum, west portal, Autun Cathedral.

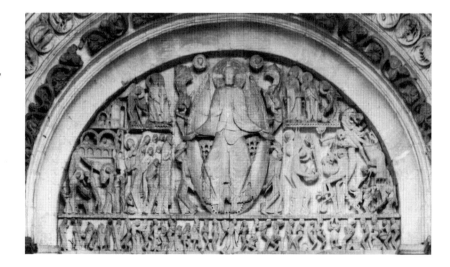

23 *Last Judgment,* c. 1140. Tympanum, west portal, Sainte Foy, Conques.

24 *Last Judgment,* 1135–1140. Tympanum, west portal, Saint Denis, Paris.

25 *Last Judgment,* 1163–
1250. Tympanum, west
portal, Paris, Notre Dame.

26 *Last Judgment,* 1230–
65. Tympanum, west portal,
Bourges Cathedral.

according to the traditional formula, related, as has been shown, to the standardized view of the layered, hierarchical cosmos. In the Gothic examples, with Christ again on a more human scale and significantly naked to the waist to reveal his wounds, the figure is set again right at the top, rather than spanning several levels as in the Romanesque. The *Last Judgment* scene thus fitted into the curved space of the tympanum in the same way as in the curved top of Cosmas' cross-sectional diagram of the cosmos. The basic format with Christ situated at the top, above hierarchical compartmentalized tiers of saints, angels, saved, and damned, is followed. This is evidently related to the prevailing worldview of Christ situated in the dome of Heaven with an orderly design of descending layers beneath.

While many earlier Romanesque depictions of the *Last Judgment* are arranged, as in Cosmas' original design, in compartmentalized tiers descending toward the lowest level of the resurrecting dead or the level of Hell itself, several examples within the Gothic period (such as Notre Dame de Paris and Rheims) tend to lay an even greater emphasis on the scriptural separation between the saved and damned to the right and left of Christ. This means that the figures of the saved and damned increasingly appear on the same horizontal level (fig. 25), demonstrating a variation from the very earliest traditional cosmological basis of the scene. A contrast is formed with earlier examples where the resurrecting dead are usually portrayed right across the lowest level (fig. 22). The souls have not yet been judged, and their open graves therefore suggest that the realm beneath the earth's surface extends below the pictorial space of the tympanum. Where the vertical (left/right) contrast receives as much emphasis as the horizontal distinctions, these examples appear to be less reliant on the strict formula. At Amiens the "mouth of hell" is actually situated on a higher level than the resurrecting dead and lies opposite the blessed on the same horizontal register. This reflects the developing importance of the left/right distinction in the scene and a diminished reliance on the cosmological formula based on a flat-earth perception of the universe, which, as we shall see, becomes even less strictly adhered to during the Renaissance period.

In keeping with the general trend of Gothic as opposed to early medieval or Romanesque art, some humanizing tendencies become evident in the later French versions. Christ's attitude and the gestures he makes are particularly significant in determining the overall approach to the subject. Where Christ is depicted seminude and showing his wounds, this emphasizes both the idea of redemption and his suffering for humanity, as well as his role as Judge. Facial expression and hand gestures often suggest condemnation or redemption or both; raised arms, while displaying the stigmata, convey the idea of the orans position as a Redemptive Savior, rather than a severe Judge, as at Paris (Notre Dame)

and Bourges.[23] The gesture and position of Christ are highly significant in determining the overall approach to the subject and are important aspects of the scene's iconography.

Similar principles to those relevant to French portal sculpture also apply to other examples of the *Last Judgment* from more northerly areas of Europe, namely Germany and the Low Countries. Although similarly not likely to have produced any direct influence on Michelangelo, versions from Northern Europe do again demonstrate the wide influence of the very traditional basis of the depiction of the *Last Judgment* in Christian iconography.

Northern examples of the *Last Judgment* from the late medieval period or early Renaissance, dating from the fifteenth century, include those by Jan van Eyck, Stephan Lochner, Rogier van der Weyden, Petrus Christus, Dieric Bouts, Hans Memlinc, and Martin Schongauer. A later group, perhaps also still Gothic rather than Renaissance in tone, includes works by Dürer, Cranach, Bosch, Jean Provost, and Lucas van Leyden, which all date from the early sixteenth century.[24] These examples are mainly in the form of panel paintings or portable altarpieces on the Last Judgment theme. Those by Van Eyck, c. 1424, and Rogier van der Weyden, after 1450, appear to be typical (figs. 27 and 28). The basic traditional format of Christ situated above with descending levels of saints and angels, saved and damned, is applied. In these altarpieces, however, the levels are not strictly separated by bands but are integrated into a unified composition to a larger extent. This is more similar, as shall be seen, to Italian Renaissance examples. Layered arrangements are sometimes combined with additional scenes in the side panels of northern altarpieces. This emphasizes the right/left distinction as the saved and condemned are additionally placed on Christ's right hand and his left or sinister, but the different zones or levels and the up/down contrasts are still easily distinguishable (fig. 27). It is interesting that in these northern examples Christ is invariably seated on an arc-en-ciel (celestial arch), a cosmological motif that conveys to a rectangular panel or altarpiece the same concept as the semicircular tympanum or the "dome of Heaven."

The work of Albrecht Dürer is especially important among Northern artists as far as an influence in Italy might be claimed. Owing to his travels and the circulation of his engravings and woodcuts, his apocalyptic visions became known in Italy, and Condivi mentions Michelangelo's acquaintance with Dürer's work.[25] Versions of the *Last Judgment* by Dürer were, however, less well known than his series like the *Apocalypse* (1498) and the various *Passion* series (1498–1510, 1509–11, 1507–12) or individual engravings like the *Melancholia* (1514). Powerful cosmological, astronomical, and even astrological concepts were expressed in works like *Nemesis* (1502) and scenes from the *Apocalypse* series. Classical aspects of his work of particular

27 *Jan van Eyck, Last Judgment*, c. 1424. Panel of altarpiece, 56.5 x 19.5 cm. New York, Metropolitan Museum of Art.

28 Rogier van der Weyden, *Last Judgment,* after 1450. Central section of altarpiece, Hospice de Beaune.

relevance include the concept of the amalgamation of Apollo and Christ as *Sol Iustitiae*.[26]

The *Last Judgment* in the Italian Renaissance

Examples of the *Last Judgment* in Renaissance Italy that predate Michelangelo's version in the Sistine Chapel are based on underlying precepts similar to medieval and Byzantine examples, which have clearly been shown to be strongly influenced by scriptural cosmology for their basic composition. The structured, layered format again corresponds to the basic cosmological formula of the "up" for Heaven, "down" for Hell approach. Many of the Italian versions would have been accessible to Michelangelo in central Italy; it would have been quite possible for him to have seen and considered versions of the *Last Judgment* in, for example, Pisa, Rome, Florence, and Padua.[27] Major examples in Florence include the mosaics of the Baptistery, which would no doubt have been familiar, Nardo di Cione's version in Sta. Maria Novella (Strozzi chapel), Orcagna's frescoes in Sta. Croce, and Fra Bartolommeo's fresco in Sta. Maria Nuovo. In Pisa, the cycle in the Camposanto would almost certainly have been known to Michelangelo on his travels, as well as, probably, Giotto's version in Padua. In Rome itself, major examples include the fresco at SS. Quattro Coronati and Cavallini's fresco in Sta. Cecilia, besides various manuscript versions and an important Benedictine altarpiece in the Vatican collections, already mentioned above. Signorelli's series of frescoes at nearby Orvieto has also been suggested as a source for Michelangelo's version. The later, Renaissance versions do vary more in emphasis and detailing and are more loosely organized than the strict, medieval or Byzantine compartmentalized format. The overall hierarchical scheme is the same, but, as will be seen, certain adjustments to the medieval iconographical formula have taken place. Later Italian examples of the *Last Judgment* from the trecento, quattrocento, and cinquecento are of particular relevance and significance since, in many cases, a direct influence on Michelangelo could be argued.

The earliest of the "proto-Renaissance" versions of the *Last Judgment* are the sculpted pulpits by the Pisani in Pisa, Pistoia, and Siena.[28] These involve designs with intertwined figures emphasizing the drama and action of the scene with a rather more unified approach to the general theme. Different areas are separated out in adjacent panels with the Christ Judge receiving a central emphasis, as at Pistoia (fig. 29). There is some relation to the French Gothic type of sculptural scene since figures are broadly arranged according to ascending and descending levels with the damned nearest to the lowest edge, on Christ's left. Similarly, the composition of other Italian examples from the thirteenth century was often based on ordered and hierarchical levels but with a somewhat more unified approach

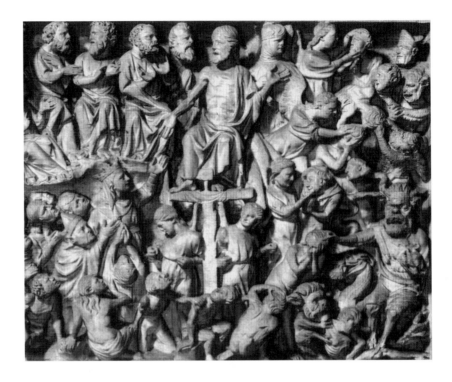

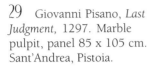 Giovanni Pisano, *Last Judgment,* 1297. Marble pulpit, panel 85 x 105 cm. Sant'Andrea, Pistoia.

to the design as a whole. The lack of emphasis on actual separating bands in these examples contrasts with the earlier French examples and also with the Italo-Byzantine type of clearly defined and separate areas, as at Torcello (fig. 20). The same basic underlying zonal structure is still present, in accordance with the celestial and cosmological hierarchies, but there is less rigid adherence to the strict, compartmentalized zonal structure. At the same time, the left/right arrangement appears to receive more emphasis and other variations include the addition of extra scenes. A certain relaxation of the medieval iconographical formula thus begins to take place in Renaissance Italy.

The mid-thirteenth-century fresco in Rome at SS. Quattro Coronati (fig. 30) is an example of this increasing variation. Christ is the dominating figure at the top, set higher than the ranks of the apostles in the traditional manner, but, in comparison with earlier versions, especially at Torcello and Sant'Angelo in Formis, adaptation of the format has taken place. The scene has still been defined as a *Last Judgment* and includes standard characteristics like the outsize enthroned Christ in Majesty, and the angels trumpeting and rolling back the starred scroll of Heaven, but it has been unusually combined with scenes from the life of Saint Sylvester (patron saint of the chapel), and Christ is partially nude, to emphasize his wounds, and not depicted in majesty.

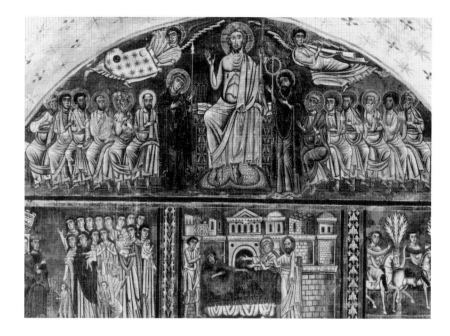

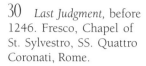

30 *Last Judgment,* before 1246. Fresco, Chapel of St. Sylvestro, SS. Quattro Coronati, Rome.

Lorenzo Maitani's marble panel at Orvieto of 1270–1330 (fig. 31) does adhere more closely to the basic layered format but with no decorative separating bands. Instead, the branches of the Tree of Life separate out the various levels. An astronomical sun symbol is included at top right. Dating from about the same time, and showing classical influence in the toga-robed figures, is Cavallini's fresco in Sta. Cecilia in Trastevere, Rome, c. 1293. Now badly damaged, the original scheme may be seen from a reconstruction (fig. 32) and the composition is ordered and hierarchical in emphasis. The use of decorative bands to split up the different areas of the fresco is, however, minimal.[29]

In Florence itself, and surely known to Michelangelo, a late-thirteenth-century mosaic of the *Last Judgment* is situated in the central dome of the Florence Baptistery (figs. 33 and 34). Attributed to Coppo di Marcovaldo, it appears more directly influenced by Italo-Byzantine schemes in the way in which the format is rigidly divided up into horizontal registers, running around the dome. Cosmological allusions are evident in the depiction of the enormous Christ seated on the rainbowlike arcs of Heaven specifically in accordance with the biblical reference; a space is left at the very top of the dome to admit the actual light of the sun.[30] Christ's gesture here also appears significant, a combination of blessing and damnation as one hand gestures upwards, the other with thumb downwards. The gesture of Christ is an important theme in versions of the *Last Judgment* and, here, a significant part of the evolution of the gesture that culminates in Michelangelo's Sistine version appears to be indicated.

31 Lorenzo Maitani, *Last Judgment,* c. 1310–30. Marble panel from the façade, Orvieto Cathedral.

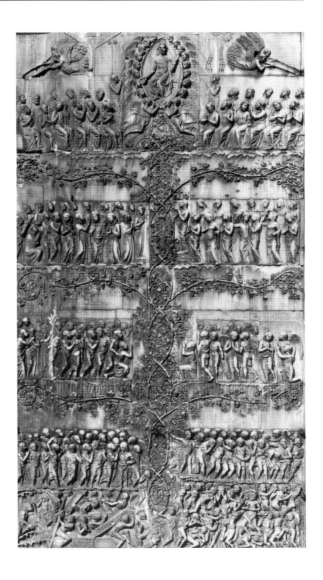

32 Pietro Cavallini, *Last Judgment,* c. 1293. Fresco (resconstruction after Wilpert), Sta. Cecilia in Trastevere, Rome.

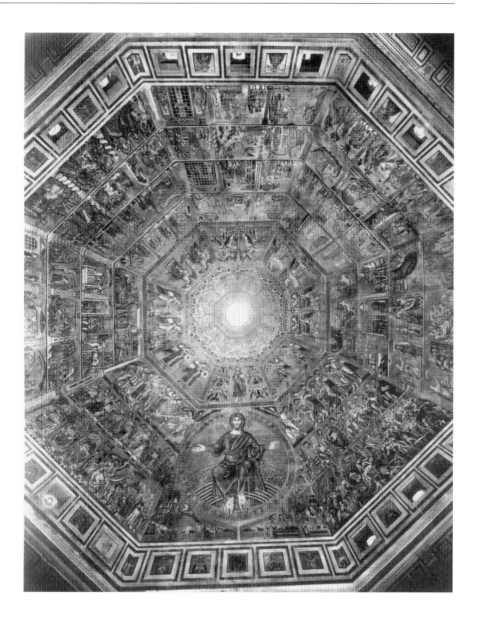

33 Coppo di Marcovaldo (attributed), *Last Judgment*,
late thirteenth century. Mosaic of the vault, Baptistery,
Florence.

Turning to the seminal series of frescoes worked at Assisi in the
late duecento (fig. 35),[31] the version attributed to Cimabue in the upper
church demonstrates what appears to be developing as the standard
approach to the subject in early Renaissance Italy. This is dependent
on the arrangement of the *Last Judgment* in hierarchical levels, but with
less formality in the iconography and composition, in comparison with

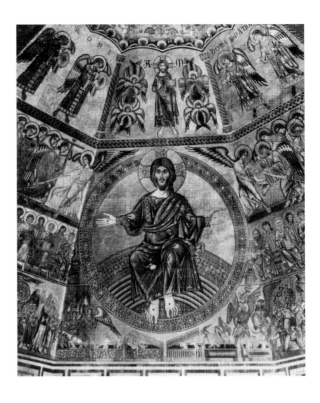

34 Detail of fig. 33, *Christ in Judgment*.

35 Cimabue, *Last Judgment*, c. 1290. Fresco, Upper Church, San Francesco, Assisi.

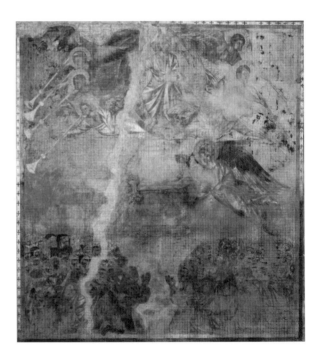

the Early Christian or Byzantine type. This increased adaptation of the traditional pattern is characterized by the absence of the strict separation of registers by decorative banding.

The most significant variation on the standard pattern or formula was undertaken at this time by Giotto in the Arena Chapel, Padua, c. 1305 (fig. 36). Giotto retains the symmetrical disposition in horizontal zones and thereby the hierarchical structure, but the levels are once more not separated by bands. The emphasis on the river of flame finds a distinct

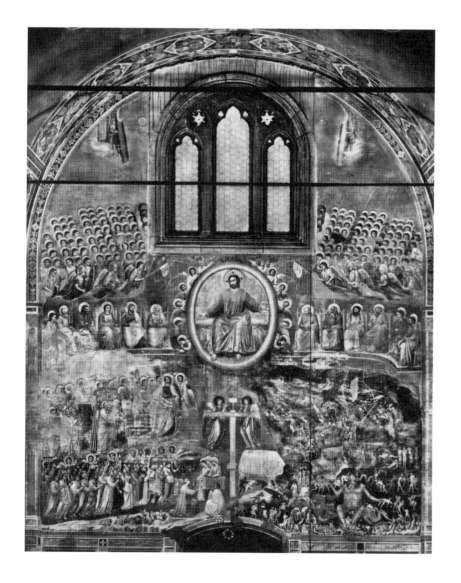

36 Giotto, *Last Judgment*, c. 1305. Fresco, Arena Chapel, Padua.

parallel in early manuscript examples (compare no. 8); it flows down and away from Christ to the bottom right hand corner, maintaining the earlier left/right distinction. In the compositional feature of the "rainbow round about the throne" and the "scroll of Heaven," the fresco also relates to tradition and indeed directly to the biblical description of the Last Day.[32] Although the major iconographic features are present, however, Giotto's Last Judgment, more than any earlier example, deviates from the tradition of independent horizontal compartments. Compared with earlier examples such as Sant'Angelo in Formis (fig. 19), Torcello (fig. 20), or the Baptistery in Florence (figs. 33, 34), Giotto has taken measures to unite the composition by placing less emphasis on the usual subdivisions. Giotto's interest in the depiction of a more naturalistic space could also be argued as having influenced this arrangement.[33] Although the figures are grouped in a single pictorial space, the iconographic tradition still underpins the fresco and has exerted considerable influence upon the differentiation of the various groups. The figure of Christ, while following the tradition of dominating in scale, is unusually placed and again demonstrates a less strict adherence to the established iconographical format. His more central position may be accounted for by the problem of the large window set in the wall. Because of this intrusion, it appears, Giotto took the step of placing Christ relatively much lower down on the picture surface, but He is still placed above all other figures except the celestial hierarchies of angels and he remains significantly much larger in size.[34] Thus, despite certain innovative elements it seems that the use of a layered, hierarchical format for the representation of the Last Judgment had become a convention for the subject to make it easily recognizable.

In Giotto's fresco at Padua, cosmological allusions, based once more on specific biblical references, are to be found in the upper area where angels roll back the heavens, with the sun and moon, revealing the heavenly Jerusalem. A rather more humane approach to the theme of the Last Judgment has been detected in Giotto's version, which perhaps parallels Gothic humanizing tendencies. Christ is turned toward the blessed on his right (dexter) rather than toward the damned (sinister), and the intercessory role of the Virgin is stressed. The prominent cross referring to Christ's sacrifice for humanity's salvation also presents a less-severe theme. Mercy and salvation rather than hopelessness and despair have been viewed as the major themes expressed, even though Hell is still vividly depicted on the lowest right-hand register.[35]

The trait of humaneness or optimism in examples of the Last Judgment, such as Giotto's in the early trecento, has been contrasted by Meiss with later trecento versions, made after the Black Death in the mid-fourteenth century.[36] From this time, Meiss argues,[37] there is an increasing note of pessimism in ecclesiastical art, a result of the impact of the Black Death, which devastated Europe. Examples of the Last Judgment dating from the

middle decades of the fourteenth century by Nardo di Cione in the Strozzi chapel at Sta. Maria Novella (figs. 37, 38), by Orcagna in Sta. Croce (fig. 39), and in the frescoes of the Camposanto at Pisa, variously attributed to Traini, Orcagna, or Buffalmacco (fig. 40), all appear to give more emphasis to the pessimistic view.[38] At Pisa, the stress is laid on the suffering and punishments of the damned rather than the bliss of the saved, and a more spiritual, abstract approach to God as a remote, awesome figure in an almost Byzantine manner becomes apparent. Meiss attributes this phenomenon to the horrors of the plague era when terror (or gratitude for escape) on the part of survivors might also have stimulated patronage. The frescoes at Pisa, he argues, show a horror such as might have been inspired by the "Hell on earth" of the Black Death, and, unlike the tortures depicted by Giotto, these are not tempered by more humane aspects. The enormous Hell at Pisa is emphasized in what could be viewed as a separate section, again on Christ's sinister. The idea of the plague as punishment for sin contributed to a fervent religious revival in the hope that piety would avert further evil, but, at the same time, a consciousness of the brevity of life and the ever-presence of death also produced a materialistic attitude, reflected in the maxim, "Eat, drink and be merry, for tomorrow we die."

As far as the cosmological basis of the scene is concerned, these later fourteenth-century examples still reflect the trend begun in the late medieval period of a slightly freer interpretation of the subject and a movement away from the strict separation of registers by bands. The overall format remains, however, as before, quite clearly related to the cosmological concept of Christ situated in a mandorla above in the Heavens with Hell, strongly emphasized at this time, at the lowest level beneath, as in altarpieces of the time (figs. 41, 42). Nardo di Cione's frescoes in the Strozzi chapel of Sta. Maria Novella, Florence (figs. 37, 38) demonstrate a fluidity in the depiction of the *Last Judgment* format since more than one wall is used. His depiction of Hell (fig. 38) separately on a side wall is intensely hierarchical in the way in which it is specifically arranged in accordance with Dante's system of the universe and his vision of the realms of *Inferno*, and it is clearly labeled by inscription as such.[39] In Nardo's *Paradise*, the depiction of Mary on a twin throne at the same level as Christ is evidence of Mariolatry in this period, as are Traini's twin figures of Christ and Mary at the Camposanto in Pisa (fig. 40).[40] The elevation here of Mary as intercessor seems to be the one counterbalance to the pessimism stressed by Meiss in these examples.

Traini's fresco may be argued as a possible direct influence on Michelangelo, owing to the latter's visits to Pisa.[41] The gesture of rejection of Traini's Christ toward the damned, shown by Meiss to fit in with the late-fourteenth-century pessimistic readings of the theme, appears to stress the effect of judgment. The resulting damnation of sinners is thus emphasized and as such has been argued as a source for the gesture of

37 Nardo di Cione,
Paradise, 1345–57. Fresco,
Strozzi Chapel, Sta. Maria
Novella, Florence.

38 Nardo di Cione, *Hell*,
1345–57. Fresco, Strozzi
Chapel, Sta. Maria Novella,
Florence.

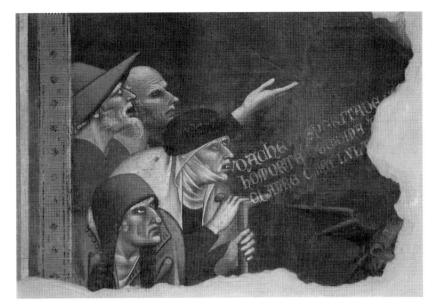

39 Andrea Orcagna, *Last Judgment*, fragment, c. 1350. Fresco, Museo dell'Opera di Santa Croce, Florence.

40 Francesco Traini, *Last Judgment*, c. 1360. Fresco, Campo Santo, Pisa.

41 Unknown Bolognese
artist, *Last Judgment*, four-
teenth century. Altarpiece,
Pinacoteca, Bologna.

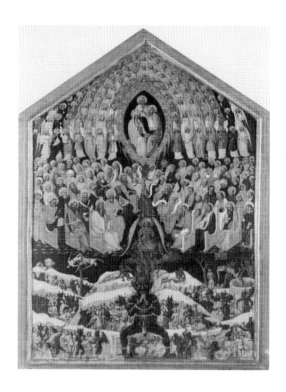

42 Master of the Bambino
Vispo or Gherardo Starnina,
Last Judgment, late four-
teenth century. Altarpiece,
Alte Pinakothek, Munich.

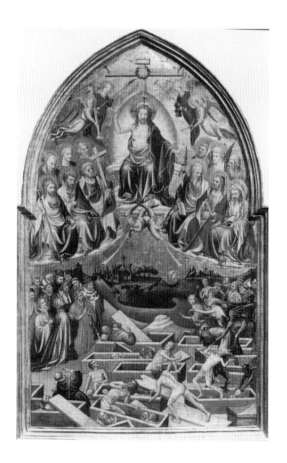

Michelangelo's Christ.[42] The huge figure of Satan in an additional scene to the right of the main fresco at the Camposanto is also evidence of the late-fourteenth-century emphasis on the pessimism of the theme. The basic disposition of the fresco, however, is still related to the traditional cosmology-based format. Although the zones and different hierarchical levels in which the figures are arranged are not separated by bands, they are clearly evident, and the overall composition according to hierarchical levels remained little altered during the following century in Italy.

In the late fourteenth century, the two major divisions of Heaven and Hell are emphasized in the fresco of the *Last Judgment* in the Bargello. Although the fresco is now badly damaged, Hell is clearly positioned in the center of the lower edge. In the fifteenth century, at least three versions by Fra Angelico (exemplified by fig. 43), the altarpiece now often considered to be by his follower Zanobi Strozzi (fig. 44), and works by Bertoldo di Giovanni, Giovanni di Paolo, and Vecchietta also show a similar overall arrangement. Here, again, the basic underlying structures remain traditional even though a more unified effect is achieved than

43 Fra Angelico, *Last Judgment*, c. 1440–50, Central panel of triptych, 54 x 74 cm. Galleria Nazionale (Corsini), Rome.

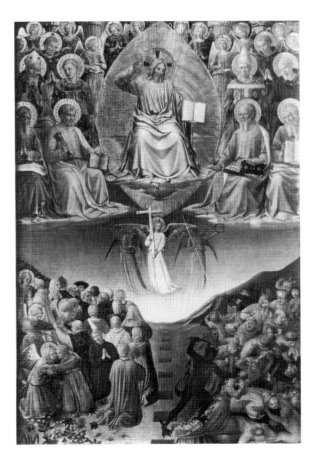

in earlier, more rigid examples. Although the damned frequently appear on Christ's sinister, the lower regions of the dead are often more implied (below the picture frame) than pictorially represented, as is also the case with Fra Bartolommeo's fresco made at the end of the century for Sta. Maria Nuovo and now in the museum of San Marco (fig. 45).

In keeping, perhaps, with a general trend in fifteenth-century Italy of an increased number of altarpieces and panel paintings in addition to schemes of fresco or mosaic church decoration, a large number of these works are in the form of altarpieces. Of this group, Fra Angelico's work may be regarded as typical of the period. In general mood and approach

44 Fra Angelico (otherwise attributed to Zanobi Strozzi), *Last Judgment*, c. 1440. Altarpiece, 105 x 310 cm, Museo di San Marco, Florence.

45 Fra Bartolommeo, *Last Judgment*, 1499–1500. Fresco, 340 x 360 cm. Museum of San Marco, Florence.

to the subject, his works demonstrate a return to a less overtly dramatic interpretation of the theme, as is characteristic of his work. In spite of the emphatic gesture of Christ, which is frequently used (fig. 43 and also 45) and reminiscent of Traini's Christ in the Camposanto (fig. 40), a gentler, more decorative approach to the subject becomes evident, and floral depictions of the Garden of Paradise become the norm (fig. 44). In this well-known altarpiece now in the Museum of San Marco, the way in which the figures, with Christ at the top, fit into the suggested dome shape of the format of the altarpiece itself appears to relate, once again, to the view of the universe alluded to above.[43] The participants in the scene are arranged in corresponding levels that are clearly defined without being separated by actual banding. With the emphasis placed optimistically on Paradise, the dramatic possibilities of Hell receive less emphasis. It is placed more to one side, Christ's sinister, while the area of the dead, below ground level, is suggested by the open tombs at the lower edge of the painting as extending beneath the space of the altarpiece itself.

In the latter part of the fifteenth century and in the early part of the sixteenth century, versions of the *Last Judgment* became rarer, although some did circulate in printed form, like the one associated with Savonarola's *Triumphis Crucis,* clearly more pessimistic, with Hell dominating across the lower section (fig. 46). Apart from the fresco by Fra Bartolommeo, Signorelli's series of frescoes in the San Brizio Chapel in Orvieto cathedral is a major example, which has also often been claimed as influential on Michelangelo (figs. 47, 48). These works date from the turn of the century, about 1499/1500.[44] Fra Bartolommeo's fresco is in poor condition but the hierarchical structuring and the separate layering of the scene are clearly visible. Here, encircled by winged cherub heads, Christ again takes the prime position at the very top of the picture space. Saints are arranged below in a semicircle that extends back into space, and the resurrected are indicated beneath. The gesture of Christ appears to be significant as a possible influence on Michelangelo's Christ.[45] The dramatic quality of the nude figures of Signorelli's fresco has also been singled out as a possible influence on Michelangelo's Sistine version.[46] In Signorelli's *Last Judgment* (figs. 47, 48), the various scenes are separated out onto different parts of the walls and vaults (like the earlier Strozzi *Last Judgment*) and include other scenes related to the Antichrist. This seems to deny the possibility of a hierarchical arrangement. Perhaps this was also a response to the architectural features, or the commission from the patron; but, from this point of view, the scheme is not strictly speaking a *Last Judgment* in the same way as the examples by artists like Giotto, Fra Bartolommeo, and Michelangelo where the iconography is expressed in a single image on one area of wall surface. The overall arrangement does still suggest the cosmic theme, however, since the program is enhanced by the starry background (fig. 47). It is significant that Signorelli's version of the *Last Judgment,* which

46 Illustration to Savonarola, *Predica dell'arte del ben morire,* 1496, Florence. Woodcut, Chapin Library, Williams College, Williamston, Mass.

splits the chronological events of the process of Judgment into separately treated areas, shows how, by the sixteenth century, not only a general "loosening up" of the iconography but major divergence was becoming more and more possible, setting a precedent for Michelangelo's own variations on the traditional cosmological arrangement. By the sixteenth century a break was being made with the traditional format or pattern of the scene that had been followed virtually unquestioned for nearly a millennium since the *Last Judgment* in the *Christian Topography* of Cosmas Indicopleustes.

Influence of Changes in Cosmology

The Renaissance versions of the *Last Judgment* in the two centuries preceding Michelangelo thus do exhibit more variation in emphasis and detailing and are more loosely organized than the strict Byzantine or medieval compartmentalized format. The overall hierarchical scheme, derived from the biblical concepts of ascent to Heaven and descent to Hell, remains the same, but certain adjustment to the traditional

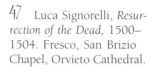

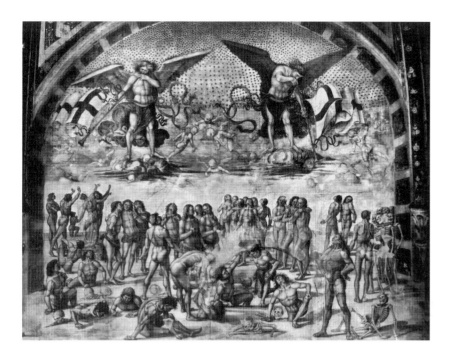

47 Luca Signorelli, *Resurrection of the Dead*, 1500–1504. Fresco, San Brizio Chapel, Orvieto Cathedral.

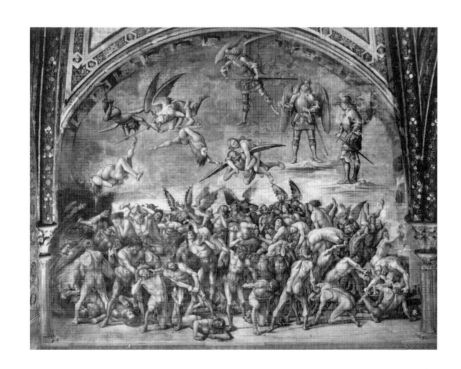

48 Luca Signorelli, *The Damned*, 1500–1504. Fresco, San Brizio Chapel, Orvieto Cathedral.

iconographical formula has taken place. This may be attributed to a number of possible factors.

First, the flat-earth view of the universe, which was based on Scripture and underlay the iconography of Byzantine and medieval depictions of the *Last Judgment* scene, had started gradually to give way to the revival of the ancient view of a spherical earth. This view had come under discussion in the early Middle Ages,[47] since the astronomer Pope Sylvester II (999–1004) had contributed to the recognition of the earth as a sphere and had constructed terrestrial globes. However, the popular flat-earth concept obviously continued in the mind of the masses well into the medieval period. The notion of the spherical earth received increasing attention throughout the medieval period, and by the time of the early Renaissance, the flat-earth view was rapidly becoming completely obsolete. Explorers like Christopher Columbus set out because they were already convinced of the earth's sphericity. As the concept of the spherical earth became acceptable, it was reflected in contemporary art.[48] In literature, too, early Renaissance writers like Dante, for example, quite clearly referred to a spherical earth in a spherical universe. But the spherical system remained problematic since, when it was combined with the biblical concepts of ascent to Heaven and descent to Hell beneath the earth's surface, the resultant spherical universe would necessarily be "haidocentric" with Hell at the center of the concentric spheres.[49]

The growing realization of the scientific inadequacies of the flat-earth theory and its questioning in Renaissance Italy could well have encouraged the relaxation of the strict cosmological structure of the depiction of the *Last Judgment* and the shift away from the traditional format. Giotto's version (fig. 36) is a case in point, and his contacts with Dante and interest in astronomy are well known.[50] Examples have also been cited above where the scene is spread across more than one area and hence not to be regarded as *Last Judgment* proper with a vertical hierarchy (figs. 37, 38, 46, 47), although the traditional iconography did continue to exert a potent influence in unified scenes of the *Last Judgment*.[51]

A second probable cause for changes in *Last Judgment* iconography in Renaissance Italy was the alteration in the positioning of the scene of the *Last Judgment* itself. In some Byzantine examples and also in French portal sculpture, the tendency had been for the Last Judgment to be depicted on the west wall of a church, related to the setting of the sun. With the advent of portable altarpieces, the scene's location in the vicinity of the east or altar wall became more frequent. It seems that, in order to further avoid the placement of Hell directly on the altar as it would be if it appeared at the lower edge of the altarpiece, it was often displaced from its central low position toward the viewer's right (that is, Christ's sinister). This arrangement had, of course, already taken place where no repositioning had occurred (as for example in French medieval

tympana), but the increasing use of altarpieces for the depiction of the *Last Judgment* provided an additional reason for the growing practice of separating the saved and damned respectively on Christ's dexter and sinister according to scriptural exegesis. This type of arrangement is evident in many fifteenth-century Italian altarpieces and also northern versions: the example of the altarpiece by Fra Angelico/Zanobi Strozzi appears typical (fig. 44).

A third possible reason for the less strict adherence to the traditional iconographic format of the *Last Judgment* by the end of the medieval period is the increased interest in the depiction of coherent, naturalistic space in the work of artists like Giotto, which was to become so important during the Renaissance. In addition, Giotto's more naturalistic approach may be argued as having influenced the arrangement of the figures without separation by banding. Modifications were also made at Padua owing to the problematic architectural features, as mentioned. Christ is placed lower down because of the intrusive window. Hell is removed to the right of the doorway. Local architectural conditions overtake the traditional schema, now less powerful.[52]

By the sixteenth century, some variation and adaptation of *Last Judgment* iconography had taken place in Italy since the medieval age. It would be unreasonable, of course, to attribute this solely to increased questioning of biblical cosmology. Similarly, it would be difficult to attempt to trace a historically continuous identification between the composition of the scene of the *Last Judgment* and contemporary cosmology and maintain it in absolute terms of precise detail, but for the basic "up/down" formula of pre-Renaissance cosmology, the correspondence undoubtedly exists. Some departures from the established "world order" become evident, and these adjustments, with the growing debate on the traditional view of the cosmos, provide a plausible precedent for Michelangelo's adjustment of the iconography of his own version of the *Last Judgment* scene in accordance, with the increasing cosmological debate in the sixteenth century. In general, up to the sixteenth century the traditional formula of a layered composition, dependent on the notion of ascent to Heaven and descent to Hell (and combined with the sinister/dexter division) still formed the basis for major versions of the scene when treated as a single image.

Set against this very strong tradition of previous depictions of the *Last Judgment,* Michelangelo's fresco in the Sistine Chapel is seen to be of remarkable design. The earlier renderings of the *Last Judgment* dealt with above share certain common ideas and features. Apart from the overall format and composition, basic themes are common to all. Whether the emphasis lies more on the salvation of the blessed or on the damnation of the lost, certain iconographic features are always evident. The iconography is complex, as different events take place simultaneously within a single picture format instead of in sequence, and the whole is used as a vehicle for

the exposition of complex dogmatic thought at the very core of Christian belief. The ordering of the scene was thus achieved by relating it to the current cosmological framework of the universe, developed primarily in superimposed, compartmentalized registers, and acting as metaphor for the fixed hierarchy of the universe and of the Christian Church.

Michelangelo's *Last Judgment* in the Sistine Chapel does contain most of the basic components of the traditional iconography—the Judging Christ, the angels with the symbols of the Passion, the Virgin as intercessor, the Resurrection of the Dead, the act of Judgment, and the fates of the saved and damned—but there is a startling change in the overall composition by comparison with the traditional arrangement or earlier Renaissance examples that have been discussed, because of the overriding circular emphasis in the design of the painting as well as other unusual features. In Michelangelo's version, a group of trumpeting angels signifies the beginning of the train of events. On the lefthand side of the fresco, the resurrecting dead—some skeletal, some clothed, some naked, rise from their tombs. They are assisted by wingless angels, one group being pulled up by a rosary symbolizing the power of prayer. Ranks of the saved are arranged around the dominating beardless Christ figure, who gestures dramatically, while the Virgin Mary seems to crouch by his side. Certain saints, significantly without haloes, are arranged near to Christ and are nevertheless identifiable by their traditional attributes, such as the keys of Saint Peter, the animal-skin robe of John the Baptist, the grid of Saint Lawrence, the wheel of Saint Catherine, the flayed skin of Saint Bartholomew, which significantly bears Michelangelo's self-portrait,[53] and so on. The areas of the lunettes are filled with angels bearing the instruments of the Passion, while other groups of angels, on the righthand side of the fresco, forcibly reject the damned—figures full of despair and pathos—and hurl them toward hellfire. The cave of Hell is, strangely, depicted directly over the altar on the center of the lower edge.

In all this vast scheme of things, where his own innovation is combined with established tradition, it is true that Michelangelo does not totally abandon the concept of "up" for Heaven and "down" for Hell in his fresco, since the saved rise as the damned fall, and Hell is at the lower level. Nor does Michelangelo abandon the right/left contrast of the traditional formula. There is some resemblance in general terms to the compositions at Padua and Torcello. Yet these aspects of the design are totally incorporated into the vast overall composition where circularity and circular motion receive the main emphasis. The Christ-centered circling movement is clearly superimposed upon, and warps into, the pattern of the familiar layers and divisions. The horizontal, hierarchical tiers and compartments of the traditional iconography that contain the figures outlined above are subsumed into a series of revolving circular movements around the figure

of Christ, who, although high up on the wall surface, is no longer at the summit of the composition but at its center. Christ is depicted as beardless and "Apollonian," but relatively small in scale.[54] He appears in the center of the composition with a somewhat disordered mêlée of saints, angels, saved, and damned twisting and turning all around him in a huge circular motion from the top to the bottom of the immense fresco.

Notes

1. Examples of all periods (early Christian, Byzantine, medieval, and Renaissance) are considered to establish the tradition of the scene's iconography. Special emphasis is laid on examples in Italy during the two centuries prior to Michelangelo, since these might have especial relevance as possibly known to the artist. See appendix 1 for details of examples.

2. Mâle, *Gothic Image,* chap. 6.

3. Réau, *Iconographie,* 727–57; see also Karl Künstle, *Ikonographie der Christlichen Kunst* (Freiburg: Herder, 1928), 521–57; Bréhier, *L'Art Chrétien,* 286–94, 391–97; and Gertrud Schiller, *Ikonographie der Christlichen Kunst,* vol. 3 (Gutersloh: Mohn, 1966).

4. Künstle, *Ikonographie,* 525; Redig de Campos, *Michelangelo, Last Judgment,* 70 n. 9.

5. Cosmas Indicopleustes, Χριστιανικη Τοπογραφια, c. 535–47, text and French trans. ed. W. Wolska-Conus (Paris: Editions Du Cerf, 1968). See also Dmitri Vlasivich Ainalov, *The Hellenistic Origins of Byzantine Art* (New Brunswick: Rutgers University Press, 1961; 1st ed. 1900–1901), 33–34, who cites Nikodim Pavlovich Kondakov, *Histoire de l'Art Byzantin* (Paris, 1886), 1:150 (reprint, New York: Burt Franklin, 1970).

6. Koestler, *Sleepwalkers,* 92–94.

7. For information on Clement of Alexandria (3d century), Lactantius (4th century) and other early medieval writers on cosmology of which these are typical, see Dreyer, *Thales to Kepler,* 208–209; Draper, *Religion and Science,* 63–67.

8. Ainalov, *Hellenistic Origins,* 37–38. See Cosmas, *Topographia,* bk. 2, sec. 35, for relationship between Moses' Tabernacle and the universe and bk. 3, sec. 80, for relationship between the universe and Christian dogma in general. The basilican form was, of course, popular in the West as well as in Cosmas' own area of Alexandria in Egypt; Huyghe, *Larousse,* 70.

9. Thomas S. Kuhn, *The Copernican Revolution* (Cambridge: Harvard University Press, 1957), 108.

10. Cosmas, *Topographia,* 566–69; Lactantius, *Divine Institutes,* trans. F. M. McDonald (Washington: Catholic University of America Press, 1964), bk. 3, chap. 24, "On False Philosophy," 228–30. Compare Saint Augustine, *City of God,* 664–65.

11. Respectively, "ΥΔΑΤΑ ΕΠΑΝΩ ΤΟΥ ΣΤΕΡΕΩΜΑΤΟΣ, ΚΑΙ ΕΚΑΛΕΣΕΝ Ο ΘΕΟΣ ΤΟ ΣΤΕΡΕΩΜΑ ΟΥΡ ΑΝΟΝ ΣΤΕΡΕΩΜΑ ΣΥΝΔΕΔΕΜΕΝΟΝ ΤΩ ΠΡΩΤΩ ΟΥΡΑΝΩ, ΓΗ ΣΥΝΔΕΔΕΜΕ ΤΩ ΠΡΩ ΤΩ ΟΥΡΑΝΩ ΚΑΤΑ ΤΟ ΠΛΑΤΟΣ."

12. See Ainalov, *Hellenistic Origins,* 38–42; Beckwith, *Early Christian and Byzantine Art,* 182–85. The original inscriptions read, "ΑΓΓΕΛΟΙ - ΕΠΟΥΡΑΝΙΟΙ, ΑΓΙΟΙ - ΕΠΙΓΕΙΟΙ, ΝΕΚΡΟΤΗΣ - ΚΑΤΑΧΘΟΝΙΟΙ."

13. Beckwith, *Early Christian and Byzantine Art,* 42.

14. See Cosmas, *Topographia,* 45–50, for details of a total of three surviving manuscripts in Rome, Florence, and Mount Sinai (in at least one case, a later ninth-century copy of Cosmas' original sixth-century work). The copy (pl.9.28) in the Laurentian Library in

Florence (where Michelangelo was working during 1524–26 and 1530–34) was recorded in the inventory of Medici books of 1495 (no. 744). The copy in the Vatican Library (Vat. Gr. 699) was included in an inventory of 1517 and again in 1533. [Information supplied through personal communications with respective libraries].

15. Réau, *Iconographie*, 733, 740–41. This is largely applicable to the examples up to the sixteenth century listed in appendix 1 and to figs. 15–48 in the text.

16. Michelangelo is known to have traveled fairly widely in Italy; see chronology in E. H. Ramsden, ed., *The Letters of Michelangelo, Translated from the Original Tuscan*, 2 vols. (London: Owen, 1963), 1:lviii–lxv and 2:lix–lxv), and art works in Italy, which could have been viewed and considered by him (in Florence, Rome, Pisa, Orvieto, Bologna, and Venice) are given special attention.

17. Byzantine examples of the *Last Judgment*, which often include these subsidiary scenes, are too numerous to deal with here, especially since they would not have been accessible to Michelangelo. However, it is also important to demonstrate the standardization of the subject's iconography. The Byzantine examples are significant because their established iconography underlies the basis of the Italo-Byzantine examples in Italy itself.

18. For details of the Torcello mosaic, see Renato Polacco, *La Cattedrale di Torcello: Il Giudizio Universale* (Canova: L'altra Riva, 1984). The enormous Christ of the *Anastasis* at the top compensates for the relatively small Christ of the *Last Judgment*.

19. See de Vecchi, "Michelangelo's *Last Judgment*," in Chastel et al., *Sistine Chapel*, 180.

20. Mâle, *Gothic Image*, 365.

21. Lehmann, *Dome of Heaven*.

22. Mâle, *Gothic Image*, 366.

23. Christ's wounds are alternatively read as a sign of his suffering or as vengeful pointing out of his betrayal by humans. A. A. Barb, "The Wound in Christ's Side," *Journal of the Warburg and Courtauld Institutes* 34 (1971): 320–21.

24. See Craig Harbison, *The Last Judgment in Sixteenth-Century Northern Europe* (New York: Garland, 1976), 267–302 for further details of northern *Last Judgment*s of which 260 examples are listed, including four by Dürer and followers. Harbison shows how the Protestants and Catholics directed the theme against one another, and also how the *Last Judgment* was used in civic buildings and courthouses as an image for the representation of law and justice, an idea also emphasized by Samuel Y. Edgerton, *Pictures and Punishment* (Ithaca: Cornell University Press, 1985), 22–29.

25. Condivi, *Life of Michelangelo*, 99.

26. Erwin Panofsky, *Life and Art of Albrecht Dürer* (Princeton: Princeton University Press, 1955), for example, *Vision of the Seven Candlesticks*, 1498 (fig. 74), *Saint John before God*, 1496 (fig. 75), and *The Seven Trumpets from the Apocalypse*, 1496 (fig. 78), all relate to the book of Revelation.

27. Condivi, *Life of Michelangelo*, 99.

28. Other sculpted versions in Italy include the tympanum of Parma Cathedral by Antelami and Maitani's marble panel at Orvieto (see Appendix 1, nn. 34, 44).

29. For further discussion see Frederick Hartt, *A History of Italian Renaissance Art*, rev. ed., (London: Thames and Hudson, 1987), 50–51 and 119–21.

30. Ezek. 1:28, Rev. 4:3. See Hartt, *Italian Renaissance*, 44. On the admission of the light of the sun, see Eve Borsook, *The Mural Painters of Tuscany* (London: Phaidon, 1967), xxi–xxii.

31. Eugenio Battisti, *Cimabue* (University Park: Pennsylvania State University Press, 1967); Alastair Smart, *The Assisi Problem and the Art of Giotto* (Oxford: Clarendon Press, 1971); Borsook, *Mural Painters*, 3–7.

32. Rev. 4:3, 6:14, and 20:9–10.

33. James Stubblebine, *The Arena Chapel Frescoes* (New York: Norton, 1969), 89–90.

34. Unlike Giotto, Michelangelo did not permit existing architectural features of the wall to intrude or affect the positioning of his figures. He had the existing windows (see fig. 4) in the Sistine Chapel filled in.

35. Stubblebine, *Arena Chapel*, 90; also Dorothy C. Shorr, "The Role of the Virgin in Giotto's *Last Judgment*," in Stubblebine, *Arena Chapel*, 169–82.

36. Millard Meiss, *Painting in Florence and Siena after the Black Death* (Princeton: Princeton University Press, 1978).

37. Meiss, *Painting in Florence,* esp. chap. 3, pp. 74–93.

38. Meiss, *Painting in Florence,* 76–77.

39. Hartt, *Italian Renaissance,* 124–25.

40. For Mariolatry (the raising of Mary's status, being revered almost on a par with Christ) at this time, see Meiss, *Painting in Florence,* 41–44.

41. Ramsden, *Letters of Michelangelo,* vol. 1, no. 112; Michelangelo visited the nearby marble quarries of Carrara on several occasions.

42. Tolnay, *Michelangelo,* 5:113.

43. John Pope-Hennessy, *Fra Angelico* (London: Phaidon, 1952). According to Pope-Hennessy, 191, fig. 43 is the only certain attribution to Fra Angelico.

44. Réau, *Iconographie Chrétien,* 756. For Orvieto see André Chastel, "L'Apocalypse en 1500: La Fresque de l'Antéchrist à la Chapelle San Brice d'Orvieto," *Bibliothèque d'Humanisme et Renaissance* 14 (1952): 124–40; and Enzo Carli, *Il Duomo di Orvieto* (Rome: Stato, 1965).

45. Although Traini's fresco in the Camposanto at Pisa has been argued as the source for the gesture of Michelangelo's Christ, there appear to be several alternatives that should be considered. It is also important to consider the ways in which gestures may vary in meaning according to time and place, for which see Desmond Morris et al., *Gestures: Their Origins and Distribution* (London: Jonathan Cape, 1979).

46. For example, Von Einem, *Michelangelo,* 155.

47. Koestler, *Sleepwalkers,* 94ff, 102–103, "The Age of Double-Think"; Dreyer, *Thales to Kepler,* 226.

48. The sphericity of the earth was finally confirmed by such phenomena as the shadow cast by the earth on the moon during an eclipse, the effect of ships disappearing from view before their masts at the horizon and the voyages of discovery and circumnavigation. For Columbus, see Felipe Fernández-Arnesto, *Columbus and the Conquest of the Impossible* (London: Weidenfeld and Nicolson, 1974). The landscape backgrounds of Piero della Francesca, *Triumphs of Federigo da Montefeltro and Battista Sforza* (c. 1470), and Antonio del Pollaiuolo, *Martyrdom of St. Sebastian* (1475) may be cited as examples (and also fig. 46), because of the curved horizons.

49. See especially Dante Alighieri, *The Divine Comedy: Inferno, Purgatorio, Paradiso,* 3 vols., text and translation by Allen Mandelbaum (New York: Bantam, 1982–86). For the "haidocentric" or "diabolocentric" nature of the late medieval universe, see Lovejoy, *Chain of Being,* 102; Koestler, *Sleepwalkers,* 99.

50. See Roberta J. M. Olson, "Giotto's Portrait of Halley's Comet," *Scientific American* 240 (May 1979): 134–42.

51. Versions by Traini, Nardo di Cione, and Signorelli, for example, do not adhere so closely to the layered format since they are spread over several areas. Other deviations from the norm at about this time are shown by the *Last Judgment* at S. Lorenzo, Genoa, where the frescoes appear to be Byzantine in style but Italian in content; Robert S. Nelson, "A Byzantine Painter in Trecento Genoa: The *Last Judgment* at San Lorenzo,"*Art Bulletin* 67 (December 1985): 548–66.

52. Michelangelo's fresco poses a unique problem in this context since, owing to the reverse orientation of the Sistine Chapel, it is on both the west wall and on the altar

wall—a unique position for a *Last Judgment* fresco. Figures are being propelled toward Hell, which seems to exist "off-stage" to the viewer's right, but a "cave" of Hell also appears to be curiously situated over the altar itself.

53. For details of the identification, which is virtually universally accepted, see Tolnay, *Michelangelo*, 5:44–45, 118–19; and, recently, Avigdor W. G. Posèq, "Michelangelo's Self-Portrait on the Flayed Skin of St. Bartholomew," *Gazette des Beaux-Arts* 124 (July-August 1994): 1–14.

54. Michelangelo's Christ is relatively small in relation to other figures in the fresco and also in comparison with earlier examples of the Christ of the *Last Judgment*, where he is invariably oversized. The figure is, nevertheless, completely dominating.

Chapter 4

Michelangelo's "Last Judgment"

His Holiness answers by saying, "Be of good heart,"
for for he has decided as soon as you return to Rome
to work work so well for you . . . and will give you
a contract for such a thing as you have never yet
dreamed of.

—*Sebastiano del Piombo,*
Letter to Michelangelo, 17 July 1533[1]

The Commission of the *Last Judgment*

Sebastiano del Piombo's enthusiastic letter to Michelangelo in Florence
in July 1533, referring to a project that was "such a thing as you have
never yet dreamed of" is the earliest known reference to the scheme to
decorate the end wall of the Sistine Chapel.[2] Following this dating, it
has been argued convincingly that the actual commission subsequently
was arranged during a meeting between Pope Clement VII Medici and
Michelangelo on 22 September 1533, at San Miniato al Tedesco, which
was recorded by Michelangelo himself (see list of relevant dates, appendix
2).[3] Clement VII was traveling at this time to attend negotiations in
France[4] and did not return to Rome until December 1533. Michelangelo's
hesitation to undertake the commission has been indicated, and he spent
more time in Florence before he returned to Rome for good in 1534, just
two days before the death of Clement VII on 25 September.[5] The new
Pope, Paul III Farnese, confirmed the commission, and in April 1535
scaffolding was erected in the chapel to prepare the wall surface for the
Last Judgment. Michelangelo's decision to work in fresco instead of oils, as
had first apparently been considered, resulted in a dispute and rift between
the artist and Sebastiano del Piombo and made it necessary for the first
preparatory surface coating to be removed from the wall (January 1536).
Thus the preparation of the wall according to Michelangelo's directions
finally was completed in April 1536 and the painting process was under

way by that summer.[6] A papal breve of 17 November 1536 stipulates
that the commission should follow the cartoons already prepared under
Clement VII.[7] The lowering of the scaffolding on 15 December 1540
indicates the date of completion of the upper part of the fresco, and
Michelangelo himself mentions the intensity of his work in a letter of 25
August 1541, but was delayed because the artist suffered an accident.[8] The
fresco was unveiled on the Eve of All Saints, 31 October 1541, when a
celebratory mass was said in the chapel by Pope Paul III; it seems to have
been opened to a wider public the following Christmas.[9]

Owing to the reverse orientation of the Sistine Chapel,[10] the immense
fresco (fig. 1) covers the west, altar wall of the Sistine Chapel. Its creation
meant the destruction of works by fifteenth-century artists including
Perugino and Michelangelo's own two frescoes in the lunettes, which
had been painted at the same time as the ceiling (fig. 4).[11] Two intrusive
windows in the altar wall were blocked up and the wall surface was made
to overhang very slightly to help prevent the settlement of dust. The
finished fresco therefore covers an area of 13.7 x 12.2 m (45 x 40 ft.) and
was the largest-known wall decoration originating as a single composition
up to this time.[12]

Even after the recent cleaning and restoration, the condition of the
fresco is variable, owing to the effects of time and dust and smoke from the
altar candles, which has resulted in possible chemical changes or alteration
of tonal values. Like Michelangelo's earlier frescoes on the ceiling, the
work has also been affected by several earlier well-intentioned attempts
at alteration and restoration. The modification of the *Last Judgment* fresco
began with the addition of draperies to some of the nude figures by Daniele
da Volterra in 1565,[13] but the cleaning of the fresco in the early 1990s
aimed to restore the fresco as near to its original state as possible. After
the completion of the restoration work on the Sistine ceiling by the end of
1989, work commenced on the cleaning and treatment of Michelangelo's
Last Judgment on the end wall. The treatment of the *Last Judgment* was
completed in 1994, and, as with the cleaning of the ceiling, as work
progressed it became increasingly evident that much of the dark effect was
in fact due to dirt and discoloration.[14] The cleaned fresco was displayed
to the public once more in April 1994, having been concealed by the
scaffolding for a period of almost four years.[15]

Formal Analysis

Compared with earlier examples of the *Last Judgment*, Michelangelo's
version of the *Last Judgment* in the Sistine Chapel evidently marks a
distinct shift from the relatively traditional to the obviously innovative. Yet
traditional and readily recognizable elements are also retained even while

Michelangelo introduces innovative ideas in his own unique approach to the subject. At this point, it is important not to overemphasize the idea of the artist as solitary genius—a concept stressed by Vasari with respect to Michelangelo to elevate the intellectual role of the artist. However, most experts agree that Michelangelo in particular, because of the stature he enjoyed by this time, did exercise a great deal of autonomy in the commission. It does seem that, in view of what we know about the artist and the way he worked on his own in other commissions (such as the Sistine Ceiling), we are here dealing with a work basically directed by the artist himself, even if he did receive some theological advice and had to seek approval by his papal patrons.

Before considering Michelangelo's finished fresco itself, to trace the evolution of Michelangelo's design it is necessary to consider preliminary drawings for the composition of the *Last Judgment*. Michelangelo is known to have destroyed the majority of his drawings, although his motives for this are unclear. Various studies for the *Last Judgment* do remain, however, including several details of separate areas of the fresco and a few sketches of individual figures.[16] More significant in terms of the overall composition are two studies of the total format (figs. 49 and 50). The drawing in the Casa Buonarroti (fig. 49) shows that the traditional tiered composition for a *Last Judgment* has been eliminated, although Michelangelo did not at first envisage the removal of all the existing decoration on the altar wall and he still allowed a space for the existing altarpiece by Perugino.[17] Usually accepted as predating the Casa Buonarroti drawing is the drawing in the Musée Bonnat, Bayonne, which is, less well known (fig. 50). It is normally taken as dating from the very beginning of the commission, in 1533. In both sketches, the gesture of Christ is already determined, although he is more distinctly separated from the Virgin on his right than appears in the final version. More significantly, the Bayonne sketch clearly demonstrates that a circular composition around the central Christ was uppermost in the artist's mind from the earliest days of the commission. The figures are here quite definitely arranged in a circle around Christ, and this has been commented on by observers like Goldscheider, Venturi, Tolnay, and more recently, Hirst.[18] Lines envelop the composition in the shape of circles tipped back from the picture surface to form the basis of the design,[19] and the compositional emphasis in this preliminary sketch remains circular, as in the final design. The artist's use of drawing as a method of evolving a composition is indicative, here, of Michelangelo's creative procedures.[20] A number of other designs and drawings for the overall scheme are of disputed attribution or appear to be later copies. Other preliminary drawings of separate areas of the fresco are not relevant to the present discussion of the overall composition.[21]

In the finished fresco in the Sistine Chapel, close formal analysis may usefully be applied to demonstrate the changes in Michelangelo's version

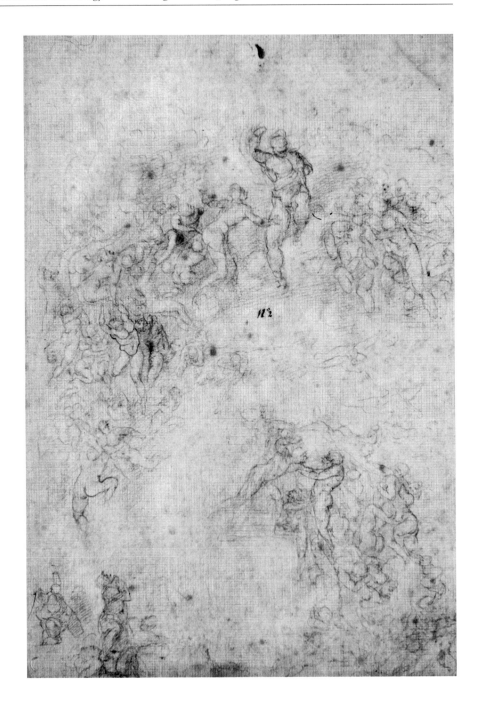

49 Michelangelo, Sketch for the Composition of the
Last Judgment, c. 1534. Black chalk, 418 x 297 mm,
(Corpus 347 recto) Casa Buonarroti, Florence.

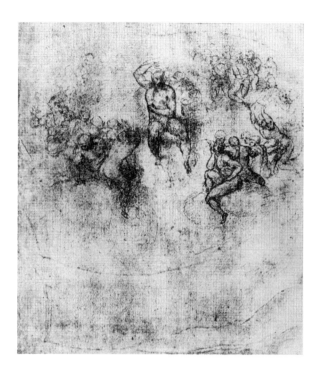

50 Michelangelo, Study for the *Last Judgment,* c. 1533. Black chalk, 345 x 290 mm (Corpus 346 recto) Musée Bonnat, Bayonne.

of the *Last Judgment* from the traditional or established norm. Horizontal divisions may be detected in the work, but the process of the loosening of the traditional tightly hierarchical scheme, which had already been started by Michelangelo's predecessors in the fifteenth century, is carried to extremes. Superimposed on the traditional program is the predominant motif of circular rather than horizontal divisions (see fig. 51). The overlaid lines indicate areas where the circularity is particularly apparent, but the idea of circularity is more important than the exact placement of circles in the diagram. The divisions here broadly relate to the limits of the inner and outer circles. Circular movement around the central figure of Christ is emphasized, with groups of figures even situated above him on the wall, instead of a carefully layered, static structure. A strong underlying organization was crucial to a work of this immense size, and this seems to suggest that the scale of the wall to be decorated may have led Michelangelo to seek innovative compositional devices. Where earlier versions of the *Last Judgment*, such as those at Torcello and Padua (figs. 20 and 36), had evidently been constructed and placed by means of the creation of a horizontal and vertical grid or network on the wall, in Michelangelo's case a new approach appears to have been explored that also utilized circles and diagonals in the method of actual composition on the wall surface. This,

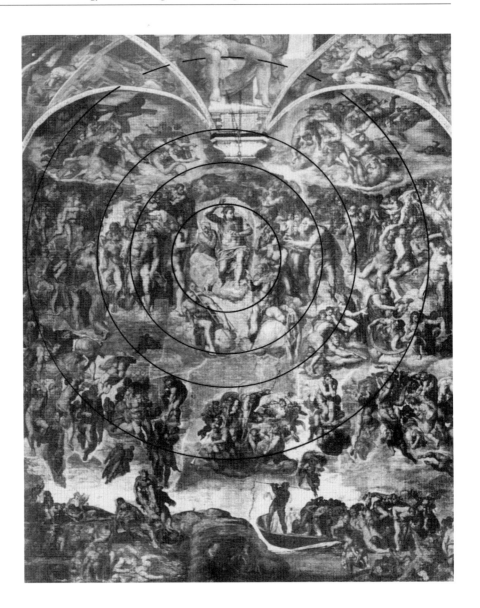

51 Michelangelo, *Last Judgment,* schematic diagram
(with circles).

in turn, would have fitted in well with the introduction of new concepts
in *Last Judgment* iconography, as will be demonstrated.

It would be unreasonable to maintain that Michelangelo totally
rejected the existing traditions of *Last Judgment* iconography. This can be
seen by a recognizable relationship with the compositions at Torcello and
Padua and by the continued use of the up/down and right/left contrasts
of the traditional format. A vertical division between the blessed and the

damned is suggested in the lower areas, and horizontal divisions may be identified in the composition, corresponding with the lunettes, the band of figures containing Christ, the level below the cornice of the lateral walls, and the lowest level across the altar (see figs. 1 and 51), but the horizontal and vertical divisions have now become activated. Set into motion, they are no longer static and self-contained but subsumed into the rotating circular movement of the whole design. The Christ-centered circling design clearly merges into these more traditional aspects of the *Last Judgment* format and overrides the familiar layers and divisions, and this has been recognized by both contemporary and later writers. Early observers like Condivi and Vasari, while acknowledging the existence of these divisions and other traditional elements, comment on the great impact of the circular design of the fresco.[22] Modern writers as well, such as Wilde, observe that there is still some suggestion of the traditional horizontal levels and that the areas of the Resurrection and Hell are still located at the lower edge of the fresco, but the circular emphasis is perceived as far greater.[23]

The immediate visual impact of the restored *Last Judgment* in the Sistine Chapel is not, therefore, one of a predominantly hierarchical arrangement in successive levels from the top to the bottom of the format. The circular arrangement around the centrally placed figure of Christ is the major distinguishing feature. Christ's position is not central on the wall in precisely measurable terms, either right to left or top to bottom. He is positioned slightly to the viewer's left, evidently to counteract the strong directional movement in his pose, which would make him appear off-center toward the viewer's right if he were centered exactly below the corbel of the vault. On the vertical axis, although Christ is placed in a considerably higher position than would be necessary for any simple optical correction, he is not isolated at the top of the wall surface in the very highest place favored traditionally, but in a position central to the masses of surrounding figures, so that, most unusually, the crowd arches above his head and there are many figures actually depicted above him on the wall surface.[24] Thus, in broad visual and compositional terms Christ is placed in the center of the overall scheme with respect to the mass of figures of the fresco arranged around him.

As an additional compositional means to the circle, used to concentrate attention on Christ, there are also a number of clear diagonals that produce a similar effect and have also been observed by some critics (fig. 52).[25] The existence of diagonals in the scheme is particularly evident when considering the figures rising from the dead (on the viewer's left) and those falling (on the right). Diagonal movement toward Christ in the center is, however, also to be observed in the arrangement of figures higher up, in the limbs of several of the saints and particularly the angels in the lunettes, which again lean toward Christ. Thus, Christ is made the focal point of the work through formal compositional and pictorial devices

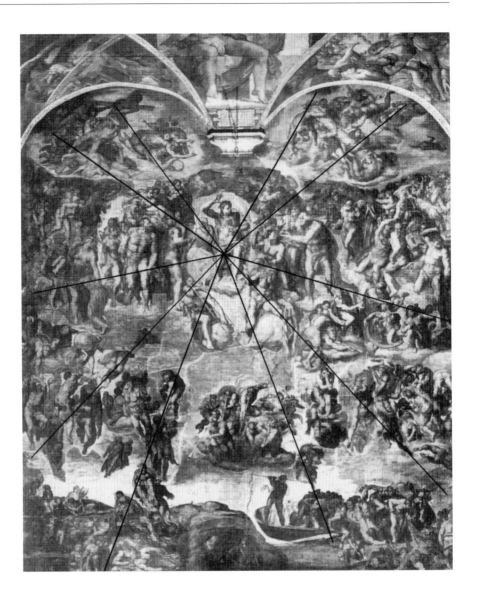

52 Michelangelo, *Last Judgment*, schematic diagram (with diagonal "rays").

rather than simply by means of a superior position on the wall surface. It may be suggested that there is here a possible relation with the Renaissance use of perspective to organize paintings, with the focal point of the composition frequently aligning with the vanishing point. This approach, in Michelangelo's fresco of the *Last Judgment*, forms a tremendous contrast with the traditional rather static scheme of the depiction of the *Last Judgment*, which was dependent upon a layered format, descending in strict order from Christ, who was most often situated in Majesty at the very top of the design.

Close, detailed formal analysis of Michelangelo's *Last Judgment,* which was deduced by means of the manipulation of transparencies overlaid with circles on a large scale reproduction, confirms its circular basis. Equally important as the circularity of the fresco's design appears to be the motion connected with it, for the design appears to be rising at left and falling at right in a continuous movement. The revolving arms of Christ seem to generate the circularity and circular movement of the fresco and the significance of Christ's gesture has received a great deal of attention and been subject to different interpretations (fig. 53). It possibly signifies a blessing and a curse simultaneously, in the same way perhaps that Michelangelo's bronze statue of Julius II at Bologna (now destroyed) was suggested to have done.[26] In this context, it is important to note the original position of Christ's thumb on his left hand, which is visible in a detail (fig. 54) and even more noticeable after the cleaning. Taken in conjunction with his middle finger, this is suggestive of the gesture of blessing; and this is the hand that points toward the wound and Christ's

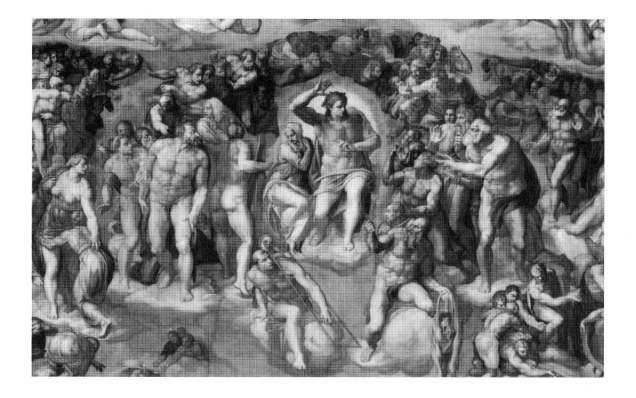

53 Detail, inner circle of figures, Christ the Judge and the Virgin, with Saint John the Baptist (*left*), Saint Peter (*right*), with other apostles, saints, and the saved.

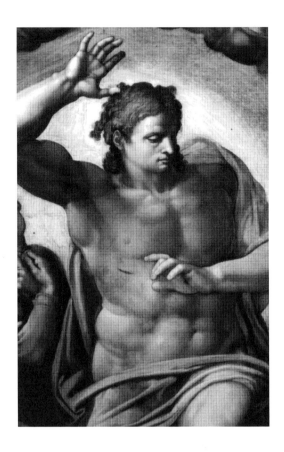

54 Detail, Christ.

redemptive suffering. Form and meaning are combined as Christ's gestures are used to relate to the iconography as well as the composition; the damned fall by his gesture of condemnation and the saved are drawn up. The arrangement of Christ's arms in a swastika-like formation (fig. 54) could perhaps be a reference to this form of sun symbol that was known from pre-Christian times and had been readily adopted by the Christians.[27] Christ's central position is accentuated by the golden light that surrounds him like a mandorla, but its resemblance to a circular sun is more striking than any correspondence with the shape of a traditional abstracted type of mandorla or radiance, and this effect has been heightened even further by the recent cleaning and restoration.[28]

Around Christ, the various figures—saints and apostles, saved and damned—apparently form and come together out of the space surrounding Christ, who appears according to the biblical description in Luke 21:27, "And then shall they see the Son of man coming in a cloud with power and great glory." Two distinct circles are created as the basis for the arrangement of the composition with areas of void or "infinity" in between.[29] Detailed examination of the figures shows how they are positioned to fit in with the two major circular masses. For example, on the inner circle (fig. 53), the

figure of Saint John the Baptist to the left of Christ is carefully composed so that his torso and limbs follow the curve of a circle (fig. 55). The subtle drawing back of his right leg, and the foreshortening of the calf demonstrate that the circular composition was contrived and intentional. The figure of Saint Peter, to the right of Christ, is similarly formed in almost a mirror image, with curved back and leg foreshortened in a very similar manner (fig. 56). Other examples of a contrived curve in the figures are to be found within the inner circle, and the arrangement of minor characters continues the formation. The inner circle of figures is completed around Christ's shoulders and above his head at the top, while the grille of Saint Lawrence and the leaning pose of Saint Bartholomew complete the suggestion of this circle at the bottom, below Christ's feet (fig. 57).[30] The inner circle is lent further emphasis by the surrounding void.

It is interesting to consider that the circle of figures around Christ may also be read as being slightly tipped back into space away from the picture plane, which tends to give it the appearance of an ellipse on the surface of the wall. This reading of the composition offers another example of Michelangelo's subtle adaptation of traditional concepts into his innovatory design. For, if the circle of lesser figures immediately

55 Detail, Saint John the Baptist.

56 Detail, Saint Peter.

57 Detail, Saints Lawrence and Bartholomew.

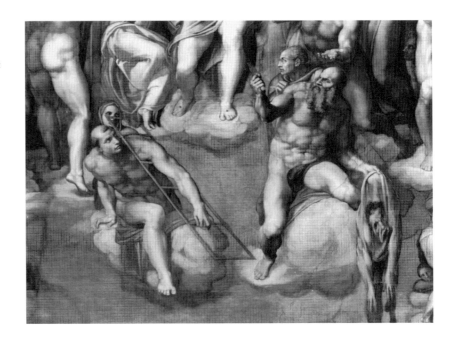

surrounding Christ is read as tipped back at an angle to the picture plane (an effect reinforced by their decreasing scale), then Christ's position in their center may be regarded as elevated above them in the conventional manner. The inner circle of figures may be read as situated below Christ (or at about waist height) in space, at the same time as being quite clearly positioned above him in the circle described on the actual vertical surface of the wall. Since the figures in the inner circle surrounding Christ may thus plausibly be read in both these ways, Michelangelo may be said to innovate without defying tradition outright.

Contemporary projectional theory, in which Michelangelo must have been versed,[31] corroborates this idea of the combination of two views of the circle. The awareness, here, that a circle projected at an angle forms an ellipse appears consonant with Michelangelo's reliance on mathematical theorems elsewhere in his work.[32] The position of the figures relative to Christ is the key factor for this hypothesis and, in spite of the subtle ambiguities suggested above, there seems little doubt that, relative to Christ, the figures are arranged in a circle around a central point—both in the two-dimensional composition on the real wall surface and in the fictive, pictorial space of the fresco.

Although the outer circle of figures around Christ may also be read as slightly tipped back into space in the same way (in the areas immediately below the lunettes), it is primarily perceived on the vertical wall surface (fig. 58). This outer circle is formed in the same way as the inner, by the use of curved and foreshortened limbs, as well as by the overall grouping of the figures as in, for example, the carefully curved bodies of the mother and child on the left, or the cross of the figure customarily identified as Saint Simon the Cyrene on the right-hand edge of the work. The circular motif, together with the idea of its implied movement, is continued across the lunettes; on the left by the placing of the cross, which is unusually and dramatically foreshortened, and on the right where the column of the flagellation is likewise diagonally placed (virtually in mirror image) so as to complete the circular format across the top of the two lunettes (figs. 59 and 60). Here, two traditional iconographic elements (the cross and the column), which were often included in versions of the Last Judgment, are both used in an unusual manner to reinforce the compositional form. The foreshortened limbs of the angel supporting the central part of the column and the position of the angel who is twisted around the cross, with foreshortened leg tucked well in, also serve to emphasize the underlying circular composition in this area. It seems appropriate that the cross, symbol of Christ's suffering but also his victory, suggests the upward movement, while the column of his pain and humiliation plummets downward.

The outer circle (indicated in fig. 51) is tightly closed lower down by the group of angels with trumpets,[33] although their trumpets splay

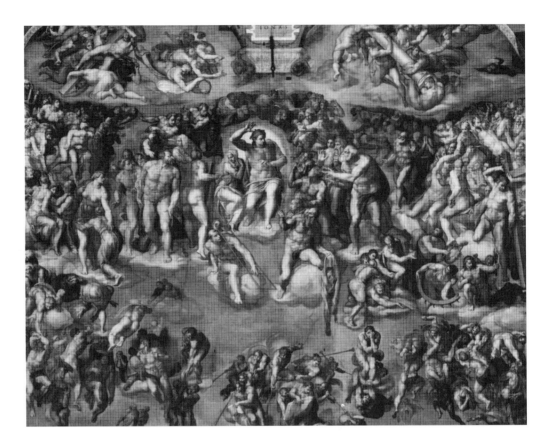

58 Detail, outer circle of figures.

outward, suggestive of the biblical reference to the four corners of the earth (Rev. 8:2–9). Within this group, the poses of various angels and even the positions of the books fit in with the circularity of the design (fig. 61). The group also serves as a linking feature between the "rising" figures on the left and the groups of figures falling toward Hell on the right (figs. 62 and 63). Some of the sinners here bear the instruments of their crimes and suffer relevant punishment in a way often depicted in medieval versions of the *Last Judgment* (like the usurer weighed down by his money). Their number and precise relevance to the Seven Deadly Sins also suggests a reference to Pope Clement's earlier scheme for a bronze group of this subject.[34] Together with the predominance of the angels' trumpets sloping toward the viewer's left, these groups are important for their contribution toward the suggested motion of the circular format in a clockwise direction for the entire composition. The only exception is the group of figures, in the bottom right hand corner, that are being propelled down and out of the picture space to the viewer's right.

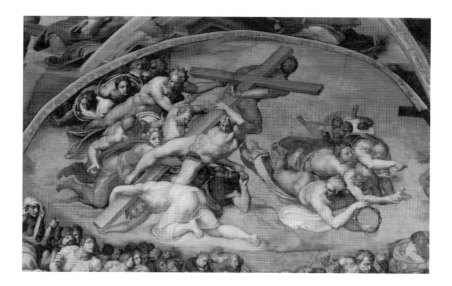

59 Detail, the left lunette (showing the cross).

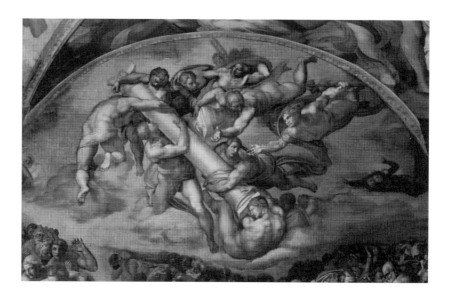

60 Detail, the right lunette (showing the column).

As far as the color or tonal (as opposed to linear) analysis of the work is concerned, very similar conclusions may be reached, in spite of the difficulties that have hitherto been caused by deterioration and discoloration of the fresco. The cleaning and restoration of the fresco has revealed Michelangelo's skill as a colorist and as a master of light and dark

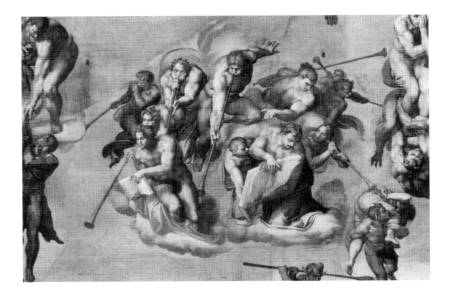

61 Detail, group of trumpeting angels.

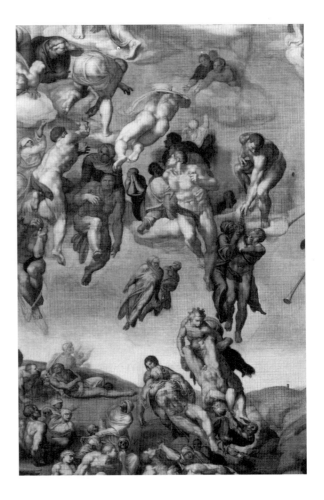

62 Detail, group of rising figures, *lower left*.

63 Detail, group of falling figures, *lower right.*

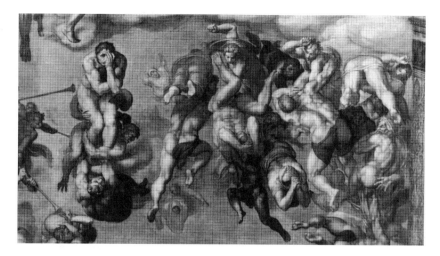

effects, and the concept of Michelangelo as a colorist immediately received increasing attention as a result of the restoration of the Sistine ceiling. The clear bright colors seen on the ceiling (and now on the altar wall) are emphasized in the postrestoration literature and the traditional concept of the master's subdued palette increasingly appears to have been related to the deterioration and obscuring of the fresco.[35]

Some art historians, notably James Beck, have voiced strong objections to the cleaning of the frescoes and their resulting postrestoration appearance. Beck appears to be in the minority in his opposition to the cleaning of the frescoes but he has argued strongly that the absence of contemporary references to Michelangelo's effective use of color suggests that he was not skilled as a colorist. Beck has argued that the manner of the cleaning and restoration process was ill advised and that the cleaning of the ceiling frescoes was no less than "tragic,"[36] but the general consensus appears to be in favor.

The restoration and cleaning of the *Last Judgment* on the altar wall has revealed further evidence of Michelangelo's prowess in the use of bright light and color. While revelations concerning Michelangelo's use of color in the *Last Judgment* are less relevant to the idea of light and sun symbolism in the fresco, his use of light and dark tonal contrasts as a basis for the composition is much more evident after cleaning. The tremendous effect of light in the fresco, particularly around Christ, is once again evident after the restoration. And that this is appropriate is confirmed by some contemporary observation of the fresco, such as the brilliant light and sun effects that are evident in early copies of it. Michelangelo's use of light and tonal contrast seem therefore to have been restored, reinforcing

the present reading of the significant emphasis on the sun/light effects, which are clearly over and above the use of conventional lighting of the figures that is directed as though from the south range of windows. The central emphasis on Christ is thus heightened and his light flesh tones, coupled with the golden aura around him, form the core of the design (see figs. 1 and 51). The space surrounding this "core" contrasts with the darker circle of figures, then another lighter area of clouds and "infinite space" follows before the outer rim of darker figures. Tonal contrast and light effects are thus directly used to reemphasize the circular composition.

The overall view of the fresco as based on two circular masses with Christ at the center thus appears to be even more strongly in evidence now that the fresco has been cleaned and restored. Also noticeable is the apparent movement of the circular basis of the design. The circles are used to set in motion the dramatic content of the fresco, beginning, as has been pointed out, with the arrangement of Christ's arms and extending to the system revolving around him. Although the overall format has been commented upon from the time of Vasari and Condivi, an explanation of the underlying circular, moving composition rarely has been considered in depth.

Previous Interpretations of Michelangelo's *Last Judgment*

Discussion of Michelangelo's artistic production has long been a major subject of art historical research and even controversy.[37] In particular the key work of the *Last Judgment*, because of the importance of the fresco's medium, scale, location, and date, has been the subject of much debate concerning its philosophical or theological meaning, hidden or otherwise. Previous interpretations of Michelangelo's fresco have tended to emphasize the dramatic mood of the judgment of humanity or the formal qualities of the artist's skill in the depiction of the nude. Other important recurring themes to come under discussion, apart from the overall composition, have included consideration of the meaning of Christ's gesture and facial expression, the significance of his beardlessness, and his ambiguous sitting, standing, or striding position. The demeanour of the Virgin Mary has also been an important factor in determining the message or meaning of the work. The exercise of a formal analysis may be used to demonstrate the singularity of Michelangelo's *Last Judgment* and the basis of its design on circularity and circular motion around Christ. This feature, however, may also be demonstrated and confirmed by the comments of previous critics of the fresco. The significant change in Michelangelo's *Last Judgment* from the well-established traditional formula to his own totally original

design, has been commented upon in numerous interpretations of the fresco, from his contemporaries in the sixteenth century to the most recent scholarship. A discussion of previous interpretations and observations concerning the fresco therefore lends weight to the present perception of the fresco as a rotating circular design with cosmological symbolic content, and an assessment of previous interpretations of the fresco will also provide a background against which the present interpretation may be considered.

The first recorded reaction to the completed fresco was that of Pope Paul III, who, on the unveiling of the fresco, spontaneously fell to his knees, overwhelmed by the drama of the scene and the emotion it aroused in him concerning his own fate and salvation.[38] The earliest specifically art historical discussions of Michelangelo's *Last Judgment* are those of his contemporaries Vasari and Condivi. In both editions of Vasari and in Condivi's text (probably written under close supervision of Michelangelo himself), the general approach and main emphasis of the interpretation is placed on the fresco as depicting the wide range of human attitudes in the physical depiction of the nude form.[39] Vasari comments on Michelangelo's portrayal of the human form in perfect proportion and "most varied attitude."[40] Strong emphasis is also placed on the range of emotions depicted at the time of Christ's Judgment; for example, Condivi describes the anger of Christ as he "wrathfully damns the guilty" and "gently gathers the righteous," while Vasari comments on the depiction of the "passions and affectations of the soul."[41] Both Vasari and Condivi also emphasize traditional iconographical elements that seem to fit in with the more customary approach to the scene, such as the inclusion of the angels of the apocalypse with the Book of Life, the raising of the dead, the role of the Judge, and the fates of the saved and the damned. The attributes of the saints and apostles, for identification, are also discussed. Biblical sources are suggested by these early biographers as mainly the Apocalypse of Saint John, Ezekiel 37, and Dante's *Inferno*.[42]

Alongside Vasari's and Condivi's recognition of such traditional features in the fresco are their important comments on its unusual format, as based on a circular design. As far as the overall composition was concerned, both Vasari and Condivi viewed Michelangelo's fresco as lying at least partly within the traditional framework of horizontal and vertical divisions. Condivi described the fresco: "The whole is divided into sections, left and right, upper, lower, and central" and Vasari also commented on the way in which certain figures are dragged down toward Hell while others fly toward Heaven. Both writers continue their descriptions, with references to the central position of Christ and the observed circular format around him. Condivi adds, significantly, that "in the central section, the blessed who are already resurrected form a *circle* or crown in the clouds of the sky around the Son of God," and Vasari also notes, "In a *circle*

around the figure of Christ are innumerable prophets and apostles."[43] This confirms the most evident visual perception of the fresco as being based on a circular design centered on Christ and shows the acceptance and obviousness of the idea of the circle in the very earliest criticism of the fresco.

Early copies of the work tend to reinforce this perception. Venusti's painted copy, 1549 (fig. 64), and engraved versions by della Casa, 1543; Giovanni Baptista de' Cavalieri, 1567; Beatrizet, 1562; and Rota, 1569 (fig. 65) also show an emphasis on the circular arrangement around the Sun-Christ.[44] The engraving by Rota in particular quite clearly demonstrates that contemporary observers perceived Christ in terms of a sun symbol, set in the middle of a bright circle of light, emphasized by the radiating rays of the sun. These early copies of the fresco give a more accurate impression of the fresco's brightness than the descriptions of later centuries that refer to the dark overall effect and the "muddy colors." The cleaned fresco is now in greater accord with these contemporary observations, which would vindicate the cleaning and restoration work that has been done.

It seems likely that Vasari and Condivi noted the circular composition and commented on it because it was a novel approach and a significant

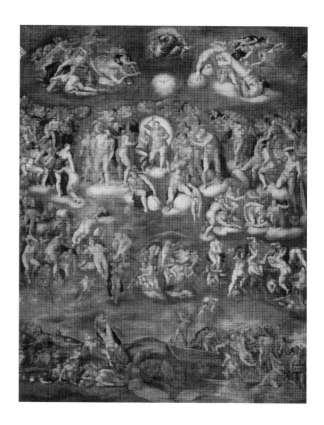

64 Marcello Venusti, copy of the *Last Judgment* of Michelangelo, 1549. Galleria Nazionale di Capodimonte, Naples.

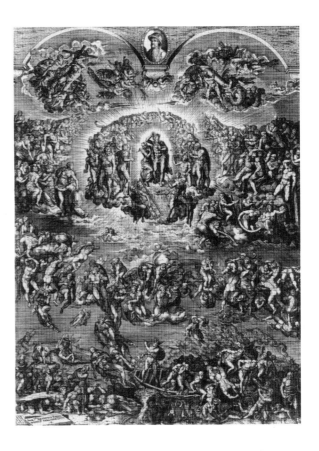

65 Martinus Rota, copy
of the *Last Judgment*
of Michelangelo, 1569.
Engraving, Bibliothèque
Nationale, Paris.

departure from the traditional formula of the *Last Judgment*. These
comments by observers like Vasari and Condivi and the evidence shown
by early copies should also be compared with Tolnay's comment that
credits Riegl (1908) with the first perception of the circular analysis
of the work, overlooking the comments of these contemporaries of
Michelangelo.[45] Although the circular emphasis of Michelangelo's design
received little additional comment until the twentieth century, it evidently
influenced several later versions of the *Last Judgment*. The subject became
increasingly rare after Michelangelo, but versions by artists such as, among
others, Pontormo, 1546 (fig. 66); Herman tom Ring, 1555; Vasari, 1560
(fig. 67); Bastianino, 1580; Tintoretto, 1589 (see sketch, fig. 68); and even
Rubens, 1615 (fig. 69), were also based on a distinctly circular design,
suggesting that Michelangelo's conspicuous circular format for the *Last
Judgment* had become totally accepted and had in fact formed the basis of
a new tradition.[46]

Apart from discussion concerning the overall composition of the
fresco, another line of interpretation of the painting also found expression
during the early days, beginning soon after the unveiling of the fresco. In
spite of the enthusiasm of some writers like Porrino (1541), Sernini (1541),

66 Jacopo Pontormo, study for *Christ in Glory*, Florence, San Lorenzo, 1546. Drawing, Uffizi, Florence.

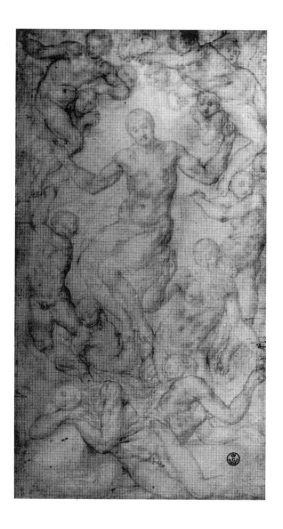

Martelli (1541), and Doni (1543),[47] at an early stage, adverse criticism was also evident, which attacked in particular the inappropriateness of the nudity in the fresco.[48] The existence of opposition to the fresco was commented upon by Sernini as early as November 1541, but its main early proponents were Pitti (1545) and Aretino (1545).[49] Aretino's correspondence with Michelangelo over the fresco and his suggestions for the design are well known. In 1537, when the design must have been established and the actual painting commenced, he wrote to Michelangelo, referring to the subject as "the end of the universe," and commenting on the idea of portraying Christ "blazing with rays" and "ringed round with splendours and terrors."[50] Having been snubbed by a somewhat sarcastic and evasive reply from Michelangelo, Aretino in 1545 began a bitter attack on the depiction of what he saw as indecency and nudity in the fresco.[51] He found it completely unsuitable for a major religious work in the papal chapel, and this line of argument, which was taken

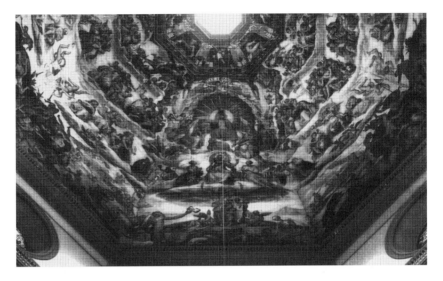

67 Giorgio Vasari, *Last Judgment*, 1560. Fresco, Sta. Maria del Fiore, Florence.

68 Jacopo Tintoretto, *Paradiso*, 1589. Oil sketch for *Paradiso*, Doge's Palace, Venice; now in the Louvre, Paris.

up by others,[52] was eventually responsible for the overpainting of parts of the fresco in 1564 by Daniele da Volterra, "the breeches maker."[53] The long-standing argument or line of criticism, which viewed the fresco simply as a "compendium of human anatomy" and blamed the artist for putting his art before the religious and spiritual interpretation of the subject, contrasts with the approach taken by Vasari and Condivi, in answer to such critics, concerning the depiction of the nude in the fresco, which is viewed by them in a totally positive light and highly praised from an artistic point of view.

69 Peter Paul Rubens,
Last Judgment, 1615. Oil on
canvas, 605 x 474cm, Alte
Pinakothek, Munich.

Aretino led the reaction against the nude in the fresco as unseemly, but
it is significant that in his criticism, although hostile in its condemnation
of nudity, he did recognize the importance of the immense work and also
that it contained hidden meaning—"the greatest mysteries of human and
divine philosophy."[54] On seeing "the complete sketch of the whole of your
Day of Judgment," Aretino also grasped the cosmological implications of
the work. For he wrote to Michelangelo, in November 1545, "When you
set about composing your *picture of the universe and hell and heaven . . .*"
[my italics], and he also suggested utilizing the "rays of the sun" ("raggi di
sole"), which were clearly evident, to cover the nudity of the blessed.[55] This
demonstrates that the traditional relationship between the depiction of
the *Last Judgment* and the perceived view of the universe was undoubtedly
carried on in Michelangelo's version of the subject, and that this was a
matter immediately recognized by contemporaries, even among those not
kindly disposed toward the artist.

Consideration of early reactions to the fresco thus demonstrates that
there was already an awareness of the circular basis of the design among
contemporaries—Aretino as well as Vasari, Condivi, and early copyists.
It is also shown that the cosmological significance of the scene as the

symbolic depiction of the physical universe was recognized by at least one critic, Aretino.

Related, perhaps, to the movement of the strict Counter-Reformation[56] critics of the later sixteenth century, like Lodovico Dolce (1557),[57] and Gilio (1564),[58] also criticized the fresco as amoral and laid their main emphasis on the fact that Christ was beardless and too young and that Michelangelo had apparently put art before religion. Yet Gilio, too, recognized the correspondence between the depiction of Christ and the sun.[59] The reputation of "the Divine Michelangelo" and agitation by the fresco's supporters (such as Anton Francesco Doni, 1543; the Florentine Academy, 1564; Lomazzo, 1590)[60] saved it from destruction, however, in spite of opposition from powerful reformers like Pope Paul IV Carafa.[61] Lomazzo was appreciative of the fresco's depiction of the range of human emotion in addition to the physical description of human form. He noted the wrathfulness of Christ, a point that was later to come very much under discussion in various significant interpretations of the fresco. Although several early writers had commented upon the anger of Christ[62] and this became an accepted approach to the interpretation of the fresco, the attitude of Christ (his gesture, general posture, and facial expression) came to be questioned in the twentieth century by Tolnay and Steinberg, among others.[63] In the intervening centuries, from the sixteenth to the twentieth, most interpretations followed a rather similar pattern of discussion of Michelangelo's dramatic depiction of the *Last Judgment*, the major concern being the expressive use of the nude or seminude human body to convey the range of emotions of the scene.

This tradition has been examined by Tolnay, who demonstrates how, during the Enlightenment, critics outside Italy, exemplified by Fréart (writing in 1662), Roger de Piles (1699), Richardson (1728), and Mengs (1785), followed similar lines in their interpretations, as did Milizia in Italy itself (1797).[64] Like Aretino and Gilio, they criticized the fresco as a mere compendium of the human form that placed art before religion. Winckelmann (1717–66)[65] disliked Michelangelo's work in general, but with the classical revival in the late eighteenth century, other critics were once more in favor of the fresco. Denis Diderot (1713–84) and Sir Joshua Reynolds (1723–92)[66] each extended their appreciation of Michelangelo specifically to this work, and Johann Wolfgang von Goethe, in 1786, commented on the *Last Judgment* as "a most grand and amazing performance" with "inner certainty, force, grandeur" and "the eye of a genius."[67] Following this, the Romantics, Stendhal (1817) and Eugène Delacroix (1830, 1837),[68] recognized the grandeur of the artist's vision. Paraphrasing Condivi and Vasari, they commented on the fresco as "the compendium of the attitudes of the human form," but they also demonstrated an awareness that the nude form was being specifically used to render the emotions (or attributes) of the Soul—that is, the joy of

the blessed, the despair of the damned, and the wrath of Christ himself. Delacroix in particular was conscious of the figures' appropriateness in the scene depicted and the "sublime nature" of the single, unified design.[69] In describing the eleven groups he perceived in the painting, Stendhal detected a rising and falling movement from the left to the right and rising again in the center to culminate at Christ in almost a spiral fashion. Delacroix was also aware of movement and the fact that there was an underlying compositional grouping that strengthened the design. Both these Romantics viewed Dante as a major source.

Nineteenth-century interest in the fresco was shown by Lenoir (1820), who stressed the stylistic interpretation of it as "an expression of dynamic unity."[70] In the middle of the nineteenth century, Jacob Burckhardt (1855)[71] appreciated the fresco's inspiration and expression of "poetical ideas," but he continued the traditional criticism of the fresco as irreligious and un-Christian in terms of its emphasis on the naked human body. Heinrich Wölfflin (1898)[72] also criticized Michelangelo's work as taking too much pleasure in the nude and emphasizing the physical rather than the spiritual, although he did recognize the grandiose nature of the project. Compositionally, he viewed the fresco in terms of two strong diagonals meeting at Christ (compare fig. 52), thus presenting a formal analysis of the fresco in addition to his comment on its content and theological meaning.

Adverse criticism of the famous work continued with John Ruskin's dismissal of Michelangelo's works as "dishonest, insolent and artificial" in 1872.[73] In the same year John Addington Symonds, commenting on the powerful expression of the athletic nudes, criticized them for not being spiritual enough. He did detect that the fresco had an "underlying mathematical severity," and regarded the figure of Christ as an Apollo in the same way as Tolnay was later to do.[74] Bernard Berenson (1896)[75] similarly expressed the idea that the "power" of the nude figures was not really spiritual enough as far as the "message" of the fresco was concerned, but he significantly recognized the importance of the fresco as "the depiction of the moment before the universe disappears" and as "a blast of energy," thereby unconsciously perhaps returning to the idea of cosmological significance in the fresco, which had already been mentioned by Aretino, Michelangelo's contemporary.

Twentieth-Century Criticism

In the early twentieth century, criticism of Michelangelo's *Last Judgment* included discussion of potential source material, but the formal analysis of the composition of the work as a whole also received attention. Steinmann (1905) stressed the importance of Dante as a source for the fresco, and Thode (1902–13) placed greater emphasis on the Bible and the *Dies Irae*

of Thomas of Celano, while still adhering to the notion of the fresco as a "compendium of human anatomy."[76] Looking at the format of the composition of the fresco as a whole instead of concentrating on the "compendium of human anatomy" in the individual figures, Riegl (1908) emphasized the revolving circular movement around Christ, whom he described as "vengeful."[77] Justi (1909) attacked the traditional idea, which originated with Vasari, that the main aim of the fresco was to display the artist's mastery of the human body by maintaining that this was only used with the purpose of bringing the iconographical meaning to a level of human understanding. Justi emphasized the dramatic unity of the painting and stressed the innovative aspects of the design in the movement rising on the left and falling on the right, which appeared to him to overrule the three major traditional zones.[78]

During the twentieth century, in line with an increasingly interpretative approach to art history, writers began to look beyond the stylistic or formal appearance of the work and a simple explanation of the scene of Judgment, to try to come to grips with the deeper levels of symbolic content. The dynamics of the rotating mass came to be viewed as being of iconographical significance in terms of an expression of inexorable fate, possibly related to the medieval wheel of fortune. The idea of *Fatum* in the fresco was examined by Dvorak and Venturi in the 1920s.[79] This linked up with the earlier pessimistic reactions to the fresco as an expression of the inexorable Day of Judgment, which had begun with the response of Pope Paul III himself.

In 1938 Panofsky interpreted the Neoplatonic content of Michelangelo's works, but without relating this theme very specifically to an examination of the *Last Judgment* fresco. He took up the idea of the design of the *Last Judgment* as associated with the tradition of the Wheel of Fortune, and also recognized the cosmological dimension of the fresco by describing the nonperspectival space as "gravitational, like a planetary system."[80] About the same time, Blunt and Goldscheider[81] emphasized the circular composition, but primarily viewed the work within its sixteenth-century historical context, arguing that Michelangelo was here utilizing the human form, not "for its own sake," but to reflect the contemporary pessimistic situation in Rome after the sack of the city in 1527 and during the period of the Counter-Reformation.[82]

It was not until 1940 that Tolnay consolidated tentative discussion of the circular format and the Apollo-Christ by presenting a much deeper interpretation of the fresco, which he viewed as a religious heliocentric image of the macrocosmos.[83] Tolnay's ideas have already been mentioned but fuller examination of his theories is now necessary. Michelangelo's *Last Judgment*, argued Tolnay in his early paper, is a vision of the universe that was closely related to that of Copernicus, although seemingly predating those theories. Tolnay implied that Michelangelo could have

independently reached the same astronomical conclusions as did the scientist.[84] This seems highly improbable. Since Tolnay felt obliged to question the likelihood of Copernicus as a source on the grounds of the later date of publication of his work *De Revolutionibus Orbium Coelestium*, he based his interpretation of the fresco's central motif of the Sun-Christ on ancient Pythagorean and astral myths.[85] These he related to the view of the fresco as dependent on a circular rotating movement around the central figure of the Apollo-Christ. In his discussion of the sun symbol of Christ in the fresco, Tolnay did support the idea of Christ's depiction as the sun with some specifically Christian references to the theme of Christ as Sol Invictus or Sol Iustitiae. He briefly recognized, but did not really develop, the possibility of a reference to the Early Christian tradition of an equivalence between the deity and the sun.[86] But Tolnay viewed the sun symbol as primarily pagan in origin and the analogy with Apollo is seen as directly corresponding with the pagan god. He cites the *Apollo Belvedere* in particular as a source for Christ's beardlessness.[87] This interpretation, proposed by Tolnay, was largely accepted and supported by Feldhusen (1953), Ferdinandy (n.d. but 1950s), and Von Einem (1955).[88]

The "cosmic" idea was also followed up by Tolnay in volume 5 of his major work on Michelangelo.[89] After concluding that the chronology of Copernicus' writings in relation to Michelangelo's work on the fresco was incompatible as a source, Tolnay did not pursue the specifically Copernican argument. As in his earlier paper, he developed an alternative, complex hypothesis for this symbolic depiction of Christ, which in his interpretation was based upon ancient cosmological myths and legends. Quoting sources from Cicero and Lucretius, Tolnay emphasized the relationship of the circular design of the fresco with the "great revolving movement of the macrocosmos" and also stressed his view that the depiction of Christ as Apollo was based on these ancient pagan sources. "This is no longer the Christ of the Gospels, but rather a divinity of Olympus," he wrote, and Michelangelo "casts the Christian content into the ancient form."[90] Tolnay linked these antique, classical, and Roman concepts with the medieval Wheel of Fortune from which, he argued, was derived the revolving circularity of the fresco's composition. He also drew parallels between the ancient idea of *Fatum* and the medieval concept of Divine Justice. Finally, he linked the overall composition of the fresco with the "Tellurian and Uranian systems of astrology" but without giving further explanation or sources for these theories.[91]

Apart from Tolnay's major emphasis on the Christ-Apollo theme, he also dwelt at length on the various literary and biblical sources that Michelangelo might have used for the fresco. Biblical references given include Matthew 24, Dan. 7:13, John 3:14, Isaiah 13–69, Rev. 1:7, 8:2, and 20:1–12, Ezekiel 37, and 1 Thess. 4:16. He gives less importance to Dante, often argued as a source for the artist, and to the *Dies Irae* of

Thomas of Celano, which was used as a source for depictions of the *Last Judgment* in the Middle Ages.[92] In addition, Tolnay's discussion here also considers the gesture, posture, and facial features of Christ. In particular, he draws attention to the fact that close examination reveals Christ's facial expression as one not of anger but of impassivity. Tension, rather than real fear, thus seems to be expressed by many of the surrounding figures at the moment of Christ's judgment; it is the depiction of humanity "in relation to macrocosmic forces." However, despite his full investigations of many aspects of the fresco, the idea of the cosmological overtones combined with the Sun-Christ theme had become Tolnay's major line of interpretation of the *Last Judgment* fresco.

In Charles de Tolnay's 1975 one-volume survey of his earlier publications the same cosmological theme was emphasized yet again, and an attempt made to draw the link with Copernicus:

> The artist has arrived by his own means at a vision of the universe which strangely anticipates that of his contemporary Copernicus. The idea of Michelangelo's composition precedes Copernicus' discovery by seven years.[93]

Although incorrect, as will be demonstrated, this reading of the chronology led him to reiterate his former argument concerning the more ancient cosmological sources for the fresco's design. Tolnay thus went on to discuss the concept of the soul's rejoining the cosmos after death as stars, which seemed to him to be portrayed in the fresco. This was an idea known to Dante as well as to Michelangelo, he argued, based on Plato's *Timaeus,* and also linked to ancient ideas concerning "the great rotation of the macrocosm." Echoing his former publication, he argued that the rotating movement of the fresco appeared to be related to the concept of the "whirling of the universe" and the "sidereal vortex of Uranus." It is "an idea depicted in primitive Bronze Age rock engravings" that also forms the basis of the "Ixion myth" as well as the Manichean symbol of the wheel and the Wheel of Fortune.[94] In attempting to trace sources for the use of the sun symbol, Tolnay mentioned the ancient astral myths, which he postulated as the basis for Michelangelo's depiction of Christ; and he also included antique references. Tolnay thus favored these rather obscure sources in preference to any other form of sun symbolism that might have had relevance in the mid-sixteenth century, and in preference to Copernicus' theory of heliocentricity, which was dismissed on the grounds of chronology.

Apart from Tolnay's study, Redig de Campos' work on Michelangelo's *Last Judgment* is perhaps the most thorough analysis of the fresco and provides a contrasting approach. The study relates to his earlier work written jointly with Biagetti in Italian in 1944 and made available in

revised form in English in 1978.[95] Redig de Campos takes pains to discuss the traditional iconography of the scene as well as the documentation of Michelangelo's commission. He goes into detail concerning the actual painting of the fresco and also the symbolic content of the completed work. The literary and iconographic sources are discussed as well as the apparent variations from traditional iconography. Redig de Campos observes three major zones in the work, one above the other, but he also perceives the circular format that is set in motion with a writhing mass of figures.[96] He summarily dismisses Tolnay's theory of sun-centered iconography as improbable, but without questioning Tolnay's dating of Copernicus' thesis in relation to the fresco. The circle he accounts for as being more probably influenced by the traditional concept of the Wheel of Fortune that fits in with the visual impact of the revolving fresco, ascending on Christ's dexter and descending on Christ's sinister.[97] An alternative explanation that Redig de Campos proposes for the circle of figures around Christ concerns the "mystical rose" of medieval tradition, which also has sources in Dante.[98]

The analogy between Christ and the sun, which seems to be visually suggested by the yellow mandorla (fig. 54) and which lies at the basis of Tolnay's consideration of the heliocentric influence, is, however, acknowledged by Redig de Campos, demonstrating the wide influence of this interpretation. Redig de Campos mentions the Apollo-Christ idea, regarded as an example of pagan classicizing reminiscence in Michelangelo's work; but, like Tolnay, he does not explore the Early Christian analogy between Christ and the sun.[99] While thus acknowledging classical influence in the fresco, Redig de Campos' main emphasis lies on the religious spirit and content of Michelangelo's *Last Judgment*, which he considers as interlinked with pre-Tridentine theological debate. This view of Michelangelo's *Last Judgment* as an expression of theological issues on the eve of the Council of Trent is an important theme to which further consideration will be given.[100]

The writings of Charles de Tolnay and Dom Redig de Campos marked significant, deeper penetration and enquiry into the fresco's meaning and, until quite recently, have very much underwritten the standard approaches to the work. During the 1950s, several authors (including more popular ones who must also be considered) expressed their agreement with the ideas of Tolnay, and references to the fresco's circular composition and cosmic qualities certainly increase from this time. Von Einem emphasized the "cosmic drama" and the view of the "Christ-Apollo" but he viewed the circle as stationary, a symbol of rest.[101] Saponaro (1955), Wilde (1950s lectures, published 1978), Allen (1953), and Morgan (1960) seem to follow an established trend and often refer to the Apollo-Christ and a circular formation with cosmic or celestial overtones.[102] Traditional features of the work have also been commented on by modern art historians, and Wilde, as already mentioned, refers in particular, like Vasari and Condivi,

to the fresco's division into horizontal and vertical zones. He detected a correspondence between horizontal layers and the cornices along the north and south walls, and he draws attention to the way the lowest level is emphasized over the altar. Wilde does concede, however, that these divisions are not strictly adhered to and that, while noticeable, they are subordinate to the overall circular basis of the design.[103] Building on Wilde's observations, it appears that the horizontal layers, less striking than the overall circular format, may be regarded as a concession to tradition, used to order the complex scene in a manner that would render its iconography recognizable and accessible, despite the innovative scheme that Michelangelo superimposed.

Writers in the 1950s tended in general to stress the pessimistic view of judgment as being one of the most evident aspects of the fresco, predominating over the more cheerful fate of the blessed, which is, however, also represented.[104] These trends continued in the 1960s as writers like Enzo Carli (1963), Rolf Schott (1963), Anthony Bertram (1964), Frederick Hartt (1964), and Valerio Mariani (1964)[105] also seem to perceive the fate of the damned as being more accentuated than the drawing up of the blessed. The influence of Tolnay's interpretation seems clear since the emphasis he laid on the circular design and the Apollo Sun-Christ is often repeated, and mention of the cosmological dimension becomes increasingly common after his major publication in 1960.[106] Among these authors, however, cosmic allusions and references still continue to be very vague and even less supported by source material than Tolnay's original exposition. It seems that, influenced by Tolnay, references to a cosmological basis for the fresco became very common in the literature, but without the specific relationship between the work and contemporary cosmology having been properly investigated. In spite of this wide assimilation of Tolnay's ideas, his interpretation of Michelangelo's *Last Judgment* has also received some adverse criticism. More than any other writer, Salvini has attempted to assess Tolnay's heliocentric and cosmological interpretation of the fresco. Salvini dismissed Tolnay's hypothesis on at least two occasions as being far too complicated in relation to what we know of the artist and his way of thinking.[107] The idea, he says, is "hardly convincing" and anyway "entirely superfluous" (1965). The complex mythological foundations that Tolnay argues as the basis for the theme are out of place according to Salvini, although he still does follow the usual pattern of references to the Christ-Apollo and the fresco as of "cosmic" and "circular" design.[108] In 1978, to these arguments against Tolnay's hypothesis, Salvini added a short discussion of potential alternative sources in Dante, Neoplatonism, and the Catholic or Protestant Reformation.[109]

Salvini thus regarded Tolnay's hypothesis of a connection between the fresco and heliocentric theory as rather improbable, and this has also been the case on the rare occasions when the concept has been considered

in scientific publications. For example, in the special publication commemorating the five-hundredth anniversary of Copernicus' birth, the idea that Michelangelo's *Last Judgment* fresco could be related to Copernican ideas did receive some comment, but the possibility was regarded as extremely unlikely—without any reasons being proposed for this conclusion.[110]

For the remainder of the 1960s and early 1970s, the majority of interpretations of Michelangelo's *Last Judgment* moved in a rather set pattern, especially with the increase of more popular literature aimed at reaching a wider and less scholarly readership. As an example, Robert Coughlan (1966) views Michelangelo's fresco as pessimistic, the result of the impact of historical events, namely the Sack of Rome.[111] He is evidently influenced by Tolnay in his description of Christ as "a great sun around which the whole action whirls" but goes no further in this discussion.

Sidney Freedberg (1979) examined the antique concept of Apollo and referred to "the cosmic simile" and "Christ seated in the Heavens like a sun,"[112] while more formal interpretation, for example that by Beck in 1981, considers the stylistic approach in the fresco, especially with regard to mannerist aspects.[113] Ettore Camesasca (and Leopold Ettlinger in the introduction to the same book, 1969) both return to the old idea of the fresco as the "compendium of the attitudes of the human body" but stress the way this is used to express the range of emotion of the participants of the drama. Camesasca refers to "circles," "cosmic terror," and "abstract infinity," and he also goes into detail concerning the possible identification of the figures with biblical or contemporary sixteenth-century characters.[114] Howard Hibbard (1975) describes the fresco as "peculiarly spaceless" with "a rising movement at the left and a falling at the right, a cosmic simile, with Christ like the sun, surrounded by clouds of figures." He sees Christ as "like an antique hero-god" developed from the ancient Helios (Sol) and "more Hellenic than Christian in inspiration." He goes on to discuss the equating of Christ with the ancient sun of Justice (*Sol Iustitiae*), which he regards as being related to Matt. 24:29–31, with its references to the sun at the time of the Last Judgment.[115] The theme of the transformation of the ancient *Sol Invictus* into the Christian *Sol Iustitiae* seems to be based on Tolnay, and similar arguments are mentioned by Furse (1975).[116] In general, art historians of this period refer to the traditional views of pessimism and the depiction of the human body in the fresco, but several among them—Camesasca, Beck, and Hibbard—also stress the cosmic overtones or the centrality of the figure of Christ within a circular format.[117]

During the postwar period, the cosmic qualities of Michelangelo's *Last Judgment*, together with its evident circular design around the Christ-Apollo (shown by formal analysis), thus continued to receive attention on a previously unknown scale. This appears to be largely attributable

to Tolnay's writings on the subject, which had been widely disseminated on a superficial level but scarcely explored in depth. Biblical and literary references retain the traditional emphasis, and analysis of the painting itself tends to be rather formal and stylistic, or simply the straightforward reiteration of previous theory to which nothing new is added—stressing either the compendium of nude anatomy, the range of emotion depicted, or the dynamism of the dramatic composition. The idea of the fresco as an expression of Michelangelo's own personal feelings gains predominance from the 1950s and is also reflected in works by Clements and Summers.[118] Since that time a more objective approach through the historical data or the documentary evidence of the commission has also been stressed by writers like Ramsden (1963)[119] and by Murray (1980 and 1984), who comments especially on the centrality of Christ and the huge circulating movement.[120]

The Current State of Research

After the major interpretations by Tolnay and Redig de Campos in the 1940s, only since the 1970s have fresh attempts been made to penetrate and interpret the deeper meaning of Michelangelo's *Last Judgment* beyond its physical appearance. Most important of these, perhaps, is that of Steinberg, who, drawing on Tolnay's observation that Christ's facial expression is not actually angry, develops the theory that the fresco's message is totally optimistic rather than pessimistic. He argues that Christ's judgment has not yet taken place at the moment depicted, and suggests that the judgment is to be less harsh and in fact less permanent than previously supposed. These ideas, as Steinberg points out, would link up with certain heretical ideas then current in Italy. In this way he argues Michelangelo's inclination toward heretical Protestant-type ideas and their expression in the fresco, behind, as it were, "the very throne of the Pope."[121] Steinberg mentions Tolnay's view of the Apollo-Christ as related to Copernican theory only in passing and seemingly as further evidence of Michelangelo's affinity with Protestant and heretical ideas.[122] This interpretation, however, disregards the actual reactions of contemporary Catholics and Protestants to Copernicus' theory.

Five years later, in 1980, Steinberg developed further theoretical views of the fresco in two papers concerning what he terms "The Line of Fate in Michelangelo's *Last Judgment*."[123] This argument of Steinberg is based on a formal analysis of the painting, which is dependent upon the existence of strong compositional diagonals (compare with fig. 52). Diagonal emphasis had been detected in the composition of Michelangelo's *Last Judgment* by Wölfflin in 1898, and Steinberg appears to return to this tradition, but he accords it symbolic significance, relating it to concepts of

Fatum (his "Line of Fate").[124] Steinberg's perception of one of the diagonals in the composition as ending up in the vicinity of Christ's right thigh is a theme that will be considered again in the course of this study, although Steinberg himself finds no apparent significance in the emphasis of the thigh. "Whoever," he asks rhetorically, "heard of thighs as conveyors of grace?" and he overlooks any possible significance here.[125]

Steinberg's rather controversial interpretations of Michelangelo's work and the *Last Judgment* in particular are very important because they have provoked considerable reaction and discussion.[126] The idea of the *Last Judgment* fresco as heretical appears unconvincing to many, not only because Michelangelo's deliberate flouting of papal authority is unlikely, but particularly because Pope Paul III almost immediately followed up with further commissions in the Pauline Chapel.[127] It is also unlikely that Michelangelo was so unable to express himself that the fresco has been read incorrectly for more than four hundred years: no contemporary or later commentary reveals an understanding of the type of heretical "messages" that, according to Steinberg, are expressed in the work.

At about the same time as Steinberg's writings in 1976, Hall also examined the question of the theological content of the fresco.[128] She recognizes the cosmological dimension in very general terms since, she says (without any specific explanation), "the event takes place in space-time." Hall also refers to "the beardless Apollonian Christ." But her main line of interpretation is based on the problematic reference, made in March 1534 by Agnello (the Venetian envoy), to the painting as a *resurrectione* and the question of a possible change of theme in the early days of the commission. Hall argues that the "resurrection" mentioned by Agnello in fact meant the fresco as we know it (meaning the "Resurrection of the Dead") and did not refer to an earlier project (namely a "Resurrection of Christ"). A major theme of the *Last Judgment*, according to Hall, refers to current theological debate on the Catholic doctrine of Resurrection of the Body at the time of the Last Judgment. Although the idea of *resurrectione* signifying resurrection of the dead, rather than that of Christ, may well be true, the implication that Agnello's reference to the work as a "resurrection" meant he must have been aware of the detailed thought of the Curia concerning this doctrine at the time seems less certain.[129] Hall also relates this argument to her proposal of 1 Corinthians 15, with its emphasis on resurrection, as the main basis for the fresco. This is an important scriptural source for the *Last Judgment,* which has received little attention and was not mentioned by Tolnay or Redig de Campos in their otherwise definitive lists of scriptural sources. Hall stresses the doctrine of the Resurrection of the Body as a contrast to the Renaissance Neoplatonic emphasis on the doctrine of the Immortality of the Soul, and she presents evidence for the doctrine of the Resurrection of the Body as gaining in importance during the sixteenth-century religious controversies. This, she

says, explains Michelangelo's emphasis in the painting on the solidity of the human form.[130]

Hall's interpretation of Michelangelo's *Last Judgment* and the evidence for the predominance of the doctrine of the Resurrection of the Flesh over the doctrine of the Immortality of the Soul at the time of the commission have been much discussed. The argument for this theme in the fresco does not appear entirely convincing in terms of the artist's known adherence to the ideas of the Viterbo group and the *Spirituali*,[131] who laid great stress on the idea of the spiritual rather than the fleshly aspect of humanity's existence. There seems little reason why the two doctrines (Catholic Resurrection of the Body and Neoplatonic Immortality of the Soul) should be regarded as mutually exclusive. The writings of the Neoplatonist Marsilio Ficino on the Immortality of the Soul were highly influential on the formation of Catholic doctrinal decisions at the Fifth Lateran Council in 1514, when this doctrine was incorporated into Catholic dogma.[132] In addition, Ficino himself also recognized the doctrine of the resurrection of the flesh, as did many other Neoplatonists. It is not necessary to distinguish exclusively between either Neoplatonic or Catholic doctrines in Michelangelo's fresco. The two themes could well have been combined in his work for it was, after all, the avowed intention of the Renaissance Neoplatonists to incorporate ancient Platonic thought within the framework of the Catholic faith.[133] It is also difficult to accept Hall's conclusion that the interpretations of Condivi and Vasari are incorrect, while Agnello's letter represents "a leak from a highly placed source privy to the discussion being held on the interpretation the subject was to be given."[134]

De Maio (1978) gives a penetrating interpretation of Michelangelo's thought in relation to the contemporary religious reforming atmosphere in Italy. He examines the fresco of the *Last Judgment* in the theological context of the Counter-Reformation, and his work is particularly useful for documentation of the early opposition to the fresco.[135] Other recent studies include that of Liebert (1983),[136] who takes a psychoanalytic standpoint for his discussions of Michelangelo's various works. This psychoanalytic approach does follow the trend of interpretation of the "hidden meaning" in the fresco, rather than simply a formal, stylistic, or straightforward art-historical approach, but the Freudian and sexually oriented standpoint appears to be too exaggerated and the arguments put forward implausible.[137] Liebert does comment at some length on Michelangelo's interest in the Apollo theme, but he also states, for example, that the central group (of Christ, the Virgin Mary, and Saint Bartholomew) is to be read in terms of Michelangelo's matricidal, patricidal, and homosexual tendencies.[138] Similar material is offered by Leites, who also appears to read a great deal of twentieth-century Freudian significance into the sixteenth-century artist's motives.[139]

Among more recent studies concerning Michelangelo's *Last Judgment*, Dixon (1983) concentrates on discussion of whether the overall theme is one of condemnation or redemption; he, too, refers to the Copernican idea but without discussion in depth.[140] Barnes' thesis (1986) is largely concerned with the patronage of the fresco, but devotes some discussion to other problems such as Christ's gesture, the role of Hell, the use of Dante as a source, and the idea of pessimism after the Sack of Rome. Tolnay's cosmological interpretation is considered, together with its foundation on Pythagorean sources, and the idea of the Christ-Apollo and the Sun-Deity analogy is discussed briefly within the Christian context.[141]

Publications in the late 1980s, such as those by Lamarche-Vadel (1986)[142] and Chastel et al. (1986)[143] demonstrate that the discussion surrounding the fresco, its meaning, and the sources used by Michelangelo continued to stimulate a great deal of interest. Lamarche-Vadel follows the usual references to the circular design of the fresco around the Sun-Christ, while the essay by De Vecchi, in a commemorative volume with essays by Chastel and others, draws attention to the way in which Michelangelo's "cosmic" depiction of the *Last Judgment* overturns the traditional arrangement of the scene based on the Christian hierarchical view of the universe, but without presenting any explanation for this. The fresco is also examined in relation to the chapel itself and with due consideration for the cleaning and restorations.

Debate on the restoration of the frescoes and the chapel as a whole continued while the treatment of the ceiling was in progress, as discussed above; but by 1989, after the completion of the restoration on the ceiling, increasing attention has been drawn to the *Last Judgment*. A paper by Greenstein in 1989, accepting and acknowledging the possibility of multilayered meaning in the fresco, presents an argument for a reading of the inner circle of figures as bearing reference to the Transfiguration as prefiguring the *Last Judgment*.[144] The controversy over the validity and necessity of cleaning and restoration also continued as art historians and the interested public looked toward the imminent treatment of the end wall, and several standard books on Michelangelo (such as those by Linda Murray, Howard Hibbard, Lutz Heusinger, and Mario Salmi) have been reprinted to cater to demand caused by increased interest in the artist's works.[145] The heated discussion that had taken place on the effects of the cleaning of the ceiling became transferred to the fresco of the *Last Judgment,* particularly over whether the draperies added at different stages, from Daniele da Volterra to later-seventeenth- and eighteenth-century additions, should be preserved or removed.[146]

Primarily based on discussion of the post-restoration fresco and the Japanese sponsorship of "the West's most treasured work of Art," an unusual book by Januszczak (1990) appears to be directed at both

specialist and academic audiences.[147] Conveying the immediacy of the experience of viewing the frescoes close up from the scaffolding, he concentrates on the ceiling rather than the *Last Judgment*. His view of the contrast on the ceiling between the "pessimistic" uncleaned monochrome and the "optimistic" brighter coloring in the restored work might also now be argued for the *Last Judgment*. Regarding the *Last Judgment* itself, he discusses the controversy over whether the additional loin cloths should be removed, and uses a suitably modern metaphor to describe the tumbling of the mêlée of figures.[148] In a final chapter, however, which takes the form of a hypothetical conversation between "art experts," he observes that Copernicus was Michelangelo's contemporary and significantly refers to the theory of the sun-centered universe in connection with the depiction of the sun in a prominent position on the Sistine ceiling, where, he says, it represents "the origin of all life, a symbol for the divine energy of the Godhead itself." The cleaning had restored this feature *on the ceiling* to its due prominence after five hundred years of darkness, and it seems also that the subsequent cleaning of the *Last Judgment* has resulted in a parallel effect of restoring the prominence of the light and sun symbol in the fresco over the altar.[149]

Also controversial is the recent work (1991) on Michelangelo's drawings in which Alexander Perrig has argued that (since it is known that Michelangelo destroyed many of his drawings) out of a total of more than six hundred drawings claimed to be by Michelangelo, a large proportion must surely have been made by students and copyists and have been wrongly attributed for centuries. Of direct relevance here is Perrig's argument that a large number of drawings must have been made by Michelangelo's friend, the young nobleman Tommaso de' Cavalieri, who was an amateur artist. Perrig virtually comes to regard Cavalieri as the "co-creator" of the *Last Judgment*, but this hypothesis has received little support.[150]

Aimed at a wide audience, works on Michelangelo by Richmond, de Vecchi, and Le Bot (published 1992–93) have again drawn attention to the Sistine frescoes; it is interesting to note the way the traditional interpretations continue to permeate both popular and specialized Michelangelo literature. Richmond includes illustrations of the restored ceiling frescoes and comments on their brightness, but still refers to "the darkening of his spiritual vision" in connection with the *Last Judgment*.[151] De Vecchi again places an emphasis on the centrality of Christ, and dramatically describes him as "charged with dynamic power."[152] Le Bot also comments on the circularity of the design and the cosmological aspect, and writes, "The whirling space in Michelangelo's *The Last Judgment* stands as a metaphor for the infinite cosmic space carrying away mankind. . . . The image of whirling shapes serves as a representation of interstellar space."[153] But he does not examine contemporary cosmology further than stating "Michelangelo did not know the work of Copernicus, nor

did Copernicus know Michelangelo's" and he presents no evidence for this supposition, beyond his further statement that they "must have had a kindred imagination."[154] In the early 1990s publications mainly concentrated on the restoration process itself, ranging from the aptly entitled "Waiting for the Last Judgment," which appeared in December 1993 as the cleaning drew to a close, to official publications by the Vatican on the restorations. George Bull's biography of Michelangelo (1995) places the artist in the context of his time, while the end of the whole restoration process was celebrated with a volume showing the restored and cleaned frescoes in their entirety, produced by the Vatican in 1996.[155]

Ranging from the conventional to the controversial, and almost since the moment of its completion, various interpretations of Michelangelo's *Last Judgment* have been put forward; the fresco, situated physically at the very center of Christendom and symbolically at the core of the Christian religion, has provoked much debate. But among all this discussion, the idea of examining the work in the context of the traditional cosmological framework of the scene's iconography has received little detailed attention. Present evidence suggests that further investigation is required into the interlinked themes of cosmology and sun symbolism in the fresco. Clearly, the most recent scholarship is primarily concerned with the cleaning and restoration—about the way it has been carried out and whether it was justifiable. Little has been done to look anew at the meaning and iconography of the frescoes in their now restored state or to assess whether the real significance of the cleaning and restoration is that it may help to make clearer the "hidden meaning" of the frescoes, especially now that the *Last Judgment* looks more as it did when first completed.

Tolnay's cosmological interpretation of Christ as a sun symbol in Michelangelo's *Last Judgment* had much influence in general terms, but it was weakened by his references to the impossibility of Michelangelo's having known of heliocentric cosmology. Hence the idea was never fully and seriously explored, leading to vagueness and confusion in the succeeding literature. It will be argued here that the fresco should properly be considered as a Christian heliocentric vision of Christ depicted as the sun and center of the universe. This approach is not to be founded upon the obscure ancient astral myths proposed by Tolnay. A purer and simpler foundation can be traced for the sun symbolism in the fresco, which fits in far more appropriately with what we know of the artist and his time. In this argument it is proposed that, just as in the traditional iconography of the *Last Judgment*, Michelangelo's ordering of the complex scene and Christ's role was achieved by relating it in broad terms to the contemporary view of the cosmos. But the current cosmological framework had changed. In addition, in Michelangelo's case this framework was also related to and dependent upon the common ground shared between other areas of contemporary thought and interest—the Catholic Reformation revival of

the traditional Christian analogy between the deity and the sun, literary sources in Dante, the Neoplatonic cult of sun symbolism, and the scientific theory of heliocentricity as outlined by Copernicus. A new biblical source for the fresco will also be proposed, which, taken in conjunction with a formal and analytic approach to the actual construction of the fresco on the wall surface, will lend weight to the central theme of this hypothesis.

Notes

1. Translation by Linda Murray, *Michelangelo, His Life, Work and Times* (London: Thames and Hudson, 1984), 157. See Paola Barocchi and Renzo Ristori, eds., *Il Carteggio di Michelangelo* (Florence, 1965–83), 4:910, for the original Italian ("farvi contrato de tal cosa che non ve lo sogniasti mai"). Pierluigi de Vecchi in Chastel et al., *The Sistine Chapel*, 176, also draws attention to this document as evidence for the dating of the commission.

2. This is argued by Murray, *Michelangelo, Life, Work and Times*, 157; Tolnay, *Michelangelo*, 5:19; Chastel et al., *The Sistine Chapel*, 176, among others. For data concerning Michelangelo's life and work, where innumerable sources could be cited, Tolnay and Murray have largely been used, as well as the important primary sources in readily available editions, namely Ascanio Condivi, *Life of Michelangelo*, 1553; and Giorgio Vasari, *Lives of the Most Eminent Painters, Sculptors and Architects*, 1568.

3. For example by Murray, *Michelangelo, Life, Work and Times*, 157; Tolnay, *Michelangelo*, 5:19, 99 n. 4; Redig De Campos, *Michelangelo, Last Judgment*, 25; Ludwig von Pastor, *History of the Popes*, English version (London: Routledge and Kegan Paul, 1901–28), 10:231; Michelangelo's *ricordo* is published by Gaetano Milanesi, *Le Lettere di Michelangelo Buonarroti* (Firenze: Le Monnier, 1875), 604; see also Chastel, et al., *The Sistine Chapel*, 268 n. 3. There are no details of what precisely was discussed; there are very few remaining documents concerning the actual planning or execution either of the ceiling frescoes or the *Last Judgment*.

4. For the marriage of Catherine de' Medici to the second son of the French king, see Pastor, *History of the Popes*, 10:230.

5. Michelangelo continued to work on the sculptures of the Medici chapel, and he also still hoped to complete the commission for the ill-fated Julius tomb; Murray, *Michelangelo, Life, Work and Times*, 157–58; Redig De Campos, *Michelangelo, Last Judgment*, 26; Tolnay, *Michelangelo*, 5:100 n. 6. The *Last Judgment* project certainly had been determined before Michelangelo's final return to Rome in September 1534 and Clement's death, since Vasari alludes to the work as having been commissioned by Clement VII and to "inventions which had been decided"; Vasari, *Lives* (ed. de Vere, 1882; ed. Bull, 378). Condivi mentions "a cartoon" and "what he had already begun in Clement's time"; Condivi, *Life of Michelangelo*, 75, 83. Also, the project to paint the altar wall of the Sistine Chapel was mentioned in a letter by the Venetian envoy on 2 March 1534; Redig De Campos, *Michelangelo, Last Judgment*, 25. For the date of Michelangelo's return to Rome, see his letter to Vasari of May 1557, Ramsden, *Letters*, vol. 2, no. 434.

6. For the dating of the preparation of the wall and scaffolding see Redig de Campos, *Michelangelo, Last Judgment*, 28–30; Tolnay, *Michelangelo*, 5:20–21; and Frederick Hartt, "The Evidence for the Scaffolding of the Sistine Ceiling," *Art History* 5 (September 1982): 273–85. Note that three years elapsed between the inception of the commission and the commencement of the painting in 1536, and that, after the cessation of the involvement of

Sebastiano del Piombo, Michelangelo worked alone, as he had on the Sistine ceiling. He almost certainly received some help with basic technical matters, like the mixing of colors, from his assistant Urbino.

7. For Pope Paul's *motu proprio,* see Redig de Campos, *Michelangelo, Last Judgment,* 97. Vasari also comments that Paul III wanted Michelangelo to continue the work commissioned by Pope Clement. Vasari, *Lives* (ed. de Vere, 1882; ed. Bull, 378).

8. Vasari, *Lives,* (ed. de Vere, 1883; ed. Bull, 380); see Tolnay, *Michelangelo,* 5:22, and Redig de Campos, *Michelangelo, Last Judgment,* 33–34, for details about the fresco's progress.

9. Contemporary documentation, the *Diary of the Sistine Chapel,* is quoted by Redig de Campos, *Michelangelo, Last Judgment,* 38 n. 67. Vasari believed it was unveiled on Christmas day that year but expressed some uncertainty; Vasari, *Lives* (ed. de Vere, 1887; ed. Bull, 383). Although the main dedication of the chapel was to the Virgin, the celebration of the completion of the fresco seems appropriate to the Vigil of All Saints because of its relevance for the Last Day. The celebration of the ceiling frescoes had also taken place on All Saints' Eve (in 1512), a date that seems unlikely to have been a coincidence.

10. Probably related to the reverse orientation of Saint Peter's itself, see James Lees-Milne, *The Story of St. Peter's Basilica in Rome* (London: Hamilton, 1967), map, fig. 71.

11. Tolnay, *Michelangelo,* 5:20 and fig. 44; Wilde, *Six Lectures,* fig. 154; see also Rona Goffen, "Friar Sixtus IV and the Sistine Chapel," *Renaissance Quarterly* 39 (1986): 218–62.

12. Salvini, *Hidden Michelangelo,* 124. Leo Steinberg, "A Corner of the *Last Judgment,*" *Daedalus* 109 (1980): 208, curiously refers to it as "three thousand square feet of impending apocalypse" (45x40=1800 square feet).

13. Murray, *Michelangelo, Life, Work and Times,* 166.

14. For details of the cleaning and restoration of the Sistine ceiling, see Chastel et al., *The Sistine Chapel, Michelangelo Rediscovered,* esp. the foreword by Carlo Pietrangeli, 6–7, and appendix, 260–65; A. Levy, "All of Michelangelo's Work Will Have to Be Restudied,"*Art News* 80 (October 1981): 114–21 (quoting restorer Gianluigi Colalucci, "now we discover that the darkness was dirt . . ."); Patricia Corbett, "After Centuries of Grime," *Connoisseur* (May 1982): 68–75; M. Kirby Talley, "Michelangelo Rediscovered," *Art News* 86 (Summer 1987): 158–70; Philip Elmer-DeWitt, "Old Masters, New Tricks," *Time Magazine* (18 December 1989): 50–51; D. Jeffery, "The Sistine Restoration: A Renaissance for Michelangelo," *National Geographic* 176 (December 1989): 688–713; G. Hill, "Judgment Day Looms for Sistine Restoration," *The Times,* 22 March 1990; Carlo Pietrangeli, *Michelangelo e la Sistina, la tecnica, il restauro, il mito* (Rome: Musei Vaticani e Biblioteca Apostolica Vaticana, 1990) esp. 55–126. The special, limited edition on the restored frescoes: Frederick Hartt, Fabrizio Mancinelli, Gianluigi Colalucci and Takashi Okamura, *The Sistine Chapel* (London: Barrie and Jenkins, 1991), may also be consulted. For the debate over the cleaning and restoration of the Sistine, see esp. the discussion in *Art Bulletin* (1989–91).

15. Two personal visits to the scaffolding for close examination of the fresco were undertaken, in March 1989 and July 1993, when close examination of the cleaned fresco, and some discussion with the restorers and Dr Fabrizio Mancinelli, curator of Byzantine, medieval, and modern art at the Vatican, was possible.

16. Tolnay, *Michelangelo,* 5, figs. 132–47 and corresponding notes on 184–85.

17. Tolnay, *Michelangelo,* 5:24.

18. Ludwig Goldscheider, *Michelangelo: Drawings,* 2d ed. (London: Phaidon, 1966), catalogue no. 99, p. 58. He refers to it as "the earliest extant drawing" and notes Thode's agreement. Adolfo Venturi, *Michelangelo, His Life and Work* (Rome: Valori, 1928), 79, comments on "the circle of martyrs." Tolnay, *Michelangelo,* 5:24, draws attention to "the full circle" and, as a recent example, Hirst also comments on the circular arrangement; Michael Hirst, *Michelangelo and His Drawings* (New Haven: Yale University Press, 1988), 51.

19. There is some uncertainty whether these are marks in the paper itself, rather than part of the drawing. The lines were described by M. Ducourau, Conservateur of the Musée Bonnat, Bayonne as "visibles à la surface parfois en creux, parfois en relief" (personal communication). Those who dispute the authenticity of this drawing are in the minority.

20. De Vecchi, in Chastel et al., *The Sistine Chapel,* 182, curiously says that this drawing demonstrates a horizontal format that shows Michelangelo was "at first thinking in terms of the traditional tiers." He does not comment on the obvious circular arrangement of figures around Christ, and, in addition, only shows a portion (wider than it is tall) of the sheet. The actual dimensions of the sheet, according to the entry in the catalogue of the Musée Bonnat (no. 67), which are also quoted by De Vecchi (344 or 345 mm x 269 mm) clearly show the sheet to be taller than it is wide, which provides a completely different emphasis.

21. The so-called Lely drawing is questionable (catalogued in the Witt Library, London), as also is the sketch in the Courtauld Institute, for which see *Burlington Magazine* 18 (July 1976): fig. 118. See also Bernadine Barnes, "A Lost Modello for Michelangelo's *Last Judgment,*" *Master Drawings* 26 (1988): 239–48. For details of drawings relating to individual areas, see Tolnay, *Michelangelo,* vol. 5, figs. 132–47. It is interesting to note that there is a drawing of a Sun symbol or star set in a dome on the verso of one of the studies in the Musée Bonnat, Bayonne (no. 681 verso), referred to by Tolnay as an "unpublished astronomical drawing," 185 n. 174.

22. Condivi, *Life of Michelangelo,* 83–84, 87; Vasari, *Lives* (ed. de Vere, 1863–65; ed. Bull, 380–81).

23. Johannes Wilde, *Michelangelo: Six Lectures* (Oxford: Clarendon, 1978), 164.

24. Where figures were unusually positioned above Christ in earlier versions (e.g., figs. 36 and 41), they were angelic beings rather than the masses of humanity. The centrality of Michelangelo's Christ would be emphasized to viewers in the eastern or "lay" areas since the chapel screen (originally situated one bay nearer to the altar, figs. 3, 4) would normally obscure the lower part of the altar wall. If Christ had been positioned any lower, the intervening screen would have caused him to appear cut off to viewers in those areas. Seen from the rear of the chapel, the top of the screen lies just below the upper circular group. As the viewer moves toward the altar, Christ does appear cut off after the first bay, until he again becomes visible through the doorway of the screen. The original position of the screen closer to the altar would have lessened this type of cut-off effect.

25. As with the overlaid circles in fig. 51, the overlaid lines in the illustration serve simply to indicate the major areas of emphasis.

26. Vasari, *Lives* (ed. de Vere, 1855; ed. Bull, 349).

27. See *Encyclopaedia Britannica;* James George Frazer, *The Worship of Nature* (London: Macmillan, 1926), 1:608; Jurgis Baltrusaitis, "Quelques survivances de symboles solaires dans l'art du Moyen Age," *Gazette des Beaux Arts* 17 (1937): 75–82.

28. Edwin Hall and Horst Uhr, "*Aureola super Auream:* Crowns and Related Symbols in Late Gothic and Renaissance Iconography," *Art Bulletin* 67 (December 1985): 568–603. The presence of a circular halo of light, a nimbus or mandorla, in previous examples of the *Last Judgment* (as in figs. 33 and 36) is acknowledged (and even the fact that angelic figures were sometimes incorporated into this frame), but any idea that the circularity is derived simply from the mandorla or nimbus is an inadequate explanation of this major work.

29. Tolnay refers to these areas as representative of infinity (Tolnay, *Michelangelo,* 5:30), but Hartt later comments, "The airy background of the fresco of course should not be construed as infinity, the notion of infinite space occurred to no one in the 1530s"; Frederick Hartt, *Michelangelo* (New York: Abrams, 1964), 50. The inaccuracy of Hartt's comment is demonstrated clearly by the scientific literature; see, for example, Edward Grant, "Medieval and Seventeenth-Century Conceptions of an Infinite Void Space Beyond the Cosmos," *Isis* 60 (1969): 39–60, and Grant McColley, "Nicholas Copernicus and the

Infinite Universe," *Popular Astronomy* 44 (1936): 525–35. In 1277 an episcopal edict banned Aristotle's writings because he said the universe was *finite*.

30. The compositions of High Renaissance paintings were often based on geometrical figures, especially the triangle or pyramid (such as Leonardo da Vinci's *Virgin of the Rocks*, c. 1483–85). The format of Leonardo's *Adoration of the Magi*, 1481, is based on the interlocking triangle and semicircle and there is also a strong circular movement around the central figure of Christ. Mannerist painting favored less stable compositional structures, such as the oval or lozenge, but the use of a strictly circular format (as in Corregio's circular compositions at Parma, in the 1520s) was unusual.

31. See William M. Ivins, *Art and Geometry: A Study in Space Institutions* (New York: Dover, 1964), esp. chap. 6; Samuel Y. Edgerton, *The Renaissance Rediscovery of Linear Perspective* (New York: Basic Books, 1975); John White, *The Birth and Rebirth of Pictorial Space*, 3d ed. (London: Faber and Faber, 1987).

32. Especially in his architectural work; see James S. Ackermann, *The Architecture of Michelangelo* (Harmondsworth: Penguin, 1970): Caterina Pirina, "Michelangelo and the Music and Mathematics of His Time," *Art Bulletin* 67 (1985): 368–82. In particular the dome of Saint Peter's and the designs for the Campidoglio are evidently as much concerned with mathematics as aesthetics.

33. The curious number of angels in this group (11), which has been commented upon by Steinberg ("Corner of *Last Judgment*," 257) and others, is accounted for by the inclusion of the seven angels of the Apocalypse (Rev. 1:20 and chaps. 15–17), two angels holding the books of life and death (Revelation 12) and the Archangels Michael and Gabriel. Saint Michael, identifiable as the largest central angel, was a "chief actor in the scene of Judgment"; Mâle, *Gothic Image*, 376, and, of course, Michelangelo's own namesake.

34. Discussed by Steinberg, "Merciful Heresy," 53–54.

35. For Michelangelo as a colorist, see Chastel et al., *The Sistine Chapel*.

36. For the controversy concerning the cleaning of the Sistine ceiling, see James Beck, "The Final Layer: *L'ultima mano* on Michelangelo's Sistine Ceiling," *Art Bulletin* 70 (1988): 502–503; Caroline Elam, "Michelangelo and the Sistine ceiling," *Burlington Magazine* 132 (1990): 434–37; Frederick Hartt, "*L'ultima mano* on the Sistine ceiling," *Art Bulletin* 71 (1989): 508–509; and David Cast, "Finishing the Sistine," *Art Bulletin* 73 (1991): 669–84 where these and a number of other commentaries on the restorations are fully discussed. See also Marcia Hall, *The Sistine Ceiling Restored* (New York: Rizzoli International, 1993); and James Beck and Michael Daley, *Art Restoration: The Culture, the Business and the Scandal* (London: John Murray, 1993), esp. chap. 3, "The Sistine Chapel," 63–102.

37. As Murray, *Michelangelo, Life, Work and Times*, 233, points out, the Michelangelo *Bibliography* of 1927 by Ernst Steinmann and Rudolf Wittkower lists 2,107 items on the artist and his works, and the supplement up to 1970 by Leopold Dussler lists a further 2,220 items. However, the present study will concentrate on major interpretations of Michelangelo's *Last Judgment* and the most significant lines of argument, which will be assessed in this section. Space obviously does not allow, nor would it serve any purpose, to include a full discussion of all previous references to the work. Owing to the immense popularity of the work, a few nonspecialist and academic works on Michelangelo will also be considered as evidence of commonplace perceptions about the work.

38. See Goldscheider, *Michelangelo*, 20. Perhaps the manner of Paul III's election to the cardinalate (his sister was Pope Alexander VI Borgia's mistress) and his illegitimate children caused him to have a guilty conscience; Geoffrey R. Elton, *Reformation Europe, 1517–1559* (London: Fontana, 1971), 186–87, 253. The first reaction to the incomplete fresco, recorded by Vasari, was that of Biagio da Cesena, who objected to the nudity in the

work. As a result, Michelangelo supposedly gave his features to the figure of Minos in Hell;
Vasari, *Lives* (ed. de Vere, 1883; ed. Bull, 379).

39. Vasari, *Lives* (ed. de Vere, 1882–87; ed. Bull, 378–83); Condivi, *Life of Michelangelo,*
75–87.

40. Vasari, *Lives,* (ed. de Vere, 1884; ed. Bull, 380).

41. Condivi, Life of *Michelangelo,* 84–87; Vasari, *Lives* (ed. de Vere, 1884; ed. Bull,
380).

42. Condivi, Life of *Michelangelo,* 83–87; Vasari, *Lives,* (ed. de Vere, 1884–86; ed.
Bull, 380–81.).

43. Vasari, *Lives* (ed. de Vere, 1,884–85; ed. Bull, 380–81); Condivi, Life of
Michelangelo, 84 [emphases mine].

44. For details of these and other reproductions, see esp. Tolnay, *Michelangelo,* vol.
5, figs. 257–59; Steinberg, "Corner of *Last Judgment,*" figs. 13–16; André Chastel, *A
Chronicle of Italian Renaissance Painting* (New York: Hacker, 1983), 196–99; and Pietrangeli,
Michelangelo e la Sistina, 245, 254, 262.

45. Tolnay, *Michelangelo,* 5:126, who quotes Alois Riegl, *Die Enstehung der Barockkunst
in Rom* (1908).

46. For details and references see appendix 1, nos. 99–108 (Tintoretto's *Paradiso* is
listed as a *Last Judgment* by Réau, *Iconographie,* 756). For details and further examples, see
also Romeo de Maio, *Michelangelo e la Controriforma* (Rome: Laterza, 1978), plates 8–13;
and Otto Benesch, *The Art of the Renaissance in Northern Europe* (London: Phaidon, 1965),
145–61. De Maio includes several examples that are so close to Michelangelo's as to be
considered copies rather than as influenced by him.

47. For references to Porrino (sonnet for the unveiling of the *Last Judgment,* 1541), Nino
Sernini (letter to Cardinal Gonzaga, 19 November 1541), Martelli (letter to *Michelangelo,*
4 December 1541), and Anton Francesco Doni (letter to *Michelangelo,* 21 January 1543),
see Pastor, *History of the Popes,* 12:613–14, and Ettore Camesasca, *Michelangelo, Complete
Paintings* (London: Weidenfeld and Nicolson, 1966), 12.

48. For further details of Counter-Reformation objections to the fresco, see De Maio,
Michelangelo e la Controriforma, 17–45, 65–108, and Chastel, *Chronicle,* chap. 9.

49. Pitti (letter to Vasari, 1 May 1545) referred to "a thousand heresies"; Camesasca,
Complete Paintings, 12. Aretino's correspondence concerning the *Last Judgment* is reproduced
in Horst Woldemar Janson, ed., *Italian Art 1500–1600: Sources and Documents* (Englewood
Cliffs, N.J.: Prentice Hall, 1962), 56–59, 123–25, and discussed by Tolnay, *Michelangelo,*
5:46.

50. Aretino, letter to *Michelangelo,* dated 16 September 1537, quoted in Janson,
Sources and Documents, 57.

51. In November 1545, Aretino described the work as "an impiety of irreligion . . .
in the greatest temple built to God . . . things in front of which brothels would shut
their eyes"; Janson, *Sources and Documents,* 122–23. In view of Aretino's own notorious
licentiouness, this appears somewhat hypocritical. It also overlooks the fact that nudity
was not unusual in versions of the *Last Judgment,* although usually of the damned rather
than saved. See Murray, *Michelangelo, Life, Work and Times,* 159–62, for further comment
on this correspondence.

52. The writer of an anonymous letter to Pope Paul III attacked the fresco and accused
the artist of heresy and "Lutheran fantasies" in 1549; Pastor, *History of the Popes,* 12:616;
Murray, *Michelangelo, Life, Work and Times* , 165.

53. Tolnay, *Michelangelo,* 5:98. Later overpaintings may be determined by comparing
the work with the copy made by Venusti in 1549, fig. 64. See Redig de Campos, *Michelangelo,*
plates 62 and 65 for diagrammatic comparisons.

54. See Robert J. Clements, *The Poetry of Michelangelo* (London: Owen, 1966), 30;

and David Summers, *Michelangelo and the Language of Art* (Princeton: Princeton University Press, 1981), 9 and 19, for Michelangelo's reputation for the inclusion of hidden meanings in his works.

55. Aretino, letter to *Michelangelo,* dated November 1545 (cited by Janson, *Sources and Documents,* 122–24). See also Chastel, *Chronicle,* 195.

56. For the possible relationship between the fresco and the Counter-Reformation, see Redig de Campos, *Michelangelo,* 80–85, where it is argued that the pessimistic theme of judgment was directly concerned with the Counter-Reformation atmosphere. The fresco (completed by 1541) predates the period of the Counter-Reformation proper, which, at the earliest, can only be said to date from 1542 (inauguration of the Roman Inquisition) or 1545 (first session of the Council of Trent). For Counter-Reformation reaction to Michelangelo's fresco see also Murray, *Michelangelo, Life, Work and Times,* 165–67; Anthony Blunt, *Artistic Theory in Italy, 1450–1660* (Oxford: Oxford University Press, 1983), 112–13; Pastor, *History of the Popes,* 12:618. The fresco was discussed specifically in the third session of the Council of Trent (1563).

57. Lodovico Dolce, *Dialogo della Pittura,* quoted by Camesasca, *Michelangelo,* 13. Dolce also interestingly states, "only the scholars understand the profundity of the allegories which they [the nudes] conceal." See also Pastor, *History of the Popes,* 12:617.

58. For Gilio, *Due Dialogi and Errori dei Pittori,* 1564, see Tolnay, *Michelangelo,* 5:123–24; Murray, *Michelangelo, Life, Work and Times,* 165; Blunt, *Artistic Theory,* 112–14; and De Maio, *Michelangelo,* esp. chap. 1.

59. Gilio, *Trattato,* 1563, cited by Bernadine Barnes, *The Invention of Michelangelo's Last Judgment* (Ph.D. diss., University of Virginia, 1986), 101; Paleotti (1582) made the association with Apollo.

60. Murray, *Michelangelo, Life, Work and Times,* 164; Tolnay, *Michelangelo,* 5:123. Michelangelo's acquaintance with Doni is confirmed by a letter written to him by Doni in January 1543 (quoted by Murray, *Michelangelo, Life, Work and Times,* 164).

61. Vasari, *Lives* (ed. de Vere, 1904; ed. Bull, 402), tells how, on hearing that Pope Paul IV wished to alter the work, Michelangelo commented that the pope should first set the world to rights; to adjust the painting was a trivial matter. See also Murray, *Michelangelo, Life, Work and Times,* 166. In contrast to the attitude of members of the Roman Inquisition, the fresco was defended in 1573 by the Venetian Inquisition (Pastor, *History of the Popes,* 12:619).

62. For example, Vasari, *Lives* (ed. de Vere, 1,884; ed. Bull, 380), "His stern and terrible countenance." Of later writers, Venturi's reference to Christ's "menacing gesture" (Venturi, *Michelangelo,* 77) appears typical.

63. Condivi had already noted the duality of Christ's attitude, namely, that he "wrathfully damns the guilty but gently gathers the righteous"; Condivi, *Life of Michelangelo,* 84. See Tolnay, *Michelangelo,* 5:122–23; Steinberg, "Merciful Heresy," 49–50.

64. For details of this critical history, see summaries by Tolnay, *Michelangelo,* 5:123–27 and Camesasca, *Michelangelo,* 13.

65. Johann Joachim Winckelmann, "Essay on the Beautiful in Art" (1763), in David Irwin, ed., *Winckelmann's Writings on Art* (London: Phaidon, 1972), 44, 89–104.

66. B. C. Tollemache, ed., *Diderot's Thoughts on Art and Style* (New York: Burt Franklin, 1971, reprint of 1893 ed.), 62, 82, 96; Joshua Reynolds, *Discourses on Art,* ed. Robert R. Wark (New York: Collier, 1966), discourse 15 (1790), 242–48.

67. Goethe, *Italienische Reise* (1786), cited in Camesasca, *Michelangelo,* 13, and Enzo Carli, *All the Paintings of Michelangelo* (London: Oldbourne, 1963), 39.

68. For discussion of criticism by Stendhal and Delacroix, see Tolnay, *Michelangelo,* 5:124–25; also Stendhal, *Voyages en Italie,* (1829; Paris: Editions Gallimard, 1973), 1133–36.

69. Eugène Delacroix, *Revue de Paris* (1830) and "Sur le Jugement Dernier" in *Oeuvres Litteraires* (1837), for which see Tolnay, *Michelangelo,* 5:125.

70. Lenoir, "Observations sur le Genie de Michel Ange," *Annales Françaises des Arts* (1820): 124.

71. See Jacob Burckhardt, *Der Cicerone* (Leipzig: Seemann, 1893 ed.), 3:751–52; see also Burckhardt, *Civilization of the Renaissance in Italy,* 2 vols. (New York: Harper and Row, 1958), 1:172.

72. Heinrich Wölfflin, *Classic Art* (London: Phaidon, 1953), 197–98.

73. John Ruskin, *The Relations Between Michel Angelo and Tintoret* (London, 1872); see also Ruskin, *Diaries,* ed. Joan Evans and John Howard Whitehouse (Oxford: Clarendon Press, 1956), 3:797, 882.

74. John Addington Symonds, *Life of Michelangelo* (New York: Modern Library, 1892), 338–39. At about the same time, Pastor also referred to the circular design and the Apollo-like Christ; *History of the Popes* 12 (1912): 623 and 629.

75. Bernard Berenson, *The Italian Painters of the Renaissance* (London: Phaidon, reprint 1967), 72–77. Berenson, 76, regarded the *Last Judgment* as a "failure."

76. Ernst Steinmann, *Die Sixtinische Kapelle,* vol. 2 (Munich, 1905), discussed by Redig de Campos, *Michelangelo, Last Judgment,* 59. Henry Thode, *Michelangelo und das ende der Renaissance* (reprinted, Leipzig: Fischer and Wittig, 1962), 3:571.

77. Alois Riegl, *Die Enstehung der Barockkunst in Rom,* 1908, discussed by Tolnay, *Michelangelo,* 5:126.

78. Karl Justi, *Michelangelo* (Berlin, 1909). This and preceding references are quoted and discussed by Tolnay, *Michelangelo,* 5:126, and Redig de Campos, *Michelangelo,* 59–60.

79. Max Dvorak, *Geschichte der italienischen Kunst im Zeitalter der Renaissance,* 2 vols. (Munich, 1927–28), vol. 2; Venturi, *Storia,* 9:1, 865–66, cited by Tolnay, *Michelangelo,* 5:127.

80. Erwin Panofsky, "Michelangelo and Neoplatonism" in *Studies in Iconology* (New York: Harper and Row, 1972 ed.), 171–230, and in an unpublished lecture at the Institute of Fine Arts, New York University 1938, referred to by Steinberg, "Merciful Heresy," 61.

81. Blunt, *Artistic Theory,* chap. 5 on *Michelangelo,* esp. 65–66 and 121–23; Ludwig Goldscheider, *Michelangelo: Paintings, Sculpture, Architecture* (London: Phaidon, 1967), 19–20.

82. For the argued effect of the Sack of Rome on the artist and hence on the fresco, see Redig de Campos, *Michelangelo, Last Judgment,* 24–25; Murray, *Michelangelo, Life, Work and Times,* 158; and André Chastel, *Il Sacco di Roma* (Turin, 1983), cited also by De Vecchi in Chastel et al. *Sistine Chapel,* 181. The fresco is perceived as a symbolic representation of the catastrophic times.

83. Charles de Tolnay, "Le *Jugement Dernier* de Michel-Ange: Essai d'Interpretation," *Art Quarterly* 3 (1940): 125–46.

84. Tolnay, "Le *Jugement Dernier* de Michel-Ange," 144.

85. Tolnay, "Le *Jugement Dernier* de Michel-Ange," 142–43. He relates Pythagorean myths to more primitive ideas concerning the sidereal movement of Uranus, the Ixion myth, and Manicheism, claiming these as the source for the circular composition of the fresco.

86. Tolnay, "Le *Jugement Dernier* de Michel-Ange," 142–43 and 146 n. 29.

87. Tolnay, "Le *Jugement Dernier* de Michel-Ange," 142, "Le Christ est ici le centre d'un système solaire; autour de lui gravitent toutes les constellations dans l'espace infini de l'univers. Ce n'est pas fortuitement que, jeune, imberbe, . . . il est si semblable à Apollon."

88. R. Feldhusen and Miguel de Ferdinandy in unpublished theses, quoted and discussed by Tolnay, *Michelangelo,* 5:120 and 127; Von Einem, *Michelangelo,* 143–58, esp. where he refers to Christ as central and like Apollo (148) and to "cosmic drama"(158).

89. See Tolnay, *Michelangelo,* 5:49, 120–22.

90. Tolnay, *Michelangelo,* 5:38 and 47.

91. Tolnay, *Michelangelo,* 5:48–49.

92. Tolnay, *Michelangelo,* 5: 33–34: "Only the motifs of Charon and that of Minos seem to revert directly to Dante," he says, and "that there was no direct influence of the *Dies Irae* has recently been proved." Compare with Redig de Campos, *Michelangelo, Last Judgment,* 64–65, where Dante is included as a source.

93. Tolnay, *Michelangelo* (1975), 59–60.

94. Tolnay, *Michelangelo* (1975), 60. Compare Tolnay, *Michelangelo,* 5:47–49, and Tolnay, *"Jugement Dernier,"* 142–43. He does not give full explanation or sources for these influences he proposes, nor how they might have been available to Michelangelo.

95. Deoclecio Redig de Campos and Biagio Biagetti, *Giudizio Universale di Michelangelo* (Milan, 1944), cited in Redig de Campos, *Michelangelo, Last Judgment,* esp. chaps. 1 and 3.

96. Redig de Campos, *Michelangelo, Last Judgment,* 43: "The entire fresco swirls around Christ's gesture," and 75, where he emphasizes Christ's "golden ring of light" and a "vortex" around the Redeemer and another vortex further out.

97. Redig de Campos, *Michelangelo, Last Judgment,* 75–76 and 89 n. 4. For the Wheel of Fortune, see also Réau, *Iconographie,* 639–40; and Ernst Kitzinger, "World Map and Fortune's Wheel," in *The Art of Byzantium and the Medieval West* (Bloomington: Indiana University Press, 1976), 344–72, which demonstrates its cosmic overtones.

98. Kitzinger, *Art of Byzantium,* 46. Redig de Campos, 63, comments on Dante as a possible, but very limited source.

99. Redig de Campos, *Michelangelo, Last Judgment,* 77, and 89 n. 4.

100. Redig de Campos, *Michelangelo, Last Judgment,* 80–81.

101. Von Einem, *Michelangelo,* 147–54.

102. M. Saponaro, *Michelangelo* (Milan: Mondadori, 1955), 203–204; Wilde, *Michelangelo: Six Lectures,* 159–68; A. Allen, *The Story of Michelangelo* (London: Faber and Faber, 1953), 158; Charles Hill Morgan, *The Life of Michelangelo* (New York: Reynal, 1960), 195, 200.

103. Wilde, *Six Lectures,* 166. Goldscheider, *Michelangelo,* 20, comments on these levels, but he also refers to "inner" and "outer" circles.

104. For example, Allen, *Story of Michelangelo,* 158–59; Morgan, *Life of Michelangelo,* 195–96.

105. Carli, *All the Paintings,* 33; Rudolf Schott, *Michelangelo* (London: Thames and Hudson, 1963), 172–92, 248; Anthony Bertram, *Michelangelo* (New York: Dutton, 1964), 115–16; Hartt, *Michelangelo,* 50–51; Valerio Mariani, *Michelangelo the Painter* (New York: Abrams, 1964), 100–101. Mariani, 119, discusses Tolnay's ideas.

106. As in Schott, *Michelangelo,* 183 ("the infinity of the metacosmos opens out"); Bertram, *Michelangelo,* 115; Hartt, *Michelangelo,* 50–51.

107. Salvini, *Hidden Michelangelo,* 131–40, and Salvini, "Michelangelo the Painter," in Salmi, *Complete Works,* 223–24, 234.

108. See Salvini, "Michelangelo the Painter," 240–41 where he refers to Christ as "Apollonian" and to the fresco's "cosmic force"; and Salvini, *Hidden Michelangelo,* 123, "cosmic scale," and 135, "Apollonian Christ."

109. Salvini, *Hidden Michelangelo,* 137–38.

110. Barbara Bienkowska, ed., *The Scientific World of Copernicus* (Dordrecht: Reidel, 1973), 104: "The interpretations which say that the great fresco is a pictorial vision of heliocentrism might go a bit far."

111. Robert Coughlan, *The World of Michelangelo* (New York: Time-Life, 1960), 127.

112. Sidney J. Freedberg, *Painting in Italy, 1500–1600* (New York: Penguin, 1979), 469–73.

113. James Beck, *Italian Renaissance Painting* (New York: Harper and Row, 1981), 341–42. Commenting on the overall composition, he says, "the geometry is only approximate." For observations on the mannerist stylistic qualities in the work, see Elizabeth Rankin, "Laying a Myth: Notes on Michelangelo's *Last Judgment*," *De Arte* 24 (1980): 18–19.

114. Camesasca, *Michelangelo, Complete Paintings,* with an introduction by Leopold D. Ettlinger, 5–7 and 102–104.

115. Howard Hibbard, *Michelangelo: Painter, Sculptor, Architect* (London: Allen Lane, 1975), 246.

116. See Tolnay, *Michelangelo,* 5:47; John Furse, *Michelangelo and His Art* (London: Hamlyn, 1975), 82.

117. Camesasca, *Michelangelo,* 102; Beck, *Italian Renaissance Painting,* 341–42; Hibbard, *Michelangelo,* 242–45.

118. See Robert J. Clements, *Michelangelo's Theory of Art* (New York: Gramercy, 1961); Clements, *The Poetry of Michelangelo* (London: Peter Owen, 1966). David Summers, *Michelangelo and the Language of Art* (Princeton: Princeton University Press, 1981), 9, 243, is especially important for Michelangelo's intellectual background.

119. Ramsden, *Letters of Michelangelo,* vol. 2, nos. 199, 202, 209, 210 (letters concerning the *Last Judgment*).

120. Linda Murray, *Michelangelo* (London: Thames and Hudson, 1980; reprinted 1990), 139–40 and 145; and Murray, *Michelangelo, Life, Work and Times,* 154–67, 183.

121. Steinberg, "Merciful Heresy," 49.

122. Steinberg, "Merciful Heresy," 49: "Christ is situated, sunlike, Copernican . . . ," he writes, which, in this context, infers that Copernicus' theory was unacceptable to the Roman Church at this time. Tolnay had also referred to "the heliocentrism which was rejected by the official theology of the sixteenth century"; Tolnay, *Michelangelo,* 5:122.

123. Leo Steinberg, "A Corner of the *Last Judgment*," *Daedalus* 109 (1980): 207–73; and Leo Steinberg, "The Line of Fate in Michelangelo's Painting," in W. J. T. Mitchell, ed., *The Language of Images* (Chicago: University of Chicago Press, 1980): 85–128. He still refers to the fresco as "cosmic" (109).

124. Steinberg, "A Corner of the *Last Judgment*" 237–38, and Steinberg, "Line of Fate," 105–106. He comments in particular on a diagonal he sees as extending from the Crown of Thorns to the genitalia of Minos, and also here develops his discussion of the significance of Michelangelo's self-portrait in the "flayed skin."

125. See Steinberg, "Corner of the *Last Judgment*," plates 7 and 9. Steinberg appears to have seriously underestimated the theological symbolic significance of the thigh.

126. For example, his interpretation of the *Last Judgment* is discussed by Marcia Hall, "Michelangelo's *Last Judgment:* Resurrection of the Body and Predestination," *Art Bulletin* 58 (March 1976): 85–92, and Frederick Hartt, *Italian Renaissance Art,* rev. ed. (London: Thames and Hudson, 1987), 642. Other controversial works on Michelangelo by Steinberg include "Michelangelo's Florentine *Pietà*: The Missing Leg," *Art Bulletin* 50 (March 1968): 343–59; *Michelangelo's Last Paintings* (Oxford: Phaidon, 1975); "Michelangelo's Florentine *Pietà*: The Missing Leg Twenty Years After," *Art Bulletin* 71 (September 1989): 480–505.

127. Paul III instigated the commission for the Pauline Chapel frescoes in mid-November 1541: he appointed a special salaried superintendent for the preservation of the Sistine and Pauline frescoes in October 1543, recognizing already the difficulties of dust and smoke damage from candles. The post was retained by successive popes, even Pope Paul IV Carafa, continuously until 1737; Pastor, *History of the Popes,* 12:615, 631; Tolnay, *Michelangelo,* 5:99.

128. Hall, "Michelangelo's *Last Judgment*," 85–92. Compare Tolnay, *Michelangelo,* 5:19–20, 99–100.

129. Hall, "Michelangelo's *Last Judgment*," 92.

130. Hall, "Michelangelo's *Last Judgment*," 88. The reference to "the most emphatically corporeal figures he had ever created" appears to discount the flayed skin.

131. For information on the *Spirituali* and Michelangelo's affinity with that group, see Tolnay, *Michelangelo,* 5, chap. 3, 51–69.

132. For Ficino (1433–99) see Paul Oskar Kristeller, *The Philosophy of Marsilio Ficino,* trans. Virginia Conant (New York: Columbia University Press, 1943).

133. Attempts to distinguish and separate Neoplatonic and Christian influences in Michelangelo's work are common, for example, Liebert, *Psychoanalytic Study,* 312.

134. Hall, "Michelangelo's *Last Judgment*," 92. It seems unlikely that the Venetian envoy would be in possession of such subtle inside information.

135. De Maio, *Michelangelo e la Controriforma,* esp. chaps. 1 and 2.

136. Robert S. Liebert, *Michelangelo: A Psychoanalytic Study of his Life and Work* (New Haven: Yale University Press, 1983), esp. chap. 18. Liebert's theories have been sharply criticized by E. H. Ramsden, "Michelangelo and the Psychoanalysts," *Apollo* 120 (October 1984): 290; and Leo Steinberg, "Shrinking *Michelangelo,*" *New York Review of Books* (28 June 1984): 41–45.

137. See also Jerome D. Oremland, *Michelangelo's Sistine Ceiling* (Madison: International University Press, 1989), 115, who curiously writes on the religious iconography: "The Jesus myth contains a basic emphasis on preoedipal attachment to an autoinseminated mother that is crucial to understanding Michelangelo's creativity." Ramsden, "Michelangelo and the Psychoanalysts," 290; Murray, *Michelangelo, Life, Work and Times,* 155; and Hartt, *Michelangelo,* 16, are among those who criticize this approach to the interpretation of deeper meaning in Michelangelo's work, which is based on "the regrettable controversy over Michelangelo's sex life."

138. Liebert, *Psychonanalytic Study,* chap. 18.

139. Nathan Leites, *Art and Life, Aspects of Michelangelo* (New York: New York University Press, 1986). Similarly Richard and Editha Sterba, "The Personality of Michelangelo Buonarroti: Some Reflections," *American Imago* 35 (1978): 156–77; and Rona Goffen, "Renaissance Dreams," *Renaissance Quarterly* 40 (1987): 682–706.

140. John W. Dixon, "Michelangelo's *Last Judgment:* Drama of *Judgment* or Drama of Redemption?" *Studies in Iconography* 9 (1983): 67–82; and Dixon, "Christology," 514–27. He discusses the Apollo-Christ and the cosmic qualities, but is one of the few to question the circularity of the composition.

141. Barnes, *Invention of Michelangelo's Last Judgment,* esp. 221–30 and chap. 5 (for Dante).

142. Bernard Lamarche-Vadel, *Michelangelo* (Paris: Nouvelles Editions Françaises, 1986), English translation, Anni Gandon Hemingway and Patricia Allen-Browne (Secaucus, N.J.: Chartwell Books, 1986), 136–37, where he refers to "concentric circles" and briefly also to heliocentricity.

143. Chastel et al., *The Sistine Chapel: Michelangelo Rediscovered,* includes relevant articles by different authors on the chapel in general, the ceiling frescoes, the *Last Judgment,* and the restorations.

144. Jack M. Greenstein, " 'How Glorious the Second Coming of Christ': Michelangelo's *Last Judgment* and the Transfiguration," *Artibus et Historiae* 20 (1989): 33–57. A preliminary summary of the present findings was also published about this time; Valerie Shrimplin, "Sun-symbolism and Cosmology in Michelangelo's *Last Judgment,*" *Sixteenth Century Journal* 21 (1990): 607–43.

145. Recent major articles concerned with Michelangelo's works (but not specifically the *Last Judgment*) include John T. Paoletti, "Michelangelo's Masks," *Art Bulletin* 74 (September 1992): 423–40; Leo Steinberg, "Who's Who in Michelangelo's Creation of Adam," *Art Bulletin* 74 (December 1992): 552–66; Andrew Morrogh, "The Magnifici Tomb: A Key

Project in Michelangelo's Architectural Career," *Art Bulletin* 74 (December 1992): 567–98. Other recent works on Michelangelo by Antonio Paolucci, William E. Wallace, Paul Barolsky, and Creighton Gilbert are reviewed together in *Art Bulletin* 76 (December 1995): 683–85. The collection by William E. Wallace, ed., *Michelangelo: Selected Scholarship in English*, 5 vols. (New York: Garland, 1995), is invaluable in providing easy access to various papers on the artist.

146. *Times*, 26 November 1993, 17. The decision was made to leave those draperies added by Daniele da Volterra, as being an essential part of the tradition, but to remove some of those added later. It was confirmed here that the draperies of Christ and the Virgin were quite definitely original work by Michelangelo himself.

147. Waldemar Januszczak, *Sayonara Michelangelo: The Sistine Chapel Restored and Repackaged* (London: Bloomsbury, 1990).

148. Januszczak, *Sayonara Michelangelo,* 33, 147.

149. Januszczak, *Sayonara Michelangelo,* 156–58. He goes on to talk about Dante and Neoplatonism as sources.

150. Alexander Perrig, *Michelangelo's Drawings: The Science of Attribution* (New Haven: Yale University Press, 1991). Perrig's theories have been seriously questioned by, among others, Martin Kemp and David Ekserdjian; see, *Times*, 6 July 1991.

151. Robin Richmond, *Michelangelo and the Creation of the Sistine* (London: Barrie and Jenkins, 1992; reprinted 1993), 130.

152. Pierluigi de Vecchi, *Michelangelo,* trans. A. Campbell (London: Barrie and Jenkins, 1992), 120.

153. Marc Le Bot, *Michelangelo*, trans. M. H. Agueros (Vaduz, Liechtenstein: Bonfini Press, 1992), 64.

154. Le Bot, *Michelangelo*, 68: he continues, "since one proposed a new form of gravitational astronomy centred on the sun, and the other, a view of man's body as if it were carried away by the stormy winds of fate."

155. Ken Shulman, "Waiting for the *Last Judgment*," *Art News* 92 (December 1993): 100–107; George Bull, *Michelangelo: A Biography* (Harmondsworth: Penguin, 1995), where the present work is cited; Pierluigi de Vecchi and Gianluigi Colalucci, *Michelangelo: The Vatican Frescoes* (New York: Abbeville Press, 1996). The continuing proliferation of short popular works (including newspaper and magazine articles, not to mention television and video) on the restored frescoes at this time should also be borne in mind but does not require detailed analysis.

Chapter 5

Religious Sources

I am the light of the world; he that followeth me shall
not walk in the darkness but shall have the light of life.
—John 8:12

Christian Light Symbolism

Biblical mysteries have from the beginning been explained by metaphors
of light. From the first chapter of the Genesis, attention is drawn to the
significance of light in a symbolic manner, for, on the first day of the
Creation, God said "Let there be light. And there was light. And God saw
the light that it was good" (Gen. 1:3–4). In the earliest books of the Old
Testament, the analogy with light is thus used to explain the meaning of
God and his creation,[1] and light is a scriptural symbol for all that is good
and true—for the knowledge of God himself.[2] Following from this, in
the New Testament the metaphor is expanded to include a direct analogy
with Christ, who is presented as the Light of the World. This concept is
greatly emphasized, particularly in the Gospel of Saint John, the so-called
Gospel of Light.[3] Throughout this book of the New Testament, light is
continuously given strong allegorical meaning, for example, in John 1:4–9;
3:19; 8:12 (quoted above); 9:5; and 12:35, 36, 46. In chapter 3, as part of
Christ's teaching to Nicodemus, the discussion moves swiftly from the use
of light metaphor to judgment (v. 19), and again at 8:12–16 and 12:46–47,
where Christ states: "I am come a light into the world, that whosoever
believeth on me should not abide in darkness . . . for I came not to judge
the world, but to save the world" (compare 3:17 and 8:15). As Dodd
points out, in linking the light metaphor with the judgment of humanity,
Saint John emphasizes the saving nature of the Second Coming as much

as the negative and destructive apocalyptic interpretation of judgment.[4] In turn, stemming from this scriptural identity between Christ and light, is the direct analogy between Christ and the sun itself.

The astronomical feature of the sun was the prime object of reverence, worship, and adoration for a major portion of the early populations of this earth.[5] The view of the sun as deity—being the source of light and warmth, and hence of human, animal, and plant life—is one of the most ancient manifestations of religious sensitivity, and the notion of sun-worship has existed since earliest recorded times. Possibly originating in the Orient,[6] the concept spread to the Mediterranean basin whence it proliferated across Europe. In these areas, Sumerians, Phoenicians, Assyrians, Egyptians, Greeks, and Romans were all involved, to varying degrees, with the idea of paying reverence and obeisance to the sun,[7] and in many instances the personification of the sun as a specific deity was maintained. In the Mediterranean basin, the cult reached its height when it became centered on the Graeco-Roman sun god, Apollo, whose popularity was immense. Son of Zeus and Leto, and equated with Helios the sun god, Apollo was a symbol of light and representative of the sun to both Greeks and Romans.[8] A powerful figure, he could act as a vengeful destroyer but was also protective against evil, in the same way, perhaps, as the sun itself. His links with Asclepius, the god of healing, make him a suitable candidate eventually to bear comparison with the Christian deity. His strength and youthful appearance also seem appropriate in the analogy between the ancient form of the sun-deity and the Christian Son of God. Thus the eventual synthesis of pagan and Christian in the adaptation of visual forms of the sun god for the Christian deity seemed more than plausible.[9]

In looking afresh at Michelangelo's possible sources for sun symbolism, such ancient tradition appears relevant, not in all its varied forms, but only inasmuch as these basic ideas were eventually to become incorporated into Christian dogma. The analogy between the pagan sun god and Christ himself appears to be related to the early scriptural tendency to identify the coming Messiah with the sun,[10] a tradition that predates many of the later sun-worshipping cults such as the Roman or Mithraic. The specific identity between the sun and the deity of the Judaeo-Christian religion is already emphasized in the Old Testament. The Psalms are noted for their light symbolism in general, as at 27:1 ("The Lord is my light and my salvation"); 36:9; 37:6; 43:3; 97:11; 118:27 ("God is the Lord who has shown us light"); and 119:105. Specific metaphorical references to the sun itself are also to be found, for example, Ps. 74:16 ("thou hast prepared the light and the sun"), and an even more specific comparison, 84:11 ("For the Lord God is a sun and a shield"). These provide very positive evidence of the comparison made with the deity.

The direct analogy between the Messiah and the astronomical feature of the sun in the Old Testament is founded on the biblical reference

in Mal. 4:2, where the coming of the Messiah on the Day of Judgment (significantly corresponding to Michelangelo's fresco) is described: "But unto you that fear my name shall the Sun of righteousness arise with healing in his wings."[11] This comparison between the Messiah and the sun itself is carried over into the New Testament, as Saint Matthew describes Christ at the Transfiguration (Matt. 17:2) when his face "did shine as the sun." Throughout the gospels of the New Testament, references to Christ as the sun, the bringer or giver of light (meaning well-being or knowledge of God) are numerous. The Gospel of Saint John, which has recently been argued as of especial interest for Michelangelo,[12] contains perhaps the most instances of the use of the light metaphor,[13] but references are also to be found in Acts 9:3, 26:23; 2 Cor. 4:6; and 2 Tim. 1:10. The more precise comparison between Christ and the sun is used on several occasions in the Revelation of Saint John the Divine, where the idea of Christ as the sun at the time of the vision of the Day of Judgment is continued. The emphasis of the sun-analogy here seems highly significant for Michelangelo's portrayal of Christ.[14] In Rev. 1:16, the "judge" is described: "and his countenance was as the sun shineth in his strength," which may be viewed as corresponding with Michelangelo's view of Christ in the fresco. This may also be compared with Rev. 10:1 ("and his face was as it were the sun") and 21:23 ("the city had no need of the sun . . . the Lamb is the light thereof"). Like the Old Testament reference in Mal. 4:2, this concept of Christ as judge being depicted as the sun at the very moment of judgment appears to relate directly to Michelangelo's interpretation of the figure.

Christianity evidently took account of the ancient solar mysticism and beliefs of the various peoples it aimed to convert, and many aspects of Christian tradition are related to former pagan custom. Apart from the appropriateness of the analogy between Christ and the sun god, there also exist broader cosmological implications. For example, the adoption of the pagan festival of the winter solstice for the celebration of Christ's birth seemed appropriate in the absence of scriptural evidence for the precise date. It seemed apt for the Savior to be born at the time when the sun begins to gain in ascendancy, to bring new life to the "dead" world.[15] The Catholic liturgical texts for Advent and Christmas amply reflect this continuing tradition: at vespers of the eve of this "Sun" day there is sung, "When Heaven's sun has arisen, ye shall see the King of Kings coming forth,"[16] and light symbolism is strongly emphasized in the masses for midnight, dawn, and Christmas day: "This day shall a light shine on us."[17]

Similarly, the concept of "resurrection" appears appropriate to the time of the spring equinox (Easter).[18] This relationship was linked, in turn, to the actual days of the week, especially the choice of the sun's day for the Sabbath; Christ was crucified and the sun was darkened on the day before Saturn's day (Saturday) and appeared resurrected on that day dedicated to

Helios (Sunday). The Christian emphasis on the day of Helios even caused the Early Christians to be regarded as a species of sun-worshippers.[19] In sum, as Rahner writes, "to this allegorical way of thinking, the whole life of Jesus, right up to his death and resurrection, is one great Sun mystery."[20]

The types of associations between sun-worship and early Christianity that have been considered are of special significance for the present discussion because of a direct relevance for the design of Saint Peter's in Rome. Special interest in the sun symbol as a means for the transition from paganism to Christianity was shown by Emperor Constantine, who legalized Christianity in 313 (Edict of Milan) but long retained his early devotion to the god *Sol Invictus*. Constantine's great interest in sun-worship has been documented,[21] and it is even given as the reason for the reverse orientation of the first Basilica of Saint Peter's and hence the Renaissance Church and the Sistine Chapel itself (fig. 70). Lees-Milne shows how Constantine's remaining concern for sun-worship caused him to have the Basilica built so that the rays of the rising sun could be viewed from the main entrance of the Basilica, and would fall on the celebrant at the high altar during the mass.[22] This orientation was retained during the Renaissance rebuilding and the Sistine chapel was naturally oriented the same way. So the unusual western altar wall, where Michelangelo's *Last Judgment* is painted, is in fact historically related to a sun-deity analogy.

The emphasis on the Early Christian analogy between Christ and the sun continued into the medieval and Renaissance periods and was also further reinforced by the subsequent writings of the Church Fathers, especially Saint Augustine (354–430).[23] The writings of Saint

70 Detail from a plan of the Vatican area, showing orientation of Saint Peter's and the Sistine Chapel.

Augustine, Bishop of Hippo, exerted enormous influence in formulating major problems of Christian philosophy and indicating their general solutions. The main sources for his teaching lay in the Bible, and many Augustinian concepts were based on standard Christian scriptural and doctrinal exegesis; but his interpretations were also guided by the tenets of Neoplatonic philosophy.[24] One of the most important themes chosen by Augustine for discussion was his interpretation of the light symbolism in the Bible, which he explained and expanded, embracing at the same time the significant analogy between Christ and the sun.[25] For example, he sums up at one point, in describing Christ, "The only begotten Son of God, who in many places in Holy Scripture is allegorically termed the sun. . . ."[26] Other references to light symbolism and the Sun-Christ analogy are to be found in Augustine's *City of God*, the *Confessions*, and his treatises on *The Magnitude of the Soul* and *The Immortality of the Soul*.[27] This symbolism also proved useful during discussion of the relationship between God the Father and God the Son, which was a major point of controversy up to medieval times.[28] The sun metaphor was used by Saint Augustine to demonstrate how, just as light issues from the sun without taking anything away from it, Christ the Son issued from God the Father without taking anything away from the former.[29] The original source was not diminished; and, according to Saint Augustine, just as the sun and its rays of light are separate yet one, so also is Christ one and the same thing with the Father.

Another important theme emphasized in the writings of Saint Augustine that appears highly significant for a cosmological discussion of the circular design of Michelangelo's *Last Judgment* fresco is Augustine's theory of beauty based on geometric regularity. Again, origins are to be found in Augustine's Neoplatonism for his theory of the circle in relation to cosmic order. Aware of the Platonic concept of order and geometry in the universe, Augustine maintained that the most beautiful figure of all is the circle, perfect and eternal: "The circle, because of its equality surpasses all other plane figures . . . what else is the regulator of this symmetry than the point placed in the centre? . . . Much can be said of the function of the point."[30] Augustine's view of the symbolism of the circle seems to relate to the cosmological concepts in which the image of the universe is shown to act as a basis for ecclesiastical architectural designs.[31]

The writings of Augustine may serve as a prime example of this type of thinking in Christian doctrine and also as evidence of the currency of such ideas in the sixteenth century, since his writings on Christian dogma received increasing attention in Renaissance Italy during a marked Augustinian revival. Discussion of such subjects was connected with the clarification of Catholic doctrine and reform at that time.[32] In addition, the influence of Augustinian thought specifically on Michelangelo has been much discussed,[33] so the artist could easily have been aware of such

metaphors and symbolic discussion, and used them intentionally in the same way.

One of the major instigators of the revival of Augustinian thought in the sixteenth century was Egidio, Bishop of Viterbo (1469–1533), who was a leading authority on doctrinal issues and reform.[34] Egidio played a major part in the clarification of theological doctrines in the early sixteenth century, and he, too, focused on the light/sun metaphor. According to authors like Wind and Dotson,[35] Egidio da Viterbo's interpretation of Augustine holds the key to highly important aspects of Renaissance theology. Further, Wind maintains that Egidio's interpretation of Augustine underlay the meaning of the program of Michelangelo's Sistine ceiling frescoes,[36] and Dotson's more recent analysis of the Sistine Chapel ceiling clearly demonstrates its Augustinian content.[37] The common identification of Christ with the sun, which was firmly established by Augustine, was supplemented on the Sistine ceiling, Dotson argues, with Neoplatonic concepts related to Egidio da Viterbo's Neoplatonic interpretation of Augustine, and based on Plato's use of the sun as allegorical for the Divine Mind or World-Soul.[38] According to Dotson, the *Separation of Light from Dark* on the ceiling panel has the figurative meaning of the *Last Judgment*, and the representation of the sun in the ceiling panels, especially in the *Creation of the Sun,* is to be regarded as a symbol of the Son of God and as an allegorical reference to the appearance of Christ in glory at the time of judgment.[39] This being so, it seems highly probable that Michelangelo could have been influenced by the same line of thought when he was working on the fresco for the end wall of the chapel. This reading may also suggest another link between the iconography of ceiling and end wall, apart from the idea of a repetition of Christ as sun symbol. In this interpretation, the depiction of the separation of light from dark on the first day on the ceiling immediately above the altar seems to fit in quite logically with the reading of the Last Day (*Last Judgment*) below on the altar wall, where the saved are separated from the damned. While the iconographical scheme of the chapel as a whole has been the subject of much discussion and dispute,[40] the symbolism of Christ as a cosmic light or sun on both first and last days—the beginning and the end—may also be understood to link these two schemes on the ceiling and altar wall.[41]

Michelangelo and the Catholic Revival of Early Christian Ideas

During the sixteenth century, Egidio of Viterbo was by no means alone in reviving the light symbolism that had been common in Early Christian doctrine and the writings of Augustine. As part of the movement for reform

within the Catholic Church, the idea of restoring the basic concepts of early Christianity, in the simple and sincere forms of the early Christian Church, was one that was adhered to by many sixteenth-century reformers, both Catholic and Protestant.[42] Michelangelo's association with Catholic reformers in the 1530s and 1540s is well known. The fact of Michelangelo's involvement, to some degree at least, with the Catholic Reformation has received much comment in the literature but needs to be reemphasized at this point. It has been widely discussed in connection with many of his late works and in particular with the *Last Judgment*. Tolnay dwells at length on the idea, as does Redig de Campos; Clements seeks evidence for Michelangelo's interest in reformist ideas, especially in his poetry.[43] De Maio's important work assesses Michelangelo's thinking in the historical context of the Counter-Reformation, and other writers like Salmi, Salvini, Hibbard, Murray, Liebert, and von Einem also dwell extensively on Michelangelo's connections with the group of Catholic Reformers known as the *Spirituali,* which became centered in the town of Viterbo.[44] The *Spirituali*[45] included such well-known figures as Pole (1500–58), Morone (1509–80), and Contarini (1483–1542), who were made cardinals by Pope Paul III in 1535–36, and Bernardo Ochino (1487–1565), leader of the austere Capuchin order of Franciscans.[46] Michelangelo's connections with this group have been traced largely through his association with Vittoria Colonna,[47] with whom he was aquainted by at least early 1536.[48] Both Redig de Campos and Tolnay have emphasized the influence of Vittoria Colonna and the *Spirituali* on the iconography of the *Last Judgment*,[49] although von Einem and Salvini maintain that Michelangelo did not know her, or the circle of Reformers, during the planning stage of the fresco.[50] Although decisions on the basic disposition of the fresco must have taken place earlier, the actual painting did not commence until the summer of 1536, so it is possible to argue some influence of the Catholic reformers, through Vittoria Colonna, on the work. In addition, it should be stressed that Michelangelo's links with this group were not solely dependent on Vittoria Colonna during the 1530s, since Michelangelo's association with other members of the Catholic Reform movement is also confirmed. The attempt to revive Christianity had been going on for some time. Egidio of Viterbo and even Savonarola, who have been argued as influential on Michelangelo, are often regarded as forerunners of the *Spirituali*.[51] The leading figures of Pole and Contarini were at the papal court and close advisers to Paul III from 1534, and Michelangelo's specific association with such members of the intellectual aristocracy was been recorded by contemporaries like Vasari, Condivi, and Francisco de Holanda.[52] Furthermore, the Spanish reformer Juan Valdés, on whose writings much of the thought of the *Spirituali* was founded, became private secretary to Clement VII until the latter's death in 1534.[53] Well before the commencement of the painting of the *Last Judgment*, Michelangelo would

thus have been exposed to the ideas of many of these Catholic reformers, who tried to return to the Bible and the Fathers of the Church and, by reviving Christianity in its early and pure forms,[54] to prevent schism in Reformation Europe. His knowledge of this circle was not dependent solely upon his relationship with Vittoria Colonna.

It is also significant that members of the *Spirituali*, with whom Michelangelo was associated from the 1530s, were not regarded as heretics and schismatics at this time.[55] Up to his death in 1534, Clement VII had given some support to the aims and ideas of the reformers, and he was close to Vittoria Colonna.[56] The group was also in contact with Pope Paul III (1534–49) and worked for renewal of the church with that pope's support. He appointed several reformers to the cardinalate in 1535–36 with their reforms in mind, and confirmed the Capuchin order at the same time.[57] In 1537, these cardinals were included in the commission to draw up the important report, *Consilium de Emendanda Ecclesia*, the declared aim of which was to reform the church and prevent heresy.[58] Through the signatories of the *Consilium*, reform in the 1530s was thus linked to the higher reaches of the Catholic Church. This phase of the Catholic Reformation should be distinguished from the later, militant phase of the Counter-Reformation. During the 1530s and the early 1540s, this moderate, reforming group undoubtedly had a great deal of influence in the Vatican; but the situation altered somewhat around 1542, when the period of toleration ended. Contributing factors were the deaths of Valdés (1541) and Contarini (1542), Ochino's apostasy (1542), and the revival of the Roman Inquisition (1542). At this time, many adherents of Italian Evangelism were forced to become more secretive (like Nicodemus in the Gospel of John, chap. 3). They became accused of heresy after 1541–42, and were pursued by militants like Cardinal Carafa. Known as Nicodemites, who outwardly conformed in spite of their sympathies with spiritual reform, the group increasingly flourished during the 1540s and even 50s, but the changed atmosphere that resulted from the fear of persecution postdated the completion of Michelangelo's *Last Judgment* fresco in October 1541.[59]

The main doctrinal interests of the reforming Italian Evangelical movement in the 1530s are outlined by E-M. Jung.[60] Among these were a preoccupation with the question of salvation through Christ's sacrifice, lack of confidence in the efficacy of good works alone, and an emphasis on the supremacy of faith. The most important emphasis of this Catholic Reform movement lay on an intense spirituality,[61] which is why these reformers became known as the *Spirituali*. Perhaps the major point at issue between the various reformers was the question of justification by faith; namely, whether salvation is dependent on good works or on faith and spiritual belief. This is a theme that has been argued, by Steinberg and others, as being expressed in Michelangelo's fresco.[62] It has been suggested

that the possible inclusion of veiled references to justification by faith in the *Last Judgment* was heretical, in spite of the fact that the Council of Trent did not condemn the doctrine until 1547.[63] In contrast to Steinberg, Hall's discussion of the *Last Judgment* argues for a position on Michelangelo's part that was in line with the stance taken by the church at the time of the commission, clearly demonstrating the official and accepted role of the Catholic Reformers in the late 1530s and early 1540s.[64]

Many of the ideas of the Italian group of reformers were related to the writings of the Spanish reformer Valdés.[65] Apart from the doctrinal tenets outlined above, one of the major themes stressed in Valdés' thought was that of Christ as the light of the world. In fact, because of the emphasis on light symbolism of Valdés and his followers, the Valdésians[66] were also known, significantly, as the Illuminists, and their doctrine as Illuminism.[67] The influence of this type of thought on Michelangelo in the formation of his view of the Sun-Christ of the *Last Judgment* should not be underestimated. Valdés' common use of light symbolism extended to the use in his writings of a direct sun metaphor, which is discussed by Nieto in his study of Valdés' works.[68] Concentrating on the biblical explanations of spiritual light and the analogy between God and light, Valdés frequently used a direct metaphor more specifically alluding to God as the sun. He describes the way in which the spirit of God illuminates man like the rays of the sun.[69] In the *Considerationes* (c. 1535–36), Valdés describes the Christian who is like a traveler walking by night until the sun has risen to show him the way.[70]

Similar themes were expressed in other popular religious writings of this period, which aroused interest among the Catholic reformer; for example, the so-called Gospel of Nicodemus,[71] which could have been a source for Michelangelo's thought from the 1530s.[72] Sun-symbolism is used in the Gospel of Nicodemus as an allegory for Christ and in particular relation to the enlightenment of humanity at the time of the Last Judgment.[73] Another key work of the Catholic Reformation was the *Trattato Utilissimo del Beneficio di Iesu Cristo Crocifisso*.[74] Its precise date of writing is unknown, but the second edition was printed in 1543 and ran to more than forty thousand copies, according to a contemporary source.[75] It was therefore probably in preparation during the late 1530s and, although possibly not available in printed form prior to the painting of the *Last Judgment*, it is a reflection of the main ideas of the Catholic Reformers that were circulating at the time. The work was probably written by the Benedictine monk, Benedetto da Mantua, and revised by Pole's colleague, Flaminio.[76] The *Beneficio di Cristo* was immensely popular as an expression of current ideas, especially in its major theme of the desire to return to the biblical Christianity of the Early Church.[77] The issue of justification by faith received major emphasis, and here the Gospel of John is stressed, especially chapter 3, Christ's teaching to Nicodemus concerning judgment,

death, and salvation of the spirit.[78] References to light symbolism in the explanations of divine power demonstrate the wide use of this type of Christian analogy.[79]

Michelangelo and Early Christian Iconography

The importance of the established analogy between Christ and the sun and the revival of this symbolism among the Catholic reformers of the sixteenth century demonstrates clearly that such concepts were current, if not commonplace, in theological exegesis at the time of Michelangelo's conception of the *Last Judgment*. This was also arguably linked to the generally expressed wish to return to the pure form of Christianity of the Early Christians. The depiction in art of Christ in the allegorical role of the sun or light was of course not new. The iconography of Christ as symbolic of light, and in the guise of a sun symbol related to the form used for the pagan sun god Apollo, was part of a strong artistic tradition that had existed parallel to theological discussions. Christ's depiction in Late Antique art as a beardless Apollonian-type of sun god is well known,[80] and Michelangelo's Sun-Christ perhaps forms the culmination of a visual tradition that was formulated at the very beginning of the Early Christian period.[81] The athletic, youthful, and beardless Apollo-type Christ, far from being a new invention in art or "a Christ unknown to the faithful," as Steinberg suggests,[82] was an iconographic type that was extremely popular in Early Christian times and of which many examples survives. It may be argued that Michelangelo's interest in the Catholic reformers' attempts to revive the ideas of Early Christianity, based on the Scriptures, could have caused him to reconsider also the Early Christian artistic tradition and, in particular, that which linked Christ with the sun-god type. Further, it was not necessary for Michelangelo to seek out Late Antique Christian sources directly because, as will be demonstrated, the form had not altogether died out.

The wide use of the halo, or in the case of Christ a full mandorla, is also linked to the idea of light symbolism as the knowledge of God.[83] The mandorla that often surrounds Christ in versions of the *Last Judgment* is a reference to his role as the Light of the World, but this hardly seems to be, by itself, sufficient explanation for the sun-like golden aura behind Michelangelo's youthful, beardless Apollo-type Christ (fig. 53). That Michelangelo's use of the beardless Christ has connections with the type of Early Christian iconography that analogized Christ to the sun appears to be far more likely in the context of Michelangelo's known associations with the Catholic Reformation.

In the early days of the Christian religion, visual reinforcement of the Scriptures appeared necessary to convince pagans used to idolatry.

The similarities between early depictions of the incarnate Christian God and Late Antique versions of the Roman sun god Apollo are evidently not coincidental but rather associated with an intent to gain converts.[84] It was a short step from the scriptural and literary analogy between Christ and solar themes to the formation of a more specific visual analogy between Christ and the actual accepted form of the pagan sun god, Apollo or Helios. As in the written sources, the visual image of the pagan sun god Apollo was thus adopted for the image of Christ, and the portrayal of Christ as the sun or the sun god was embodied in the concept of Christ as the true Sun, having replaced the pagan gods.[85] Lack of details of Christ's actual physical appearance in written accounts suggests that his physical appearance initially had not been considered important, especially in the iconoclastic east.[86] In the western empire, however, similarities between Christ and a recognized youthful god (namely Apollo) were emphasized, and Christ and Apollo were thus often viewed as visual equivalents in Early Christian times. This iconography was apparently used to allow Christianity to present more readily acceptable visual forms to the pagan masses. Since the sun god Apollo was the son of Zeus (Father of Heaven) and renowned for being good-willed and clement, but strong and powerful, even vengeful when necessary, he was perhaps a logical candidate for equation with the Christian Son of God as incarnate on earth.[87] The significance of the symbolism of the sun—as source of light, heat, and life itself—was common to both the pagan god and to Christ, and would have served as an additional reason for the identity, as would the appeal which the concept of youthfulness and perfection might have had to early Christian converts. In Early Christian art, therefore, Christ is depicted in a manner quite similar to that of the Roman Apollo: vigorous, youthful, and muscled, often with short tunic and bare limbs, fairly closely cropped hair in the Roman style, and, significantly, beardless.[88] And Michelangelo's Christ of the *Last Judgment* evidently bears comparison with this traditional Early Christian type of Christ, and not just pagan Apollo statuary.

Surviving examples of the Apollo-type Christ are relatively common in Late Antique art. A floor mosaic of about 520 at Beth Alpha is a fine example of the Deity as sun symbol (fig. 11), as is the sixth-century theophany of Christ at Bawit, already mentioned, where Christ is youthful and beardless. Examples may also be found on mainland Greece that clearly attest to the existence of the tradition of the beardless, youthful Christ in this area as well.[89] More pertinently, as possible source material for Michelangelo, examples are quite plentiful in Italy and could therefore have played a part in the formulation of Michelangelo's concept. Here especially, existing forms of pagan Roman art were taken over and adapted to fit biblical concepts, and the classical Apollo-type figure was frequently integrated with the biblical idea of Christ as the sun or light of the world.

It was often also used in conjunction with the theme of Christ as the Good Shepherd, possibly because one of Apollo's duties was to guard the herds and flocks of the gods.[90] Christ may be depicted beardless with short hair and tunic, as in earlier, third-century examples, or, more commonly, with longer robes and lengthier hair, but still beardless (fig. 71). Even when longer robes are used, stylistic characteristics show similarities with the Antique concepts of physical proportion since (in contrast with the Byzantine type) bodily form is suggested beneath draperies of voluminous Roman togalike garments (fig. 72).

This western depiction of Christ contrasts with the slightly later Eastern Orthodox portrayal of the dark, long-haired, and bearded Christ of the Byzantine type, from which the standard type developed, although sometimes both types coexist. Examples of the Apollo-type beardless Christ survive especially on the eastern coast of Italy at Ravenna. There is no concrete evidence that Michelangelo could have viewed these examples,[91] but the type is common here, in the mausoleum of Galla Placidia (c. 430), where the beardless Christ is depicted as the Good Shepherd (fig. 71); in Saint Apollinare Nuovo (mid-sixth century), where the beardless Christ of

71 *The Good Shepherd*, detail, c. 440. Mosaic, Mausoleum of Galla Placidia, Ravenna.

72 *Christ in Majesty,* c.
500. Apse mosaic, chapel of
Sant'Aquilino, San Lorenzo,
Milan.

the Miracles series (fig. 73) exists side by side with the bearded Christ of
the Passion series; and in Saint Vitale (sixth century), where the beardless
Christ is seated on the sphere of the universe (fig. 10).[92] Vasari's pejorative
descriptions and his scathing attacks on the "awkwardness and crudeness"
of the so-called Greek style demonstrate an awareness of such monuments
even if he did not regard them highly.[93] The arousal of Michelangelo's
interest from the 1530s in Christian revival and reform does, however, make
it seem possible that he might have reconsidered this type of iconography.

The beardless Apollo-type Christ, which is indicative of Christ's role
as an equivalent to the sun deity is also to be found in Early Christian
mosaics elsewhere in Italy. A good example still exists at Milan in the
apse of Saint Aquilino, fifth century (fig. 72), and nearby in the frescoes
of Castelseprio, sixth century.[94] Michelangelo did not travel to Milan,
but his contemporary Bramante was a native of Milan, and Bramante's
designs for Saint Peter's on a central domed plan demonstrate interest in
the revival of early Christian forms of church building and decoration.
It has been argued that Bramante actually based his concept for Saint
Peter's on the design of the Early Christian church of Saint Aquilino.[95]

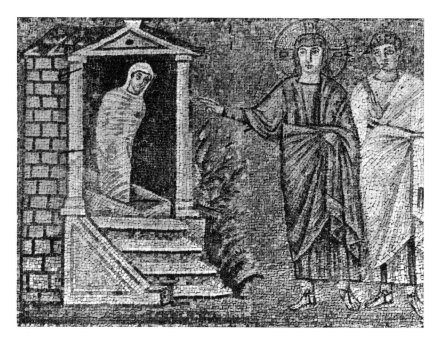

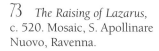
73 *The Raising of Lazarus,*
c. 520. Mosaic, S. Apollinare
Nuovo, Ravenna.

Michelangelo could well have learned of mosaics like this through such
contacts. The similarity between Christ's gesture in this fifth-century Milan
mosaic (fig. 72) and the gesture of Christ in Michelangelo's fresco is also
suggestive of a possible link.

More important than these examples are instances of the Early
Christian beardless Apollo-type Christ in areas known to have been
accessible to Michelangelo, especially in Rome itself. Here, familiarity
coupled with an interest in the revival of Christianity in its original
forms, could well have provided additional iconographical influence on
Michelangelo. Mention is made of a conscious Early Christian revival
in the decorations of the Sistine Chapel even prior to Michelangelo;
for, as Shearman writes, "the chapel and its decoration were already
distinguished by conscious revival in form and symbolism of medieval
and Early Christian usage."[96] The earliest examples of this iconography in
Christian art at Rome are in the Vatican grottoes and in the catacombs,[97]
where the beardless type of Christ is depicted, clearly demonstrating the
existence of the tradition.

The systematic investigation of the catacombs took place in the
second half of the sixteenth century, but the existence of ancient buildings
and catacombs beneath Rome and beneath Saint Peter's itself had been
known long before the sixteenth century.[98] Some ancient subterranean
buildings were known and explored before the end of the fifteenth century,
as, for example, the Domus Aurea, or Golden House, of Nero.[99] This is

confirmed artistically by certain decorative elements in the work of artists like Ghirlandaio, to whom Michelangelo was apprenticed for a short while.[100] Michelangelo's direct knowledge of the underground remains is confirmed by his drawing of the archers in the Volta Dorata, demonstrating his interest in underground antique remains (even though there is no specific example of an Apollo known here).[101] Knowledge of subterranean remains in Rome is also confirmed by the artist and goldsmith Benvenuto Cellini (1500–71) in his autobiography, where he refers specifically to "certain underground caves in Rome which in ancient times were used as dwelling rooms, studies, halls, and so forth."[102] Vasari also referred to "buildings in Rome . . . [which] were buried under the ruins and only in our own day have many of the rare works been rediscovered."[103] Of course in the sixteenth century there was some confusion by Vasari and others over whether these ancient works were pagan or Christian in origin, but antique works in the classical style would undoubtedly have aroused interest and would not have been bracketed with the Byzantine or medieval "monstrosities" that Vasari disliked. Some of the grottoes beneath Saint Peter's had been discovered during the demolition and rebuilding of Saint Peter's with which Michelangelo became deeply involved.[104] Significantly, one of the finest examples of the early depiction of Christ as a beardless Apollo-type sun-god is in those grottoes (mausoleum M) beneath Saint Peter's itself (fig. 74).[105] This mausoleum, with its outstanding mosaic dated to the third century, was rediscovered in the twentieth century, but evidence provided by the records of the excavations suggests that the vault had been opened on other unrecorded occasions. Documentation confirms that it was known by the late sixteenth century.[106]

Among the surviving Early Christian basilicas and churches of Rome, such as Sta. Costanza (c. 350), Sta. Pudenziana (c. 387–90), and SS. Cosmas and Damian (526–30),[107] specific depictions in mosaic of the beardless Apollo-type Christ are less common, although the general type of classical imagery and the Early Christian style is evident in the portrayal of short-haired, beardless figures of holy personages in the Roman style. Especially notable are the Early Christian mosaics of Sta. Maria Maggiore (400–440),[108] that immense Christian basilica in which Michelangelo had at one time expressed a desire to be buried.[109] The nave panels of mosaics are well preserved and typical of Early Christian style and iconography, with innumerable figures of saints and angels (significantly wingless) depicted in the Roman manner (fig. 75). It is interesting that in the apse mosaic (a thirteenth-century restoration by Jacopo Torriti) the sun and moon are depicted beneath the figures of Christ and the Virgin, apparently according to the symbolism of Rev. 1:16 and 12:1.

Apart from Michelangelo's possible knowledge of these early Christian monuments, there is also the strong likelihood of his knowing similar depictions of the beardless Christ on smaller artifacts of a general type,

74 *Christi as the Sun-
God*, third century. Mosaic,
cemetery under Saint Peter's,
Tomb of the Julii, Rome.

75 *Abraham and Three
Celestial Visitors*, c. 400–440.
Mosaic, S. Maria Maggiore,
Rome.

like ivories, antique sarcophagi, or even manuscripts, although the dates
of rediscovery of these small works are hard to trace with any precision
(typified by fig. 76).[110] Early Christian artifacts were more frequently
included in Renaissance collections than is often supposed, alongside
classical pagan examples, sometimes with little distinction between the
two types.[111] Examples of sarcophagi in Renaissance collections in Rome
and Florence, at the Duomo and in the possession of Lorenzo de' Medici,

76 Unknown Syrian artist, *Crucifixion*, mid-fifth century. Ivory, British Museum, London.

would have been familiar to Michelangelo as well as to groups at Pisa and in Rome itself.[112] Bober demonstrates the contemporary interest in sarcophagi and their influence on Renaissance art, and comments on "their sheer ubiquity" as "the single most accessible class of ancient art to inspire subsequent artists." She discusses direct borrowings and draws attention to the interest in both Early Christian examples and as in pagan subjects, such as the Apollo theme.[113]

The influence specifically of antique sarcophagi on Renaissance and even proto-Renaissance artists is well known: their importance for the Pisani, among others, has been carefully traced.[114] Relevance for fifteenth-century painters is also clear when one notes, for example, the emphasis given to the inscribed classical sarcophagus in the *Adoration of the Shepherds*, c. 1485, by Ghirlandaio.[115] Antique sarcophagi, both pagan and Christian, which depict the beardless Apollo or the Christian Apollo-Christ, exist in Rome and Florence to such an extent that knowledge of them in the time of Michelangelo may be assumed. One of the most famous of Early Christian sarcophagi is that of Junius Bassus (fourth century), which was known by the mid-sixteenth century. Christ is here depicted young and beardless, in cosmological terms as the master of the universe above the arch of Heaven (fig. 77).[116] Although this particular example may have been unknown at the time of the *Last Judgment*, the Junius Bassus sarcophagus is by no means the sole example of the type.[117]

Of course the purely pagan monuments, many of which bore reference to the pagan god Apollo, were also plentiful in Rome and

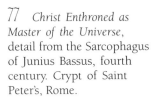

77 *Christ Enthroned as Master of the Universe*, detail from the Sarcophagus of Junius Bassus, fourth century. Crypt of Saint Peter's, Rome.

aroused great interest during the Renaissance. Influence of classical statuary upon Renaissance artists, especially Michelangelo, has received much comment and does not need to be reexamined in detail here. Seznec draws attention to the way in which interest in the various pagan gods was revived during the Renaissance, and Wind comments on the revival of "Pagan Mysteries."[118] Neither of these authors, however, presents the Renaissance as an era of neopaganism; they both emphasize the way in which classical references were utilized by the advocates of the classical revival, but within a Christian framework.[119] Blunt also demonstrates the fusion of classical and Christian ideas during the Renaissance and the incorporation of pagan doctrines and symbolism into Christianity.[120] As far as examples of the classical god Apollo are concerned, one has only to consider the famous example of the Apollo Belvedere (discovered by 1491). This pagan work has been indicated as possible source material for Michelangelo's Christ. The drapery and hairstyle of the Apollo Belvedere and Pope Clement's interest in the work, ordering its restoration in 1532, make this seem likely.[121] The idea that such classical forms were sometimes given Christian meaning in Michelangelo's work, according to the tradition outlined above, also requires due emphasis. It does seem plausible that, in view of his involvement with the movement for religious reform, Michelangelo developed his idea of the Apollo Sun-Christ of the *Last Judgment* from Antique Christian sources of the type discussed, rather than looking only at pagan monuments, and utilizing the classical Apollo-type form for his depiction of Christ without any reference to the Early Christian tradition. The influence on Michelangelo of Roman remains like sarcophagi, mosaics, and frescoes (which were at once classical in

style while Christian in content) should not be discounted, and there thus appears to be sufficient evidence to demonstrate not only that the beardless Apollo-type Christ was an established iconographic type, but also that Michelangelo undoubtedly would have had access to it. The close correlation between the traditional iconography of the Sun-Christ and Michelangelo's Christ of the *Last Judgment* suggests that it should therefore be considered in the early Christian context, not simply as a borrowing of the antique, classical, and pagan form of the god Apollo as suggested by Tolnay, nor as an heretical form as suggested by others, including Steinberg. While Tolnay does comment briefly on the existence of the Christian tradition of the fusing of Christ with the sun god Apollo (as the *Sol Invictus* becomes the *Sol Iustitiae*),[122] Michelangelo's depiction is viewed by Tolnay as paganized instead of related to the Early Christian type. He states,

> It has often been said, and rightly so, that this is no longer the Christ of the Gospels, but rather a divinity of Olympus. This fact has been interpreted as a manifestation of the fundamental paganism of the artist, which also reveals itself in other features such as the angels without wings, the saints without halos, the nudity of almost all the figures, the Charon and Minos scene, etc. It is thought to be a striking paradox that the *Last Judgment* painted for the Chapel of the Popes in the Vatican in fact "celebrates the paganizing of Christian art."[123]

Owing to the scriptural and early Christian tradition of the Sun-Christ, Michelangelo's view in this context could be argued as wholly Christianized, bearing a secondary, instead of primary, reference to the original pagan deity. The question of Michelangelo's "fundamental paganism" will be discussed further in the course of this book, but, as will be demonstrated, references in Michelangelo's work to themes in Antique art and Neoplatonism are neither pagan nor heretical but frequently integrated into Christian philosophy with the fervor of one involved in the deeply religious questions of the age.[124]

Continuation of the Sun-Christ Tradition

In the same way that the written tradition of the analogy between Christ and the sun received renewed emphasis during the Renaissance, so also was the visual reinforcement of the concept continued. It has often been assumed that during the period between Early Christian art and the time of the Renaissance, the depiction of the youthful beardless Christ was completely superseded by the dark, bearded type in Western Europe. The depiction of the former type did not, however, entirely die out. Some of the best remaining examples are in medieval manuscripts, which show

that the tradition continued to a certain measure at least, although the bearded type was, much more common. The youthful, beardless Christ reappeared in the ninth and tenth centuries in Carolingian and Ottonian manuscripts and later in Bibles of the twelfth century.[125] Such works kept the traditional iconographic identity between Christ and the Apollo-type sun god alive through the Middle Ages (figs. 78 and 79).

A very conspicuous, almost life-size example of the beardless Christ, in mosaic from the thirteenth century, with cosmic overtones and starry background, is in a prominent position on the north wall of the nave of Saint Mark's in Venice (fig. 80).[126] Clearly identified as Christ by the inscription, this example is further evidence of the availability of this type and is related, perhaps, to the attempts made in the late medieval period to restore the Italian churches to their ancient, paleo-Christian grandeur.[127] Even more remarkable is the direct visual reference to the Sun-Christ in Renaissance works, by artists like Albrecht Dürer. His engraving *Sol Iustitiae* or *The Judge*, 1499 (fig. 81), is clearly a reference to scriptural sources like Mal. 4:2, which linked the Messiah with the sun symbol at the time of Judgment, since it corresponds closely to a contemporary text on this subject and was made at a time when Judgment was expected to be imminent (in 1500). Among Dürer's illustrations of the Apocalypse, his

78 *Christ in Majesty*, c. 870.
Manuscript, Bibliothèque
Nationale, Paris.

79 *The Creation and Fall of Man,* Pantheon Bible, first half of the twelfth century. Illuminated manuscript, 454 x 285 mm (Vat. Lat. 12958, folio 3 verso) Biblioteca Apostolica, Vatican.

interpretation of the text of Rev. 10:1 also makes use of the sun symbol (fig. 82).[128] The facial resemblance of Dürer's engraving of *Sol Iustitiae* (fig. 81) to the Venetian mosaic (fig. 80) is perhaps accounted for by his visit to Venice in 1494–95, and his use of this type here for the "Sun of Righteousness" shows that the beardless Apollo-type Christ was well known and regarded as a sun symbol during the Renaissance. It was associated with the cosmological depiction of Christ as the sun, especially at the time of Judgment. In addition, the origin of the type in the conscious adaptation of the figure of Apollo to Christ also seems to have been known to Dürer, as is confirmed by his own writings: "the same proportions the heathens assigned to their idol Apollo, we shall use for Christ the Lord, the fairest of them all."[129]

The beardless and youthful Apollo-type Christ also recurs in some examples of Italian art of the Renaissance in the fifteenth century. These prove on closer examination to be fairly numerous: a drawing of the *Lamentation* by Jacopo Bellini of the 1440s shows a beardless Christ with

80 *Christt the Saviour*, thirteenth century. Mosaic, north wall of nave, Saint Mark's, Venice. Reproduced by permission, Procuratoria della Basilica di S. Marco.

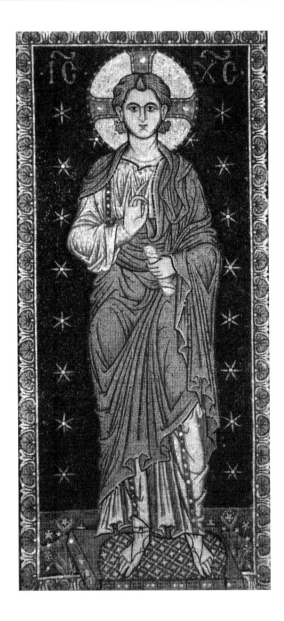

his sarcophagus,[130] and a sarcophagus is significantly also included in Castagno's well-known depiction of a beardless Apollonian-type Christ in his fresco of the *Resurrection*, 1447–49 (fig. 83), in S. Apollonia in Florence.[131] As with Michelangelo's Christ, Castagno's version is beardless and also has his right arm raised, but this has not received attention as possible source material for Michelangelo (compare also figures 40, 43, 45, 72). In the adjacent frescoes of the *Crucifixion* and *Lamentation*, Castagno again depicts Christ beardless, but his use of the type has not been adequately explained; it is perhaps an indication of a consciousness of the Early Christian type, gained from mosaics and sarcophagi.[132] Two

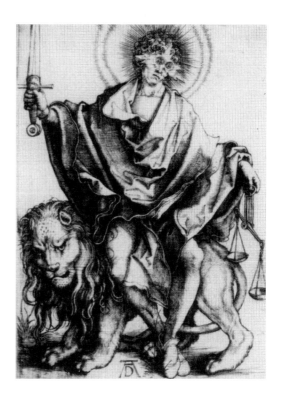

81 Albrecht Dürer, *Sol Iustitiae* or *The Judge*, 1499. Engraving, 108 x 77mm, Metropolitan Museum of Art, New York.

82 Albrecht Dürer, *St John Devouring the Book*, 1498. Woodcut from the *Apocalypse* series, 391 x 284 mm. Staatliche Graphische Sammlung, Munich.

83 Andrea del Castagno,
Resurrection, 1447–1449.
Fresco, refectory of Sant'
Apollonia, Florence.

versions of the *Lamentation* (1470s) by Cosimo Tura also show Christ
beardless, and in one of these an antique sarcophagus, possibly the source
for the motif, is shown.[133] It does appear to be significant that in the
examples of the Italian quattrocento, Christ is depicted beardless more
often in scenes that relate to the events of the Passion and especially the
Lamentation, so the feature is evidently not simply associated with youth.

Botticelli also chose to depict Christ youthful and beardless in several
works, including the Lamentation theme.[134] The *Lamentation* now in
Munich, dating from the early 1490s (fig. 84), clearly depicts Christ as
youthful, athletic, and beardless, and a sarcophagus is revealed in the
background. It seems significant that this work was made for the church
of Saint Paolino, whose prior was the Neoplatonist Angelo Poliziano, tutor
to Michelangelo.[135] A later version by Botticelli, know as the Poldi-Pezzoli
Pietà, c. 1495, and painted as an altarpiece for Sta. Maria Maggiore, is less
distinct. In a late work, Botticelli again portrayed Christ beardless and
"rayed" in the *Transfiguration* (fig. 85), according to the text "and his face
did shine as the sun," (Matt. 17:2); Filippino Lippi, pupil of Botticelli,

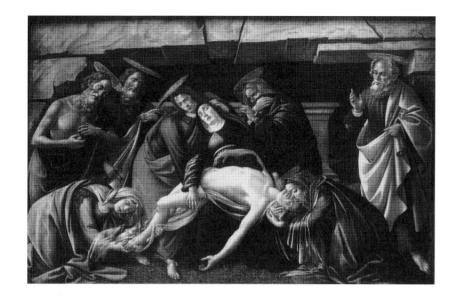

84 Sandro Botticelli, *Lamentation*, early 1490s. Panel, 207 x 140 cm, Alte Pinakothek, Munich.

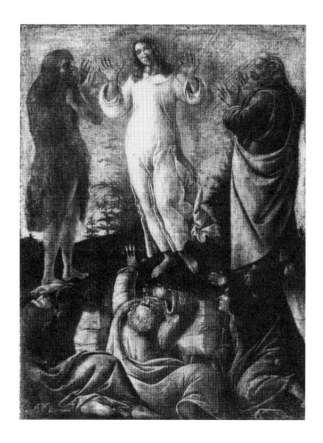

85 Sandro Botticelli, *Transfiguration*, c. 1500. Central panel of altarpiece, 272 x 194 mm, Galleria Pallavicini, Rome.

made use of the same iconography in his drawing of the resurrected Christ appearing to Mary Magdalene.[136] In Botticelli"s example of the *Transfiguration*, as with the example of the *Sol Iustitiae* by Dürer, it appears highly significant that the beardless Apollo-type Christ is chosen for the illustration of a biblical text specifically associated with the Sun-Christ analogy.

Neoplatonic ideas as well as the religious reforms of Savonarola could have influenced Botticelli's depiction of Christ—and these are themes to which Michelangelo was exposed also, as discussed in the following chapters. These influences may not, however, constitute a possible explanation for the earlier quattrocento examples mentioned above, where, in the cases of Castagno, Bellini, and Tura, one can only assume an interest in paleo-Christian forms and a consciousness of the Early Christian type from rediscovered antique sources like sarcophagi, ivories, or mosaics. In the case of these beardless Christs, especially in works by artists like Botticelli, the interest in classical pagan gods such as Apollo may have served as a contributing factor, but Christian meaning is given to pagan and Platonic philosophy. It does seem more than mere coincidence that Botticelli and Michelangelo used a similar iconography in this respect, when the important influences of Neoplatonism, Savonarola and, as we shall see, Dante, were common to both artists. The purely Christian context of the sun symbol is also made clear by late-fifteenth-century use of sunbursts and designs that have no allusion to any classical deity, but only to the Christian symbol. In Ghirlandaio's frescoes in the Sassetti Chapel, the sun symbol is used for Christ, and again, significantly, in the Medici Palace (fig. 86).[137] This use of the sun symbol may be compared

86 Domenico Ghirlandaio, *Trigram and Solar Symbol*, 1484–85. Fresco, detail, Medici Chapel, Palazzo Medici, Florence.

with another typical example in the Florentine style, at Sulmona, where sun and lamb are combined.[138]

Sixteenth century examples of the beardless Christ are still to be found, such as in Rosso Fiorentino's *Risen Christ* (1528–30); Pontormo's *Supper at Emmaeus* (1525; rather indistinct),[139] and the *Flagellation* by Sebastiano del Piombo (1516–21) that is based on Michelangelo's designs (links between these two artists are discussed by Hirst).[140] Among Michelangelo's own works, several drawings use a similar facial type, such as his *Resurrection* drawings (figs. 87, 88), which are approximately contemporary with the commission of the *Last Judgment*, and either related to the Medici chapel lunettes or the possible earlier proposal for a *Resurrection* in the Sistine Chapel. The *Crucifixion* drawing for Vittoria Colonna is too indistinct to permit certainty in this regard (fig. 89).[141]

It is thus erroneous to suggest that in the Italian Renaissance the beardless Apollo-type Christ was completely out of the ordinary and unknown, or that it implied heresy at the time,[142] although this type was admittedly less common. It is evident that an ongoing tradition of this portrayal of Christ existed in Italy. Even if it was rather sporadic, there was some revival of the type in the late fifteenth and early sixteenth centuries.

87 Michelangelo, *Resur-rection of Christ*, c. 1533. Black chalk, 326 x 286 mm, British Museum, London.

88 Michelangelo, *Resurrection of Christ*, late 1532. Black chalk, 190 x 330 mm, Royal Collection, Windsor Castle.

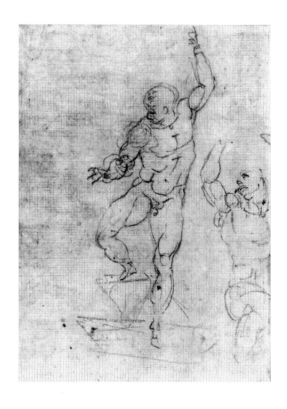

89 Michelangelo, *Crucifixion* (for Vittoria Colonna), c. 1540–41. Black chalk, 370 x 270 mm. London, British Museum.

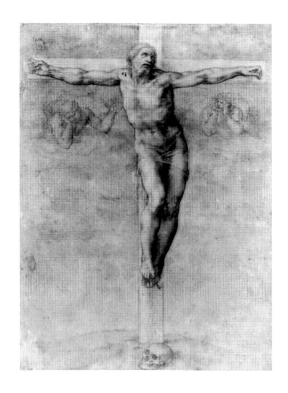

It is on occasion specifically related to biblical texts concerning the analogy between Christ and the sun, as well as to classical prototypes, as part of an ancient tradition. Whether Michelangelo's beardless Judge of the Sistine Chapel is a deliberate revival of the Early Christian depiction of Christ as a sun symbol evidently merits consideration. The currency in Italy at the time of such ideas, based on Scripture and propagated by Catholic reformers interested in revival of the primitive forms of Christianity, tends toward a reinforcement of the argument.

Along the same lines, it may be argued that Michelangelo's depiction of wingless angels,[143] and haloless saints[144] in the *Last Judgment* and the "live" crucified Christ in his drawing for Vittoria Colonna[145] (which are all common features in Early Christian schemes) were deliberately intended to refer back to Early Christian practice, and correspond with the aims of the Catholic reformers. Such works therefore, including and especially the depiction of a beardless Apollo-type Christ, are not to be viewed as totally innovative, and even less as heretical or pagan but rather as being informed by a wish to return to the early Christian tradition, at least as much as by the influence of pagan Apollo statues such as the *Apollo Belvedere*.

Because of the emphasis given to the depiction of Christ as an Apollonian figure, surrounded by an aura of light, it is also relevant here to refer back to previous comments on the formal analysis of the work and its divisions into areas of light and dark. As demonstrated, light and dark contrasts are used to emphasize the inner and outer "circles," and Christ is emphasized by the surrounding golden aura. This view should be considered in conjunction with observations on the cleaning and restoration of the Sistine frescoes, which have shown that the emphasis on light and color on both the ceiling and the altar wall is actually greater in Michelangelo's frescoes than had been supposed. The effects that have resulted from the cleaning of the *Last Judgment*, 1990–94, relate well to observations made about the frescoes by contemporaries. Anton Francesco Doni, for example, commented on the darkness of the lower areas of the fresco in contrast with the brightness above,[146] and the cleaning of the fresco provides reinforcement for the present reading of the fresco, where light and sun symbolism are major concerns.

In view of the links between cosmology, theology, and the scene of the *Last Judgment* and in view of Michelangelo's depiction of the beardless and youthful Christ in a manner related to the traditional analogy between Christ and the sun, it appears that the fresco can be read as containing deliberate reference to theological cosmological concepts. In the light of Michelangelo's contacts with Catholic reformers, his depiction of Christ as sun symbol may be reconsidered in the context of the Christian religion rather than that of classical statuary. Religious sources, the Bible, and

the writings of the Church Fathers laid a firm foundation for the strong tradition of Christ as a sun symbol. This was expressed in the iconography of early Christian art by the transference of the cult of sun-worship, associated with the Graeco-Roman Apollo, to the depiction of Christ. So it may be argued that Michelangelo's beardless Apollonian Christ is to be viewed in terms of a deliberate allusion to the Christian analogy, and not primarily as a classical Renaissance "pagan" interpretation of the male nude.

In reexamining the fresco in the context of Christian cosmological symbolism, it is important to consider additional ways in which Christian cosmology and Christian light and sun symbolism were perpetuated in sources that might have relevance for Michelangelo. The popularity of the theological Sun-Christ analogy in the sixteenth century has been emphasized with reference to the prevailing theological sources, but literary, philosophical, and scientific sources also exist to strengthen and support the idea that sun symbolism and cosmology, as related to the Christian Deity, were a major part of a well-established tradition, which at that period, had great significance for Michelangelo and his contemporaries. Among several literary sources popular in Italy during the Renaissance that demonstrate the importance and assimilation into common acceptance of the tradition of the deity as a sun symbol, the most important is undoubtedly the *Divina Commedia* of Dante.[147]

Notes

1. Examples are numerous: Ps. 27:1, "the Lord is my light and my salvation"; Ps. 118:27, "God is the Lord, who hath shown us light"; Isa. 60:19, "the Lord shall be to thee an everlasting light."

2. This concept is also commonplace in Christian exegesis. For comment on light symbolism in Christian iconography, see George Ferguson, *Signs and Symbols in Christian Art* (New York: Oxford University Press, 1980), 43, 148–49; and Umberto Eco, "The Aesthetics of Light," chap. 4 in *Art and Beauty in the Middle Ages* (New Haven: Yale University Press, 1986).

3. See Charles Harold Dodd, *The Interpretation of the Fourth Gospel*, 2d ed. (Cambridge: Cambridge University Press, 1972), esp. pt. 2, chap. 1, "Symbolism," and chap. 7, "Light, Glory, Judgment." Dodd places an emphasis on the Platonic influences in John's Gospel, especially with respect to the use of light symbolism (as in Plato's metaphors of the sun and cave, 139). Also Robert Henry Lightfoot, *St. John's Gospel: A Commentary*, 2d ed. (London: Oxford University Press, 1963), esp. 189–203, "The Lord as the Light of the World."

4. The concept of Christ as "the true light . . . which lighteth every man" (John 1:4) is emphasized from the beginning of this Gospel. Dodd demonstrates how the symbol of light is used here to give a cosmological account "of the relation of the absolute to phenomena, of God to the universe," since "light communicates itself by radiations which are emanations of its own substance"; Dodd, *Fourth Gospel*, 202. For links between light symbolism and judgment, see 208–12.

5. James George Frazer, *The Worship of Nature* (London: Macmillan, 1926), chaps. 12–16, 441–668; Arnold Whittick, *Symbols, Signs and Their Meaning* (London: L. Hill, 1960), 266–67; James Ballantyne Hannay, *Symbolism in Relation to Religion: Christianity, the Sources of Its Teaching and Symbolism* (Port Washington, N.Y.: Kennikat, 1971), pt. 1, chap. 4; also H. Rudolf Engler, *Die Sonne als Symbol* (Zurich: Helianthus Verlag, 1962), esp. sec. 4, "Christus, das Licht der Welt, als Symbol der Sonne," 237–86.

6. Frazer, *Worship of Nature*, 441–528; Hannay, *Symbolism,* 260–61.

7. Frazer, *Worship of Nature*, 441–528; J. Goodwin and A. Doster, eds., *Fire of Life: The Smithsonian Book of the Sun* (New York: Norton, 1981); *Encyclopaedia of World Art*, s.v. "Astronomy" and "Cosmology". Note Tolnay's comment on primitive sun symbols in rock paintings; Tolnay, *Michelangelo*, 5:48.

8. For details of the myth, see Robert Graves, *The Greek Myths*, 2 vols., (Harmondsworth: Penguin, 1977), 1:76–82.

9. Graves, *Greek Myths*, 1:173–74. Comparison between Christ and the sun god is presented in table form by Hannay, *Symbolism*, 314. See Frazer, *Worship of Nature*, 519–20, 526–28, for the adaptation of sun symbolism to Christianity.

10. As especially in Mal. 4:2; this symbolism evidently has astronomical and cosmological overtones that are connected with the concept of the rising sun. See also Hautecoeur, *Mystique et Architecture*, "Le Christ Solaire,"177–78.

11. The Christian reading, of course, would take this to mean Christ (confusion or similarity between the words "sun" and "son" occurs by chance in the English language). Tolnay commented on the idea of Michelangelo's Christ as related to the Christian identification of Christ and the sun, and also to this concept of Christ as the Sun of Righteousness (*sol iustitiae*) or Unconquered Sun (*sol invictus*); Tolnay, *"Jugement Dernier,"* 142; Tolnay, *Michelangelo*, 5:47; but it is not really considered in depth. As previously mentioned, he seems to perceive the Christ-Apollo as a pagan form.

12. St. John's gospel is a major source for the reform movement of Nicodemism in which Michelangelo's involvement has been argued. See Valerie Shrimplin, "Michelangelo and Nicodemism: The Florentine *Pietà*," *Art Bulletin* 71 (March 1989): 58–66, esp. 60.

13. Light symbolism in John has been related to its Neoplatonic content. See Dodd, *Fourth Gospel,* chaps. 1–3 and passim; Lightfoot, *St. John's Gospel,* 49–56, "The Greek Background."

14. George B. Caird, *A Commentary on the Revelation of St. John the Divine* (London: Black, 1984), 3–6, discusses the question of whether the author of the Revelation was the same as the author of Saint John's gospel. The "mighty angel" linked with the sun in the book of Revelation is identified with Christ (125–26).

15. This was commonly accepted from the fourth century and commented on by the Church Fathers such as Saints Ambrose, Augustine, John Chrysostom, Clement of Alexandria, and Gregory of Nyssa as well as Pseudo-Dionysius the Areopagite. The religious symbolism of the sun continued even into the later medieval period, as for example in Saint Francis of Assisi's famous "Hymn to the Sun," where he says "O Lord, he signifies to us Thee." See Hugo Rahner, *Greek Myths and Christian Mystery* (London: Burns and Oates, 1963), chap. 4, "The Christian Mystery of Sun and Moon," esp. 129–30, "The Christmas Sun," and Prosper Guéranger, *The Liturgical Year* (Dublin: Dufy, 1886), vol. 2 "Christmas," esp. chaps. 1–2, "The History of Christmas" and "The Mystery of Christmas."

16. Quoted by Rahner, *Greek Myths*, 154.

17. See *The Roman Missal: Being the Text of the Missale Romanum,* ed. John O'Connell and H. P. R. Finberg, (London: Burns, Oates, and Washbourne, 1950). This gives the mass "in its most ancient form," xxiii. For the Christmas liturgy, see esp. 31, 34, "Lux fulgebit hodie super nos," 36, 39. The theme that the coming of Christ at Christmastime prefigures the coming at the Last Judgment is also expressed in the Christmas liturgy (28, 31). It is

interesting that Vasari (*Lives*, ed. Bull, 383) believed that the *Last Judgment* was "unveiled" on Christmas Day, 1541.

18. Rahner, *Greek Myths,* 103–29, "The Easter Sun." According to Rahner (89–93, 99), such symbolic concepts are related to, if not founded on, the solar mysticism of Platonic philosophy, especially to be found in the writings of Plotinus (c. 205–70).

19. Rahner, *Greek Myths,* 105–6.

20. Rahner, *Greek Myths,* 136–37.

21. Philip Peirce, "The Arch of Constantine: Propaganda and Ideology in Late Roman Art," *Art History* 12 (December 1989): 387–418, esp. 407–8. Peirce discusses Constantine's interest in sun-worship and the inclusion of sun-motifs on the arch of Constantine in the Roman Forum.

22. Lees-Milne, *St. Peter's,* chap. 3, "Constantine's Basilica," esp. 77.

23. For Augustine, see for example, Etienne Gilson, *The Christian Philosophy of St. Augustine* (London: Victor Gollancz, 1961).

24. For Neoplatonic elements in Augustine's works, see Gilson, *Augustine*, 77. Also Dodd, *Fourth Gospel*, 10–11.

25. For use of the sun/light metaphor in Augustine, see Gilson, *Augustine,* esp. 77–96, "The Light of the Soul." Gilson emphasizes the Neoplatonic aspects of this, relating Augustine's thought to that of Plotinus and Plato himself.

26. *Ennarationes*, Psalm 10 in *Patrologia Latina*, 36:132. Quoted by Esther Gordon Dotson, "An Augustinian Interpretation of Michelangelo's Sistine Ceiling, part 1," *Art Bulletin* 61 (1979): 223–56, esp. 244–45 n. 117. See also Dotson, Part 2, pp. 61, 404–29.

27. Saint Augustine, *City of God*, esp. 374–75, 436–37, 450–51; idem, *Confessions*, trans. Vernon J. Bourke (Washington: Catholic University of America Press, 1953), 180–81, 410–14, 424–25; and idem, *The Immortality of the Soul* and *The Magnitude of the Soul,* ed. L. Schopp (New York: Catholic University of America Press, 1947), 3–152.

28. See Etienne Gilson, *History of Christian Philosophy in the Middle Ages* (London: Sheed and Ward, 1955).

29. Discussed by Gilson, *Augustine*, 77–96. (The idea was, of course, scientifically incorrect.) See also Meiss's discussion on the symbolism of light rays in depictions of the Immaculate Conception, "Light as Form and Symbol in Some Fifteenth-Century Painting," in Creighton Gilbert, ed., *Renaissance Art* (New York: Harper and Row, 1970), 43–68.

30. Saint Augustine, *On the Magnitude of the Soul*, chaps. 7–12, esp. 71, 75–80, 85, 89, where he comments on the symbolism of the circle and its "Godlike harmony." Of course the central "point" of the circular format of Michelangelo's fresco is the figure of Christ himself.

31. See Hautecoeur, *Mystique et Architecture*, 145–292.

32. For the Augustinian revival see Paul Oskar Kristeller, "Augustine and the Early Renaissance," *Review of Religion* 8 (1944): 339–58; Dermot Fenlon, *Heresy and Obedience in Tridentine Italy* (Cambridge: Cambridge University Press, 1972), 138–39; Geoffrey R. Elton, *Reformation Europe* (London: Fontana, 1971), 193; Hubert Jedin, *History of the Council of Trent* (London: Nelson, 1957), 364–65. Augustine's popularity in Renaissance Italy probably stemmed from his interest in the incorporation of Neoplatonic elements into Christianity.

33. For example, Dotson, "Augustinian Interpretation," esp. 250–51. Dotson comments that Egidio da Viterbo was particularly involved at this time with Plato and the apparent harmony of his writings with the fundamental principles of Christian theology.

34. For Egidio da Viterbo, see Dotson, "Augustinian Interpretation"; John W. O'Malley, *Rome and the Renaissance: Studies in Culture and Religion* (London: Variorum, 1981); John C. Olin, *The Catholic Reformation: Savonarola to Ignatius Loyola: Reform in the Church,*

1495–1540 (New York: Harper and Row, 1969), 40–53, esp. 46–48 for Egidio's use of light symbolism.

35. Dotson, "Augustinian Interpretation"; Edgar Wind, *Pagan Mysteries of the Renaissance*, rev. ed. (Oxford: Oxford University Press, 1980), 248–49.

36. Edgar Wind, *Michelangelo's Prophets and Sibyls* (Oxford: Oxford University Press, 1960), and idem, "Maccabean Histories in the Sistine Ceiling," in *Italian Renaissance Studies*, ed. Ernest Fraser Jacob (London: Faber and Faber, 1960), 312–27.

37. Dotson, "Augustinian Interpretation." Augustine is cited to justify the Renaissance conviction of Egidio and others that Plato "had access to divinely revealed truth" (252).

38. Dotson, "Augustinian Interpretation," esp. 240 n. 91, 244–45.

39. Dotson, "Augustinian Interpretation," see 233, 236, and 245 n. 117 (an idea also referred to by Januszczak, *Sayonara Michelangelo*, 155–156). Dotson, "Augustinian Interpretation," pt. 2, pp. 412 n. 193, ("Thine own Apollo now is king"), also traces similar symbolism in connection with the Sibyls on the ceiling. Dotson draws attention to the emphasis on Christ as sun in Egidio's *Historia*, 419, and gives a short discussion on the *Last Judgment* on p. 428.

40. For example, Tolnay, *Michelangelo*, 5:102; Murray, *Michelangelo, Life, Work and Times*, 158. Murray suggests that how the *Last Judgment* might fit into the iconography of the chapel as a whole is problematic.

41. The natural light in the chapel is discussed by Tolnay, who comments on the way that the figures of Christ and the Virgin are placed in the best naturally lighted zone (*Michelangelo*, 5:31–32).

42. Fenlon, *Heresy and Obedience*, chap. 1, "The Movement ad fontes" Roland H. Bainton, *Early and Medieval Christianity* (Boston: Beacon, 1962), 180; Jedin, *Council of Trent*, 1:363.

43. Tolnay, *Michelangelo*, vol. 5, chaps. 2–3; idem (1975), 103–8, 114, 184–85; Redig de Campos, *Michelangelo, Last Judgment*, chap. 4, sec. 5; Robert Clements, *The Poetry of Michelangelo* (London: Owen, 1966), chaps. 11 and 17.

44. De Maio, *Michelangelo e la Controriforma*, esp. chaps. 1–3 and 9; Salmi, *Complete Works*, 261–63; Salvini, *Hidden Michelangelo*, 139–42; Hibbard, *Michelangelo*, 254–63; Murray, *Michelangelo, Life, Work and Times*, 155; von Einem, *Michelangelo*, 158–59; Liebert, *Psychoanalytic Study*, esp. chaps. 17, 18, and 20, and recently Chastel et al., *The Sistine Chapel*, 200–201.

45. The *Spirituali* were active in Italy from 1530; Fenlon, *Heresy and Obedience*, 21–23. The group became centered on Viterbo (where Egidio da Viterbo had greatly contributed to the movement for reform) from about 1540, following Reginald Pole's appointment as papal governor there; Fenlon, *Heresy and Obedience*, 46. For chronology, see also Delio Cantimori, "Italy and the Papacy," chap. 8 in Geoffrey R. Elton, ed., *New Cambridge Modern History*, vol. 2, *The Reformation, 1520–1559* (Cambridge: Cambridge University Press, 1958), 265–74.

46. For background on these reformers and the Catholic Reformation in Italy, see George Kenneth Brown, *Italy and the Reformation to 1550* (Oxford: Blackwell, 1933); Beresford James Kidd, *The Counter-Reformation, 1550–1600* (London: Church Union Association, 1958) (1st ed. 1933); Henri Daniel-Rops, *The Catholic Reformation* (London: Dent, 1962); Arthur Geoffrey Dickens, *The Counter-Reformation* (London: Thames and Hudson, 1968); Henry Outtram Evenett, *The Spirit of the Counter-Reformation* (Cambridge: Cambridge University Press, 1968); George Huntston Williams, *The Radical Reformation*, 3d ed. (Kirksville, Mo.: Sixteenth Century Journal Publishers, 1993), esp. chaps. 21–23; Frederic C. Church, *The Italian Reformers, 1534–1564* (New York: Octagon, 1974); John Tedeschi, "Italian Reformers and the Diffusion of Renaissance Culture," *Sixteenth Century Journal* 5 (1974): 79–94; Elisabeth Gleason, "On the Nature of Sixteenth-Century Italian

Evangelism; Scholarship 1953–1978," *Sixteenth Century Journal* 9 (1978): 3–26; Steven Ozment, *The Age of Reform* (New Haven: Yale University Press, 1980). For Cardinal Pole, see Fenlon, *Heresy and Obedience*; for Ochino, see Roland H. Bainton, *Bernardo Ochino: Esule e riformatore senese del Cinquecento* (Florence: Sansoni, 1940), and idem, *The Travail of Religious Liberty* (Hamden, Ct.: Archon, 1953), chap. 6.

47. Eva-Maria Jung, "Vittoria Colonna: Between Reformation and Counter-Reformation," *Review of Religion* 15 (1951): 144–59, and idem, "On the Nature of Evangelism in Sixteenth-Century Italy," *Journal of the History of Ideas* 14 (1953): 511–27. Tolnay, *Michelangelo*, vol. 5, chap. 3; Roland H. Bainton, "Vittoria Colonna and Michelangelo," *Forum* 9 (1971): 34–41; Shrimplin, "Michelangelo and Nicodemism."

48. The date of Michelangelo's meeting with Vittoria Colonna is fully discussed by Ramsden, *Letters*, 237–38. The precise date is nowhere stated, but the most likely appears to be March 1536. Other dates have also been proposed, including 1532 and 1538 and even 1517–21, when both were at the court of Pope Leo X Medici; D. J. McAuliffe, "Vittoria Colonna: Her Formative Years as a Basis for Analysis of Her Poetry" (Ph.D. diss., New York University, 1978), 48–49.

49. Redig de Campos, *Last Judgment*, 84; Tolnay, *Michelangelo*, 5:51–52.

50. Von Einem, *Michelangelo*, 158; Salvini, *Hidden Michelangelo*, 139.

51. Jung, "Evangelism," 513. For Michelangelo and Savonarola, see esp. Hartt, *Michelangelo*, 21–22.

52. Vasari, *Lives* (ed. de Vere, 1923–25; ed. Bull, 418–22); Condivi, *Life of Michelangelo*, 102; Francisco de Holanda, *Dialogues*, reproduced in Charles Holroyd, *Michael Angelo Buonarroti* (London: Duckworth, 1903), 269–327. Although not especially reliable as a source, Holanda's *Dialogues* provide general evidence for meetings and intellectual discussions of this group; Tolnay, *Michelangelo*, 5:55–56.

53. Williams, *Radical Reformation*, 819, where he is called papal chamberlain and secretary to the emperor.

54. For the aims of the Catholic reformers to return to the simple obedience and pure forms of the Early Christian Church, see Fenlon, *Heresy and Obedience*, esp. 1–23; McAuliffe, *Vittoria Colonna*, 48; Gleason, "On the Nature of Sixteenth-Century Italian Evangelism," 4, 20; Gerhard B. Ladner, *The Idea of Reform,* (Cambridge: Harvard University Press, 1959); Jung, "On the Nature of Evangelism," 520; Anne Schutte, "The Lettere Volgari and the Crisis of Evangelism in Italy," *Renaissance Quarterly* 28 (1975): 639–88, esp. 640; Bainton, "Michelangelo and Vittoria Colonna," 40, speaks of "the general tendency of the Catholic liberal reform to restore primitive Christianity."

55. Pastor, *History of the Popes*, 11:495–96, comments that the Italian religious situation in the 1530s and early 1540s was extremely complex, a judgment that appears to be related to the transitional nature of the period.

56. Elton, *Reformation Europe*, 185.

57. Fenlon, *Heresy and Obedience*, 47; Elton, *Reformation Europe,* 183–86; Pastor, *History of the Popes*, 11:94–95, 142–44, 159 (including Cardinals Carafa, Sadoleto, and Pole).

58. For the *Consilium de Emendanda Ecclesia* (1537, published 1538), see Olin, *Catholic Reformation,* 182–97, which includes a full transcription. The document refers to the teachings of Augustine and expresses a desire to turn back to Christ (197); Cardinals Contarini, Carafa, Sadoleto, and Pole were among the signatories.

59. See Delio Cantimori, "Submission and Conformity: Nicodemism and the Expectations of a Conciliar Solution to the Religious Question," in Eric Cochrane, ed., *The Late Italian Renaissance, 1525–1630* (London: Macmillan, 1970), 244–65; Jung, "Evangelism," 518–19; Heiko A. Oberman, "The Nicodemites: Courageous Alternative to the Refugee," in E. I. Kouri and Tom Scott, eds., *Politics and Society in Reformation Europe*

(London: Macmillan, 1987), 15–20; Shrimplin, "Michelangelo and Nicodemism," (where Michelangelo's self-portrait as Nicodemus in the Florentine *Pietà* is argued as evidence for his involvement with the movement), and idem, "Once More, Michelangelo and Nicodemism," *Art Bulletin* 71 (1989): 693–94, for further details and references for the post-1542 situation.

60. Jung, "On the Nature of Evangelism"; also by Schutte, "Lettere Volgari," 639–88, esp. 662, and Cantimori, "Italy and the Papacy."

61. Jung, "Evangelism," 513–14, and others have argued a relationship between the spiritual emphasis of the movement and Neoplatonic thought, derived from Ficino as much as, for example, from John 3:6. Calvin also recognized the combination of the Italian reformers' ideas with Neoplatonism, since he accused them of reducing Christianity to a philosophy full of Neoplatonic ideas. John Calvin, *Three French Treatises,* ed. Francis M. Higman (London: Athlone Press, 1970), 139–40; see Carlos N. M. Eire, "Calvin and Nicodemism: A Reappraisal," *Sixteenth Century Journal* 10 (1979): 45–69.

62. Steinberg, "Corner of *Last Judgment*," 209–10; Tolnay, *Michelangelo*, 1975, 104–7.

63. Elton, *Reformation Europe*, 196. The doctrine of justification by faith was not specifically heretical prior to the Council of Trent (held in three sessions 1545–47, 1551–52 and 1561–63). For Catholics, the concept had its basis in Augustinian doctrine, not Lutheran. Contarini attempted to present a solution amenable to all (which he termed "double justification") when he represented the Pope at the Colloquy of Regensburg in 1541 (Fenlon, *Heresy and Obedience*, 57–59); and Pole advised Colonna "to believe as if her salvation depended upon faith alone, and to act, on the other hand, as if it depended upon good works"; Fenlon, *Heresy and Obedience*, 96.

64. Hall, "Michelangelo's *Last Judgment*." For further discussion on these issues see Fenlon, *Heresy and Obedience,* esp. 53–54; Oliver M. T. Logan, "Grace and Justification: Some Italian Views of the Sixteenth and Early Seventeenth Centuries," *Journal of Ecclesiastical History* 20 (April 1969): 67–78, and Marvin W. Anderson, "Luther's *Sola Fide* in Italy," *Church History* 38 (1969): 17–33. Cardinal Pole supported the doctrine of justification by faith, and since he was very nearly elected pope as late as 1549 this could well have become official; Fenlon, *Heresy and Obedience*, 200, 227–29.

65. For Valdés, see José Nieto, *Juan Valdés and the Origins of the Spanish and Italian Reformation* (Geneva: Droz, 1970; Fenlon, *Heresy and Obedience*, chap. 5; Williams, *Radical Reformation*, 819–29; and Anne Jacobson Schutte, *Pier Paolo Vergerio: The Making of an Italian Reformer* (Geneva: Droz, 1977).

66. The mysticism of Italian Evangelism was derived from Spanish Illuminism, and the term "Valdésiani" came to stand for all the *Spirituali* and for the whole movement of Evangelism, which was characterized more by a common attitude than by a defined theological system; Jung, "Evangelism," 514. For the relationship between Valdés, the *Spirituali* and the Protestants, see Nieto, *Valdés*, 334–35.

67. For the origins of the Illuminist or Alumbrado movement in Spain, see Nieto, *Valdés*, 56–57; for Valdés' doctrine of the illumination of the spirit, see 232–39.

68. For Valdés' use of sun and light symbolism, see Nieto, *Valdés*, esp. 202–10 and 232–39.

69. Nieto, *Valdés*, 240 n. 170.

70. Valdés, *Considerationes*, 46, quoted in Nieto, *Valdés*, 212–13. Nieto discusses common ground between the thought of Valdés, Augustinian doctrine, and the Neoplatonic revival. He comments especially on similarities in the use of sun and light symbolism and the spirit/flesh dichotomy; 96–97, 108–11, 233–34, 294.

71. The Gospel of Nicodemus was popular during the medieval period, and a vernacular version circulated in late-fifteenth-century Italy. See Gesta Salvatoris, ed. H. C. Kim, *The Gospel of Nicodemus* (Toronto: Centre for Medieval Studies, 1973); Wolfgang

Stechow, "Joseph of Arimathea or Nicodemus?" *Studien zur Toschanischen Kunst,* Festschrift Heydenreich, ed. W. Lotz and L. L. Moller, (Munich: Prestel, 1964), 298. Although Nicodemism as a movement increased in the post-1542 period, it is not unreasonable to suggest an interest in this Gospel already by the 1530s.

72. Shrimplin, "Michelangelo and Nicodemism," esp. 60. See also a later paper by Jane Kristof, "Michelangelo as Nicodemus: The Florence *Pietà*," *Sixteenth Century Journal* 20 (1989): 163–82.

73. Montague Rhodes James, *The Apocryphal New Testament* (Oxford: Clarendon, 1969), 94–146, esp. 123–24.

74. An original copy of the first edition 1543, which is small and easily portable (actual size 75 mm x 106 mm, 3"x 4.25"), exists in the Library of Saint John's College, Cambridge. See Ruth Prelowski, *The Beneficio di Cristo,* translated with an introduction, in *Italian Reformation Studies in Honor of Laelius Socinus,* ed. John A. Tedeschi, (Florence: Le Monnier, 1965), 21–102; Elisabeth Gleason, *Reform Thought in Sixteenth-Century Italy* (Ann Arbor: American Academy of Religion, 1981), 103–217; Fenlon, *Heresy and Obedience,* 73–88, discusses its dating and summarizes its content. Written in the vernacular, the *Beneficio di Cristo* was popular with laity.

75. "It was read and discussed in manuscript form before its publication" (Gleason, "Italian Evangelism," 10), and was defended and circulated by Pole and other members of the Curia, especially the signatories of the *Consilium* (Prelowski, ed., *Beneficio di Cristo,* 23–24; Gleason, *Reform Thought,* 103). The *Beneficio* was eventually condemned by the Inquisition and was included in the first Venetian Index, published by Giovanni della Casa in 1549; see Prelowski, *Beneficio di Cristo,* 24.

76. Prelowski, ed., *Beneficio di Cristo,* 26–27; Barry Collett, *Italian Benedictine Scholars and the Reformation* (Oxford: Clarendon, 1985).

77. Prelowski, ed., *Beneficio di Cristo,* 38–40.

78. Prelowski, ed., *Beneficio di Cristo,* 58: "God so loved the world, that he gave his only begotten Son, that whosoever believes in him should not perish but may have life eternal. God did not send his Son into the world so that he might judge it, but so that the world might be saved through him," John 3:16–18. According to the *Beneficio,* 53, 92, to claim that salvation comes through our own works and maintain that Christ's sacrifice was not enough is ingratitude and to call God a liar.

79. Prelowski, ed., *Beneficio di Cristo,* 59: "I came into the world as a light, so that everyone who believes in me may not remain in darkness," John 12:46, 69–70, 94. Christ is perceived as Lord of the Universe, 67, 73.

80. See for example, André Grabar, *The Beginnings of Christian Art* (London: Thames and Hudson, 1967); André Grabar, *Christian Iconography: A Study of its Origins;* David Talbot Rice, *Byzantine Art* (Harmondsworth: Penguin, 1968); John Beckwith, *Early Christian and Byzantine Art* (Harmondsworth: Penguin, 1970); Schiller, *Iconography of Christian Art;* Michael Gough, *The Origins of Christian Art* (London: Thames and Hudson, 1973).

81. Tolnay and others have referred to the concept of Michelangelo's beardless Christ appearing like an Apollo (Tolnay, *Michelangelo,* 5:47), but the comparison with the pagan Apollo receives far more emphasis than the Christianized form (cf. Tolnay, *Michelangelo,* 5:47, "the figure of the nude pagan god"). Tolnay claims that the artist has expressed the Christian content by means of a pagan form, rather than emphasize the fact that the beardless type of Sun-Christ was a wholly Christianized iconographic type, to which Michelangelo was probably presenting a conscious reference and for very specific reasons.

82. Steinberg, "Merciful Heresy," 49.

83. For comment on the origins and complex iconography of the halo and aureole, see Edwin Hall and Horst Uhr, "*Aureola super Auream*: Crowns and Related Symbols in Late

Gothic and Renaissance Iconography," *Art Bulletin* 67 (December 1985): 568–603. Apart from the circular gold area around Christ, Michelangelo dispenses with haloes altogether in the *Last Judgment*. Thin circlets had replaced golden discs in many sixteenth-century works and are also sometimes omitted altogether, for example in works by Leonardo da Vinci, and in several of the paintings by various artists on the lower lateral walls of the Sistine Chapel.

84. Visual material related to existing known forms was thus used to reinforce the scriptural analogy of Christ as the Light of the World or the sun. See esp. Rahner, *Greek Myths and Christian Mystery*, chap. 4.

85. Shapiro, *Late Antique, Early Christian and Medieval Art*, 115–25.

86. This problem is discussed in *Encyclopedia of World Art*, vol. 3, cols. 596–600.

87. See table of comparison in Hannay, *Symbolism*, 314.

88. Within the Christian Church, as also in ancient Roman times, the wearing of a beard was often less a matter of personal choice or fashion than a symbolic or religious gesture, which merits some comment here. The beardlessness of the Graeco-Roman sun god (Apollo-Helios) probably derives from his role as a warrior (Alexander the Great prohibited beards in his armies in battle, so they could not be seized by an opponent). According to the Bible, to cut off the beard signified mourning (Isa. 15:2, Jer. 48:37) as in ancient Roman culture. Beards had generally been discouraged among the clergy in the Western Church although worn in the East in emulation of Christ, but increased in popularity in the sixteenth century; *Catholic Encyclopaedia*, 2:362–63. Many sixteenth-century Popes were beardless (Leo X, Julius III, Marcellus II, and Paul IV), others bearded (Paul III). Clement VII grew a beard specifically as a sign of mourning after the Sack of Rome, 1527; conversely, Julius II shaved his beard in 1512 "because things were going well"; see Loren Partridge and Randolph Starn, *A Renaissance Likeness* (Los Angeles: University of California Press, 1980), 42–47.

89. For example, at Hosios David in Thessaloniki, fifth century; Grabar, *Christian Iconography*, 117 and fig. 280.

90. Graves, *Greek Myths*, 77.

91. Michelangelo's knowledge of the type at Ravenna is not necessarily to be excluded since he visited nearby Ferrara in 1530.

92. Antonio Paolucci, *Ravenna: An Art Guide* (Ravenna: Edizioni Salera, 1971); Patizia Angiolini Martinelli, *L'immagine di Cristo nell'antica arte Ravennate* (Faenza: Fratelli, 1969).

93. Vasari, Preface to the *Lives* (ed. de Vere, 28–29, 33–35; ed. Bull, 33, 38, 45).

94. See Meyer Shapiro, *Late Antique, Early Christian and Medieval Art* (London: Chatto and Windus, 1980), 115–25, for discussion of Christ as sun symbol at Castelseprio.

95. For the sixteenth-century revival of the central-domed plan, see Rudolf Wittkower, *Architectural Principles in the Age of Humanism* (London: Tiranti, 1962). Wittkower argues that the popularity of the harmonious circular plan was based on the known cosmic significance of buildings like Sta Costanza, Rome (fourth century) and also related to the writings of Alberti and Filarete on domes and circles and their symbolic meaning. For recent study of the contacts between Michelangelo and Bramante, see Charles Robertson, "Bramante, Michelangelo, and the Sistine Ceiling," *Journal of the Warburg and Courtauld Institutes* 49 (1986): 91–105. It is perhaps significant that when Michelangelo later reverted to the centralized plan in his design for Saint Peter's, he was accused of creating a church "in the image of the sun's rays"; Ramsden, *Letters*, 2:291 and 309–10.

96. See John Shearman, *Raphael's Cartoons in the Royal Collection* (London: Phaidon, 1972), 7, and Leopold D. Ettlinger, *The Sistine Chapel Before Michelangelo* (Oxford: Clarendon, 1965), 12, "the Return to Early Christian Usage."

97. See Fabrizio Mancinelli, *Catacombs and Basilicas: The Early Christians in Rome* (Florence: Scala, 1987); Gough, *Origins of Christian Art*.

98. E. Kirschbaum, *The Tombs of St. Peter and St. Paul* (London: Secker and Warburg, 1959), 25.

99. Nicole Dacos, *La Découverte de la Domus Aurea et la Formation des Grotesques à la Renaissance* (London: Warburg Institute, 1969); Sven Sandstrom, *Levels of Unreality: Studies in Structure and Construction in Italian Mural Painting During the Renaissance* (Uppsala: Almquist and Wiksells, 1963), 20.

100. Vasari, *Lives*, (ed. de Vere, 1833–35; ed. Bull, 327–28.). Compare Condivi, *Life of Michelangelo*, 9–10.

101. Condivi, *Life of Michelangelo*, 9–10, 25, and fig. 21; for Michelangelo's drawing of *The Archers*, see Hirst, *Michelangelo Drawings*, color plate 6.

102. Benvenuto Cellini, *Autobiography*, trans. G. Bull, (Harmondsworth: Penguin, 1966), 63.

103. Vasari, *Lives*, (ed. de Vere, 37; ed. Bull, 37).

104. Kirschbaum, *Tombs of St. Peter and St. Paul*, 25; George Holmes, *Florence, Rome, and the Origins of the Renaissance* (Oxford: Clarendon, 1986), 132–33. For Michelangelo's involvement with the rebuilding of Saint Peter's see Murray, *Life, Work and Times*, 202–6.

105. Kirschbaum, *Tombs of St. Peter and St. Paul*, 35–39. Kirschbaum also mentions here the Christian adaptation of the sun symbolism of antiquity, Christ-Helios, (pp. 40–42), relating it, in the context of this mosaic, to the liturgical explanation of Sunday (Day of the Sun).

106. The earliest description of the tomb was that of Tiberio Alfarano (1574), but Kirschbaum's records of the 1950s excavations show it had been opened previously, as for example, when its entrance had been walled up by the foundations for a column for the new Saint Peter's at an unspecified date in the sixteenth century (p. 36).

107. See Mancinelli, *Catacombs and Basilicas*, 51–59; William Oakeshott, *The Mosaics of Rome* (London: Thames and Hudson, 1967); Hautecoeur, *Mystique et Architecture*, 186–87, discusses several examples where the sun analogy is signified even if Christ is not beardless (see figs. 110–20 and fig. 136, a reconstruction of the apse of the Old Saint Peter's). The mosaics of Old Saint Paul's were destroyed by fire in the nineteenth century, but G. Parthey, ed., *Mirabilia Roma* (Berlin, 1869), described the mosaics: "The majestic head of the Lord appears like the sun god amid his rays" (cited by Kirschbaum, *Tombs*, 193–94).

108. For these see Oakeshott, *Mosaics of Rome*, 73–89; Grabar, *Christian Iconography*, 139–40 and fig. 274, *Three Celestial Visitors*.

109. Condivi, *Life of Michelangelo*, 90 and 140 n. 101.

110. Examples are numerous; see Grabar, *Beginnings of Christian Art*, fig. 304 (ivory), and idem, *Christian Iconography*, figs. 113 (terracotta), 171 (glass vase), 204 (ivory diptych).

111. Roberto Weiss, *The Renaissance Discovery of Classical Antiquity* (Oxford: Blackwell, 1969), discusses the Renaissance attitude toward ancient remains and artifacts, both classical and pagan. He gives details of several writers and collectors (Biondo, Rucellai, Fulvio) who showed an interest in Late Antique Christian works as well as ancient pagan remains, and he detects an enthusiasm for early Christian mosaics and other late antique Christian masterpieces in the mid-fifteenth century (chap. 6). Commenting on interest in remains outside Rome itself, he also mentions the circulation of publications in the late fifteenth and early sixteenth century concerning the early Christian remains at Ravenna (108–9, 123–24) and the collecting of early Christian inscriptions (157). He also notes that the collection of Lorenzo de' Medici included early Christian ivories (186–87).

112. Tolnay, *Michelangelo*, 3:65, emphasizes Michelangelo's reference to ancient sarcophagi, for example, in the Medici tombs.

113. Phyllis Pray Bober and Ruth O. Rubinstein, *Renaissance Artists and Antique Sculpture* (Oxford: Oxford University Press, 1986), esp. 31, 50, 69–72, 76–77.

114. See John Pope-Hennessy, *Italian Gothic Sculpture* (London: Phaidon, 1972).

Pope-Hennessy also draws attention to Maitani's incorporation of "lost souls" emerging from antique sarcophagi in his *Last Judgment* panel at Orvieto (19–21).

115. Illustrated in Peter and Linda Murray, *The Art of the Renaissance* (London: Thames and Hudson, 1971), 255.

116. Grabar, *Beginnings of Christian Art*, 246–49 and figs. 41, 273–75.

117. See Mancinelli, *Catacombs and Basilicas;* Grabar, *Beginnings of Christian Art*, and idem, *Christian Iconography,* for further examples of Early Christian sarcophagi and statuettes discovered at various dates in and around the Vatican. The majority show the beardless Christ.

118. Jean Seznec, *The Survival of the Pagan Gods: The Mythological Tradition and Its Place in Renaissance Humanism and Art* (New York: Harper, 1961); Edgar Wind, *Pagan Mysteries in the Renaissance* (Oxford: Oxford University Press, 1980).

119. For the Renaissance attempts to incorporate classical thought with Christian philosophy, see especially Wind, *Pagan Mysteries.*

120. Blunt, *Artistic Theory*, 109.

121. For Apollo Belvedere, see Tolnay, *Michelangelo*, 5:113. Clement VII was responsible for the purchase of the Belvedere Torso, another possible reference to Apollo. See A. Levy, "A Papal Penchant for Classical Art" and "The Tormented History of the Apollo Belvedere," *Art News* (October 1981): 86–89 and 124–25. Other pagan classical works extant in Rome that may be pertinent include the Horsetamers on the Capitoline. Their striding poses with upraised arms, in particular, appear to be related to Michelangelo's Christ See Edit Pogány-Balás, *The Influence of Rome's Antique Monumental Sculptures on the Great Masters of the Renaissance* (Budapest: Akademiai Kiado, 1980), plates 1–7.

122. Tolnay, *Michelangelo*, 5:47; idem, *Michelangelo* (1975), 59.

123. Tolnay, *Michelangelo*, 5:38. Réau, *Iconographie*, makes similar comments concerning "Le paganisme foncier de Michel-Ange," 753; also, more recently, Liebert, *Psychoanalytic Study*, 355.

124. That the Reformation took place at all is a reflection of the deep religious feeling of the age, not, as is often supposed, a symptom of growing agnosticism. It is difficult to see how any part of Dante's *Divina Commedia*, even the inclusion of Charon and Minos, could be regarded as pagan.

125. For example, the *Godescal Evangelistary,* c. 781. Denis Thomas, *The Face of Christ* (London: Hamlyn, 1975), 55; the Metz fragment, c. 870 (Thomas, *The Face of Christ,* 56); the Gero Codex, tenth century (Thomas, *The Face of Christ,* 32); the Pantheon Bible, twelfth century, André Grabar, *Romanesque Painting* (Geneva: Skira, 1958), 137; Bodleian Bible, twelfth century (Thomas, *Face of Christ*, 54).

126. Otto Demus, *The Mosaics of San Marco in Venice* (Chicago: University of Chicago Press, 1984), vol. 2, plates, fig. 16. Michelangelo's several visits to Venice are recorded. Another thirteenth-century example, in Rome itself, is to be found in S. Giovanni a Porta Latina, illustrated in Zahlten, *Creatio*, fig. 23.

127. The apse of Sta. Maria Maggiore, Rome was restored in mosaic at this time. Chastel notes a similar revival of the fashion for mosaic icons in the late fifteenth century, for example, Florence, Duomo, as part of a "dream of restoring the splendour of paleo-Christian painting." See André Chastel, *The Flowering of the Italian Renaissance* (New York: Odyssey, 1965), 81; Oakeshott, *Mosaics of Rome,* chap. 7, "The Roman Renaissance as expressed in Mosaics."

128. As mentioned, the "mighty angel" of Rev. 10:1, whose face was "as it were the sun," is identified with Christ.

129. Quoted by Ernst H. Gombrich, "Criticism in Renaissance Art," in Charles S. Singleton, ed., *Art, Science and History in the Renaissance* (Baltimore: Johns Hopkins, 1967), 11. Even though Michelangelo would not have known it, the Christ of the *Resurrection*

in Grunewald's *Isenheim Altarpiece* (1509–11) is another excellent (northern) example of Christ as a Sun symbol.

130. Beck, *Italian Renaissance Painting*, fig. 57.

131. Marita Horster, *Andrea del Castagno* (Oxford: Phaidon, 1980), 25–26.

132. Horster, *Andrea del Castagno*, 25. Horster compares Castagno's Christ here with the beardless Christ painted by Piero della Francesca on the pinnacle of his *Madonna della Misericordia*. The Venetian mosaic (fig. 82) is again a possible source, since Castagno lived and worked in Venice in 1442.

133. Horster, *Andrea del Castagno*, fig. 169; Lionello Venturi, *Italian Painting* (Geneva: Skira, 1950), 158. About the same date, the same facial type occurs in the *Baptism* by Francesco Francia; Thomas, *Face of Christ*, 16.

134. Lightbown, *Botticelli*, 1:112–13, 140, color plate 6 and plates 38 and 51.

135. Lightbown, *Botticell*, 112. See 40–41, 88–89, for Angelo Poliziano (Politian) and his influence on Botticelli. See Murray, *Michelangelo, Life, Work and Times*, 16, for his influence on Michelangelo.

136. Thomas, *Face of Christ*, 15.

137. Eve Borsook and Johannes Offerhaus, *Francesco Sassetti and Ghirlandaio at Santa Trinità, Florence* (Doornspijk: Davaco, 1981), 31, fig. 19 and figs. B and C.

138. Engler, *Die Sonne*, fig. 585. Similar but earlier examples of this type of symbol are given by Baltrusaitis, "Quelques Survivances," 75–82; see also Francesco Negri Arnoldi, "L'Iconographie du Soleil dans la Renaissance Italienne," Université de Brussels, *Le Soleil à la Renaissance*, Colloque International (Brussels: Presses Universitaires de Bruxelles, 1965), 519–38.

139. Beck, *Italian Renaissance Painting*, fig. 380; Thomas, *Face of Christ*, 22. Compare Caravaggio's version as late as 1600 where Christ is also beardless (38) and other examples of the type even in modern times (52).

140. See Michael Hirst, *Sebastiano del Piombo* (Oxford : Clarendon, 1981), plates 75 and 79 and pp. 59, 123–24 and 143–44, for the strong links between Michelangelo and Sebastiano in the early 1530s. See also Hartt, *Italian Renaissance Painting*, fig. 565. For other examples, see also M. Wheeler, *His Face: Images of Christ in Art* (New York: Chameleon, 1989), e. g., the *Flagellation* by Bacchiacca, 1494–1559.

141. See Tolnay, *Michelangelo* (1975), fig. 245, and Venturi, *Michelangelo*, plates 219–25, where the representations of Christ are all beardless.

142. Steinberg, "Merciful Heresy," 49.

143. Wingless angels are common in Sta. Maria Maggiore and other Early Christian sites, and not unknown in the Renaissance, for example in the work of Donatello, such as the S. Croce *Annunciation*, where some are winged, others not: John Pope-Hennessy, *Donatello, Sculptor* (New York: Abbeville, 1993); also see Leonardo's angel in Verocchio's *Baptism*, 1470–73, fig. 8 above. It may be argued that, in view of the inclusion of winged angels in the earlier sketches for Michelangelo's Sistine ceiling and their omission in the final scheme, the ignudi are to be read as "wingless angels."

144. Although seized on by Michelangelo's critics, haloless saints were common not only in Early Christian works but also in the Renaissance, for example, Leonardo da Vinci's *Last Supper*, 1495–98, and Raphael's *Transfiguration*, 1518–20.

145. Compare figs. 76 and 89. See also Bainton, "Vittoria Colonna and Michelangelo," 40: "in this mode of treatment Michelangelo was returning to the styles of the earliest portrayals of the crucifixion in the fifth century . . . he was in line with a general tendency of the Catholic liberal reform to restore primitive Christianity."

146. Anton Francesco Doni, *Letter to Michelangelo*, 1543, quoted by Murray, *Michelangelo, Life, Work and Times*, 164.

147. Dante Alighieri, *The Divine Comedy: Inferno, Purgatorio, Paradiso*, 3 vols., ed. and trans. Allen Mandelbaum (New York: Bantam, 1982–86).

Chapter 6

Literary Sources

No object of sense in all the universe is more worthy
to be made the symbol of God than the sun which
enlightens with the light of sense itself.
—*Dante Alighieri*
Convivio 3, 12[1]

Italian Renaissance Literature

Literary sources available during the Renaissance demonstrate continuing
interest in the traditional theological interpretation of Christ in terms of the
sun symbol, as well as continuing interest in cosmology in general. While
the tracing of similarities is not necessarily proof of literary dependence,
discussion of the type of literature available at the time of Michelangelo can
help us to assess the popularity of ideas like the cosmological Sun-Deity
analogy. Space does not allow consideration of the full range of Italian
Renaissance writings and their dissemination, but a major emphasis may
reasonably be placed upon the writings of Dante, long regarded as an
established source for Michelangelo. Although the writings of other poets,
including Vittoria Colonna and Michelangelo himself, may be considered
as evidence of continued interest in sun symbolism and cosmology in the
Renaissance, Dante's works may be used to clarify prevalent general beliefs
about cosmology and the arrangement of the universe from the early
Renaissance period, as well as for their relevance specifically as a source
for Michelangelo. A brief examination of the *Divina Commedia* (begun c.
1307–1308) confirms the wide use of the overall cosmological approach
and of sun symbolism, suggesting how Michelangelo's knowledge of the
scriptural and Early Christian written and visual images of the Sun-Deity
analogy were likely to have been reinforced by his knowledge of Dante.

_____The *Divina Commedia* of Dante Alighieri

The writings of Dante Alighieri (1265–1321) were among the most popular in Italian literature, and during the Renaissance period, as Lightbown neatly expresses it, "the *Divina Commedia* was a household book to the Florentines."[2] Michelangelo is known to have been particularly well versed in Dante's writings, as is confirmed by contemporary sources. Condivi states that Michelangelo "especially admired Dante . . . whose work he knows almost entirely by heart"[3]; Vasari confirms this, and comments that Michelangelo "was especially fond of Dante whom he greatly admired, and whom he followed in his ideas and inventions."[4] Michelangelo's interest in Dante is also confirmed by other contemporaries of Michelangelo, such as Benedetto Varchi.[5] The issue has also received emphasis in more recent art historical discussion of Michelangelo,[6] and various works of his have been assessed as reliant on Dante for their source material, such as his *Lamentation* drawing for Vittoria Colonna and the well-known figures of Charon and Minos from Dante's *Divina Commedia,* which are included in the *Last Judgment* itself.[7] Apart from these themes, commonly emphasized as originating in Dante, other subjects treated by Michelangelo could also have been derived from this source, reinforcing the idea of Michelangelo's knowledge and use of Dante's poetry. For example, themes connected with the Julius tomb,[8] the Sistine ceiling, and the presentation drawings[9] are prominent in Dante's *Divina Commedia.* However, the major part of the discussion surrounding Dante as source material for Michelangelo has centered on the fresco of the *Last Judgment* itself.

Both Condivi and Vasari refer to Dante's *Divina Commedia* as a specific influence upon Michelangelo's *Last Judgment.* Condivi comments on the depiction of Charon, "exactly as Dante describes him in his *Inferno.*"[10] Vasari states that, in the figures of Charon and Minos, Michelangelo "was following the description given by his favorite poet, Dante," and he also refers to the *Last Judgment* when he comments "the paintings he [Michelangelo] did were imbued with such force that he justified the words of Dante: 'Dead are the dead, the living truly live.'"[11] Following from such contemporary observation, the *Divina Commedia* (particularly the *Inferno*) has been widely discussed as a source used by Michelangelo for elements in the *Last Judgment.*

Redig de Campos comments on the necessity for caution in claiming Dante as a direct source in the *Last Judgment.*[12] He comments on the two characters that are directly traceable to Dante (Charon and Minos, respectively *Inferno* 3:76–136 and 5:4–24) as the only certain ones, but maintains that there is a "reminiscence" in the central circular group surrounding Christ of the Mystical Rose in Dante's *Paradiso.* He concludes: "the influence of Dante is limited."[13] Tolnay also emphasizes similar isolated features and concludes: "only the motifs of Charon and Minos

seem to revert directly to Dante." Referring to classical legend rather than to Dante himself, he views their inclusion as an expression of Michelangelo's "fundamental paganism."[14]

More recently, Steinberg has commented on the presence of "Charon of pagan legend" as "out of place" in the *Last Judgment*,[15] even though, as will be demonstrated, reference to Charon became a common *Last Judgment* motif in the period following Dante's *Divina Commedia*. Steinberg further examines the importance of Dante for the fresco, but he confines his remarks, like most other commentators, largely to the debate surrounding the inclusion of Charon and Minos.[16]

Discussion has thus centered on the inclusion of Charon and Minos, but there are other highly significant aspects of Dante's great work that might be argued as influential on Michelangelo's fresco. These have so far received very little attention. Not only the *Inferno*, but also the *Purgatorio* and the *Paradiso* may be viewed as source material for certain features of *Last Judgment* iconography in general and Michelangelo's *Last Judgment* fresco in particular. Dante's great literary work is not only noted for his metaphysical interpretation of the cosmological arrangement of the universe based on the perfection of the circular form, but also, significantly, for the all-pervading theme of the depiction of the deity as symbolized by the sun. In addition, visual interpretations of such themes in Dante's work that survive show that, in specific details as well as in the broader cosmological approach, correspondences may be discerned between Dante's writings and *Last Judgment* iconography. Dante had provided source material for the iconography of the *Last Judgment* well before the time of Michelangelo, as examples postdating the *Divina Commedia* demonstrate.

Visual Images

Relevant visual material and images include not only direct illustrations of manuscript texts of the *Divina Commedia*, but other works such as depictions of Heaven and Hell, which were clearly influenced by Dante's work. In the Duomo, Florence, a portrait of Dante himself has been combined with an illustration of Hell, Purgatory, and the celestial spheres of Heaven (1465) in accordance with the *Divina Commedia* (fig. 90); more prevalent than this type is the inclusion in versions of the *Last Judgment* itself of scenes of Heaven and Hell that relate directly to Dante's interpretation and show the widespread influence of Dante's writings. Meiss discusses the effect the *Divina Commedia* might have had on *Last Judgment* iconography in Italy from the fourteenth to the sixteenth century, and clearly demonstrates the interaction between Dante's description of Hell and popular depictions of the Last Judgment.[17]

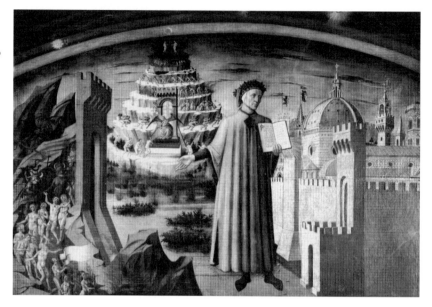

90 Domenico di Francesco
(called Michelino), *Dante
and his Poem*, 1465. Fresco,
Santa Maria del Fiore,
Florence.

Giotto is known to have been a close friend of Dante, and common
ground or reciprocal influence seems evident in the case of the *Last
Judgment* at Padua (1305). The *Last Judgment* by Nardo di Cione in the
Strozzi Chapel, Sta. Maria Novella, c. 1345–57 (fig. 37), includes a portrait
of Dante among the Blessed, and the fresco of the *Inferno* on the adjacent
wall (fig. 38) relates closely to his writings. This is a striking example of
the effect of Dante's cosmology on the iconography of the *Last Judgment*
and demonstrates that it was considered in literal and physical terms,
not just as a metaphysical system. The Strozzi *Judgment* draws away from
tradition in placing separate scenes on different walls. It bears some
relation to Dante's *Divina Commedia*, both in episodic approach to the
individual areas of Heaven and Hell and in specific details in different
areas. The fourteenth-century frescoes by Traini in the Camposanto at Pisa
(fig. 40) similarly relate to Dante's poem in both composition and subject
matter.[18] Signorelli's inclusion of a portrait of Dante in a lower register in
his series of frescoes at Orvieto, 1499–1500 (figs. 47, 48), also suggests a
consciousness of the descriptions in *Inferno* and *Paradiso*. Here, the *Last
Judgment* is again broken up into distinct areas. The influence of the *Divine
Comedy* is thus reflected in several important versions of the *Last Judgment,*
especially notable in the way some deviated from the traditional format.
Reference to Dante's *Inferno* had increasingly become the norm, and totally
expected and acceptable for Italian depictions of the Last Judgment in the
centuries following Dante.

In addition to the influence of Dante on *Last Judgment* iconography
in general, it is important to consider the actual form of the manuscripts of
the *Divine Comedy* that were circulated with illustrative material alongside

the written text. Several fourteenth- and fifteenth-century manuscript copies of the *Commedia* survive, with accompanying illustrations as well as commentaries.[19] Approximately thirty illuminated manuscripts remain that contain comprehensive illustrative schemes, serving a function similar to the commentaries, namely to elucidate the text. Another highly important set of illustrations to the *Divine Comedy* was the series of drawings (of which ninety-two survive) made by Botticelli for Lorenzo di Pierfrancesco de' Medici.[20] These were much admired, and nineteen of Botticelli's drawings, engraved by Baccio Bandini, were included in the first printed edition of Dante issued "with great fanfare" in 1481, together with a commentary by the Neoplatonist Cristoforo Landino (1424–92).[21]

As Panofsky points out, "Nobody read Dante without a commentary." Since Landino's *Dante* remained standard until 1544 and Michelangelo was "no less familiar with this commentary than with the Dante itself,"[22] this edition merits special attention. It is of particular significance for the present hypothesis because of the Neoplatonic interpretation Landino gave to Dante's text. Dante was, of course, primarily a follower of Aristotle (described by him as "the master of men who know," *Inferno*, 4:131), but also expressed great interest in Socrates and Plato. Dante's writings were also very much informed by the medieval scholastics and Thomism, but, by the late fifteenth century, especially with the work of Landino, a Neoplatonic interpretation was given to the work. Indeed, Dante himself had pointed out Platonic overtones in his work, and several authors have suggested that Platonism became available to the Florentines partly through the work of Dante.[23]

Landino himself was very much a part of the erudite circle attached to the house of the Medici, with which Michelangelo was also to become closely associated.[24] Perhaps because of this association, in Landino's commentary "every line of the poet is interpreted on Neoplatonic grounds," and there is a particular emphasis on the idea (also discussed by subsequent commentators) that Dante had based some of his concepts on Plato's thought.[25] In his *Proemio* to his *Commentary on the Divina Commedia*, Landino describes Aristotle as "a man of great intellect and in learning, apart from Plato, exceptional," demonstrating his emphasis on the superiority of Plato and the basis of his Platonic reading.[26] In view of Michelangelo's known interest in Neoplatonism, Landino's *Commentary* with its emphasis on the Neoplatonic content of the *Divina Commedia* is particularly significant.[27]

Dante's Cosmology

In the *Divina Commedia*, Dante describes his journey as he is guided through the nine circles of Hell extending downward in a conical cavity to the

center of the earth's sphere. Emerging on the opposite hemisphere, he visits the mountain of Purgatory, then ascends, through the different celestial spheres, until he reaches the sphere of fixed stars and the Crystalline Heaven or Primum Mobile. Dante finally reaches the Empyrean where he beholds a vision of God and the angels (see diagrams, figs. 91 and 92).

Dante's *Divine Comedy* may be interpreted from a number of angles and on various levels. It is, at the same time, a detailed "journey through the universe" or traveler's tale told at first hand by one who had actually "been there"; an encyclopedic discussion of philosophical and theological problems; a discourse on astronomy with excursions into history, mythology, and even physics; a metaphysical "Vision" of Paradise; the autobiography of a soul; a discourse on love; a mystic and moral allegory.[28] These aspects have been discussed at length in the extensive literature, as also have the various sources, which Dante, in his erudition, used as the basis for his great work. These include numerous classical works, especially those of Aristotle, Virgil, and Ovid, and the writings of the Church Fathers, especially Pseudo-Dionysius, Saint Augustine, and Saint Thomas Aquinas.[29] As well as these sources, as mentioned above,

91 Modern diagram of Dante's system of the Universe, drawn by Barry Moser.

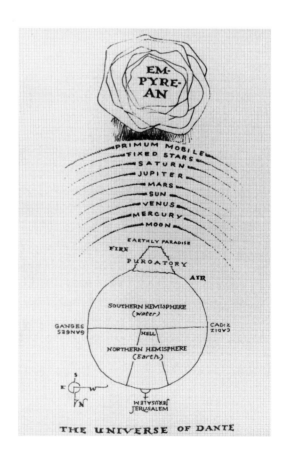

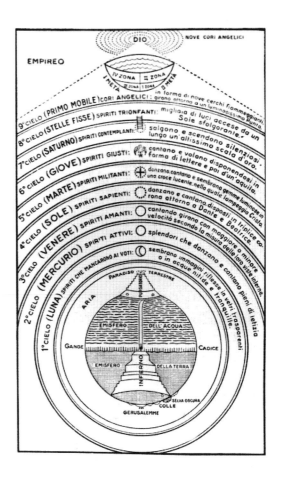

92 Modern diagram of
Dante's system of the
Universe (Provenzal).

the presence of Platonic ideas in the work has also been discussed. As
Singleton points out, the mixing of Christian and pagan sources was
not incongruous: the ancient classical writers were viewed as precursors
who had grasped the idea of truth that was later to be properly revealed
through Christianity.[30] Although Plato's works were not generally available
at this time, with the exception of the *Timaeus*, Platonism itself was
widespread and the elements of Plato's doctrines were diffused in Italy
through other writings, especially those of the early Church Fathers. The
main issue here, for the interpretation of Michelangelo's *Last Judgment*, is
not so much whether Dante was himself a Thomist, an Aristotelian, or
a Platonist, but the way in which he was likely to have been regarded
by Michelangelo and his circle, and which aspects of his works would
have been regarded as important for Michelangelo and his patrons. There
are strong reasons to consider a Neoplatonic reading of Dante in this
context, especially in view of the enormous predominance of Landino's
interpretation, which was very popular about this time. Michelangelo
knew Dante well, and in view of the approach to the *Divine Comedy*

established by Landino, a consideration of Neoplatonic overtones in the work seems appropriate.

Among the major themes in Dante that might be susceptible to Neoplatonic interpretation and that are relevant here are the cosmological framework of the *Divina Commedia* and the poet's use of light and sun symbolism, related to his expression of the sun-deity analogy as evolved from antiquity and linked to the Christian God. Dante's cosmology has been the subject of much attention and discussion and has recently been examined in depth by Boyde,[31] but not specifically as source material for Michelangelo. Dante's general cosmological framework for the universe, divided into Hell, Purgatory, and Heaven, has been represented visually both by his contemporaries and by modern commentators (see figs. 91, 92). Precise astronomical references to the sun, moon, stars, and planets have been regarded as evidence of his interest in serious scientific astronomy and cosmology, which he utilized in his attempts to explain both the metaphysical and literal arrangement of the universe. The scientific aspects of Dante's astronomy and its significance have been examined in a detailed study by Orr[32] in both its symbolic and scientific contexts. Dante's interest in an accurate scientific approach is witnessed by numerous references to actual astronomical observations in his writings, and his view of the spherical earth in a spherical universe is significant evidence of the waning of the flat-earth theory by the late Middle Ages.

Dante's writings clearly show that the concept of the earth as a globe was becoming acceptable by this time, and that the idea of a stationary spherical earth in a spherical universe was a view held by the educated classes by the fourteenth century (see representation, fig. 93).[33] The emphasis on the inherent perfection of a spherical system probably contributed to the interest shown in it.[34] At the same time, Dante clearly accepted the existence of the antipodes, where he positions Purgatory. Thus the traditional flat-earth construction, based on Scripture and the writings of men like Cosmas and Lactantius, increasingly was being questioned some time before the sphericity of the earth was confirmed by circumnavigation.[35] The idea of a spherical earth, which was known to have been considered by the ancients, had been gradually moving into common acceptance. These concepts, which had been laid in abeyance by the dominance of Christian scriptural doctrine during the Middle Ages, now came under ever-increasing reconsideration and the influence that scriptural sources held for cosmology was evidently slackening. Yet although Dante and others conceived a spherical earth and a spherical universe, the system was still imagined as having a "top" (where the Empyrean was situated) and "bottom," within the depths of Hell. The increasing variations from the earlier strict format of *Last Judgment* iconography in Italy from about this time could well be related to this questioning of the traditional cosmological formula. It has already been

mentioned that Giotto, for example, had close connections with Dante, so his looser and less strictly hieratic interpretation of the *Last Judgment* could have been formed in connection with this type of questioning of the biblical cosmological structure.

Scientifically speaking, the circular geocentric system could not account for all the movements of the planets. In addition, this system, as utilized by Dante, contained one major philosophical stumbling block. According to Dante, the earth was situated at the center of the universe but the circles of Heaven remained in hierarchical order of importance above and around the earth, and the circles of Hell in descending order below the earth's surface (fig. 91).[36] This approach was evidently based on the

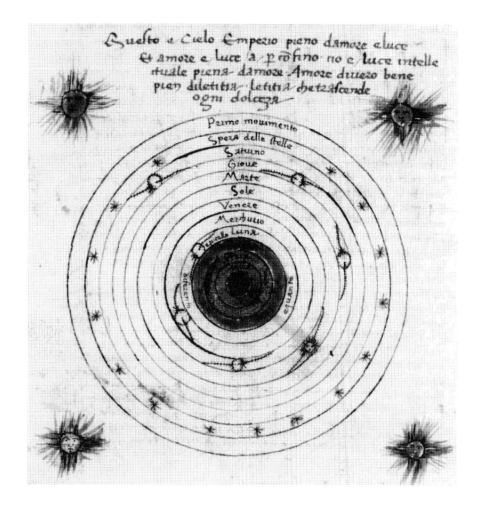

93 *Diagram of the Cosmos*, Florentine, second half of fifteenth century. Tinted schematic drawing, 295 x 220 mm, Biblioteca Riccardiana (1038, 240v), Florence.

Aristotelian system of motion, according to which heavy bodies, including those metaphorically weighed down by sin, moved in a straight line down toward the center of the universe (that is, the center of the earth); pure, light bodies tended to move in a straight line upward to the Heavens. Bodies of ethereal substance, like stars, planets, and the heavenly spheres, were the only ones that moved not in a straight line but in perfect, circular, eternal motion.[37] Medieval astronomy was closely interlinked with magic and metaphysics as well as with religion in a way that contrasts with the twentieth-century scientific approach.[38]

Since the earth was regarded as the center of the universe, the difficulty with this geocentric system was that, where the innermost circle of Hell is placed at the center of the earth, then Hell is actually at the very center of the universe.[39] The problem of a haidocentric universe that results when the flat-earth "up for Heaven" and "down for Hell" approach is juxtaposed with the known sphericity of the earth caused some concern during the Middle Ages. Many diagrams thus place the earth in the center of the system and omit any reference to Hell; others, like the so-called T-and-O maps, place Jerusalem at the center of the earth's surface, according to Ezek. 5:5.[40] In the *Divina Commedia*, Dante placed Jerusalem at the center of the Northern Hemisphere, although Hell remains the center of the earth; but he also gave serious consideration to alternative structures, including the idea that the earth revolved around the sun. This he discussed, but rejected, in the *Convivio*.[41] This demonstrates knowledge and continuing awareness of the ancient idea of the sun-centered universe in the later medieval period and early Renaissance, long before the time of Copernicus.

Sun Symbolism and Cosmology in Dante's *Divina Commedia*

Bearing in mind the above, it could therefore be argued that the influence of Dante's cosmology on Michelangelo's *Last Judgment* fresco is of greater significance than the various isolated features like the figures of Charon and Minos. The view of the universe, as primarily based on the perfect, eternal form of the circle, is common to both, and a shared source in Augustine's comments on the perfection of the circular form seems probable. An equally significant way Michelangelo could have used Dante's *Divina Commedia* as a source for his depiction of the *Last Judgment*, however, is in Dante's use of light symbolism and the analogy continually expressed between God and the sun.

Light symbolism, linked with the idea of representing the Christian God by the sun, is common in Dante's writings. In the *Convivio* he states

plainly, "no object of sense in all the universe is more worthy to be made the symbol of God than the sun which enlightens with the sense of itself."[42] But it is in the *Divina Commedia* that the potency of the theme is fully developed. Landino comments on Dante's use of "comparisons beyond compare" ("comparatione incomparabile").[43] Indeed, it has even been claimed that, apart from the Gospel of Saint John, the *Divina Commedia* is the greatest Christian writing in which God as a metaphysical concept is represented by light—and specifically as a material symbol, the sun or a point of light.[44] Sun symbolism in the *Divina Commedia* itself has been discussed extensively. Mazzeo, for example, traces its origins to the ancient notion of light as symbolic of Divinity as well as what he calls "the residue of sun mythology in the Scriptures."[45] He comments on the importance of light metaphysics in the medieval period, through the writings of the Church Fathers, emphasizing the likelihood here of the influence of Plato's famous analogy between the Good and the sun in the *Republic*.[46] Gardner also draws attention to the writings of Plato and the Neoplatonists as a source for Dante's sun symbolism, as well as the references to be found in the Scriptures, so the writings of these authors do emphasize the Platonic reading of the *Divine Comedy*.

Boyde also comments on the extensive use of the analogy[47] and important sources for Dante's use of light and sun symbolism are also traced in detail by Flanders Dunbar, who stresses Dante's use of the sun symbol for the Christian God and carefully traces the origins of the theme within the wider context of medieval symbolism in general.[48] Specific sources used by Dante are discussed, which include analysis of ancient sun worship, the Early Christian concept, and the continuance of the tradition in the Middle Ages through the agency of the Church Fathers, especially Augustine and Pseudo-Dionysius, much of which has been discussed in the context of Michelangelo's probable source material. Writing on Dante, Flanders Dunbar demonstrates the way Christianity appeared to combine its concept of the deity with the old sun gods by drawing attention to the notion of Christ as the Divine Sun, as expressed in the Scriptures.[49] The continuation of the traditional use of the sun deity analogy through the medium of Dante is emphasized.[50] In a recent publication, Priest[51] examines similar themes in the *Divina Commedia* in terms of the Trinitarian structure of the work and a relationship between the sun-deity analogy and the Trinity.[52]

The important role of light and sun symbolism in Dante's work, together with its possible Platonic overtones, has thus already received much attention, from the Renaissance commentator Landino to modern criticism. This role does not, however, seem to have been examined in relation to its possible influence on Michelangelo's use of a sun symbol. Since the *Divina Commedia* represents an accepted and easily accessible source for Michelangelo, a brief look at the way sun symbolism

is expressed in its different sections will demonstrate the way in which this literary source reinforced the traditional or Early Christian approach to the motif. The sun-deity provides the central imagery in the *Divina Commedia* as it does in Michelangelo's *Last Judgment*. Dante's cosmology in general is dependent on this symbolism: Heaven is the source of light, heat, and movement; Hell is the dark depth where Satan is frozen motionless. Actual references to sun or light symbolism in the *Divina Commedia* are far too numerous for individual discussion,[53] but such references are evidently far more numerous in the final section, *Paradiso*, than in the *Inferno*, which is the section usually claimed as source material for Michelangelo's *Last Judgment*. Yet light symbolism is evident from the very beginning of the work as a whole, since in the opening of canto 1 of *Inferno* Dante describes how, astray in a dark wood, he soon found himself on a sun-clad hill, where the light from the sun could lead him.[54] From this opening point, commentators, including Landino, take the sun to represent an image of God. Manuscript illustrations of Dante's writings of the type that were popular in Florence in the fourteenth and fifteenth centuries confirm this interpretation (fig. 94), and, conversely, the darkness of the entrance into the "cavern of Hell" is also emphasized.[55] Light, or rather the absence of it, is noted as Dante descends into the deeper and darker inner circles of Hell and the darkness of Hell is common in illustrated versions (fig. 95). Charon tells his passengers, "I come to lead you to the other shore, / to the eternal dark" (*Inferno*, 3:86–87), while Minos takes his stand in "a place where every light is muted" (*Inferno*, 5:28).[56] In their physical attributes, Michelangelo's depictions of Charon and Minos clearly relate to manuscript illuminations of the *Inferno* of a type with which he must have been familiar (figs. 96, 97), and also to Botticelli's drawings of the subject. In other words, the personages of ancient mythology had

94 *Dante Confronts the Three Beasts in the Dark Wood*, illustration to *Inferno* I, Bolognese, early fifteenth century. Miniature, 343 x 233 mm (sheet), Biblioteca Angelica (1102, 1r), Rome.

come to be regarded as "demons" in the Christian scheme; their inclusion by Dante or Michelangelo does not make the user "pagan."[57]

The innermost circle of Hell, that of Judas, is described as "the deepest and darkest place" (*Inferno,* 9:28),[58] and darkness here is clearly

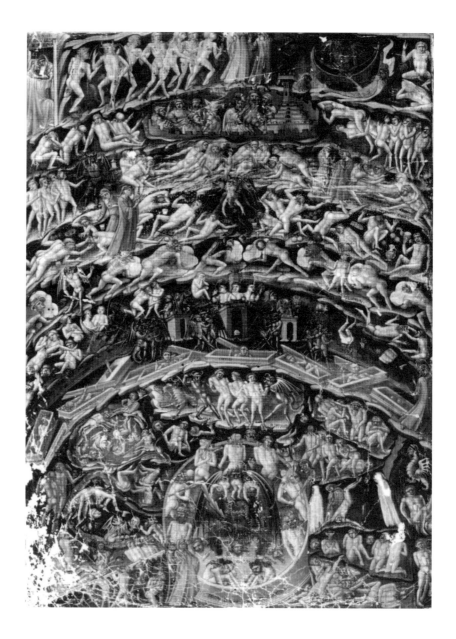

95 Bartolommeo di Fruosino, *Topography of Hell,* c. 1420. Miniature, 265 x 365 mm (sheet), Bibliothèque Nationale (it. 74, 1v), Paris.

96 *Charon Ferries Dante, Virgil and Some Souls Across Acheron*, illustration to *Inferno* III, Pisan, c. 1345. Tinted drawing, 330 x 245 mm, Musée Condé (597, 50r), Paris.

97 *Minos*, illustration to *Inferno* V, Florentine, 1405. Miniature, 400 x 293 mm (sheet), Biblioteca Trivulziana (2263, 16r), Milan.

the metaphysical and symbolic antithesis of the light of God. The innermost circle is the furthest point from the light of the Savior. In the final lines of *Inferno*, Dante's cosmology and his view of the composition of the universe are further clarified. Lucifer himself is placed in the deepest point of Hell in the very center of the earth, the three mouths of his three-faced figure holding the three worst sinners: Brutus and Cassius, betrayers of the empire and earthly monarchy, and Judas, betrayer of the spiritual Savior.[59] This is illustrated by Botticelli's drawing (fig. 98), among others. The center of the earth, and hence of the sphere of the universe surrounding it, is thus Lucifer himself. This is emphasized by Cristoforo Landino in his *Commentary* of 1481.[60]

Where Dante's view of the universe as a reflection of current concepts is concerned, it is interesting to consider his view of the central point of the universe, since Dante then goes on to pin down this point even more specifically. With Virgil, his guide, he continues the descent down Lucifer's body until they reach "the point at which the thigh revolves, just at the swelling of the hip" (*Inferno* 34:76–77).[61] At this point they become "reversed," as, now climbing upwards, they begin to make their way out

98 Sandro Botticelli,
Lucifer, illustration to *Inferno*
XXXIC, 1480s–1497. 640 x
470 mm, Staatliche Museen,
Berlin.

toward Purgatory, in the Southern Hemisphere, as seen at the bottom of
Botticelli's drawing (fig. 98). The middle of Satan's body is thus the precise
point chosen by Dante for the very center of the universe, and Botticelli's
drawing for this particular canto clearly places the center of Satan's body
in a circle, with the figures of Dante and Virgil in descent/ascent. An early
manuscript of the *Divina Commedia* adheres even more closely to Dante's
text in placing the center of the universe more specifically at Satan's thigh
("coscia"). In the fifteenth-century version in the Biblioteca Nazionale,
Florence (fig. 99), the point on Satan's thigh has clearly been used by
the artist as the pivotal center for the point of the pair of compasses in
drawing the circle of the universe. In view of the fact that either the navel
or the groin was conventionally chosen as the midpoint of the body (as
in Vitruvian man), it seems strange that no explanation for Dante's choice
of the thigh (as distinct from the navel or groin) seems to have been put
forward in the Dante literature.[62]

In his analysis of the innermost circle, Singleton explains how, along
with the light/dark contrast between Good and Evil, Heaven and Hell,
the figure of Lucifer in Hell is presented as the antithesis of the Christian
God.[63] Dante's Satan is presented as an allegory, "the image of sin, the
principle of evil, the negative counterpart of God, who is the principle of

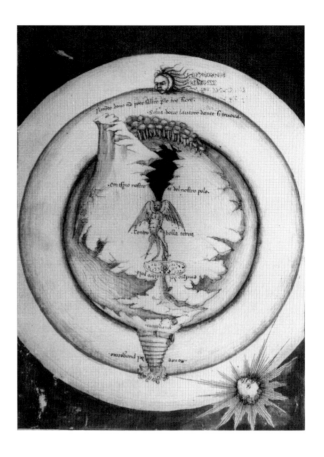

99 *Topography of Hell*,
schematic diagram of Dante's
Inferno and *Purgatorio*,
Florentine, second quarter of
fifteenth century. Miniature,
251 x 154 mm (sheet),
Biblioteca Nationale (Palat.
320, fol. IIIv), Florence.

good. As the Godhead comprises three persons . . . so Lucifer is pictured
three-faced."[64] In view of Dante's extensive use of Revelation as a source,[65]
it seems highly possible that the choice of Satan's thigh is used as the
obvious antithesis of Christ's thigh, which according to Rev. 19:16 bore the
inscription "King of Kings and Lords of Lords" and thus stands for Christ
as both temporal and spiritual ruler of the universe.[66] While Christ's thigh
symbolizes all that is good in the universe, the devil's thigh represents the
absolute and final antithesis of this, the absolute nadir.

Sun symbolism continues to receive emphasis in the second part
of the *Divina Commedia* as Dante visits Purgatory. Here, too, the light
symbolism is emphasized with an increased number of specific references
to the sun-deity analogy, as the symbol of the sun appears in its main
function as the symbol of God. A distinction is made between the elements
of the Trinity as the rising sun is used as an image of Christ (*Purgatorio*
1:107 and 2:1–9).[67] The analogy is continued throughout that section,
as God the sun is used as a symbol for all that is best and desirable (for
example, *Purgatorio* 4:16, 7:26, and 12:74).[68] In *Purgatorio* 13:13–21,
the metaphor is extended as Virgil prays directly to the sun for guidance

(*Purgatorio* 13:13–21).[69] The sun-deity analogy is further developed as the sun moves round to the west when it starts to set (*Purgatorio* 15:4–12),[70] contrasting with the appearance of the sun as it rises in the eastern sky (*Purgatorio* 30:22–27).[71] A direct confrontation occurs as the procession turns to face the sun (*Purgatorio* 32:17) and Dante compares this with the moment of Christ's Transfiguration (70–84).[72] The section concludes after the sun has reached noon, directly overhead (*Purgatorio* 33:103–105). As a symbol of God and the illumination of Divine Knowledge, it is appropriate for it to appear at its brightest at this point, just before Dante prepares to leave Purgatory and climb upward to the stars (*Purgatorio* 33:145, see fig. 100).[73]

In the third and final section of the *Divina Commedia*, the *Paradiso*, the analogy between sun and deity is given its fullest expression. Here Dante describes his journey through the different celestial spheres, including the sphere of the sun, until he reaches the Empyrean, where he experiences his vision of Heaven. According to Landino's interpretation, Dante's journey serves as a metaphor for Platonic ideals of humanity's striving to reach the good and happy life;[74] in view of Michelangelo's interest in Platonism, such an interpretation of Dante would reinforce the likelihood of Michelangelo's use of the *Paradiso* as source material.

The primary function of the sun symbol in *Paradiso* is as the symbol of God, and not only as the source of everything (Knowledge, Wisdom, and Goodness), but also as the means by which such things are communicated or illuminated to humanity.[75] As potential source material for Michelangelo,

100 *Dante Before Beatrice, Who Points to the Stars and the Sun*, illustration to *Purgatorio* XXXIII, North Italian, 1456. Tinted drawing, 255 x 350 mm (sheet), Biblioteca Laurenziana (Plut. 40.1, 206r), Florence.

it is important to consider, once more, not only Dante's written text where the sun is used as a symbol of the deity, but also the visual material in the form of illustrated Dante manuscripts of a type likely to have been familiar to the artist.

Paradiso, the last section of the Divina Commedia, opens with a reference to light symbolism, which Landino emphasizes by showing how, like the light of the sun, the glory of God penetrates the universe.[76] Paradiso 1:13–14 continues with a reference to Apollo, the classical sun god, since Dante pleads for inspiration from Apollo;[77] and the idea that "Apollo" is synonymous with God is another theme emphasized by Landino in the proemio to his commentary on the Divina Commedia.[78] Further specific references to the sun as deity and to light symbolism in general are numerous in the early cantos (Paradiso 1:47, 79–80; 2:32–36, 80; 3:1–3). The importance of sun and light symbolism is also conveyed by the illustrative material (for example, fig. 101), as well as by the discussions of contemporary and later commentators.[79] Of particular importance are cantos 10–13, where Dante's visit to the "Heaven of the Sun" is described. In the "sphere of the Sun," Dante distinguishes between the actual sun and the spiritual sun. The visible sun corresponds to Christ, the incarnate form of the Godhead, while God, the immaterial sun, is not yet visible.[80] Later illustrations to these cantos, especially those by Giovanni di Paolo that circulated in fifteenth-century Florence, also show this interpretation as an overriding theme, because it seems to be a clear reference to the use of an actual "sun" (fig. 101) and not purely an artistic convention for the depiction of light.[81]

As discussed, the main problem attached to Dante's system was the haidocentric nature attained by the spherical system when it was combined with the traditional concept of Heaven above and Hell beneath the earth's surface. Dante himself seems to have been conscious of this problem (that the spheres of the universe appeared to rotate with Hell as

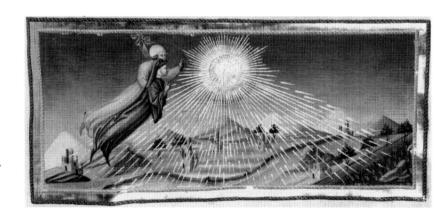

101 Giovanni di Paolo, Beatrice and Dante Hover Beside the Heaven of the Sun, illustration to Paradiso X, mid-fifteenth century. Miniature, 320 x 221 mm (sheet), British Museum (Yates Thompson 36, 146r), London.

their center), which he attempted to overcome by including the notion of a separate circular motion in the celestial areas. In canto 21, among several references to the sun, he introduces the idea of a specific "point of light" in the Empyrean around which the Heavens revolve and around which the celestial spirits move in perfect, eternal, circular motion:

> And I had yet to reach the final word
> when that light made a pivot of its midpoint
> and spun around as would a swift millstone.[82]

From the following canto (22), when Dante leaves the planets to move on to the sphere of the "fixed stars," references to light and sun-symbolism are increased significantly, far outweighing those in the central sections. Light, the sun, and circular motion are stressed as Dante travels within the sphere of stars and beyond, toward the Empyrean. The sun analogy is combined with the idea of the point of light as the center of the circular composition of the Heavens, and motion around the central point is emphasized. This concept seems to bear reference to Augustine's discussion on the symbolism of the circle and the significance of its central point, which generates the form.

Canto 23:1–9 of *Paradiso* opens with the sun symbol and then describes the sunrise in the form of a metaphor of Christ:

> I saw a sun above a thousand lamps;
> it kindled all of them as does our sun
> kindle the sights above us here on earth;
> and through its living light the glowing Substance
> appeared to me with such intensity—
> my vision lacked the power to sustain it.[83]

This description, in which the sun is used as a symbol of the deity, may be compared with Michelangelo's vision of the Last Judgment and his depiction of the Sun-Christ in the center of a circular composition (figs. 1, 51, 52), especially in view of the fact that Dante had acknowledged his own sources for these concepts in Plato.[84] The correspondence with Dante's text seems remarkable when the scene is described where Christ "glows" over all that is "beneath Christ's rays" (*Paradiso* 23:72, "sotto i raggi di Cristo"), "under a ray of sun that streams/ down from a broken cloud" (*Paradiso* 23:79–80).[85] The use of sun symbol for the deity is here combined with the cosmological concept of eternal circular motion, as Dante describes the spirits revolving in a circle or "crown" around the deity as a sun or central point of light (*Paradiso* 23:95, see fig. 102).[86] This is also amply illustrated by Botticelli's drawing to canto 23 (fig. 103), where the Sun-Christ symbol is clearly positioned in the center of the circular orbits (figs. 104, 105) in a visual representation of Dante's transcendental realm of the Empyrean.[87]

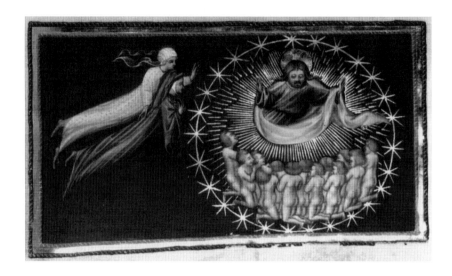

102 Giovanni di Paolo, *Beatrice and Dante Hover Beside a Circle of Stars Surrounding Christ*, illustration to *Paradiso* X, mid-fifteenth century. Miniature, 320 x 221 mm (sheet), British Museum (Yates Thompson 36, 170), London.

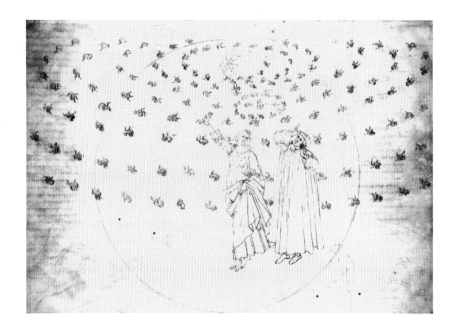

103 Sandro Botticelli, illustration to *Paradiso* XXIII, 1480s–1497. Silverpoint/pen and ink on parchment, 320 x 470 mm, Staatliche Museen, Berlin.

Botticelli's drawing for canto 24:9–12 of *Paradiso,* which refers to the revolving circular movement of the joyful heavenly spirits as well as to light symbolism, again illustrates a circular movement around the central Sun-Christ, and this is similar to the movement of the resurrected spirits around Christ in Michelangelo's fresco. Botticelli's subsequent drawings for Cantos 24–26 all retain the same emphasis (figs. 103–5).[88]

In Dante's sphere of the fixed stars, the revolving spirits are analogized to the stars in the Platonic sense,[89] and it is at this point that Dante clearly

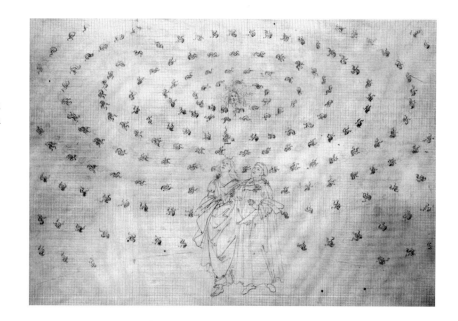

104 Sandro Botticelli, illustration to *Paradiso* XXIV, detail, 1480s–1497. Silverpoint/pen and ink on parchment, 320 x 470 mm (sheet), Staatliche Museen, Berlin.

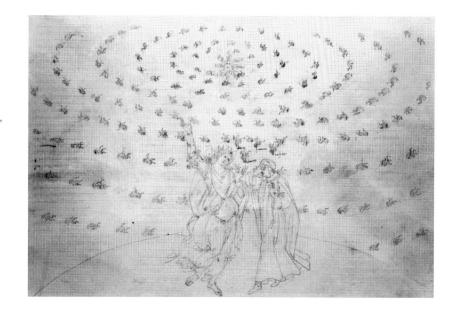

105 Sandro Botticelli, illustration to *Paradiso* XXVI, detail, 1480s–1497. Silverpoint/pen and ink on parchment, 320 x 470 mm, Staatliche Museen, Berlin.

states his ultimate belief that it is God who sets the heavenly spheres in motion:

> . . . I believe in one God—sole
> eternal—He who, motionless, moves all
> the heavens with His love and love for Him.[90]

The idea is repeated when Dante reaches the Primum Mobile, the last and swiftest sphere of Heaven, beyond which lies only the Empyrean. The mind of God here sets in motion the whole universe:

> The nature of the universe, which holds
> the centre still and moves all else around it,
> begins here as if from its turning-post . . .
> As in a circle, light and love enclose it,
> as it surrounds the rest . . .[91]

Themes expressed here, such as God represented by light as the central point and motivating force of the entire circular system, correlate well with Michelangelo's fresco. The perception of Michelangelo's *Last Judgment* as a huge revolving formation, set in motion by the gesture of Christ, which is so different from preceding examples of the subject, could well be linked with Dante's description of the circling Heavens. It appears highly probable that Dante's concept of the circling motion of the Heavens, as expressed in *Paradiso*, thus had some measure of influence upon the overall composition of Michelangelo's fresco. Dante's image here of the "Point," which acts like the hub or pivot of a wheel, causing the revolving, turning movement, is also reminiscent of the concept of the medieval "Wheel of Fortune,"[92] but it does seem that, in the circular arrangement of the saved around Christ, Dante's cosmological arrangement of spirits circling the Godhead demands equally serious consideration as a source.[93]

Visual images of Dante's analogy between sun and deity in the center of a circular cosmological scheme were reflected in several manuscripts of the *Divina Commedia*, showing an established tradition, some time before Michelangelo. In particular, the manuscript by Giovanni di Paolo (fig. 106), with Christ in the center of a sun-aureole, is an excellent demonstration of this concept. The gesture of Christ's right arm here is another example of the use of a type that relates to the form used by Michelangelo for his figure of Christ. It may further be compared with the prominent figure in Botticelli's drawing for canto 27, which utilizes a gesture almost identical to that of the Christ of Michelangelo's *Last Judgment* (fig. 107, compare fig. 106).

The idea of the Heavens as concentric circles of light revolving around a point of light of infinite intensity demonstrates Dante's key distinction between the revolving spheres of the material universe and the transcendental realm of the Empyrean. The idea is further developed in canto 28, where the important concept of the Point is combined with the analogy, previously expressed, between the sun and the Deity.[94] These ideas are also demonstrated by Giovanni di Paolo's illustration to this canto (fig. 106).[95] Dante's vision culminates in his description of the Point, read by commentators (and by artists) as the sun:

I saw a point that sent forth so acute
a light, that anyone who faced the force
with which it blazed would have to shut his eyes . . .[96]

The true significance of the Point of Light seen by Dante is explained by Beatrice:

"On Yonder Point
depend the heavens and the whole of nature.
 Look at the circle that is nearest it
and know: its revolutions are so swift
because of burning love that urges it."[97]

She also describes (from l.98) the different circles that revolve around this central Point in the Heavens (cf. l. 126).[98] Dante does not, of course, specify that the central point of light that is the pivot of the circular scheme of the Heavens is the sun in a proto-Copernican way. But visual interpretations by artists in the late fifteenth century like Botticelli and Giovanni di Paolo did read Dante's Point as equivalent to the sun. Christ is clearly viewed as this "central point" of the celestial Heavens and He is

106 Giovanni di Paolo, *Beatrice and Dante Hover Before Christ Within the Heaven of the Primum Mobile*, illustration to *Paradiso* XXVII, mid-fifteenth century. Miniature, 320 x 221 mm (sheet), British Museum (Yates Thompson 36, 178r), London.

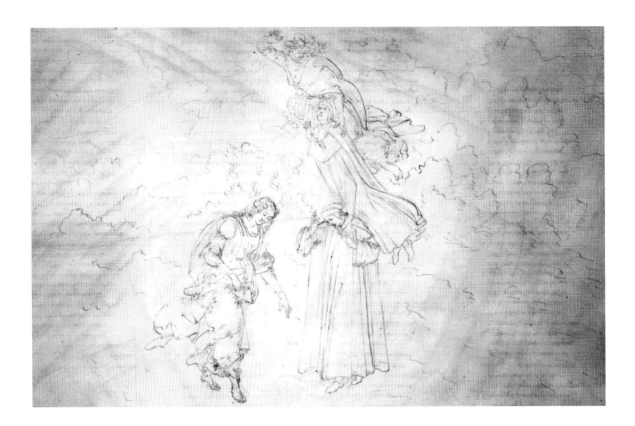

107 Sandro Botticelli, illustration to *Paradiso* XXVII,
detail, 1480s–1497. Silverpoint/pen and ink on
parchment, 320 x 470 mm, Staatliche Museen, East
Berlin.

thus positioned, "indivisible and eternal," and analogized with the sun,
at the central point of both Dante's vision and of the rotating circular
composition of Michelangelo's huge fresco. Christ forms the focus upon
which the composition and all else is dependent (figs. 1, 51, and 52).

In the remainder of Dante's epic, Christ is again referred to in
conjunction with the sun and light symbolism and the Point of light is
emphasized as the central pivot around which the celestial orbs rotate
in contrast to the central position of the earth in the terrestrial system.[99]
Dante's use of the Point of light as the center of his transcendental celestial
system cannot be conflated with the later heliocentric theory in scientific
terms, but, because of his extremely precise astronomical references in his
work,[100] his view of the rotation of the Heavens around a focus other than
the earth could suggest that Dante was ahead of his time in considering
alternative theories of cosmology. Dante's variations on the Aristotelian
system in his introduction of two separated but related schemes for the

celestial and terrestrial regions, as well as his awareness of the proposed idea that the universe was actually sun-centered, are mentioned above.

The existence of the one specific central Point is a major theme in the last three cantos alongside the emphasis on the sun-deity analogy. This is referred to again in the form of pure light (*Paradiso* 30:46–54), the river of light (*Paradiso* 30:61–69), and the radiance of God (*Paradiso* 30:97–114). A circle of light is filled with human souls (30:103–104) and this idea is closely related to Dante's famous vision of the Celestial Rose, described in cantos 30–32.[101] Illustrations of this concept from contemporary manuscripts demonstrate the emphasis on a cosmic circular design around the sun symbol (fig. 108).[102]

Dante concludes his whole work when a sudden flash of heavenly inspiration completes his vision, and he attains for one instant full understanding of the meaning of the Incarnation and the perfect union of the human and divine in Christ. Christ as Sun is finally perceived as the center point of the Empyrean and of the circular celestial universe. Dante understood, at last, "like a wheel rolling uniformly/ . . . the Love that moves the sun and the other stars" (*Paradiso* 33:144–45);[103] and this format, as Singleton explains, is dependent upon the concept that "the circle, being the perfect figure, is the emblem of perfection; and circular motion symbolizes full and faultless activity."[104] Dante evidently adhered to the traditional idea of the moving sun and stationary earth, astronomically speaking, yet his view of the deity as a personified sun, situated in the center of the heavens with all else revolving and propelled by its forces, is an overriding theme in the latter part of his *Divina Commedia*. Dante's ultimate vision and perception of the Trinitarian Godhead in the universe, depicted in a fifteenth-century Florentine illustration to canto 33 as three

108 Giovanni di Paolo, *Heaven of the Primum Mobile, with God in the Center,* illustration to *Paradiso* XXXVIII, mid-fifteenth century. Miniature, 320 x 221 mm (sheet), British Museum (Yates Thompson 36, 179r), London.

interlocking circles (fig. 109), incidentally seems to relate to the symbol Michelangelo used for his mason's logo.[105]

Ideas in Dante that recur again and again—the analogy between the deity and the sun, the eternal circular motion of Paradise, the rays that extend toward humanity, and, finally, the importance of the point in the Heavens as the pivot of the celestial universe (as opposed to the role of Hell at the center of the earth)—show a marked correspondence with features perceived in Michelangelo's *Last Judgment*. The above discussion of Dante's

109 Pietro Buonaccorsi, Diagram of *Paradiso*, from *Il cammino di Dante*, Florentine, c. 1440. Tinted schematic drawing, size not given, Biblioteca Ricci (1122, fol. 28r), Florence.

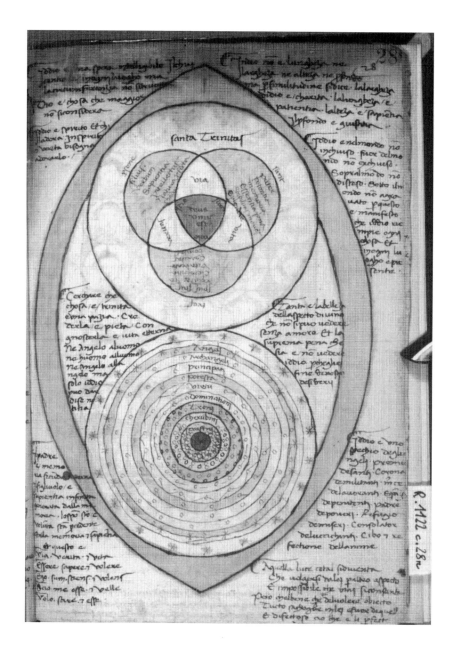

Divina Commedia demonstrates the significant roles that the Christian notions of sun and light symbolism held for its author, and the immense popularity of Dante's writings bears witness to the continuance of such a tradition and similar interests amongst a wide section of the population during the Italian Renaissance, including Michelangelo himself. Dante's *Divina Commedia*, particularly the last cantos of the *Paradiso*, clearly may be viewed as important source material for Michelangelo's circular design of the *Last Judgment* around the central Sun-Christ. To argue that Michelangelo's *Last Judgment* is a simultaneous depiction of all three sections of Dante's *Divina Commedia* (*Inferno, Purgatorio, Paradiso*), might be overextending the case, but the fresco does seem to be suffused with broader Dantean concepts. It seems reasonable to assume that the artist would have considered visual images of his favorite text. Both Dante's writing itself and the type of visual images that became customary in illustrated versions could have contributed to Michelangelo's concept of the *Last Judgment* and his vision of Christ in Glory.

Michelangelo and Vittoria Colonna

Dante's *Divina Commedia* reinforced for Michelangelo both a cosmological approach and the traditional Christian analogy between Christ and the sun. In addition to its inclusion in Dante's writings, this type of symbolism was often repeated in Italian Renaissance literature, and references to the sun, in particular, also permeate much poetry and literature of this period. Although Dante has been claimed as a major literary source of the theme accessible to Michelangelo, the theme was not unique to Dante. Since it is not possible here to examine the literature of the period in full, emphasis may be laid on works likely to have been known to Michelangelo, or already accepted as related source material for the artist, especially the poems of Vittoria Colonna and the artist himself.

The works of Petrarch (1304–74), for example, are proposed less often as a source for Michelangelo,[106] but Petrarch, too, frequently refers to the sun in his poetry and uses it in a metaphorical sense that has religious connotations.[107] References to cosmological ideas—specifically the sun as a cosmological phenomenon with metaphorical associations—are found in the work of several important Italian Renaissance poets closer to Michelangelo's own time. The poets' references might be attributed to Dante's influence reinforcing the original Christian association.[108] Probably of closer access to Michelangelo are references to the sun in the poetry of the patron of his youth, Lorenzo de' Medici (1449–92). Here, the use of the sun symbol possesses more directly theological implications since Lorenzo, for example, laments that "the sun is spent" in his poem "To Jesus Dead."[109] Michelangelo's one-time tutor, the Neoplatonist Angelo

Poliziano (1454–94), included use of the sun metaphor in his poetry,[110] and, another great influence in Michelangelo's early years, Fra Girolamo Savonarola (1452–98), also made use of the sun-deity metaphor in his poetry as well as in his famous sermons. Christ is described in Savonarola's *Triumphus Crucis*, "above his head . . . a light like a sun, with three faces in the form of the Holy Trinity."[111]

Arguably the greatest Italian epic poem after Dante's *Divina Commedia*, the *Orlando Furioso* by Ludovico Ariosto (1474–1533), was first published in 1516 and enjoyed a wide circulation; its references to the sun are numerous.[112] Astronomical questions are raised as Ariosto discusses the concept of the sun standing still, which is particularly noteworthy in view of Ariosto's friendship with Celio Calcagnini (1479–1541), famous for scientific writings on this topic, whom Ariosto mentions specifically by name.[113] Metaphorical references to the sun are also included in the work of several other lesser-known sixteenth-century Italian poets, demonstrating the enormous extent of solar references in the literature of the period and confirming the prevalence of the concept, which in all probability owed much to the seminal work of Dante.[114]

Apart from poetic works, the concept of cosmic symbolism permeates other types of secular writing of the Renaissance, such as the books on art and architecture by Leon Battista Alberti (1404–72).[115] Even Castiglione's immensely popular *Il Cortegiano* (1528) refers to similar concepts, since he too discusses "the fabric of the Universe," and he uses the direct metaphor: "just as in the heavens the sun . . . exhibit[s] to the world, as if in a mirror, a certain likeness of God. . . ." He concludes with a description of Divine Goodness "pouring itself over all created things like the rays of the sun."[116] However, these literary sources, although available to Michelangelo, have not generally been regarded as major influences upon the artist. They serve merely to illustrate the pervasiveness of Renaissance sun symbolism,[117] and it is clearly important to consider other literary works that are more directly linked to the artist. Amongst the *Spirituali* and those involved with the reform of the Catholic Church with whom Michelangelo was associated, a number of leading figures became known for their poetry and literary works as much as for their theological discourses. The traditional symbolic association between sun and deity expressed in theological works may be seen to spill over into the literary component of certain of the reformers' works. For example, Pietro Bembo (1470–1547), made cardinal by Pope Paul III in 1539, also enjoyed a wide reputation as a literary authority and was noted for his classical erudition. His sonnet, "When the Sun Leaves Us," demonstrates the inclusion of the notion of the sun symbol in religious poetry of the era.[118] More important for Michelangelo is the prevalence of sun metaphor in the writings of Vittoria Colonna, who is here to be considered as poet, as much as theologian.

Sun imagery plays a major part in the poetry of Vittoria Colonna. In a recent study, McAuliffe has shown how the image of the sun is first used in mystic reference to her husband, following his death in 1525.[119] This image is then transferred to Christ in Colonna's later "Spiritual Sonnets," as she expresses the well-known concept of the deity as light or the sun itself. Speaking of salvation and mercy, she invokes "the sun who shares his rays among us . . . let us pray to him."[120] She develops the metaphor of Christ, "the true sun" (il vero sole)[121] and also often uses the image of the phoenix or rising sun.[122] In Colonna's important work, *The Triumph of the Cross of Christ* (published in 1539), the influence of Dante seems apparent since it is written in terza rima in imitation of the *Divina Commedia* and it describes how the spirit of her deceased spouse leads her to a vision of Christ.[123] Christ is described triumphant, giving light to the sun, and McAuliffe here proposes Savonarola's *Triumphus Crucis*, cited above, as the immediate source of inspiration for this work.[124]

Bainton also refers to Vittoria Colonna's use of the sun metaphor for Christ, in his paper on Michelangelo and Vittoria Colonna. He links the concept with the Catholic reformers' attempt to return to the simple obedience of the Early Christians, based on the Scriptures, and shows how the idea of restoring the simple and sincere forms of Christianity is reflected in several of Vittoria Colonna's works. Bainton examines her famous sonnet *The Cross* (undated), where she describes Christ in direct terms of the sun-deity analogy, "He is the sun whose brilliance blinds our eyes," which could well be taken as descriptive of Christ in Michelangelo's *Last Judgment*.[125]

Finally we come to Michelangelo and consideration of the literary works of the artist himself, as important perhaps as his artworks for an understanding of his troubled soul-searching. Examination of Michelangelo's poetry reveals some interest in cosmological concepts, as well as a wealth of light and sun imagery, which is at once evident. The artist's interest in cosmological concepts like the universe, creation, time and eternity is confirmed by many of his literary works. For example, the sonnet "Colui che fece, e non di cosa alcuna," dated to about 1535–41, discusses concepts of time, the creation of the universe, and the creation of sun and moon.[126] Michelangelo's description here of the creation "not from any matter" and "time which did not exist prior to man" demonstrates an awareness of complex theological and cosmological problems, as discussed, for example, by Saint Augustine.[127]

In several of the earlier poems, the traditional cosmological concept of ascent to Heaven/ descent to Hell is implied, as when Michelangelo speaks, for example, of his body, which "rises up divine to Heaven."[128] Elsewhere, however, Michelangelo clearly refers to the spherical universe: "over the earth . . . / from one to the other pole they search," (1534).[129] The spiritual contemplation of the afterlife of the soul is often combined

with astronomical features, as expressed in the Neoplatonic concept of souls as stars: "the soul, released goes to its star."[130] References to stars and moon are frequent but references to the sun itself are even more common, and its use as a symbol may be related to the use of light symbolism in general in Michelangelo's poems. Light symbolism is frequently used by Michelangelo with the same type of religious or spiritual connotations as have already been demonstrated, namely as an image for concepts of the light of understanding, knowledge, goodness, or truth. For example, light symbolism is very evident in several earlier poems written in connection with the creation panels on the Sistine ceiling (1508–12)[131] and is also a major theme in several poems written at about the time Michelangelo was working on the tombs for the Medici chapel (1521–33). The day/night symbolism of the tomb sculptures has been discussed by Tolnay, and similar themes occur in several sonnets of the 1530s.[132] Elsewhere, light symbolism is used to represent the loved one,[133] but the specific analogy with the "light of Heaven" is also a strong theme,[134] and in a late poem Michelangelo significantly uses light symbolism in discussion of the afterlife, "the promised great light."[135]

Apart from Michelangelo's use of light symbolism in general, the sun itself is frequently contemplated in a metaphorical sense and is specifically referred to in at least thirty-six of his poems. The metaphorical references to the sun vary in type, since it is sometimes used to symbolize time,[136] sometimes the loved one, often Cavalieri or Colonna,[137] or the world or universe in general.[138] An unusual use is in an early work in which Michelangelo refers to Pope Julius as the sun and uses the metaphor to indicate their relationship: "I am to you as the sun's rays are his."[139]

The sun is frequently referred to, however, in Michelangelo's poems in a more theological metaphorical sense and used to suggest highly spiritual meaning. An early reference to the way in which the poet is left weeping "when the sun has stripped his rays from earth" has spiritual overtones, and the idea of "the sun's sun, quenched by death" seems to refer to the death of Christ.[140] The poet often expresses a wish "to return to the light of the sun" or a "yearning for the sun . . . to get to Heaven."[141] Sun metaphor in G79 and G85 easily could be understood as referring to Christ with spiritual overtones, as also in G87. The metaphor is used here in highly symbolic sense, and it appears to be significant that the majority of these are dated, by Testori following Girardi, to the period of the *Last Judgment*. In rather later works, comments like, "the sun can make of my dark night bright day" suggest the spiritual power and strength of the sun, as also do metaphorical associations of the sun "driving out shadow," and its great heat. The idea of "the sun playing its glittering game" is strongly suggestive of the manipulative power of the deity.[142]

In Michelangelo's poems, cosmological phenomena, especially the sun, are infused with implicit spiritual and theological meaning in a way

very similar to that expressed by Dante.[143] The sun is referred to as the source of life and the means of lighting up the poet's wretched state. Thus the spiritual meaning of the sun and its affinity with the deity are reflected in the poems in a way that appears relevant to an understanding of Michelangelo's interpretation of the symbolic Sun-Christ in the *Last Judgment.*

The influence of Dante's poetry on Michelangelo has been widely discussed, and Michelangelo actually wrote two sonnets addressed to, or in honor of Dante.[144] Michelangelo's "addiction to the theme of the flaming sun" has been commented upon by Clements in his important discussion of Michelangelo's poetic works. Clements examines poems of Michelangelo that involve the sun, moon, and stars in the context of Michelangelo's "nature poetry," but he also demonstrates the poet's symbolic use of these themes.[145]

The analogy between Christ and the sun, as conveyed by Michelangelo's *Last Judgment* fresco is thus not to be regarded as an entirely innovative and revolutionary concept in its religious context, nor simply as a reference to a classical deity, in spite of his presentation as a beardless, muscular, seminude figure. The identification between Christ and the sun was part of a very well established tradition, founded on the ancient scriptural sources and reinforced by medieval and Renaissance theological exegesis. It was a popular concept in Italian Renaissance literature, to the point of being virtually unavoidable. Together with the concept of the perfect, eternal, and circular universe, based during the Renaissance on Augustine and Dante, sun symbolism was evidently well known to Michelangelo and his contemporaries. It appears probable, therefore, that such widely held and linked concepts could have influenced Michelangelo in the formation of his interpretation of the *Last Judgment.*

Strong evidence exists for interest in the Christian analogy between Christ and the sun at the time of Michelangelo's *Last Judgment*—evidence based firmly upon the Scriptural sources, theological sources like writings of Church Fathers, the work of Catholic reformers like Valdés, and literary figures like Dante. The concept of sun symbolism and the accent on cosmological discussion was widespread owing to these theological and literary sources, but another realm of influence that served to reinforce these concepts in the Renaissance was the revival of the ancient philosophical tradition of Plato.

Notes

1. Dante Alighieri, *The Convivio* (London: Dent, 1903), 203. Discussed by Patrick Boyde, *Dante Philomythes and Philosopher: Man in the Cosmos* (Cambridge: Cambridge University Press, 1981).

2. Lightbown, *Botticelli*, 1:151. This is also confirmed by the large number of editions of Dante's works in the two hundred years following his death, estimated by Brieger as being well over six hundred; Paul Brieger, "Pictorial Commentaries to the *Commedia*," in Paul Brieger, Millard Meiss, and Charles S. Singleton, *Illuminated Manuscripts of the Divine Comedy*, 2 vols. (London: Routledge and Kegan Paul, 1969), 1:83.

3. Condivi, *Life of Michelangelo*, 103.

4. Vasari, *Lives*, (ed. de Vere, 1840 and 1926; ed. Bull, 333, 422).

5. See Rudolf and Margot Wittkower, *The Divine Michelangelo: The Florentine Academy's Homage on His Death in 1564* (Oxford: Phaidon, 1964), 78.

6. For example, Wind (*Pagan Mysteries*, 188) speaks of Michelangelo as a "profound expositor" of Dante; Panofsky, *Studies in Iconology,* 179, says that his "scholarly knowledge of Dante was a byword."

7. The *Lamentation* drawing for Vittoria Colonna includes direct quotation from Dante, *Paradiso* 29: 91, discussed by Tolnay, *Michelangelo*, 5:60 and fig. 159 (also 34, for Michelangelo and Dante). For other references to Dante as an influence on Michelangelo, see Redig de Campos, *Michelangelo, Last Judgment,* 59–60; Von Einem, *Michelangelo*, 164; Wilde, *Michelangelo*, 39, 63, 166; Hartt, *Michelangelo*, 140; Salvini, *Hidden Michelangelo*, 132, 137; Hibbard, *Michelangelo*, 32–33, 264–65; Liebert, *Psychoanalytic Study,* 357; and Barnes, *Invention*, chap. 5. Michelangelo was very much involved in the project to bring back Dante's remains from Ravenna to Florence, and offered to construct the tomb in 1519; Tolnay, *Michelangelo* (1975), 179.

8. Mention could be made of Moses and Saint Paul as parallel figures of the Old and New testaments, who each had the experience of perceiving God, as well as the figures of Rachel and Leah as personifications of the Active and Contemplative life; Dante, *Purgatorio* 27:101–8. See Joseph Anthony Mazzeo, *Structure and Thought in the Paradiso* (New York: Greenwood, 1968), 89.

9. These include themes like Judith and Holofernes (Dante, *Purgatorio* 12:59, *Paradiso* 32:10) and the execution of Haman (*Purgatorio* 17:26), depicted in the spandrels of the Sistine ceiling. The themes mentioned by Dante of the flaying of Marsyas by Apollo (*Paradiso* 1:13–21), and the legends of Tityos (*Inferno* 31:124), Ganymede (*Purgatorio* 9:22–30), and Phaeton (*Purgatorio* 4:73, *Paradiso* 17:1–2, 31:124–26), all connected with the Apollo legend, are subjects that evidently held interest for Michelangelo during the 1530s, as shown by the presentation drawings, but they are seldom discussed in relation to Dante. See Liebert, *Psychoanalytic Study*, 277–78, 350–52, and 389–90; Von Einem, *Michelangelo*, 133–34, 174.

10. Condivi, *Life of Michelangelo*, 84.

11. Vasari, *Lives* (ed. de Vere, 1883–85; ed. Bull, 380–81, referring to *Purgatorio* 12:67).

12. Redig de Campos, *Michelangelo, Last Judgment*, 59–60.

13. Redig de Campos, *Michelangelo, Last Judgment*, 63–64, 68, 75.

14. Tolnay, *Michelangelo*, 5:34 and 38. Also, concerning Redig de Campos' interpretation, he comments: "One can hardly detect a resemblance to a rose."

15. Steinberg, "Merciful Heresy," 49. Steinberg also argues that, at the time of the painting of the *Last Judgment,* Dante's "authority as a teacher of Christian doctrine did not rank high" (53). He cites critics of the 1560s for this, however, and in a later paper he himself calls this into question when he maintains that in defense of the *Last Judgment* in 1549, Benedetto Varchi pointed out references to Dante as "a way of giving it status"; Steinberg, "Corner of the *Last Judgment*," 234.

16. Steinberg, "Corner of the *Last Judgment*," esp. 211–37, and idem, "Line of Fate," 105–6. The discussion concerns the pose of Charon and an alternative explanation of the

Minos/Biagio da Cesena identification, linked with Steinberg's perception of the diagonal compositional emphasis in the work.

17. Millard Meiss, "The Smiling Pages," in Brieger, Meiss, and Singleton, *Illuminated Manuscripts;* similarities between Dante's manuscript and *Last Judgment* frescoes are discussed on pp. 39–49, 61–62.

18. For Dantean influence on the *Last Judgment* by Giotto, Nardo, Traini, and others, see Brieger, Meiss, and Singleton, *Illuminated Manuscripts*, vol. 1, esp. 39–44 and fig. 18, and fig. 75, a detail of Vecchietta's *Last Judgment* showing a figure obviously based on Dante's Minos.

19. Brieger, Meiss, and Singleton, *Illuminated Manuscripts*. See esp. Brieger, "Pictorial Commentaries to the *Commedia*," 83–113.

20. See Lightbown, *Botticelli*, 2:172–205, and Kenneth Clark, *The Drawings by Sandro Botticelli for Dante's Divine Comedy* (London: Thames and Hudson, 1976). Dante's writings had become less popular in the early fifteenth century until, at the end of that century, they were revived, mainly through the efforts of the Neoplatonist circles who lent their interpretation to the text. See Brieger, Meiss, and Singleton, *Illuminated Manuscripts*, 1:47; André Chastel, *Arte e umanesimo a Firenze al tempo di Lorenzo il Magnifico* (Turin: Einaudi, 1964), 113–36, "Dante, l'Accademia platonicae e gli artisti."

21. See Arthur Field, "Cristoforo Landino's First Lectures on Dante," *Renaissance Quarterly* 39 (1986): 16–49. For Landino's *Commentary* on Dante and its links with Botticelli, see Lightbown, *Botticelli*, 1:56–58, 148; Clark, *Drawings by Botticelli,* 8–9; Eugenio Garin, *L'umanesimo italiano* (Bari: Laterza, 1964), 110–11 (English translation [New York: Harper and Row, 1965], 84).

22. Panofsky, *Studies in Iconology*, 179. See also Lightbown, *Botticelli*, 1:56.

23. See Dante, *Letter to Can Grande Epistolae,* Letter 10, sec. 29, where he acknowledges his debt to Plato. For modern interpretation, see, for example, Mazzeo, *Structure and Thought*, 2–3; Field, "Landino's First Lectures," 37–38. As Mandelbaum points out, "Dante is not to be called an unequivocal Thomist"; Mandelbaum, ed., *Divine Comedy*, 1:xv.

24. For Landino, see Cristoforo Landino, ed. Roberto Cardini, *Scritti critici e teorici,* 2 vols. (Rome: Bulzoni, 1976); Cristoforo Landino, *Commentary on Dante,* 1481 (microfilm kindly supplied by the British Library); Panofsky, "Neoplatonic Movement in Florence," and "Neoplatonic Movement and Michelangelo," in *Studies in Iconology,* 129–230; Ottavio Morisani, "Art Historians and Art Critics, 3: Cristoforo Landino," *Burlington Magazine* 95 (1953): 267–70; Field, "Landino's First Lectures," 16–49. Field (37–38) emphasizes the fact that no further commentary was written until the mid-sixteenth century.

25. See Mazzeo, *Structure and Thought*, 2. Mazzeo emphasizes the existence of many Platonic notions in the *Divina Commedia*, esp. chaps. 1 ("The Phaedrus tradition"), 3 ("Love and Beauty"), and 5 ("Plato's 'Eros' and Dante's 'Amore' "). Dante's access to Plato's writings differed from that of the later Florentine Neoplatonists, by which time Plato's writings were far more readily available, especially through the work of Marsilio Ficino (1433–99).

26. Landino, *Proemio* to the *Commentary on the Divina Commedia*, 16 ("huomo di grande ingegno e di doctrina doppo Platone singulare"). Cf. Cardini, ed., *Scritti*, 140.

27. Space does not allow a full discussion of Landino's *Commentary* and its relevance as source material for Michelangelo. However, it will be considered and referred to at a number of key points.

28. See Charles H. Grandgent, *Companion to the Divine Comedy,* ed. Charles S. Singleton (Cambridge: Harvard University Press, 1975), 12–18.

29. Grandgent, *Companion*, 11–12; Edmund G. Gardner, *Dante and the Mystics: A Study of the Divina Commedia and Its Relation with Some of Its Medieval Sources* 1913; rptd. (New York: Octagon, 1968), esp. chaps. 2 and 3, "Dante and St. Augustine" and "Dante and

Dionysius"; Etienne Gilson, *Dante and Philosophy* (Gloucester, Mass: Peter Smith, 1968), esp. sec. 4.

30. Grandgent/Singleton, *Companion to the Divine Comedy,* 14. See also Bruno Nardi, *Dante e la cultura medievale* (Rome: Laterza, 1983), for Dante's knowledge of Aristotle in relation to other philosophies esp. 142–54, ("Platonismo agostiniano e aristotelianismo"); Lorenzo Minio-Paluello, "Dante's Reading of Aristotle," in *The World of Dante: Essays on Dante and His Times,* ed. Cecil Grayson, (Oxford: Clarendon Press, 1980), 61–80.

31. Boyde, *Dante Philomythes,* esp. pt. 1, "The Cosmos."

32. M. A. Orr, *Dante and the Early Astronomers* (New York: Kennikat, 1969). See also Dreyer, *History of Astonomy;* and Mark A. Peterson, "Dante and the 3-sphere," *American Journal of Physics* 47 (1979): 1031–35, for recent scientific study of Dante's cosmological framework.

33. Cosmology had reverted to a form of geocentrism, based on the Ptolemaic system, with a solid, motionless spherical earth surrounded by concentric crystal spheres bearing the stars and planets. For cosmology in the time of Dante, see Koestler, *Sleepwalkers,* 102–3; Grandgent/Singleton, *Companion to the Divine Comedy,* 24–25; Orr, *Dante and the Early Astronomers,* 147; Dorothy L. Sayers, *Divine Comedy,* vol. 3, *Paradiso* (Harmondsworth: Penguin, 1962), 350–51.

34. See Georges Poulet, "The Metamorphoses of the Circle," in John Freccero, ed., *Dante: A Collection of Critical Essays* (Englewood Cliffs, N.J.: Prentice-Hall, 1965), 151–69. He notes the importance of the center of the circle and the relationship between center and circumference.

35. For rejection of the flat-earth view, see above, chap. 2. For Dante's views, see also his *De Aqua et Terra* (London: Dent, 1925), sec. 3, where he comments: "the centre of earth, as all admit, is the centre of the universe . . ." (391), and even touches on gravitational pull (sec. 16, p. 404). He discusses variations in the views of land from the sea as evidence for the earth's sphericity (sec. 23, pp. 420–21). See also Orr, *Dante and the Early Astronomers,* 147 and 224–25, for common acceptance of such concepts in Dante's time.

36. Boyde, *Dante Philomythes,* 68–71, 143–44, "The Difficulties of Geocentric Astronomy."

37. Aristotle, *De Caelo,* 2, xiv, 296a—297b, Loeb edition, trans. W. K. C. Guthrie (London: Heinemann, 1971), 240–51. Aristotle perceived the sphere of the universe as having a "top" and "bottom"; *De Caelo,* 4, i, 307b—308a, 327–31. See Orr, *Dante and Early Astronomers,* 83. Dante's cosmology also retains the concept of movement upward to Heaven and downward to Hell in numerous places (e.g. *Inferno* 4:13; *Paradiso* 21:7–8 and 28–29); Aristotle's theory of motion and its allegorical correspondence with metaphysical concepts is also discussed by Orr, *Dante and Early Astronomers,* 324–25.

38. Demaray relates Dante's poem to medieval and early Renaissance cosmological concepts, and compares it with the way the medieval cathedral is based on the perception of God's created universe. John G. Demaray, "Dante and the Book of the Cosmos," *Transactions of the American Philosophical Society,* 77, pt. 5 (1987), esp. 1–3. Demaray also draws comparisons between Dante's structure of the Universe and medieval *mappa mundi* and rose windows (58–59 and 99–103).

39. Grandgent/Singleton, *Divine Comedy,* 110. Hell, in fact Lucifer himself, is at the center of Dante's universe.

40. See S. J. Heninger, *The Cosmographical Glass: Renaissance Diagrams of the Universe* (San Marino, Calif.: Huntington Library, 1977), esp. chap. 2, "The Geocentric Universe," 31–44.

41. Dante, *Convivio* 3 (London: Dent, 1903), 157–63. *Convivio* gives a clear account of the theories of Plato and Philolaus. Dante's rejection of the ancient speculation that it

was the earth and not the skies that moved was based on Aristotle's *De Caelo*. Orr, *Dante and the Early Astronomers*, 164.

42. *Convivio*, 3, 12. This has important Platonic overtones, in spite of the fact that *Convivio* was strongly influenced by Aristotle's *Ethics* and the *Commentary* of Saint Thomas Aquinas on that text.

43. Landino, *Commentary*, preface, 10.

44. G. L. Bickersteth, *Dante Alighieri, The Divine Comedy* (Oxford: Blackwell, 1965).

45. Mazzeo, *Structure and Thought*, 142.

46. Mazzeo, *Structure and Thought*, 142–43.

47. Gardner, *Dante and the Mystics*, 82–83, traces Dante's various sources, the Bible, the Church Fathers, like Augustine and Pseudo-Dionysius, as well as the early Neoplatonists like Plotinus (c. 203–70) and Proclus (410–85), known for his commentary on *Timaeus*. See also Boyde, *Dante Philomythes*, esp. 144–59, for Dante's obsession with the philosophical and scientific problems, and 208–17, for the different aspects of Dante's light and sun symbolism.

48. Helen Flanders Dunbar, *Symbolism in Medieval Thought and Its Consummation in the Divine Comedy* (New York: Russell and Russell, 1961). See esp. chap. 3, "Symbolism in Medieval Thought and its Center in the Sun," and appendix 4, "Imagery of the Sun-Storm God in the New Testament."

49. Dunbar, *Symbolism*, 130–31 and 180–82. New Testament sources for sun symbolism given by Dunbar (257–61) are related to Dante's text as well as their medieval continuations (437–39). Dunbar (123, 254, 344) discusses the origins of sun symbolism in Plato's *Republic*, bk. 6, and its relation to Plato's famous metaphor of the Cave, *Republic*, bk. 7. Dunbar (160 n. 167) points out that, in Dante's time, the Greek word for the sun, "Helios," was thought to have derived from the Hebrew word "Eli" for God.

50. Dunbar, *Symbolism*, esp. 157–239.

51. Paul Priest, *Dante's Incarnation of the Trinity* (Ravenna: Longo, 1982), 43–44. The rising sun represents Christ, the noonday sun represents the Father, and the setting sun represents the Holy Spirit.

52. Also, Dunbar, *Symbolism*, 58, 144–48; the relationship between God the Father and the Son is like that between the sun and its rays; J. Quillet, " 'Soleil' et 'Lune' chez Dante," in *Le Soleil, la Lune et les Étoiles au Moyen Age*, Université de Provence (Marseilles: Editions Jeanne Lafitte, 1983), 327–37.

53. E. H. Wilkins and Thomas G. Bergin, eds., *A Concordance to the Divine Comedy* (Cambridge: Harvard University Press, 1965). This lists 186 instances of the words *luce* and *lume* and 117 instances of the use of *sol* or *sole*. The nuances of *lume* (radiated light) and *luce* (source of light) are discussed by Mazzeo, *Structure and Thought*, 150–51, as well as associated words like *fulgor, rai, fuoco, lucerna, lampa,* and so forth.

54. *Inferno* 1:1–3, 16–18. Landino compares the symbolism of canto 1 to the writings of Saint John the Evangelist (Landino, *Commentary*, 1). See also discussion in Dunbar, *Symbolism*, 158–60.

55. See also Brieger, Meiss, and Singleton, *Illuminated Manuscripts*, 2:39–46. Titles given here to manuscript illustrations are based on Brieger, Meiss, and Singleton, *Illuminated Manuscripts*.

56. Respectively, "i' vegno per menarvi a l'altra riva/ ne le tenebre etterne" and "in loco d'ogne luce muto." According to Landino, Charon's boat stands for Free Will (*Commentary to Inferno* 3), discussed by Field, "Cristoforo Landino," 18.

57. Also Brieger, Meiss, and Singleton, *Illuminated Manuscripts*, 2:54–57, 82–89. It is interesting to note the similarity of Michelangelo's figures of Charon and Minos to the standard depictions of the figure. Compare Clark, *Botticelli's Drawings*, 34, Charon. As in Michelangelo's version, a snakelike appendage is often substitued for Minos' tail, in the

manner of the punishment accorded to thieves (*Inferno* 25:95, "their head and tail right through the loins"). Cf. Steinberg "Corner of the *Last Judgment*," 229, 235–37.

58. "'l piu basso e 'l piu oscuro/ e 'l piu lontan dal ciel che tuto gira." Landino draws attention here to the structure of the circle and how its central point must be the furthest point from the circumference ("Quello e piu basso locho. *Se l'Inferno* scende infino al centro della terra: e questo cerchio e el piu basso conviene che lui sia nel centro: e perche ogni centro e la piu lontana parte che sia dalla circumferentia pero e piu lontano da cieli," Landino, *Commentary*, *Inferno*, 9).

59. *Inferno* 34:38–67. For Dante's political theory concerning secular rule and kingship, see Dante Alighieri, *Monarchia* in *The Latin Works of Dante* (London: Dent, 1925), 127–280.

60. Landino writes: "nella piu bassa parte del mondo laquale e el centro della terra" which is "puncto indivisibile. . . ." ("in the deepest part of the world which is the centre of the earth. . . . a point indivisible. . . ." *Commentary* on *Inferno* 34). See also Charles S. Singleton, *Dante Alighieri, The Divine Comedy: Inferno*, vol. 2, *Commentary* (London: Routledge and Kegan Paul, 1971). Singleton (633) comments on the way in which Dante and Virgil start to turn at Satan's thigh, "i. e., at the exact center of Satan's body, also at the exact center of the earth and of the Universe in the Ptolemaic system."

61. "là dove la coscia/ si volge, a punto in sul grosso de l'anche . . ." See illustrative material in Brieger, Meiss, and Singleton, *Illustrated Manuscripts*, vol. 2, figs. 319, 320.

62. The *Enciclopedia Dantesca* (2:230) lists other references in Dante to "coscia" but does not explain the choice in *Inferno* 34; nor, for example, does Dino Provenzal, *Dante Alighieri, La Divina Commedia*, 3 vols. (Venice: Mondadori, 1980). It does seem to require some biblical exegesis.

63. Grandgent/Singleton, *Companion to the Divine Comedy*, 110.

64. Grandgent/Singleton, *Companion to the Divine Comedy*, 110–11. The three aspects that in the Trinity represent Power, Wisdom, and Love, here represent Hate, Ignorance, and Impotence in the devil; the six wings of Lucifer correspond to the "beasts" at God's throne in Rev. 4:8. Mandelbaum also states that Satan's three faces are "a grotesque counterversion of the three Persons of the Trinity"; Mandelbaum, *Divine Comedy*, 1:393. Also Boyde, *Dante Philomythes*, 70–71.

65. References to the book of Revelation (believed by many to be by the same author as Saint John's Gospel) are numerous in *Inferno*, *Purgatorio*, and *Paradiso*, for example, in *Inferno* 1:100 and 117; 15:99. Numerous precise comparisons are discussed in Grangent/Singleton, *Companion to the Divine Comedy*, and Mandelbaum, *Divine Comedy*, notes to the three volumes.

66. "And he hath . . . on his thigh a name written, king of kings and lord of lords." This verse in the Bible is followed by a reference to the sun symbol (v. 17). Dante's concern with the secular and spiritual aspects of Rule, which are suggested by this verse, are demonstrated in *Purgatorio* 16:106 and *Monarchia*. Singleton identifies several precise references to Revelation 19 in the *Divina Commedia* (*Purgatorio* 30:15, *Purgatorio* 32:75, and *Paradiso* 24:2), which confirm Dante's likely familiarity with it. The direct relevance for Michelangelo's *Last Judgment* of Dante's cosmological use of thigh symbolism will become clear in chapter 9 of this book.

67. Priest, *Dante's Incarnation*, chap. 5, esp. 124–25.

68. "l'alto Sol che tu disiri/ e che fu tardi per me conosciuto," 7, 26.

69. Mazzeo, *Structure and Thought*, 147–48.

70. See Priest, *Dante's Incarnation*, 138–41.

71. Priest, *Dante's Incarnation*, 161–62.

72. See note by Mandelbaum, *Divine Comedy*, 2:401.

73. See Brieger, Meiss, and Singleton, *Illustrated Manuscripts*, vol. 2, fig. 422c.

74. Platonic notions are discussed by Landino in his preface to his *Commentary* on Dante. In the section entitled "Furore Divino," he refers to sources used by Dante, namely Pythagoras, Empedocles, Heraclitus, and Plato who, like Hermes Trismegistus before, had discussed concepts like wisdom, justice, harmony, the nature of the divine, and the human soul ("finalmente el divino Platone. Questi, come prima avea scritto T[r]imegisto, affermavono che l'animi nostri, innanzi che ne' corpi discendano, contemplano in Dio come in suo specchio la sapienza, la iustizia, l'armonia e la belleza della divina natura . . .") (Landino, *Commentary*, preface, 9). Landino also included in his publication a letter from Marsilio Ficino, whom he calls "el nostro platonico." For modern transcription of introductory passages to Landino's *Commentary*, see Cardini, *Scritti*, 97–164, esp. 143–44 and 153–55 for references to Plato.

75. Mazzeo, *Structure and Thought*, 145–46; "He is both Divinity itself and the source of the "light" which mediates the mind and the object of its knowledge"; and Priest, *Dante's Incarnation*, esp. chap. 6, "*Paradiso*," 167–216.

76. "La gloria di colui che tutto move per l'universo penetra. . . ." cf. Landino, *Commentary* on *Paradiso* 1.

77. He refers to the legend of the flaying of Marsyas (*Paradiso* 1, 13–21), regarded as of interest to Michelangelo in his use of the flayed skin bearing a self-portrait in the *Last Judgment* and his reference to similar themes in his poems. Creighton Gilbert, *Complete Poems and Selected Letters of Michelangelo* (Princeton: Princeton University Press, 1980) nos. 150 and 159. The popularity of the Marsyas legend among the Neoplatonists, as referring to the flaying as an ordeal of purification to release the spirit from the flesh, is discussed by Wind, *Pagan Mysteries*, 142–47. Raphael also treated the subject of Marsyas on the ceiling of the Stanza della Segnatura. His adjacent *Parnassus* and *Disputa* both contain portraits of Dante.

78. Landino, *Commentary* on the *Divina Commedia*, 16–17 ("Ne altro intendono per Apolline se non el sommo dio"—nor other do they understand by Apollo if not the highest God . . .), cf. Cardini, ed., *Scritti*, 142.

79. For additional illustrative material for these cantos, see Brieger, Meiss, and Singleton, *Illuminated Manuscripts*, vol. 2, figs. 425a, 426, 432a. The Sun-Deity analogy is particularly emphasized in *Paradiso* 5:133–39; 9:8; 10:41–54; 12:15, 51; 15:76; 19:4–6.

80. Especially *Paradiso* 10:52–54. See Mazzeo, *Structure and Thought*, 144; Priest, *Dante's Incarnation*, 138, 155; John Freccero, "*Paradiso* X: The Dance of the Stars," *Dante Studies* 86 (1968): 85–112.

81. For other examples see Brieger, Meiss, and Singleton, *Illuminated Manuscripts*, vol. 2, figs. 446a, 453b, and 456 to 465, for illustrations to the "sphere of the sun" where the sun symbol is quite clearly shown in all major examples. The example of Giovanni di Paolo is particularly important because of his known interest in astronomy, Laurinda S. Dixon, "Giovanni di Paolo's Cosmology," *Art Bulletin* 67 (December 1985): 604–13; also, John Pope-Hennessy, *Paradiso: The Illuminations to Dante's Divine Comedy by Giovanni di Paolo* (London: Thames and Hudson, 1993).

82. Canto 21:79–81 ("N venni prima a l'ultima parola,/ che del suo mezzo fece il lume centro,/ girando sé come veloce mola;"). The movement of the celestial spirits in perfect, circular motion (around Dante) is already mentioned at canto 10:64–65, but the image of God as a specific point of light as the central pivot for circular motion in the Empyrean is emphasized from this section of canto 21, where the analogies of sun, light, circular movement and central point are combined. Peterson ("Dante and the 3-sphere," 1033–34) discusses the scientific connotations of the introduction of the central "Point" in the Empyrean as opposed to the central point in Hell.

83. *Paradiso* 23:28–33 ("vid' i' sopra migliaia di lucerne/ un sol che tutte quante l'accendea,/ come fa 'l nostro le viste superne;/ e per la vive luce trasparea/ la lucente sustanza tanto chiara/ nel viso mio, che non la sostenea"). Compare *Purgatorio* 30:22–32.

84. See Dante, *Epistolae*, esp. letter 10, which is his letter to his patron Can Grande and, in effect, his own commentary on the *Divina Commedia*. He writes: "for we see many things by the intellect for which there are no vocal signs, of which Plato gives sufficient hint in his books by having recourse to metaphors, for he saw many things by intellectual light which he could not express in direct speech" (sec. 29).

85. At this point, Landino describes Christ directly as the "True Sun" ("Christo vero sole,"— Landino, *Commentary*, Paradiso 23). See also Mazzeo, *Structure and Thought*, 148–49. The naturalistic overtones of Dante's description of the sun's rays can be appreciated, see fig. 127.

86. Compare *Paradiso* 31:71. A correspondence with Michelangelo's fresco is suggested since Condivi describes the blessed in the fresco as forming "a circle or crown in the clouds of the sky around the Son of God," Condivi, *Life of Michelangelo*, 84. Dante's circles of souls are discussed by Mazzeo, *Structure and Thought,* 155–58.

87. Clark, *Botticelli's Drawings*, 200. It is interesting to note here that Botticelli's circles are drawn in perspective, as ellipses, which may be compared with Michelangelo's rendering of the "inner circle" in his fresco.

88. Clark, *Botticelli's Drawings*, 200–207; see also Lightbown, *Botticelli*, 2:203 (figs. E103, E104, E105).

89. Compare *Paradiso* 4:22–23 and 49–50, where the origins of this notion in *Timaeus* are considered.

90. *Paradiso* 24:130–32, ("Io credo in uno Dio/ solo ed etterno, che tutto 'l ciel move,/ non moto, con amore e con disio"). This cosmology relates, of course, to Aristotle's "Unmoved Mover" (for which see Aristotle, *De Caelo,* ed. Guthrie, xviff.).

91. *Paradiso* 27:106–14 ("La natura del mondo, che quieta/ il mezzo e tutto l'altro intorno move,/ quinci comincia come da sua meta;/ e questo cielo non ha altro dove/ che la mente divina, in che s'accende/ l'amor che 'l volge e la virtu ch' ei piove./ Luce e amor d'un cerchio lui comprende,/ si come questo li altri; e quel precinto/ colui che 'l cinge solamente intende). See Boyde, *Dante Philomythes*, 159–60, for further discussion.

92. Tolnay, *Michelangelo*, 5:48–49 and figs. 278–81, supported by Redig de Campos, *Michelangelo, Last Judgment*, 89, but disputed by Steinberg, "Merciful Heresy," 49. Dante also refers to the Wheel metaphor at *Paradiso* 28:22–26.

93. For further discussion of the "Wheel of Fortune" (based on Ezek. 1:16 and 10:2 and Pseudo-Dionysius*, Celestial Hierarchy,* 15, 9) as source for Dante see Grandgent/Singleton, *Companion to the Divine Comedy*, 458–59; Demaray, *Dante*, 99–100.

94. Landino relates the light symbolism of canto 28 to biblical sources, specifically the creation of light in Genesis ("Fiat lux et facta est"). God is the highest light from which comes all other ("Somma luce dalla quale nace ognaltra luce"), Landino, *Commentary*, canto 33.

95. See Brieger, Meiss, and Singleton, *Iluminated Manuscripts*, 2:506. Giovanni di Paolo provides a rare precedent for Christ beardless in a *Last Judgment* scene (Tolnay, *Michelangelo*, vol. 5, fig. 270). For Giovanni's cosmology, see Dixon, "Giovanni di Paolo," 604–13, and Pope-Hennessy, *Giovanni di Paolo,* showing interaction between biblical views and Renaissance observation.

96. *Paradiso* 28:16–18: "un punto vidi che raggiava lume/ acuto si, che 'l viso ch'elli affoca/ chiuder conviensi per lo forte acume." The point is the center and source of everything. For discussion, see Grandgent/Singleton, *Companion to the Divine Comedy,* 287, 301, and Singleton, *Divine Comedy,* vol. 3, *Paradiso,* 448–51. Umberto Eco, *Foucault's Pendulum* (London: Secker and Warburg, 1989), 5, also discusses the idea of "the Only Fixed Point in the universe, eternally unmoving."

97. *Paradiso* 28:41–45: "Da quel punto/ depende il cielo e tutto la natura./ Mira quel cerchio che piu li congiunto;/ e sappi che 'l suo muovere si tosto/ per l'affocato amore ond'

elli punto." Thus where the center of the terrestrial universe is earth (as discussed above), the center of the celestial universe is God.

98. See Singleton, *The Divine Comedy*, vol. 3, *Paradiso*, 449–50. Sources are traced to Aristotle (*Metaphysics*, 12, 7, 1072: "Ex tali igitur dependet caelum et natura"). See also Mandelbaum *Paradiso*, n. for lines 41–42, on 411, and Gardner, *Dante and the Mystics*, 347. Mazzeo, *Structure and Thought*, 171, views the concept of the universe as deriving from a single outpouring "radiation" of light in Neoplatonic terms.

99. Especially *Paradiso* 29:99, 136, and 145), and Landino uses this passage to emphasize the idea of Christ as sun symbol showing how the sun grew dark at Jesus' Passion ("Sole obscuro nella passione di Christo," *Commentary*, canto 29). *Paradiso* 30:11 contains further references to the Point of dazzling light.

100. Beniamino Andriani, *Aspetti della Scienza in Dante* (Florence: Felice le Monnier, 1981), esp. sec. 1, "L'Astronomia."

101. For discussion of the celestial rose, see Barbara Seward, *The Symbolic Rose* (New York: Columbia University Press, 1960).

102. Brieger, Meiss, and Singleton, *Illuminated Manuscripts*, vol. 2, figs. 506–20. Even much later interpretations, by artists like William Blake (1757–1827) and Gustave Doré (1832–83), read Dante in the same way; see *Enciclopedia Dantesca*, 1:642–43 and 2: fig. opposite 592; Milton Klonsky, *Blake's Dante: The Complete Illustrations to the Divine Comedy* (London: Sidgwick and Jackson, 1980), plates 94 and 101.

103. "si come rota ch'igualmente mossa, l'amor che move il sole e l'altre stelle."

104. Grandgent/ Singleton, *Companion to the Divine Comedy*, 302.

105. For which see Ludwig Goldscheider, *Michelangelo, Paintings, Sculptures, Architecture* (London: Phaidon, 1975), cover; Ramsden, *Letters*, 2:284.

106. Clements, *Poetry of Michelangelo*, esp. 8, where Michelangelo's probable reading material is listed, and 319–25.

107. Joseph Tusiani, *Italian Poets of the Renaissance* (Long Island City: Baroque Press, 1971), 4, 6, 13, 23.

108. Such as Matteo Boiardo (1441–94), Girolamo Benivieni (1453–1542), Iacopo Sannazaro (c. 1455–1530) and Serafino Aquilano (1466–1500), for which see Tusiani, *Italian Poets*, 57–61, 89, 105, and 110, respectively. For popular use of sun imagery in sensuous Renaissance poetry ("much of which is designated unquotable") see Dunbar, *Symbolism*, 426–27.

109. Tusiani, *Italian Poets*, 66–67, 6–77. See also Nesca Robb, *Neoplatonism of the Italian Renaissance* (London: Allen and Unwin, 1935), 100–101, 135–36, 159. The influence of Dante and the revival of a Dante cult amongst the Neoplatonists is noted, as well as the recurrence of the familiar idea of the Deity as sun.

110. Tusiani, *Italian Poets*, 98–103.

111. For Savonarola as a poet, see Tusiani, *Italian Poets*, 78–81; see also McAuliffe, *Vittoria Colonna*, 161–62.

112. Ludovico Ariosto, *Orlando Furioso*, trans. G. Waldman (Oxford: Oxford University Press, 1983). Symbolic meaning is clear, for example, 61, 148, 406, 416–18. References to the popular myths of Phaeton (24), Ganymede (35), Charon (498), and Minos (322) also occur. Ariosto's use of sun symbolism is discussed by Dunbar, *Symbolism*, 426.

113. Ariosto, *Orlando*, 384 (concerning Joshua), 507, 511 (describing a sorceress who could "arrest the sun, set the earth in motion"), and 558 for Calcagnini.

114. Among the poets discussed by Tusiani, *Italian Poets*, are works by Francesco Maria Molza (1489–1544), Luigi Alamanni (1495–1556), Francesco Berni (1497–1535), Giovanni Guidiccioni (1500–41), Giovanni della Casa (1503–66), Annibal Caro (1507–66), Angelo di Costanzo (1507–91), Luigi Tansillo (1510–60), and Galeazzo di Tarsia (1520–53) all refer to the sun metaphorically in one way or another, demonstrating the

common interest and concern with the natural phenomenon and what it might symbolize. Even as late as 1594, the important poet Torquato Tasso (1544–95) began his theogony, *Il mondo creato,* with an address to the Trinity as "Triplicata Sole"; Torquato Tasso, *The Creation of the World,* trans. Joseph Tusiani (Binghamton, N.Y.: Center for Medieval and Early Renaissance studies, 1982), 3. Tommaso Campanella's utopia, City of the Sun, was based on similar symbolism in 1602; Tommaso Campanella, *La Città del Sole, The City of the Sun: A Political Dialogue,* trans. D. Donno (Berkeley: University of California Press, 1981). The continuation of the tradition into the seventeenth century in Milton's *Paradise Lost* is dealt with by Raymond B. Waddington, "Here Comes the Son," *Modern Philology* 79 (1982): 256–66.

115. Especially *De Re Aedificatora,* bk. 7, chap. 4. See Wittkower, *Architectural Principles,* 13, 23, 115. Wittkower (19) notes the cosmic symbolism of Alberti's designs and comments on the way in which the symbolism of the circle, rooted in Neoplatonism "had an almost magical power over these men."

116. Baldassare Castiglione, *The Book of the Courtier,* trans. George Bull (Harmondsworth: Penguin, 1980), 299, 409. Discussed by Eugenio Garin, *Italian Humanism* (Oxford: Blackwell, 1965), 119.

117. See also Université Libre de Brussels, *Le Soleil à la Renaissance,* Colloque International (Brussels: Presses Universitaires de Bruxelles, 1963).

118. Tusiani, *Italian Poets,* 116–18.

119. McAuliffe, *Vittoria Colonna,* 75–76, 79. See also Althea Lawley, *Vittoria Colonna* (London: Gilbert and Rivington, 1898), for views of the poetess in general.

120. "Se 'l sole che i raggi fra noi comparte . . . preghiamo lui" (sonnet 18), quoted by McAuliffe, *Vittoria Colonna,* 106.

121. McAuliffe, *Vittoria Colonna,* 109. Man must "close his heart to shadow and open it to the pure ray which transforms him in God." See also 119, "the dawn of the true sun." References to light symbolism in general are numerous in the *Rime,* see 114–16, 118.

122. McAuliffe, *Vittoria Colonna,* 158–59.

123. McAuliffe, *Vittoria Colonna,* 160–61.

124. McAuliffe, *Vittoria Colonna,* 161–63. McAuliffe also notes Colonna's links with Ariosto (87), Castiglione (47), and Cardinal Bembo (45).

125. Bainton, "Vittoria Colonna," 35–41, esp. 38. See also idem, *Women of the Reformation in Germany and Italy* (Minneapolis: Augsburg, 1971).

126. See Creighton Gilbert, *Complete Poems and Selected Letters of Michelangelo,* ed. Robert N. Linscott (Princeton: Princeton University Press, 1963), no. 102. For the original Italian (in a more easily obtainable version than Girardi's classic edition) see Michelangelo Buonarroti, *Rime,* ed. G. Testori (Milan: Rizzoli, 1975), no. 104. Since both these editions base their numbering and dating on Girardi, with two minor exceptions, the numbering basically corresponds with a difference of two, and the English and Italian references to the poems will henceforward be given thus: "G" for Gilbert and "T" for Testori as in G102/T104.

127. See Augustine, *City of God,* bk. 11, chaps. 4–7, where he discusses such concepts as the eternity of time and the infinity of space. Augustine contemplates God's reasons for the creation and concludes that "the beginning of the world and the beginning of time are the same" (chap. 6). Concern with "the beginning" and "the end" appears to be reflected in Michelangelo's *Creation* frescoes on the ceiling, taken in conjunction with the adjacent *Last Judgment* on the end wall of the Sistine Chapel. Modern science continues to attempt explanation of these concepts; Steven Weinberg, *The First Three Minutes* (London: Fontana, 1987); Paul Davies, *The Last Three Minutes* (London: Weidenfeld and Nicolson, 1994).

128. For example, G105/T107; G132/T134; G152/T154; G186/T188.

129. G66 (l. 41)/ T68: "sopra la terra/ . . . totto l'uno e l'altro polo."

130. G119/T121 ("l spirto sciolto/ ritorna alla suo stella), see also G 127/T129; G253/T255, and discussion, Clements, *Poetry of Michelangelo,* 197–99. In G68/T70 the stars evidently signify "fate."

131. See Clements, *Poetry of Michelangelo*, 91–96.

132. Tolnay, *Michelangelo*, 3:68–75. For example G100/T102. Also J. A. Symonds, *Michelangelo's Sonnets*, nos. 41–43, 50, 53, and T14 (a fragment not included in Gilbert). For further discussion see Clements, *Poetry of Michelangelo*, 93–104.

133. G28/T30; G32/T34; G74/T76; G256/T258.

134. G93/T95 ("celeste lume"); G127/T129; G271/T273, concerning "the only Mover . . . His face and power . . . a guide and a light." Cf. Clements, *Poetry of Michelangelo*, 285.

135. G293/T295 ("tanto lume altrui prometta").

136. For example G70/T72 (the sun in its track signifies the passage of time); G84/T86 (referring to the passage of time on the death of his father); G201/T203, G206/T208, G216/T218 (referring to the death of Bracci); also G259/T261 and G273/T275.

137. For example, G38/T40 and G106/T108, to an unknown lady. A large group dated by Girardi to the 1530s (G59/T61, G70/T72; G73/T75, G78/T80, G79/T81, G85/T87) are usually assumed to refer to Michelangelo's idolization of the youthful Cavalieri, but references like "the sole sun" and "the sun of your light" could equally well refer to Christ at this period. The spirituality is intense. G99/T101 seems to be addressed to Febo di Poggio, owing to the pun on Phoebus/sun. G176/T178 similarly addresses another unknown. G227/T229 seems to refer to Colonna as "sun," whilst G247/T249 draws analogy with the city of Florence.

138. For example, G1/T1, G19/T21, G41/T43, G52/T54, G65/T67, G218/T220, G250/T252.

139. G6/T6.

140. G2/T4 and G45/T47.

141. Respectively G50/T52 and G66/T68.

142. Respectively G102/T104, G314/T316, G318/T320, G101/T103.

143. Michelangelo's interest in the symbolism of the Sun/Apollo theme was also recorded in a letter dated 26 July 1543, where an associate of the artist recorded a conversation and discussion on this subject, shortly after the completion of the *Last Judgment* ("the sun and center" cited by Summers, *Language of Art,* 12–13). Michelangelo's understanding of the central importance of the sun (literally as well as figuratively) is indicated.

144. Namely G246/T248 and G248/T250.

145. Clements, *Poetry of Michelangelo*, chap. 5 and p. 285, relevant to the *Last Judgment*.

Philosophical Sources

> But in the sixth book on the Republic, that divine man [Plato] explains the whole thing and he says that the light of the intellect for understanding all things is the same God himself by whom all things are made, and he compares the sun and God to each other.
>
> *Ficino*
> Commentary on Plato's Symposium[1]

Florentine Neoplatonism

The Renaissance revival of Neoplatonism was probably the major intellectual feature of the age. As Panofsky expresses it, "Florentine Neoplatonism achieved a success comparable only to that of psychoanalysis in our own day."[2] Based on the revival of the works of Plato (428–348 B.C.),[3] the movement attempted to demonstrate the basic unity and shared ground of two major elements of Western thought, the Judaeo-Christian religion and classical Greek thought.[4] With their center in Florence, under the patronage of the Medici, Neoplatonists like Marsilio Ficino (1433–99),[5] Cristoforo Landino (1424–92), Angelo Poliziano (1454–94), and Giovanni Pico della Mirandola (1463–94) (see fig. 110) exerted deep and lasting influence on European thought.[6] Among these, Marsilio Ficino was a major force in the movement and "the philosophical mouthpiece of the Renaissance"; translator of Plato and head of the Platonic Academy of Florence. "He was their centre and they were the centre of the Renaissance."[7]

For Ficino and others, Plato's writings held the key to major philosophical questions of the age, subjects of perennial and topical interest, such as knowledge of the divine or "Good," knowledge of Love and Beauty, the creation of the universe, the immortal spirit or soul of humanity, and one's role in the universe. In his preoccupation with humankind and the universe, Ficino's writings reflect a deep interest in

110 Domenico Ghirlandaio, *Ficino, Landino and Poliziano*,
(identified by Vasari), c. 1486. Fresco, detail from *Scenes
in the Life of John the Baptist*, Sta. Maria Novella, Florence.

cosmological speculation and in this way may provide another major
source for the cosmological interpretation of Michelangelo's *Last Judgment*.
Plato's views concerning the cosmological ordering of the universe, which
are closely related to his famous concept of the Good ("Αγαόν"),[8] are
fully discussed by Ficino in his translations and commentaries on Plato.
More importantly, Plato's use of the metaphor of the Sun for the Good is
also discussed and developed by Ficino, and Plato is clearly recognized
by Ficino as a major ultimate source for that concept. Examination of the
Christian Neoplatonic interpretation of classical philosophy thus reinforces
the traditional Christian analogy between sun and deity. It is important to
remember, in discussion of the Renaissance revival of classical texts, that
the continuous aim of writers like Ficino was to bring the Platonic view
of the universe into line with Christian thinking and reconcile classical
thought and Christian doctrine in a single system. Ficino and his circle
were undoubtedly convinced Christians, and he was himself ordained as a
priest in 1473. Plato's doctrines, regarded at this time as the nearest of the
ancient philosophies to Christian thinking and the Gospels, thus came to
be viewed as precursory to Christianity, thereby giving validity to classical
philosophy previously rejected as pagan. True religion, Christianity, was

to be combined with true philosophy—namely, the Greek philosophy of Plato.[9]

While there are many facets to Ficino's Christian Neoplatonism, a major theme in his writings, as in Plato's, is that of cosmology, and strongly incorporated into this theme is Ficino's use of the metaphor of the sun, which was interpreted as virtually a literal correspondence between the sun and the deity. Many specific parallels with Christianity were emphasized by Ficino and other Renaissance Platonists who aimed at the integration of Christian and classical themes: the story of the Creation, the great questions of death and immortality or, more specifically, the equating of the Christian God and the Platonic One, or Νοῦς.[10] As Cassirer succinctly expresses it, Neoplatonism represented a Christianizing of paganism, not a paganizing of the Christian religion. In spite of the classical revival and an added interest in the pagan gods, Neoplatonism was not neopaganism.[11]

Michelangelo and Neoplatonism

Michelangelo is known to have been well acquainted with the Neoplatonism of Ficino and his circle, for the household of the Medici, where Michelangelo spent his formative years, was the very center of the Neoplatonic movement in Italy.[12] The tradition continued under Lorenzo de' Medici (1449–92) as it had done with his grandfather Cosimo (1389–1464), the original sponsor of Ficino.[13] It is also significant for the present discussion that the two papal patrons of Michelangelo's commission of the *Last Judgment* had the same formative educational background as Michelangelo, for both the papal patrons of the fresco, Clement VII de'Medici[14] and Paul III Farnese, grew up in the household of Lorenzo the Magnificent and there absorbed the doctrines of Neoplatonism.[15]

The enormous influence of Neoplatonism on artists and writers in the late-fifteenth and first half of the sixteenth century in Italy should not be underestimated.[16] In the realm of painting especially, men like Sandro Botticelli, Raphael, Leonardo da Vinci, and even Dürer are well known for their inclusion or depiction of Neoplatonic themes in their works.[17] This was also extended to architecture, since, as Wittkower points out, the revival of the circular form in architecture was also rooted in Platonic ideas.[18] However, because of the extent of his involvement in the doctrine, even in comparison with these artists, Michelangelo stands alone. The influence of Neoplatonic ideas on Michelangelo's art—in his poetry as well as his figurative work—has already been extensively dealt with in the literature and "almost unanimously acknowledged in modern scholarship."[19] Neoplatonic influences have been determined especially in Michelangelo's earlier works, and particularly in the sculptural schemes for the Julius tomb and the Medici Chapel, by writers like Wilde and Tolnay.[20]

Edgar Wind examines Michelangelo's involvement with Neoplatonic philosophy in his *Pagan Mysteries of the Renaissance*,[21] and the influence of the doctrine on Michelangelo's theory of art and in his poetry has been dealt with by writers like Blunt, Clements, Summers, and Robb.[22] Suffice it to quote from Panofsky:

> Among all his contemporaries Michelangelo was the only one who adopted Neoplatonism not in certain aspects but in its entirety and not as a convincing philosophical system, let alone a fashion of the day, but as a metaphysical justification of his own self.[23]

Among the various interpretations of Neoplatonic themes in Michelangelo's work, certain major aspects of Neoplatonic influence have repeatedly been discussed. More strongly emphasized perhaps than any other is the Neoplatonic attitude toward Love and Ideal Beauty, which has received much comment in connection with Michelangelo's art and poetry. The basic idea is one of divine love as the goal of human desire, dependent on related themes of Goodness and Truth, and based on Plato's dialogues, especially *Phaedrus* and *Symposium*. Love of humanity is seen as a way to the Love of God,[24] and the combining of Platonic influence with the idea of Christian love in the works of Ficino demonstrates a harmony and affinity between the two.[25] The revival of the Platonic ideals of Love and idealized Beauty added an impetus to the new conception of idealism in art in the Renaissance.[26]

Other important Neoplatonic themes that have received emphasis in iconological interpretations of Michelangelo's works include the Neoplatonic idea of hierarchy and ascent to God, or the World-Soul, according to which each being occupies its place according to its degree of perfection, from God and the angels to the lower levels.[27] This concept is often related to the sculptural schemes for the Julius tomb and the Medici Chapel. Tolnay in particular interprets these schemes as symbolizing the cosmic hierarchy and as an image of the Neoplatonic Universe and he relates them to Plato's *Phaedo* and *Symposium*.[28] Linked to the idea of the ascent of the soul was the Neoplatonic discussion concerning the relative merits of the contemplative or active life. Again, this has been related to Michelangelo's funerary schemes. Another major Neoplatonic theme, that of the question of the immortality of the soul, has also been much discussed in relation to Michelangelo's works and has been understood as expressed particularly in the slaves of the sculptural scheme of the Julius tomb, as well as the Medici Chapel.[29] The important Platonic discussions about death and the concept of the immortality of the soul, expounded by Plato in *Phaedo*, were developed by Ficino in his *Theologia Platonica de Immortalitate Animorum* (1469–74).[30] The theme of death, especially the way in which the mortal flesh is shed at that time to release the spirit, is

also one referred to by Michelangelo in his poems.[31] The doctrine of the immortality of the soul was officially pronounced dogma of the Catholic Church at the Fifth Lateran Council in 1513, partly as the result of Ficino's influence.[32] And the opening address of the council by Egidio of Viterbo confirms the prevailing attitude toward the Neoplatonic definition of death as the separation of soul from body. It is important to remember that this same man has been proposed as the theologian behind the program of Michelangelo's Sistine ceiling.[33]

Much discussion of Neoplatonism in Michelangelo's works thus exists, and it has been largely accepted as a major influence; yet, as shown, it is frequently confined to isolated ideas, or the overall Platonic concept of Love and the idea of Beauty. In addition, such discussion is also usually confined to the discovery of Neoplatonic influences in Michelangelo's earlier works and seems to have been largely discounted after the increase of his religious motivation from the 1530s.[34] The emphasis of scholarship is laid firmly on the expression in Michelangelo's works of those Neoplatonic ideas discussed above, but several themes of major importance in Neoplatonic philosophy, and their possible relationship to Michelangelo's choice of iconography, have yet to receive sufficient attention. Neoplatonic cosmology has been discussed briefly in relation to Michelangelo's important funerary schemes but has not been considered, together with its corollary of the sun-deity analogy, in connection with the *Last Judgment* fresco.

Neoplatonic Themes

Time and Creation, the ordering of the universe, its uniqueness, its maker, its soul, its manner of movement and geometric basis, and the nature and role of humanity in the universe—the finding of explanations for these timeless concepts forms a major preoccupation of Plato's Socratic dialogues.[35] Similarly, during the Renaissance, the Neoplatonic interpretation of Plato's key works like *Timaeus, Republic, Symposium, Phaedo,* and *Phaedrus,*[36] placed a strong emphasis on cosmology and related questions concerning the ordering of the universe. Plato's idea of the sun as a symbol of the deity (*Republic,* 6), his concept of the World-Soul as related to the immortality of the human soul, the flesh/spirit dichotomy (*Phaedo*), and the symbolic significance of the circularity and circular motion of the universe (*Timaeus*) all received attention, particularly from Ficino. These major themes may also be traced as meaningful in Michelangelo's works and in the fresco of the *Last Judgment* in particular, where tradition required a cosmological interpretation, the influence of Neoplatonic cosmology may be argued. The relationship between the Christian standpoint on these issues and the classical view (influenced by

Platonic philosophy) should also be considered with respect to the *Last Judgment* fresco.

The writings of Ficino provide a major source for the Renaissance understanding of Plato's cosmology and for the Neoplatonic interpretation of the sun symbol in particular, although other philosophical writings also merit attention. As has been demonstrated, theological writings and the *Divina Commedia* of Dante had served to reinforce interest in cosmology and the sun-deity analogy during the Renaissance. But Ficino's interpretation of Plato also may be viewed as a major source of influence for the Renaissance view of the cosmos as well as the symbolic identification of the sun and the deity, which is found so often in Renaissance literature and philosophy. By translating Plato's works, Ficino made available the texts that had been "lost" during the Middle Ages.[37] Apart from a few fragments, only the *Timaeus* of Plato's dialogues was known in the West during the medieval period.[38] This work is largely concerned with cosmology, but, as is well known, Plato's cosmology was suppressed in favor of Aristotelian thought by medieval scholastics. Aristotle's more empirical view of the universe, as expressed for example in *De Caelo* (*On the Heavens*), held sway over the more abstract and spiritual approach of Plato.[39] But Ficino, building on the achievements of the Byzantines, Gemistos Plethon (1355–1450), and Bessarion (1403–72), who came to Italy in the mid-fifteenth century,[40] was largely responsible for the revival and propagation of Platonic philosophy. This revival was not a revival of purely classical, pagan thought; the aims and ideas of Ficino and the other Florentine Neoplatonists were to emphasize a Christian reading of Plato's ideas. Concerning cosmological issues and the symbolic use of light or the sun as symbol of the deity, it is important to consider the ways in which Ficino and others integrated the Platonic and Christian standpoints, continually emphasizing their similarities.[41]

Ficino's translations and commentaries on major works by Plato provide important source material for Renaissance cosmology. In addition to works directly based on Plato, Ficino's own writings like *Platonic Theology* (1469–74), *Christian Religion* (1474), *De Vita* (1489), the important *De Sole* (1493), and even his *Letters* (printed 1495) also include much that is relevant.[42] Interest in these writings of Ficino and his circle as an essential source for an understanding of the Renaissance has led to the appearance of much new material in the literature in the form of new editions and commentaries on his work. It should be noted that the major part of scholarly discussion concerning Platonic influences in Michelangelo's work dates from the 1940s and earlier, by writers like Panofsky, Wittkower, Gombrich, Wind, Blunt, and Tolnay. A large part of this discussion is related to Plato's own texts, as much as to Ficino's translations and commentaries, which contain more than a simple transmission of Plato.[43] Ficino's *Opera*

Omnia (Basel, 1576) seems to have been used relatively little because it was, and is still to a certain extent, difficult to access.[44] Recently, however, commentaries as well as modern editions and transcriptions of some of Ficino's key works are widely available, but this wealth of material has yet to be used fully in conjunction with the interpretation of Renaissance art. Michelangelo's Neoplatonism appears to be accepted in general terms by modern art historians, but there is room for more in-depth discussion of its precise potential sources and especially consideration of the ever-increasing amount of material on Ficino and his circle. Works now even more readily available include the *Commentary on Plato's Symposium* (*De Amore*), *Theologia Platonica*, *De Sole*, *De Vita*, *Philebus Commentary*, *Phaedrus Commentary*, *Sophist Commentary*, and four volumes of Ficino's letters,[45] as well as numerous other extracts, together with an increased amount of scholarly debate on Ficino as philosopher.[46]

The importance of cosmology in Plato's thought is reflected and emphasized in Ficino's own writings and is particularly evident when *Timaeus* and *Republic* are considered. The theme is also significant in both Plato and Ficino for the way in which it is so often linked with the allegorical interpretation of the astronomical symbol of the sun. *Timaeus* is the major source for Plato's cosmology, and evidence of interest in this dialogue continuing into the sixteenth century is confirmed by the fact that the figure of Plato in Raphael's *School of Athens* (1510–11) in the Stanza della Segnatura, Vatican, bears that volume under his arm (fig. 111). In the *Timaeus*, Plato describes the creation of the universe by its Maker, and its uniqueness of form, which is dependent upon the geometrical basis of the perfect sphere or circle.[47] The question of circular celestial motion is also related to the sphericity of the cosmos, being dependent upon the circular form. The universe, says Plato, is enveloped within the world-soul and dependent upon two circles that interlock like a cross and revolve about the same point.[48] Plato also discusses the concepts of time and infinity, the creation of sun and planets, and the idea of the stars as immortal souls. These issues—time and space, infinity and eternity, the concepts of Being and Becoming—are also clearly the issues that concerned thinkers of the Renaissance period.[49]

Plato refers to similar themes again and again as, for example, in the *Republic*, where he speaks of the importance of the circle as a symbol of perfection and continuous generation, and he gives a clear description of the structure of the universe as composed of revolving circles.[50] The *Republic* is also particularly significant as a source for Ficino's concept of the Good. This is combined with cosmology by Plato in *Republic* 6, where he introduces his famous metaphor of the sun as symbol of the Good and as the central point of the cosmic system.[51] In discussing the ideal state and ideal values, the idea of the Good as source of reality and

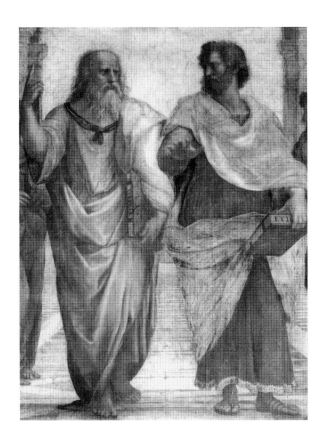

III Raphael, *School of Athens,* detail of Plato, 1510–11. Fresco, base 770 cm. Stanza della Segnatura, Vatican, Rome.

truth, which gives intelligibility to forms and the power of knowledge to the mind, is explained by means of a direct comparison with the sun. Source of light and heat and life, the sun renders objects visible and gives seeing to the eye as the Good gives the power of knowing to the mind. The same important metaphors of light/dark contrast and the sun symbol are developed by Plato in conjunction with his equally famous metaphor of the Cave,[52] as Plato explains how men are to escape from the darkness of human ignorance in the cave to come out into the light of the sun, that is, to attain knowledge and understanding of the Good. Attention paid by Ficino to the dialogues *Timaeus* and *Republic* confirms his interest in these themes, but Platonic concepts of a circular cosmology and the sun as symbol of the Good or Godhead are also developed elsewhere in Ficino's commentaries and letters, especially in his *Commentary on Plato's Symposium*, where the ideas are further combined and developed as Ficino presents his own interpretation of God and the universe.

Of all Ficino's works, the *Commentary on Plato's Symposium* (also referred to as *De Amore*) is especially significant as a potential source for Michelangelo because of its widespread popularity and because it was regarded by Ficino as his major work and avowed by him as a condensed

view of his theories and ideas.[53] It was more widely available and had more influence than many of his other works, possibly because, unlike other commentaries, it was available in Italian as well as Latin.[54] In addition, it is a work with which Michelangelo was known to have been acquainted.[55] Ficino's *Commentary on Plato's Symposium* (*De Amore*) is of major importance for the Neoplatonic idea of the sun as symbol of the deity and the cosmological ordering of the universe, but other writings of Ficino—especially *De Sole*, *Platonic Theology*, *Phaedrus Commentary*, *De Vita*, and Ficino's letters—also appear significant.[56] Comments made by Ficino on Plato's *Timaeus* and Plato's *Republic* 6–7, where the sun-deity analogy is put forward in conjunction with Plato's associated idea of the dark cave, are also relevant. These facets of Ficino's philosophy and the Neoplatonic doctrine of ascent to God through illumination by divine light should be examined in relation to the circular cosmology of Michelangelo's *Last Judgment*, arranged as it is around the depiction of Christ in the form of an Apollo-Christ—a classicized version of the traditional Judaeo-Christian sun-deity.

Ficino's Cosmology

The nature of Platonic Love is a major theme in Ficino's commentary on Plato's *Symposium*, but Love is viewed as the means to reach God. According to Ficino, the universe is made coherent by God's cosmic love, which pervades all creation.[57] So Ficino's discussion in *De Amore* incorporates his quite specific views concerning the arrangement of the universe. The two major themes of a circular, moving cosmology and the interpretation of the deity as a sun symbol in the center of the universe permeate this work. References to the creation and ordering of the universe and the Platonic concept of the deity are always brought, by Ficino, firmly into line with Christian thinking. Plato's monotheism has also received much comment. He uses the term "Demiurge" to refer to the single divine force or maker, and he also uses the term "τηεός" or "God" in a distinctly monotheistic way.[58] Viewed as a personification of "the Good," the supreme intelligence or world-soul, the Platonic concept is taken by Ficino as a direct equivalent to the Christian God, and this is emphasized in Ficino's *Commentary on Plato's Symposium*.[59] In the first speech of this work, Ficino explains his discussion of the creation in these terms, and he immediately introduces the metaphor of the sun. As in the book of Genesis, Ficino speaks of the importance of light, the divine light of knowledge, in the creation of the world; he explains how the mind or soul is turned toward God "in the same way in which the eye is directed towards the light of the sun," as light gives form to the chaos of darkness.[60] This use of light/dark symbolism

and the sun metaphor, familiar to Ficino from Plato's *Republic*, books 6 and 7, was to be used repeatedly in this and later works by Ficino.

Soon after the introduction of the Platonic sun metaphor, in speech 1, chapter 3, Ficino introduces the other major issue, namely that of circularity and circular motion of the universe, "there exists a certain continuous attraction (beginning from God, emanating to the World, and returning at last to God) which returns again, as if in a kind of circle, to the same place whence it issued."[61] Ficino continues by relating this concept to other well-known Neoplatonic ideas concerning Love and Beauty.[62] He links the concept of Divine Love and the Good to the idea of the circularity of the universe by referring to traditional writings and interpretations of the Church Fathers and quoting Dionysius the Areopagite, "Love is a good circle which always revolves from the Good to the Good."[63] Coupled here with the Neoplatonic themes of Love and Beauty in which Michelangelo undoubtedly had interest, Ficino's view of cosmology does seem to correspond well with the circular arrangement of the cosmos in Michelangelo's *Last Judgment* fresco, contrasting with the medieval approach to a horizontally layered hierarchical scheme.

Ficino's references to Pseudo-Dionysius serve to confirm his Christian intent and his view of the Christian God as synonymous with Platonic concepts like Beauty, Love, and the Good. He also quotes Dionysius as supportive of the specific analogy between sun and deity. He continues,

> Not without reason does Dionysius compare God to the Sun, for just as the sun gives light and warmth to the body, so God offers the light of truth and the warmth of love to souls. We certainly infer this comparison from the sixth book of Plato "*On the Republic*". . . .[64]

This clearly confirms that the Early Christian analogy between the sun and Christ and the exegesis of the metaphor by the early Church Fathers were well known in the Italian Renaissance, to Ficino among others. Ficino traces the analogy even further back to its origins in Greek philosophy, and, acknowledging his own sources in Plato, he repeatedly summarizes Platonic ideas, drawing a direct comparison between the Christian analogy of sun and deity and Plato's writing in the sixth book of the *Republic*.[65]

Linked with his discussions of the Platonic sun symbol are Ficino's comments on the circular cosmological arrangement of the universe. References in the *De Amore* are numerous, but in particular, chapter 3 of speech 2 appears significant. The section is entitled "Beauty is the radiance of Divine Goodness and God is the center of Four Circles" ("Pulchritudo est Splendor Divinae Bonitatis et Deus est Centrum Quattuor Circulorum"), and Ficino is quite specific about his concept of the arrangement of the universe. He reasons carefully why God should be situated at the center of a circular universe, and his views continue to be linked tightly to Plato's

concept of the Good, viewed as equivalent to the Christian God. Referring again to ancient precedent, Ficino places the Good in the single center of a circular universe.

Although Ficino is dealing with metaphysical, metaphorical, and transcendental hierarchies to explain his ideas, he does imbue them with an almost physical existence. His circular cosmological arrangement is not presented as a system of reality in the modern scientific sense, but he seems to perceive it in a literal or physical way, as well as in the spiritual manner in which the Platonic concept of the Deity is viewed as the central point of the universe. He writes in chapter 3, "The single center of everything is God. The four circles around God are the Mind, the Soul, Nature and Matter the reason why we call God the 'center' and the other four, 'circles,' we explain"[66] Whether or not Ficino considered that this system possessed potential for actual physical existence, Michelangelo, as an artist, would surely tend toward a visual interpretation even of concepts that could be interpreted both metaphysically and literally.

Ficino proceeds to explain his circular cosmology in terms of the meaning of the circle as symbol of perfection and eternity along lines similar to Saint Augustine. In a passage remarkably similar to Dante and Augustine, he, too, stresses the central generating point of the circle where God is situated. Ficino lays great emphasis on the point of origin of the circle, namely that point which generates the form in all its perfection.[67] He demonstrates how a circle must be dependent upon a single point, and, referring once more to the sun symbol, he expands this metaphor to relate to the formation of the universe, showing how "rays" or lines move outward in the universe from a single point of origin in the same way that rays spread out from the sun. He emphasizes the significance of the point that generates the circles of the universe:

> The center of the circle is a point, single, indivisible, and motionless. From it, many lines which are divisible and mobile are drawn out to the circumference, which is like them. This divisible circumference revolves around the center as its axis.[68]

Ficino compares this "point" with God himself and continues:

> Who will deny that God is rightly called the center of all things since he is present in all things, completely single, simple, and motionless? But all things produced from him are many, composite, and in some way movable, and as they flow from him so they flow back to him, in the manner of lines and a circumference.[69]

Ficino's view of the central deity, which he explains and develops further in this chapter,[70] contains echoes of Dante. His exposition of the central

point in his conceptual universe conjures up a visual image of the sun and its rays, which seemingly corresponds with the composition of Michelangelo's *Last Judgment* fresco (figs. 1, 51, and 52). The importance of the sun's rays as originating at a specific point and extending outward to the circumference may easily be perceived in the fresco and was evidently read as such by early copyists, as has already been demonstrated (fig. 65). Ficino's interpretation here would seem to correspond well with Michelangelo's fresco in the way the circles and circular movement appear to be generated from the same central point. The diagonal lines in the *Last Judgment,* fanning outward like "rays," also seem to originate in the same area as the circular composition, namely in Christ himself.

Ficino's comments on the immobility of the central generating point raise the question of the ambiguity of the pose of Christ in Michelangelo's fresco. The view of God as center and mover of the universe may be related here to the somewhat complex question of movement in Michelangelo's fresco. Most scholars are in agreement about the idea of circular movement in the overall composition of the fresco and also with the view that Christ's pose is suggestive of movement, although some art historians regard Christ's pose as ambiguous, being neither seated nor standing, neither moving nor still.[71]

Aristotle's view of the universe, as outlined in his *De Caelo,* which was so influential through the Middle Ages, concurs with the concept of the Creator as "Unmoved Mover" of the universe. Aristotle reasons that if everything in motion must be moved by some other force, then self-motion becomes impossible. He deduces, therefore, that the originator of circular, celestial motion must be something capable of instigating motion while itself remaining unmoved, that is, the Unmoved Mover.[72] This theme apparently fits in well with Ficino's concept of a stationary point generating the movement of the cosmos, which is also emphasized by Dante. Yet Michelangelo's Christ is set in an ambiguous pose, which may imply either motion or a stationary generating force.

Aristotle's theory of celestial motion bears some relation to that of Plato, but for Plato self-motion was not impossible. In fact, in complete contrast to Aristotle, Plato argues "motion" as evidence of immortality: "Spontaneous motion is prior to communicated [motion], and the Prime Mover of all is a self-mover, identified with Soul, the life principle."[73] The same concept is expressed in *Phaedrus* and *Timaeus.*[74] Aristotle did consider this premise of original, self-caused motion, stating at one point, "The activity of a god is immortality, that is, eternal life. Therefore, the god must be characterized by eternal motion," but he later disputes this, saying that even if the whole body of the universe revolves in circular motion, the central point of that circle must remain still.[75] Reinterpretations of Aristotle's doctrines, including that of the Unmoved Mover, were the most

commonly accepted bases of thought during the Middle Ages. His views lay behind the medieval concept of the universe and, as such, contributed to the standard and traditional interpretation of the *Last Judgment*. With the revival of Plato in the late fifteenth century, however, this view came to be reconsidered, as evidenced by the writings of Ficino. It seems unlikely that Michelangelo, in that climate of discussion between Platonic and Aristotelian thought (epitomized by Raphael's *School of Athens,* fig. 111), should arbitrarily decide on the depiction of circular movement energized by a forceful Christ figure in his *Last Judgment* fresco without considering such theological and philosophical connotations. If the pose of Christ is to be read as ambiguous, it is possible to suggest that here, as elsewhere, Michelangelo may have been incorporating Neoplatonic ideas into an existing framework of traditional ideas. It seems as if the depiction of movement in the fresco, and the ambiguous pose of Christ himself, is related to Platonic cosmology, and that Christ's pose is ambiguous because he is an immortal deity to whom the confinements of human posture do not apply. Reference is made to the Aristotelian concepts based on a single unmoving point, as well as the Platonic, which views the immortal God, the Prime Mover, or World-Soul, as a self-moving circle, identified with the life principle. Michelangelo suppresses the Aristotelian view in favor of the Neoplatonic while yet not totally rejecting the tradition, but incorporating it into the new framework.

In a similar manner, the circularity of Michelangelo's scheme appears to take up another Platonic concept without totally abandoning the traditional or Aristotelian view—namely, the "up for Heaven" and "down for Hell" concept of the universe. The Aristotelian view was that earthly motion took place in a straight line, and only celestial motion was perfect, circular, and eternal. While light objects tend up and away from the earth, heavy objects tend straight downward; circular motion was attributed only to celestial objects. Plato discusses this in *Timaeus* and presents alternative arguments, which are also considered by Ficino in his *Commentary* on that book. Plato examines the notions of "heavy" and "light," of "above" and "below," and concludes "inasmuch as the whole heaven is spherical, all its outermost parts, being equally distant from the center, must really be 'outermost' in a similar degree."[76] According to Plato, Aristotle's view of "above and below" is erroneous and there is no up or down but only innermost or outermost in the universe. He says: "seeing that the whole is spherical, the assertion that it has one region 'above' and one region 'below' does not become a man of sense."[77] This transition from the Aristotelian view accepted in the Middle Ages to the Platonic view popular in Renaissance Italy appears to fit in well with the overall disposition of Michelangelo's *Last Judgment,* where the circular format is stressed. Yet, in many respects, Michelangelo does not wholly reject the ancient tradition, for the suggestion of a layered up/down arrangement in the fresco is

not totally abandoned. Rather, Platonic cosmology is imposed upon and within the existing framework.

As a potential source for Michelangelo's *Last Judgment*, Plato's *Timaeus* is important for the way Plato also discusses the state of individual souls in relation to the concept of the immortality of the soul. Plato's analogy between souls and stars, and the assimilation of this concept by the Renaissance Neoplatonists, is well known; the theme does seem to fit in well with the cosmological interpretation of Michelangelo's *Last Judgment,* where the souls of the blessed and damned are arranged around the figure of Christ, just as the stars and other heavenly bodies are arranged near the sun.[78] In addition, in *Timaeus* Plato actually describes the physical disposition and movement of the individual souls:

> They were causing constant and widespread motion . . . joining with
> the perpetually flowing stream in moving and violently shaking
> the revolutions of the soul, they totally blocked the course of the
> same by flowing contrary thereto. . . . they produced all manner of
> twistings, and caused in their circles fractures and disruptions of
> every possible kind, with the result that, as they barely held together
> with one another, they moved indeed but irrationally, being at one
> time reversed, at another oblique and again upside down.[79]

This passage reads as though it was a description of the individual figures in Michelangelo's fresco (see figs. 1 and 63).

Thus the concepts of circularity and circular motion appear to have been inextricably linked with broader cosmological concepts that were under discussion at the time and were very much related to Renaissance Neoplatonic thinking—Christian and Platonic notions of the generation and composition of the universe, the world-soul, and the immortality of the soul. Concern with the human soul and its fate after death is a concept that comes under discussion again and again in Ficino's translations and commentaries on Plato's dialogues.[80] Drawing on Plato, in his *Commentary on Plato's Symposium*, Ficino draws attention to the role of God as the center of everything, but he equates this with the Platonic concept of the world-soul, which is also viewed as a movable circle. Ficino's cosmology is thus closely related to his concept of the immortality of the soul—a concept that, it has often been stated, has found expression in Michelangelo's works. The central God is viewed as pure spirit, the Good or World-Soul to which the human soul is united on death.

Ficino also analyzes the different regions within the cosmic ordering of the universe around the central concept of God. Four regions—mind, soul, nature, and matter—proceed from God, who is the fifth element in Ficino's "Theory of Five Substances."[81] The "Angelic Mind" is immovable ("it is movable only in that it turns towards God").[82] The

world-soul is a movable circle ("mobile but orderly"). Nature is mobile but confused, and matter concludes the cosmological scheme.[83] This scheme is discussed by Gombrich, together with its relevance in Renaissance Italy, and a diagrammatic interpretation is suggested in the form of a series of concentric circles.[84] Some visual correspondence might be traced between this scheme and the distinct areas of Michelangelo's fresco; namely, that the Angelic Mind is represented in the area of the Lunettes (figs. 59, 60), the soul in the figures of the inner circle (fig. 53), nature in the outer circle, and matter in the earthly zone at the base (fig. 1), which is a subject that merits further investigation.

Parallels between Platonic cosmology and the concept of the deity as equivalent to the symbol of the sun are continuously drawn throughout Ficino's *Commentary on Plato's Symposium* and especially in speech 2, chapter 5. Here, Ficino draws an analogy between the "supreme light of the sun itself" and the "glow of God," which illuminates the universe in the same way. The light of the sun is often used with symbolic meaning in connection with the deity throughout the remainder of the work.[85] When considering the Sun-Christ of Michelangelo's *Last Judgment,* it is interesting to follow the way Ficino draws the analogy between God and Beauty, as well as God and the sun, and then discusses how this allegorical symbolical God may be depicted in human form. He relates how Agathon, the poet in Plato's *Symposium,* describes the figure in the image of a handsome young man, "young, tender, flexible, or agile, well-proportioned, and glowing,"[86]—in fact, as Beauty personified, analogized with the Good. A correspondence between this physical description and Michelangelo's Apollo-Christ seems to be not implausible.[87]

In his *De Amore,* Ficino thus not only refers to circular cosmology and includes direct use of the sun-deity metaphor, but he also frequently acknowledges his own ultimate philosophical source for these concepts in Plato's *Timaeus* and *Republic* (book 6). Ficino's translations and interpretations of Plato's *Symposium, Timaeus,* and *Republic* are evidently very important for the formation of Renaissance cosmology and worldview, but the related themes of sun-symbolism in the perception of the deity and the cosmological ordering of the universe also permeate many of Ficino's other writings. These, in turn, serve to demonstrate the widespread discussion and acceptance of the concept. For example, in his translation and commentary on Plato's *Philebus* (1469),[88] which is closely related to his *Symposium Commentary,* Ficino is mainly concerned with discussion of Plato's concept of the Highest Good, the One; and he refers again to cosmology, sun symbolism and specifically to *Republic* 6 and 7.[89] Similarly, the *Phaedrus Commentary* (published 1496) contains several references to the idea of the One and related themes of the movement and central point of the universe. He describes how "various souls circle round with various heavenly beings, and repeat these same circuits by turns," an image that,

bearing similarities to Dante's description of the spirits in *Paradiso*, might also be taken as descriptive of the arrangement of figures in Michelangelo's *Last Judgment*.[90]

Apart from his direct commentaries on Plato, in Ficino's independent writings (which were obviously closely related to Plato's thought even if not direct commentaries or translations) similar themes are used repeatedly. The *Theologia Platonica de Immortalitate Animae* (1469–74)[91] and *De Christiana Religione* (1474)[92] represent a synthesis of Plato's thought and Ficino's own Christian thinking, greatly influenced by Augustine and Proclus. The *Platonic Theology* represents Ficino's attempt to understand his own soul and embraces discussion of the familiar themes of Ficino's thought: the notions of time and eternity, the relationship between the flesh and the spirit or soul, and the cosmological ordering of the universe. The metaphors of light as symbolic of knowledge and the Good, and the sun as symbolic of the deity are examined where Ficino describes the paradoxical concept of how the light descends from the sun without leaving the sun, and how, to see the sun, the light of the sun is necessary.[93] Notions derived from Plato are clearly imbued with Christian meaning. In book 3, chapter 2, Ficino turns his discussion to the cosmological arrangement of the universe, based, as in *De Amore*, on the cosmology of the circle and the point at the center of the circle. Referring to previous discourses on the importance of the World-Soul (mentioned above), he describes the perpetual circular motion of the universe and its all-important center: "The greatest wonder in Nature . . . the middle point of all that is, the chain of the world, the face of all and the knot and bond of the universe."[94]

Ficino's interest in sun-symbolism and cosmology also permeates his more popular work, *De Vita Libri Tres* or *Book of Life* of 1489.[95] Begun as a commentary on Plotinus, *De Vita* is indicative of Ficino's interests in astrology and even magic.[96] Here, amidst recommendations for the ideal way of life for the student or learned scholar, the theme of the sun and its symbolism is presented particularly strongly. The text concerns medicine, astrology, and magic and refers to sun imagery in these specific contexts, but this specialized use still demonstrates the prevalence of such themes. References to the sun's influence on people's lives and work are numerous and embrace the use of the same type of metaphorical symbolism.[97] The desirability of association with "solar" elements is recommended since "the Sun is Lord of Life," and the comparison between the deity and the sun is again demonstrated.[98]

Ficino's popular *Book of Life*, with its pervading emphasis on sun imagery, was almost certainly known to Michelangelo[99] as also, perhaps, were Ficino's letters, which, although written privately, were gathered by Ficino and published in 1495.[100] The sun-deity metaphor again occurs intermittently in Ficino's letters and is used by him with reference to both the Christian deity and Platonic notions of the Good.[101] Similar references

to the themes of the *Commentaries*, like the ordering of the universe and the concept of the God-centered cosmology, are also frequent and demonstrate the topical subjects of debate, which often had interest shown in them by those in authority, including art patrons.[102]

Most important, perhaps, of all Ficino's writings, that may have been a direct influence upon Michelangelo's view of a God-centered cosmology based on the Christian interpretation of the Platonic sun metaphor, are his *Orphica Comparativo Solis ad Deum* (1480) *De Lumine* and *Liber de Sole* (1487), which were published together in 1493.[103] Described as a "fine example of the solar literature of the period," in which Ficino attempted "to synthesize age-old doctrines concerning the sun with his own Neoplatonized version of Christianity,"[104] *De Sole* was likely to have been known to Michelangelo, because of its general popularity. Here, Ficino begins by discussing the significant analogy between the light of the sun and God, the Supreme Good, with reference to the nature of allegory, and he comments on the ways in which the light of the sun is similar to God, the Supreme Good.[105] "Nothing," he says, "reminds us of the nature of Good more than light," and the metaphor of the Good as light is extended to embrace the Christian God: "The Sun alone can indicate to you God himself. The sun will give you clear signs. Who will dare to say that the sun is false?"[106] Ficino emphasizes the role of the Sun as the illuminating lord and regulator of the skies, and he refers directly to the "solar deity." Conscious of the ancient reverence paid to the sun and Apollo, he stresses the sun's role in cycles of birth and death.[107] The analogy with the Christian deity is emphasized as Ficino explains why the sun serves as metaphor for the Trinity and that it is the visible image of God. In chapter 9 in particular, the image is very strongly developed and Ficino even alludes to the role of Christ as sun at the time of judgment when he will awaken the dead like the new sun awakens the world each spring (caput 9).[108] Ficino then turns his attention to the role of the sun in creation: "the sun was the first to be created and was placed at the center of the sky It sits, as if occupying a rock in the center in the manner of a king."[109] Ficino was clearly aware of sources for the metaphor in the Old Testament and the Church Fathers like Augustine and Pseudo-Dionysius, as well as Plato. He was also aware of the association between the pagan and Early Christian traditions, since he refers to the institution of the Day of the Lord as the solar day.[110] Ficino's following chapters develop his discussion of the sun as symbol for God, its appropriateness as an analogy with the Trinity, and as explanation of the relationship between God the Father and God the Son. Indeed, the work as a whole is strongly suggestive of source material for Michelangelo's fresco, as is the associated *De Lumine*, which contains similar material, especially since the influence of these texts and commentaries was known to be far-reaching.[111] His writings were not only known in Italy. They also circulated in Europe as

far as Cracow, and the possible influence of the Neoplatonic cult of the sun on Copernicus' formulation of his heliocentric theory has been noted and will be discussed more fully in the next chapter.

Michelangelo's Hell and Plato's Cave

Among Ficino's commentaries on the Platonic texts of *Timaeus*, *Symposium*, *Phaedo*, and *Republic*, which appear relevant to a discussion of Michelangelo's *Last Judgment*, book 6 of the *Republic*, with its exposition of the analogy between the sun and the Good or God, appears to be a key text. The close relationship between this and the following section (*Republic* 7) has been widely recognized by modern commentators no less than Ficino himself, and thus also merits consideration in connection with Michelangelo's fresco. It appears significant that *Republic* 7 is where Plato introduces his famous metaphor of the Cave, one of the most familiar of all Platonic passages, which is inextricably linked with the sun metaphor of his previous section. This in turn may help to explain Michelangelo's depiction of the lower regions and of Hell in his *Last Judgment* fresco, which has long puzzled scholars, mainly owing to the unusual depiction of a "Cave of Hell" immediately above the altar of the Sistine Chapel.[112]

Following on from his use of sun imagery in *Republic* 6, Plato begins his description of the cave, "Picture men dwelling in a sort of subterranean cavern . . ."[113] and then he goes on to describe men who sit fettered with their backs to a fire, able to see only the shadows cast on the wall of the cave by moving objects or artifacts. These they assume to be "reality." Philosophy can enable them to become free by drawing them out in painful ascent to the realm of day, where all is illuminated "by the dazzling light of the sun . . . to rise through the pure ideas of reason to the idea of Good."[114] Simply stated, their situation in the cave is symbolic of human bondage and ignorance.[115] Plato demonstrates how these "perpetual prisoners" may be freed by light; and here he refers back to the sun metaphor, which dominates the previous section.

The men of the cave are to be freed and "drawn out into the light of the sun." At first the light of the sun blinds even more, but then the human soul becomes accustomed to the light and enveloped in its warmth and goodness. This process allegorically represents the contemplation of higher things (the Good according to Plato, God according to Ficino). The soul can then ascend to the intelligible region. As in the analogy with the sun, the last and most difficult thing to perceive is the idea of the Good—the sun itself. The process of illumination is arduous for the soul because "the passage from the deeper dark of ignorance into a more luminous world and the greater brightness had dazzled its vision," until "the soul is able to endure the contemplation of essence and the brightest

region of being—and this we say is the Good" (understood as God by Ficino).[116] The simple but effective metaphor of coming out of the dark into the light of reason and the Good is one that is readily understood, more so, perhaps, than some of Plato's more complex notions. The same metaphor is again emphasized in a later section.[117] Here, the progress from cave to sunlight is stressed, and the key is said to be contemplation and education, which direct the soul to what is best in reality. Plato's Cave is thus based on the symbolism of the sun in the context of its analogy with the Good, and dependent upon the way in which the sun, by its own light, makes its own realm or self intelligible.[118]

Ficino's translation and commentary on the *Republic* places an emphasis on the combined sun-cave metaphor,[119] which is strengthened by his references to it elsewhere, such as in *Theologia Platonica* where *Republic* 7 is specifically discussed.[120] Plato's Cave became a topical matter for discussion in the Renaissance, as shown by references in Ficino's letters to friends and associates, in particular his letter to the theologian Angiolieri, which incorporates Ficino's "word-for-word" translation of Plato's text of *Republic* 7.[121] Ficino explains the allegory, commenting on its spiritual as well as educational aspects. He gives a clear image of the arrangement of the cave and demonstrates how humanity is able to escape the darkness of the cave of ignorance and "go forth from darkness into sunlight . . . rising from utter folly to the vision of brilliance."[122] If, in Michelangelo's fresco, the Sun-Christ is depicted as Ficino's "vision of brilliance," then the cave at the lower edge of the fresco above the altar might also possess an association with *Republic* 6–7.

In the center of the lower edge of Michelangelo's fresco of the *Last Judgment,* a large cave is clearly defined, usually assumed to be an analogy of Hell or perhaps Purgatory or Limbo.[123] Some figures peer from the gloom. A clearly human presence is suggested by the nude back view of a figure outlined by the central fire whose glow is seen in the depths (fig. 112). Outside the cave, to the viewer's left, are figures moving away, outward through a breach in the cave and upward toward the Sun-Christ (fig. 113).

This cave, then, might be considered as capable of possessing reference to not only the Christian Hell as depicted by Michelangelo, but also to Plato's Cave. This seems reasonable in terms of Michelangelo's interest in Plato. The figures close by the cave are not being drawn into it (feet first), but are coming out of it. Those who have been damned are not being pulled into this "Cave of Hell," but they are being propelled (on the right-hand side of the fresco) in a completely different direction. The idea of figures coming out of the cave appears far more appropriate to Plato's Cave than to the Christian Hell. Hell itself seems, in fact, hardly to be depicted in the fresco at all, since Charon and Minos, situated in the extreme lower right-hand corner, are avowed, by both ancient writers and by Dante, to be situated at the entrance to Hell (figs. 96, 97).[124]

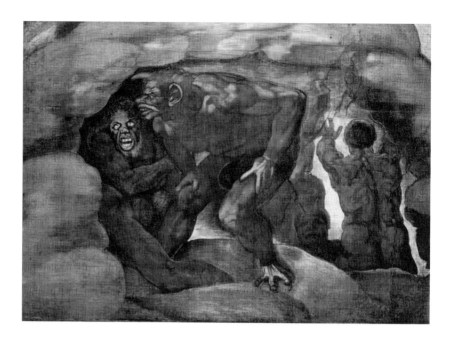

112 Detail, rear of nude figure in the Cave. Black and white, prerestoration.

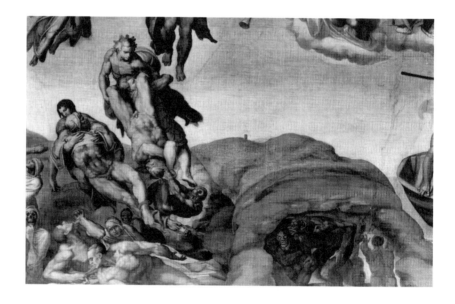

113 Detail, figures emerging from the Cave. Black and white, prerestoration.

The placement of the cave over the altar, when perceived as the Cave of Hell, has long puzzled scholars. One explanation that may be proposed is based upon the argued interest of Michelangelo in Nicodemism and the Gospel of Nicodemus, which has already been discussed. The Gospel of Nicodemus embraces the theme of sun-symbolism and provides comment on the light of truth at the time of the Resurrection. In addition, the

second section of this "gospel" concerns the visit of Christ to Hell, where he erected a cross as a sign of victory over Hell.[125] This may provide the reason for this placement at the altar since the altar would carry a freestanding cross in the center (see fig. 114).[126] The cross would therefore be positioned so as to concur with the Gospel of Nicodemus: "And so it was done, and the Lord set his cross in the midst of Hell, which is the sign of victory; and it shall remain there forever."[127] This would confirm the notion that the theme of the fresco is hope and salvation, as in John 3:17, as much as gloom and despair, and partly resolves the additional problems incurred in the fresco as the result of the unusual orientation of the chapel. The depiction of Hell on the altar wall might appear to be inappropriate (even though the west wall was often employed for depictions of the Last Judgment), but this reading or interpretation renders it more acceptable.

The Nicodemist interpretation of the cave and Christ's conquering it does not necessarily contradict the idea of the cave in Michelangelo's

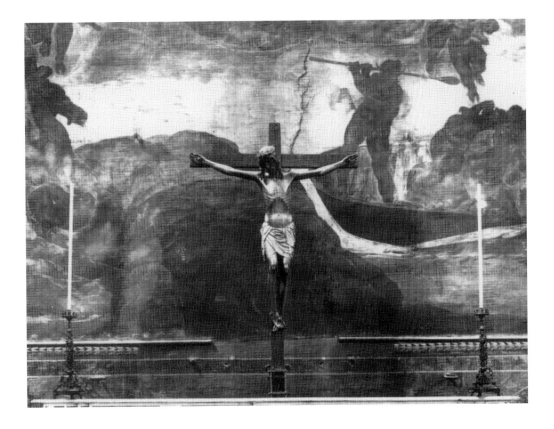

114 Detail, altar of the Sistine Chapel, in front of the Cave. Black and white, prerestoration.

fresco as being also representative of the Cave of Plato, but is, rather, complementary. In terms of Christian Neoplatonism, the two concepts share the overriding theme of salvation through knowledge of the Good, equated with Christ and his sacrifice. In Platonic thought, men are freed from the cave of ignorance by spiritual contemplation. Just as Christ conquers the darkness of Hell to set men free, so, according to the Platonists, reason conquers the darkness of ignorance, despair, and spiritual death. There thus appears to be in Michelangelo's cave a synthesis of spiritual Platonic and Christian concepts that are mutually reinforcing and far more subtle than medieval depictions of Hell's tortures. The darkness of Plato's Cave is equated with the Christian Hell, and men are freed by coming out into the light of the sun-deity.[128] This idea of Platonic Cave symbolism significantly has been discussed in the context of Michelangelo's frescoes for the Sistine ceiling. In a recent work, Chastel observes that the figures of the ancestors of Christ in the lunettes on Michelangelo's ceiling are "reminiscent of the dwellers in the Cave of Plato's *Republic*." This interpretation seems appropriate for those who lived prior to Christ, but it seems strange that the cave over the altar has not been considered in the same context.[129] This same interpretation, which relates to the contrasts between the darkened cave and the bright vision above, has been reinforced by the cleaning and restoration of the fresco. While the upper areas have had their former brightness revealed, the lower areas still remain relatively dark even after cleaning, fitting in with contemporary engravings and reports that depict or describe the fresco in these terms.[130]

The Neoplatonic interpretation of sun-symbolism and cosmology in the *Last Judgment* fresco, which can be related to *Republic* 6, may thus lead to the conclusion that the cave over the altar really represents Plato's Cave (*Republic* 7). Conversely, it might be argued that the presence of a cave in the work, corresponding to *Republic* 7, confirms the idea that depiction of the Sun-Christ in a circular format is related to Ficino's interpretation of Plato's *Republic* 6—an argument notable for its perfect circularity. Again, as elsewhere in this hypothesis, no single framework appears necessarily to dominate Michelangelo's interpretation, but the final synthesis is based on an elaborate merging of a number of current concepts.

Other Philosophical Sources; the Hermetic Writings

While Ficino's writings in his capacity as the leader of the Platonic Academy in Florence are clearly paramount as a source for Platonic cosmology and the Christianized view of Plato's sun-deity analogy, other philosophical writings, while not so directly linked to Michelangelo, demonstrate the ubiquitous nature of the theme in philosophical as well as literary and

theological writings of the period. For example, the writings of Pico della Mirandola, Ficino's colleague, include similar themes. The idea of the sun-deity analogy occurs in Pico's *Oration on the Dignity of Man* (1486), where he refers to "the true Apollo."[131] The idea of Christ as sun symbol also reappears in Pico's *Heptaplus*, where it is a major theme. Waddington comments on the Christocentric nature of the *Heptaplus*, and then shows how, owing to a numerological midpoint structuring, the work is in fact sun-centered.[132] "Nothing represents the Messiah to us more fittingly than the sun," writes Pico, and he presents the sun as the image of Christ by referring to Plato's *Republic*.[133] It is also of interest that a letter of Pico's contains discussion of Plato's metaphor of the Cave, showing how well known this passage was.[134]

The writings of other Renaissance philosophers also demonstrate the recurrence of the same symbols. The work of Cristoforo Landino is discussed in the previous chapter, and the sun image and circular cosmology are examined by Leone Ebreo (1460–1521), Pomponazzi (1462–1525), and later writers like Bernardino Telesio (1509–88) and Patrizi (1529–97).[135] Similar Platonic themes recur in the writings of Renaissance philosophers originating north of the Alps, like Nicholas Cusanus (1401–64), Erasmus (1466–1536), and even John Colet (1467–1519) and Thomas More (1478–1535) in England, showing an interest in Platonic themes and the analogy of "the Divine Sun," which was stimulated even further by increasing contact with Italy.[136] At the very end of the sixteenth century, the same imagery was still being used by Tommaso Campanella (1568–1639), Giordano Bruno (1548–1600), and Johannes Kepler (1571–1630), clearly demonstrating the extent to which such ideas were entrenched.[137] These writers were, like Ficino and Pico before them and also like Copernicus himself, very much influenced by the Hermetic writings and the Cabala.

In many of his writings, Ficino refers to the sources from which he has developed his cosmology, and Plato, Plotinus, Augustine, and Pseudo-Dionysius feature prominently. But Ficino often refers to the writings of the ancients, Hermes Trismegistus, Zoroaster, and the Orphic hymns. He specifically refers to these sources in *De Sole*, especially chapter 6: "The Sun is the Eternal Eye which sees everything, the supreme heavenly light which rules over the things of the sky and of the world. It guides and rules the harmonious course of the world, since it is the Lord of the Universe"[138] Before moving on to the discussion of scientific cosmology in the sixteenth century, this further aspect of Ficino's work requires discussion—namely his translations and interpretations of the so-called Hermetic writings, which are also concerned with the overall view of the universe and emphasize the sun as a symbol of the deity.[139] While their direct influence on Michelangelo is less certain, the Hermetic writings are relevant because of their popularity at the time

as well as their contribution to Neoplatonic thought. Moreover, special interest was shown in these writings by Egidio of Viterbo, the probable theological adviser for the Sistine ceiling, suggesting a connection with Michelangelo. Egidio accumulated texts on the Hermetic writings, which were published by his "disciple" Johannes Widmanstadt.[140] Likewise, the Cabalistic writings, although not usually proposed as influential upon Michelangelo, are generally accepted as having played an important role during the Renaissance, especially, for example, in the philosophy of Pico della Mirandola and the work of Leonardo da Vinci.[141]

The writings of Hermes Trismegistus (now known to be of the second or third century A.D.) were believed by Ficino and his circle to have been written by a pre-Christian Egyptian priest, a contemporary of Moses.[142] As such, they were viewed as forerunners of Plato and precursors to Christian thought, especially as source for the concept of the relationship between humans and the cosmos.[143] Only *Asclepius* was known, at least in the Latin West, until the fifteenth century, but knowledge of the writings increased during the Renaissance, which is demonstrated also by the way in which a portrait of Trismegistus occurred in Christian context, at Siena Cathedral (c. 1480, fig. 115). The mosaic is inscribed "Hermis Mercurius Trismegistus contemporaneus Moysi."

At the request of Cosimo de' Medici, Ficino actually translated all of the Hermetic writings before those of Plato, and these were widely circulated from 1463. Regarded almost as source for Plato, these transcripts became Ficino's most frequently published work.[144] Ficino's interest in the magical aspects of these writings has received some attention, as has the importance of cosmology and sun symbolism in the Hermetic writings as a source for Ficino's use of similar themes.[145] The links between Renaissance thought and Eastern magic as well as Christian cosmology and symbolism are demonstrated clearly in Ficino's writings, which also embrace discussion of astrology and medicine.[146]

The Hermetic writings can be viewed only tentatively as a direct source for Michelangelo, but they were clearly a major source for Ficino and because of their widespread availability during the sixteenth century, cursory examination of the major Hermetic writings will serve to confirm the prevalence of the themes.[147]

The idea of light and the sun as an analogy with the deity recurs often, and especially in the so-called *Poimander*.[148] For example, light is an important symbol to be used in the account of the Creation of the universe.[149] Cosmology is a major theme of the *Discourse of Hermes Trismegistus to Asclepius,* and is particularly concerned with an explanation of the movement in the cosmos. This is perceived as circular movement around a point and it is related to the Hermetic idea that the earth moves because it is alive.[150] It appears to be impossible, states the writer, that a thing that causes movement should be moved together with the thing it

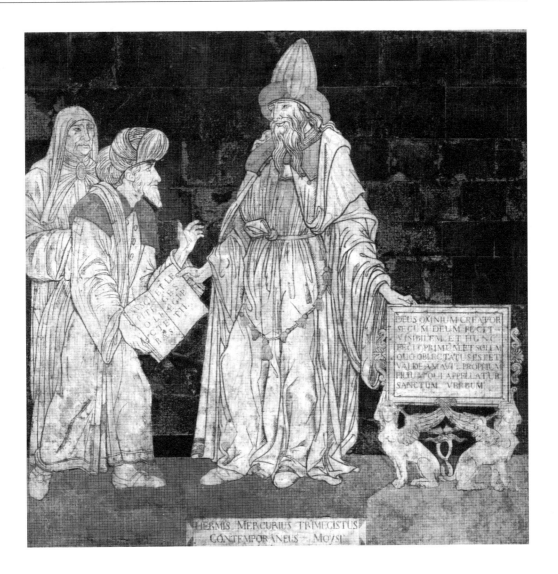

115 Unknown Sienese master, *Hermes Trismegistus*,
c. 1480. Mosaic pavement, Siena Cathedral.

moves, but the unmoved God may be perceived as possessing mobility
as well:

> Thus may one also believe that god stirs within himself—but in
> the same immobility, for because of its immensity the stirring of his
> stability is in fact immobile It carries on in exalted stability, and
> its stability acts within it: god, eternity, both, one in the other or both
> in both.[151]

Discussion continues on circles and circular motion and the eternal circular
movement of the cosmos. But Hermes bids his hearers to "hide these divine

mysteries among the secrets of your heart and shield them with silence."[152] Light symbolism in general is also important in the arrangement of the universe, as God is equated with the Good,[153] which illuminates, rather than blinds, by its light.[154]

The specific analogy with the sun is also used on several occasions:

> If you want to see god, consider the sun, consider the circuit of the moon, consider the order of the stars. Who keeps this order? . . . The sun, the greatest god of those in Heaven, to whom all heavenly gods submit as to a king and ruler, this sun so very great, larger than earth and sea, allows stars smaller than him to circle above him[155]

These descriptions appear as an obvious source for Ficino and, in turn, as a possible influence on the thought behind Michelangelo's fresco. The idea that it is God who is the creator of everything, that "god begins, contains and composes all things" is strongly reminiscent of Ficino's "knot and bond of the universe," quoted above; and further writings, in the main derived from Plato's *Timaeus* (but thought by Ficino and the Platonists to be precursory), also relate closely to Ficino's thoughts on the immortality of the soul and life after death.[156] Also noteworthy is the Hermetic use of symbols, numerology, and talismans, which was adopted by Ficino.[157] Among these, the most significant for the present argument is the use of the Apollo image, which consisted of a sun king with a crown. This was used as a talisman "to enable a king to overcome all other kings," again suggesting the appropriateness of the analogy between the ancient sun god and Christ, the King of Kings.[158]

The possible influence of these texts, alongside Ficino's other commentaries and translations, clearly deserves further consideration as evidence for prevailing interest in this type of cosmology, as well as for sun symbolism itself. The Hermetic tradition was popularized through Ficino's works, and this influence continued well into the sixteenth century.[159] The effects of these "magical writings" and of Ficino's solar mysticism are evident even on later philosophers like Giordano Bruno and Campanella, who are crucial for cosmological and astronomical discussion toward the end of the sixteenth century in Italy.[160] The great influence of Ficino's interpretation of sun-symbolism in the Hermetic writings of Bruno and Campanella in the late sixteenth century is beyond the scope of this work, but it does undoubtedly demonstrate that if the philosophy was still current and available to those men at the end of the sixteenth century, it was likely to be known and accessible to Michelangelo in the middle period of that century and that there is thus good cause to consider the *Hermetica* as influential on the thought of the artist.[161]

Christian Neoplatonism

It becomes increasingly evident that a case may be put forward for Ficino's interpretation of Platonic, and also perhaps Hermetic, writings as a contributory source for Michelangelo's *Last Judgment*. Because of the way Ficino combines Platonic and Christian concepts in his view of the Good, personified as the deity and analogized to the sun, Neoplatonic philosophy serves to reinforce the Christian concept of the analogy between Christ and the sun. Christian thought and Neoplatonic philosophy, acknowledged as two forceful influences in the life and work of Michelangelo, apparently come together in his interpretation of the *Last Judgment*, and Neoplatonism reinforces the religious and Dantean sources available to Michelangelo for the depiction of the Sun-Christ in a circular cosmological framework. The concept of the Sun-Christ in the center of a circular cosmology permeates sixteenth-century religious thought and is common to Michelangelo's accepted sources of Ficino and Dante, as well as corresponding very neatly to his *Last Judgment* fresco. As a late work, Michelangelo's *Last Judgment* has largely been viewed as a predominantly religiously inspired work, since a major line of interpretation of Michelangelo's works is that his early works were largely inspired by Neoplatonism, his late works by religious or Catholic sentiment. This view appears far too simplistic. As has been shown, the essentially Christian nature of Renaissance Neoplatonism appears to be expressed in the *Last Judgment* fresco, which is evident in many realms, from the sun symbol of Christ to individual items, like the cave, which may be read as a synthesis in the same way.

This interpretation underlies an entirely new approach to the study of Michelangelo's late works, which have often been simply categorized as the product of the Counter-Reformation or some personal religious "transformation."[162] It appears that Neoplatonism is a theme that, far from being dismissed or rejected by the aging master, acted as a lifelong influence and continued to be in his thoughts and represented in his works. It was, at the same time and owing to his increasing involvement in religion, integrated more and more into Christian thought. For Michelangelo as for Ficino, Neoplatonism was not neopaganism. From Saint Augustine and Dionysius onward (and especially for those of the Italian Renaissance), it was the avowed intention of the Neoplatonists to combine and integrate Platonic thought with Christianity. The Christianizing of Plato's writings is exactly what aroused interest in the sixteenth century, and the combining of Platonic and Christian thought is exactly what is reflected in the iconography of Michelangelo's *Last Judgment*. These two currents in Michelangelo's thinking should not be split into distinct phases, but seen as complementary influences throughout his career, of which the *Last Judgment* could be viewed as the culmination.

The sources that have been dealt with thus far and that demonstrate the importance of sun-symbolism and cosmology as themes of discussion on the Renaissance are all to be found among the generally accepted sources for Michelangelo. The different sources are not identical in detail, and Ficino often refers to either four or five cosmic areas or circles. Plato describes eight and Dante nine (fig. 91).[163] As we shall see, Copernicus' basic scheme (fig. 2) contains at least seven circles. But it is the main idea of the sun as deity at the center of the circular universe that is of primary concern in the proposed source material, where a correlation with Michelangelo's *Last Judgment* is being sought. The circularity of Michelangelo's design, which seems to result from a synthesis of these views, is of the essence, rather than a precise correspondence with the number of circles of any particular scheme. In addition, the examination of Platonic and other philosophical sources, alongside the theological and literary or Dantean sources for sun-symbolism and circular cosmology, should not be construed as the offering of alternative suggestions of source material for Michelangelo's interpretation and composition of the *Last Judgment*. These views of the deity as sun, whether taken from the Scriptures, the Church Fathers, Dante, Plato, or Ficino, are to be regarded, at the time of the Renaissance, as different aspects of one and the same thing. Thus far, the fresco has been interpreted as illustrative or suggestive of the Gospel of Saint John, of Dante's *Divina Commedia,* and of Plato's *Republic* 6 and 7, but these are all inextricably linked within the context of Renaissance humanity's attempt to explain the universe in which one lived and the God who created it. Early Neoplatonism influenced the writer of the Gospel of John, as well as Dante at a later date. Dante, in turn, clearly influenced later Renaissance writers like Ficino. For the Renaissance, the links between cosmology and theology, which were expressed in literature and philosophy, were all part of the same discipline, and mutually reinforcing as the exegesis of God's truth. The way scientific theory fitted into this interdisciplinary framework in the Renaissance, and whether Copernicus himself might have been influenced by similar sources, remains to be seen.

While recognized sources for Michelangelo have been reconsidered from a new point of view so far in the present hypothesis, the scientific material of the works of Copernicus and his predecessors may now be newly proposed as a definite field of influence that has been entirely unexplored. As we shall see, Neoplatonism and Christian belief acted as major influences on Copernicus and in fact contributed to his scientific thinking and his formulation of the heliocentric view of the universe.

Notes

1. Marsilio Ficino, *Commentary on Plato's Symposium on Love,* trans. with introduction and notes by Sears Reynolds Jayne, 2d ed. (Dallas: Spring Publications, 1985), speech 6,

chap. 13, 134 (this edition henceforward referred to as Ficino, *De Amore*). For the Latin original, which reads "In sexto autem De Republica libro, divinus ille vir totam rem aperit, dicitque lumen esse mentis ad intelligenda omnia, eundem ipsum Deum, a quo facta sunt omnia. Solem namque et Deum ita invicem comparat . . ."; see Sears Reynolds Jayne, *Marsilio Ficino's Commentary on Plato's Symposium* (Columbia: University of Missouri Press, 1944), 96, henceforth Ficino, *Commentary on Symposium,* ed. Jayne, 1944.

2. Erwin Panofsky, *Renaissance and Renascences in Western Art* (New York: Harper and Row, 1972), 187. See similar comment by Nesca Robb, *Neoplatonism of the Italian Renaissance* (London: Allen and Unwin, 1935), 180.

3. For succinct commentary on Plato and his works, see esp. W. K. C. Guthrie, *A History of Greek Philosophy* (Cambridge: Cambridge University Press, 1986), vols. 4 and 5; and Paul Shorey, *What Plato Said* (Chicago: University of Chicago Press, 1933).

4. See Robb, *Neoplatonism,* esp. chap. 3; and Paul Shorey, *Platonism Ancient and Modern* (Berkeley: University of California Press, 1938). See also James Hankins, *Plato in the Italian Renaissance,* 2 vols. (Leiden: Brill, 1990), pt. 1, "Florence," pt. 2, "Rome," but esp. pt. 4, chaps. 1–3, on Ficino.

5. For biographical details of Ficino, see esp. Paul Oskar Kristeller, *The Philosophy of Marsilio Ficino,* trans. Virginia Conant (New York: Columbia University Press, 1943; reprinted Gloucester, Mass.: P. Smith, 1964), chap. 2. The Italian version, *Il pensiero filosofico di Marsilio Ficino* (Florence: Sansoni, 1953), contains more original language quotations from Ficino. Also see Giuseppe Saitta, *La filosofia dell'Umanesimo* (Bologna: Fiammenghi e Nanni, 1954), esp. chaps. 1 and 2, and, Members of the Language Department of the School of Economic Science, trans., *The Letters of Marsilio Ficino,* 4 vols. (London: Shepheard-Walwyn, 1975–88), 1:21–24.

6. For short biographies of Pico della Mirandola, Poliziano, Landino and other major Neoplatonists, see John R. Hale, ed., *A Concise Encyclopaedia of the Italian Renaissance* (London: Thames and Hudson, 1981), and relevant entries in Arturo B. Fallico and Herman Shapiro, eds., *Renaissance Philosophy,* vol. 1, *The Italian Philosophers, Selected Readings from Petrarch to Bruno* (New York: Modern Library, 1967).

7. Kristeller, *Ficino,* 266, and *Letters,* 1:20. For Ficino's importance, see also Paul Oskar Kristeller, "Renaissance Platonism" in *Facets of The Renaissance* (New York: Harper and Row, 1963), 103–23; idem, *Eight Philosophers of the Italian Renaissance* (London: Chatto and Windus, 1965), chap. 3; and idem, *Renaissance Thought and the Arts: Collected Essays* (Princeton: Princeton University Press, 1980), esp. 71–72. See also Raymond Marcel, *Marsile Ficin* (Paris: Les Belles Lettres, 1958), "Renaissance et Platonisme," 31–49.

8. For succinct explanation of Plato's concept of the Good, see Guthrie, *Greek Philosophy,* 4:503–21; Shorey, *What Plato Said,* 230–31. Ficino's *Commentaries* and translations of Plato were influenced by his study of the earlier Neoplatonists, especially Plotinus and Proclus; he also tends to treat Plato's writings selectively.

9. Kristeller emphasizes the Christian nature of Renaissance Neoplatonism, demonstrating its agreement with Christian thought (Kristeller, *Ficino,* esp. 24–29, 320–23; idem, *Facets,* 105 and 110–11). See also Eugenio Garin, *Italian Humanism: Philosophy and Civic Life in the Renaissance* (Oxford: Blackwell, 1965), 9–11, "Humanism and Platonism." The legitimacy of Plato as a source for Christian wisdom was also emphasized at the time by Erasmus, especially in his *Enchiridon* (see Nieto, *Valdés,* 96–97).

10. For further discussion and parallels (like Plato's reference to the just, crucified man, *Republic* 362A), see Paul Shorey, *Platonism Ancient and Modern* (Berkeley: University of California Press, 1938), esp. chap. 3, "Plato and Christianity"; Raymond Klibansky, *The Continuity of the Platonic Tradition in the Middle Ages* (London: Warburg Institute, 1939); and Robb, *Neoplatonism,* 22–23. Such parallels had already been drawn by the earlier Platonists, such as Plotinus, Proclus, Porphyry, Iamblicus, and also Augustine, but it is the Christian nature of Renaissance Neoplatonism which is the main concern here.

11. Ernst Cassirer, *The Individual and the Cosmos in Renaissance Philosophy* (New York: Barnes and Noble, 1963), 68; idem, "Ficino's Place," 491. Seznec, *Revival of the Pagan Gods*, shows how Christian philosophers could be involved with the Olympian gods but still remain faithful to monotheism.

12. For Michelangelo's stay there, and the direct influence of men like Poliziano (Politian), see Vasari, *Lives* (ed. de Vere, 1836–38; ed. Bull, 331), and Condivi, *Life of Michelangelo*, 14–15, 93, 105.

13. Robb, *Neoplatonism*, chap. 4, "The Medici Circle"; Christopher Hibbert, *The Rise and Fall of the House of Medici* (Harmondsworth: Penguin, 1983), pts. 1–3; André Chastel, *Marsile Ficin et l'Art* (Geneva: Droz, 1954), 7–22.

14. Clement VII was the orphaned nephew of Lorenzo the Magnificent. He was the illegitimate son of Lorenzo's brother, killed in the Pazzi conspiracy, 1478 (Hibbert, *Medici*, 144).

15. For the early years of Alessandro Farnese, later Pope Paul III, see Liebert, *Psychoanalytic Study*, 331–32.

16. For the influence of Neoplatonism on art during the Italian Renaissance, see, for example, Robb, *Neoplatonism*, chap. 7, "Neoplatonism and the Arts"; Chastel, *Marsile Ficin et l'Art*; Paul Oskar Kristeller, *Renaissance Thought and the Arts* (Princeton: Princeton University Press, 1980); Erwin Panofsky, "The Neoplatonic Movement in Florence and North Italy," in *Studies in Iconology: Humanistic Themes in the Art of the Renaissance* (1939; rptd. New York: Harper and Row, 1972), 129–70; Wind, *Pagan Mysteries*; Blunt, *Artistic Theory*; Ernst H. Gombrich, "Icones Symbolicae: The Visual Image in Neoplatonic Thought," *Journal of the Warburg and Courtauld Institutes*, 11 (1948): 163–92, reprinted with additions in idem, *Symbolic Images, Studies in the Art of the Renaissance II* (Oxford: Phaidon, 1985), 123–96.

17. For Neoplatonism in Botticelli's works, see Ernst H. Gombrich, "Botticelli's Mythologies: A Study in the Neoplatonic Symbolism of his Circle," *Journal of the Warburg and Courtauld Institutes* 8 (1945): 7–60 (reprinted in Gombrich, *Symbolic Images*, 31–81), also Wind, *Pagan Mysteries*, chaps. 7 and 8; for Raphael (notable for his portrait of Plato in the *School of Athens*), chap. 11; for Leonardo da Vinci, Kenneth Clark, *Leonardo, An Account of his Development as an Artist* (Cambridge: Cambridge University Press, 1952), and Garin, *Italian Humanism*, 186–88; for Dürer, Erwin Panofsky, Raymond Klibansky and Fritz Saxl, *Saturn and Melancholy* (Princeton: Princeton University Press, 1980).

18. Wittkower, *Architectural Principles*, esp. 9–19, 23–25. He quotes the examples of Filarete, Bramante, Sangallo, and Leonardo.

19. Erwin Panofsky, "The Neoplatonic Movement and Michelangelo," in *Studies in Iconology: Humanistic Themes in the Art of the Renaissance* (New York: Harper and Row, 1972) (1st ed. 1939), 171–230, esp. 178–79.

20. Wilde, *Six Lectures*, chap. 4 on the Julius Tomb, chap. 5 on the Medici chapel, and 58–63. See also Tolnay, *Michelangelo*, esp. 3:62, 68–75 on the Medici Chapel, and 4:23 on the Julius Tomb.

21. Wind, *Pagan Mysteries*, esp. chap. 12.

22. See Blunt, *Artistic Theory*, 58–81; Clements, *Poetry of Michelangelo*, chap. 12, 228–37; Summers, *Michelangelo and the Language of Art*, 11–17; Robb, *Neoplatonism*, 225–29, 239–69.

23. Panofsky, *Studies in Iconology*, 180; see also Erwin Panofsky, *Idea: A Concept in Art Theory* (1924; rptd. New York: Harper and Row, 1968), 45–68, 113–26.

24. For discussion of themes connected with Neoplatonic concepts of Love and Beauty in Michelangelo's work, see esp. Panofsky, "Neoplatonic Movement and Michelangelo"; Tolnay, *Michelangelo*, esp. vols. 3 and 4; Garin in Salmi, ed., *Michelangelo*, 517–30; and Edith Balas, "Michelangelo's Victory," *Gazette des Beaux Arts* 113 (1989): 67–80. The sophisticated concepts of Platonic Love, the intense spiritual awareness of ideal youth,

or the bonds between master and pupil are discussed by Plato in *Symposium*, and are far removed from certain modern psychoanalytic discussion of Michelangelo's friendships with young men (e.g. Liebert, *Psychoanalytic Study*, 294–307). For further understanding of Plato's writings on such subjects see Guthrie, *Greek Philosophy*, esp. vols. 4 and 5.

25. For Ficino's theory of Love, see Kristeller, *Ficino*, 110–15, 263–69, 276–88, and esp. Ficino, *De Amore*, speeches 1–3, 7.

26. James A. Devereux, "The Object of Love in Ficino's Philosophy," *Journal of the History of Ideas* 30 (1969), 161–70.

27. Discussed by Kristeller, *Ficino*, 74–91; Cassirer, *Individual and Cosmos*, 142–47.

28. See esp. Tolnay, *Michelangelo*, 3:61–75, and 4:24–25, 74–75; Von Einem, *Michelangelo*, 109–10. Von Einem comments on difficulties attached to the use of a Neoplatonic theme for a Christian chapel. He finds it unlikely that the ecclesiastical patrons would have agreed. Yet these were the Medici, Pope Leo X, and Cardinal Giulio (later Clement VII), respectively the son and nephew/adopted son of Lorenzo the Magnificent, whose tomb the scheme embraced.

29. See Tolnay, *Michelangelo*, 3:61–75 and 4:24–25, 74–75; also Wilde, *Six Lectures*, chapter 4. These schemes are viewed as images of the progress of the soul from the earthly to the heavenly life and as a condensed representation of the Neoplatonic hierarchy of the universe, a reflection of Plato's worlds of spirit and matter. The view of the body as the mortal prison and Plato's emphasis on wisdom over bodily pleasure, as expressed in *Phaedo* may be perceived not only in Michelangelo's works, but also in his austere way of life.

30. See Marsilius Ficinus, *Theologia Platonica de Immortalitate Animorum* (1559; rptd. Hildesheim: Olms, 1975). See also Josephine L. Burroughs, "Marsilio Ficino, Platonic Theology," *Journal of the History of Ideas* 5 (1944): 227–39, for extracts. Ficino's *Platonic Theology* borrowed a great deal, including its title, from the work of Proclus, for which see Proclus, *Théologie Platonicienne*, ed. and trans. H. D. Saffrey and L. G. Westerink (Paris: Les Belles Lettres, 1968–74), esp. bk. 2, pp. 43–50, "L'analogie du soleil dans le République." For the influence of the earlier Neoplatonists, Plotinus (third century) and Proclus (fifth century), on Ficino, see Kristeller, *Ficino*, 26–27.

31. Gilbert, nos. 31, 49, 92, 103, 150, 159, 265. Compare Dante, *Purgatorio* 2:122.

32. See Kristeller, *Ficino*, 324–50. For further discussion of the doctrine, see C. H. Moore, *Ancient Beliefs in the Immortality of the Soul with Some Account of Their Influence on Later Views* (New York: Cooper, 1963), where the influence of Plato, Plotinus, and Proclus is stressed, as well as the Gospel of John (3:6–7) and the Church Fathers (Pseudo-Dionysius and Augustine); also Oscar Cullman et al., *Immortality and Resurrection: Death in the Western World: Two Conflicting Currents of Thought* (New York: Macmillan, 1965), and J. A. Schepp, *The Nature of the Resurrection Body: A Study of the Biblical Data* (Grand Rapids: Eerdmans, 1964). These works discuss contrasts and points of contact between the Christian doctrine of the Resurrection of the Flesh and the Greek notion of the Immortality of the Soul, which both appear relevant in the context of the *Last Judgment*.

33. Dotson, "Augustinian Interpretation." For Egidio [Giles] of Viterbo, see Garin, *Italian Humanism*, 113. Calvin's comments on the influence of Plato on religious thinking in the mid-sixteenth century confirm the notion; Eire, "Calvin and Nicodemism," 67.

34. A few authors maintain that Neoplatonic influence on Michelangelo is minimal. See, for example, Leopold D. Ettlinger in *Encyclopedia of Italian Renaissance Art*, ed. Hale, who states that there is no Neoplatonic influence in the Medici chapel and "it is imbued with a devout Christian spirit," as if the two areas of influence were incompatible. Also Hall, "Michelangelo's *Last Judgment*," 88.

35. For discussion of Plato's cosmology, see esp. Francis M. Cornford, *Plato's Cosmology: The "Timaeus" of Plato* (London: Routledge and Kegan Paul, 1937); Guthrie, *Greek Philosophy*, vols. 4 and 5.

36. Emphasis has been laid, in this study, on these key works of Plato and, where possible, Neoplatonic translations and commentaries on these. Text and translations of Plato's works from the Loeb editions have been utilized.

37. At the behest of the Medici, Ficino translated all of Plato's works into Latin during the period 1463–69. These were subsequently revised and first printed in 1496. Dating of Ficino's writing is derived from Kristeller, *Ficino*, 17. Ficino added a brief "argumentum" to each dialogue; some he commented on at length, like *Symposium* and *Timaeus*.

38. Robb, *Neoplatonism*, 11–12. The Platonic tradition was diffused through Augustine and Pseudo-Dionysius; see Shorey, *Platonism*, chap. 4, "Platonism in the Middle Ages."

39. For Aristotle's own discussions of Platonic cosmology, the sphericity of the earth and its possible movement, see Aristotle, *De Caelo*, 3, i, 289a—300a (ed. Cit. 257–69).

40. For further information on the influence of Plethon and Bessarion (who became a Catholic cardinal) on the formation of Renaissance Neoplatonism, see Robb, *Neoplatonism*, 46–47, and Shorey, *Platonism*, chap. 5, "The Renaissance."

41. It is significant that Ficino also translated earlier Neoplatonic sources like Plotinus and Proclus in the 1480s, as well as the so-called Hermetic writings by 1463; Kristeller, *Ficino*, 17–18.

42. For details of dating, see Kristeller, *Ficino,* 17–18.

43. References to discussions by these authors have been given above. Much subsequent discussion concerning Michelangelo's Neoplatonic tendencies in the literature remains generalized and based on these secondary sources.

44. Modern reprints of Ficino's *Opera Omnia* have been produced (reprinted in Turin: Bottega d'Erasmo in 1956 and 1983), but a large number of Ficino's works, which are highly relevant, have been individually reprinted in recent years and are therefore now more accessible, both in original and in translation.

45. See Marsilio Ficino, *Commentary on Plato's Symposium,* ed. Jayne (1944); *De Amore,* ed. cit; for *De Sole,* see Arturo B. Fallico and Herman Shapiro, eds., *Renaissance Philosophers: The Italian Philosophers* (New York: Modern Library, 1967), 118–41; Michael J. B. Allen, ed. and trans., *Marsilio Ficino: The Philebus Commentary* (Berkeley: University of California Press, 1981); idem, *The Sophist Commentary* (Berkeley: University of California Press, 1989); Charles Boer, trans., *Marsilio Ficino: The Book of Life (De Vita Triplici)* (Dallas: Spring Publications, 1980); Members of the Language Department of the School of Economic Science, London, trans., *The Letters of Marsilio Ficino,* 4 vols. (London: Shepheard-Walwyn, 1975–88). See also Raymond Waddington, "Ficino in English," *Sixteenth Century Journal* 14 (1983): 229–31, now somewhat superseded.

46. For recent discussion of Ficino and the importance of his philosophy, see Michael J. B. Allen, *The Platonism of Marsilio Ficino* (Berkeley: University of California Press, 1984), and Konrad Eisenbichler and Olga Zorzi Pugliese, eds., *Ficino and Renaissance Neoplatonism* University of Toronto Italian Studies (Ottawa: Dovehouse, 1986).

47. *Timaeus,* 29A—34A. See R. G. Bury, trans., *Plato,* vol. 9 (London: Heinemann, 1981). For commentary on *Timaeus,* see Guthrie, *Greek Philosophy,* 5:241–320.

48. *Timaeus* 36C—37D.

49. See Plato, *Timaeus* 38–41, 50. For discussion of the Platonic Being and Becoming (where that which is celestial, stable, and unchanging is contrasted with the earthly or human, imperfect and unstable), see *Timaeus,* 27D—28A. For discussion of Neoplatonic themes in Michelangelo's poetry, see Clements, *Poetry of Michelangelo,* 228–37. Michelangelo's poem (G 102) is very much concerned with the creation of Time. For Neoplatonic ideas in the poetry of Vittoria Colonna, see also D. J. McAuliffe, "Neoplatonism in Vittoria Colonna's Poetry," in Eisenbichler and Pugliese, *Ficino and Renaissance Platonism,* 101–12.

50. Plato, *Republic,* book 10, 616B–617D, trans. Paul Shorey (London: Heinemann,

1935). Also see the edition *Plato, The Republic,* ed. Betty Radice and Robert Baldick (Harmondsworth: Penguin, 1971).

51. *Republic,* bk. 6, 508E–509B. For discussion, see Guthrie, *Greek Philosophy,* 4:503–20, also Plato, *The Republic,* ed. Radice and Baldick, 265, where the comparison is presented in tabular form. Michelangelo's well-known concern for republican ideals in his own Florence would suggest a particular interest in this work of Plato.

52. *Republic* 7, 514A–518B.

53. See Ficino, *Commentary on Plato's Symposium* (ed. Jayne, 1944), 8; Ficino, *De Amore,* 19–20; and Kristeller, *Renaissance Thought and the Arts,* 52.

54. Ficino, *De Amore,* 20.

55. Summers, *Language of Art,* 9.

56. Ficino's concerns with sun-symbolism and cosmology are widely discussed by Kristeller, *Ficino,* esp. in pt. 2, "Being and the Universe." Allen also lays a great emphasis on Ficino's concern with cosmology (Allen, *Platonism of Ficino,* esp. chap. 6).

57. Jayne suggests Dante's *Convivio* as influential on this thought (Ficino, *De Amore,* 11–13).

58. *Timaeus* 28C, 30A, and *Republic,* bk. 2. For discussion see Guthrie, *Greek Philosophy,* 4:503–21.

59. Kristeller, *Ficino,* especially 60–62, 145, 261; Allen, *Platonism of Ficino,* 56–57, 108–10. See Ficino, *De Amore,* 38, "The first of all things is God, the author of all things, whom we call 'the Good' itself." ("Primum omnium est Deus, universorum auctor, quod ipsum bonum dicimus," ed. Jayne, 1944, 39). As elsewhere, Ficino makes reference to "God" without distinction between the three persons of the Christian Trinity.

60. Ficino, *De Amore,* 38–39. See also Chastel, *Ficin et l'art,* esp. 81–85, for adaptation of Ficino's light symbolism in art.

61. Ficino, *De Amore,* speech 2, chap. 2, 46 (ed. Jayne, 1944, 43).

62. Ficino, *De Amore,* 46 (" prout in Deo incipit et allicit, pulchritudo; prout in mundum transiens ipsum rapit, amor; prout in auctorem remeans ipsi suum opus coniungit, voluptas," ed. Jayne, 1944, 43).

63. Ficino, *De Amore,* 46 ("Id sibi voluit Hierothei et Dionysii Areopagitae hymnus ille praeclarus, ubi sic hi theologi cecinerunt: Amor circulus est bonus a bono in bonum perpetuo revolutus," ed. Jayne, 1944, 43).

64. Ficino, *De Amore,* 46–47 ("Nec inuria soli Deum comparat Dionysius, quia quemadmodum sol illuminat corpus et caleficit, ita Deus animis veritatis claritatem praebet, et caritatis ardorem. Hanc utique comparationem ex Platonis libro *De Republica* sexto hoc quo dicam modo colligimus . . ." ed. Jayne, 1944, 43). Ficino emphasizes the similarities between Dionysius and Plato: "Thus the difference between Plato and Dionysius is only a matter of words rather than of opinion"; *De Amore,* 111.

65. See above, opening quotation to this chapter, from Ficino, *De Amore,* speech 6, chap. 13. Compare *Plato, Republic* 6, trans. Paul Shorey, 100–107, and the version in Radice and Baldick, eds., 265 and 272–74.

66. Ficino, *De Amore,* 47 ("Centrum unum omnium Deus est. Circuli quattuor circa id assidue revoluti, mens, anima, natura, materia. . . . Caeterum cur Deum quidem centrum, quattuor illa cur circulos appellemus exponam." ed. Jayne, 1944, 44).

67. Ficino, *De Amore,* 47 (ed. Jayne, 1944, 45). Compare Augustine, *On the Magnitude of the Soul,* chaps. 7–12, and Dante, esp. *Paradiso,* from canto 28.

68. Ficino, *De Amore,* 47 ("Centrum circuli punctum est, unum, indivisibile, stabile. Inde lineae multae dividuae, mobiles ad earum similem circumferentiam deducuntur; quae sane circumferentia divisibilis circa centrum quasi cardinem volvitur"; ed. Jayne, 1944, 44).

69. Ficino, *De Amore,* 47–48 ("Quis negat Deum centrum omnium merito nominari, cum omnibus insit unus penitus, simplex, atque immobilis; cuncta vero ab ipso producta,

multa, composita, et mobilia sint, atque ut ab eo manant, ita in eum instar linearum et circumferentiae refluant? Ita, mens, anima, natura, materia procedentes a Deo in eundem redire nituntur, seque undique pro viribus in illum circumferunt." ed. Jayne, 1944, 44). Similarities with Dante's system from *Paradiso* 38 are apparent. As Kristeller states ("Renaissance Thought and the Arts," 58–59), it is an exaggeration to say that the Renaissance was completely man-centered and no longer God-centered.

70. Other references to circular cosmology, the sun symbol as Deity and the sun's rays in Ficino, *De Amore*, are numerous, for example, 48–49, 76–78, 90–92. For discussion of Ficino's use of sun-symbolism, see esp. Kristeller, *Ficino*, 98, 127, 153–59, 228–33, 251–53.

71. Steinberg in particular comments on the ambiguity of Christ's pose and the discussion surrounding it; Steinberg, "Merciful Heresy," 50; idem, "Missing Leg, Twenty Years After," 501.

72. Aristotle, *De Caelo*, xvii–xix.

73. For Ficino's comparison of Aristotle and Plato, see Allen, *Philebus*, 175.

74. Also *Laws* 897–98. The concept is discussed by Ficino in his *Phaedrus Commentary* (Allen, *Phaedran Charioteer,* 86).

75. For Aristotle on the significance of the circular universe, see Aristotle, *De Caelo*, esp. bk. 2, iv, and bk. 3, sec. ii. He declares the immobility of the center of the rotating circular universe (ed. cit. 245) but locates this in the earth at this time.

76. Plato, *Timaeus*, 62C–63A.

77. Plato, *Timaeus*, 63B (and compare 37A for comment on the circularity of the universe and notions of infinity and eternity). Ficino and others followed Plato in questioning the arrangement of the Aristotelian spherical universe, which still had a "top and bottom."

78. Plato, *Timaeus* 38D–39E. See Kristeller, *Ficino*, 386–87, for discussion.

79. Plato, *Timaeus* 43B–43E. Compare Ficino, *De Amore*, speech 6, chap. 15 for the motion of souls.

80. See Kristeller, *Ficino*, esp. chap. 15, "The Theory of Immortality."

81. According to Kristeller, the concept derives from Plotinus and Proclus and ultimately Plato's *Republic* 6 (Kristeller, *Ficino*, 106–8, 167–69, 400–401, etc.); for further discussion, see also A. Sheppard, "The Influence of Hermias on Marsilio Ficino's Doctrine of Inspiration," *Journal of the Warburg and Courtauld Institutes* 43 (1980): 97–109; Michael J. B. Allen, "Two Commentaries on the Phaedrus: Ficino's Indebtedness to Hermias," *Journal of the Warburg and Courtauld Institutes* 43 (1980): 110–29; and idem, "Ficino's Theory of the Five Substances and the Neoplatonists' Parmenides," *Journal of Medieval and Renaissance Studies* 12 (1982): 19–44.

82. Allen contends that Ficino's theory of the Five Substances leads to the disappearance of the traditional role of the angels from the universal hierarchy, replaced to an extent by the concept of soul. This interpretation could perhaps account for Michelangelo's unusual approach to angels in his fresco, whose winglessness remains a point of controversy; Michael J. B. Allen, "The Absent Angel in Ficino's Philosophy," *Journal of the History of Ideas* 36 (1975): 219–40. Allen further demonstrates the importance of wing-symbolism in Ficino's writings and his image of the soul "shedding its wings" as it flies up to God (Allen, *Platonism of Ficino*, 100–101, 106–8).

83. Discussed by Ficino, *De Amore*, 47–49, and also developed in the *Theologia Platonica*. For further explanation, see Kristeller, *Ficino*, 106–108, 167–69, 400–401.

84. Ernst H. Gombrich, *Symbolic Images, Studies in the Art of the Renaissance* (Oxford: Phaidon, 1985), 168–70 and unnumbered fig. on 170.

85. Ficino, *De Amore*, 71, 73, 75–79, 89–91, 134–35.

86. The chapter is entitled "De Amoris Pictura" and Ficino significantly refers here

to the art of painting. Ficino, *De Amore*, 95 ("Agatho vero poeta veterum poetarum more deum istum humana vestit imagine pingitque ipsum hominum instar formosum, iuvenum, tenerum, flexibilem, sive agilem, apte compositum atque nitidum," ed. Jayne, 1944, 72).

87. Many other themes dealt with by Plato, esp. in the *Symposium*, *Phaedo,* and *Timaeus*, and by Ficino in his *Commentaries*, appear relevant to an understanding of Michelangelo and his work, although space does not allow for additional discussion of these. For example, the flesh/spirit dichotomy is examined (*Phaedo*, esp. 62D–64D, 70C—84B), as well as the theme of interconnection between Love and Beauty (*Symposium*, 182A—84D, and *De Amore*, esp. speeches 3 and 5). The idea of the Immortality of the Soul is discussed in terms of immortality through one's progeny or achievements (*Symposium*, 208C—209E) and, although his letters demonstrate his concern for the continuation of his family through his nephew's heirs, Michelangelo noted "the works I leave behind will be my sons" (Vasari, *Lives*, ed. de Vere, 1931; ed. Bull, 428). Ficino's interpretation of the character of Socrates suggests a great affinity with Michelangelo: Socrates was fearless and brave, but melancholic by nature. He was lean and sinewy and lived simply and frugally, sometimes sleeping in his clothes. Socrates was the son of a stone-cutter and midwife and "made his living with his own hands by cutting stones" (Ficino, *De Amore*, 155–57; compare Vasari's descriptions of Michelangelo, ed. de Vere, 1933; ed. Bull, 430–31). That Socrates might have had an influence, as role model, upon the youthful Michelangelo in the house of Lorenzo de' Medici seems highly likely.

88. See Allen, *Philebus Commentary*; for the importance and dating of this work, see 1–2, 15, and 48–49.

89. Allen, *Philebus Commentary*, for example, 108, 228, 230, and 238–39; for sun and light symbolism in general, see 92, 118, 144, 182–84, 196 and, for cosmic circular motion of the souls, 86, 124, 156, and for the "central point," 358–62.

90. See Allen, *Phaedran Charioteer,* 86–87, 106–107, 236–38 (note the references to Apollo). For sun symbolism and the Apollo theme in Ficino's *Phaedrus Commentary*, see Allen, *Platonism of Ficino*, 30, 66–67, 119–20. Allen deals with the Platonic idea of the soul's returning to its maker upon death, which seems appropriate to Michelangelo's subject; also, Garin, *Italian Humanism*, 91.

91. See Ficino, *Theologia Platonica* (ed. cit., reprint Olms, 1975). A recent French work is ed. and trans. Raymond Marcel, *Marsile Ficin: Théologie Platonicienne de l'immortalité des âmes*, 3 vols. (Paris: Société d'Edition "Les Belles Lettres," 1964–70); and in Italian, *Marsilio Ficino, Teologica Platonica*, ed. Michele Schiavone, 2 vols. (Bologna: Zanichelli, 1965). Certain extracts have also been published by Burroughs, "Ficino," reprinted in Ernst Cassirer, Paul Oskar Kristeller, and John Herman Randall, *The Renaissance Philosophy of Man* (Chicago: University of Chicago Press, 1948), 185–212. The great importance of this work is discussed by Kristeller, *Ficino*, 33–34. See also Ardis B. Collins, *The Secular Is Sacred: Platonism and Thomism in Marsilio Ficino's Platonic Theology* (The Hague: Nijhoff, 1974), esp. 2, 28–29, 76–83, for Ficino's use of sun metaphor.

92. See Kristeller, *Ficino*, 17, 293, 339.

93. For sun and light symbolism in the *Theologia Platonica*, see bk. 8F (ed. cit., p. 121), 15E (p. 261), 18B (p. 334); for the Sun as the Good, bk. 2, caput 10 (ed. cit., 16–17); for the circular universe with God as center, Book 2E (p. 30), 4B (p. 56), 11D (p. 185), 16D (p. 300), 18F (p. 326). Cf. translated sections in Burroughs, "Ficino," 228, 230–32, 237. Note the interesting section on art from bk. 13, chap. 3, pp. 233–34, and cf. similar comments in *De Christiana Religione*, where the simile of the sun is used in the same way: "one cannot see without the sun . . . the soul is illuminated by divine light and recognizes God," quoted by Garin, *Italian Humanism*, 94.

94. Ficino, *Theologia Platonica,* bk. 3, caput 2 (ed. cit. 45) "Hoc maximum est in natura miraculum . . . centrum naturae, universorum medium, mundi series, vultus omnium,

nodusque et copula mundi." Translation from Burroughs, "Ficino," 231, also quoted by Kristeller, *Ficino*, 120; and see also *Théologie Platonicienne*, ed. Marcel, 141–42 (where the variation "miraculorum" is given).

95. See Carol V. Kaske and J. R. Clarke, *Marsilio Ficino, Three Books on Life: A Critical Edition and Translation with Introduction and Notes* (Binghampton, N.Y.: Center for Medieval and Early Renaissance Studies, 1989). See also Charles Boer, trans., *Marsilio Ficino, The Book of Life (De Vita Triplici)* (Dallas: Spring Publications, 1980), which must, however, be treated with care; see review by Michael J. B. Allen, *Renaissance Quarterly* 25 (1982): 69–72 and Waddington, "Ficino in English," 230. Thomas Moore, *The Planets Within: Marsilio Ficino's Astrological Psychology* (Lewisburg, Pa.: Bucknell University Press, 1982), chap. 7, "Sol," should be used with caution.

96. For which see Garin, *Astrology;* Daniel Pickering Walker, *Spiritual and Demonic Magic from Ficino to Campanella* (Nendeln: Kraus Reprint, 1976); Frances A. Yates, *Giordano Bruno and the Hermetic Tradition* (London: Routledge and Kegan Paul, 1964), chap. 4, "Ficino's Natural Magic," 62–83.

97. See, for example, Ficino, *Book of Life*, ed. Boer, esp. 13–17, 48–49, 89–90, 97–101, 129–31, 151–52.

98. Ficino, *Book of Life*, 98. Ficino also makes numerous references to Apollo as guide, doctor, and the means of healing for the soul in a kind of parallel to the Christian context (1–3, 12, 17, 35, 59, 162). Cf. also Hyacinthe Brabant and Salomon Zylberzac, "Le Soleil dans la médecine la Renaissance," in Université de Bruxelles, *Le Soleil,* 279–98.

99. *De Vita* has also been claimed as an important source for Dürer (Panofsky et al., *Saturn and Melencolia*).

100. Ficino's letters were widely known and circulated; they have recently become more easily available through the four-volume edition cited.

101. Ficino, *Letters*, esp. 1:61, 81, 165, 193, 197; 2:29; 3:14, 19, 46, 56–58; 4:12, 23, 34, 47, and 62, "the Sun signifies God."

102. For example, *Letters*, vol. 1, nos. 7, 42 and 43; vol. 2, no. 63; vol. 4, no. 33. Interest was shown in astrological sources by various members of the Medici family, particularly Pope Leo X and Cosimo I; see Janet Cox-Rearick, *Dynasty and Destiny in Medici Art: Pontormo, Leo X and the Two Cosimos* (Princeton, N.J.: Princeton University Press, 1984), esp. pt. 3, "Cosmic and Dynastic Imagery in the Art of Leo X,'" 155–228. Reference is made to Michelangelo's commission by the Medici for the Medici chapel in S Lorenzo and the cosmic imagery used there (225–27).

103. A Latin manuscript edition of *De Sole* and *De Sole et Lumine* is in the University Library Cambridge (ref. L.9.23); for a modern translation see Fallico, *Renaissance Philosophy*, 1:118–41.

104. Fallico, *Renaissance Philosophy*, 1:xi.

105. Fallico, *Renaissance Philosophy*, 119.

106. Fallico, *Renaissance Philosophy*, 120–21. "Nulla magis quam lumen refert naturam boni . . . Sol vero maxime Deum ipsum tibi significare potest. Sol tibi signa dabit sole quis dicere falsum audeat (caput 2). Compare Virgil, *Georgics*, trans. H. R. Fairclough (London: Heinemann, 1978), 1463 ("Solem quis dicere falsum audeat," 112) as a possible source.

107. Fallico, *Renaissance Philosophy*, 121–24.

108. Fallico, *Renaissance Philosophy*, 129.

109. Caput 10, "Comparatio Solis ad Deum," Fallico, *Renaissance Philosophy*, 131–32, ("Sol primo creatus et in medio coelo"). Compare with quotation from Copernicus' *De Revolutionibus* (see chap. 1 of this work).

110. Fallico, *Renaissance Philosophy*, 132.

111. Particularly chap. 14. For dissemination of Ficino's writings and ideas, see

Kristeller, *Ficino*, 93, idem, *Eight Philosophers*, 42–43; Koyré, *Astronomical Revolution*, 65; and Kuhn, *Copernican Revolution*, 130.

112. A full examination of the following discussion has been developed in a separate paper: Valerie Shrimplin, "Hell in Michelangelo's *Last Judgment*," *Artibus et Historiae* 30 (Vienna 1994): 83–107. See also discussion by Tolnay, *Michelangelo*, 5:43 and Steinberg, "Corner of the *Last Judgment*," esp. 243–50. Connected with this problem is the reason for the reverse orientation of the chapel, already discussed.

113. Plato, *Republic* 7, 514A–517B. For commentary and notes, see Plato, *Republic* (ed. Shorey), 118–33; and Shorey, *What Plato Said*, 234–39. Since space does not allow full discussion of what is considered to be reality by Plato, the word "real" is here used in quotations, following Shorey.

114. Shorey, *What Plato Said*, 517–521D.

115. This description also bears comparison with Michelangelo's *Slaves* from the Julius tomb, esp. those known as "The Dying Slave" and "The Rebellious Slave" (for which see Tolnay, *Michelangelo*, 1975, figs. 91 and 93).

116. *Republic*, esp. 517–518D.

117. *Republic*, 532A–D.

118. For further explanation and discussion of Plato's metaphor of the Cave and its links with light and sun-symbolism, see Plato, *Republic* (ed. Radice and Baldick), 278–86; Guthrie, *Greek Philosophy*, 4:503–20; J. E. Raven, "Sun, Divided Line and Cave," *Classical Quarterly*, new series, 3, no. 1 (1953): 22–32; John Ferguson, "Sun, Line and Cave Again," *Classical Quarterly*, new series, 13, no. 2 (1963): 188–93; Julia Annas, *An Introduction to Plato's Republic* (Oxford: Clarendon, 1981), esp. chap. 10, "Understanding and the Good: Sun, Line and Cave," 242–72.

119. Rahner, *Greek Myths and Christian Mysteries*, 89, says that Plato's metaphor of the Cave is related to ancient solar beliefs. For Ficino on the Cave, see Kristeller, *Ficino*, 223, 384.

120. *Theologia Platonica*, book 4G (ed. cit., 58), 6B (83), 16A (303).

121. See Ficino, *Letters*, vol. 3, no. 26.

122. Ficino, *Letters*, vol. 3, no. 58.

123. Authors who refer to the problem of the "cave" or its positioning at the altar, but without suggesting an explanation, include Valerio Mariani (1964), Robert Coughlan (1966), Ettore Camesasca (1969), Johannes Wilde (1978), Pierluigi De Vecchi (1986), Charles de Tolnay (*Michelangelo*, 5:43). Salvini curiously refers to the "mouths" of Hell (*Hidden Michelangelo*, 132). Steinberg discusses the problem in greater depth and explains why the explanations of "Limbo" or "Purgatory" appear inadequate ("Corner of *Last Judgment*," 249–50).

124. References in Homer, Virgil and Ovid are summarized in Graves, *Greek Myths*, 1:120–25, "Gods of the Underworld." See also Dante, *Inferno* 3:76–77; and 5:4–5.

125. Gospel of Nicodemus (ed. James), 94–146.

126. For details of the cross, which would have been in use at the time, see Tolnay, *Michelangelo*, 5:105.

127. Gospel of Nicodemus (ed. James), 123–24. See also Salvatoris, ed. Kim, *Gospel of Nicodemus*, 5, with comparative references to Christ's victory over death. See also the popular *Beneficio di Cristo*, (ed. Prelowski) 56, and cf. 1 Cor. 15:54–57.

128. It is interesting to consider other representations of caves in Christian iconography that might have been influenced by similar themes, such as the Cave of the Nativity (more commonly depicted as such in the Eastern Greek Orthodox Church) and the Cave of the Entombment. In both cases, Christ emerges from the cave for the salvation of mankind from ignorance and darkness. Cf also the raising of Lazarus, whose grave was a "cave" John 11:39.

129. Chastel et al., *Sistine Chapel*, 172. For other comment on the importance of Plato's Cave metaphor during the Renaissance, see David Summers, *The Judgment of Sense: Renaissance Naturalism and the Rise of Aesthetics* (Cambridge: Cambridge University Press, 1987): 40–41, 76, 264.

130. See the letter of Anton Francesco Doni, quoted by Murray, *Michelangelo, Life, Work and Times,* 164 ("that darkness that you have painted").

131. Pico della Mirandola, *Oration on the Dignity of Man,* in Fallico, *Renaissance Philosophy,* especially 153, 155; cf also Cassirer, Kristeller and Randall, *Renaissance Philosophy of Man,* 234–36, and Robb, *Neoplatonism,* 60–61.

132. Raymond B. Waddington, "The Sun at Center: Structure as Meaning in Pico della Mirandola's *Heptaplus,*" *Journal of Medieval and Renaissance Studies* 3 (1973): 69–86.

133. See Waddington, "The Sun at Center," esp. 78–79. Waddington's study on sun symbolism in Milton discusses the continuing influence and popularity of similar themes in the following century; Waddington, "Here Comes the Sun," *Modern Philology,* 79 (1982): 256–66.

134. Fallico, *Renaissance Philosophy,* 113.

135. For examples, see respectively, Fallico, *Renaissance Philosophy,* 1:198–99, 275, 311–12, and Kristeller, *Eight Renaissance Philosophers,* 120–21.

136. See Fallico, *Renaissance Philosophy,* 2:3–23, 149–62, 277–93, 296–309; also John B. Gleason, "Sun-worship in More's Utopia," in Université de Bruxelles, *Le Soleil,* 433–46.

137. For Campanella, see esp. his *City of the Sun,* (ed. cit.), and Fallico, *Renaissance Philosophy,* 1:338–78. For Bruno, 339–423; and esp. Yates, *Giordano Bruno and the Hermetic Tradition,* where Bruno's debt to Ficino is examined. For the later influence of Ficinian and Hermetic solar mysticism on Kepler (1571–1630), see Koestler, *Sleepwalkers,* pt. 4.

138. Ficino, *De Sole,* 126–27. He also quotes Iamblicus, "All the good we have, we have from the Sun" (127) and shows how "very many Platonists place the soul of the World in the Sun" (128; cf. chap. 9 on 129–30). Ficino also acknowledges the Hermetic writings as his sources elsewhere; for example, *De Amore,* 37, and *Philebus Commentary* (Allen, *Philebus,* 180, 246).

139. For the influence of these ancient writings on Ficino and his circle, see Robb, *Neoplatonism,* 48–49; Kristeller, *Ficino,* 25–26; idem, *Renaissance Thought and the Arts,* 98; Allen, *Platonism of Ficino,* 35. Copernicus' knowledge of the Hermetic writings should especially be borne in mind.

140. See François Secret, "Le Soleil Chez les Kabbalistes Chrétiens de la Renaissance," in Université de Bruxelles, *Le Soleil,* 211–40, esp. 215.

141. For further examination of the influence of the Cabala, which space does not permit here, see Joseph L. Blau, *The Christian Interpretation of the Cabala* (1944; rptd. New York: Kennikat, 1965); Secret, "Le Soleil chez les Kabbalistes Chrétiens"; and R. Schrivano, "Platonism and Cabalistic elements in the Hebrew culture of Renaissance Italy," in Eisenbichler and Pugliese, *Ficino and Renaissance Neoplatonism,* 123–39. For the popularity and influence of the Hermetic writings and the Cabala on artists like Leonardo, see Vassili P. Zoubov, "Le Soleil dans L'oeuvre scientifique de Léonard de Vinci," in Université de Bruxelles, *Le Soleil,* 179–98; and Yates, *Giordano Bruno,* 179–80, 260–51, and 449.

142. See *Hermetica: The Greek Corpus Hermeticum and the Latin Asclepius in a New English translation, with notes and introduction,* trans. and ed. Brian Copenhaver, (Cambridge: Cambridge University Press) (henceforward *Hermetica*), esp. xlviii; Yates, *Giordano Bruno,* 398; Kristeller, *Facets of the Renaissance,* 112–13.

143. See also, Frances A. Yates, "The Hermetic Tradition and Renaissance Science," in Charles S. Singleton, *Art, Science and History in the Renaissance* (Baltimore: Johns Hopkins Press, 1967), 255–74; and Walker, *Spiritual and Demonic Magic from Ficino to Campanella,* esp. 19–24; also Ingrid Merkel and Allen G. Debus, eds., *Hermeticism and the Renaissance:*

Intellectual History and the Occult in Early Modern Europe (Washington: Folger Library, 1988), sec. 2, "Magic, Philosophy and Science."

144. Ficino, *Letters*, 1:21.

145. Yates, *Giordano Bruno*, 81–82; Walker, *Spiritual and Demonic Magic*, 36ff.

146. Eugenio Garin, *Astrology in the Renaissance: The Zodiac of Life* (London: Routledge and Kegan Paul, 1983), especially 58–67 ('Neoplatonism and Hermeticism').

147. See *Hermetica*, ed. Copenhaver, esp. xlv; "Hermes and his readers." The four-volume edition by Walter Scott, ed. and trans., *Hermetica: The Ancient Greek and Latin Writings Which Contain Religious or Philosophic Teachings Ascribed to Hermes Trismegistus* (London: Dawson, 1968), may also be consulted; it includes the original Greek and Latin texts, but the translations should be regarded with care.

148. See *Hermetica*, ed. and trans. Copenhaver, *Corpus Hermeticum 1 (Poimandres)*, 1–7 (and compare with Genesis and the Apocalypse); Yates, *Giordano Bruno*, esp. 23–28, 49–50, and Garin, *Astrology*, chap. 2.

149. *Hermetica, Corpus Hermeticum 1 (Poimandres)*, 2, 4; *Corpus Hermeticum* 3:13–14; *Corpus Hermeticum* 10:30–32. For discussion of the concepts of the beginning of time and space, *Asclepius*, 75–76.

150. See *Hermetica, Corpus Hermeticum* 2, esp. 8–10; *Corpus Hermeticum* 10:32–33. *Corpus Hermeticum* 12:47. It is argued that nothing is motionless, not even the earth, since immobility suggests idleness. See also Yates, *Art of Memory*, 310.

151. *Hermetica*, Asclepius, 86.

152. *Hermetica*, Asclepius, 85–91, esp. 87. The deliberate combination of mobility and immobility is suggestive of source material for the ambiguous pose of Michelangelo's Christ. The attitude toward secretiveness attached to divine revelations has also been mentioned in connection with the fresco.

153. *Corpus Hermeticum* 2:11–12; 6:21–23.

154. *Corpus Hermeticum* 10:31. The idea that one's soul is illumined by rays of light from God bears a clear resemblance to Ficino's thought, quoted above, as does the idea of one's escape from the darkness of error into light (*Corpus Hermeticum* 7:24).

155. See *Corpus Hermeticum* 5:18–19. The sun is viewed as King of the universe for "the sun is situated in the center of the cosmos, wearing it like a crown" (*Corpus Hermeticum* 16:59).

156. *Corpus Hermeticum* 8:26. Scott, *Hermetica*, 178–79, translates this more literally as "it is God that is the author of all and encompasses all and knits all things together" (ἀρχὴ δὲ καὶ περιοχὴ καὶ σύστασις παντονο Θεος—σύστασις meaning "knot together"). Regarding the immortality of the soul, see esp. *Corpus Hermeticum* 13:49–57, and *Asclepius*, 84–85 on punishment after death. See also Yates, *Giordano Bruno*, 36–37, 153–56, 172, for sun-symbolism in the *Hermetica*. The influence of these writings on Ficino deserves closer scrutiny.

157. Yates, "Hermetic Tradition," in Singleton, 258–59; idem, *Giordano Bruno*, 71–72.

158. Yates, *Giordano Bruno*, 71. Detailed in the *Picatrix*, the Latin version of an Arabic text on astral magic, also popular in Renaissance Italy.

159. Yates, *Art of Memory*, esp. 138–39 and 151–53, deals with the later influence of sun mysticism and magic and shows how far Neoplatonic and Hermetic thought has to be taken into account as contributory to the heliocentric revolution.

160. See Yates, *Giordano Bruno*, esp. chap. 20, and idem, *Art of Memory*, 228 and 297–98. Also Luigi Firpo, "La cité idéale de Campanella et le Culte du Soleil," Paul-Henri Michel, "Le Soleil, le Temps et l'Espace: Intuitions cosmologiques et images poétiques de Giordano Bruno," and Mikhail Dynnik, "L'Homme, le Soleil et le Cosmos dans la philosophie de Giordano Bruno," in Université Libre de Bruxelles, *Le Soleil à la Renaissance* (Brussels: Presses Universitaires de Bruxelles, 1965), 325–40, 397–414, 415–32, respectively.

Hermetic influence, combined with Ficino's Neoplatonism, has also been claimed as an influence on Kepler and even Newton (Koestler, *Sleepwalkers*, pt. 4; Pierre Thuillier, "Isaac Newton: Un alchémiste pas comme les autres," *La Recherche*, 20 (212), (1989): 876– 86).

161. The continuation of the Hermetic tradition, later combined with so-called Rosicrucian ideas, is dealt with by Yates, *Giordano Bruno*, 407–14, 440–47. Giordano Bruno associated heliocentricity with solar magic and the idea of the terrestrial movement being founded on the Hermetic concept that the earth moves because it is alive.

162. See, for example, Tolnay, *Michelangelo*, 5:94. He comments that "Michelangelo's early Platonism and late Christianity are not irreconcilable," and "Michelangelo's Platonism can be considered a prelude to his later Christianity," but this in itself implies the that the two aspects are broadly related rather than inextricably linked.

163. See Plato, *Republic* (ed. Radice), appendix, 402, with diagram, 405. Compare Dante, *Paradiso* (ed. Mandelbaum), 305.

Chapter 8

Scientific Sources

So we find underlying this ordination [the heliocentric system] an admirable symmetry in the Universe and a clear bond of harmony in the motion and magnitude of the spheres such as can be discovered in no other wise. . . . So great is this divine work of the Great and Noble Creator.

—Nicholas Copernicus
De Revolutionibus Orbium Coelestium[1]

In the tenth chapter of his introductory book of *De Revolutionibus Orbium Coelestium*, Copernicus demonstrates, in one breath as it were, both his affinity with Neoplatonic concepts of perfection, symmetry, and harmony and his acknowledgment of the Christian God. The expression of Platonic notions, as well as specific references to Plato in Copernicus' work, demonstrates the influence on Copernicus of the same Renaissance background and sixteenth-century currents of thought that also informed the thinking of Michelangelo.

The Importance of Copernicus

It is curious that general histories of the Renaissance period usually only afford a line or two—at most half a page—to the assessment of Copernicus' theory.[2] Considering the eventual impact of the heliocentric theory on philosophy, religion, and general worldview, not to mention astronomy, it seems extraordinary that so little discussion of it takes place in books of general or cultural history. Perhaps this marks reluctance on the part of cultural historians to deal with a subject that also involves complex scientific and mathematical discussion.[3] Conversely, many historians of

science tend to analyze and discuss Copernicus' achievement on a scientific basis, without delving too deeply into his importance in the context of Renaissance humanist and Neoplatonic learning or in the upheaval of the Renaissance in general.[4]

Although the core of the Copernican revolution was the transformation of mathematical astronomy, it embraced conceptual changes in cosmology, physics, philosophy, and religion as well. Simply put, the importance of Copernicus' heliocentric theory of the universe lies in the fact that it eventually displaced the medieval view of the universe in which the earth was situated in the central, most significant position, surrounded by a series of immovable spheres that supported the heavenly bodies and the celestial regions. By contrast, according to Copernicus' heliocentric theory, the earth was simply one of a number of planets that revolved in circular orbits around the sun, now assumed to be at the central point of the universe.[5] The change in worldview that stemmed from Copernicus' heliocentric theory was to have enormous implications for theology and philosophy, mainly because it altered the implicit relationship between God and humanity, and because it eventually impinged on all areas of cultural thought.

Tolnay, Copernicus, and Michelangelo

In the course of his analysis of Michelangelo's *Last Judgment,* Tolnay did attempt to consider the relevance of Copernicus' heliocentric theory within this type of wider, cultural framework by considering its possible influence on Michelangelo's fresco. He discounted the possibility because Michelangelo, at the time of the fresco's creation,

> could not have known Copernicus' book [*De Revolutionibus Orbium Coelestium*] which was published in 1543, at least seven years after Michelangelo had conceived his fresco.[6]

Because the book's date of publication postdated the completion and unveiling of Michelangelo's *Last Judgment* in 1541, strictly speaking Tolnay was correct: it would have been impossible for Michelangelo to have read *De Revolutionibus Orbium Coelestium* in its published form either before or during his work on the fresco. In fact, it is unlikely that Michelangelo would have read the complete work even if it had already been published since, as Kuhn points out, Copernicus had made the book unreadable to "all but the erudite astronomers of the day," and Koestler characterizes *De Revolutionibus* as "the book that nobody read."[7]

However, it was not necessary (either then or now) for Copernicus' detailed thesis to be read to grasp the heliocentric idea. The astronomical

thesis of *De Revolutionibus*, including the observational data, is extremely complex, even "confused,"[8] but its enormous impact over the succeeding centuries is to be explained by the fact that the details were less important than the underlying heliocentric idea. Contrary to what Tolnay implies, reading *Revolutions* and hearing about heliocentricity were (and still are) two very different things. It was not necessary for anyone to read *De Revolutionibus* to grasp the basic concept of a moving earth rotating about a stationary sun. It would, of course, be necessary for the idea to be under debate and in circulation. Not only did the heliocentric idea originate well before the Renaissance in the midst of an increasing amount of cosmological speculation, but Copernicus' own ideas were formulated, discussed, and even circulated well before the publishing of *De Revolutionibus* in 1543. Nor were such ideas always regarded as heretical by the Catholic Church, as is sometimes implied.[9]

The Waning of Medieval Cosmology and the Revival of Ancient Concepts

By the time of the Middle Ages, and the era of the Renaissance, the medieval concept that the earth was flat, with the landmass occupying the center, edged by water and covered by the Dome of Heaven, had been questioned for some time. This cosmology, based on interpretations by men like Cosmas and Lactantius, was losing ground, especially in the west where there was a return to classical ideas of sphericity. Although this crude idea of a flat earth system probably continued throughout the period in the minds of a large proportion of the masses, it did not survive among educated scholars, who had thought of the earth as a sphere for some time.[10] The celestial regions, too, were regarded as spherical, consisting of a series of concentric spheres, which revolved around the earth and carried the stars and planets. It is thus erroneous to suppose that the earth was considered flat until the voyages of discovery by Columbus and others from 1492. Heninger, in a consideration of Renaissance views of the world, demonstrates clearly, through medieval and Renaissance diagrams of the universe, that cosmological speculation enjoyed certain popularity in the fifteenth century, in the absence of any authoritative determination to the contrary by the church.[11]

The generally held view of the universe was based, in the later Middle Ages and early Renaissance, on Aristotle and Ptolemy as much as on Scriptural sources. Since Gerbert, the astronomer and mathematician elected pope in 999, had discussed the spherical earth and introduced the notion of its representation by a globe, variations on the spherical geocentric theory had come under consideration, and the Church and the scholastic movement had even contributed to this debate.[12]

By the time of the Renaissance, the heliocentric theory was also under discussion. It had, as mentioned above, been considered by Dante in connection with his concept of the spherical universe, and it was among the various alternative theories that had been proposed regarding the ordering and composition of the universe. This discussion could well have been connected with the difficulties attached to combining the biblical view of the cosmos (with Heaven above and Hell beneath the earth's surface) with a world now known to be spherical.[13] With Hell situated beneath the earth's surface but with a spherical earth as the center of the universe, the end result was virtually "haidocentric" (or "diabolocentric").[14] On the one hand this fitted in with the religious concept of the universe as a "golden apple with a rotten core," but it appeared incongruous and quite unacceptable to have the whole of creation and the celestial spheres rotating around Hell. The unease this created has already been demonstrated in the discussion on Dante since, having placed Hell below in the center of the earth, he felt forced to introduce a second point (symbolic of God) around which the Heavens revolved, to avoid this problem (figs. 91, 92).[15]

It is important to remember that, prior to the Renaissance, the possibility of a heliocentric universe had also been considered by ancient philosophers. Previous proponents of the idea, both among the ancient Pythagoreans and Platonists as well as amongst fifteenth-century Italian and German astronomers, were duly acknowledged by Copernicus in his writings.[16] Copernicus recognized that the heliocentric idea had originated in antiquity and had been dimly kept alive through the intervening centuries. In his writings he quotes ancient sources as a means of giving increased credibility to his theory, and in the preface to *Revolutions* he explains how, being dissatisfied with the complexities and inconsistencies of the accepted Ptolemaic and Aristotelian system, he held a conviction that the solution to the composition and workings of the universe should be simple and harmonious.[17] Thus, as a Neoplatonist, he set out to consider whether the ancient philosophers might have proposed more systematic solutions to the problem of the universe. This led him, as he states,[18] to search the ancient authors and classical writings to look for alternative, or-derly solutions. He discovered references to the moving earth in Cicero and Plutarch,[19] who in turn were discussing the work of ancient Pythagorean and Platonic astronomers: Hicetas, Philolaus the Pythagorean (Plato's own teacher), Heraclides of Pontus, and Ecphantus the Pythagorean.[20] Copernicus' purposeful searching of the ancient authors to stimulate and corroborate his own ideas demonstrates his Renaissance interest in classical learning and its revival, which was part of a general tendency of the time.

In his discussion Copernicus also included reference to Aristarchus of Samos,[21] whose theory went furthest of all the ancients since he developed the discussion of the moving earth to the placement of a static sun in the center of the universe. The sources into which Copernicus delved

to find this information (Cicero and Plutarch) would have been as easily available to Michelangelo in Rome as to Copernicus in Poland, especially these most important references to Aristarchus of Samos. It is particularly noteworthy that Aristarchus' theories are mentioned by Vitruvius in his *Ten Books of Architecture,* a text with which Michelangelo was undoubtedly familiar.[22]

Renaissance Predecessors of Copernicus

The main scientific problem of the Renaissance was astronomy, and as far as Copernicus' immediate Renaissance predecessors are concerned, there is evidence that several thinkers had tackled the problem of the spherical geocentric cosmos. In spite of the ancient thinkers, the question of whether it was the earth or the sun that was in motion had been dismissed in the Middle Ages for basically observational reasons,[23] but it did come under discussion again well before Copernicus, as early as the fourteenth century. The philosopher Jean Buridan (1297–1358)[24] discussed the concept of relative motion, which was fundamental to a consideration of whether the earth or the other celestial bodies (sun, stars, and planets) were in motion, and hence to Copernicus' own hypothesis. Buridan related this to the idea of a ship moving out from harbor in which case it is the shore the appears to recede.[25] Although the idea that the whole huge earth was moving seemed impossible, was it not even less likely, he argued, that the immense sphere of stars was rotating daily on its axis.[26]

The French philosopher Bishop Nicholas Oresme (1323–82) in a treatise, *On the Heaven and the Universe,* also examined the theory of motion of the earth as opposed to the sun in the same terms, highly suggestive of the sun-centered universe.[27] In the fifteenth century, another ecclesiastic, Nicholas of Cusa (1401–64), formulated new cosmological ideas, based on the idea of the earth as mobile and spherical. Thus the traditional picture of the universe was not accepted unconditionally by all learned members of the church.[28] Kuhn sums up Cusanus' importance: In the fifteenth century the eminent cardinal and papal legate Nicholas of Cusa had propounded a radical Neoplatonic cosmology and had not even bothered about the conflict between his views and Scripture. Though he portrayed the earth as a moving star, like the sun and other stars, and though his works were widely read and had great influence, he was not condemned or even criticized by his church.[29]

Cusanus, moreover, believed that the universe, equated with God in Neoplatonic terms, was an infinite sphere, whose center was everywhere and whose circumference was nowhere.[30] Cusanus' concept of infinity is especially relevant for the discussion of Michelangelo's fresco since the

notion that the background of the fresco is a representation of infinity has been discussed in the literature.[31]

Other more immediate predecessors of Copernicus who were also acknowledged by him include the German astronomer Peurbach (1423–61) and his pupil Johann Mueller called Regiomontanus (1436–76), who had brought about the revival of astronomy as an exact science in the fifteenth century.[32] Copernicus' own principal teacher in astronomy was the Italian Domenico da Novara, who was, in turn, a pupil of Regiomontanus and also a well-known Platonist.[33]

Neoplatonic Influences on Copernicus

In many ways, therefore, by the early sixteenth century the world was ready for an innovative view of the universe. Copernicus came on the scene at the very moment when the increased flow of information could both bring him the raw materials for his theory and also disseminate his own ideas, especially through the innovation of the printing press.[34] Copernicus' links with humanist and Neoplatonic circles, which were reexamining the heliocentric idea are confirmed by his direct contacts. Born in Torun, Copernicus initially studied at the University of Cracow, before being appointed canon at Frauenburg through the offices of his uncle, the Bishop of Ermland; most of his lifetime was spent in this area. However, Copernicus obtained extensive leave from this remote corner of Europe and traveled a great deal. He studied in Italy and was strongly influence during his of seven years at humanist universities.[35] Virtually contemporary with Michelangelo (Copernicus was born in 1473, Michelangelo in 1475), Copernicus moved in similar circles of learning in Italy in the late fifteenth and early sixteenth centuries. He was in Bologna, an important center of humanist learning, from autumn 1496, when he was registered for law. He was in Rome in the Jubilee year of 1500, where he served as apprentice for the Roman Curia and lectured on mathematics and astronomy.[36] It is significant that this paralleled Michelangelo's own movements, for the artist also visited Bologna in the late 1490s and was in Rome at the turn of the century.[37] In 1501–1502 Copernicus studied medicine at Padua; in 1503 he received a doctorate in canon law from Ferrara. These were all well-known centers of humanist and Neoplatonic learning of a type that also influenced Michelangelo.[38]

The Neoplatonic undercurrent in Copernicus' work has been argued with almost as much fervor as the Neoplatonic influence on Michelangelo.[39] In particular, the writings of Ficino, including *De Sole* and *Platonic Theology*, which were available to Copernicus in Poland, have been maintained as having been influential on Copernicus' formation of his theory.[40] Ficino's

approach to the sun as deity and symbolic center of the universe, and his reference, "the sun was created first and in the middle of the universe," have been argued as especially pertinent for Copernicus. A comparison might also be drawn between Copernicus, who wrote, "In the middle of all resides the sun. . . . So indeed the Sun remains, as if in his kingly dominion," and Ficino, who wrote, "The sun sits as if occupying a rock in the centre, in the manner of a king."[41]

Quotations from Plato are quite common in Copernicus' writings,[42] as well as the expression of more generalized Neoplatonic ideas concerning the harmony of the universe. Copernicus' defence of the heliocentric system was very much related to aesthetic concepts, especially the Platonic principle of simplicity and perfection. Copernicus also significantly referred to the writings of Hermes Trismegistus, regarded by him as the precursor of Plato.[43] Copernicus' ideas of simplicity, order, and harmony in physics, astronomy, and mathematics correspond to similar Neoplatonic concepts expressed in philosophy and art. This type of Neoplatonism was not regarded as incompatible with Christianity. Like other Neoplatonists, Copernicus was neither neopagan nor atheist. He continually referred to God as the architect of the universe, albeit a sun-centered one. His search for perfection and harmony fits in with the Neoplatonic standpoint:

> If he did have a metaphysics serving to guide his early speculations towards a heliocentric universe, it seems likely to have been compounded out of two elements; a humanist's neo-Platonic Sun-worship, together with a mathematician's commitment to the rationality of the system of the created world.[44]

Koyré and Kuhn also emphasize how the ancient interest in the metaphysics of light and Neoplatonic ideas are evident in Copernicus' attitude toward both the sun and the idea of mathematical harmony, "these traditions alone," writes Koyré "are capable of explaining the emotion with which Copernicus speaks of the Sun. He adores it and almost deifies it."[45]

The Neoplatonic element in Copernicus' writings has been disputed seriously only by Rosen, who overlooks Copernicus' several direct references to Plato, and whose arguments seem unconvincing.[46] Apart from this, the only argument that might be put forward against Copernicus' being influenced by Neoplatonism is that Plato's physical cosmology would seem to be basically geocentric. In spite of Plato's reverence for the sun as symbol of the Good or the personification of the deity, it is not placed at the center of the physical universe (as is God in Ficino's cosmology), but, allegorically, a central position is inferred, even by Plato.[47] This suggests that Copernicus was concerned with Platonic ideas and metaphysical concepts as much as with Plato's cosmology in the technical sense. In any case Copernicus was somewhat ambiguous about Plato's cosmological view.

In the *Narratio Prima* (a preliminary publication in 1540 of Copernicus' theory by his "disciple" Rheticus, 1514–1576), it was made quite clear that Copernicus understood Plato's cosmology as having the earth in motion both on its own axis and around the sun, and scholars continue to discuss whether Plato's universe was geocentric or heliocentric and whether he viewed the earth as mobile.[48]

The fact that Copernicus' system was not entirely innovative but did retain certain aspects of the Aristotelian system of the universe has often received comment.[49] The old views were not entirely discarded as they became superseded by the new, but the same basic approach might be argued as that which has been argued above for Michelangelo in his art, namely, that innovation and tradition may be combined in a unique synthesis. The integration of ideas is the keynote.

Copernicus and His Writings

Copernicus' outline of his heliocentric system *De Revolutionibus Orbium Coelestium* (also referred to as *Revolutions*) was published in 1543, the year of his death at the age of seventy. Recognized tradition has it that Copernicus received the first copy on his deathbed and expired later the same day (24 May 1543).[50] That date, therefore, clearly does not mark the date of origin of his heliocentric theory; the availability of the book in published form has little to do with the date of Copernicus' formulation of his ideas. Obviously, Copernicus' theory originated well before this time, even if it was to some extent kept secret, or, rather, not specifically made public by him.

When it was finally published in 1543, Copernicus' *Revolutions* was dedicated to Pope Paul III, the same Pope who patronized Michelangelo's *Last Judgment*. In his Preface,[51] Copernicus explains the reasons for the delay in publication and describes how he was finally persuaded to publish the volume and permit it to appear "after being buried amongst my papers and lying concealed not merely until the ninth year but by now the fourth period of nine years."[52] This suggests a date of origin for the work right at the beginning of the sixteenth century and confirms that his ideas had originated well before the time of publication. Fear of ridicule, rather than fear of persecution, appears to have been his motive for delaying publication, but how successful Copernicus was in keeping his secret is of great importance if an influence on Michelangelo in the years 1533–41 is to be argued. The concealment of sophisticated intellectual ideas from the masses appears to have been common in this age. Ficino's comment that "it was the practice of the ancient theologians to clothe the divine mysteries in mathematical symbols and poetic images lest they be exhibited defenselessly to the gaze of the vulgar" seems to

be applicable in the case of Copernicus and is, coincidentally, strongly reminiscent also of Aretino's comment on Michelangelo's *Last Judgment*, cited above (preface).[53]

Kuhn demonstrates how, for two decades before the publication of his principal work, Copernicus had been widely recognized as one of Europe's leading astronomers[54] and how reports about his research, including his new hypothesis, had circulated since about 1515. Far from his ideas being secret, as Thorndike writes,

> The scientific world of that time, if not public opinion generally, had been gradually prepared for the final publication of the full text of Copernicus' *De Revolutionibus* in 1543, and may even be said, as a result of this previous propaganda, to have been looking forward eagerly to its appearance. Copernicus already had a great reputation as an astronomer . . . he reached the height of his reputation *about 1525*.[55] [my italics]

As evidence of his reputation, it may also be cited that Copernicus was included in the general invitation of 21 July 1514 issued by Pope Leo X (de' Medici) at the Fifth Lateran Council to leading astronomers to advise on the reform of the calendar. The Bishop of Fossombrone, who was the astronomer Paul of Middelburg (1445–1533) and was in charge of this project, asked Copernicus to participate and give some advice. Copernicus himself referred to this encouragement nearly thirty years later in the preface to *Revolutions*, an interesting point when one considers that Paul of Middelburg was also a close associate of Ficino.[56] Copernicus is known to have replied to the council but to have declined the invitation to travel to Rome.[57]

Authorities tend to agree that Copernicus probably formulated the basic core of his ideas on heliocentricity while still a student at Cracow (1491–94),[58] but it is important to bear in mind Copernicus' seven years of study in Italy (1496–1503). His contact here with Domenico of Novara has already been mentioned.[59] In Ferrara he probably also met Celio Calcagnini (1479–1541), poet and philosopher, whose short book, *On the Immobility of Heaven and the Mobility of the Earth*, also echoed an idea that was "very much in the air."[60] It is thus possible that Copernicus was already referring to heliocentricity in his years at Bologna and Rome, where he lectured in public. In any case his theory was certainly formulated in the main by the time he wrote *Nicolai Copernici de Hypothesibus Motuum Coelestium a se Constitutis Commentariolus*.[61] The *Commentariolus*, as it is called, is less well known than the *Revolutions* of 1543. Its precise date of writing is uncertain but it was circulating in manuscript form by 1514, since on 1 May that year, the historian Matthias Miechow recorded in the library at Cracow a copy of "a short treatise maintaining that the earth moves and the sun remains in a state of rest."[62] In the *Commentariolus*,

Copernicus states quite clearly his seven assumptions, which include the statement that "all the spheres revolve about the sun as their mid-point and therefore the sun is the center of the universe."[63] So Copernicus' theory of heliocentricity was available in written form, at least to a limited extent, and circulated from as early as 1514. This manuscript was probably not meant for general public consumption at this stage and seems to have been circulated only to selected friends and colleagues.[64]

In addition to the *Commentariolus*, Rosen cites Copernicus' "Letter against Werner" of 3 June 1524, written in reply to the astronomical tract of Professor Werner, as further evidence of growing interest in Copernicus and scholarly knowledge of his theories in the early part of the sixteenth century. This letter, which rebuked Werner's *On the Motion of the Eighth Sphere* because it was critical of the ancient astronomers, also circulated in duplicated and handwritten form in the 1520s.[65] In learned circles, there was undoubtedly an increasing knowledge and interest in the astronomer from Varmia and his ideas. During the next twenty years, Copernicus' reputation grew on an international scale and his personal fame, as well as his yet unpublished hypothesis, became popularly known.

Copernicus in Art

The depiction of sun symbols in Renaissance art is discussed in chapter 5 from the theological point of view, but the influence of scientific theory and Copernicus also merits consideration. Evidence that a new worldview was already having an effect on a wider audience becomes clear in the context of painting by the first third of the sixteenth century.[66] Copernicus' physical appearance was known, and several portraits exist (for example, fig. 116). Giorgione's painting of *The Three Philosophers*, 1509–10 (fig. 117), with their scientific apparatus and diagrams, has been argued as having an astronomical theme, and Pignatti discusses Copernicus as one possible identification of the youngest philosopher on the left.[67] This idea has also been discussed in scientific publications,[68] and the figure does seem to bear some resemblance to known portraits of the astronomer (fig. 116).[69] The inclusion of the setting (or rising) sun here also seems apt as the young astronomer turns toward it with his back to the older men. It is probably significant that documentary evidence confirms that this painting was completed by Sebastiano del Piombo (1485–1547), and that the young, seated philosopher has been claimed as his work. Sebastiano's close association with Michelangelo is discussed above; their friendship and collaboration was well known to contemporaries, and there is ample evidence of their association in the 1520s and 30s. Sebastiano's letter about the commission and a poem written by Michelangelo confirm their close connection up to the early

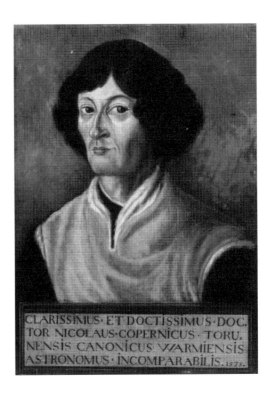

116 *Portrait of Nicholas Copernicus*, anonymous. Photo by Janusz Kozina, 1992.

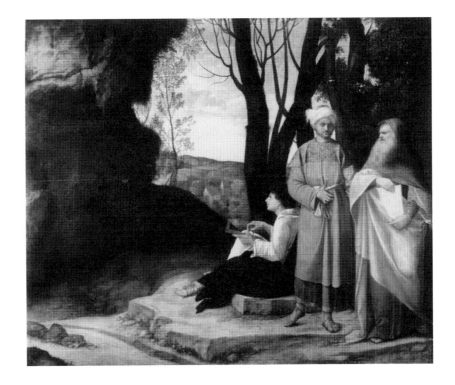

117 Giorgione, *Three Philosophers*, c. 1509–10. Canvas, 123.5 x 144.5 cm. Kunsthistorisches Museum, Vienna.

1530s, until they became estranged as a result of disagreement over the preparation of the altar wall of the Sistine Chapel in 1535.[70]

Leonardo da Vinci, almost as famous for his scientific observations as for his art, wrote "The sun does not move" ("il sole no si move"). This comment, Richter remarks, occurs in the middle of mathematical notes and is written in "uncommonly large letters."[71] The passage is not dated but must be prior to 1519, when Leonardo died in France, and it suggests that Leonardo might either have heard of Copernicus or come to similar conclusions. Dürer's cosmic symbolism in his apocalyptic visions and his use of sun-symbolism in the late fifteenth and early sixteenth century have already been mentioned, and attest to the contemporary importance of these themes.[72] Altdorfer's *Nativity of Christ*, c. 1520, and his *Battle of Alexander the Great,* 1529 (fig. 118), have also been discussed by Benesch as relating to the new heliocentric cosmology.[73] Yet Copernican influence on Michelangelo was said by Tolnay to have

118 Albrecht Altdorer, *The Battle of Alexandeer,* detail, 1529. Wood panel, 158 x 120 cm. Alte Pinakothek, Munich.

been an impossibility. His conclusions seem all the more strange, since Tolnay was Benesch's pupil and evidently familiar with and influenced by Michelangelo's approach to cosmology in art. In the light of these interpretations, it seems inexplicable that Tolnay dismissed the idea of a direct Copernican influence on Michelangelo's painting which was completed at a much later date.[74]

Copernicus' theory was evidently becoming popular knowledge in Italy by the 1530s, for Chastel records:

> The first literary echo of the discoveries of Copernicus, long in advance of any scholarly reaction, is Doni's account of the conversations of the common people gathered in the evening on the Piazza del Duomo [in Florence].[75]

Copernicus' ideas were well enough known in common circles for a public satire to take place at Elblag in Poland in 1531, when "a certain schoolmaster with dramatic malevolence in the theatre ridiculed his opinion about the motion of the earth."[76] It was probably this type of critical reaction from the unlearned that made Copernicus reluctant to publish, lest he be ridiculed by the ignorant.[77]

It is acknowledged that all this evidence remains inconclusive and somewhat circumstantial if a direct influence of Copernican cosmology on Michelangelo's *Last Judgment* is to be argued; but it is possible to find even more positive support for the idea that Michelangelo could have been acquainted with the heliocentric theory at the time of the creation of the *Last Judgment*.

Reaction of the Church, Protestant and Catholic

Owing to the relationship between theology and cosmology, the attitude of the church at the time is significant and must also be considered, especially if the inclusion of a Copernican theme in Michelangelo's fresco is proposed and especially if such an inclusion might be considered to have heretical overtones.

It is also significant that, notwithstanding the change in the traditional relationship between artist and patron that had held since Saint Basil and the Council of Nicaea II (787), "the execution alone belongs to the painter, the selection and arrangement of the subjects is the prerogative of the Holy Fathers." This stance was still largely applicable, even in the case of Michelangelo.[78] It has been presumed that Michelangelo had instructors and theological advisers for the program of the ceiling of the Sistine Chapel, even though his own ideas might have been incorporated.[79] However, evidence does suggest that he was given an unusual amount of leeway

over the content and design of the fresco for the altar wall, where he again worked basically on his own. Without overemphasizing the concept of the artist as "solitary genius," it seems highly probable that, with or without some contact with additional theological advisers, Michelangelo assumed a major responsibility for the design and execution of the fresco.[80] Nevertheless, the prerogative of the Holy Fathers certainly would be still be applicable, particularly for such a fresco executed in the key position in the most important chapel in Christendom. Pope Clement VII, who instigated the fresco, had a reputation as a discerning and particular patron;[81] and where complex dogma was to be expressed in a single image at the very heart of Christendom, it does seem unlikely that Michelangelo would deliberately have introduced notions that would be disagreeable or even heretical in the eyes of his patron.[82] The argument that ideas associated with Lutheran heresy were introduced into the fresco thus appears to be implausible. It seems far more probable that ideas expressed, even ones that deviated slightly from what has come to be regarded as the Catholic norm, were perpetrated with the consent of Clement VII, who instigated the fresco, and Paul III, who saw the commission to its conclusion.[83]

From Early Christian times up to the Renaissance, the Church's attitude had been a determining factor in the progress of science and especially of astronomy.[84] The main feature of the Copernican system, that the earth lost its central place and became no more than another one of the planets, had great religious significance. Copernicus' conclusion that the earth was not at the center of the universe, but traveled around a stationary sun, challenged all the traditional and Scriptural concepts. It eventually caused great anxiety, because it appeared to contradict common sense observation and required a measure of sophisticated abstract thinking.[85] Throughout the Middle Ages and much of the Renaissance, it had generally been agreed that the sun circulated around the earth, and the majority of people thus viewed the earth, and hence humanity, as situated in the center of a spherical universe. Copernicus' heliocentric view spoiled this neat arrangement and, since the new cosmological view challenged also the central authority of the Catholic Church and the Scriptures, Copernicus' theory was eventually condemned. However, these implications were not fully realized until very much later than the middle of the sixteenth century. *De Revolutionibus* was not placed on any versions of the *Index of Prohibited Books* in the second half of the sixteenth century and was not banned by the Catholics until 1616, seventy-three years after its publication and the death of its author.[86] It thus took more than half a century for the wider implications of the theory to be realized. In the years immediately following Copernicus' lifetime, his theories caused little conflict in the Catholic Church.

In fact, the Protestants took exception to Copernicus' theories far more speedily than did the Catholics, and reacted by condemning the

theory of heliocentricity.[87] Luther himself was acquainted with Copernicus' theory by the 1530s. He cited Scripture against the heliocentric idea in 1539, some time before the publication of *Revolutions,* again reinforcing the evidence that Copernicus' theory was by then in circulation. This also preceded the publication in 1540 of the *Narratio Prima,* the summary of Copernicus' ideas published by his devotee and follower Rheticus, who was a Protestant himself and had evidently heard of Copernicus and his ideas by 1538, when he resolved to travel from Wittenberg to Varmia to become Copernicus' "disciple."[88] Evidently informed by rumor in the same way, in one of his *Table Talks* held in 1539, Martin Luther was quoted as saying:

> People gave ear to an upstart astrologer who strove to show that the earth revolves, not the heavens or the firmament, the sun and the moon. . . . This fool wishes to reverse the entire science of astronomy; but sacred Scripture tells us that Joshua commanded the sun to stand still and not the earth.[89]

Philipp Melanchthon, Luther's supporter, also spoke out against Copernicus and harshly condemned the new doctrine, assembling anti-Copernican biblical passages (for example, Eccles. 1:4–5) and denouncing him in public.[90] On 16 October 1541, in a letter to a friend he wrote of "that Sarmatian astronomer who is trying to stop the sun and move the earth" ("rem tandem absurdam");[91] Copernicus' theory of heliocentricity was clearly known by this time. The Protestants were heated in their denunciation of Copernicus, so the idea that any acceptance of Copernican ideas might be linked with Protestant heresies at this time is unwarranted.

On the other hand, contrary to what might be expected, we discover that the Catholic Church at this time made no move. Kopal writes, "Its thesis was accepted with lukewarm interest on the part of the educated Catholic clergy and without demur by Pope Paul III to whom Copernicus' book was dedicated."[92] Copernicus' theories made "quite spectacular progress very quickly amongst learned circles" and "neither the pope nor anyone else at Rome appears to have been shocked by the new cosmological system."[93] As Kopal further points out, the extremely complex religious implications of the work were not fully realized until a very much later date:

> The real theological storm, in which both Catholics and Protestants began to outbid each other in their denunciations of the heliocentric system did not break out until the first third of the seventeenth century in the wake of the experimental work of Galileo and Kepler.[94]

As Galileo himself argued[95] in defense of the heliocentric system in 1616, Copernicus had been a sincere Catholic as well as a celebrated astronomer and "when printed, the book [*Revolutions*] was accepted by the holy

church, and it has been read and studied by everyone without the faintest hint of any objection ever being conceived against its doctrines."[96]

Clement VII and the Vatican Lecture

The likelihood of a general knowledge of heliocentricity, and more specifically Copernican heliocentricity, in Italy by the 1530s has been demonstrated, alongside evidence of the absence of resistance by the Catholic Church. What is more, and what shows that it was neither impossible nor heretical for Copernicus' ideas to have influenced Michelangelo's design for the *Last Judgment*, is the fact that Clement VII, who inaugurated that commission, had also shown a high degree of personal interest in the heliocentric theory long before its publication. Significantly for our argument, in 1533 Clement VII actually requested that Copernicus' theory, of which he had evidently heard, should be explained to him and a number of other high dignitaries of the Catholic Church in the Vatican itself.[97] This fact, evidently better known in scientific circles than in art historical ones, was documented by the lecturer Albert Widmanstadt on the cover of a precious manuscript presented to him by the pope to mark the occasion (see figs. 119 and 120). The inscription reads in translation:

> Clement VII Supreme Pontiff presented this codex to me as a gift
> A.D. 1533, in Rome, after I had, in the presence of Fra Ursino,
> Cardinal Joh. Salviati, Joh. Petrus, Bishop of Viterbo, and Matthias
> Curtius medical physician, explained to him in the garden of the
> Vatican, Copernicus' teaching concerning the motion of the earth. Joh.
> Albertus Widmanstadius, cognomitatus Lucretius, personal familiar
> and secretary to our Most Serene Lord. (fig. 120)[98]

There thus exists conclusive evidence that knowledge of Copernicus' theories, prior to publication, was circulating not only in areas of Europe somewhat distant from Michelangelo, but also in the heart of the Vatican. As Pastor expresses it, "the pope [Clement VII] is entitled to special honour for the attitude he assumed towards the new system of Nicholas Copernicus," and it is quite certain that Clement VII, Giulio de' Medici, the instigator of the Sistine *Last Judgment,* who was also a close friend and associate of his chosen artist Michelangelo, definitely knew about Copernicus' sun-centered universe as early as 1533.[99]

Widmanstadt, it will be remembered, was an associate of Egidio of Viterbo (the probable theological adviser on the Sistine ceiling), and they had been involved in the publication of Hermetic writings together (chapter 7). Although Koestler describes the manuscript, which was given

119 Codex Graecus Monacensis 151, title page showing
inscription, fifteenth century. Greek illuminated
manuscript (presented by Clement VII to Albert
Widmanstadt), dated "6.33." Bayerische
Staatsbibliothek, Munich.

to Widmanstadt by the pope, as of little importance in itself, it seems
significant that it was a copy of *On the Senses and Sensibilities* by the
Greek philosopher Alexander of Aphrodisias, whose work was of some
interest to the Renaissance Neoplatonists.[100] More importantly, bound
in with this manuscript in the Munich Codex, and apparently part of
the same "gift," is a copy of *Elements of Physics* by the early Neoplatonist
Proclus, who exerted a strong influence upon Ficino. This work is
concerned with Neoplatonic concepts of infinity, circularity, and circular
motion.[101]

It is possible to make further deductions from the list of officials
who attended the Vatican lecture, apart from Widmanstadt, and work
out a more precise timing of the meeting. Since Johannes Petrus (Grassi)
became Bishop of Viterbo on 6 June 1533,[102] and Clement VII left Rome
to travel to attend negotiations in France on 9 September that year,[103] we
can place the meeting at some point between June and early September

120 Codex Graecus
Monacensis 151, detail.

1533. Rosen suggests that the meeting was probably associated with the escalating interest in astronomy after the comet of the 18 June that year, so the date of the meeting can plausibly be narrowed even further.[104] The "6.33" below the inscription at the foot of the manuscript page (fig. 120) suggests June 1533; so a date between 18 and 30 June is quite probable. Michelangelo was in Rome in 1533 until the end of June when he left for his last visit to Florence.[105]

Apart from Michelangelo's close relationship and contact with Clement VII, who had grown up with him in the Neoplatonic atmosphere of the court of Lorenzo the Magnificent (as had Paul III, Farnese),[106] there also existed close links between Michelangelo and at least two of the other four members of the Curia who attended that lecture. Johannes Petrus succeeded Egidio at Viterbo, which was the center for the movement of the *Spirituali* with whom Michelangelo was associated in the 1530s and 40s.[107] Cardinal Giovanni Salviati was the son of Michelangelo's

close friend Jacopo Salviati, who was, in turn, son-in-law of Lorenzo the Magnificent.[108] Salviati was a leading cardinal and also closely associated with Michelangelo through the distinguished circle of Florentine emigrés (*fuorusciti*) in Rome; Michelangelo had recently offered to give him a painting in 1531.[109] Even though the artist was not present himself at the lecture, Michelangelo's knowledge was thus not dependent solely on his association with Clement VII but may also be attributed to his exposure to ideas current in the papal court, where he had such close contacts.

Far from it being "impossible,"[110] therefore, for Michelangelo to have heard of the Copernican sun-centered universe at the time of the *Last Judgment* fresco, it seems highly unlikely that he would have been ignorant of the theory. It is possible to compile a concrete list of persons in Rome, within the higher reaches of the Catholic Church, who quite definitely knew of the theory and with whom Michelangelo came into close contact. Michelangelo's acquaintance with the ideas and discussion taking place in the papal court, important as it is, is probably of lesser significance than his direct relationship with Clement VII, the initiator of the *Last Judgment* project. Clement's background does suggest that he was likely to have been interested in and receptive to such new ideas and to have permitted them to have an effect on important painted religious schemes. In his personal character, he has recently been described as, "an Italian prince, a de' Medici and a diplomat first, a spiritual ruler afterwards,"[111] and Francesco Guicciardini, a contemporary historian, characterized Clement as "reputed to be a serious person, constant in his judgments . . . a man full of ambition, lofty-minded, restless and *most eager for innovation*" [my italics].[112]

Clement's sympathy with new ideas and reform of the church was demonstrated by his friendly relations with Erasmus and the Capuchins, who showed an interest in the doctrine of Justification by Faith.[113] The concept that heretical ideas were included in the fresco "behind the very throne of the pope" seems unlikely, therefore, since both Pope and artist alike sympathized with the movement for Catholic Reform and this was by no means heretical. Clement VII was evidently on good terms with Michelangelo, but neither he, nor his successor, was likely to have permitted the public expression in the papal chapel of ideas of which they did not approve, whether of the Catholic Reform movement or of Copernican heliocentricity.

In spite of some confusion over the dating of the original commission for the fresco on the altar wall of the Sistine Chapel and references to a scheme involving a *Resurrection* and a *Fall of the Rebel Angels*,[114] Vasari and Condivi both attest to the fact that Clement VII was the initiator of the project.[115] It should also be recalled that, after Clement's death in 1534, Pope Paul III took over the project but without significantly altering it.[116]

It is largely accepted that the commission was decided upon and discussed at the meeting between Pope Clement VII and Michelangelo at S. Miniato al Tedesco on 22 September 1533.[117] This seems likely in view of the fact that Michelangelo spent most of the following year in Florence, returning to Rome only two days before Clement's death on 25 September 1534.[118] It is also significant that Cardinal Alessandro Farnese, later Pope Paul III, whose pontificate saw the completion of the fresco after Clement's death, accompanied Clement VII on this journey and was also present at S. Miniato, and perhaps at the meeting with Michelangelo.[119]

The discussion between pope and artist about the *Last Judgment* commission thus took place remarkably soon after Clement VII had had Copernicus' theory explained to him by a professional lecturer. Widmanstadt had probably obtained his information from Theodoric of Radzyn, the representative of Copernicus' chapter of Varmia in Rome, so a direct contact through a chain of no more than five persons is traceable between Michelangelo and Copernicus in mid-1533, at exactly the time of the commission of the *Last Judgment* (namely, Copernicus—Radzyn—Widmanstadt—Clement and/or Salviati—Michelangelo).[120] Even though Clement's knowledge of the theory does not necessarily confirm his approval, the circumstances surrounding the lecture do strongly suggest this probability.

Paul III and the Heresy Question

After Clement VII died, the Vatican continued to show an interest in Copernican ideas. Subsequent to the meeting in the Vatican garden, another cardinal, Nicholas Schönberg,[121] wrote a direct letter to Copernicus in 1536, urging him to publish his theory.[122] The painting of Michelangelo's *Last Judgment* fresco commenced in the early summer of that year, so Schönberg's letter, dated 1 November 1536 could be viewed as an urgent request for further information as the fresco got under way. A possible relationship between Schönberg's request and the painting of the fresco appears particularly likely in view of Pope Paul's *motu proprio* forbidding Michelangelo to undertake any other work, which was dated the same month, 17 November 1536.[123] The letter itself was quite possibly written with the assistance of Widmanstadt, who had, moreover, become Schönberg's secretary in 1534.[124] The letter makes it absolutely clear that for several years Copernicus' hypothesis had been regarded as common knowledge, that his talent was recognized by the Catholic Church, and that the Vatican itself was urging him to "publish and communicate this discovery of yours to scholars" as soon as possible. Schönberg's comment, "Some years ago word reached me concerning your proficiency of which everybody constantly spoke," shows clearly how well known

Copernicus' theories were at the time in such circles, and he mentions his high regard of Copernicus and the latter's prestige. Schönberg's letter summarizes Copernicus' achievement of placing the sun in the central place in the universe and its relation to ancient and new ideas, and he also demonstrates his knowledge of the fact that Copernicus had already "written a treatise" in detail on the whole system. Theodoric of Reden (or Radzyn) is mentioned by Schönberg as the direct contact with Copernicus, and he had been asked to arrange for the manuscript to be copied at the cardinal's expense. Schönberg's concluding comments on Copernicus' "fine talent and reputation" shows clearly that knowledge of and interest in the sun-centered universe continued in the Curia after the initial "lecture" and during the period that Michelangelo's fresco was being painted. It seems unlikely that an important cardinal like Schönberg would have been acting against the wishes of the then Pope Paul III, instead of according to his instructions in these matters.[125] Thus, after the death of Clement VII in 1534, interest in Copernicus remained unabated in the Vatican.

"Approval" rather than mere "knowledge" in Vatican circles in the 1530s is suggested, and this seems to have continued as Paul III took over patronage of Michelangelo's fresco from his predecessor Clement VII. The Farnese pope, perhaps to be viewed as the "last Renaissance pope," was a humanist and lover of the arts at the same time as being a spiritual religious leader and something of a reformer.[126] He had a close relationship with Michelangelo, since, as mentioned, he shared a similar background.[127] Paul III was on good terms with members of the Catholic Reformation during the early years of his pontificate, and it was Paul III who elevated members of the *Spirituali* like Pole and Contarini to the rank of cardinal. The stricter measures introduced during his rule, such as the Roman Inquisition (1542) and the *Index of Prohibited Books* (1549), did not take place until after the completion of Michelangelo's *Last Judgment* fresco. The strict phase of the Counter-Reformation and direct persecution of heretics did not really assume significant proportions until the 1550s with the election of Pope Paul IV Carafa.[128]

After Pope Paul III assumed control, he insisted on Michelangelo's pursuing the commission of the fresco for the altar wall of the Sistine Chapel, but the original design of the fresco was not to be altered in any significant way.[129] In spite of this, there has been some discussion in the literature as to whether a change in commission took place with the accession of the new pope, which has in turn been related to the references to a scheme for a *Resurrection*. Liebert suggests that Clement VII's original proposal was for the *Resurrection of Christ* on the altar wall and the *Fall of the Rebel Angels* at the entrance, and that it was Paul III who, at this stage, altered the commission.[130] The idea of an alteration in the plan at this late stage is discounted by the papal breve of Paul III, which shows clearly that no such change was intended.[131]

As completion of the fresco progressed according to the design formulated by Michelangelo between 1533 and 1536, it becomes clear that Paul III showed approval of the way the commission was carried out. Pope Paul's appointment in October 1543 of a superintendent for the preservation of the paintings in the Sistine Chapel confirms his view of the paintings' worth, as also does the fact that the *Last Judgment* was barely finished when, in November 1541, he followed with another commission for Michelangelo to paint the frescoes in the Pauline Chapel. He was obviously impervious to the early criticism of the fresco by men like Biagio of Cesena.[132]

By implication, Paul III also exhibited tacit approval of the idea of the heliocentric universe, since Rheticus' summary of Copernicus' theory, *Narratio Prima*, was allowed to appear in print in 1540, and did not meet with any opposition on publication. It ran to a second edition almost immediately (1541).[133] Rheticus firmly linked the new hypothesis with Neoplatonic thought as well as with Christian ideals; he even linked the astronomical theories at one point with the very theme of the Last Judgment and "the coming of our Lord Jesus Christ."[134] No opposition to this was forthcoming from the Vatican, and it appears that, in spite of objections like the contradiction of commonsense observation, the Copernican system, which placed the sun instead of the earth at the center of the planetary system, was perceived to have merit as an exciting innovation that appealed to and was understood by astronomers, scholars, and clergy.

When Copernicus' *Revolutions* finally appeared in print in 1543, it was with the dedication and preface addressed to Pope Paul III. Considering the implication of a dedication and the more severe atmosphere after reintroduction of the Roman Inquisition in 1542, tacit approval of the ideas is indicated. Increasingly strict regulations concerning the papal imprimatur[135] had come into effect during the decade following the completion of Michelangelo's fresco, but the pope seems not to have objected to the publication of the work or to his name in the dedication, for he took no action. The fact that no official action was taken against Copernicus' ideas by the Pope at this stage is crucial to our understanding of Michelangelo's *Last Judgment*. Indices of prohibited books were in preparation from the 1540s, but even under Carafa's sweeping controls after he became Pope Paul IV in 1555—when works by Savonarola, Boccaccio, Aretino, and even Dante were banned—Copernicus' book was left unmolested and not prohibited until 1616.[136]

In his preface, addressed to Paul III, Copernicus takes pains to point out that he was encouraged in his work not only by eminent scholars, but also by a cardinal (Schönberg) and two bishops (Tiedemann Giese of Chelmno and Paul of Middelburg, Bishop of Fossombrone). That Copernicus received encouragement from members of the Catholic

hierarchy in pursuing and finally publishing his ideas is not disputable, and it is important to remember that he was a canon of the Church himself. Aware of apparent illogicalities in his scheme and the fact that the motion of the earth appeared contrary to sense perception, Copernicus stated his reasons for not publishing sooner as fear of ridicule by the ignorant, not fear of the Church.

As Copernicus' work was about to be printed, the publisher, Osiander, added an extra preface. Addressed to the reader, this has as a major theme a discussion of the difference between truth and hypothesis, and suggests that Copernicus' work was to be regarded as a useful working hypothesis rather than a factual account of the system of the universe. Since the theory was, at the time, not provable, Osiander's preface seems to indicate some fear of criticism.[137] Osiander, almost certainly without Copernicus' consent or approval, presented heliocentricity as an interesting hypothesis, rather than as truth, in order perhaps to avert criticism from the church. But Osiander was a Protestant, and Protestants were generally more opposed to the theory. Acting with the best of intentions, he was also concerned, as publisher, with his potential market amongst the widest possible audience.[138]

During the years 1533–41, which saw the inception and completion of Michelangelo's *Last Judgment,* Copernicus' theory of the sun-centered universe was not only well known in the Vatican, but quite simply was not regarded as being in conflict with Catholic doctrine. It is possible that the new idea had an easy passage at first because Copernican theory was presented as a hypothesis (owing to Osiander's preface), and it did work well, to "save the appearances." However, as demonstrated, Copernicus himself evidently regarded his theory as truth and it was unlikely to have been presented as otherwise at the Vatican lecture. The Roman Catholic Church never persecuted or ridiculed Copernicus or his followers at this stage. *Revolutions* was read and occasionally taught at Catholic universities, and when the calendar was reformed under Pope Gregory XIII in 1582, it was based on Rheinhold's interpretations of Copernicus' observations.[139] The work of Kepler and Tycho Brahe[140] and the persecution of Bruno[141] and Galileo[142] followed much later. It is important not to be blinded by hindsight in our knowledge of what later happened to the adherents of Copernicanism.[143]

In medieval thought, the earth was regarded as central and humanity's existence and salvation as the central event; the idea that the sun was central and immobile while the earth hurtled through space was regarded as absurd. The realization that the earth was merely a planet like many others that rotated around the sun, in an apparently infinite universe, came increasingly under consideration and did eventually shatter theological understanding.[144] The placement of Heaven and Hell had to be considered as symbolic instead of astronomical or geographical. The church then

prohibited the teaching that placed the sun at the center of the universe—
but not at the time when Michelangelo painted the *Last Judgment*. Seen
against the tremendous interest in the sun in theology, literature, and
philosophy, which served as background for Copernicus in the same
way as for Michelangelo, the identification of God with the sun made
the heliocentric theory the logical next step toward a solution of the
anomalies of the haidocentric nature of the spherical geocentric system. It
is, therefore, erroneous to suggest that it would have been either impossible
or heretical for Michelangelo to have incorporated this concept into his
great fresco, and the depiction of Christ as the sun in the center of the
circular format is clearly the overriding theme, not an incidental feature
of the fresco. The metaphysical or literal view of the universe as circular,
God-centered, and heavily dependent on light and sun-symbolism seems
clear. Like the earlier examples of the *Last Judgment*, the ordering of the
complex scene was achieved by relating it to the contemporary view of
the cosmological structure of the universe. It was simply the cosmological
framework that had changed. The implication of this hypothesis is that
the relationship between figure 1 and figure 2 is the same as that between
figures 14 and 15.

Set against the demonstrable theological and philosophical interests
of the time in cosmology and sun symbolism, the revelation of Copernicus'
scientific theory acted as a precipitating factor to cause these concepts to
fall into their rightful place. The idea of placing God personified as the
sun in the center of the universe solved the inconsistency in the Christian
tradition of equating the deity with the sun—which, in the flat-earth or
geocentric view was merely a minor and fluctuating cosmological feature.
Humankind, it is true, had been taken away from the central place in
the universe; but God was far more logically placed there instead. The
traditional analogy between sun and deity was vindicated at last.

Notes

1. See Nicholas Copernicus, *De Revolutionibus Orbium Coelestium* (Nuremberg,
1543); facsimile edition, ed. Jerzy Dobrzycki (London: Macmillan, 1978), 22. This edition
will be used throughout. Translation taken from Kuhn, *Copernican Revolution*, 180.

2. See comment by Koestler, *Sleepwalkers*, 9–10.

3. See, for example, H. A. L. Fisher, *A History of Europe*, 2 vols. (London: Eyre and
Spottiswode, 1957), 1:432 and 692; Marcel Dunan, ed., *Larousse Encyclopedia of Modern
History from 1500 to the Present Day* (London: Hamlyn, 1984), 27, 28. For works on the
Renaissance itself: Henri S. Lucas, *The Renaissance and the Reformation,* 2d ed. (New York:
Harper and Row, 1960), 183, 370–71; A. J. Grant, *A History of Europe, 1494–1610* (London:
Methuen, 1964), 539; John Harold Plumb, ed., *The Horizon Book of the Renaissance* (London:
Collins, 1961), 185; Vivian Hubert Howard Green, *Renaissance and Reformation* (London:
Arnold, 1972), 50–51.

4. For example, Stephen P. Mizwa, *Nicholas Copernicus* (Washington: Kennikat, 1943), and Fred Hoyle, *Nicholas Copernicus: An Essay on His Life and Work* (London: Heinemann, 1973), where little attention is paid to the cultural context. An exception that treats Copernicus' work within a wider context is Fernand Hallyn, *The Poetic Structure of the World: Copernicus and Kepler,* (Cambridge, Mass.: MIT Press, 1990).

5. Modern scientific theory demonstrates, of course, that the sun lies at one epicenter of the elliptic orbits of the planets that make up the solar system, not at the center of the universe. The sun is just one of one hundred thousand million (10^{11} or 100,000,000,000) stars in our galaxy, which is, in turn, one of over one million million (10^{12} or 1,000,000,000,000) galaxies in the universe, which is acentric, presently expanding, and infinite. For modern, scientific details, see, for example, W. M. Smart, *Spherical Astronomy* (Cambridge: Cambridge University Press, 1960), 37–38, and Misner, Thorne, and Wheeler, *Gravitation*, 752–62, "A Brief History of Cosmology." See also, Richard Berendzen, "From Geocentric to Heliocentric to Galactocentric to Acentric" in Arthur Beer and Kaj Aage Strand, *Copernicus, Yesterday and Today,* in *Vistas in Astronomy* 17 (Oxford: Pergamon Press, 1975), 65–81, for the change in conception of the universe.

6. Tolnay, *Michelangelo*, 5:49.

7. Kuhn, *Copernican Revolution*, 185; Koestler, *Sleepwalkers*, 194–95.

8. Koestler, *Sleepwalkers*, 194–95. Because of its technical content, Michelangelo would probably have been unable to read it at any stage, but the main themes of the theory are easily grasped. Copernicus discusses the earth as spherical, the motions of the heavenly bodies (uniform, eternal, and circular), the position of the earth in the system, and the immensity of the heavens in addition to the core idea of the sun as immobile in the center of the known universe. Extensive technical and astronomical details are included.

9. See Tolnay, *Michelangelo*, 5:122; Steinberg, "Merciful Heresy," 49; Christ is described as "Sunlike, Copernican" as Steinberg argues that the fresco contains heretical ideas (chap. 4). The erroneous idea that the Catholic Church immediately condemned and persecuted Copernicus himself still occurs. The Catholic Church decree that the idea of the sun as central and immobile was "foolish and absurd, philosophically false and formally heretical" did not follow until 1616.

10. Koestler, *Sleepwalkers*, 102–6, "The Age of Double-Think"; Sidney Painter, *A History of the Middle Ages* (London: Macmillan, 1968), 435. As mentioned in chap. 3, the conviction that the earth was spherical stemmed from the observation of phenomena such as the shadow of the earth on the moon during an eclipse, the alteration of position of stars as travelers move south, and the fact that land not visible from a ship at sea is visible from the top of the mast (conversely, from the land a ship goes out of sight before its mast). Discussion surrounding heliocentricity followed soon after the voyages of discovery, since heliocentricity seemed a possible next step after the confirmation of the sphericity of the earth. In addition, although it might appear difficult to consider the earth's motion, this perhaps seemed more probable than the idea of the rotation of the rest of the universe. These phenomena are summarized by Copernicus in *Revolutions*, bk. 1, chap. 2 (ed., cit., 8).

11. Heninger, *Cosmographical Glass*, esp. xv–xvi, and Roberta J. M. Olson, "Renaissance Representations of Comets and Pretelescopic Astronomy," *Art Journal* 44, no. 3 (Fall 1984): 217–23.

12. Koestler, *Sleepwalkers*, 95; Kuhn, *Copernican Revolution*, 105–6.

13. Belief that the earth was spherical was reflected in contemporary art by the fifteenth century. The slight curve on the horizons in the landscape backgrounds of Piero dell Francesca's *Triumphs of Federigo da Montefeltro and Battista Sforza*, c. 1470, and Antonio del Pollaiuolo's *Martydom of Saint Sebastian*, 1475 (see Beck, *Italian Renaissance Painting*, 143, 261), have already been cited as examples.

14. Koestler, *Sleepwalkers*, 99; Lovejoy, *Great Chain of Being*, 102.

15. Dante, *Paradiso* 28; see above, chap. 6.

16. See esp. Copernicus' *Preface,* which was published with *Revolutions*, reproduced by Dobrzycki, ed., *De Revolutionibus Orbium Coelestium*, 3–6, and Kuhn, *Copernican Revolution*, 137–43. See also *De Revolutionibus*, 12, 25, 122, 129, 144, for further acknowledgement by Copernicus of his predecessors. Copernicus' preface should not be confused with the extra preface to *De Revolutionibus*, added later by the publisher Osiander, almost certainly without Copernicus' approval. It presented the book as hypothesis rather than fact, the probable motive being to forestall opposition (Koestler, *Sleepwalkers*, 169–74).

17. Copernicus, *De Revolutionibus*, 4.

18. Copernicus, *De Revolutionibus*, 4: "I undertook the task of rereading the works of all the philosophers which I could obtain to learn whether any had ever proposed other motions of the universe's spheres." See also extract in appendix 4.

19. For references to Cicero and Plutarch, see Copernicus, *De Revolutionibus*, 4, 12, and 342–49. See also Eugeniusz Rybka, "The Influence of the Cracow Intellectual Climate at the End of the Fifteenth Century Upon the Origin of the Heliocentric System," *Vistas in Astronomy*, 9 (1967): 165–69, esp. 168, for Copernicus' access to these.

20. Copernicus, *De Revolutionibus*, 4–5. For further information on these ancient authors, see Bienkowska, ed., *World of Copernicus,* 42–43; Koestler, *Sleepwalkers*, 43–50; Angus Armitage, *Sun, Stand Thou Still: The Life and Work of Copernicus the Astronomer* (London: Sigma, 1947), 38–45; Colin A. Russell, *The Background to Copernicus* (Bletchley: Open University Press, 1972), 28–31; Milton K. Munitz, ed., *Theories of the Universe from Babylonian Myth to Modern Science* (Glencoe, Ill.: Free Press, 1957).

21. Copernicus, *De Revolutionibus*, 25, 122, 144. For Aristarchus of Samos, see Thomas L. Heath, *Aristarchus of Samos, the Ancient Copernicus* (Oxford: Clarendon Press, 1913). Compare, Russell, *Background to Copernicus,* 43, who states incorrectly that Copernicus did not mention Aristarchus and was probably unaware of his work.

22. Vitruvius refers to Aristarchus in his section on astronomy, *Ten Books of Architecture,* ed. M. H. Morgan (New York: Dover, 1960), bk. 9, chap. 2, p. 263. Vitruvius's book was known to Copernicus (*De Revolutionibus*, 350) and also to Michelangelo (Wittkower, *Architectural Principles*, 14).

23. Arguments tending toward the rejection of the moving earth included the evidence of Scripture and the concept of humankind as "central" to the universe. Naked-eye observation from the earth itself appears to confirm that it remains stationary while the heavenly bodies (sun, moon, planets, and stars) rotate around it. There was no evidence that "flying" objects like birds or clouds might be "left behind" by a moving earth: there was no evidence of alteration in the positions of stars that would be expected if the earth were in motion. Stellar parallax was not observed until 1838, by Friedrich Wilhelm Bessel; see Herbert Butterfield, *Origins of Modern Science* (London: Bell, 1958), 58–60. These appear to be the reasons why the ancient ideas concerning the motion of the earth never became generally accepted, although discussion had taken place, for example, by Dante (*De Aqua et Terra*).

24. For Buridan, see John David North, "The Medieval Background to Copernicus," in Beer and Strand, "Copernicus," 11–12; Kuhn, *Copernican Revolution*, 119–22; Bienkowska, ed., *World of Copernicus*, 8, 86.

25. Beer and Strand, "Copernicus," 11–12. Buridan's pupil, Nicholas Oresme, used a similar analogy of the movement of boats to demonstrate that one body alters its position only relative to another, and Copernicus later repeated the same idea; Copernicus, *De Revolutionibus*, 16. Butterfield, *Origins of Modern Science,* 28, uses an interesting modern analogy of perception of motion in two adjacent trains. This concept of relative motion is crucial for Copernicus' transference of motion from the sun to the earth.

26. Butterfield, *Origins of Modern Science*, 28–29.

27. For Oresme, see Edward Grant, *Nicholas Oresme and the Kinematics of Circular Motion* (Madison, Wisc.: University of Wisconsin Press, 1971); Kuhn, *Copernican Revolution*, 115–17, 120–21; Koestler, *Sleepwalkers*, 202–203.

28. Such ideas were expressed in Cusanus' *De Docta Ignorantia* (esp. ii, 12). See also Kuhn, *Copernican Revolution*, 197, 233–35; Koestler, *Sleepwalkers*, 209–10; Cassirer, *Individual and Cosmos*, chaps. 1 and 2, esp. p. 69; Stephen Toulmin and June Goodfield, *The Fabric of the Heavens* (Harmondsworth: Penguin, 1961), 182. Poulet emphasizes the similarities between Cusanus and Dante; Poulet, "Metamorphoses of the Circle," 167, and Wind, *Pagan Mysteries,* 54, 239–40, notes the influence of Cusanus on the Italian Neoplatonists.

29. Kuhn, *Copernican Revolution*, 197. See also Maurice de Gandillac, "Le rôle du Soleil dans la pensée de Nicolas de Cues," in Université de Bruxelles, *Le Soleil*, 341–61.

30. "Deus est sphaera infinita cuius centrum est ubique et circumferentia nusquam"; Nicholas Cusanus, *De Doctora Ignorantia*, ii, 12, referred to by Cassirer, *Individual and Cosmos*, 69, 176. See also Pierre Duhem, *Medieval Cosmology, Theories of Infinity, Place, Time, Void, and the Plurality of Worlds* (Chicago: University of Chicago Press, 1985), where he demonstrates the type of discussion prevalent in the thirteenth and fourteenth centuries and prior to Copernicus. See also Alexandre Koyré, *Du Monde Clos à l'Univers Infini*, available in English as *From the Closed World to the Infinite Universe* (Baltimore: Johns Hopkins University Press, 1957), esp. 6–12, on Cusanus's cosmology. For the concept of infinity as expressed in art at this time, see Samuel Y. Edgerton, *The Renaissance Rediscovery of Linear Perspective* (New York, 1975), 20–21, where Giotto's Padua frescoes (c. 1305) are quoted as an example.

31. For precursors of Copernicus on the topic of infinity, see also Edward Grant, "Late Medieval Thought, Copernicus and the Scientific Revolution," *Journal of the History of Ideas* 23 (1962): 197–220; idem, "Medieval Conceptions of an Infinite Void Space," 39–60; McColley, "Nicholas Copernicus and the Infinite Universe," 525–35. Copernicus himself preferred "to leave the question of infinity to the philosophers" (Copernicus, *De Revolutionibus*, bk. 1, chap. 8), but it was certainly implied by his thesis (Kuhn, *Copernican Revolution*, 232–37; Koestler, *Sleepwalkers*, 220; Koyré, *Closed World*, 33–34). This discussion bears comparison with Hartt's comment on Michelangelo's fresco: "The airy background of the fresco of course should not be construed as infinity, the notion of infinite space had occurred to no-one in the 1530s," which is incorrect. As Koyré observes, "The concept of the infinity of the universe, like everything else . . . originates, of course, with the Greeks" (Koyré, *Closed World*, 5).

32. Copernicus, *De Revolutionibus*, 129, 285; also Koestler, *Sleepwalkers*, 210–12. Regiomontanus had, significantly, compared the sun with the king and heart of the planetary system (Rybka, "Cracow Intellectual Climate," 167).

33. Koestler, *Sleepwalkers*, 212.

34. The importance of the printed word, especially in Italy, is highly significant for the development of Copernicus' ideas; first, because of the increased availability of Latin and Greek classics as well as humanist literature, and second, for the final spread of Copernicus' own ideas. See Owen Gingerich, "Copernicus and the Impact of Printing," in Beer and Strand, "Copernicus," 201–2.

35. Bienkowska, ed., *World of Copernicus*, 36–37; Koestler, *Sleepwalkers*, 131–34; Owen Gingerich, "Crisis versus Aesthetic in the *Copernican Revolution*," in Beer and Strand, "Copernicus," 85–93; A. C. Crombie, *Augustine to Galileo*, rev. ed. (London: Heinemann, 1970), 2: 175–76; Toulmin, *Fabric of the Heavens*, 187–99.

36. Bienkowska, ed., *World of Copernicus*, 36; Angus Armitage, *Sun, Stand Thou Still* (London: Sigma, 1947), 72–84. Copernicus' "disciple" Rheticus stated that, "he lectured

before a large audience of students and a throng of great men"; Rheticus, *Narratio Prima,* 1540, reproduced in Edward Rosen, *Three Copernican Treatises,* (New York: Octagon, 1971), 111.

37. Michelangelo was in Bologna between 1493 and late 1496 and visited there intermittently thereafter; he was in Rome 1496–1501 (Murray, *Michelangelo, Life, Work and Times,* 17–18; Ramsden, *Letters,* 1: lviii—lix). Another link is provided by the fact that while in Rome, Copernicus associated with Bernard Sculteti (the representative of his chapter of Varmia in Rome), who was afterwards private chaplain to Pope Leo X Medici (Koestler, *Sleepwalkers,* 133–34, 149).

38. Kuhn, *Copernican Revolution,* 123–33; Bienkowska, ed., *World of Copernicus,* 17–18.

39. A copy of Plato's works, edited by Ficino and annotated by Copernicus, has recently been found; Russell, *Background to Copernicus,* 39. For Copernicus and Neoplatonism, see also Hallyn, *Poetic Structure,* 35–36, "The World and the Cave," and 111–25.

40. See Kuhn, *Copernican Revolution,* 130–31. Also Rybka, "Cracow Intellectual Climate," 165–69, where the connection between Italian Neoplatonism and Cracow is effectively argued. Rybka stresses the fact that followers of Neoplatonism "propagated a cult of the Sun which was equated by them with God," and he traces direct links between Copernicus and Ficino. On the relationship between the Copernican Revolution and Renaissance solar myths, see also E. Garin, "La rivoluzione Copernicana e il mito solare," in *Rinascite e Rivoluzioni: Movimenti Culturali dal XIV al XVIII secolo* (Rome: Laterza, 1976), 255–96.

41. Ficino, *De Sole* , ed. cit., 132.

42. Copernicus, *De Revolutionibus,* 7, 12, 18, 19, 25, 227. Quotations from Plato are also common in Rheticus' *Narratio Prima,* a summary preview of Copernicus' printed work; in Rosen, *Three Copernican Treatises,* 142–50 and 162–68.

43. Copernicus, *De Revolutionibus,* 22. See Yates, *Giordano Bruno,* 241–43, and Garin, *Astrology,* 111, for Hermeticism in Copernicus.

44. See Jerome R. Ravetz, "The Humanistic Significance of Our Copernican Heritage," in Beer and Strand, "Copernicus," 147, and idem, "Origins of the Copernican Revolution," *Nature* 189 (March 1961): 854–60: "Sun and circle worship and mathematical elegance play their part, but a belief in the intelligibility of God's heavens may have been crucial," 860.

45. Alexander Koyré, *The Astronomical Revolution* (London: Methuen, 1973), 65. Kuhn, *Copernican Revolution,* 131–33. This, of course, should be compared with the Neoplatonic attitude toward the sun, and with the Christian attitude toward the Sun as a symbol of the deity. Copernicus makes many references to God throughout his writings; Copernicus, *De Revolutionibus,* 7, 22. He was a canon of the cathedral of Frauenburg, and the fact that in 1537 he was nominated as candidate for the bishopric of Ermland makes it highly probable that he did enter the priesthood (*Catholic Encyclopaedia,* 4:353).

46. Edward Rosen, "Was Copernicus a Neoplatonist?" *Journal of the History of Ideas* 44 (1983): 667–69. Rosen bases his argument against Copernicus as a Neoplatonist by presenting evidence that his friend and teacher, Domenico of Novara, was not a Neoplatonist. Without any supporting evidence, other than "like master, like pupil," Rosen then concludes that neither Novara, Copernicus, nor Rheticus was a Neoplatonist. He misconstrues the significance of the Hermetic writings and does not take into account other Neoplatonic influences to which Copernicus was exposed at centers in Cracow and in Italy; nor does he consider the Platonic sentiment expressed in *De Revolutionibus Orbium Coelestium* and *Narratio Prima.*

47. Cornford, *Plato's Cosmology.* See also S. K. Heninger, "Pythagorean Cosmology and the Triumph of Heliocentrism," in Université de Bruxelles, *Le Soleil,* 35–53. This is

useful for the ancient background to Copernicus and also for the recognition of Platonic and Pythagorean aspects of his ideas.

48. Rheticus, *Narratio Prima*, ed. cit., 147–48, 150. Rheticus writes: "Following Plato and the Pythagoreans . . . my teacher [Copernicus] thought, that in order to determine the causes of the phenomena, circular motions must be ascribed to the spherical earth" and "the first motion which my teacher, in company with Plato, assigns to the earth." For discussion concerning whether Plato argued for heliocentricity and the motion of the earth, see Heath, *Aristarchus of Samos,* 174–85.

49. Explained more fully by Koestler, *Sleepwalkers,* 200–205; Butterfield, *Origins of Modern Science,* chap. 2, "The Conservatism of Copernicus."

50. Koyré, *Astronomical Revolution,* 34. This was recorded by Bishop Tiedemann Giese (Copernicus' friend and fellow canon, later bishop) in a letter to Rheticus, dated 26 July 1543; see Copernicus, *De Revolutionibus,* 339.

51. Copernicus, *De Revolutionibus,* 3–6; Pastor, *History of the Popes,* 12:550 (see appendix 4.)

52. ⁵²Copernicus, *De Revolutionibus,* 3. Since the preface was completed in 1542, the reference to the work having been concealed for nine years suggests that the ideas had been kept in abeyance specifically since 1533 (the year of the inception of the *Last Judgment* commission). In the *Narratio Prima*, written in 1539, Rheticus also refers to the fact that Copernicus had already written out his theory (in Rosen, *Three Copernican Treatises,* 109–10). The use of astronomical observations from around 1530 suggests this as about the time Copernicus wrote out *Revolutions.*

53. Ficino's comment cited by Garin, *Italian Humanism,* 91. Cf. Also the Hermetic concept of secrecy, above, chapter 7.

54. Kuhn, *Copernican Revolution,* 185.

55. Lynn Thorndike, *A History of Magical and Experimental Science* (New York: Columbia University Press, 1923), 5:408.

56. Koestler, *Sleepwalkers,* 149; Kuhn, *Copernican Revolution,* 125–26; Copernicus, *De Revolutionibus Orbium Coelestium,* 5. For correspondence between Paul of Middelburg and Ficino, see Kristeller, *Ficino,* 22–23 ("in you, Oh Paul, it seems to have perfected astronomy. And in Florence it restored the Platonic doctrine from darkness to light"); Ficino, *Letters,* 2:xvii; and Peter and Linda Murray, *The Art of the Renaissance* (London: Thames and Hudson, 1971), 7.

57. See Copernicus, *De Revolutionibus,* 343. Paul of Middelburg listed Copernicus among those who replied. It is curious that Copernicus' reply was lost.

58. Jerome R. Ravetz, "The Origins of the *Copernican Revolution,*" *Scientific American* 215 (October 1966): 86–98, 92; Koyré, *Astronomical Revolution,* 20–21; Bienkowska, ed., *World of Copernicus,* 86; Rybka, "Cracow Intellectual Climate," 166.

59. Novara avowed that Copernicus was "not so much his pupil as his assistant"; see Rheticus, *Narratio Prima,* 111.

60. The Latin title reads: *Quomodo coelum stet, terra moveatur, vel de perenni motu terrae,* for which see Koestler, *Sleepwalkers,* 212–13. Koestler uses this and other examples to demonstrate how Copernicus "crystallized" an idea that was much under discussion. As mentioned above, Calcagnini was friend to Ariosto (*Orlando Furioso,* 558) and knew the work of Egidio of Viterbo and Cusanus (Wind, *Pagan Mysteries,* 13 and 240).

61. Printed in full in Rosen, *Three Copernican Treatises,* 57–90; Copernicus' name was included in the title. Cf. Hawking's comment that Copernicus circulated his work anonymously in 1514 because he feared persecution; Stephen Hawking, *Brief History of Time* (London: Bantam, 1988), 34.

62. Koyré, *Astronomical Revolution,* 25, 85 n. 51; Bienkowska, ed., *World of Copernicus,* 19; Rosen, *Three Copernican Treatises,* 67 n. 21.

63. See Rosen, *Three Copernican Treatises*; 58–59 for the seven assumptions, which also include the notions that the center of the earth is not the center of the universe and that the earth's motion on its axis and its orbit around the sun are responsible for the apparent motion of the sun and the Heavens. Copernicus also comments on the magnitude of the universe.

64. Rosen, *Three Copernican Treatises*, 6; Koestler, *Sleepwalkers*, 148. *Commentariolus* was not published until 1878.

65. Rosen, *Three Copernican Treatises*, 7–9. This form of correspondence and the circulation of handwritten "letters" apparently served the function now accorded to scientific periodicals. The *Letter*, which is printed in full (91–106), indicates that Copernicus had formulated his own special theory which he intended to publicize (106).

66. This is discussed in terms of the influence of religious, philosophical, and scientific background by Francesco Negri Arnoldi, "L'Iconographie du Soleil dans la Renaissance," in Université de Bruxelles, *Le Soleil*, 521–38. Arnoldi refers to astronomical and solar imagery from the Old Sacristy at San Lorenzo (1439), to Sun-Deity symbolism on the tomb of Sixtus IV, and to Tolnay's theory concerning Michelangelo's *Last Judgment* as anticipatory of Copernican heliocentricity, which is dismissed (567). It is surprising that at this interdisciplinary conference (from which many papers have here been cited), the combination of scientific and art historical experts did not then result in the questioning of Tolnay's conclusions.

67. See Johannes Wilde, *Venetian Art from Bellini to Titian* (Oxford: Clarendon, 1974), cover and 66–69; and Terisio Pignatti, *Giorgione* (Venice: Alfieri, 1969), 104–5.

68. Bienkowska, ed., *World of Copernicus*, 97.

69. Several contemporary portraits of Nicholas Copernicus are known. See Bienkowska, ed. *World of Copernicus*, opposite p. 96, and compare Russell, *Background to Copernicus*, 35.

70. See Hirst, *Sebastiano*, 6–8 (esp. for links between Sebastiano and Giorgione), 41–42, 123–24, 143 n. 87 (for links between Michelangelo and Sebastiano); also Tolnay, *Michelangelo*, 5:21.

71. Now at Windsor (RL12669 verso). Jean Paul Richter, *The Notebooks of Leonardo da Vinci* (New York: Dover, 1970), 2:152; it occurs amidst Leonardo's extensive work on light and optics. See also Vassili P. Zoubov, "Le Soleil dans l'Oeuvre Scientifique de Léonard de Vinci," in Université de Bruxelles, *Le Soleil*, 177–98; Vincent Cronin, *The View from Planet Earth* (London: Collins, 1981), 89, 100; and Garin, *Italian Humanism*, 186–87, where Leonardo's debt to Ficino in his conception of the sun is noted. Cf. also comments on the circular movement around Christ in Leonardo's *Adoration*.

72. Strauss, *Complete Engravings, Etchings and Drypoints of Albrecht Dürer*, plates 37, 67, 79 and esp. 25.

73. Otto Benesch, *The Art of the Renaissance in Northern Europe: Its Relation to Contemporary and Intellectual Movements* (London: Phaidon, 1965), chap. 8, "Related Trends in Art and Science of the Late Renaissance," esp. 56–59, 144–45. The relationship between art in the Renaissance and Copernican ideas (especially circle and point symbolism) is also discussed by Hallyn, *Poetic Structure*, 114–18, 129–39.

74. For this connection, see obituary by Tolnay on Benesch (in Benesch, *Art of Renaissance*, ix). Tolnay evidently looked only at the publication date and made a judgment accordingly, without considering the far-reaching and interwoven aspects of the intellectual society of the time.

75. André Chastel, *The Age of Renaissance Humanism: Europe, 1480–1530* (New York: McGraw Hill, 1962), 92. No date is given for Doni's letter, which was, however, published by 1543 (see Schutte, "Lettere Volgari," 652). Anton Francesco Doni (1513–74) was a well-known Copernican: *Enciclopedia Italiana* (Rome: Istituto della Enciclopedia Italiana,

1949), 3:144. He also corresponded with Michelangelo (Murray, *Michelangelo, Life, Work and Times,* 164).

76. Rosen, *Three Copernican Treatises,* 375–78; Koestler, *Sleepwalkers,* 156.

77. Koestler, *Sleepwalkers,* 156, "it was not martyrdom he feared but ridicule." Although convinced he was right, Copernicus was unable to prove his thesis; it appeared contrary to tradition and to visual observation. See Copernicus' preface, *De Revolutionibus,* 3.

78. For the ruling of the Council of Nicaea, see Mâle, *Gothic Image,* 392. For changes in patronage and the relationships between artist, patron, and client in the Renaissance, see Hale, *Encyclopaedia of the Renaissance,* 239; Burke, *Culture and Society,* chap. 4.

79. Although he was able to have more freedom than usually permitted (Ramsden, *Letters,* vol. 1, no. 157, 149). See Dotson, "Augustinian Interpretation," for the suggestion of Egidio da Viterbo as adviser.

80. Vasari, *Lives,* (ed. de Vere, 1882–83; ed. Bull, 378–79). Vasari, of course, was keen to elevate the position of artists, emphasizing their increasingly intellectual role, and especially culminating in the career of Michelangelo. See also John Stephens, *The Italian Renaissance: The Origins of Intellectual and Artistic Change Before the Reformation* (London: Longman, 1992), esp. pt. 2, "The Artist, the Patron, and the Sources of Artistic Change," 57–103.

81. Murray, *Michelangelo, Life, Work and Times,* 59, 156–58. For example, in the projects for the S. Lorenzo facade and the Laurentian Library, Clement (then cardinal) made it quite clear that it was essential for his wishes to be carried out exactly to the most minor details concerning types of marble and wood to be used: "see you carry out the orders we have given you and fail not to do so"; Liebert, *Psychoanalytic Study,* 218; Murray, *Michelangelo, His Life, Work and Times,* 93, 146; Ramsden, *Letters,* 1:263. The idea of Clement (as pope) giving totally free rein or Michelangelo flouting his wishes in a major fresco thus appears unlikely.

82. Steinberg, "Merciful Heresy." Hall, "Michelangelo's *Last Judgment,*" 85 n., disagrees with Steinberg's perception of heresy in the fresco, giving further reasons for its improbability.

83. Paul III, in requesting the completion of the fresco, determined that the original designs should be followed without alteration. See the *Breve* of Paul III; Redig De Campos, *Last Judgment,* 97–99, and Vasari, *Lives,* (ed. de Vere, 1882; ed. Bull, 378).

84. See White, *History of the Warfare of Science with Theology;* Russell, *Religion and Science;* Draper, *Religion and Science.*

85. See esp. Koestler, *Sleepwalkers,* 219–22.

86. Copernicus, *De Revolutionibus,* 342 n.

87. Kuhn, *Copernican Revolution,* 185–86, 191–92. Luther's approach to cosmology remained biblical and traditional: "Our eyes bear witness to the revolution of the Heavens" (quoted by Bienkowska, ed., *World of Copernicus,* 123).

88. Rosen, *Three Copernican Treatises,* 393–95.

89. Martin Luther, *Table Talks,* ed. G. Tappert, Philadelphia: Fortress, 1967), 54, 358–59.

90. Kuhn, *Copernican Revolution,* 191–92; Calvin later also denounced Copernicus. See also Koestler, *Sleepwalkers,* 156 and 572.

91. Beer and Strand, *Copernicus,* 139.

92. Zdenek Kopal, foreword in Bienkowska, ed., *World of Copernicus,* xi; George Sarton, *The Appreciation of Ancient and Medieval Science During the Renaissance* (Philadelphia: University of Pennsylvania Press, 1955), 162.

93. Koyré, *Astronomical Revolution,* 27–28. At this stage the population statistics of Renaissance Italy should be recalled, since the "learned circles" were small and extremely close knit (as has already been suggested by the connections between different persons). Burke, *Culture and Society,* 252–53, gives the population of Rome c. 1550 as only 45,000,

hardly larger than a small town by present-day standards (about half the size of Cambridge, England, pop. 90,440 in 1981 census), where leading figures in intellectual circles would surely be well known to one another.

94. Kopal, in Bienkowska, ed., *World of Copernicus*, xi.

95. See Galileo Galilei, *Letter to the Grand Duchess Christina,* 1616, ed. Stillman Drake (New York: Doubleday, 1957), 175–216, esp. 178–81. This letter was written in defense of Copernicus in the face of the imminent banning of his work by the Catholic Church.

96. Galileo, *Letter to the Grand Duchess Christina,* 178. Although Galileo's career postdates the period in question (he was born 15 February 1564, just days before Michelangelo died, 18 February 1564), it is here necessary to address Rosen's paper "Galileo's Misstatements about Copernicus," *Isis* 49 (1958): 319–30. Rosen argues that Galileo was incorrect in stating that Copernicus' book was "accepted by the holy church" overlooking the fact that Galileo qualifies the statement "when printed." Rosen also claims as mistakes by Galileo his statements that Copernicus was called to Rome, was encouraged by "a supreme pontiff," was ordained priest, and contributed to the basis for the Gregorian Calendar. Nevertheless, as has been shown, Copernicus was a canon and sincere member of the Catholic Church, he was included in the general call to Rome by the Lateran Council, he did receive support from the Church and within the Vatican itself, and his work did contribute to late-sixteenth-century calendrical reform. As one who was obviously very concerned about the proposed banning of Copernicus' theory, Galileo tended to bind Copernicus closely to the Catholic Church. Space does not allow more detailed comment on Rosen's paper.

97. See Leopold Prowe, *Nicholas Copernicus* (Berlin, 1883), 1:273; Thorndike, *Magic and Experimental Science,* 5:410; Rosen, *Three Copernican Treatises,* 387; Pastor, *History of the Popes,* 10:336–37; Koestler, *Sleepwalkers,* 155.

98. The manuscript is now in the Bayerische Staatsbibliothek, Munich (Codex Graecus Monacensis, 151), dated "6. 33." It is curious that no record of this event seems to have survived in the Vatican, and the destruction of documents at the time of the subsequent banning might even be speculated. For Widmanstadt, who was papal secretary, see Rosen, *Three Copernican Treatises,* 387. The Latin text reads: "Clemens VII Pontifex Maximus hunc codicem mihi dono dedit Anno MDXXXIII Romae, postquam ei, praesentibus Fr. Ursino, Joh. Salviato Cardinalibus, Joh. Petro episcopo Viterbiensi, et Mattaeo Curtio Medico physico, in hortis Vaticanis Coperniciana de motu terrae sententiam explicavi. Joh. Albertus Widmanstadius cognomitatus Lucretius Serenissimi Domini Nostri Secretarius domesticus et familiaris" (copy kindly supplied by the Bayerische Staatsbibliothek, Munich). The inscription is illustrated in Hermann Hauke, "Bücher sind Gefässe der Erinnerung . . ." *Bayerland* 3 (September 1986): 18–21.

99. For Clement and Copernicus, see Pastor, *History of the Popes,* 10:336 and 12:549. For Clement and Michelangelo, see Vasari, *Lives,* (ed. de Vere, 1878; ed. Bull, 373). Pastor's comment, taken with those of Tolnay, was the starting point in 1982 for the present study from which the rest developed.

100. Koestler, *Sleepwalkers,* 155. For the importance of Alexander of Aphrodisias, see Cassirer et al., *Renaissance Philosophy of Man,* 260, 265; and Garin, *Italian Humanism,* 140, where he comments on Alexander's view that intellectual light and God are identical.

101. For which see Proclus, *Elements of Physics,* ed., H. Boese (Berlin: Akademie Verlag, 1958). A short tract by Michael of Ephesus is also included. The additional inscription notes that Pope Pius VI saw this manuscript in 1782.

102. Rosen, *Three Copernican Treatises,* 387 (Egidio of Viterbo died in 1533).

103. Pastor, *History of the Popes,* 10:231. This was in connection with the proposed marriage of the pope's niece, Catherine de' Medici, and the French prince, Henri (who

subsequently became dauphin on the death of his elder brother Francis in 1536, eventually succeeding Francis I as Henri II in 1547).

104. Rosen, *Three Copernican Treatises*, 372–74, 387. This was not Halley's comet, which had recently appeared in 1531; Olson, "Giotto's Portrait of Halley's Comet," 137; E. M. Hulme, "The Turk, the Comet and the Devil," chap. 20 in *The Renaissance, the Protestant Revolution and the Catholic Reformation* (New York: Appleton, 1915), esp. 405–7.

105. Ramsden, *Letters*, 1:lxv and 183–85; Murray, *Michelangelo, His Life, Work and Times*, 155; Henry Thode, *Michelangelo und das Ende der Renaissance*, 1st ed., 3 vols. in 4, (Berlin: G. Grote, 1902–12), 1:425.

106. See Liebert, *Psychoanalytic Study*, where he discusses Michelangelo's relationship with Clement VII, since their youth in the household of Lorenzo de' Medici (225–26, 238–40); see also Ramsden, *Letters*, 1:135, 142–43, 164, 169, 303). Michelangelo was readily forgiven for turning against the Medici while fighting for the Florentine Republic (Liebert, *Psychoanalytic Study*, 153); Paul III had also spent some time in Lorenzo's household, and was on friendly terms with the artist (Liebert, *Psychoanalytic Study*, 379, 384; Vasari, *Lives* (ed. de Vere, 1880, 1889–92; ed. Bull, 378, 388–91).

107. See Shrimplin, "Nicodemism." Johannes Petrus, otherwise known as Gian Petro Grassi or Gratti, also held high office under Pope Paul III; Pastor, *History of the Popes*, 11:231.

108. See Ramsden, 2:110–11, for family relationships and passim for Michelangelo and Jacopo Salviati (also Murray, *Michelangelo, Life, Work and Times,* 98). See Pastor, *History of the Popes,* 10:61, 11:314, for the importance of Cardinal Salviati under both Clement VII and Paul III. At a later date, Salviati seemed to be aware that Michelangelo's circular and centralized design for Saint Peter's was tantamount to "making a temple in the image of the sun's rays"; Ramsden, *Letters,* 2:291, 309–10.

109. For direct traceable links between Michelangelo and Cardinal Salviati, see Redig De Campos, *Michelangelo, Last Judgment*, 67, 71 n. 40; Tolnay, *Michelangelo*, 5:175 (for the gift of the painting); idem, *Michelangelo*, 1975), 182; Salmi, *Michelangelo, Complete Works,* 578, and Barocchi, *Carteggio,* vol. 3, p. 315, *amico nostro.* The family of the other cardinal present (Orsini) was closely related to the Medici by marriage (Lorenzo the Magnificent to Clarice Orsini). Matthias Curtius (1474–1544) was a professor of medicine at Bologna and Padua M. Cosenza, *Biographical and Bibliographical Dictionary of the Italian Humanists* (Boston: G. K. Hall, 1962), 5:155 (no. 588).

110. As argued by Tolnay, *Michelangelo,* 5:49.

111. *Catholic Encyclopedia,* 4:27.

112. Francesco Guicciardini, *The History of Italy,* trans. and ed. Sidney Alexander, (Princeton: Princeton University Press, 1984) (1st ed. 1561), 338.

113. Pastor, *History of the Popes*, 10:337 and 342–43 for his patronage of the arts.

114. Esp. the letter of Agnello concerning a *"resurrectione."* See Tolnay, *Michelangelo,* 5:197; Hall, "Michelangelo's *Last Judgment,*" 85–86; Murray, *Michelangelo, Life, Work and Times,* 157; Redig De Campos, *Michelangelo, Last Judgment,* 85–86.

115. Vasari, *Lives,* (ed. de Vere, 1882; ed., Bull, 378); Condivi, *Life of Michelangelo,* 75–76.

116. Murray, *Michelangelo, Life, Work and Times,* 157; Tolnay, *Michelangelo,* 5:19. This is also confirmed by the papal breve of Paul III, reprinted in Redig de Campos, *Michelangelo, Last Judgment,* 97.

117. Tolnay, *Michelangelo,* 5:19; Redig de Campos, *Michelangelo, Last Judgment,* 25; Murray, *Michelangelo, Life, Work and Times,* 157.

118. Ramsden, *Letters,* 1:lxv; 2:176.

119. Pastor, *History of the Popes,* 10:231. Cardinal Farnese here replaced the recently deceased Jacopo Salviati as Pope Clement's trusted adviser.

120. For Radzyn and Widmanstadt, see Rosen, *Three Copernican Treatises*, 387. We can also recall Copernicus' statement in his preface to *Revolutions* (written in 1542) that the work had been dormant for "nine years." This appears to be a reference to its discussion in the Vatican in 1533.

121. For Schönberg, see Pastor, *History of the Popes*, 10:38, 61; Schönberg was at the negotiations for the Treaty of Cambrai, 1529, together with Salviati and was promoted to cardinal by Paul III in 1535 at the same time as the Catholic Reformer Contarini (11:142).

122. Schönberg's letter is to be found printed in full in Copernicus, *De Revolutionibus*, xvii; and Koestler, *Sleepwalkers*, 154–55. It was included in the printed versions of *Revolutions* in 1543. See also Pastor, *History of the Popes*, 12:549.

123. Tolnay, *Michelangelo*, 5:20–21; Redig de Campos, *Michelangelo*, 97. In addition, Schönberg commissioned a drawing from Michelangelo in 1532. (Barocchi, *Carteggio*, vol. 3, pp. 301, 328, 340.)

124. Rosen, *Three Copernican Treatises*, 387.

125. Koestler, *Sleepwalkers*, 155.

126. Pastor, *History of the Popes*, esp. vol. 11; Hale, *Encyclopaedia of Italian Renaissance*, 241; Armitage, *Sun, Stand Thou Still*, 132–33.

127. For Michelangelo and Pope Paul III, see Liebert, *Psychoanalytic Study*, 331, 379; also Ramsden, *Letters*, 2:91 (Michelangelo sent him a gift of 33 pears).

128. The first changes took place around 1542, but mildness was again experienced in 1549 when Cardinal Pole narrowly missed election to the papacy, and under Julius III (1550–55). The strict phase of the Counter-Reformation received impetus from the election of Paul IV Carafa (1555–59). For background, see Fenlon, *Heresy and Obedience*; Cantimori, "Italy and the Papacy," in *New Cambridge Modern History*, ed., Elton, vol. 2.

129. Even the pope's proposal to include the Farnese coat of arms was not permitted by the artist; Condivi, *Life of Michelangelo*, 83.

130. Liebert, *Michelangelo, Psychoanalytic Study*, 331–33.

131. Vasari, *Lives*, (ed. de Vere, 1879; ed., Bull, 374), mentions an original scheme of a *Last Judgment* on the altar wall, and the *Fall of Lucifer* on the opposite wall, which was simply not executed. It is possible that an earlier concept of a *Resurrection* and *Fall*, with its obvious emphasis on the "up for Heaven/ down for Hell" connotations, was abandoned in the light of the new cosmology of which Clement had just learned.

132. Pastor, *History of the Popes*, 12:615 and 631. For Michelangelo's Pauline frescoes, see Tolnay, *Michelangelo*, 5:70–77.

133. Koestler, *Sleepwalkers*, 161–69.

134. Rheticus, *Narratio Prima*, in Rosen, *Three Copernican Treatises*, 122.

135. Paul F. Grendler, *The Roman Inquisition and the Venetian Press* (Princeton: Princeton University Press, 1973).

136. *De Revolutionibus* was finally removed from the Catholic Index in 1845. It is necessary at this point to address Rosen's paper "Was Copernicus' *Revolutions* approved by the Pope?" *Journal of the History of Ideas* 36 (1975): 531–42 (cf. also Rosen's comments in Dobrzycki, ed., *De Revolutionibus*, 336–37). Rosen puts forward evidence that Friar Tolosani, supported by Bartolommeo Spina, Master of the Sacred Palace responsible for the censorship of unsuitable works, had suggested the banning of *Revolutions* in 1544. According to Rosen, 542, this implies that Paul III therefore did not approve of the book. However, this evidence, while demonstrating that small pockets of anti-Copernicanism existed in 1544, rather proves the opposite. Namely, that even when someone as important and influential as the Master of the Sacred Palace suggested condemning the book, neither Pope Paul III nor any of his immediate successors (including Paul IV Carafa) took any action. The subject was not even raised at the Council of Trent: Anthony David Wright, *The Counter-Reformation* (London: Weidenfeld and Nicolson, 1982), 107; Garin, "Alle origini

della Polemica Anti-Copernicana," in *Rinascite e Rivoluzioni,* 283–96), and the fact remains that the book was not prohibited until 1616. With regard to the present hypothesis, this episode of 1544, postdates the completion of Michelangelo's *Last Judgment.*

137. Osiander's preface is reprinted in full in Copernicus, *De Revolutionibus,* xvi. For discussion of its inclusion and significance, see Koestler, *Sleepwalkers,* 170–75; Kuhn, *Copernican Revolution,* 187; Hallyn, *Poetic Structure,* 49–52.

138. Osiander was probably also responsible for the "sales talk" on the cover page; Copernicus, *De Revolutionibus,* xv, and 334. Useful for summary of these events is Frederick Charles Copleston, *History of Philosophy: The Philosophy of the Renaissance* (London; Burns and Oates, 1960), 3:282–87, "The Scientific Movement of the Renaissance."

139. Koestler, *Sleepwalkers,* 216; Kuhn, *Copernican Revolution,* 187, 196; Bienkowska, ed., *World of Copernicus,* 124; Heninger, *Cosmographical Glass,* chap. 3, "Copernicus and his Consequences for Immediate Recognition," 45–60; Dorothy Stimson, *The Gradual Acceptance of the Copernican Theory of the Universe* (Gloucester, Mass.: Peter Smith, 1972).

140. For Kepler and Tycho Brahe (1546–1601), see Kuhn, *Copernican Revolution,* 200–19. Although outside this period of study, it is of interest that Neoplatonic influence on the formation of the heliocentric theory and modern cosmology is also evident in the work of Kepler (1571–1630). Pauli shows how Kepler's championing of Copernicanism was not only attributable to scientific reasoning, but also to Kepler's interest in the symbolic analogy he saw between the role of the sun in the universe and the Divine Mind. This demonstrates continuing interest in Neoplatonism in the late sixteenth and early seventeenth centuries (C. G. Jung and W. Pauli, *The Interpretation of Nature and the Psyche* (New York: Pantheon, 1955); Giorgio de Santillana, *The Age of Adventure: The Renaissance Philosophers* (New York: Mentor, 1957), 201–2; Koestler, *Sleepwalkers,* pt. 4).

141. In any event, Bruno's execution resulted from his idiosyncratic religious ideas, not from his opinions on astronomy. See Yates, *Giordano Bruno,* 235–38, 241–44, 248–49, 355–56. Also outside the period of discussion is the *Discourse* of Cardinal Bérulle of 1644, where christocentricism and heliocentricism are discussed in the theological context. It is of note that the Sun-Deity analogy is still strongly expressed, as in "Jesus est le vray Soleil qui nous regarde des rayons de sa lumière. . . . Disons maintenant qu'il est le Soleil"; see Clémence Ramnoux, "Héliocentrisme et Christocentrisme," in Université de Bruxelles, *Le Soleil,* 447–61; Hallyn, *Poetic Struture,* 141–45.

142. For basic information on Galileo, see Kuhn, *Copernican Revolution,* 219–25, and Koestler, *Sleepwalkers,* pt. 5. See Garin, *Astrology,* 9–11, on the influence of the solar cults on Kepler and Galileo. Yates ("Hermetic Tradition," ed. Singleton, 271–72) emphasizes the complexities of the transition from Renaissance philosophy to modern science and celestial mechanics, and the way in which Kepler, Galileo, and Newton "grew out of" the Pythagorean, Platonic, and Hermetic traditions of the Renaissance.

143. For further reading and references for views of the universe, before, during, and after the Renaissance, see B. G. Dick, "An Interdisciplinary Science-Humanities Course," *American Journal of Physics* 51 (August 1983): 702–708, which contains an extensive further bibliography.

144. Koestler, *Sleepwalkers,* 220–22; White, *History of Warfare of Science and Theology,* esp. chap. 3, "The war upon Galileo," and chap. 4, "Theological Efforts to Crush the Scientific View"; Bertrand Russell, *Religion and Science;* John William Draper, *Religion and Science.*

Chapter 9

The Central Point

And on his vesture and on his thigh was a name
written, king of kings and lord of lords.

—*Rev. 19:16*

Art Historical Method

In Copernicus' theory of the heliocentric universe, the predominate idea
is to place at the center of the physical universe that body which is most
naturally regarded as the counterpart of the deity, namely the sun. The
kind of source material that demonstrates the prevalence and popularity
of this concept in the first half of the sixteenth century has been examined
for its direct relevance and availability to Michelangelo. Sources in the
Scriptures and the Church Fathers, in Ficino and Dante are all generally
accepted and documented as influential upon the artist: here they have
been examined from a different point of view. The new source of influence
that is claimed, namely that of Copernicus' theory, is precisely documented
and fits in well with the chronology of the commissioning of the fresco.
Taken together, these sources correspond neatly to the visual aspects of
Michelangelo's *Last Judgment* fresco. The hypothesis that sun symbolism
and cosmology play a major role in the overall interpretation and design of
the work does not rest on obscure argument or improbable and unproven
source material.

However, while this interdisciplinary approach, which would appear
to correspond with what we know of the sixteenth-century way of
thinking, is vital in the study of a single work of this magnitude, it is also
important not to lose sight of the artwork itself. Using the tools of the art
historian, it is necessary to return to the methods of art history rather than

287

the history of ideas and to look once more at the strictly formal aspects of the painting itself, considered in relation to the techniques of fresco construction that were used during the Renaissance. It is also vital not to forget the theological basis of the fresco, among the other, nonscriptural, sources that have been put forward, and it will be seen that formal analysis may actually provide us with a direct Scriptural basis for the overall format of the fresco, both technically and iconologically.

The Centralized Format Around Christ

The cosmological interpretation of Michelangelo's *Last Judgment* argues that the circular emphasis of the design is centered on Christ, depicted in terms of a Christian and Neoplatonic sun symbol and influenced by Copernican heliocentricity. This assessment, having as its starting point the composition of the work itself, forms a prime example of how the formal analysis of a painting may be used as a point of departure for an iconological interpretation. The metaphysical or transcendental concept of the circular universe centered on a single point was stressed in the source material provided by the works of Augustine, Dante, and Ficino; the description of the physical universe centered on the sun forms the core of Copernicus' scientific theory. Thus far in this hypothesis the central, pivotal point of the universe has been read broadly as the figure of Christ in the guise of the sun in Michelangelo's fresco. Yet, if the principles of formal analysis are more precisely applied and related to knowledge of Renaissance fresco technique, it should be possible to locate, even more specifically, the "single indivisible and stationary point" (Ficino)[1] on which "depend the heavens and the whole of nature" (Dante).[2] In turn, it might also be possible to discover some further meaning or implications in the way the formal construction of the fresco might have been carried out; it is necessary for any theological or philosophical reading and interpretation of the central theme of the fresco to fit in precisely with the physical ordering and centrality of the fresco itself.

A brief reconsideration of our sources reminds us that not only the circle but also its central point was of great importance. In the Neoplatonic cosmology of Ficino, the central point of the universe was emphasized, and this is clearly equated throughout with God. In addition, Ficino considers the nature of the point itself in very specific terms that can be recalled thus:

> The center of the circle is a point, single, indivisible and motionless. From it, many lines, which are divisible and mobile, are drawn out to the circumference which is like them. This divisible circumference revolves around the center as its axis.[3]

The point is emphasized as the center or generating point both of the circles of the universe and of the rays of the sun at center. These concepts are related to the Platonic cosmology expressed in *Timaeus* where the importance of the single point which generates the circular cosmology is stressed[4] (see figs. 51, 52). In Christian terms, the writings of Saint Augustine, strongly influenced by Neoplatonic concepts, show a similar emphasis in the discussion of the circle as the most perfect form and also in the significance of the central point of the circle and the role it plays in the generation of this perfection.[5]

Such ideas were also taken up by Dante, as he apparently became aware of the difficulties of combining the now-accepted spherical earth with the concept of Heaven above and Hell beneath the earth's surface. This would have rendered Hell the center of the universe and, hence, the focus around which the earth and heavens revolved. Finding this unacceptable, Dante introduced a separate point in the Empyrean around which all the Heavens revolved "in perfect, eternal, circular motion." This point he describes as a source of light, the focal point of the universe, analogized with the deity.[6] In addition, apart from the idea of the circle and its central point, in his interpretation of Heaven and earth, Dante also often refers to the diagonal lines, or "rays" that extend from this point to earth.[7]

In the scientific realm, Copernicus' writings refer to the sun at the center of the universe (fig. 2) as surely a more logical hypothesis for its construction. Yet, in a later section of *De Revolutionibus*, Copernicus also refers to the existence of a specific or generating point for the universe and the orbits of the planets (including the earth).[8] To account for certain features in the astronomical data, Copernicus, too, employed the concept of a generating point, adjacent to but not quite situated in the center of the sun.[9]

The cosmologies of Plato, Ficino, Dante, and Copernicus outlined and discussed here do, of course, vary in detail although they share much common ground in basic overall scheme. It has already been pointed out that Ficino frequently refers to either four or five cosmic areas, or he describes four circles.[10] Plato describes eight and Dante nine (fig. 91).[11] Elsewhere (in *Timaeus*, again) Plato describes two circles that interlock in the form of a Greek letter chi (χ).[12] Dante's scheme contains nine concentric circles in the Heavens; Copernicus' scheme (fig. 2) contains seven, plus the moon's epicycle. Michelangelo's fresco is basically divided into two main circles plus various subsidiary areas, but it should again be stressed that we are here dealing with the sun-centered *idea* and Michelangelo's own subtle synthesis of religious, philosophical, and scientific themes. The idea of the sun-deity at the center of the universe is of primary concern, rather than any precise analogy to a specific number of circles, which might suggest a privileged position for one of the sources suggested. It is not possible, or

necessary, to force his fresco into one concrete scheme. The rigid following of one selected scheme or number of circles is of lesser importance than the synthesis of a number of current concepts or ideas into Michelangelo's own unique interpretation.[13]

Common to all the schemes put forth for Michelangelo's *Last Judgment* is the acknowledgment of a specific central point, the center of both circles and diagonal rays. In spite of art historical references to the "circular" design of the fresco and the general acceptance of Christ's central position, an attempt should be made to conduct a formal analysis to determine whether there is a more precise center, or "point" nor whether such a "point" might have particular significance.[14]

An artist of caliber, belonging to any age, must be able to draw or compose a circular design freehand when on a small scale,[15] but a work of the size of Michelangelo's *Last Judgment* must have required some more technical basis to achieve the required visual impact of the figure of Christ centrally placed in a composition consisting chiefly of two concentric circles (see figs 1, 51). This would surely imply a fixed central point for the fresco's construction.[16] As far as the diagonal elements are concerned, the same principles would apply. The diagonals similarly appear to center on the figure of Christ and some attempt has been made in this case, more perhaps than with the circles, to trace the underlying geometry of the composition. Wölfflin had placed Christ at the center of the two major diagonals that intersect the fresco in the form of a great χ (Greek chi, the symbol of Christ, *Cristo*), and Steinberg has commented further on the existence of diagonals and published diagrammatic overlays of the fresco to demonstrate his interpretation.[17]

More detailed analysis is necessary to discover whether, by returning to the formal analysis and pursuing it to its logical conclusion, it is possible to establish the specific location of a particular point that generates the circularity of the fresco's composition—that is, more precisely than simply the figure of Christ. The relationship between the formal analysis of a completed fresco and its method of construction should be considered to determine how the final effect was obtained.

Fresco Construction—Formal and Iconological

Michelangelo's decision to paint the altar wall of the Sistine Chapel in fresco, like the ceiling, seems to have been related to his attitude toward oil painting, which became well known.[18] Michelangelo's use of drawings to evolve the design and his use of cartoons (pricked for transfer) affixed to individual areas of the fresco wall have been much discussed and well documented.[19] But the manner in which the overall circular emphasis of

the composition was achieved in fresco on such a large wall surface needs further examination.

The compositional use of circles and diagonals renders order to the fresco, but such features could not be sketched in freehand on such a scale. In the construction of a fresco of this size,[20] certain mathematical and constructional devices would have been utilized. This is especially likely in the work of Michelangelo, well known for his mathematical and architectural designs.[21] It is unlikely that either the compositional design or the actual basis of its construction would have been chosen fortuitously.

The manner of construction of a large design on a wall surface often suggests the division of the surface into separate areas to be treated, as might have been utilized, for example, at Torcello (fig. 20), but Michelangelo's fresco suggests some centralized system. Vitruvius described the manner of construction of a centralized design where all points converge to a single point, and these ideas were taken up in the Renaissance by writers like Alberti, Ghiberti, Pacioli, and Filarete, and often linked with the science of optics.[22] Perhaps the most useful source of information for the techniques of fresco construction during the period of the Italian Renaissance is Cennino Cennini's *Il Libro dell'Arte*.[23] Relevant here are Cennini's instructions concerning the techniques of fresco painting. Although Michelangelo's *Last Judgment* is exceptional as the largest area of wall surface to be decorated with a single image at that time, the same principles may be seen to apply. Cennini gives detailed instructions concerning fresco painting in section 3 of his book, especially chapters 67–88.[24] In the first of these, he describes carefully how to prepare the wall itself, make a design, and then transfer it to the wall surface. The design should be marked on the intonaco, and cartoons or grids were often affixed to the wall surface and the design "pricked" through or dusted over with chalk for each day's area of work.[25] For the marking out of larger areas or longer lines, such as the diagonals or orthogonals used in schemes of one-point perspective, Cennini indicates that stretched strings coated with chalk should be used, which, being struck, would mark the wall. The use of plumb-lines is advocated for verticals, especially where fresco is concerned, in the ordering of the scene on a large wall surface: "The perpendicular line by means of which the horizontal one is obtained must be made with a plumb-line."[26] An emphasis is also laid on the use of compasses in the method of construction, both for the creation of parallel lines and for the circles themselves.[27] The general use of this method is well known and can easily be detected in the works of quattrocento artists known for their frescoes, like Masaccio, Piero della Francesca, and Ghirlandaio.

In quattrocento fresco painting the use of compasses, plumb lines, and stretched strings was linked to the use of the system of one-point

perspective, as developed by Alberti, Brunelleschi, and others.[28] The method of using vertical plumb lines or fixed snapped lines that converged at a single point was linked to the idea of using linear perspective, where orthogonals met at the vanishing point, as an organizational method. In Michelangelo's *Last Judgment* there is obviously no use of a converging grid of orthogonals in the Quattrocento manner, but the idea of the use of such constructional devices in the method of organization and in the transference of designs remains highly relevant to fresco painting of large surfaces.[29]

Masaccio's *Trinity* is an early example of the rigorous use of linear perspective, and the method of its construction is based on multiple vanishing points in the vicinity of the base of the Cross (at about spectator eye-level). Incisions are visible in the plaster, and compass marks denote the position from which the central plumb line was suspended.[30] Masaccio's use of plumb lines as part of his working method is also clear in his frescoes, the *Tribute Money,* and the *Raising of Tabitha.* In the former, the perspective seems to have been organized from the vanishing point to the right of Christ's head; in the latter, a nail-hole corresponds with the vanishing point of the perspective, to the right of the strolling gentlemen. Vertical lines made by snapped cords establish the verticality of the figures, and, according to Borsook, "This is the earliest known instance of the use of plumb lines as an aid to make figures stand firmly on their feet—a practice that has since become the stock-in-trade of every art school."[31] Roskill has also recently noted Masaccio's use of plumb lines in his frescoes, emphasizing the use of stretched pieces of chalk-coated string.[32] Borsook draws attention to evidence of this type of fresco construction and the use of plumb lines in her detailed discussions of the technique of several other quattrocento artists.[33] More importantly for Michelangelo, Borsook demonstrates how the method continued into the late fifteenth century and has particularly been detected and commented on in the work of Ghirlandaio, to whom Michelangelo was apprenticed for a short while and from whom he probably learned the methods of fresco painting.[34] Borsook has shown how Ghirlandaio made use of plumb lines in the manner described by Cennini, as in the Sassetti Chapel frescoes, where the technique has clearly been used. In *The Confirmation of the Rule of Saint Francis,* for example, the nail holes from which cords were suspended are visible in a detail of the Loggia dei Signori (fig. 121).[35] These nail holes provided the vanishing point for the orthogonals, as well as the point from which the circumferences of the painted arches were sprung. Similar nail holes are traceable in the scene below (they converge on the man on horseback) and in other frescoes by Ghirlandaio such as the *Visitation* and the *Birth of the Virgin* in Sta. Maria Novella.[36]

As White points out, the underlying geometrical construction was of crucial importance in large-scale frescoes, but the vanishing point

121 Domenico Ghirlandaio, *The Confirmation of the Rule of Saint Francis*, detail showing nail holes, 1484–85. Fresco, Sassetti chapel, Sta. Trinita, Florence.

frequently did not coincide with any specific object of importance in the early days of its usage.[37] However, as White shows, such compositional devices came to be used to enhance the narrative or symbolic meaning, and were a powerful means of pictorial organization to increase the unity of the composition and create fictive space. White comments on the use of such a central point to highlight particular areas of importance in works like Masaccio's *Tribute Money*, Donatello's *Resurrection of Drusiana,* or Filippo Lippi's *Pitti Tondo*.[38] There is a balance drawn here, he says, between the use of the focal point as meaning as well as part of the design. Kubovy has also recently examined the same phenomenon.[39]

At a later stage, and especially by the time of the High Renaissance in the very late fifteenth and early sixteenth century, while the use of perspectival grids or schemes is less rigid and dominating than in the quattrocento and the delineation of space more subtle, the use of a central or vanishing point to underline meaning takes on an increased significance. It is often used to emphasize the iconological focal point of the work. The classic examples here are the *Last Supper* by Leonardo da Vinci, in Santa Maria delle Grazie, Milan (detail, fig. 122) and Raphael's *School of*

Athens (detail, fig. 111) and *Disputa* (fig. 123) in the Vatican Stanza della Segnatura, adjacent to the Sistine Chapel.[40]

Although Michelangelo's *Last Judgment* has no clear spatial organization in terms of linear perspective, knowledge of this type of Renaissance fresco construction does suggest the use of a device such as a rotating plumb line affixed to the picture surface and used as an "axis" to obtain the circular emphasis of Michelangelo's design on a wall about seventeen meters high. The circularity of the design has received much comment, yet it is important to determine the way the effect was actually achieved on the wall surface. This could hardly have been produced freehand; it would thus have been necessary to select a specific point

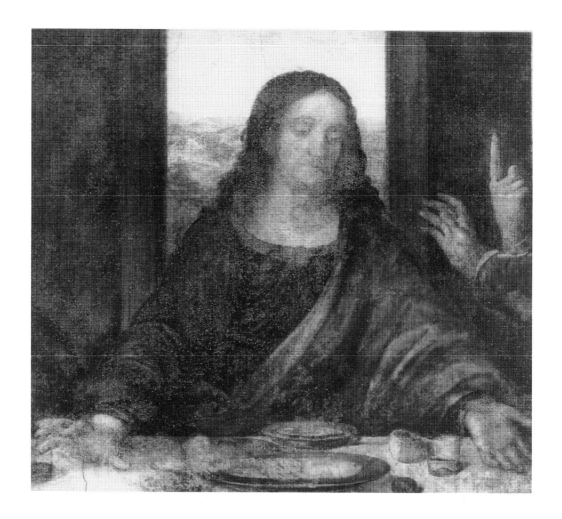

122 Leonardo da Vinci, *The Last Supper*, detail, c. 1495–98. Wall painting in oil tempera, 460 x 880 cm, Refectory, Convent of Sta. Maria delle Grazie, Milan.

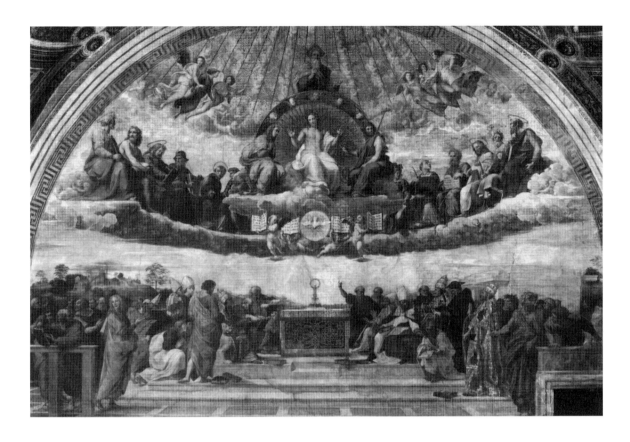

123 Raphael, *Disputa (Disputation Over the Sacrament)*,
1510–11. Fresco, Stanza della Segnatura, Vatican, Rome.

on the wall around which to arrange the composition. It seems safe to
assume that Michelangelo, who avowed he "painted with his brains not his
hands,"[41] would not have selected such a point for purely pictorial reasons.

By very careful formal analysis of the fresco's composition, using
the manipulation of transparencies marked with circles on a large-scale
reproduction, it is possible to locate the precise center of the circles that
underlie the main features of the design (fig. 51)—a location that seems
confirmed in the fact that the diagonals also converge at the same point
(fig. 52). The yellow sun-aureole, which forms a halo around the head of
the central figure of Christ, reechoing the gesture of his arms, does not
form the center of the circularity of the composition or the converging
diagonals. Nor can the center be found at Christ's head or heart (suggesting,
respectively, intellect or emotion) as might perhaps be expected. The focal
point of the formal analysis, both of the circular and diagonal lines of the
composition, appears to lie lower down on the drapery[42] in the exact center
of Christ's right thigh. Christ's thigh may thus be regarded as the specific

pivotal point for both the circularity of the design and for the diagonal rays extending outward from the central Sun-Christ. From the roundness of the contours of the thigh itself to the inner and outer circles of figures, the composition of the entire fresco seems to be precisely constructed from this point. No other point generates the same effect, and the thigh is quite clearly the point, undivided and stationary, upon which Michelangelo's Heavens depend.

A precise mark in the center of the thigh where a constructional device such as a rotating or hinged plumb line could have been affixed is clearly visible at this point on the fresco or in any detailed photograph of it (fig. 124). The mark is clear on the fresco itself and is not a superficial discoloration shown in reproductions. The mark has not been removed by the cleaning and restoration of the work, and it could well indicate the position of a nail hole or central pivot that was used in this place in the way suggested. Michelangelo's use of nails and plumb lines was noted during the restoration of the ceiling, and this seems to be the method of construction of circular motifs like the sun and moon in the *Creation* panels. Close examination from the scaffolding during the cleaning of the altar wall of the mark on Christ's thigh confirmed that it is not simply a stain or accidental indentation that would have been rectified or obliterated by the cleaning and restoration. And this tends to verify the hypothesis that this is indeed the compositional and iconological center point of the fresco.[43] The mark on the thigh remains quite distinct on the postrestoration fresco, where, in general, the feeling of air and light and space has undoubtedly been heightened. Thus, apart from the much lighter and brighter appearance of the fresco in general after the cleaning, the point on Christ's thigh may be regarded as the key to the design and as evidence of the means by which the circular emphasis of the fresco's composition was achieved.[44]

Bearing in mind Michelangelo's own ideas about imbuing artistic design with intellectual or religious meaning, as well as considering the relation between meaning and formal design in Renaissance art in general, an explanation for this point of focus should be sought. The underlying reason for Michelangelo's selection of this specific point on Christ's thigh as the pivotal center of the entire cosmological fresco must surely relate to the biblical reference (Rev. 19:16), which, describing the Christ of the Judgment, reads, "And he hath on his vesture and on his thigh a name written, king of kings and lord of lords."[45] It does not seem to be mere coincidence that this is followed immediately by a reference to the sun symbol: "And I saw an angel standing in the sun . . ." (v. 17).[46] The formal interpretation of the painting's structure would thus also serve to reinforce Michelangelo's interpretation of the Christ of the *Last Judgment* in his role as supreme ruler of the universe in both temporal and spiritual realms.

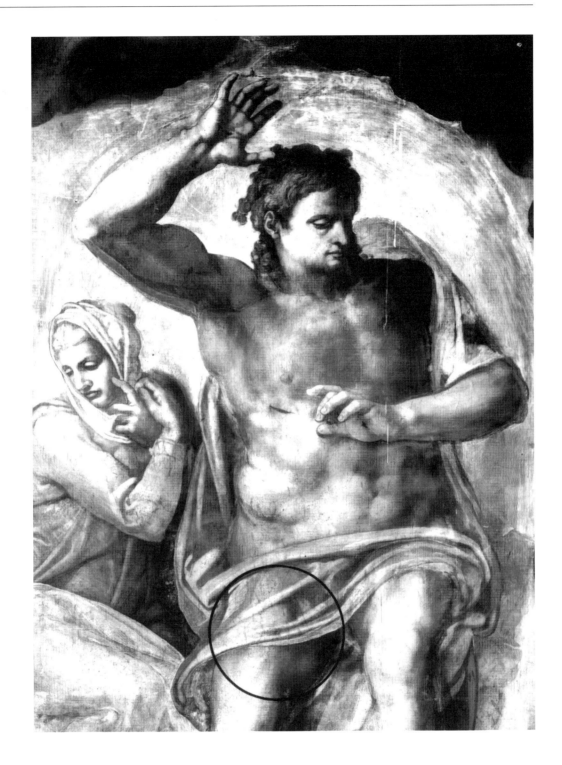

124 Michelangelo's *Last Judgment*, detail of Christ's thigh.

The Symbolism of Revelation 19:16

It is essential to consider additional evidence that might confirm this reading of the thigh of the Sun-Christ as both the literal and symbolic center of Michelangelo's design. To do this, it is necessary to return to the type of source material that has already been discussed in the preceding chapters: art historical, theological, philosophical, and literary.

Formal analyses of Michelangelo's *Last Judgment* that include specific discussion of the geometrical underpinning of the composition are few. In one rare analysis, Steinberg comments briefly on the thigh as a focal point and acknowledges Michelangelo's emphasis on that area of the design.[47] However, Steinberg did not recognize that this focal point might have special symbolism, and he dismissed out of hand any deeper meaning. "Whoever," he says, "heard of thighs and tibias as conveyors of grace?"[48]— and he pursued this line of investigation no further. This omission appears even more curious when one notes the pronounced emphasis on the thigh in the earlier "Casa Buonarroti" sketch for the *Last Judgment* (fig. 49), where the figure of Mary is used to focus attention on Christ's thigh since her hand is significantly laid in this position. The mother of Christ is clearly depicted here in apocalyptic fashion, with reference to the book of Revelation since the moon lies at her feet (specifically Rev. 12:1). This sketch, therefore, seems to reinforce the positive emphasis on Christ's thigh in the finished work, and the link to Revelation as a source.

The range of symbolism attached to parts of the human body is amply demonstrated by different medieval and Renaissance texts, many of which connect the human form with astronomical or astrological symbolism (as in fig. 125).[49] Leonardo da Vinci's drawing of man at the focus of both square and circle is well known, and here the navel forms the central point.[50] In a consideration of Michelangelo's usage, however, it is necessary to examine the biblical meaning of the symbol. Several other references in the Scriptures to the thigh are to be found, especially in Genesis, where the thigh is used as a symbol for truth to reinforce the swearing of an oath.[51] Elsewhere, it stands as a symbol for power and strength, especially as the place that customarily bore the sword.[52] This Scriptural meaning spilled over into Christian iconography, and Shapiro comments on the symbolic significance of the thigh in Early Christian iconography.[53]

The biblical usage of the symbol of the thigh forms the foundation for the explanation of the verse Rev. 19:16 in the majority of commentaries on Revelation. Caird points out that it is natural for the title "King of Kings" to be centered on Christ's thigh since all would readily understand that the thigh was the place where the sword hung, the weapon with which the victory and the title had been won.[54] Lenski emphasizes that, with the

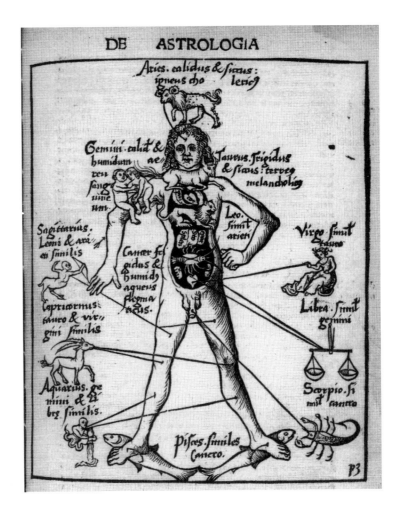

125 Gregor Reisch, *Margarita Philosophica*, detail, *The Human Body and Signs of the Zodiac*, Freiburg, 1503. Engraving, Huntington Library, San Marino, California.

location of Christ's title on the thigh, the name was clearly written in a place "where all could see it without effort," an idea also stressed by other commentators.[55] LaHaye perceptively points out that, as a warrior goes into battle with his sword on his thigh, so Christ's "sword" or weapon is his spoken word. Being written in the place where the sword was customarily worn, the inscription "King of Kings and Lord of Lords" demonstrates the power of Christ at the actual moment of Judgment.[56]

As a further reinforcement of the importance of the biblical text of Rev. 19:16 and the likelihood of Michelangelo's allusion to it in his fresco, it is important to consider the liturgy of the Roman Church. A special mass (Vespers) was said at the unveiling of the *Last Judgment* on All Saints' Eve, 31 October 1541, and it cannot be coincidence that exactly twenty-nine years earlier in 1512, the completion and unveiling of Michelangelo's frescoes on the Sistine ceiling were also celebrated on the same festival.[57] This seems curious in view of the fact that the primary dedication of the

Sistine Chapel was to the Virgin Mary.[58] The festival of All Saints and its Vigil (the previous evening) does seem relevant to the subject of the Last Judgment, however, for, in the mass, readings concerning judgment and the fate of the blessed and damned are taken from Revelation.[59] What appears to be more significant, in relation to Michelangelo's emphasis on the thigh, is that, according to the *Catholic Missal*, the Kingship of Christ was always a major theme connected with the time of All Saints. The services for late October (particularly the last Sunday) are presently dedicated to the theme of "The Kingship of our Lord Jesus Christ,"[60] and the precise biblical reference of Rev. 19:16 is included in a special service at the end of October.[61] Pope Paul III had, it seems, returned especially from Bologna to conduct the service, on the last day of October, at the Vigil of All Saints.[62]

The belief that the unveiling took place on Christmas day that year, expressed by Vasari, probably refers to a significant second ceremony, associated perhaps with the admission at that time of a wider public. The coming of Christ at Christmas was traditionally taken as a prefiguration of the Last Judgment, and is still expressed as such in the Christmas mass. At Vespers on Christmas Eve, the singing of "When Heaven's Sun has arisen, ye shall see the King of Kings coming forth" seems to indicate the exact theme of the fresco itself.[63] Ettlinger, in his discussion of the earlier frescoes in the Chapel, comments on the idea that a major iconographic theme of the chapel is one of Christ as King and Priest, which may further explain the choice of the celebration of All Saints for the inauguration of the frescoes, both on ceiling and altar wall.[64]

Among the sources examined here as influential on Michelangelo's work on the fresco, further references to the theme of Kingship and even the symbolism of the thigh are to be found. In the philosophical context, Ficino drew attention to the concept of Christ as King of Kings, as well as the classical, mythological idea of symbolic birth from the thigh.[65] And in the Hermetic writings the use of the talisman of Apollo as "King of Kings" seems to reinforce the relevance of the theme and Michelangelo's likely awareness of it.[66] Visual evidence may also be found for the combination of Christ as sun and as King of Kings, for this was a theme popular in Florence in the early sixteenth century. Examples of the sun being used to symbolize Christ in Renaissance Florence have already been cited (fig. 87), but a more remarkable instance is in a highly prominent position on the front of the Palazzo della Signoria (Palazzo Vecchio). Here, the sun symbol signifying Christ is specifically combined with the biblical quotation "Rex regum, Dominus Dominatium." The lions and Christ's emblem were placed over the entrance in 1528 and the inscription inserted (before 1540) by Cosimo I (fig. 126).[67]

As for the literary sources that are proposed, Dante's *Divina Commedia* provides strong motivation for Michelangelo's centering the fresco

Florence Palazzo della Signoria. Photo: Katy Shrimplin, 1993.

physically and symbolically upon the location of Christ's thigh for, at the end of *Inferno*, references to thigh symbolism are made in a specifically cosmological context. It will be remembered, as argued above, that in Dante's spherical, geocentric view, where he was faced with the problem of finding an exact center for the spheres of the universe, he selected Lucifer's thigh as the center of the terrestrial system. In terms of the antithesis between the earthly and celestial areas, Dante chose Lucifer's thigh almost certainly because it was the antitype of Christ's thigh as described in Revelation.[68] It therefore seems entirely possible that Michelangelo, who was so imbued with the ideas of Dante, logically transferred the idea of the central point of the universe from Lucifer (specifically Lucifer's thigh in the geocentric system) not only to the Deity in the form of the sun, but even more precisely to the symbolic thigh of Christ himself. Dante's images of Lucifer's thigh as the center of the terrestrial system and the "Point" of light of the Sun-Christ as the center of the celestial system could this be combined in one system. Precipitated, it seems, by the knowledge of Copernicus' idea of the sun-centered universe (made known at Rome by 1533) and set against the background factors that have been outlined, Michelangelo's fresco offered a more logical solution than Dante's system, because the centers of both celestial and terrestrial regions were fused in a single point.

Michelangelo's knowledge of and interest in Dante supports the reading of Christ's thigh as symbolic center of the circular universe, but the biblical text cited itself seems to provide a fitting answer to the choice

of central point for the overall circular arrangement of the fresco around the Sun-Christ.[69] The Christ of the *Last Judgment* is depicted as the cosmic ruler of universe, and the idea that Michelangelo centered his great fresco on the important text of Rev. 19:16 confirms this view. Christ is here depicted theologically, Neoplatonically, and scientifically, as Michelangelo viewed him—as King of Kings and Lord of Lords, the Sun, the center of the Universe.

Notes

1. Ficino, *De Amore*, 47.

2. Dante, *Paradiso* 28:41–42.

3. Ficino, *De Amore*, 47.

4. Plato, *Timaeus* 37A, 62D.

5. Augustine, *On the Magnitude of the Soul,* ed. cit., 80; "What else is the regulator of this symmetry than the point placed in the center? Much can be said of the function of the point." This concept has recently been reiterated by Umberto Eco in his reference to "the Only Fixed Point in the universe . . . one single point, a pivot, bolt or hook around which the universe could move"; Eco, *Foucault's Pendulum*, 5, 206–7.

6. Dante, *Paradiso* 28:16.

7. Dante, *Paradiso* 23:72, 79–80.

8. Copernicus, *De Revolutionibus*, bk. 3, chap. 25, 169, 242–43.

9. Copernicus' later suggestion that a "point" is the center of the planetary orbits appears to have been an attempt to account for certain irregularities caused by the real nature of the orbits that are in fact elliptical; this being discovered and calculated in the seventeenth century, by Kepler; see Koestler, *Sleepwalkers*, 328–38.

10. Ficino, *De Amore,* 47–48.

11. See Plato, *Republic* (ed. Radice) appendix, 402, with diagram, 405. Compare Dante, *Paradiso* (ed. Mandelbaum), 305.

12. Plato, *Timaeus,* 36C.

13. The planets, for example, do not figure in *Last Judgment* iconography and it is therefore not relevant to force correspondences with planetary orbits or to look for analogies with Venus, Mercury, and so on in Michelangelo's fresco. The Copernican reference to the sun surrounded by heavenly bodies or stars (*astrorum*) would seem to correspond well in Michelangelo's fresco with the Neoplatonic concept of the transmutation of souls into stars after death.

14. For example, Lamarche-Vadel has described "a series of concentric circles" but without making any attempt to determine their single center; Lamarche-Vadel, *Michelangelo*, 136. Very recently, Greenstein has commented freely on the "inner circle" and Christ in the "center of the double round," showing total acceptance of the idea without the necessity of formal analysis; Greenstein, "How Glorious the Second Coming of Christ," 35.

15. Giotto's "O" may be recalled; (Vasari, *Lives*, ed. de Vere, 104–5; ed. Bull, 64–65).

16. Beck's comment on the *Last Judgment*, "the geometry is only approximate . . . ," must here come under consideration; Beck, *Italian Renaissance Painting*, 341.

17. Wölfflin, *Classic Art,* 197–98. Steinberg, "Line of Fate," 105–109, fig. 19. Steinberg concentrates on what he perceives as the bar sinister in Michelangelo's paintings including the *Last Judgment*. In a slightly later paper ("Corner of the *Last Judgment*, esp. 237–41 and plates 5, 7, 9), he traces further diagonal lines and movement in the *Last Judgment*, from

the angels to Christ, passing through the flayed skin and ending on the genitalia of Minos to which he gives his own unique interpretation.

18. Michelangelo did not regard oil painting highly and fell out with Sebastiano del Piombo over the matter when the wall was at first prepared for oil painting; Tolnay, *Michelangelo,* 5:21.

19. Redig de Campos, *Michelangelo's Last Judgment,* plate 64. Michelangelo is not known to have used the method of "squaring" up a design for a large fresco. Hirst has recently commented on the difficulty of finding "a satisfactory explanation of how he scaled up his designs," Michael Hirst, *Michelangelo and his Drawings* (New Haven: Yale University Press, 1988), 8.

20. 13.7m x 12.2m.

21. Pirina, "Michelangelo and the Music and Mathematics of His Time," 368–82. In the curves of the staircase of the Laurentian Library, the designs for the dome of Saint Peter's or for the piazza of the Campidoglio, mathematical "tools" must surely have been used.

22. Vitruvius, *Ten Books of Architecture,* discussed by John White, *The Birth and Rebirth of Pictorial Space,* 3d ed. (London: Faber and Faber, 1987), 252. For Alberti, Pacioli, Filarete, and others see Gilbert, *Sources and Documents,* ed. Janson, 54–55; Wittkower, *Architectural Principles.*

23. The earliest copy is dated 1437. See C. J. Herringham, trans., *The Book of the Art of Cennino Cennini* (London: Allen and Unwin, 1922), and D. V. Thompson, trans., *Cennino d'Andrea Cennini, The Craftsman's Handbook* (New York: Dover, 1933).

24. See Herringham, *Cennini,* 55–78; Thompson, *Craftsman's Handbook,* 42–57.

25. See D. V. Thompson, *The Materials and Techniques of Medieval Painting* (New York: Dover, 1956), 69–73. The application of this method can be seen on the Sistine ceiling as a result of the recent cleaning; see Pietrangeli, *Michelangelo e la Sistina,* 72; Jeffery, "Renaissance for Michelangelo," 705.

26. Herringham, *Cennino Cennini,* 56; Thompson, *The Craftsman's Handbook,* 43.

27. Thompson, *The Craftsman's Handbook,* 43 n. 3.

28. See White, *Birth and Rebirth,* esp. chap. 8; Erwin Panofsky, "I Primi Lumi: Italian Trecento Painting and Its Impact on the Rest of Europe," in *Renaissance and Renascences in Western Art* (Stockholm: Almquist and Wiksell, 1960; reprint, New York: Harper and Row, 1972), 114–61, esp. 123–24.

29. Such mechanical aids to drawing are discussed in Fred Dubery and John Willats, *Perspective and Other Drawing Systems* (London: Herbert, 1983); note esp. fig. 73, showing Dürer's use of plumb lines; William M. Ivins, *Art and Geometry: A Study in Space Institutions* (New York: Dover, 1946).

30. Eve Borsook, *The Mural Painters of Tuscany: From Cimabue to Andrea del Sarto* (Oxford: Clarendon, 1980), 60–61 and fig. 7. See also Pierre Thuillier, "Espace et Perspective au Quattrocento," *La Recherche* 160 (1984): 1384–98, esp. fig. 1; Lawrence Wright, *Perspective in Perspective* (London: Routledge and Kegan Paul, 1983), 60–61; and Sven Sandstrom, *Levels of Unreality: Studies in Structure and Construction in Italian Mural Painting during the Renaissance* (Uppsala: Almqvist and Wiksells, 1963), 29.

31. Borsook, *Mural Painters,* 65.

32. Mark Roskill, *What is Art History?* (London: Thames and Hudson, 1982), 51.

33. Borsook, *Mural Painters,* for example, 82 (the work of the Prato Master), 124 (Filippo Lippi).

34. Michelangelo minimized the extent to which he had learned from others (Condivi, *Life of Michelangelo,* 10), but Vasari points out the documentary evidence of his apprenticeship with Ghirlandaio and also tells us how Michelangelo made sketches of the process of fresco construction (Vasari, *Lives,* ed. de Vere, 1833–35; ed. Bull, 327–29). See also Everett Fahy, "Michelangelo and Ghirlandaio," in Irving Lavin and John Plummer,

eds., *Studies in Late Medieval and Renaissance Painting in Honour of Millard Meiss* (New York: New York University Press, 1977), 152–56.

35. Borsook, *Mural Painters,* 119–20 and figs. 144 and 145. Recent restoration has obscured these marks. See also Eve Borsook and Johannes Offerhaus, *Francesco Sassetti and Ghirlandaio at Sta Trinita, Florence* (Doornspijk: Davaco, 1981), esp. appendix 2, "Technique and Condition."

36. Beck, *Italian Renaissance Painting,* figs. 227 and 228.

37. White, *Birth and Rebirth,* 189.

38. White, *Birth and Rebirth,* 191, 197–98.

39. Michael Kubovy, *The Psychology of Perspective and Renaissance Art* (Cambridge: Cambridge University Press, 1988), 1–7. He refers to examples by Masaccio, Piero, Veneziano, and Perugino.

40. For Leonardo's *Last Supper,* where the vanishing point is centered on Christ's head, see Ludwig Goldscheider, *Leonardo* (Oxford: Phaidon, 1969), figs. 73 and 74; and Wright, *Perspective,* 94–99. A nail hole that forms the focal point of both the orthogonals of the room and the circular springing of the arch of the window seems to be visible just above Christ's left ear, in the detail shown. In Raphael's *School of Athens,* a nail hole is visible at the vanishing point between the figures of Plato and Aristotle, just below waist height; in the *Disputa,* the vanishing point of the orthogonals coincides with the Host (see figs. 156 and 164, in Freedberg, *Painting of the High Renaissance,* vol. 2).

41. Ramsden, *Letters,* 2:26; Clements, *Theory of Art,* 35, "Io rispondo che si dipinge col ciervello e non con le mane." Michelangelo viewed the hand as agent of the intellect: "Non ha l'ottimo artista alcun concetto/ c'un marmo solo in se non circonscriva/ col suo superchio, e solo a quello arriva/ la man che ubidisce all'intelletto," ("the best of artists never has a concept/ A single block of marble does not contain/ Inside its husk, but to it may attain/ Only if hand follows intellect"), see Gilbert, no. 149, and Summers, *Language of Art,* 206.

42. Christ's drapery is original and not part of Volterra's later additions, as is demonstrated by Venusti's copy of 1549 (fig. 65) and confirmed by the restoration work. While the Vatican announced (November 1993) that some overpainted draperies or "loincloths" would be removed during the cleaning, it was confirmed, at this time, that the drapery covering Christ was certainly painted by Michelangelo (cf. *Times,* 26 November 1993, 17).

43. See, Fabrizio Mancinelli, "Michelangelo at Work," in Chastel et al., *Sistine Chapel,* 218–59, esp. 247. Concerning the "nail hole" on Christ's thigh, after some discussion with Dr. Fabrizio Mancinelli on this issue while standing on a level in front of the figure of Christ on the scaffolding, it was concluded that it does seem possible, but will probably never be known for certain, whether a system such as a rotating plumbline was used at this point. Evidence may exist in a deeper layer of the intonaco, beneath the painted plaster. I was most grateful to Dr Mancinelli for discussing this problem with me (July 1993).

44. See discussion of the use of X-ray machines and computers in the examination of the frescoes, reported by Philip Elmer-DeWitt, "Old Masters, New Tricks," *Time International* 134 (18 December 1989): 50–51. The existence of arcs or straight lines discovered in the sinopia and corresponding to the suggested "circles" or "rays" of the design might verify the central point of construction of the circular composition (as in figs. 52, 53) but these would be deep beneath the surface layers, which were cleaned and exposed during the cleaning and restoration process. There may be remains also of the partially destroyed frescoes, which previously decorated the wall still further underneath.

45. The Vulgate reads: "Et habet in vestimento, et in femore suo scriptum: Rex regum et Dominus dominantium"; taken from *Bibliorum Sacrorum; Latinae Versione Antiquae,* ed. D. Petri (Sabatier: Brepols, 1981), 3:1,028.

46. The "angel" here is identified with Christ as the "Mighty Angel" of Revelation; Caird, *Revelation of St. John*, 125–26. The reference to Rev. 19:17 interestingly brings to mind the painting of the same name (*The Angel Standing in the Sun*, 1846), in the Tate Gallery, London, by J. M. W. Turner, whose obsession with sun and light effects is well known, relating to his reputed deathbed pronouncement, "The sun is God." See M. Butlin and E. Joll, *Paintings of J. M. W. Turner* (New Haven: Yale University Press, 1984), vol. 2, plate 431.

47. Steinberg, "Corner of *Last Judgment*," 240 and plates 7 and 9.

48. Steinberg, "Corner of *Last Judgment*," 240, quotes Goethe for corroboration: "Did not Goethe declare, 'Every ethical expression pertains only to the upper part of the body'?" Steinberg returns to the examination of the same theme in a recent renewed discussion of his theory of the "Slung Leg" of the Florentine *Pietà* (Steinberg, "The Missing Leg, Twenty Years After"), but here he describes Goethe's dictum as "silly" (495). He insists that widespread objections to his theory concerning Christ's "Missing Leg" are simply based on "the scandalous notion that Michelangelo would involve an inferior limb in Christological symbolism" This Freudian interpretation appears inappropriate to anyone familiar with the immense significance of Rev. 19:16.

49. For further examples, see Heninger, "The Human Microcosm," chap. 5 in *Cosmographical Glass,* 144–58; W. Kenton, *Astrology, The Celestial Mirror* (New York: Avon, 1974), plate 27 and figs. 30, 34, 64, 67. For Michelangelo's own comment on the symbolic relationship between the limbs of man and architecture, see Ramsden, *Letters*, no. 358 (dated 1550), 2:129, which derives from Vitruvius, *De Architectura*, bk. 3.

50. See Chastel, *Humanism*, fig. 179; also Wittkower, *Architectural Principles*, 13, 19, for the circle as symbolic of God and "rooted in Neoplatonism." Wittkower further adds, "the geometry of the circle had an almost magical power over these men."

51. Gen. 24:2–3 and 47:29 ("put thy hand under my thigh. And I will make thee swear by the Lord . . ."); cf. also Jer. 31:19.

52. For example, Ps. 45:3 ("gird thy sword on thy thigh O most mighty"); Song of Sol. 3:8; Judg. 3:16 and 15:8.

53. Shapiro, *Late Antique, Early Christian and Medieval Art*, chap. 5, pp. 125–30, comments on the symbolic significance of the thigh in Christian iconography and detects an emphasis on it in several early manuscripts illustrating the Apocalypse (for example, the so-called Trier Apocalypse). The *Last Judgment* was more often based on sources in the Gospels, but references to the Apocalypse were commonly included, for which see Montague Rhodes James, *The Apocalypse in Art* (Oxford: Oxford University Press, 1931). See also Dürer's two *Apocalypse* series, which feature similar themes, like the "woman clothed with the sun" and the Apocalyptic Sun-Christ (Strauss, *Complete Engravings*, figs. 25, 27, 51, 85).

54. Caird, *Revelation of St. John the Divine*, 246–47.

55. R. C. H. Lenski, *The Interpretation of St. John's Revelation* (Minneapolis: Augsburg, 1963), 556; Homer Hailey, *Revelation: An Introduction and Commentary* (Grand Rapids: Baker, 1979), 386; William Barclay, *The Revelation of St. John* (Edinburgh: St. Andrews Press), 1960, 235.

56. T. LaHaye, *Revelation: Illustrated and Made Plain* (Grand Rapids: Zondervan, 1975), 264.

57. Tolnay, *Michelangelo*, 5:22 and 2:6.

58. Ettlinger, *Sistine Chapel*, 14.

59. See *Catholic Missal*, ed. cit., 1245–49. The lesson for the Vigil of All Saints is Rev. 5:6–12 ("And I John saw in the midst . . .") and for All Saints itself is Rev. 7:2–12 ("I John saw a second Angel Coming . . .").

60. This very special festival of the last Sunday of October was decreed in 1925

by Pope Pius XI, but, as he stated in the encyclical giving reasons for the festival and its celebration at the end of October, it was based on an already existing and important tradition of Christ as King at the time of All Saints. This very ancient tradition, he said, associated the concept of Christ as King of Kings with the end of the liturgical year in October, at the time of "the glory of him who triumphs in all the saints and all the elect." Pope Pius cited the same biblical verse, Rev. 19:16 (see Claudia Carlen, *The Papal Encyclicals, 1903–1939,* (New York: McGrath, 1981), 271–79, esp. 273, 277).

61. *Catholic Missal,* ed. cit., xxxviii, 1237; also *Breviarium Romanum ex Decreto Sacrosancti Concilii Tridentini. Pars Autumnalis* (Turonibus: A. Mame et Filiorum, 1933), 786 ("Habet in vestimento et in femore suo . . ."). So strong is this theme in association with All Saints, that the biblical reference is used in Anglican worship at All Saints. The table of Lessons in the English Prayer Book gives Rev. 19:1–17 as the second lesson for evening prayer for the Festival of All Saints. The importance of the links between the liturgy and iconography, esp. in the Sistine Chapel, is demonstrated by Tolnay, *Michelangelo,* 5:35–36.

62. According to the diary book of the Sistine Chapel, 31 October 1541 was a Monday ("die lune ultima octobris") and the pope had returned from Bologna the day before (Redig de Campos, *Michelangelo,* 38 n. 67). Details are also given here of the fresco's inauguration to a wider audience the following Christmas.

63. See Rahner, *Greek Myths and Christian Mystery,* 154. For this theme, see also Jaroslav J. Pelikan, *Jesus through the Centuries* (New Haven: Yale University Press, 1985), esp. chap. 4, "King of Kings" 46–56 and chap. 5, "The Cosmic Christ," 57–70.

64. Ettlinger, *Sistine Chapel,* 76–93, esp. 86–87.

65. For example, Ficino, *De Amore,* 49–51; idem., *Philebus Commentary,* 244 (where he quotes Plato, *Laws*); and idem, *De Vita,* 1 (on the idea of birth from Jove's thigh).

66. Yates, *Giordano Bruno,* 71.

67. Hibbard draws attention to the inscription, "Sol Iustitiae Christus Deus noster regnat in aeternum," placed in 1529 in the audience hall of the Palazzo Vecchio (Hibbard, *Michelangelo,* 246).

68. See chap. 6 and Dante, *Inferno* 34:76–77. This idea has also been developed in a separate, unpublished, paper, "The Centre of the Universe in Dante's Cosmology."

69. The formal analysis, revealing the thigh as center and the biblical reference to support it, was realized on 28 February 1986.

Chapter 10

New Hypotheses

> Therefore alongside the ancient hypotheses, which are
> no more probable, let us permit these new hypotheses
> also to become known, especially since they are
> admirable as well as simple and bring with them a
> huge treasure of very skilful observations. So far as
> hypotheses are concerned, let no-one expect anything
> certain from astronomy [art history?], which cannot
> furnish it, lest he accept as the truth ideas conceived
> for another purpose, and depart from this study a
> greater fool than when he entered it. Farewell.
>
> —*Osiander*
> Preface to De Revolutionibus[1]

Art Historical Interpretation

The cleaning and restoration of Michelangelo's *Last Judgment* fresco brings
renewed emphasis to its brightness, particularly in the upper areas and
surrounding the Sun-Christ. The evidence of the mark on Christ's thigh
supports the theory that the composition of the fresco is formally centered
at this point. Although no actual hole is now visible on the surface of the
fresco, this does not exclude the possibility of its having been filled in.
Traces of a nail hole at this point, or the existence of underlying "arcs of
circles" may well exist in deeper layers of the wall in the intonaco or in the
sinopia. The mark has not been removed by cleaning, and it is impossible
to say whether an actual nail hole is concealed in a deeper layer. It is
simply not possible to state this positively, especially bearing in mind that
it is not known whether there are any remains of those earlier paintings on
the altar wall, by Michelangelo and others, which may have been wholly

or partly destroyed as the new surface for the *Last Judgment* was bound to the existing wall surface. The mark appears intentional and permanent. So the probability remains.

The cleaning and restoration of the *Last Judgment* has, as with the frescoes on the ceiling, resulted in clearer, brighter colors and a greater emphasis on light and the sun than on the "dark desperate atmosphere" that has often been described. Although the fresco's exact original condition may never be regained precisely, the intention has been to achieve this as nearly as possible. Clearly, the fresco may now be viewed once more in those terms perceived by early copyists such as Rota, who evidently viewed it in terms of light and sun symbol, to judge by his engraving of 1569 (fig. 65). Here, in the black and white engraving, rays are used to indicate the brightness of the sun, which contrasts with the darkness of the lower areas. The cleaning and restoration work thus appears appropriate in terms of more nearly presenting the work according to its original appearance.

It is not possible to prove conclusively the biblical source and constructional basis of Michelangelo's *Last Judgment*, nor does the main argument rest upon this deduction. However, the apparent use of a formal constructional device underlying the composition of the fresco and centered upon a point based on a relevant Scriptural source does seem to confirm the issue of circularity and to tie all the previous cosmological arguments together. Definite evidence of the use of Christ's thigh as the pivot of the composition would tend to verify the present interpretation of the fresco, but the broader interpretation, which links together the concept of the Apollonian Sun-Christ, the idea of God as the center of the circular system of the universe, and the specifically Copernican analogy, does not rest solely on this final point. Each stage of the argument is related but at the same time independently viable. Although it is difficult conclusively to prove this hypothesis, the weight of evidence built up amongst the theological, philosophical, and literary sources does tend to confirm it.

The sources examined, with the exception of Copernicus' writings, have been suggested in the literature as influential upon different works by Michelangelo, and they are, according to this present argument, finally brought together in this most important late work. The discussion has not been based on obscure or arbitrary sources used to force meaning or superimpose an interpretation. The accepted sources simply have been examined in a different way, as a result of the realization that Tolnay's dismissal of *direct* Copernican influence, which had been uncritically transmitted for so long, was unreasonable. The linking of the accepted sources with the specifically documented interest in Copernicus, which took place at exactly the right moment just prior to the commission, leads to the full interpretation developed here. The key piece of evidence, the 1533 lecture on Copernican ideas given in the Vatican before Clement VII, may be used as a final historical fact to reinforce an already strongly

developed argument based on the correspondence between visual elements and theological, literary, and philosophical factors. Even though these areas have been examined in separate chapters here for the purposes of discussion, the highly interwoven and interdisciplinary aspects of humanity's view of the sun during the Renaissance will have become clear. The possibility of a direct connection between the cosmological symbolism found in this material and Michelangelo's fresco seems plausible and, in addition, seems to be related to the idea of Michelangelo's knowledge of the Copernican universe, knowledge that may reasonably be argued. Indeed, arguing "backwards" and considering the proliferation of cosmological concepts concerning the circular universe and the deity as sun in a mass of theological, literary, and philosophical works familiar to Michelangelo, together with his probable recent exposure to Copernicus' heliocentric theory (which would surely have recalled the more traditional cosmological symbols to both artist and patrons), it begins to seem impossible that Michelangelo conceived the *Last Judgment* in any other way.[2]

It was acknowledged by early observers that the fresco did contain certain hidden meanings, and the way the religious, philosophical, and scientific aspects of the argument all accord and correspond closely with the actual physical disposition of the fresco seems to render the present explanation probable if not provable. Short of the discovery of handwritten explanatory notes by the artist, concrete proof of this type of art historical interpretation is virtually impossible to establish. Plausibility is the keynote. It is not simply a question of correcting a few points of detail or discovering a few new facts: a whole new frame of reference for complex underlying ideas is being built up, with the intention to reconstruct as much as to rediscover. If the weight of evidence consistently adds up to a sufficiently convincing argument, with nothing in contradiction, then that argument is worthy of serious consideration and the hypothesis may be considered to be satisfactory, not as "absolute truth" but (as in a court of law) "beyond all reasonable doubt."[3]

Modern art historical method, which embraces what Gombrich terms "historical detective work"[4] within this type of interdisciplinary framework, has been carefully discussed in the literature. The arguments of Gombrich, Wind, and Panofsky in particular have attempted to determine the method and purpose of an iconological approach.[5] Panofsky determines the differences between iconography and iconology and evaluates the process of analysis, divided into different levels of meaning from primary or natural subject matter to the existence of intrinsic meaning which may be hidden; Professor Gombrich warns of the dangers of citing too many obscure sources, forcing a work into a preconceived mold, and reading in meanings that were clearly not the original intention of the artist.[6] Gombrich also warns of the problems that ensue when an iconological interpretation becomes too detached from formal art history. While it can

be argued that there may be different levels of meaning in a work, he says, the probable existence of a dominant theme in a work of art usually precludes the likelihood of multiple and divergent meanings. Each area of interpretation must appear to correspond with others, and if the whole sequence fits, then the possibility that it is due to accident or coincidence must be very remote.[7]

Better known examples of this type of interdisciplinary approach to art historical interpretation in Renaissance studies include works by Gombrich himself, as well as studies by Lavin and Ginzburg on Piero della Francesca and by Hartt and Steinberg on Michelangelo.[8] These authors have set out criteria by which iconological interpretation of an analytic type may be assessed. Steinberg requires of art historical interpretations that they should be "probable if not provable" and "make visible what had not previously been apparent," so that "the picture seems to confess itself." He points out the dangers of underestimating an art work as well as the problems of "overinterpreting."[9] Ginzburg requires that "every piece of the puzzle must fit into place" and "the pieces must form a coherent composition"; in addition, the simplest and neatest hypothesis should "generally be taken as the most probable."[10] Another factor deserving of consideration, but not often mentioned in the assessment of this type of art historical interpretation, is the author's state of conviction concerning the truth of his or her own hypothesis, which should also carry some weight, within the context of being "satisfied beyond all reasonable doubt."[11] In the case of the present interpretation of Michelangelo's *Last Judgment*, not only does the multiplicity of sources point to a single overall meaning, but the intellectual background also corresponds closely to the work's formal aspects.

Hypothesis or Truth?

The difficulties of distinguishing between truth and hypothesis were already recognized in the sixteenth century. In the absence of concrete proof of Copernicus' sun-centered view of the universe, the publisher Osiander, stressed the importance of reasoned hypothesis. As Osiander said of Copernicus' theory, it is important to consider new ideas and hypotheses, especially if they appear to be well argued and plausible, even though absolute certainty is not possible. Osiander chose to add his preface to present Copernicus' theory as hypothesis rather than truth, and he may well have done this to alleviate potential criticism of the heliocentric theory.[12] It is possible to argue that the theory survived because it was presented only as theory, not truth, an idea unlikely to have been put forward by Copernicus himself. Whether Widmanstadt

presented "Copernicus' teaching concerning the motion of the earth" to the pope as hypothesis or truth can never be known, but if the idea that it was influential upon such an important fresco is accepted,[13] this would seem to indicate that it was presumably proposed as truth, for an artist is surely less likely to incorporate a hypothesis.[14]

Space does not allow full philosophical discussion of the concept of truth here, nor the associated concepts of logic, probablity, and deductive reasoning.[15] It is perhaps enough to acknowledge that lack of absolute proof does not necessarily render a thing untrue.[16] The fact that Copernicus was unable to *prove* that it was the sun and not the earth at the center of our planetary system does not, of course, mean that the concept is not true.[17] As it happened, proof was found at a later date, by Galileo, and it was his telescopic observations that contributed to the final banning of *Revolutions*. Although the present art historical argument cannot be advanced as absolute truth, it may still serve to increase our understanding of the artist and his times and can be regarded as an eminently workable system of reference that explains many features of the work.

A Valid Framework

Michelangelo was nurtured on Ficino, then exposed to Valdésian and Evangelical thought, and commissioned to paint what was traditionally a cosmological subject at a time when Copernican heliocentricity was receiving a great deal of attention in Vatican circles. It seems highly probable that his interpretation of the *Last Judgment* could have developed out of the common ground shared by the different sources of knowledge suggested above (religious, literary, philosophical, and scientific), where the broad concept of the God-centered and sun-centered universe is pertinent to all these areas of source material.

It is, above all, Michelangelo's supreme synthesis of the whole, his combination of tradition and innovation, and his assimilation (rather than direct borrowing) from different areas of source material into his own personal expression that predominates. Michelangelo's *Last Judgment* is not a direct illustration of the Scriptures, Dante, Ficino, or Copernicus—nor of the quotations featured, by way of example, at the beginning of each chapter of this work. It is not to be claimed as the result of borrowings of individual features from a variety of existing artworks, such as versions of the *Last Judgment* by Giotto, Traini, Fra Bartolommeo, Signorelli, Early Christian sun symbols, Castagno's Beardless Christ of the *Resurrection*, Botticelli's illustrations to Dante's work, or the *Apollo Belvedere*, with which comparison has often been made (see figs. 36, 40, 45, 47, 72, 74, 80, 83, 104, 107). Nor can it be claimed as a naturalistic view of the sun itself and the phenomenon of light rays, although this, too, may well have played

a part, as it probably did in Dante's description of the Sun-Christ and his rays in *Paradiso* 23:72–80 (see fig. 127). Rather, it is a synthesis, conscious or even unconscious, of all these motifs. If, as is currently fashionable, it is necessary to make excursions into the realms of psychoanalysis in the study of Michelangelo's art, it might be necessary to study the ways in which previous visual experience may consciously or subconsciously affect the artist's formation of images. Although Vasari describes Michelangelo's exceptional capacity to remember and retain visual images,[18] the tracing of similarities is not necessarily proof of direct dependence,[19] and many factors can merge to produce a final result.[20]

It is in this fresco of the *Last Judgment* that the various elements in Michelangelo's thinking appear to come together in a single work. In addition, it is important to assess what further significance this analysis might have. Conclusions drawn from this study can provide information in a number of fields, first concerning the painting itself but also about Michelangelo's late works, about theology and philosophy in the mid-sixteenth century, about Copernicus' theory and reactions to it, and about the kind of questions in the history of ideas that concerned humanity in the late Renaissance/Reformation period.

As far as the work of the *Last Judgment* itself is concerned, this study, which differs substantially from previous interpretations, explains several unusual aspects that have long puzzled scholars. Apart from the assessment of the overall cosmological theme of the composition, it offers an explanation of apparently inexplicable features like the beardless Christ, who seems to be depicted like a sun-deity without being presented as a pagan solar god; the circular composition, which is contrary to all iconographic tradition; the presence of the cave over the altar; the unveiling of the fresco on 31 October and the special significance of an additional Christmas celebration; the reason for the abandonment of the scheme for the *Resurrection* and *Fall of Lucifer*; the probable constructional method used; and the reason why, while still retaining some traditional features, the work is so different from any previous treatment of the subject. The hypothesis is thus an eminently workable one.

Furthermore, there seem to be far too many coincidences (apart from the ubiquity of the major themes of sun-symbolism and cosmology) in the proposed source material for the hypothesis not to be considered seriously. Examples of these coincidences include: Dante's emphasis on Lucifer's thigh; the overlapping visits of Copernicus and Michelangelo in Rome and Bologna; the links between Ficino and Copernicus, through writings as well as through Paul of Middelburg at the Lateran Council; the presence of Michelangelo, Clement VII, and Paul III in both the house of Lorenzo de' Medici and at S. Miniato in 1533; the presence of Valdés as Clement's secretary; the probable date of Michelangelo's meeting with

127 Photographic study of sun and cloud effects. Photo:
Valerie Shrimplin, 1990.

Vittoria Colonna; the link between Widmanstadt, who gave the lecture on Copernicus to the pope, and Egidio of Viterbo, who probably advised Michelangelo on the Sistine ceiling; the relationship of Cardinal Salviati, present at Widmanstadt's lecture, to Michelangelo's friend Jacopo Salviati (the cardinal was Jacopo's son and also Michelangelo's *amico nostro*); the dating of Paul III's breve and Schönberg's letter (in November 1536—at a time when Widmanstadt was his secretary); the celebration on the Vigil of All Saints and its correspondence with the proposed biblical source of the fresco; above all, the dating of the Vatican lecture (June 1533) and the commission of the *Last Judgment* (September 1533); and finally, the visual appearance of Michelangelo's *Last Judgment* in its now cleaned and restored state.

Derived from the present interpretation of the real meaning of the fresco, further deductions can be made about Michelangelo's late period. According to this hypothesis, influences that previously have been relegated to different and separate periods of Michelangelo's *oeuvre* are combined in this late work. The complexity of his thought even at this late stage of his career shows that the simplistic approach that is often argued, namely, that of Neoplatonism in his early works and Catholic influences in his later works, no longer holds. Themes were integrated throughout his career as Neoplatonism was combined with Christian ideals. Neoplatonic ideas continued to function in the late works as a lifelong influence and are by no means to be regarded as classical and irreligious—and even less as pagan. Much of the existing literature attributes Neoplatonism to Michelangelo's early works, contrasting this with a later spirituality,[21] but readings that categorize the work of this artist simplistically into various Neoplatonic and religious stages are inappropriate. The two trains of thought are not to be regarded as mutually exclusive. Evidently Michelangelo's association with the *Spirituali* in the 1530s exerted a great influence upon the artist, but his interests in Neoplatonic and Dantean themes continued at this time and, as with other figures of the Catholic Reformation, were incorporated within a Christian framework. Similarly, as Hartt points out, it is unrealistic to maintain that Michelangelo had "ever been anything but profoundly religious." Christian and Neoplatonic themes have been acknowledged together in the Sistine ceiling.[22]

As far as the movement for Catholic Reform in the 1530s up to about 1542 is concerned, the study of the rendering of such an important fresco yields further information concerning Catholic attitudes.[23] It reinforces the concept of the Catholic Reformers' wishes to return to the ideals of the Early Christian church, as well as the importance of Christology and the view of Christ as Savior. Christ appears to be regarded less as an angry Judge than as a powerful Savior, according to biblical concepts that show that, while the damned will be condemned, the just have nothing to fear

from the Last Judgment.[24] It does not seem possible to categorize the painting simply as either benign or pessimistic. The atmosphere seems rather to be inspirational, where Christ is depicted as immensely powerful, neither as "gentle Jesus meek and mild" nor as a vengeful judge. The elements of hope and light (which the cleaning has revealed more fully) relate well to the problems of the age of Catholic Reform, when the Church was threatened but not in total gloom and despair. It has been said that the pessimism of the theme of Judgment relates to despair at the effect of the Reformation and the split in the Church, but at the time of the *Last Judgment* (1533–41) reconciliation with the Protestants was still very much envisaged. As the contemporary historian Guicciardini writes, Clement VII had great hopes for a solution to the major problems of 1533, including the secession of the English Church under Henry VIII.[25] The Sack of Rome in 1527 had taken place six years earlier and marked a particularly bad time for Italy and for the pope. Shameful captivity of Pope Clement was followed by rebellion in Florence, plague, and a humiliating peace treaty, but, as Guicciardini relates, by 1528 the pope, who had fallen from power, been held in captivity, and suffered the loss of Rome and his dominions, was "within the space of a few months . . . restored to liberty" and "once more restored to his former greatness."[26] Peace was established on terms not unfavorable to the pope, and the emperor assisted Clement in quelling the rebellion in Florence,[27] which "put an end to the long and grave wars which had continued for more than eight years with so many horrible occurrences."[28]

A call was made for a council to reform the Church, which displeased the pope because he feared loss of power, but he was able to stave this off, and tranquility continued through 1530–32. All this, added to the departure of the Turks from Eastern Europe and the removal of this contingent threat to Italy by 1532, meant that Pope Clement was once more in a strong position by the time of the commission of the *Last Judgment*. Just after the earliest preliminary discussions concerning the redecoration of the altar wall of the Sistine Chapel, Guicciardini relates the Pope's "incredible" joy over the marriage treaty with France (the betrothal of his niece Catherine de' Medici in late 1533), and how he then "returned to Rome with the greatest reputation and marvelous happiness, especially in the eyes of those who had seen him prisoner in the Castel Sant' Angelo." This hardly describes an atmosphere of doom and pessimism in late 1533/early 1534.[29] As in the metaphor of Plato's Cave, the pope and his entourage had come out of the darkness and into the light in the years 1528–33.

Clement's sense of success was short-lived for he died soon afterwards, but his successor Paul III, who saw the commission unchanged through to its conclusion, similarly experienced quite a strong position. The relationship between patron and artist, which was deemed rather special

in the case of Michelangelo, has supported the idea that the program or approach to the fresco was probably discussed and approved by the two popes concerned. According to the doctrine of free will, which was also emphasized by Dante in the *Divina Commedia,* the choice of repentance and forgiveness lies with the individual. Such ideas stressed by the movement for Catholic Reform (and the Nicodemists) contrast with the stricter attitudes of the Counter-Reformation, with which Michelangelo does not appear to have been so involved.[30] In any case, the fresco predates the Counter-Reformation proper, the inception of which is usually dated from 1542, and it was largely members of the Counter-Reformation (after the first session of the Council of Trent 1545–47) who campaigned to have the fresco destroyed.[31]

Scientifically speaking, the cosmological and Copernican interpretation of Michelangelo's fresco may be regarded as further evidence of the early acceptance of the heliocentric theory within the upper reaches of the Catholic Church. This is particularly significant because of the turnabout of the Catholic Church in the early seventeenth century, and especially in view of often held misconceptions concerning the position of Copernicus and the potential heresy of his theory at the time of its publication. Even if the theory escaped condemnation for so long because it was regarded as hypothesis only, the fact remains that it was not condemned as heresy at the time, and it did apparently tie together several aspects of existing philosophical and scientific thinking in placing the sun, regarded by contemporaries as an analogy of the deity, at the center of the universe. The theory apparently fitted in extremely well with the Renaissance background and attitudes, and this perhaps helps to explain why there was at first little objection to it. The final waning of the medieval view is confirmed, alongside the solving of problems, such as the Hell-centered universe, inherent in the spherical geocentric system of thinkers like Dante Alighieri.

Finally, the interdisciplinary nature of this study appears significant for the light it may shed on the history of ideas in the sixteenth century and the wider context of humanity's view of the universe. The inclusion of Catholic, Dantean, classical, or Neoplatonic themes in Michelangelo's late work of the *Last Judgment* demonstrates that this type of inter-related thought was important in the mid-sixteenth century. Neoplatonism as a phenomenon of the Italian Renaissance was not something that flourished and died in late quattrocento Florence, but it continued to influence art and iconography (and indeed philosophy and even scientific thinking) well into the sixteenth century. It is, perhaps, the key to the understanding of the Renaissance as being classical without being pagan.[32] Concerned particularly with his own faith and salvation, Michelangelo in his *Last Judgment* created more than just a simple image of a scene from Revelation, as with its medieval counterparts; in a combination of tradition and innovation, the work shows involvement also with the widest range of

concepts. The type of questions raised by Michelangelo's fresco of the *Last Judgment* that concerned humanity at this stage of history are still pertinent to us at the start of the new millenium: the immense questions concerning human fate, life after death, salvation, and the immortality of the human soul, the human condition, and the relationship between sin and punishment. Michelangelo's sophistication is revealed here as the threats of Hellfire and boiling oil are omitted as disciplinary propaganda. Instead, his figures show a psychological aspect where conscience is regarded as a safeguard for human conduct. At the same time, the concept of light and hope is conveyed in the figures of the saved and in Christ himself. In its cosmological framework, the awesome concepts of the end of time and creation, and of the universe, are considered—whether space is infinite and time eternal.[33] To coin a word, what might be termed "telophobia," the fear of the end,[34] is a concept that is of perennial concern. Although viewed in terms rather different from the Christian *Last Judgment*, concern with the fate of our planet is still related to the idea of whether humanity is the master of its environment or whether it might be controlled by a greater force, be it physics or a deity.

Deductions made in the light of this interdisciplinary research into the intellectual background of Michelangelo's late period, and confirmed by direct analysis of the *Last Judgment* itself, demonstrate that it is important for the specifically cosmological and heliocentric interpretation of the fresco to be acknowledged and not dismissed, as it has been so far, because of misconstrued dating or unwarranted implications of heresy. To understand Michelangelo, including his late works, it is necessary to read Dante and Ficino, the Scriptures, and the artist's own poetry. To identify the "divine mysteries" and "profound allegorical meanings" of the Last Judgment, it is essential to recognize Michelangelo's overlapping and interweaving of the sources provided by the Gospels with the literature, philosophy, and science of the Renaissance. The Copernican theory of heliocentricity, combined with the Catholic Reformers' emphasis on Christian concepts that analogized Christ with the sun, Dante's cosmology and Neoplatonic sun-symbolism, would appear to present convincing sources for the overall iconography and circular composition of the fresco around a central Sun-Christ, and to provide a valid framework within which to consider, once more, Michelangelo's *Last Judgment*.

Notes

1. Concluding lines of Osiander's preface to Copernicus' *De Revolutionibus*, which was issued in the printed editions. See Nicholas Copernicus, *De Revolutionibus*, ed. cit., xvi. The question of "certainty" in art historical hypotheses as well, including the present one, would appear to share common features.

2. This method is used by Baxandall in *Patterns of Intention*.

3. The concept of "absolute certainty" is avoided in the legal systems of the western world. See, for example, John Henry Wigmore, *Evidence*, 10 vols. (Boston: Brown, 1981 ed.), esp. vol. 9, for discussion of the problem of proof and evidence; also L. Jonathan Cohen, *The Probable and the Provable* (Oxford: Clarendon, 1977), esp. 247–52, "Proof Beyond Reasonable Doubt," and 252–56, "Proof on the Preponderance of Evidence."

4. Ernst H. Gombrich, "Aims and Limits of Iconology," in *Symbolic Images: Studies in the Art of the Renaissance* (Oxford: Phaidon, 1972), 1–25, here at p. 6.

5. Gombrich, *Symbolic Images*, 1–22; Wind, *Pagan Mysteries*, esp. chap. 1, "The Language of Mysteries"; Panofsky, *Studies in Iconology*, chap. 1, pp. 1–31.

6. Panofsky, *Studies in Iconology*, esp. 1–17; idem, *Meaning in the Visual Arts*, 54; Gombrich, *Symbolic Images*, 18; see also, Mieke Bal and Norma Bryson, "Semiotics and Art History" *Art Bulletin* 73 (June 1991): 174–208, and subsequent discussion, *Art Bulletin* 74 (September 1992): 522–31.

7. Gombrich, *Symbolic Images*, 19–20

8. For studies of this type, see for example, Gombrich, "Botticelli's Mythologies," in *Symbolic Images*, 31–81; Marilyn Aronberg Lavin, *Piero della Francesca's Baptism of Christ* (New Haven: Yale University Press, 1981); Carlo Ginzburg, *The Enigma of Piero*, (London: Verso, 1985); Frederick Hartt, *David by the Hand of Michelangelo: The Original Model Discovered* (London: Thames and Hudson, 1987); L. Steinberg, *Michelangelo's Last Paintings* (Oxford: Phaidon, 1975).

9. Steinberg, *Michelangelo's Last Paintings*, preface.

10. Ginzburg, *Enigma of Piero*, 21, also introduction by Peter Burke, entitled "Carlo Ginzburg, Detective," (1–4). For the deductive process, see also Umberto Eco and Thomas Albert Seboek, eds., *The Sign of Three* (Bloomington: Indiana University Press, 1983), esp. Carlo Ginzburg, "Morelli, Freud and Sherlock Holmes: Clues and Scientific Method," 81–118.

11. Gombrich, "Botticelli," 31–32, and Steinberg, "Line of Fate," 107, and "Corner of the *Last Judgment*," 240, 256, 260, seem to express some doubts concerning their own ideas.

12. As mentioned, Copernicus' own motives concerning delay in publication were rather for fear of ridicule by the ignorant than for fear of persecution.

13. The incorporation of scientific theory in art has also been claimed for our century, showing how ideas at first in the possession of the intelligentsia gradually become "public property" even if not fully understood; as, for example, the influence claimed of general relativity on the Cubists, for which see Linda Dalrymple Henderson, *The Fourth Dimension and Non-Euclidean Geometry in Modern Art* (Princeton: Princeton University Press, 1983).

14. In fact, according to modern scientific theory, whether the earth moves around the sun or vice versa is irrelevant, suggesting that Osiander's point of view was way ahead of his time. According to Einstein's theory of general relativity, either view may present a workable system of coordinates, which renders the struggle between the Ptolemaic and Copernican systems quite meaningless. Einstein explains this in his work for nonspecialists: Albert Einstein and Leopold Infeld, *The Evolution of Physics, From Early Concepts to Relativity and Quanta* (New York: Simon and Schuster, 1966), 212.

15. For which see, for example, John Leslie Mackie, *Truth, Probablity and Paradox: Studies in Philosophical Logic* (Oxford: Clarendon Press, 1973); Christopher John Fards Williams, *What is Truth?* (Cambridge: Cambridge University Press, 1976); Clark N. Glymour, *Theory and Evidence*, (Princeton: Princeton University Press, 1980).

16. For a biblical parallel, see John 3:1–15 and 20:25–29; regarding "Doubting Thomas," Jesus says, "Blessed are they that have not seen and yet have believed."

17. Scientifically speaking, of course, Copernicus was incorrect in placing the sun

at the center of the universe, although it does lie at the center of our planetary system (more correctly, at one of the foci of the elliptical orbits of the planets). The earth and other planets revolve around the sun but the sun, in turn, possesses movement imparted by the rotation of our galaxy.

18. Quoted and discussed by Panofsky, *Studies in Iconology*, 171.

19. It has been argued, for example, that, consciously or otherwise, Traini's Christ of the *Last Judgment* is the probable source for Michelangelo's (Von Einem, *Michelangelo*, 155), that the pose of Duccio's figure of Mary is forerunner of Michelangelo's *David* (Wilde, *Michelangelo*, 39 and figs. 29 and 30), and that Maitani's figure of a damned soul is the source for Michelangelo's Christ in the Florentine *Pietà*: Frederick Hartt, *Michelangelo's Three Pietàs* (New York: Abrams, 1975), 83, followed by Liebert, (*Psychoanalytic Study*, 398–401)—as if those artists could "invent" those poses while Michelangelo could not.

20. See Jean Piaget and Barbel Inhelder, *The Psychology of the Child* (New York: Basic Books, 1969), sec. 3, chaps. 3 and 4, "Drawing" and "Mental Images," for influences on the formation of visual images. Freud's famous analysis of Leonardo examines such themes but focuses on underlying sexual motivation, which remains questionable; see Sigmund Freud, "Leonardo da Vinci and a Memory of His Childhood," in *The Standard Edition of the Complete Psychological Works*, ed. James Strachey, 24 vols. (London: Hogarth Press, 1953–74), 11:63–137. This type of analysis has often been applied to Michelangelo. An interesting recent study by Peter Gay raises the question of whether it is possible to "psychoanalyze the dead," and discusses Geoffrey R. Elton's admonitions against the prevalence of "some pretty awful bits of Freudian or post-Freudian commonplaces" in analyses of historical figures: Peter Gay, *Freud for Historians* (Oxford: Oxford University Press, 1985), 5 and 9.

21. For example, Liebert, *Psychoanalytic Study*, 294 ("[Michelangelo] relinquished Neoplatonism and turned to Christian beliefs in the 1530s"), 312 ("battle between Christianity and Neoplatonism") and 340 and 355–56 ("pagan quality of Michelangelo's painting," "pagan substratum of the fresco"); Herman Arend Enno van Gelder, *The Two Reformations in the Sixteenth Century* (The Hague: Nijhoff, 1964), 95–97; Blunt, *Artistic Theory*, 70; Chastel, *Humanism*, 320 n. 46; Réau, *Iconographie Chrétienne*, 753–54 ("le paganisme foncier de Michel-Ange" and "le triomphe de la paganisation de l'art chrétien" [*Last Judgment*]); Steinberg, "Merciful Heresy" ("Colonna . . . the agent of his religious conversion"), idem, "Line of Fate," 208 ("recently undergone a profound religious conversion"). See also Eugenio Garin, "Thinker," in Salmi, *Complete Works*, 517–30, for Michelangelo and Neoplatonism.

22. Hartt, "Evidence for the Scaffolding of the Sistine Ceiling," 285. One has only to contemplate the early Rome *Pietà* of 1499 to reject the idea of Michelangelo as "pagan" at any stage.

23. As with the study of the Florentine *Pietà* (see Shrimplin, "Michelangelo and Nicodemism," and "Once More, Michelangelo and Nicodemism"). As far as other late works are concerned, it is interesting that the drawing known as the *Dreamer* of 1533 is suggestive of the earth (in the form of human beings depicting the Seven Deadly Sins) in a circular formation around a globe or sun (Tolnay, *Michelangelo*, 5:181 and fig. 131). The circular emphasis in the Pauline frescoes (*The Conversion of Saint Paul*, 1542–45, and the *The Crucifixion of Saint Peter*, 1546–50) has also received comment (Tolnay, *Michelangelo*, 5:70–77 and figs. 58 and 59). The way in which the picture space in both of these works tips forward toward the viewer could be read as suggestive of a moving or rotating earth.

24. As for example, John 3:17, where Nicodemus is told that Christ is sent to save, not condemn; and 1 Cor. 15:55 ("O death, where is thy sting? O grave, where is thy victory?")—references already cited and also emphasized in the *Beneficio di Cristo*, where it is maintained that to doubt salvation is to "call God a liar" (ed. cit., 56. 58, 60). Michelangelo

himself wrote in a letter to his father (1510), "God has not created us in order to abandon us," in similar optimistic vein (Murray, *Michelangelo, Life, Work and Times*, 63). For further discussion of Christological meaning, see Dixon, "Christology of Michelangelo," and idem, "Michelangelo's *Last Judgment:* Drama of Judgment or Drama of Redemption?"

25. Guicciardini, *History of Italy,* 401–405.

26. Guicciardini, *History of Italy,* respectively 384–90, 391–92, 394, 397, and 398. Ramsden also refers to the period as "relatively peaceful" and to the "triumph" of the marriage treaty with France (*Letters*, 2:286).

27. The Treaty of Barcelona between pope and emperor and the Treaty of Cambrai between the emperor and the king of France, manipulated by Salviati and Schönberg, were signed in the summer of 1529 (*Letters*, 408–12). Florence was brought back under Medici rule in 1530, with the assistance of the emperor (*Letters*, 417–18 and 430).

28. *Letters*, 425.

29. *Letters*, 440. Compare Chastel et al. *Sistine Chapel,* 181 (a period of "catastrophe").

30. Authors who emphasize the expression of Counter-Reformation attitudes include Redig De Campos, *Michelangelo, Last Judgment,* 85.

31. See esp. De Maio, *Michelangelo e la Controriforma*, esp. chap. 9, pp. 409–32.

32. For information on the later influence of Neoplatonism, see Robb, *Neoplatonism*, and Shorey, *Platonism Ancient and Modern.*

33. Compare modern scientific cosmology, such as, for example, Weinberg, *The First Three Minutes*, and Paul Davies, *The Last Three Minutes* (London: Weidenfeld and Nicolson, 1994), where the beginning and end of the universe are explained (respectively) in scientific as opposed to theological and philosophical terms. It is interesting that Davies deals partly with the end of our planet as well as the end of the universe (and that his introductory scenario of "the end" (2) reads almost like a description of Michelangelo's *Last Judgment*).

34. From the Greek τελος—"end."

Appendix 1

Selected Versions of the *Last Judgment*, Sixth through Seventeenth Centuries

Information includes date, artist if known, present location, and medium. Figure numbers of those illustrated in the present text are indicated. Alternatively, a source of illustration or further information is provided.[1]

Early Christian, Byzantine, Medieval

1	6th C.	Cosmas Indicopleustes, m/s.	fig. 15
2	7th C.	St. Peter's, Rome, wall painting.	Redig de Campos, *Michelangelo,* 70
3	9th C.	Sacra parallela, Paris, m/s.	fig. 16
4	c. 1000	Reichenau Psalter, Bamberg, m/s.	Künstle, *Ikonographie,* fig. 297
5	11th C.	Bamberger Apocalypse, msc.	Künstle, *Ikonographie,* fig. 298
6	c. 1028	Panaghia Halkeon, Thessaloniki, frsc.	Lazarev, *Storia,* 158
7	11th C.	Psalter, no. 752, fol. 44, Vatican, msc.	Ainalov, *Origins,* 42
8	11th C.	Byz. Paris. Bibl. Nat. Gr. 74, fol. 51, m/s.	Tolnay, *Michelangelo,* vol. 5, fig. 260a
9	11th C.	Plut. 9. cod. 28, (copy of no. 1), Biblioteca Laurenziana, Florence	Beckwith, *Early Christian and Byzantine,* p. 182
10	1072–87	S. Angelo in Formis, frsc.	fig. 19
11	1175	S. Michael, Burgfelden, frsc.	Demus, *Romanesque,* fig. 241
12	c. 1100	St. George, Oberzell, frsc.	fig. 18
13	11th C.	St. Jouin de Marne, frsc.	Bréhier, *Art Chrétien,* 291

Twelfth Century

14	1105–28	Angoulême, sc.	Bréhier, *Art Chrétien,* 290
15	1115–25	Ste. Foy de Conques, Avreyon, sc.	fig. 23
16	1115–36	Moissac, sc	Focillon, *Romanesque,* fig. 102
17	1129–43	Palatine Chapel, Palermo, msc.	Réau, *Iconographie,* 735.
18	1130–40	Gislebertus, Autun, sc.	fig. 22
19	1135	Beaulieu, Correze,	Hughye, *Larousse,* fig. 596
20	12th	C. Carennac, Lot, sc.	Focillon, *Romanesque,* fig. 99
21	1135–44	St. Denis, Paris, sc.	fig. 24
22	1150	St. Trôphime, Arles, sc.	Bréhier, *Art Chrétien,* 290

23	1160–1225	Laon, sc.	Mâle, *Gothic Image*, fig. 172
24	12th C.	C. Benedictine altarpiece in Vatican.	fig. 21
25	1163–1250	Notre Dame, Paris, sc	fig. 25
26	1174–82	Monreale, Sicily, msc.	Réau, *Iconographie*, 735
27	late-12	C. Sta. Maria Assunta, Torcello, msc.	fig. 20
28	1185	Porte de St. Gall, Bâle, sc.	Réau, *Iconographie*, 749
29	12th	C. Mount Sinai, icon.	Nelson, "Genoa," fig. 18
30	late-12	C. Bordeaux Cathedral, sc.	Mâle, *Gothic Image*, fig. 177
31	late-12	C. St. Sulpice, Favières, sc.	Mâle, *Gothic Image*, fig. 178
32	late-12	C. Portail des Libraries, Rouen, sc.	Mâle, *Gothic Image*, fig. 180
33	1194	Wolfenbutteler evangeliar, m/s.	fig. 17
34	1196	Antelami, Baptistery, Parma, sc.	Künstle, *Ikonographie*, fig. 301

Thirteenth Century

35	1200–60	South portal, Chartres, sc.	Aubert, *Gothic*, fig. 181
36	1210–75	West portal, Bourges, sc.	fig. 26
37	1211–90	North portal, Rheims, sc.	Aubert, *Gothic*, fig. 194
38	1220–88	West portal, Amiens, sc.	Mâle, *Gothic Image*, fig. 179[2]
39	c. 1235	Princes portal, Bamberg, sc.	Künstle, *Ikonographie*, fig. 305
40	1246 SS.	Quattro Coronati, Rome, frsc.	fig. 30
41	1250–90	Leon Cathedral, Spain, sc.	Martindale, *Gothic*, fig. 93
42	1259	Nicola Pisano, Pisa Baptistery, pulpit, marble, sc.	Pope-Hennessy, *Gothic*, 3
43	1265–68	Nicola Pisano, Siena, pulpit, marble, sc.	Pope-Hennessy, *Gothic*, 4
44	1270–1330	Lorenzo Maitani, Duomo, Orvieto, marble, sc.	fig. 31
45	1290–1301	Giovanni Pisano, Pistoia, pulpit, marble, sc.	fig. 29
46	c. 1293	Cavallini, S. Cecilia, Rome, frsc.	fig. 32
47	late-13	C. Coppo di Marcovaldo, Florence Baptistery, msc.	fig. 33
48	late-13	C. Guido of Siena, Grossetto, frsc.	Schmeckebier, *Handbook*, 40
49	1296	Lagrasse, Aude, France, frsc.	Deschamps, *Peinture Murale*, pl. 5
50	c. 1290	Cimabue, Upper Church, S. Francesco, Assisi, frsc.	fig. 35

Fourteenth Century

51	1305–08	Giotto, Arena Chapel, Padua, frsc.	fig. 36
52	14th C.	Giovanni da Modena, S. Petronio Bologna, frsc.	Chastel, *Sistine Chapel*, 183
53	1308	Cavallini (and assistants), Sta Maria, Naples, frsc.	Schmeckebier, *Handbook*, 9
54	c. 1310	Giovanni Pisano, Pisa Duomo pulpit, marble, sc.	Ayrton, *Giovanni Pisano*, fig. 299
55	1310	S. Lorenzo, Genoa, frsc. Nelson, "Genoa,"	fig. 3
56	1317–20	Pietro da Rimini, Sant'Agostino, frsc.	Smart, *Italian Painting*, fig. 163.
57	c. 1320	Christ in Chora, Constantinople, msc.	Rice, *Byzantine Art*, pl. 6.[3]
58	1336	Maso di Banco (Giottino), Bardi chapel S. Croce, Florence, frsc.	Schmeckebier, *Handbook*, 29

59	14th C.	Bolognese school, Pinacoteca, Bologna, alt.	fig. 41
60	1345–57	Nardo di Cione, Strozzi chapel, Novella, Florence, frsc.	S. Maria figs. 37, 38
61	1349	Lombard School, Milan, S. Viboldone, frsc.	Schmeckebier, *Handbook*, 64
62	c. 1350	Orcagna, S. Croce, Florence, frsc. (fragments).	fig. 39
63	mid-14 C.	Follower of Giotto, Bargello, Florence frsc. (fragment).	fig. 43
64	mid-14 C.	Master of the Bambino Vispo, alt. (now in Munich).	fig. 42
65	1355	Magl. II.I, 212, f. 64v. Florence, Biblioteca Nationale, m/s	Meiss, *Florence and Siena,* fig. 90
66	1360	Traini (otherwise attr, Orcagna or Buffalmacco) Campo Santo, Pisa, frsc.	fig. 40
67	mid-14 C.	Niccolo di Tommaso, Livorno, alt.	Meiss, *Florence and Siena,* 76
68	1365	Andrea da Firenze, Spanish chapel S. Maria Novella, Florence, frsc.	Schmeckebier, *Handbook,* 32
69	1368	Lombard School, Lentate, Milan, frsc.	Schmeckebier, *Handbook,* 64
70	1370s	Antonio Veneziano, Torre degli Angeli	Schmeckebier, *Handbook,* 36

Fifteenth Century

71	1424	Jan van Eyck, New York, Metropolitan Museum, alt.	fig. 27
72	1430	Stephan Lochner, Cologne, alt.	Réau, *Iconographie,* 756
73	1430	Fra Angelico (or follower), San Marco.	fig. 45
74	1430s	Fra Angelico, Galleria Corsini Rome, alt.	fig. 44
75	1445–48	Fra Angelico (or Zanobbi Strozzi) Berlin, alt.	Pope-Hennessy, *Fra Angelico,* fig. 33
76	c. 1445	Fra Angelico, Orvieto, frsc.	Pope-Hennessy, *Fra Angelico,* fig. 121
77	15th	C. Bertoldo di Giovanni, medallion.	Tolnay, *Michelangelo,* vol. 5, fig. 276
78	1445	Giovanni di Paolo, Bologna, alt.	Tolnay, *Michelangelo,* vol. 5, fig. 270
79	1445–52	Rogier van der Weyden, Beaune, alt.	fig. 28
80	1448	Vecchietta, Sta. Maria Annunziata Siena, frsc.	Van Os, *Vecchietta,* fig. 28
81	1455	Petrus Christus, Berlin, alt.	Friedlander, *Early Netherlandish,* vol. 1, pl. 77a
82	mid-15	C. Domenico di Bartolo, Sta. Maria della Scala, Siena, frsc.	Réau, *Iconographie,* 749
83	c. 1470	Dieric Bouts, Munich, alt.	Friedlander, *Early Netherlandish,* vol. 3, pl. 126
84	1471	Ulm Cathedral, archway, frsc.	Künstle, *Ikonographie,* 548
85	1473	Hans Memlinc, Notre Dame, Danzig, alt.	Friedlander, *Early Netherlandish,* vol. 6a, fig. 8
86	1488	Voronets, Moldavia, frsc.	Stryzgowski, *Art Chrétien,* plate 58

87	c. 1490	Neamt, Moldavia, frsc.	Bréhier, *Art Chrétien*, 184
88	1490	Martin Schongauer, Brisach, frsc.	Réau, *Iconographie*, 756
89	1496	Illustration to Savonarola's *Arte del ben Morire*, woodcut.	fig. 47
90	1499–1500	Fra Bartolommeo, S. Marco, Florence, frsc.	fig. 46

Sixteenth Century

91	1500	Albi Cathedral, frsc.	Bréhier, *Art Chrétien*, 394
92	1500	Signorelli, Capella Brizio, Orvieto, frsc.	figs. 48, 49
93	c. 1500	Cranach, Berlin, alt.	Bax, *Bosch and Cranach*, fig. 1
94	1503–04	Bosch, Venice, alt.	Bax, *Bosch and Cranach*, fig. 11
95	1510	Dürer,[4] Washington, woodcut	Harbison, *Last Judgement*, fig. 13
96	1525	Jean Provost, Bruges, alt.	Friedlander, *Early Netherlandish*, vol. 2, fig. 207
97	1526	Lucas van Leyden, Leyden, alt.	Friedlander, *Early Netherlandish*, vol. 10, fig. 113
98	1533–41	Michelangelo, Sistine Chapel, frsc.	see fig. 1 and details

Post-Michelangelo[5]

99	1546–56	Pontormo, S. Lorenzo, drawing for frsc. (now destroyed).	fig. 67
100	1551	Pieter Pourbus, Musée Communal de Beaux Arts, Bruges, alt.	De Maio, *Michelangelo*, fig. 19
101	1550	Herman tom Ring, Vienna, dwg.	Benesch, *Renaissance*, fig. 74
102	1560	Giorgio Vasari, S. Maria del Fiore, Florence, frsc.	fig. 68
103	1566	Tintoretto, Madonna dell'Orto, Venice oil on canvas.	Newton, *Tintoretto*, fig. 18
104	1580–83	Bastianino, Ferrara cathedral, apse frsc.	Tolnay, *Michelangelo*, vol. 5, fig. 289
105	1589	Tintoretto, oil sketch for *Paradiso*, Paris, Louvre.	fig. 69
106	1589	Tintoretto, *Paradiso*, Doge's Palace Venice	Réau, *Iconographie*, 756
107	1615–19	Rubens, Munich, oil on canvas.	fig. 70
108	1618–20	Rubens, Munich, oil on canvas.	Baudouin, *Rubens*, 190

Appendix 2

_____Important Dates

1468	Birth of Alessandro Farnese, later Pope Paul III
1473	Birth of Nicolas Copernicus
1474	Birth of Giovanni de' Medici, later Pope Leo X
1475	Birth of Michelangelo Buonarroti
1478	Birth of Giulio de' Medici, later Pope Clement VII
1481	Landino's Neoplatonic _Commentary_ on Dante published
1490s	Michelangelo, Leo, Clement, and Paul in house of Lorenzo de' Medici
1496	Copernicus and Michelangelo in Bologna
1496	Ficino's translations and edition of Plato's works published
1500	Michelangelo and Copernicus in Rome
1512	31 October, unveiling of Sistine ceiling frescoes
1514	Copernicus' _Commentariolus_ in circulation
1514	Fifth Lateran Council
1524	Copernicus' _Letter against Werner_ in circulation
1527	Sack of Rome
1531	Satires on Copernicus in Northern Europe
1533	Valdés secretary to Clement VII
1533	Michelangelo in Rome until end of June
1533	Lecture on Copernicus in Vatican (probably June)
1533	Michelangelo in Florence (working on Laurentian Library, Medici Chapel)
1533	17 July, Sebastiano's letter concerning "a contract for such a thing . . ."
1533	22 September, Michelangelo, Clement VII, and Paul I at S. Miniato
1533	"Bayonne" drawing of _Last Judgement_
1533–34	Clement returns from successes in France; Michelangelo in Florence
1534	"Buonarroti" drawing of _Last Judgement_
1534	September, Michelangelo returns to Rome; Clement dies; Paul III elected pope
1535	April, scaffolding erected in Sistine Chapel for _Last Judgement_
1536	April, preparations complete
1536	March, probable date of Michelangelo's meeting Vittoria Colonna
1536	Between April and early summer, painting commenced
1536	1 November, Schönberg's letter to Copernicus urging publication
1536	17 November, Papal breve re: _Last Judgement_ commission
1537	_Consilium de Emendanda Ecclesia_ for Catholic Reform
1540	_Narratio Prima_ of Copernicus' theory published
1540	_Beneficio di Cristo_ written and in circulation

1541	Second edition of *Narratio Prima*
1541	Death of Valdés
1541	31 October, completion and unveiling of *Last Judgement*
1542	Revival of Inquisition; Death of Contarini; Apostasy of Ochino
1543	Death of Copernicus; publication of *Revolutions*
1545	First session of Council of Trent
1545	Opposition to Michelangelo's fresco and to Copernicus' heliocentric theory commences

Appendix 3

Letter of Nicholas Schönberg to Copernicus[6]

Nicholas Schönberg, Cardinal of Capua, to Nicholas Copernicus, Greetings.

Some years ago word reached me concerning your proficiency, of which everybody constantly spoke. At that time I began to have a very high regard for you, and also to congratulate our contemporaries among whom you enjoyed such great prestige. For I had learned that you had not merely mastered the discoveries of the ancient astronomers uncommonly well but had also formulated a new cosmology. In it you maintain that the earth moves; that the sun occupies the lowest, and thus the most central, place in the universe; that the eighth heaven remains perpetually motionless and fixed; and that, together with the elements included in its sphere, the moon, situated between the heavens of Mars and Venus, revolves around the sun in the period of a year. I have also learned that you have written an exposition of this whole system of astronomy, and have computed the planetary motions and set them down in tables, to the greatest admiration of all. Therefore with the utmost earnestness I entreat you, most learned sir, unless I inconvenience you, to communicate this discovery of yours to scholars, and at the earliest possible moment to send me your writings on the sphere of the universe together with the tables and whatever else you have that is relevant to this subject. Moreover, I have instructed Theodoric of Reden to have everything copied in your quarters at my expense and dispatched to me. If you gratify my desire in this matter, you will see that you are dealing with a man who is zealous for your reputation and eager to do justice to so fine a talent.

Farewell.

Rome
1 November 1536

Appendix 4

Copernicus' Preface to *De Revolutionibus*.[7]

To His Holiness, Pope Paul III:

I can readily imagine, Holy Father, that as soon as some people hear that in this volume, which I have written about the revolutions of the spheres of the universe, I ascribe certain motions to the terrestrial globe, they will shout that I must be immediately repudiated together with this belief. For I am not so enamoured of my own opinions that I disregard what others may think of them. I am aware that a philosopher's ideas are not subject to the judgment of ordinary persons, because it is his endeavor to seek the truth in all things, to the extent permitted to human reason by God. Yet I hold that completely erroneous views should be shunned. Those who know that the consensus of many centuries has sanctioned the conception that the earth remains at rest in the middle of the heaven as its center would, I reflected, regard it as an insane pronouncement if I made the opposite assertion that the earth moves. Therefore I debated with myself for a long time whether to publish the volume which I wrote to prove the earth's motion or rather to follow the example of the Pythagoreans and certain others, who used to transmit philosophy's secrets only to kinsmen and friends, not in writing but by word of mouth, as is shown in Lysis' letter to Hipparchus. And they did so, it seems to me, not, as some suppose, because they were in some way jealous about their teachings, which would be spread around; on the contrary, they wanted the very beautiful thoughts attained by great men of deep devotion not to be ridiculed by those who are reluctant to exert themselves vigorously in any literary pursuit unless it is lucrative; or if they are stimulated to the nonacquisitive study of philosophy by the exhortation and example of others, yet because of their dullness of mind they play the same part among philosophers as drones among bees. When I weigh these considerations, the scorn which I had reason to fear

on account of the novelty and unconventionality of my opinion almost induced me to abandon completely the work which I had undertaken. But while I hesitated for a long time and even resisted, my friends drew me back. Foremost among them was the cardinal of Capua, Nicholas Schönberg, renowned in every field of learning. Next to him was a man who loves me dearly, Tiedemann Giese, bishop of Chelmno, a close student of sacred letters as well as of all good literature. For he repeatedly encouraged me and, sometimes adding reproaches, urgently requested me to publish this volume and finally permit it to appear after being buried among my papers and lying concealed not merely until the ninth year but by now the fourth period of nine years.[8] The same conduct was recommended to me by not a few other very eminent scholars. They exhorted me no longer to refuse, on account of the fear which I felt, to make my work available for the general use of students of astronomy. The crazier my doctrine of the earth's motion appeared to most people, the argument ran, so much more the admiration and thanks would it gain after they saw the publication of my writings dispel the fog of absurdity by most luminous proofs. Influenced therefore by these persuasive men and by this hope, in the end I allowed my friends to bring out an edition of the volume, as they had long sought me to do

[Copernicus goes on to describe his dissatisfaction with the current system of astronomy, which resulted in his searching in the writings of the ancient philosophers. He explains how, building on the basic concept of the mobility of the earth, he then developed his own theory, which he outlines section by section, giving further references to his sources of inspiration and encouragement.]

Notes to Appendices

1. Short titles have been cited; for full details of source references, see bibliography. Abbreviations used in this section: m/s=manuscript; sc=sculpture; msc=mosaic; frsc=fresco; alt=altarpiece; dwg=drawing; o/c=oil on canvas; C=century; c=circa.

2. For other French examples, see Mâle, *Gothic Image*, 365, "scenes of the *Last Judgement* decorate almost all the cathedrals of the thirteenth century."

3. For other Byzantine examples, see Mâle, *Gothic Image*, 365 and Hughye, *Larousse*.

4. For other examples by Dürer and followers, see Harbison, *Last Judgement*, 271–76.

5. Versions so heavily influenced by Michelangelo as to be termed "copies" rather than independent works are not included here. See De Maio, *Michelangelo*, plates 8–35.

6. From Nicholas Copernicus, *De Revolutionibus Orbium Coelestium* (Nuremberg, 1543); facsimile edition, ed. Jerzy Dobrzycki, trans. Edward Rosen (London: Macmillan, 1978), xvii.

7. Written in 1542; from Copernicus, *De Revolutionibus*, ed. cit. 3–6.

8. This clearly indicates that Copernicus had been "accused" of keeping the completed work suppressed for nine years, that would be since 1533 (the year of the Vatican lecture). In fact, he says, it had been completed thirty-six years earlier — i.e., by 1506.

Bibliography

Ackerman, James Sloss. *The Architecture of Michelangelo*. Harmondsworth: Penguin. 1970.

Ainalov, Dmitri Vlasivich. *The Hellenistic Origins of Byzantine Art*. New Brunswick, N.J.: Rutgers University Press, 1961 (first ed. 1900–1901).

Alighieri, Dante. *The Divine Comedy: Inferno. Purgatorio. Paradiso*, 3 vols. Text and trans. Allen Mandelbaum. New York: Bantam, 1982–86.

———. *Convivio*. London: Dent, 1903.

———. *De Aqua et Terra*. London: Dent, 1925.

———. *Monarchia*, and *Letter to Can Grande*, in *The Latin Works of Dante Alighieri*. London: Dent, 1925.

Allen, A. *The Story of Michelangelo*. London: Faber and Faber, 1953.

Allen, Michael J. B., ed. and trans. *Marsilio Ficino: The Philebus Commentary*. Berkeley: University of California Press, 1975

———. "The Absent Angel in Ficino's Philosophy." *Journal of the History of Ideas* 36, no. 2 (1975): 219–40.

———. "Two Commentaries on the *Phaedrus*: Ficino's Indebtedness to Hermias." *Journal of the Warburg and Courtauld Institutes* 43 (1980): 110–29.

———, ed. and trans. *Marsilio Ficino and the Phaedran Charioteer*. Berkeley: University of California Press, 1981.

———. Review of Charles Boer, trans., "Marsilio Ficino: The Book of Life." *Renaissance Quarterly* 25 (1982): 65–72.

———. "Ficino's Theory of the Five Substances and the Neoplatonists' *Parmenides*." *Journal of Medieval and Renaissance Studies* 12, no. 1 (1982): 19–44.

———. *The Platonism of Marsilio Ficino*. Berkeley: University of California Press, 1984.

Anderson, Marvin W. "Luther's *Sola Fide* in Italy, 1542–1551." *Church History* 38 (1969):17–33.

Anderson, Ray Sherman. *Theology, Death and Dying*. Oxford: Basil Blackwell, 1986.

Andriani, Beniamino. *Aspetti della Scienza in Dante*. Firenze: Felice le Monnier, 1981.

Annas, Julia. *An Introduction to Plato's Republic*. Oxford: Clarendon Press, 1981.

Armitage, Angus. *The World of Copernicus*. New York: American Library, 1959.

———. *Sun, Stand Thou Still: The Life and Work of Copernicus the Astronomer*. London: Sigma, 1947.

Ariès, Philippe. *Western Attitudes Toward Death from the Middle Ages to the Present,* trans. Patricia M. Ranum. Baltimore: Johns Hopkins University Press, 1974.

Ariosto, Ludovico. *Orlando Furioso*, trans. Guido Waldman. Oxford: Oxford University Press, 1983.

Aristotle, *De Caelo*, trans. W. K. C. Guthrie. London: Heinemann, 1971.

Aubert, Marcel. *French Sculpture at the Beginning of the Gothic Period*. New York: Hacker, 1972.

———. *Gothic Cathedrals of France*. London: Kaye, 1959.

Augustine, St. "On the Immortality of the Soul," and "On the Magnitude of the Soul," ed. L. Schopp. in *Fathers of the Church Series*, vol. 4, pp. 3–50 and 51–152. Washington: Catholic University of America Press, 1947.

———. *City of God*, trans. Henry Bettenson. Harmondsworth: Penguin, 1984.

———. *Confessions*, trans. Vernon J. Bourke. Washington: Catholic University of America Press, 1953.

Badham, Paul. *Christian Beliefs about Life after Death*. London: MacMillan, 1976.

Bainton, Roland H. *Bernardo Ochino: Esule e riformatore senese del cinquecento, 1487–1563*. Florence: Sansoni, 1940.

———. *The Travail of Religious Liberty*. Hamden, CT: Archon Books, 1953.

———. *Early and Medieval Christianity*. Boston: Beacon Press, 1962.

———. "Man, God and the Church in the Age of the Renaissance." In W. Ferguson, ed. *The Renaissance: Six Essays*. New York: Harper, 1962.

———. *Erasmus of Christendom*. New York: Scribner, 1969.

———. "Vittoria Colonna and Michelangelo." in *Forum* (Houston) 9, no. 1 (1971): 35–41.

———. *Women of the Reformation in Germany and Italy*. Minneapolis: Augsburg, 1971.

Bal, Mieke and Norma Bryson, "Semiotics and Art History." *Art Bulletin* 73 (June 1991): 174–208 [and discussion, *Art Bulletin* 74 (September 1992): 522–53].

Balas, Edith. "Michelangelo's *Victory*." *Gazette des Beaux Arts* 18 (1989): 67–80.

Baldini, Umberto. *The Complete Sculpture of Michelangelo*. London: Thames and Hudson, 1982.

Baltrusaitis, Jurgis. "Quelques Survivances de Symboles Solaires dans l'Art du Moyen Age." *Gazette Des Beaux Arts* 17 (1937): 75–82.

Barb, A. A. "The Wound in Christ's Side." *Journal of the Warburg and Courtauld Institutes* 34 (1971): 320–23.

Barclay, William. *The Revelation of St. John*. Edinburgh: St. Andrew's Press, 1960.

Barnes, Bernadine. A. "The Invention of Michelangelo's Last Judgment." Ph.D. diss., University of Virginia. Ann Arbor: University Microfilms, 1986.

———. "A Lost Modello for Michelangelo's *Last Judgment*." *Master Drawings* 26 (1988): 239–48.

Barocchi, Paola and Renzo Ristori, eds., *Il Carteggio di Michelangelo*, Florence: 1965–83.

Barrett, C. K. *The Gospel According to St. John*. London: SPCK, 1958.

Battisti, Eugenio. *Cimabue*, University Park: Pennsylvania State University Press, 1967.

Baxandall, Michael. *Painting and Experience in Fifteenth-century Italy*. Oxford: Clarendon Press, 1972.

———. *Patterns of Intention: On the Historical Explanation of Pictures*. London: Yale University Press, 1985.

Beck, James. *Michelangelo: A Lesson in Anatomy*. London: Phaidon, 1975.

———. *Italian Renaissance Painting*. New York: Harper and Row, 1981.

———. "The Final Layer: *L'ultima mano* on Michelangelo's Sistine Ceiling." *Art Bulletin* 70, no. 3 (1988): 502–503.

Beck, James and Michael Daley, *Art Restoration: The Culture, the Business and the Scandal*. London: John Murray, 1993.

Beckwith, John. *Early Christian and Byzantine Art*. Harmondsworth: Penguin, 1970.

Beer, Arthur and Kaj Aage Strand, "Copernicus, Yesterday and Today." In *Vistas in Astronomy* 17. Oxford: Pergamon Press, 1975.

Bellosi, Luciano. *Michelangelo Buonarroti. Painting: The Life and Work of the Artist*, trans. G. Webb. London: Thames and Hudson, 1970.

Benesch, Otto. *The Art Of the Renaissance in Northern Europe: Its Relation to Contemporary, Spiritual and Intellectual Movements*. London: Phaidon, 1965.

Berendzen, Richard. "From Geocentric to Heliocentric to Galactocentric to Acentric." In A. Beer and Aage Strand *Copernicus, Yesterday and Today*. in Vistas in Astronomy, 17. Oxford: Pergamon Press, 1975.

Berenson, Bernard. *Italian Painters of the Renaissance*. London: Phaidon, 1967 (1st ed. 1896).

———. *Homeless Paintings of the Renaissance*. London: Thames and Hudson, 1969.

Bernen, Satia and Robert Bernen. *Myth and Religion in European Painting, 1270–1700*. New York: Braziller, 1973.

Bertram, Anthony. *Michelangelo*. New York: Dutton, 1964.

Bickersteth, Geoffrey L. *Dante Alighieri: The Divine Comedy*. Oxford: Blackwell, 1965.

Bienkowsa, Barbara., ed., *The Scientific World of Copernicus*. Dordrecht: Reidel, 1973.

Blau, Joseph L. *The Christian Interpretation of the Cabala in the Renaissance*. New York, 1944. Reprint, Port Washington, N.Y.: Kennikat, 1965. (Reprint of ed. New York, 1944).

Blunt, Anthony. *Artistic Theory in Italy, 1450–1660*. Oxford: Clarendon Press, 1983 (1st ed. 1940).

Boase, Thomas S. R. *Giorgio Vasari, The Man and the Book*. Princeton: Princeton University Press, 1979.

Bober, Phyllis Pray and Ruth O. Rubinstein, *Renaissance Artists and Antique Sculpture: A Handbook of Sources*. Oxford: Oxford University Press, 1986.

Boese, Helmut, ed., *Proclus, Elements of Physics* (Στοιχεωσις Φνσικης). Berlin: Akademie Verlag, 1958.

Bondi, Hermann. *Cosmology*. Cambridge: Cambridge University Press, 1960.

Borsook, Eve. *The Mural Painters of Tuscany*. London: Phaidon, 1967.

Borsook, Eve, and Johannes Offerhaus. *Francesco Sassetti and Ghirlandaio at Santa Trinita, Florence*. Doornspijk: Davaco, 1981.

Bortle, J. E. "A Halley Chronicle." *Astronomy* 13, no. 10 (October 1985): 98–110.

Boyde, Patrick. *Dante Philomythes and Philosopher: Man in the Cosmos*. Cambridge: Cambridge University Press, 1981.

Bréhier, Louis. *L'Art Chrétien*. Paris: Rénouard, 1928.

Breviarum Romanum, ex decreto Sacrosancti Concilii Tridentini: Pars Autumnalis. Turonibus: Typis A. Mame et Filiorum, 1933 [see also *Missale Romanum*].

Brieger, Paul., Millard Meiss, and Charles S. Singleton. *Illuminated Manuscripts of the Divine Comedy*. 2 vols. London: Routledge and Kegan Paul, 1969.

Brown, George Kenneth. *Italy and the Reformation to 1550*. Oxford: Blackwell, 1933.

Bull, George. *Michelangelo: A Biography*. Harmondsworth: Penguin, 1995.

Burckhardt, Jacob C. *The Civilization of the Renaissance in Italy*. 2 vols. Germany: 1860. Reprint, New York: Harper and Row, 1958.

Burke, Peter. *Culture and Society in Renaissance Italy, 1420–1540*. London: Batsford, 1972.

Burroughs, Josephine. "Ficino and Pomponazzi on Man." *Journal of the History of Ideas* 5 (1944): 227–39.

Butlin, M. and E. Joll, *Paintings of J. M. W. Turner.* New Haven: Yale University Press, 1984.

Butterfield, Herbert. *The Origins of Modern Science, 1300–1800.* London: Bell, 1958.

Caird, George B. *A Commentary on the Revelation of St. John the Divine.* London: Black, 1984.

Calvin, John. *Three French Treatises,* ed. Francis M. Higman. London: Athlone Press, 1970.

Camesasca, Ettore. *Michelangelo Buonarroti (1475–1564): The Complete Paintings.* London: Weidenfeld and Nicolson, 1969.

Campanella, Tommaso. *City of the Sun,* text and trans. D. J. Donno. Berkeley: University of California Press, 1981.

Cantimori, Delio. "Italy and the Papacy." In G. R. Elton, ed., *New Cambridge Modern History,* vol. 2 *The Reformation, 1520–1559,* 251–74. Cambridge: Cambridge University Press, 1958.

———. "Submission and Conformity: Nicodemism and the Expectations of a Conciliar Solution to the Religious Question." In Eric Cochrane, ed., *The Late Italian Renaissance,* 244–65. London: MacMillan, 1970.

Cardini, Roberto. *Cristoforo Landino. Scritti, critici e teorici.* 2 vols. Rome: Bulzoni, 1976.

Carli, Enzo. *All the Paintings of Michelangelo.* London: Oldbourne 1963.

———. *Il Duomo di Orvieto.* Rome: Stato, 1965.

Cassirer, Ernst. "Ficino's Place in Intellectual History." *Journal of the History of Ideas* 6 (1945): 483–501.

———. *The Philosophy of the Enlightenment.* Princeton, N.J.: Princeton University Press, 1951.

———. *The Individual and the Cosmos in Renaissance Philosophy.* New York: Barnes and Noble, 1927. Reprint, 1927.

Cassirer, Ernst, Paul Oskar Kristeller, and John Herman Randall. *The Renaissance Philosophy of Man.* Chicago: University of Chicago Press, 1965.

Cast, David. *The Calumny of Apelles: A Study in the Humanist Tradition.* New Haven: Yale University Press, 1981.

———. "Finishing the Sistine." *Art Bulletin* 73, no. 4 (December 1991): 669–84.

Castiglione, Baldassare. *The Book of the Courtier,* trans. George Bull, Harmondsworth: Penguin, 1980.

Cavendish, Richard. *Visions of Heaven and Hell.* London: Orbis, 1977.

Cellini, Bevenuto. *Autobiography,* trans. George Bull. Harmondsworth: Penguin, 1966.

Cennini, Cennino. *The Book of the Art of Cennino Cennini,* trans. C. J. Herringham. London: Allen and Unwin, 1922.

Chadwick, Henry. *History and Thought of the Early Church.* London: Variorum Reprint, 1982.

Chastel, André. "L'Apocalypse en 1500: La fresque de l'Antéchrist à la Chapelle Saint-Brice d'Orvieto." *Bibliothèque d'Humanisme et Renaissance* 14 (1952): 124–40.

———. *Marcel Ficin et l'Art.* Geneva: Droz, 1954.

———. *The Age of Humanism: Europe 1480–1530.* New York: McGraw-Hill, 1963.

———. *The Flowering of the Italian Renaissance.* Trans. J. Griffen. New York: Odyssey Press, 1965.

———. *Le Mythe de la Renaissance, 1420–1520.* Geneva: Skira, 1969.

———. *Arte et umanesimo à Firenze al tempo di Lorenzo il Magnifico.* Turin: Einaudi, 1964.

———. *A Chronicle of Italian Renaissance Painting.* New York: Hacker, 1983.

———, et al. *The Sistine Chapel: Michelangelo Rediscovered.* London: Muller, Blond and White, 1986. (American ed. entitled *The Sistine Chapel: The Art, the History, and the Restoration.* New York: Crown Publishers, 1986).

Church, Frederic C. *The Italian Reformers, 1534–1560.* New York: Octagon, 1932. Reprint, 1974.

Clark, Kenneth. *Leonardo, An Account of his Development as an Artist.* Cambridge: Cambridge University Press, 1952.

———. *The Drawings by Sandro Botticelli for Dante's Divine Comedy.* London: Thames and Hudson, 1976.

Clements, Robert J. *Michelangelo's Theory of Art.* New York: Gramercy, 1961.

———. *The Poetry of Michelangelo.* London: Peter Owen, 1966.

Cochrane, Eric. "The Florentine Background of Galileo's work." Ed. E. McMullin. In *Galileo, Man of Science.* New York: Basic Books, 1968.

———, ed. *The Late Italian Renaissance, 1525–1630.* London: Macmillan, 1970.

Cohen, L. Jonathan. *The Probable and the Provable.* Oxford: Clarendon Press, 1977.

Cohn, Norman. *The Pursuit of the Millennium.* Fairlawn. Princeton, NJ: Essential Books, 1957.

Collins, Ardis B. *The Secular is Sacred: Platonism and Thomism in Ficino's Platonic Theology.* The Hague: Nijhoff, 1974.

Condivi, Ascanio. *The Life of Michelangelo, 1553.* Ed. Helmut Wohl. Oxford: Phaidon, 1976.

Copernicus, Nicholas. *Nicolai Copernici de Hypothesibus Motuum Coelestium a se Constitutis Commentariolus.* In Edward Rosen, *Three Copernican Treatises.* New York: Octagon, 1971.

————. *De Revolutionibus Orbium Coelestium* (facsimile ed. by Jerzy Dobrzycki). 2 vols. Nuremberg: 1543. Reprint, London: Macmillan, 1978.

————. *Complete Works*, vol. 3. *Minor Works*, ed. by P. Czartoryski. London: Macmillan, 1986.

Corbett, Patricia. "After Centuries of Grime." *Connoisseur* (May 1982): 68–75.

Cornford, Francis MacDonald. *Plato's Cosmology: The "Timaeus" of Plato Translated with a Running Commentary*. London: Routledge Kegan Paul, 1937.

Cosenza, Mario. *Biographical and Bibliographical Dictionary of the Italian Humanists and of the World of Classical Scholarship in Italy, 1300–1800*. 2d ed., 6 vols. Boston: G. K. Hall, 1962.

Cox-Rearick, Janet. *Dynasty and Destiny in Medici Art: Pontormo, Leo X and the Two Cosimos*. Princeton, N.J.: Princeton University Press, 1984.

Coughlan, Robert. *The World of Michelangelo (1475—1564)*. New York: Time-Life, 1966.

Crombie, A. C. *Augustine to Galileo*. 2 vols. London: Heinemann, 1970.

Cronin, Vincent. *The Florentine Renaissance*. London: Collins, 1967.

————. *The View from Planet Earth: Man Looks at the Cosmos*. London: Collins, 1981.

Cullman, Oscar, et al., *Immortality and Resurrection: Death in the Western World: Two Conflicting Currents of Thought*. New York: Macmillan, 1965.

Dacos, Nicole. *La Découverte de la Domus Aurea et la Formation des Grotesques à la Renaissance*. London: Warburg Institute, 1969.

Daniel-Rops, Henri. *The Catholic Reformation*. London: Dent, 1962.

Dante Alighieri, see "Alighieri."

Davies, Paul. *God and the New Physics*. Harmondsworth: Penguin, 1983.

————. *The Last Three Minutes*. London: Weidenfeld and Nicolson, 1994.

Davis, H. M. "Gravity in the Paintings of Giotto." In Laurie Schneider, *Giotto in Perspective*. Englewood Cliffs, N.J.: Prentice Hall, 1974.

De Maio, Romeo. *Michelangelo e la Controriforma*. Rome: Laterza, 1978.

Demaray, John G. "Dante and the Book of the Cosmos." *Transactions of the American Philosophical Society*, 77, pt. 5, 1985.

Demus, Otto. *Byzantine Mosaic Decoration*. London: Routledge and Kegan Paul, 1948.

————. *Romanesque Mural Painting*. London: Thames and Hudson, 1968.

————. *The Mosaics of San Marco in Venice*. Chicago: University of Chicago Press, 1984.

————. *Michelangelo*. Trans. A. Campbell. London: Barrie and Jenkins, 1992.

————. and Gianluigi Colalucci, *Michelangelo, The Vatican Frescoes*. New York and London: Abbeville Press, 1996.

Devereux, James A. "The Object of Love in Ficino's Philosophy." *Journal of the History of Ideas* 30 (1969): 161–70.

Dick, B. G. "An Interdisciplinary Science-Humanities Course." *American Journal of Physics* 51, no. 8 (Aug. 1983): 702–8.

Dickens, Arthur Geoffrey. *The Counter-Reformation.* London: Thames and Hudson, 1968.

Dixon, John W. "Michelangelo's *Last Judgment:* Drama of Judgment or Drama of Redemption." *Studies in Iconology* 9 (1983): 67–82.

———. "The Christology of Michelangelo: The Sistine Chapel." *Journal of the American Academy of Religion* 55, no. 3 (fall 1987): 502–33.

Dixon, Laurinda S. "Giovanni di Paolo's Cosmology." *Art Bulletin* 67, no. 4 (December 1985): 604–13.

Dobrzycki, Jerzy, ed. *The Reception of Copernicus's Heliocentric Theory.* Dordrecht: Reidel, 1972.

Dodd, Charles Harold. *The Interpretation of the Fourth Gospel.* Cambridge: Cambridge University Press, 1972.

Dotson, Esther Gordon. "An Augustinian Interpretation of Michelangelo's Sistine Ceiling." pts. 1 and 2, *Art Bulletin* 61, no. 2 (1979): 223–56, and 61, no. 3 (1979): 405–29.

Draper, John William. *Religion and Science.* London: King, 1875.

Dreyer, John Louis Emil. *A History of Astronomy from Thales to Kepler.* New York: Dover, 1953.

Dubery, Fred, and John Willats. *Perspective and Other Drawing Systems.* London: Herbert, 1963.

Duhem, Pierre. *Medieval Cosmology: Theories of Infinity, Place, Void and the Plurality of Worlds.* Chicago: University of Chicago Press, 1985.

Dunan, Marcel, ed., *Larousse Encyclopedia of Modern History from 1500 to the Present Day.* London: Hamlyn, 1984.

Dussler, Luitpold. *Michelangelo: Bibliographie, 1927–1970,* Wiesbaden: Harrassowitz, 1974.

Eco, Umberto. *Art and Beauty in the Middle Ages.* New Haven and London: Yale University Press, l986.

———. *Foucault's Pendulum.* London: Secker and Warburg, 1989.

Eco, Umberto, and Thomas Albert Seboek. *The Sign of Three,* Bloomington, In.: Indiana University Press, 1983.

Edgerton, Samuel Y. *The Renaissance Rediscovery of Linear Perspective.* New York: Basic Books, 1975.

———. *Pictures and Punishment.* Ithaca, N.Y.: Cornell University Press 1984.

Einstein, Albert, and Leopold Infeld. *The Evolution of Physics from Early Concepts to Relativity and Quanta.* New York: Simon and Schuster, 1966.

Eire, Carlos M. N. "Calvin and Nicodemism. A Reappraisal." *Sixteenth Century Journal* 10 (1979): 45–69.

Eisenbichler, Konrad and Olga Zorzi Pugliese, eds., *Ficino and Renaissance Neoplatonism*, University of Toronto Italian Studies. Ottawa: Dovehouse, 1986.

Elmer de Witt, Philip. "Old Masters. New Tricks." *Time International* 134, no. 25 (18 December 1989): 50–51.

Elam, Caroline. "Michelangelo and the Sistine Ceiling." *Burlington Magazine* 132 (1990): 434–37.

Elton, Geoffrey R., ed. *New Cambridge Modern History*, vol. 2, *The Reformation*. Cambridge: Cambridge University Press, 1958.

Engler, H. Rudolf. *Die Sonne als Symbol*. Zurich: Helianthus Verlag, 1962.

Ephram le Syrien. *Textes Arméniens relatifs à S Ephrem*. Trans. B. Outtier. Louvain: Corpus Scriptorum Christianorum, 1985, vol. 16.

Ettlinger, Leopold D. *The Sistine Chapel before Michelangelo: Religious Imagery and Papal Primacy*. Oxford: Clarendon Press, 1965.

Evenett, Henry Outtram. *The Spirit of the Counter-Reformation*. Cambridge: Cambridge University Press, 1968.

Faggin, Giorgio T. *The Van Eycks*. London: Weidenfeld and Nicolson, 1970.

Fahy, Everett. "Michelangelo and Ghirlandaio." in Irving Lavin and John Plummer, eds. *Studies in Late Medieval and Renaissance Painting in Honour of Millard Meiss*. New York: New York University Press, 1977.

Fallico, Arturo B., and Herman Shapiro, eds. *Renaissance Philosopy*, vol. 1, *The Italian Philosophers: Selected Readings from Petrarch to Bruno*. New York: Modern Library, 1967.

Fenlon, Dermot. *Heresy and Obedience in Tridentine Italy*. Cambridge: Cambridge University Press, 1972.

Ferguson, John. "Sun, Line and Cave Again." *Classical Quarterly* 13, no. 2 (1963): 188–93.

Ferguson, George. *Signs and Symbols in Christian Art*. Oxford: Oxford University Press, 1980.

Fernàndez-Arnesto, Felipe. *Columbus and the Conquest of the Impossible*. London: Weidenfeld and Nicholson, 1974.

Ficino, Marsilio. *Marsilio Ficino's Commentary on Plato's Symposium*. Ed. and trans. Sears R. Jayne, Columbia: University of Missouri Press, 1944.

———. *Commentary on Plato's Symposium on Love*. Trans. with introduction and notes by Sears R. Jayne, Dallas: Spring Publications, 1985.

———. *Theologia Platonica de Immortalitate Animorum*. 1559. Reprint, Hildesheim: Olms, 1975.

———. *Marsile Ficin: Théologie Platonicienne de l'Immortalité des Ames*. ed. and trans. Raymond Marcel, 3 vols. Paris: Société d'Edition "Les Belles Lettres," 1964–70.

———. *Marsilio Ficino, Teologica Platonica*, ed. Michele Schiavone, 2 vols. Bologna: Zanichelli, 1965.

————. *Letters*. Trans. and ed. by members of the Language Department, School of Economic Science, London, 4 vols. London: Shepheard-Walwyn, 1975–86.

————. *The Sophist Commentary*. Berkeley: University of California Press, 1989.

————. *Three Books on Life: A Critical Edition and Translation with Introduction and Notes*, ed. and trans. by Carol V. Kaske and J. R. Clark. Binghamton, NY: Center for Medieval and Early Renaissance Studies, 1989.

————. *The Book of Life*, ed., Charles Boer. Dallas: Spring Publications, 1980.

Field, Arthur. "Cristoforo Landino's First Lectures on Dante." *Renaissance Quarterly* 39, no. 1 (spring, 1986): 16–49.

Fisher, H. A. L. *A History of Europe*. 2 vols. London: Eyre and Spottiswode, 1957.

Flanders Dunbar, Helen. *Symbolism in Medieval Thought and its Consummation in the Divine Comedy*. New York: Russell and Russell, 1961.

Frazer, James George. *The Worship of Nature*. London: Macmillan, 1926.

Freccero, John., ed. *Dante: A Collection of Critical Essays*. Englewood Cliffs, NJ: Prentice Hall, 1965.

————. "*Paradiso X*, the Dance of the Stars." *Dante Studies* 86 (1968): 85–112.

Freedberg, Sidney J. *Paintings of the High Renaissance in Rome and Florence*. Cambridge: Harvard University Press, 1961.

————. *Painting in Italy, 1500–1600*. New York: Penguin, 1979.

Freud, Sigmund "Leonardo da Vinci and a Memory of His Childhood." In *The Standard Edition of the Complete Psychological Works of Sigmund Freud*, ed. J. Strachey, 11:63–137. 24 vols. London: Hogarth, 1953–74.

Furse, John. *Michelangelo and His Art*. London: Hamlyn, 1975.

Galilei, Galileo. *Letter to the Grand Duchess Christina, 1616*, ed. by Stillman Drake). New York: Doubleday, 1957.

Gandillac, Maurice de. "Neoplatonism and Christian Thought in the Fifteenth century." In D. J. O'Meara, ed., *Neoplatonism and Christian Thought*. Albany, N.Y.: State University of New York Press, 1982.

Gardner, Edmund G. *Dante and the Mystics: A Study of the Divina Commedia and its Relation with Some of Its Medieval Sources*. New York: Octagon, 1968.

Garin, Eugenio. *Chronache di filosofia italiana*. Rome: Laterza, 1959.

————. *L'Umanesimo italiano*, Bari: Laterza, 1958. (English trans., *Italian Humanism: Philosophy and Civic Life in the Renaissance*. Oxford: Blackwell, 1965).

————. *Rinascite e rivoluzione: Movimenti culturali dal XIV al XVIII secolo*. Rome: Laterza 1976.

————. *Astrology in the Renaissance: The Zodiac of Life*. London: Routledge and Kegan Paul, 1983.

Gay, Peter. *Freud for Historians*. Oxford: Oxford University Press, 1985.

Gelder, Herman Arend Enno van. *The Two Reformations in the Sixteenth Century: A Study of the Religious Aspect and Consequences Renaissance Humanism*. The Hague: Nijhoff, 1964.

Gilbert, Creighton, ed. *Renaissance Art*. New York: Harper and Row, 1970.

————, trans., and Robert N. Linscott, ed. *Complete Poems and Selected Letters of Michelangelo*. Princeton, N.J.: Princeton University Press, 1980.

Gilson, Étienne. *History of Christian Philosophy in the Middle Ages*. London: Sheed and Ward, 1955.

————. *The Christian Philosophy of St. Augustine*. London: Victoria Gollancz, 1961.

————. *Dante and Philosophy*, Gloucester, MA: Peter Smith, 1968.

Ginzburg, Carlo. *Nicodemismo: Simulazione e dissimulazione religiosa nell'Europa del'500,* Turin: Einaudi, 1970.

————. *The Enigma of Piero*. London: Verso, 1985.

Gleason, Elisabeth. "On the Nature of Sixteenth-Century Evangelism." *Sixteenth Century Journal* 9 (1978): 3–26.

————. *Reform Thought in Sixteenth-century Italy*. Ann Arbor, Mich.: The American Academy of Religion, 1981.

Glymour, Clark N. *Theory and Evidence*. Princeton, N.J.: Princeton University Press, 1980.

Goffen, Rona. "Friar Sixtus IV and the Sistine Chapel." *Renaissance Quarterly* 39, no. 2 (Summer 1986): 218–62.

————. "Renaissance Dreams." *Renaissance Quarterly* 40 (1987): 682–706.

Goldscheider, Ludwig, ed. *The Sculptures of Michelangelo*. London: Allen and Unwin, 1939.

————. *The Paintings of Michelangelo*. London: Phaidon Press, 1939.

————. *Michelangelo: Drawings*. London: Phaidon, 1966.

————. *Leonardo*. Oxford: Phaidon, 1969.

————. *Michelangelo, Painting, Sculptures, Architecture*. London: Phaidon, 1975. Reprint, 1986.

Gombrich, Ernst H. "Botticelli's Mythologies. A Study in the Neoplatonic Symbolism of His Circle." *Journal of the Warburg and Courtauld Institutes* 8 (1945): 7–60.

————. "Icones Symbolicae: The Visual Image in Neoplatonic Thought." *Journal of the Warburg and Courtauld Institute* 11 (1948): 163–92.

————. *Symbolic Images: Studies in the Art of the Renaissance II,* Oxford: Phaidon, 3rd ed. 1985.

Gontard, Friedrich. *The Popes*. Trans. from the German by A. J. and E. F. Peeler, London: Barrie and Rockliff, 1964.

Goodwin, J., and A. Doster, eds. *Fire of Life: The Smithsonian Book of the Sun*. New York: Norton, 1981.

Gough, Michael. *The Origins of Christian Art*. London: Thames and Hudson, 1973.

Grabar, André. *Early Medieval Painting from the Fourth to the Eleventh century*. Lausanne: Skira, 1957.

————. *Romanesque Painting from the Eleventh to the Thirteenth Century*. Geneva: Skira, 1958.

————. *The Beginnings of Christian Art, 200–395*. London: Thames and Hudson, 1967.

————. *Christian Iconography: A Study of its Origins*. London: Routledge and Kegan Paul, 1969.

Grandgent, Charles H. *Companion to the Divine Comedy*. Ed. Charles S. Singleton, Cambridge: Harvard University Press, 1975.

Grant, Edward. "Late Medieval Thought, Copernicus and the Scientific Revolution." *Journal of the History of Ideas* 23 (1962): 197–220.

————. "Medieval and Seventeenth-century Conceptions of an Infinite Void Space Beyond the Cosmos." *Isis* 60 (1969): 39–60.

————. *Nicholas Oresme and the Kinematics of Circular Motion*. Madison: University of Wisconsin Press, 1971.

————. *Studies in Medieval Science and Natural Philosophy*. London: Variorum, 1981.

Graves, Robert. *The Greek Myths*. 2 vols. Harmondsworth: Penguin, 1977.

Green, Vivian Hubert Howard. *Renaissance and Reformation*. London: Arnold, 1972.

Greenstein, Jack. M. "'How Glorious the Second Coming of Christ': Michelangelo's *Last Judgment* and the Transfiguration." *Artibus et Historiae* 20 (1989): 33–57.

Grendler, Paul. F. *Critics of the Italian World 1530–1560*. Madison: University of Wisconsin Press, 1969.

————. *The Roman Inquisition and the Venetian Press*. Princeton, N.J.: Princeton University Press, 1973.

————. *Culture and Censorship in Late Renaissance Italy*. London: Variorum, 1981.

Guéranger, Prosper. *The Liturgical Year*. Dublin: Dufy, 1886.

Guicciardini, Francesco. *The History of Italy (1561)*. Trans. and ed. by Sidney Alexander, Princeton, N.J.: Princeton University Press, 1984.

Guthrie, W. K. C. *A History of Greek Philosophy*. 6 vols. Cambridge: Cambridge University Press, 1985–6.

Hailey, Homer. *Revelation: An Introductory Commentary*. Grand Rapids, Mich.: Baker, 1979.

Hale, John Rigby. *Italian Renaissance Painting from Masaccio to Titian*. London: Phaidon, 1977.

————, ed. *A Concise Encyclopaedia of the Italian Renaissance*. London: Thames and Hudson, 1981.

Halewood, William. H. *Six Subjects of Reformation Art: A Preface to Rembrandt.* Toronto: University of Toronto Press, 1982.

Hall, Edwin, and Horst Uhr. "*Aureola Super Auream*: Crowns and Related Symbols of Special Distinction for Saints in Late Gothic and Renaissance Iconography." *Art Bulletin* 67, no. 4 (December 1985): 568–603.

Hall, Marcia B. "Michelangelo's *Last Judgment*: Resurrection of the Body and Predestination." *Art Bulletin* 58, no. 1 (March 1976): 85–92.

———. *Renovation and Counter-Reformation: Vasari and Duke Cosimo in Sta Maria Novella and Sta Croce, 1565–1577.* Oxford: Oxford University Press, 1979.

———. *The Sistine Ceiling Restored.* New York: Rizzoli International, 1993.

Hallyn, Fernand. *The Poetic Structure of the World: Copernicus and Kepler,* trans. D. M. Leslie. New York: Zone Books, 1990.

Hankins, James. *Plato in the Italian Renaissance.* 2 vols. Leiden: Brill, 1990.

Hannay, James Ballantyne. *Symbolism in Relation to Religion: Christianity, the Sources of its Teaching and Symbolism.* Washington: Kennikat, 1971.

Harbison, Craig. *The Last Judgment in Sixteenth-century Northern Europe: A Study of the Relationship Between Art and the Reformation.* New York: Garland, 1976.

Harding, D. E. *The Hierarchy of Heaven and Hell. A New Diagram of Man in the Universe.* London: Faber and Faber, 1952.

Hartt, Frederick. *Michelangelo.* New York: Abrams, 1964.

———. *Drawings of Michelangelo.* London: Thames and Hudson, 1971.

———. "The Evidence for the Scaffolding of the Sistine Ceiling." *Art History* 5, no. 3 (September 1982): 273–86.

———. *A History of Italian Renaissance Art: Painting, Sculpture, Architecture,* rev. ed. London: Thames and Hudson, 1987.

———. *David by the Hand of Michelangelo: The original model discovered.* London: Thames and Hudson, 1987.

———. "*L'ultima mano* on the Sistine Ceiling." *Art Bulletin* 71, no. 3 (1989): 508–509.

Hartt, Frederick and Finn, D. *Michelangelo's Three Pietàs.* New York: Abrams, 1975.

Hauke, Hermann. "Bücher sind Gefässe der Erinnerung . . ." *Bayerland,* no. 3 (September 1986): 18–21.

Hauser, Arnold. *Mannerism and the Crisis of the Renaissance.* London: Routledge and Kegan Paul, 1965.

Hautecoeur, Louis. *Mystique et Architecture: Symboles du Cercle et de la Coupole.* Paris: Picard, 1954.

Hawking, Stephen. *A Brief History of Time.* London: Bantam, 1988.

Hay, Denys. *The Italian Renaissance in Its Historical Background.* Cambridge: Cambridge University Press, 1961.

———. *The Age of the Renaissance.* London: Thames and Hudson, 1967.

Heath, Thomas L. *Aristarchus of Samos. The Ancient Copernicus*. Oxford: Clarendon Press, 1959.

Heller, Agnes. *Renaissance Man*. London: Routledge and Kegan Paul, 1978.

Henderson, Linda Dalrymple. *The Fourth Dimension and Non-Euclidean Geometry in Modern Art*. Princeton, N.J.: Princeton University Press, 1983.

Heninger, S. K., Jr. *Touches of Sweet Harmony: Pythagorean Cosmology and Renaissance Poetics*. San Marino, Cal.: Huntington Library, 1977.

———. *The Cosmographical Glass: Renaissance Diagrams of the Universe*. San Marino, Cal.: Huntington Library, 1977.

Herbst, Stanislaw. "The Country and the World of Copernicus." In Barbara Bienkowska ed., *The Scientific World of Copernicus*, 1–13. Dordrecht: Reidel, 1973.

Hermetica, (The writings of Hermes Trismegistus). Trans. and ed. Brian Copenhaver. Cambridge: Cambridge University Press, 1991.

———. ed. Walter Scott. 4 vols. London: Dawson, 1968.

Herringham, C. J. trans., *The Book of the Art of Cennino Cennini*. London: Allen and Unwin, 1922.

Heusinger, Lutz and Fabrizio Mancinelli. *The Sistine Chapel*. London: Constable, 1973 (reprinted Rome: Monumenti, Musei e Gallerie Pontificie, 1992).

———. *Michelangelo: Life and Works in Chronological Order*. London: Constable, 1978.

Hibbard, Howard. *Michelangelo*. London: Allen Lane, 1975 (2d ed. New York: Harper and Row, 1985).

Hibbert, Christopher. *The Rise and Fall of the House of Medici*. Harmondsworth: Penguin, 1983.

Highet, Gilbert. *The Classical Tradition: Greek and Roman Influence on Western Literature*. Oxford: Clarendon Press, 1951.

Hill, G. "Judgement Day Looms for Sistine Restoration." *The Times*, 22 March 1990.

Hirst, Michael. *Michelangelo and his Drawings*. New Haven: Yale University Press, 1988.

———. *Sebastiano del Piombo*. Oxford: Clarendon Press, 1981.

Holanda, Francis de. *Dialogues*. In Charles Holroyd, *Michael Angelo Buonarroti*. 269–327. London: Duckworth, 1903.

Holmes, George. *Dante*. Oxford: Oxford University Press, 1980.

Hook, Judith. *Lorenzo de Medici*. London: Hamish Hamilton, 1984.

Hope, Charles. Review of Chastel et al., *The Sistine Chapel. Times Literary Supplement*. 12 Dec. 1986, 1399.

Hopkins, Jasper. *Concise Introduction to the Philosophy of Nicholas of Cusa*. Minneapolis: University of Minnesota Press, 1978.

Horster, Marita. *Andrea del Castagno*. Oxford: Phaidon, 1980.

Hoyle, Fred. *From Stonehenge to Modern Cosmology.* San Francisco: Freeman, 1972.

———. *Nicholas Copernicus: An Essay on His Life and Work.* London: Heinemann, 1973.

———. *Astronomy and Cosmology.* San Francisco: Freeman, 1975.

Hughes, Robert. *Heaven and Hell in Western Art.* London: Weidenfeld and Nicolson, 1968.

Hulme, E. M. *The Renaissance, the Protestant Revolution and the Catholic Reformation.* New York: Appleton, 1915.

Indicopleustes, Cosmas. *Topographie Chrétienne*, ed. W. Wolska-Conus. Paris: Éditions du Cerf, 1968.

Infeld, Leopold. "From Copernicus to Einstein." in Barbara Bienkowska, ed. *The Scientific World of Copernicus,* 66–83. Dordrecht: Reidel, 1973.

Irwin, David. ed, *Winckelmann's Writings on Art.* London: Phaidon, 1972.

Ivins, William M. *Art and Geometry: A Study in Space Institutions.* New York: Dover, 1964.

Jacob, Ernest Fraser, ed., *Italian Renaissance Studies.* London: Faber and Faber, 1960.

James, Montague Rhodes, *The Apocalypse in Art.* London: Oxford University Press, 1931.

———. *The Apocryphal New Testament.* Oxford: Clarendon Press, 1969.

Janson, Horst Woldemar, ed. *Italian Art: Sources and Documents 1500–1600.* Englewood Cliffs, NJ: Prentice—Hall, 1962.

Januszczak, Waldemar. *Sayonara Michelangelo.* London: Bloomsbury Publishing, 1991.

Jayne Sears R., ed., *Marsilio Ficino's Commentary on Plato's Symposium*, text and translation. Columbia: University of Missouri Press, 1944.

———. *Marsilio Ficino's Commentary on Plato's Symposium on Love,* (trans. with introduction and notes), Dallas: Spring Publications, 1985.

Jeans, James. *The Mysterious Universe.* Cambridge: Cambridge University Press, 1947.

Jedin, Hubert. *A History of the Council of Trent,* trans. E. Graff. London: Nelson, 1957.

Jeffery, D. "A Renaissance for Michelangelo." *National Geographic* 176, no. 6 (December 1989): 688–713.

Jung, Carl. *Man and his Symbols.* London: Pan, 1978.

Jung, C. G., and W. Pauli. *The Interpretation of Nature and the Psyche.* New York: Pantheon, 1955.

Jung, Eva-Maria. "Vittoria Colonna-Between Reformation and Counter Reformation." *Review of Religion* 15 (1951): 144–59.

———. "On the Nature of Evangelism in Sixteenth-century Italy." *Journal of the History of Ideas* 14 (1953): 511–27.

Kenton, W. *Astrology: The Celestial Mirror*. New York: Avon, 1974.

Kidd, Beresford James. *The Counter-Reformation. 1550–1600*. London: Church Union Association, 1958.

Kirby Talley, M. "Michelangelo Rediscovered." *Art News* 86, no. 6 (summer 1987): 158–70.

Kirschbaum, E. *The Tombs of St. Peter and St. Paul*. London: Secker and Warburg, 1959.

Kitzinger, Ernst. "World Map and Fortune's Wheel: A Medieval Mosaic Floor in Turin." in *The Art of Byzantium and the Medieval West*, 327–56. Bloomington: Indiana University Press, 1976.

Kleinbauer, W. Eugene. *Modern Perspectives in Western Art History*. New York: Holt, Rinehart and Winston, 1971.

Klibansky, Raymond. *The Continuity of the Platonic Tradition during the Middle Ages*. London: Warburg Institute, 1939.

Klonsky, Milton. *Blake's Dante: The Complete Illustrations to the Divine Comedy*. London: Sidgwick and Jackson, 1980.

Koestler, Arthur. *The Sleepwalkers: A History of Man's Changing Vision of the Universe*. Harmondsworth: Penguin, 1984.

Kondakov, Nikodim Pavlovich. *Histoire de L'Art Byzantin*. New York: Franklin, 1970 (1st ed. Paris, 1886).

Kouri, E. I., and Tom Scott, eds. *Politics and Society in Reformation Europe*. London: Macmillan, 1987.

Koyré, Alexandre. *Du monde clos à l'univers infini*. Paris: Presses Universitaires de France, 1962. (English ed., *From the Closed World to the Infinite Universe*. London: Oxford University Press, 1957).

———. *The Astronomical Revolution*. London: Methuen, 1973.

Kristeller, Paul Oskar. "Augustine and the Early Renaissance." *Review of Religion* 8 (1944): 339–58.

———. *The Philosophy of Marsilio Ficino,* trans. Virginia Conant. New York: Columbia University Press, 1943 (reprinted 1964).

———. *Il Pensiero Filosofico di Marsilio Ficino*. Florence: Sansoni, 1953.

———. "Renaissance Platonism." In *Facets of the Renaissance*. New York: Harper and Row, 1963.

———. *Eight Philosophers of the Italian Renaissance*. London: Chatto and Windus, 1965.

———. *Renaissance Thought and its Sources*. New York: Columbia University Press, 1979.

———. *Renaissance Thought and the Arts*. Princeton, NJ: Princeton University Press, 1980.

Kubovy, Michael. *The Psychology of Perspective and Renaissance Art*. Cambridge: Cambridge University Press, 1988.

Kuhn, Thomas. S. *The Copernican Revolution: Planetary Astronomy in the Development of Western Thought*. Cambridge: Harvard University Press, 1957.

————. *The Structure of Scientific Revolutions.* Chicago: University of Chicago Press, 1969.

Kunstle, Karl. *Ikonographie der Kristelike Kunst.* Freiburg: Herder, 1928.

Lactantius. *Divine Institutes,* trans. F. M. McDonald, Washington: Catholic University of America Press, 1964.

Ladner, Gerhard B. *The Idea of Reform.* Cambridge: Harvard University Press, 1959.

LaHaye, T. *Revelation: Illustrated and Made Plain.* Grand Rapids, Mich.: Zonderman, 1975.

Lamarche-Vadel, Bernard. *Michelangelo.* Paris: Nouvelles Editions Françaises, 1986 (English ed.. New York: Chartwell, 1986).

Landino, Cristoforo. *Commentary on Dante's Divina Commedia,* (Florence, 1481) British Library Microfilms. London.

————. *Scritti, critici e teorici,* ed. R. Cardini. 2 vols. Rome: Bulzoni, 1976.

Landsberg, Peter T., and David A. Evans. A. *Mathematical Cosmology: An Introduction.* Oxford: Clarendon Press, 1977.

Lavin, Irvin, and J. Plummer. *Studies in Late Medieval and Renaissance Painting in Honor of Millard Meiss.* New York: New York University Press, 1977.

Lavin, Marilyn Aronberg. *Piero della Francesca's Baptism of Christ.* New Haven, CT: Yale University Press, 1981.

Lawley, Althea. *Vittoria Colonna.* London: Gilbert and Rivington, 1888.

Lazarev, Viktor Nikitich. *Storia della pittura bizantina.* Turin: Einaudi, 1967.

Le Bot, Michel. *Michelangelo,* trans. M-H. Agueros. Vaduz, Liechtenstein: Bonfini Press, 1992.

Lees-Milne, James. *The Story of St. Peter's Basilica in Rome.* London: Hamilton, 1967.

Leff, Gordon. *Heresy in the Later Middle Ages.* 2 vols. Manchester: Manchester University Press, 1967.

Lehmann, Karl. "The Dome of Heaven." In W. Eugene Kleinbauer, *Modern Perspectives in Western Art History,* 227–70. New York: Holt, Rinehart, and Winston, 1971: 227–70.

Leites, Nathan. *Art and Life: Aspects of Michelangelo.* New York: New York University Press, 1986.

Lenski, R. C. H. *The Interpretation of St. John's Revelation.* Minneapolis: Augsburg, 1963.

Leonardo da Vinci, *Notebooks,* ed. Jean Paul Richter. 2 vols. New York: Dover, 1970.

Levey, Michael. *Early Renaissance.* Harmondsworth: Penguin, 1967.

————. *The High Renaissance.* Harmondsworth: Penguin, 1975.

Levy, A. "A Papal Penchant for Classical Art." *Art News* 80 (October 1981): 86–89.

————. "All of Michelangelo's Work Will Have to Be Restudied." *Art News* 80 (October 1981): 114–21.

————. "The Tormented History of the Apollo Belvedere." *Art News* 80 (October 1981): 124–25.

Liebert, Robert S. *Michelangelo, A Psychoanalytic Study of His Life and Images.* New Haven: Yale University Press, 1983.

Lightbown, Ronald William. *Sandro Botticelli: Life and Work.* 2 vols. London: Elek, 1978.

Lightfoot, Robert Henry. *St. John's Gospel: A Commentary.* Oxford: Oxford University Press, 1963.

Logan, Oliver. M. T. "Grace and Justification: Some Italian Views of the Sixteenth and Early Seventeenth Centuries." *Journal of Ecclesiastical History* 20 (April 1969): 67–78.

Lovejoy, Arthur O. *The Great Chain of Being.* Cambridge: Harvard University Press, 1936.

Lucas, Henri S. *The Renaissance and the Reformation.* New York: Harper and Row, 1960.

Luther, Martin. *Table Talks,* ed. and trans. by G. Tappert. Philadelphia: Fortress 1967.

McAuliffe, D. J. *Vittoria Colonna: A Study of Her Formative Years as a Basis for an Analysis of Her Poetry.* Ann Arbor, Mich.: University Microfilms, 1978.

————. "Neoplatonism in Vittoria Colonna's Poetry." In Konrad Eisenbichler and Olga Zorzi Pugliese, eds. *Ficino and Renaissance Neoplatonism.* 101–12. University of Toronto Italian Studies. Ottawa: Dovehouse, 1986.

McColley, Grant. "Nicholas Copernicus and the Infinite Universe." *Popular Astronomy* 44 (1936): 525–35.

McDannell, Colleen and Bernhard Lang. *Heaven: A History.* New Haven: Yale University Press, 1988.

Mackie, John Leslie. *Truth, Probability and Paradox: Studies in Philosophical Logic.* Oxford: Clarendon Press, 1973.

Mâle, Emile. *The Gothic Image.* London: Fontana, 1961.

Mancinelli, Fabrizio. *Catacombs and Basilicas: The Early Christian Rome.* Firenze: Scala, 1987.

————, et al. *Michelangelo e la Sistina: La technica, il restauro, il mito,* Rome: Fratelli Palombi, 1990. [see also under Pietrangeli, C.].

Marcel, Raymond. *Marsile Ficin.* Paris: Belles Lettres, 1958.

————. *Marsile Ficin: Théologie Platonicienne de l'immortalité des. Ames.* 3 vols. Paris, 1964–70.

Mariani, Valerio. *Michelangelo the Painter.* New York: Abrams, 1964.

Martin, James P. *The Last Judgment.* Grand Rapids, MI: Eerdmans, 1963.

Martindale, Andrew. *Man and the Renaissance*. London: Paul Hamlyn, 1966.

————. *Gothic Art*. London: Thames and Hudson, 1967.

Martinelli, Patrizia Angiolini. *L'immagine de Cristo nell'antica arte Ravennate*. Faenza: Fratelli, 1969.

Martines, Lauro. *Power and Imagination: City States in Renaissance Italy*. Harmondsworth: Penguin, 1979.

Mazzeo, Joseph Anthony. *Structure and Thought in the Paradiso*. New York: Greenwood, 1968.

Mead, George Robert Stow. *Thrice-Greatest Hermes*. 3 vols. London: Watkins, 1964.

Meiss, Millard. *Painting in Florence and Siena after the Black Death*. Princeton, N.J.: Princeton University Press, 1978.

————. "Light as Form and Symbol in some Fifteenth-century Painting." In Creighton Gilbert, ed. *Renaissance Art*. New York: Harper and Row, 1970.

————. *The Painter's Choice: Problems in the Interpretation of Renaissance Art*. New York: Harper and Row, 1976.

Merkel, Ingrid and Allen G. Debus, eds. *Hermeticism and the Renaissance: Intellectual History and the Occult in Early Modern Europe*. Washington: Folger, 1988.

Michelangelo Buonarroti, *The Letters of Michelangelo, translated from the Original Tuscan,* 2 vols. Ed. E. H. Ramsden. London: Owen, 1963.

————. *Complete Poems and Selected Letters*. ed. Robert N. Linscott, trans. Creighton Gilbert. Princeton, NJ: Princeton University Press, 1980.

Minio-Paluello, Lorenzo. "Dante's reading of Aristotle." In *The World of Dante: Essays on Dante and His Times*, ed. Cecil Grayson. Oxford: Clarendon Press, 1980.

Milanesi, Gaetano. *Le Lettere di Michelangelo Buonarroti*. Florence: Le Monnier, 1875.

Misner, Charles W., Kip S. Thorne and James A. Wheeler. *Gravitation*. San Francisco: Freeman, 1973.

Mizwa, Stephen P. *Nicholas Copernicus*. Washington: Kennikat, 1943.

Mohr, Richard D. *The Platonic Cosmology*. Leiden: Brill, 1985.

Moore, C. H. *Ancient Beliefs in the Immortality of the Soul: Some Account of Their Influence on Later Views*. New York: Cooper Square, 1963.

Moore, Thomas. *The Planets Within: Marsilio Ficino's Astrological Psychology*. Lewisburg, PA: Bucknell University Press, 1982.

Morgan, Charles Hill. *The Life of Michelangelo*. New York: Reynal, 1960.

Morisani, Ottavio. "Art Historians and Art Critics: Cristoforo Landino." *Burlington Magazine* 95 (1953): 267–70.

Morris, Desmond, et al., *Gestures: Their Origins and Distribution*. London: Jonathan Cape, 1979.

Morrogh, Andrew. "The Magnifici Tomb: A Key Project in Michelangelo's Architectural Career." *Art Bulletin* 74, no. 4 (December 1992): 567–98.

Munitz, Milton K., ed. *Theories of the Universe: From Babylonian Myth to Modern Science.* Glencoe, IL: The Free Press, 1957.

Murray, Linda *The High Renaissance.* London: Thames and Hudson, 1967.

———. *Late Renaissance and Mannerism.* London: Thames and Hudson 1967.

———. *Michelangelo.* London: Thames and Hudson, 1980, reprinted 1990.

———. *Michelangelo: His Life and Work and Times.* London: Thames and Hudson, 1984.

Murray, Peter and Linda. *The Art of the Renaissance.* London: Thames and Hudson, 1971.

Nardi, Bruno. *Dante e la cultura medievale.* Rome: Laterza, 1983.

Nauert, Charles G. Jr. *Humanism and the Culture of Renaissance Europe,* Cambridge: Cambridge University Press, 1995.

Nelson, Robert S. "A Byzantine Painter in Trecento Genoa: *The Last Judgment* at S. Lorenzo." *Art Bulletin* 67, no. 4 (December 1985): 548–66.

Newman, John Henry, Cardinal. *An Essay on the Development of Christian Doctrine.* New York: Image Books, 1992.

Newton, Eric. *Tintoretto.* London: Longman, 1952.

Nieto, José. *Juan Valdés and the Origins of the Spanish and Italian Reformation.* Geneva: Droz, 1970.

North, John David. "The Medieval Background to Copernicus." In Arthur Beer and Kaj Aage Strand, eds. *Vistas in Astronomy*, vol. 17, *Copernicus.* Oxford: Pergamon, 1975.

Oakeshott, William. *The Mosaics of Rome.* London: Thames and Hudson, 1967.

Oberman, Heiko Augustinus. In I. Kouri and Tom Scott, eds. *Politics and Society in Reformation Europe.* Basingstoke: Macmillan, 1987.

Olin, John C. *The Catholic Reformation: Savonarola to Ignatius Loyola.* New York: Harper and Row, 1969.

Olson, Roberta J. M. "Giotto's Portrait of Halley's Comet." *Scientific American* 240, no. 5 (May 1979): 134–42.

———. "Renaissance Representations of Comets and Pretelescopic Astronomy." *Art Journal* 44 (1984): 217–23.

O'Malley, John W. *Praise and Blame in Renaissance Rome.* Durham: Duke University Press, 1979.

———. *Rome and the Renaissance: Studies in Culture and Religion.* London: Variorum, 1981.

O'Meara, Dominic J. *Neoplatonism and Christian Thought*. Albany: State University of New York Press, 1982.

Oremland, Jerome D. *Michelangelo's Sistine Ceiling*. Madison, WI: International University Press, 1989.

Orr, M. A. *Dante and the Early Astronomers*. London: Kennikat, 1969.

Osler, Margaret J., and Paul Lawrence Farber. *Religion, Science and World View*. Cambridge: Cambridge University Press, 1985.

Ozment, Steven. *The Age of Reform*. New Haven: Yale University Press, 1980.

Pagel, Walter. *Religion and Neoplatonism in Renaissance Medicine*. London: Variorum, 1985.

Painter, Sidney. *A History of the Middle Ages, 284–1500*. London: Macmillan, 1968.

Panofsky, Erwin. *Meaning in the Visual Arts*. New York: Doubleday, 1955.

———. *Idea: A Concept in Art Theory*. New York: Harper and Row, 1968 (1st ed. 1924).

———. *Studies in Iconology: Humanistic Themes in the Art of the Renaissance*. Stockholm: Almquist & Wiksell, 1960; reprint, New York: Harper and Row, 1972 (1st ed. 1939).

———. "The Neoplatonic Movement and Michelangelo." and "The Neoplatonic Movement in Florence and North Italy." In *Studies in Iconology*. New York: Harper and Row, 1972.

———. *Renaissance and Renascences in Western Art*. New York: Harper and Row, 1972.

———. *The Life and Art of Albrecht Dürer*. Princeton, N.J.: Princeton University Press, 1980.

Panofsky, Erwin, Raymond Klibansky, and Fritz Saxl. *Saturn and Melancholy*. Princeton, N.J.: Princeton University Press, 1980.

Paoletti, John T. "Michelangelo's Masks." *Art Bulletin* 74, no. 3 (September 1992): 423–40.

Paolucci, Antonio. *Ravenna: An Art Guide*. Ravenna: Edizioni Salera, 1971.

Parker, J., ed. *The Works of Dionysius the Areopagite*. New York: Richwood, 1976.

Partner, Peter. *Renaissance Rome, 1550–1559*. Berkeley: University of California Press, 1979.

Partridge, Loren., and Randolph A. Starn. *Renaissance Likeness*. Berkeley: University of California Press, 1980.

Pastor, Ludwig von, *The History of the Popes,* English ed. 24 vols. London: Routledge and Kegan Paul, 1901–28.

Pater, Walter. *The Renaissance,* (1893 text), Berkeley: University of California Press, 1980.

Pelikan, Jaroslav J. *The Development of Christian Doctrine: Some Historical Prolegomena*. New Haven: Yale University Press, 1969.

————. *Jesus through the Centuries.* New Haven: Yale University Press, 1985.

Perrig, Alexander. *Michelangelo's Drawings: The Science of Attribution.* New Haven: Yale University Press, 1991.

Peterson, Mark A. "Dante and the 3-sphere." *American Journal of Physics* 47, no. 12 (1979): 1031–35.

Piaget, Jean and Bärbel Inhelder. *Psychology of the Child.* New York: Basic Books, 1969.

Pietrangeli, Carlo; Fabrizio Mancinelli, et al. *Michelangelo e la Sistina: La tecnica, il restauro, il mito.* Rome: Musei Vaticani e Biblioteca Apostolica Vaticana (Fratelli Palombi Editori), 1990. [see also under Chastel et al].

Peirce, Philip. "The Arch of Constantine: Propaganda and Ideology in Late Roman Art." *Art History* 12, no. 4 (December 1989): 387–418.

Pignatti, Terisio. *Giorgione.* Venice: Alfieri, 1969.

Pirina, Caterina. "Michelangelo and the Music and Mathematics of His Time." *Art Bulletin* 67, no. 3 (1985): 368–82.

Pittaluga, Mary. *The Sistine Chapel.* Rome: Drago, 1962.

Plato, *Complete Works,* in 12 vols. London: Heinemann, 1978–82, (first printed, 1914–35), esp. vols. 1 (*Phaedo* and *Phaedrus*), 3 (*Symposium*), 5 and 6 (*Republic*) and 9 (*Timaeus*).

————. *Works,* ed. Betty Radice and Robert Baldick. Harmondsworth: Penguin Classics Series, reprinted, 1985 (esp. *Republic* and *Symposium*).

Plumb, John Harold, ed. *The Horizon Book of the Renaissance.* London: Collins, 1961.

Pogany-Balas, Edit. *The Influence of Rome's Antique Monumental Sculptures on the Great Masters of the Renaissance.* Budapest: Kiado, 1980.

Polacco, Renato. *La Cattedrale di Torcello: Il Giudizio Universale.* Canova: L'altra Riva, 1984.

Pope-Hennessy, John. *Italian Gothic Sculpture.* London: Phaidon 1972.

————. *Fra Angelico.* London: Phaidon, 1952.

————. Review of Carlo Pietrangeli, André Chastel et al. *The Sistine Chapel,* in *New York Review of Books,* 34 (15), 8 October 1987.

————. *Paradiso: The Illuminations to Dante's Divine Comedy by Giovanni di Paolo.* London: Thames and Hudson, 1993.

————. *Donatello, Sculptor.* New York: Abbeville, 1993.

Portoghesi, Paolo. *Rome of the Renaissance.* London: Phaidon, 1972.

Posèq, Avigdor W. G. "Michelangelo's Self-Portrait on the Flayed Skin of St. Bartholomew." *Gazette des Beaux-Arts* 124 (July/August 1994): 1–14.

Poulet, Georges. "The Metamorphosis of the Circle." In John Freccero, *Dante: A Collection of Critical Essays,* 151–69. Englewoood Cliffs: Prentice—Hall, 1965.

Prelowski, Ruth., trans. *The Beneficio di Cristo.* In *Italian Reformation Studies in Honour of Laelius Socinus,* ed. John Tedeschi, Florence: Le Monnier, 1965.

Priest, Paul. *Dante's Incarnation of the Trinity.* Ravenna: London Editore, 1982.

Proclus, *Elements of Physics,* ed. H. Boese. Berlin: Akademie-Verlag, 1958.
———. *Théologie Platonicienne,* text and trans. H. D. Saffrey and L. G. Westerink. 2 vols. Paris: Les Belles Lettres, 1968–74.

Provenzal, Dino. *Dante Alighieri: La Divina Commedia.* 3 vols. Venice: Mondadori, 1980.

Prowe, Leopold. *Nicolaus Copernicus.* Weidmannsche Buchhandlung, Berlin, 1883.

Quillet, J. "Soleil et Lune chez Dante." In Université de Provence, *Le Soleil, La Lune et Les Etoiles au Moyen Age,* Marseilles: Editions Lafitte, 1983.

Rahner, Hugo. *Greek Myths and Christian Mystery.* London: Burns and Oates, 1963.

Ralph, Philip Lee. *The Renaissance in Perspective.* London: Bell, 1974.

Ramsden, E. H., ed. *The Letters of Michelangelo, translated from the Original Tuscan,* 2 vols. London: Owen, 1963.
———. "Michelangelo and the Psychoanalysts." *Apollo* 120, no. 272 (October 1984): 290.

Raven, J. E. "Sun, Divided Line and Cave." *Classical Quarterly.* New series, 3, no. 1 (1953): 22–32.

Ravetz, Jerome R. "The Humanistic Significance of our Copernican Heritage." In Arthur Beer and Kaj Aage Strand, eds. *Vistas in Astronomy,* vol. 17, *Copernicus.* Oxford: Pergamon, 1975.
———. "Origins of the Copernican Revolution." *Nature* 189 (March 1961): 854–60.
———. "The Origins of the Copernican Revolution." *Scientific American* 215, no. 4 (October 1966): 86–98.

Réau, Louis. *Iconographie de L'art Chrétien.* Paris: Presses Universitaires de France, 1957.

Redig de Campos, Deoclecio. *Michelangelo, The Last Judgment.* trans. Serge Hughes, New York: Doubleday, 1978 (originally published in Italian as *Il Giudizio Universale di Michelangelo,* Milan, 1964).

Reynolds, Joshua. *Discourses on Art, 1790,* ed. R. R. Wark. New York: Collier, 1966.

Rheticus, Georg Joachim. *Narratio Prima.* in Edward Rosen, ed. *Three Copernican Treatises.* New York: Octagon: 1971.

Rice, David Talbot. *Byzantine Art.* Harmondsworth: Penguin, 1964.

Richmond, Robin. *Michelangelo and the Creation of the Sistine.* London: Barrie and Jenkins, 1992, reprinted 1993.

Robb, Nesca. *Neoplatonism of the Italian Renaissance.* London: Allen and Unwin, 1935.

Robertson, Charles. "Bramante, Michelangelo and the Sistine Ceiling." *Journal of the Warburg and Courtauld Institutes* 49 (1986): 96–105.

Roman Missal: Being the Text of the Missale Romanum, ed. J. O'Connell and H. P. R. Finberg. London: Burns Oates and Washbourne, 1950.

Rosen, Edward. "Galileo's Misstatements about Copernicus." *Isis* (1958): 319–30.

———. *Three Copernican Treatises*. New York: Octagon, 1971.

———. "Was Copernicus" *Revolutions* approved by the Pope?" *Journal of the History of Ideas* 36 (1975): 336–37.

———. "Copernicus as a Man and Contributor to the Advancement of Science." *Vistas in Astronomy*, 17. Oxford: Pergamon, 1975.

———. "Was Copernicus a Neoplatonist?" *Journal of the History of Ideas* 44 (1983): 667–69.

Roskill, Mark. *What is Art History?* London: Thames and Hudson, 1982.

Ruskin, John. *The Diaries*, selected and ed. J. Evans and J. Whitehouse, 3 vols. Oxford: Clarendon Press, 1956–59.

Russell, Bertrand. *Religion and Science*. London: Oxford University Press, 1960 (1st ed. 1935).

Russell, Colin A. *Copernicus: The Background to Copernicus: The Copernican Revolution*. Milton Keynes: Open University Press, 1972.

———. *Cross-currents: Interactions Between Science and Faith*. Leicester: Inter Varsity Press, 1985.

Saitta, Giusseppe. *Marsilio Ficino e la Filosofia dell'umanesimo*, Bologna: Fiammenghi, 1954.

Salmi, Mario. *The Complete Works of Michelangelo*. New York: Reynal, 1965.

Salvatoris, Gesta. *The Gospel of Nicodemus*, ed., H. C. Kim. Toronto: Center for Medieval Studies, 1973.

Salvini, Roberto. "Painting." In Mario Salmi, ed. *The Complete Works of Michelangelo*, 149–272. New York: Reynal, 1965.

———. *The Hidden Michelangelo*. London: Phaidon, 1978.

Sandstrom, Sven. *Levels of Unreality: Studies in Structure and Construction in Italian Mural Painting during the Renaissance*. Uppsala: Almqvist and Wiksells, 1963.

Santillana, Giorgio de. *The Age of Adventure: The Renaissance*. New York: Mentor, 1957.

Saponaro, M. *Michelangelo*. Milan: Mondadori, 1955.

Sarton, George. *The Appreciation of Ancient and Medieval Science During the Renaissance*, Philadelphia: University of Pennsylvania Press, 1955.

Sayers, Dorothy L. *Dante's Divine Comedy*, 3 vols. Harmondsworth: Penguin, 1962.

Schepp, J. A. *The Nature of the Resurrection Body: A Study of the Biblical Data*, Grand Rapids, MI: Eerdmans, 1964.

Schiller, Gertrud. *Iconography of Christian Art,* vols. 1 and 2. London: Lund Humphries, 1971.

Schott, Rudolf. *Michelangelo.* London: Thames and Hudson, 1963.

Schutte, Anne Jacobson. "The Lettere Volgari and the Crisis of Evangelism in Italy." *Renaissance Quarterly* 28 (1975): 639–88.

———. *Pier Paolo Vergerio: The Making of an Italian Reformer.* Geneva: Droz, 1977.

Setton, K. M. *The Renaissance: Maker of Modern Man.* Washington: National Geographic Society, 1970.

Seward, Barbara. *The Symbolic Rose.* New York: Columbia University Press, 1960.

Seznec, Jean. *The Survival of the Pagan Gods: The Mythological Tradition and its Place in Renaissance Humanism and Art.* New York: Harper, 1961.

Shapiro, Meyer. *Late Antique, Early Christian and Medieval Art.* London: Chatto and Windus, 1980.

Shearman, John. *Mannerism.* Harmondsworth: Penguin, 1967.

———. *Raphael's Cartoon in the Collection of Her Majesty the Queen and the Tapestries for the Sistine Chapel.* London: Phaidon, 1972.

Sheppard, A. "The Influence of Hermias on Marsilio Ficino's Doctrine of Inspiration." *Journal of the Warburg and Courtauld Institutes* 43 (1980): 97–109.

Shorey, Paul. *What Plato Said.* Chicago: University of Chicago Press, 1933.

———, ed. and trans. *Plato's Republic.* London: Heinemann, 1935.

———. *Platonism Ancient and Modern,* Berkeley: University of California Press, 1938.

Shorr, Dorothy C. "The Role of the Virgin in Giotto's *Last Judgment.*" in James Stubblebine, ed. *Giotto, the Arena Chapel Frescoes,* 169–82. New York: Norton, 1969.

Shrimplin, Valerie. "Michelangelo and Nicodemism: The Florentine *Pietà.*" *Art Bulletin* 71, no. 1 (March 1989): 58–66. Reprinted in William E. Wallace, ed. *Michelangelo: Selected Scholarship in English,* New York: Garland, 1995.

———. "Once More, Michelangelo and Nicodemism." *Art Bulletin* 71, no. 4 (December 1989): 693–94.

———. "Sun-symbolism and Cosmology in Michelangelo's *Last Judgment.*" *Sixteenth Century Journal* 21 (1990): 607–44.

———. *Sun-symbolism and Cosmology in Michelangelo's Last Judgment.* Ph.D. diss., University of the Witwatersrand, Johannesburg, submitted 6 March 1991.

———. "Hell in Michelangelo's *Last Judgment.*" *Artibus et Historiae,* no. 30, 15 (Vienna 1994): 83–107.

Shulman, Ken. "Waiting for the *Last Judgment.*" *Art News* 92, no.10 (December 1993): 100–107.

Shumaker, Wayne. *The Occult Sciences in the Renaissance. A Study in Intellectual Patterns.* Berkeley: University of California Press, 1972.

Simson, Otto von, *The Gothic Cathedrals: Origins of Gothic Architecture and the Medieval Concept of Order.* Princeton, NJ: Princeton University Press, 1956.

Singleton, Charles. S. *Art, Science and History in the Renaissance.* Baltimore: Johns Hopkins Press, 1967.

———. *Dante Alighieri. The Divine Comedy.* 3 vols. London: Routledge and Kegan Paul, 1971.

———. ed. *Companion to the Divine Comedy,* by C. H. Grandgent. Cambridge: Harvard University Press, 1975.

Smart, Alastair. *The Renaissance and Mannerism in Italy.* London: Thames and Hudson, 1971.

———. *The Assisi Problem and the Art of Giotto.* Oxford: Clarendon Press, 1971.

———. *The Dawn of Italian Painting, 1250–1400.* Oxford: Phaidon, 1978.

Smart, W. M. *Spherical Astronomy.* Cambridge: Cambridge University Press, 1960.

Sophocles, *Electra,* ed. George Patrick Goold, trans. F. Storr. London: Heinemann, 1975.

Stechow, Wolfgang. "Joseph of Arimathea or Nicodemus?" In *Studien zur toskanischen Kunst,* ed. W. Lotz and L. L. Möller, 289–302, Munich, 1964.

Steinberg, Leo. "Michelangelo's Florentine *Pietà*: The Missing Leg." *Art Bulletin* 50, no. 1 (1968): 343–59.

———. "Michelangelo's *Last Judgment* as Merciful Heresy." *Art in America* 63 (1975): 49–63.

———. *Michelangelo's Last Paintings: The Conversion of St. Paul and The Crucifixion of St. Peter in the Cappella Paolina, Vatican Palace.* Oxford: Phaidon, 1975.

———. "A Corner of the *Last Judgment.*" *Daedalus* 109 (1980): 207–73.

———. "The Line of Fate in Michelangelo's Paintings." In *The Language of Images,* ed. W. J. T. Mitchell, Chicago: University of Chicago Press, 1980.

———. "Shrinking Michelangelo." *New York Review of Books,* 28 June 1984, 41–45.

———. "Michelangelo's Florentine *Pietà*: The Missing Leg Twenty Years After." *Art Bulletin* 71, no. 3 (September 1989): 480–505.

———. "Who's Who in Michelangelo's Creation of Adam." *Art Bulletin* 74, no. 4 (December 1992): 522–66.

Steinmann, Ernst. *Die Sixtinische Kapelle,* Munich, 1905.

Stendhal, *Voyages en Italie, 1829.* Paris: Editions Gallimard, 1973.

Stephens, John. *The Italian Renaissance: The Origins of Intellectual and Artistic Change Before the Reformation.* London: Longman, 1992.

Sterba, Richard F., and Editha Sterba. "The Anxieties of Michelangelo Buonarroti." *International Journal of Psychoanalysis*, 37 (1956): 325–30.

———. "The Personality of Michelangelo: Some Reflections." *The American Imago*, 35 (1978): 158–77.

Stevenson, James. *Catacombs, Rediscovered Monuments of Early Christianity*. London: Thames and Hudson, 1978.

Stimson, Dorothy. *The Gradual Acceptance of the Copernican Theory of the Universe*. Gloucester, Mass.: Smith, 1972.

Stone, Michael E. "Judaism at the Time of Christ." *Scientific American* 228, no. 1 (January 1973): 80–87.

Strachan, Gordon. *Christ and the Cosmos*. Dunbar: Labarum, 1985.

Strauss, Walter L. ed. *The Complete Engravings, Etchings and Drypoint of Albrecht Dürer*. New York: Dover, 1973.

Strzygowski, Josef. *Origins of Christian Art*. Oxford: Clarendon Press 1923.

Stubbelbine, James., ed. *Giotto: The Arena Chapel Frescoes*. New York: Norton, 1969.

Summers, David. *Michelangelo and the Language of Art*. Princeton, N.J.: Princeton University Press, 1987.

———. *The Judgment of Sense: Renaissance Naturalism*. Cambridge: Cambridge University Press, 1987.

Symonds, John Addington. *Renaissance in Italy: The Fine Arts*. London: Smith and Elder, 1877.

———. *The Life of Michelangelo Buonarroti*. New York: Modern Library, 1892.

Tedeschi, John. *Italian Reformation Studies in Honour of Laelius Socinus*. Florence: Felice le Monnier, 1965.

———. "Italian Reformers and the Diffusion of Renaisssance Culture." *Sixteenth Century Journal* 5 (1974): 79–94.

Testori, Giovanni. *Michelangelo Buonarroti: Rime*. Milan: Rizzoli, 1975.

Thode, Henry. *Michelangelo und das Ende der Renaissance*. Leipzig: Fischer and Wittig, 1962; first ed., 3 vols. in 4, Berlin: G. Grote, 1902–12.

Thompson, D. V., ed. and trans. *Cennino d'Andrea Cennini, Craftsman's Handbook*. New York: Dover, 1933.

———. *Materials and Techniques of Medieval Painiting*. New York: Dover, 1956.

Thorndike, Lynn. *A History of Magic and Experimental Science*, 8 vols., esp. vols. 5 and 6. New York: Columbia University Press, 1947–64.

Thuillier, Pierre. "Espace et Perspective au Quattrocento." *La Recherche* 160 (1984): 1384–98.

Tollemache, B. C., ed. *Diderot's Thoughts on Art and Style*. New York: Burt Franklin, 1973 (reprint of 1893 ed.).

Tolnay, Charles de, "Le *Jugement Dernier* de Michel Ange: Essai d'interpretation." *Art Quarterly* 3, no. 2 (spring 1940): 125–46.

―――. *Michelangelo*, 5 vols. Princeton, N.J.: Princeton University Press, 1943–60.

―――. "Michelangelo Buonarroti." In *Enciclopedia Universale dell'Arte*, 9, 263–306. Rome, 1963.

―――. *Michelangelo: Sculptor, Painter, Architect*. Princeton, N.J.: Princeton University Press, 1981.

Toulmin, Stephen, and June Goodfield. *The Fabric of the Heavens*. Harmondsworth: Penguin, 1961.

Trinkaus, Charles. *In our Image and Likeness: Humanity and Divinity in Italian Humanist Thought*, 2 vols. London: Constable, 1970.

―――. *The Scope of Renaissance Humanism*. Ann Arbor, Mich.: University of Michigan Press, 1983.

Turner, Almon Richard. *The Vision of Landscape in Renaissance Italy*. Princeton, N.J.: Princeton University Press, 1966.

Tusiani, Joseph. *Italian Poets of the Renaissance*. Long Island City: Baroque Press, 1971.

Ullman, Walter. *A Short History of the Papacy in the Middle Ages*. London: Methuen, 1972.

Université de Provence. *Le Soleil, La Lune et Les Étoiles au Moyen Age*. Marseilles: Editions Lafitte, 1983.

Université Libre de Bruxelles, *Le Soleil à la Renaissance: Colloque International*. Bruxelles: Presses Universitaires de Bruxelles, 1965.

Vasari, Giorgio. *Lives of the Artists*, ed. George Bull, Harmondsworth: Penguin, 1971.

―――. *Lives of the Most Eminent Painters, Sculptors and Architects*, trans. Gaston du C. de Vere, 3 vols. New York: Abrams, 1979.

Venturi, Lionello. *Italian Painting*. Geneva, Skira, 1950.

Virgil, *Georgics*, trans. H. Rushton Fairclough. London: Heinemann, 1978.

Vitruvius, *Ten Books of Architecture*, ed. and trans. M. H. Morgan. New York: Dover, 1960.

Von Einem, Herbert. *Michelangelo*. London: Methuen, 1973.

Voragine, Jacobus de. *Legenda Aurea*. New York: Arno, 1969.

Waddington, Raymond B. "The Sun at Centre. Structure and Meaning in Pico della Mirandola's Heptaplus." *Journal of Medieval and Renaissance Studies* 3 (1973): 69–86.

―――. "Here Comes the Sun." *Modern Philology* 79, no. 3 (1982): 256–66.

―――. "Ficino in English." *Sixteenth Century Journal* 14 (1983): 229–31.

Walker, Daniel Pickering. *Spiritual and Demonic Magic from Ficino to Campanella*, Nendeln: Kraus Reprint, 1976 (1st ed. London, 1958).

―――. *The Decline of Hell: Seventeenth-Century Discussions of Eternal Torment*. London: Routledge and Kegan Paul, 1964.

————. *The Ancient Theology: Studies in Christian Platonism from the Fifteenth to the Eighteenth Century*. London: Duckworth, 1972.

Wallace, William E., ed. *Michelangelo: Selected Scholarship in English*, New York: Garland, 1995.

Weinberg, Steven. *The First Three Minutes*. London: Fontana, 1987.

Weiss, Roberto. *The Renaissance Discovery of Classical Antiquity*. Oxford: Blackwell, 1969.

Wheeler, M. *His Face: Images of Christ in Art*. New York: Chameleon, 1989.

White, Andrew Dickson. *A History of the Warfare Between Science and Theology in Christendom*. New York: Dover, 1960 (reprint of 1896 ed.).

White, John. *The Birth and Rebirth of Pictorial Space,* 3d ed. London: Faber and Faber, 1987.

————. *Art and Architecture in Italy, 1250–1400*. Harmondsworth: Penguin, 1966.

Whittick, Arnold. *Symbols, Signs and their Meaning*. London: Hill, 1960.

Wigmore, John Henry. *Evidence*, 10 vols. Boston: Little, Brown, 1981.

Wilde, Johannes. *Venetian Art from Bellini to Titian*. Oxford: Clarendon Press, 1974.

————. *Michelangelo: Six Lectures,* ed. John Shearman and Michael Hirst) Oxford: Clarendon Press, 1978.

Wildiers, N. Max. *The Theologian and his Universe: Theology and Cosmology from the Middle Ages to the Present*. New York: Seabury, 1982.

Wilkins, E. H., and Thomas G. Bergin, eds. *A Concordance to the Divine Comedy*. Cambridge: Harvard University Press, 1965.

Williams, Christopher John Fards. *What is Truth?* Cambridge: Cambridge University Press, 1976.

Williams, George Huntston. *The Radical Reformation*, Philadelphia: Westminster Press, 1962; 3d ed., rev., Kirksville, MO: Sixteenth Century Journal Publishers, 1992.

Wind, Edgar. *Pagan Mysteries of the Renaissance*, rev. ed.) Oxford: Oxford University Press, 1980.

————. *Michelangelo's Prophets and Sibyls*. Oxford: Oxford University Press, 1960.

————. "Maccabean Histories in the Sistine Ceiling." In *Italian Renaissance Studies,* ed. Ernest Fraser Jacob. London: Faber and Faber, 1960.

Wittkower, Rudolf. *Architectural Principles in the Age of Humanism*. London: Tiranti, 1962.

————. *Idea and Image: Studies in the Italian Renaissance*. London: Thames and Hudson, 1978.

————. *Allegory and the Migration of Symbols*. London: Thames and Hudson, 1987.

Wittkower, Rudolf, and Margot Wittkower, eds. *The Divine Michelangelo: The Florentine Academy's Homage on his Death in 1564*. London: Phaidon, 1964.

Wölfflin Heinrich. *Classic Art*. London: Phaidon, 1961.

Wright, Anthony David. *The Counter-Reformation*. London: Weidenfeld and Nicolson, 1982.

Wright, Lawrence. *Perspective in Perspective*. London: Routledge and Kegan Paul, 1983.

Yates, Frances. A. *Giordano Bruno and the Hermetic Tradition*. London: Routledge and Kegan Paul, 1964.

Yourgrau, Wolfgang and Allen D. Breck, eds. *Cosmology, History and Theology*. New York: Plenum, 1977.

Zalten, J. *Creatio Mundi*. Stuttgart: Klett-Cotta, 1979.

Zoubov, Vassili P. "Le Soleil dans l'oeuvre scientifique de Léonard de Vinci." In Université de Bruxelles, *Le Soleil à la Renaissance*, Brussels: Presses Universitaires de Bruxelles, 1965.

Index

Note: Illustrations are indicated by *italic* numerals.